THE INVISIBLE MASTERPIECE

THE INVISIBLE MASTERPIECE

Hans Belting

The University of Chicago Press

HANS BELTING is professor of art history at the Staatliche Hochschule für Gestaltung, Karlsruhe, Germany. Previously he held an endowed chair in the Department of Art History at the University of Munich. He is the author of numerous books in medieval and Northern European art. The University of Chicago Press has published two of his books, *The End of the History of Art?* (1987) and *Likeness and Presence: A History of the Image before the Era of Art* (1993).

The University of Chicago Press, Chicago 60637
Reaktion Books, London EC1M 3JU, UK

First published in English 2001

This is a revised edition of a book published in 1998 by Verlag C. H. Beck, Munich, under the title *Das unsichtbare Meisterwerk: Die modernen Mythen der Kunst*
© Hans Belting

English-language translation © Reaktion Books 2001
English translation by Helen Atkins

The publication of this translation was subsidized by a grant from
INTER NATIONES, Bonn

Printed and bound in Great Britain
00 09 08 07 06 05 04 03 02 01 1 2 3 4 5

Library of Congress Cataloging-in-Publication Data

Belting, Hans
 [Unsichtbare Meisterwerk, English]
 The invisible masterpiece / Hans Belting; English translation
 by Helen Atkins
 p. cm.
 Includes bibliographical references and index.
 ISBN: 0-226-04265-0 (cloth: alk. paper)
 1. Art appreciation–History. 2. Art criticism–History. I. Title

 N7475 B45313 2001
 701'18—dc21

 2001027411

This book is printed on acid-free paper.

Contents

701.18
Bel

Preface

This edition in English lacks three chapters to be found in the original edition published in German in 1998. I took this decision in order to bring out the essential argument of the book more clearly. *The Invisible Masterpiece* is a conceptual history of the modern work of art. *Modern*, in this case, means a time span that reaches from *c.* 1800 – the rise of Romanticism and the public art museum – to *c.* 1960, when art production increasingly turned from the traditional work of art and its firm profile as a personal creation of an object for exhibition. For the purposes of the arguments followed in this book, it is crucial to convince the reader that the art-work, considered in the above-described sense as a topic in its own right, deserves a new inquiry that should include the history of art institutions and art criticism.

The aim of this book is not to insist that modern art is nothing more than a myth, as one sometimes reads these days, but that it celebrated, or suffered, myths of its own that also profoundly influenced the general public or were imposed on art by art literature and its leading authorities – writers, philosophers and poets. Paradoxically, a book devoted to the analysis of an ideal of art production (the work) is not limited to a discussion of the works themselves but gives more room to the lives and thoughts of artists who faced the unending task of redefining and reinventing the idea of art they had to apply in their works. A reader who is familiar with topics such as the 'aura' of the unique museum piece will nevertheless agree that a truly conceptual history of the work of art (including the loss of the work as an accepted norm one generation ago) has not been firmly established as a familiar topic. If it had been, then this book would have been easier to write and less difficult for readers to accept. On the contrary, the subject of the book will remain controversial for some time to come. And yet it is not an arbitrary question to ask what it was that distinguished art production (and also the discussion of single works) in the period around 1800 from that of previous centuries, nor is it to ask what it was that the avant-garde resisted and criticized after 1960.

The term 'modern' is still ambivalent enough to divide an audience that either identifies with classical modernism or views it in retrospect. Another matter dealt with in this book that will also cause difficulties for some readers is the view that modern art shared modern utopian thought and thus always transgressed or transcended its own limits toward the idea of absolute art or of an art that was to appear at some later date. The permanent departure from what has been done and understood already is such a salient feature of modern history and culture that art by necessity had to follow the same route. This means that an idea (Art) never came to rest in the actual work production but required an ever new and unexpected realization. In addition, the 'quest of the absolute', to quote from the title of a book by Erich Franz, implied an unwillingness to accept the embodiment of the idea of art in a given work.

I must admit that writing *The Invisible Masterpiece* began as an attempt to take up the subject of a previous book by me that dealt with the conceptual history of medieval images prior to Renaissance art entitled *Likeness and Presence*. If one viewed my project as a triptych, then the history of Renaissance and post-Renaissance art would be the middle part. But the Renaissance and its immediate aftermath is the period most fully studied in art history, and thus may be allowed to be the dispensable part of my project.

The reader needs to be told what the three chapters dealt with that are missing from this English edition. Chapter One discussed the existing theories that art production and its symbol, the autonomous 'work', attracted in modernity. Its structure somewhat contradicted the narrative style adopted for other chapters. Chapter Two traced the masterpiece as well as the dominant views on art in the centuries preceding the rise of 'modern art' as I understand it. This was a kind of 'prehistory' of the book's topic, contrasting it with the history and theory of art production in the nineteenth century. A third chapter, number Seventeen in the German edition, situated on the one hand the Bauhaus and on the other Surrealism as the two opposite ends of art discussion in their day. At the Bauhaus, 'style' and 'design' were discussed in an attempt to refute the traditional idealism inherent in the creation of the autonomous art-work. Thus, a first crisis in art production, as a self-sufficient ritual, had already occurred in the 1920s. Today we are used to a permanent crisis in art production, not least because of the fresh directions made possible by the latest technologies. But this topic is beyond the limits of this book's purpose. I therefore do not attempt to make value judgements or

to adopt a nostalgic position when I write of the modernist or classical modern work as a memory, however much it continues to be produced today. The time may have come for looking at my subject as one in a chapter of art history that may not belong completely in the past but which already allows for a historical view.

This book was first conceived ten years ago at Munich university when I directed a lecture series dedicated to 'famous works of art in the mirror of conflicting interpretations'. Speakers that included André Chastel, the late doyen of French art history, and Wolfgang Hildesheimer, the author of a novel about an art critic named Talbot, contributed to the series' success. Chastel's final book, on the *Mona Lisa*, was a direct outcome of his Munich lecture. Later, the topic of my book, as soon as I began writing it, no longer centred on the masterpiece and the modern dissent surrounding it, but concentrated on the hybrid nature of what we call 'a work of art'. Most of us are unaware that we apply an essentially modern conception when we speak of it, and therefore tend to ignore its special significance when we speak vaguely of a history of art in general terms.

The bulk of this book was written in 1995 at the Wissenschafts-Kolleg in Berlin, to which I had been invited by its rector, Wolf Lepenies, and where I received much encouragement. John Onians, who shared my year in Berlin, later invited me to a conference on the masterpiece in Japanese art held at the University of East Anglia, Norwich, where I first met Michael Leaman and discussed with him the possibility of an English edition of the book. At Columbia University I lectured on the less familiar aspects of the masterpiece idea, with my good friend Arthur Danto acting as respondent. Shortly thereafter, in the spring of 1998, I participated in a lecture series organized by the Louvre, the papers from which were recently published by Gallimard with the title *Qu'est-ce qu'un chef-d'œuvre?* In every case I had to defend the aim of my book, which in fact deals with a different topic and studies the idea and burden of the artist's 'work' in modern times.

Victor Stoichita gave me helpful advice in our Munich years when I was not yet fully aware of what it was I was heading towards. Henk van Os also lent me much support when most of my friends were struggling to figure out what it was I was writing about. The German edition of this book met with a truly controversial response, as it seemed to threaten the accepted idea of modern art, which, however, was neither its aim nor its topic. Even the synopsis of nineteenth- and twentieth-century art seemed reason enough to defend the one against the other, without allowing a common perspective on their utopian ideas and their

relation to cultural history. Thus I hope that the English edition will clarify what it is that this book is concerned with, whether its readers share my views or not. I was greatly supported by the team at Reaktion Books, and found an invaluable helper in Robert Williams, who assisted me in getting the English edition into shape.

Introduction

I

A masterpiece cannot be invisible. If it were, we could not discuss it. So I use the term as a metaphor for the idea of a work that comprises art in the absolute – a state beyond the reach of every tangible art-work. This book's title, therefore, does not refer to any specific work, but only to an unattainable ideal, a work in which a dream of art (or art as a dream) is incorporated. People used to imagine just such a work in much the same way that they imagined the art of previous ages to have been far superior to that of their own day, or projected how marvellous art would be in the future. Such musings and arguments were fuelled by optimism and doubt, both of which called existing works into question, measuring them against the far superior *idea* of the work of art.

My inquiry into the invisible masterpiece was inspired by Honoré de Balzac's *Le Chef-d'œuvre inconnu* (1831), a prophetic warning that has by turns unnerved and encouraged artists, not least Cézanne, Gauguin and Picasso, ever since it appeared. Balzac's story concerns a masterpiece worked on over many years by the elderly artist Frenhofer, a painting Frenhofer frequently comments on approvingly to his friends yet stead-fastly refuses to show them. Finally he relents, but on confronting it they are totally bewildered: they can see paint on a canvas, but no subject. Frenhofer had repeatedly effaced and repainted the work over the years because he sought to realize an art-work that triumphed over reality and the constraints imposed on every work that could be said to be finished or completed. For the self-deluding Frenhofer, the act of creation had become more important than the product. So the long-hidden work was not, after all, Frenhofer's masterpiece, but a failed attempt to make *art itself* visible in an authoritative and definitive epiphany. While in real works, art necessarily becomes an object, the ideal of art had to be released from such reification in order to serve the unbounded imagina-tion. As long as no one was able to create the kind of work that qualified as absolute art, painters and sculptors could continue in the hope that one day this remote goal would be realized.

I am not using this fiction of an invisible masterpiece to disparage

the art of the last two centuries or to suggest to the reader – as some have done in recent years – that modern art has failed. I am not concerned with questions of quality or value judgements. My aim is to draw attention to that constant restlessness so characteristic of modern artistic creativity and which has driven it forward at such a breathless pace. The modern idea of art gained mastery over works themselves, and as a result fed the unceasing production of yet more works, none of which, however, could be anything more than a milestone on the long road to an art of the future. So my subject is the ideal of absolute art, which persistently drove artistic production but always eluded it. This unrealizable aspiration in art is often confused with the compulsion to produce something truly new and original, whereas in fact the new is often only a mask for an ideal that is still seeking its place in the world of art.

The work's idea – the art-work as an entity of its own – is, therefore, distinct from the general idea of art, even though this may strike some readers as an arbitrary discrimination. This book, in fact, is not about the history of modern art, for then its narrative would necessarily have to take a very different road. What I intend to do is to trace, in art criticism as well as in art itself, the preoccupation with the changing status of the work of art, including its ultimately hyperbolic concept. In the nineteenth century, 'masterpiece' was a means of speaking of an absolute work, which of course remained an unfulfilled ideal. But soon the term 'masterpiece' became devalued as a result of its excessive and arbitrary use, not least as a term of flattery. So the twentieth century's avant-garde abandoned an exhausted term that no longer served the idea of absolute art, since the latter now defied the scope of any single work. But even in the nineteenth century the term 'masterpiece' implied a dream that transcended the individual work.

In the discourse on modern art the anachronistic idea of a masterpiece seemed to betray the experimental project of the avant-garde, for the anachronism left art the victim of an 'aura' (as Walter Benjamin called it) that was nothing short of sacred. It is therefore necessary to go back to the nineteenth century and reconstruct a discussion in which the masterpiece represented simply a dramatic way of speaking of the idea of the work. An absolute masterpiece was not an *excellent* work, it was an *impossible* one. Even when people borrowed that concept as a yardstick for all actual works, they could only permit the ideal to exist in preliminary blueprints or to loom invisibly behind serial attempts as deliberately unsuccessful circumscriptions. Thereafter, the celebrated works of the past were viewed with a mixture of melancholy and frustration, for they

seemed to have attained everything that was denied to modern art. Artists saw the *Mona Lisa*, so deeply revered by the public, as a mere artistic fetish from which they had to liberate themselves. Not only did the artists insist that such so-called 'masterpieces' were myths rather than works, in other words of owing their fame not to the achievement they represented but to a fiction; they also revolted against a false myth of the work of art in general, that is, a false myth of what a work was to be.

The cult of the *Mona Lisa* conjured an arbitrary experience in front of the work of art that many generations of modern artists personally rejected. The *Mona Lisa* was not merely a work, it also embodied a phantom. It was anything but an 'invisible masterpiece' – even if in this particular case the cliché was more visible than the work itself. Twentieth-century artists not only had a different conception of what a work of art was, they often wholly rejected the idea of the completed and definitive piece as the proper goal of their creative efforts. So these debates (and the programmes and manifestos of many avant-garde movements) questioned the idea of the work as such. The concept of the work seems to us today so traditional and as ancient that, in our view, the nineteenth century appears to have inherited it as a legacy from earlier times, and that modern artists continued to struggle with an ideal that was no longer of their own taste. The fact that the history of the museum coincides with the history of modern art seems to support this assumption. Benjamin's critique of the 'aura', which he directed against the museum piece as a unique object, backs the same view.

This book sets out to show that, on the contrary, the concept of the autonomous work was of modern invention. Due to a crisis originating in a new estimation of art, a painter's work was expected to represent a lofty ideal that as yet defied any certain definition. Now, when people praised a work by 'the divine Raphael', they celebrated their modern gaze, not Raphael's. Such a work re-emerged in a modern 'history of art', a history remarkably different from the traditional lives of individual artists. One visited museums in order to worship famous works, whose subject-matter had ceased to be of interest. A new type of art discourse guided not only the viewing but the production of art too. Any given work was expected to compensate for the loss of a reliable and generally valid definition. And so the modern artist's struggle was not merely a continuation of the artist's perennial effort of self-expression, it had the task of demonstrating, a conception of art that had general validity. From now on a new work was by definition a kind of programme that was judged as an argument for a general theory of art. This is the darker side of the bright dawn of autonomous art, for the new freedom imposed on

artists the burden of producing results for justifying art. The creative artist (who, ultimately, could only turn out to be either a genius or a total failure) felt constrained by a positively ontological duty to express the 'truth' of art. The work became, in André Malraux's phrase, the ultimate 'monnaie de l'absolu'.

Arthur Schopenhauer provided a philosophical analysis of the modern idea of the work of art in *Parerga and Paralipomena* (1851): 'The separation of form from matter [is part of] the character of the aesthetic work of art, precisely because it is the function of the work of art to make us cognizant of a [Platonic] idea.' The form liberates itself from the matter, just as an idea detaches itself from an object, which is what the work, in its material aspect, is. Schopenhauer left open the precise definition of the idea, which is why he wrote of a Platonic idea. But others have understood it to mean the idea of art itself. Schopenhauer saw the work of art, though of physical substance, as coming close to an idea, as it emerges, as an object that has 'already passed through a subject', that is, through the imagination of its maker. The idea is general, whereas things in the real world can only signify something particular. True, a work of art is also merely an individual object, but 'the true work of art leads us away from any individual experience' to something we can see in many things or works – the 'form or idea as such'. The form acts 'only upon the eye', and this effect makes it appear as the agent of an idea (§209).

If, then, the modern work of art was always in thrall to an idea of art that made it into the representative of that idea, it is hardly surprising that it soon found itself in continuing crisis. The fact that it was more a demonstration than a work explains why artists eventually decided to free themselves from all the dead weight associated with the art-work. We tend to forget that the growing resistance, from 1960 onwards, to the idea that art production required years of training was not an 'accident' in the history of modern art, but merely brought out into the open problems that had long been inherent. Some commentators have seen this as marking the end of modern art – hence the contemptuous label 'recent art' that is sometimes applied, notably in French criticism, to the art of the last few decades. I take a wholly different view. To me the new kinds of artistic practice – Performance art, Conceptual art or Video Installation – reveal a determination to be free from the contradictions imposed by the compulsion to produce works of art, a compulsion that had always subjected even the most radical avant-garde artists to the tyranny of the convincing single work. They also originally were meant as a rebellion against the art market, which had forced even artists of an

anarchistic bent to deal in the 'currency' of the work, so that a work seemed ultimately to be serving the art market rather than art itself. By writing texts or making stage appearances, artists sought to avoid producing works, but without thereby ceasing to create art. It was simply art by other means – free from the canon, and the constraints, associated with a work. A work of art had anyway tended to forfeit the freedom of the creative process the moment the artist declared the work to be finished. Where hitherto the artist had expressed himself through the authority of a work, he now tried to fill the void that replaced the work with his own body or with the living word. If he did continue to produce works, these were in effect critical commentaries on what he now regarded merely as the ideology of the work.

One need only invoke a name like that of Marcel Duchamp to indicate the degree of reflection that the debate on the work of art had reached by the early twentieth century. One aspect of this reflection was the critical attitude adopted towards that hybrid entity comprising the work (the tangible object) and art (the intangible idea). Duchamp confronted the art world not with parodies but with emblems of the former work idea; his were not works in the usual sense, they were performances that enabled him to question the traditional idea of the work. Prior to Duchamp, Manet attempted a painted theory of the work in his *Olympia* (illus. 56), a revision of the traditional museum Venus, and turned pictures like the *Bar at the Folies-Bergère* (illus. 58) into a mirror of modern life. At an advanced age Picasso deconstructed his own working canon when he painted more than 50 variations on an old masterpiece, thereby dissolving it into series of individual *aperçus*. I prefer to view these critical statements or painted revolts as an uninterrupted feature of modern art rather than in terms of a historical chronology or as a personal trait.

This is essential if one attempts a conceptual history of the modern work of art. The conflicts about the work, in fact, far from emerging only in retrospect, were an integral part of the history of the work of art in the modern period (the era of the museum and the avant-garde). From the very outset the modern work took on the responsibility of representing a most elusive concept of art. Since the Romantic period there has been no theory of art with generally accepted rules and values; the burden of proof, in the name of art, fell to the individual work. This is why programmes and manifestos were protecting groups of artists: a group could offer mutual support in the uncertain adventure of art. But to think along these lines one has to be willing to isolate the project of the work (and the history of the idea of the work) as a topic in its own

right. This means paying greater attention to the utopian nature of modern art (as a general feature of the modern age), which conflicts with the finite and limited character of a given work. True, there have always been works that seemed to anticipate an art of the future and point ahead, beyond themselves. But this anticipation of a meaning they would gain only in the future actually intensified the conflict with their own finality as works. This dichotomy between vision and reality makes the art-work an apt paradigm of the modern period.

If visual artists were tormented by the problems of legitimizing the work, poets and novelists recognized the same difficulties. In *Doctor Faustus* (1947), Thomas Mann gives eloquent expression, in a conversation between the narrator and the composer Leverkühn, to his doubt as to whether the work (in this case the novel) could bear true witness to the experience of its own time. Leverkühn ironically remarks that 'art experience … is the actual agent of the work-idea – not the idea of a particular work but the idea of the opus itself, the objective and harmonic creation complete … In a work there is much seeming and sham, one could even say that as a "work" it is fiction in its own right. Its ambition is to make one believe that it is not made, but born … But that is a delusion. Never did a work come like that. It is labour: labour for fiction's sake.' Leverkühn therefore asks himself whether 'this little game is still permissible, still intellectually possible … whether the work as such, the construction, self-sufficing and in harmony with itself, still stands in any legitimate relation to the total insecurity and lack of harmony of our social situation; whether all fiction, even the most beautiful … has not today become a lie.'

2

The narrative in this book should not obscure the fact that we lack still the methodology (and even a consensus) for writing a history of the work of art (as an experience and as an idea) in the modern age. Though my account is arranged in chronological terms so as to trace the debate from generation to generation, we are still at a preliminary stage, collecting the sources required for a history of the concept of the work. It is therefore also necessary to speak of the artists themselves, who participated in the ongoing debate about the work and argued their case with the art critics. The history of modern art is usually understood as a history of progress – as a history of innovations. But for my purposes we also need to consider, for example, the rôle of art criticism and art insti-

tutions (the museum and the Salon), or that of literary culture (not least Proust), Japonisme and Primitivism in order to trace out the network that provided the debate about the work with a contemporary meaning and which made even the proclamation of an anti-work possible.

The topic of the masterpiece – which, however, is not my primary theme – is better established. In *Masterpieces: Chapters on the History of an Idea* (1979), Walter Cahn distinguishes between the 'absolute masterpiece', a conception born in the Romantic period, and the 'classical masterpiece' of the eighteenth century that conformed to the rules of composition prescribed by the academies. Of course the term 'masterpiece' existed much earlier, and it originally designated the piece of work required from a craftsman as his qualification for admittance, as a master, to the guild. This *Meisterstück* was the product of a craft or art education, the rules of which were enforced by a corporation – in short, it represented the very reverse of freedom and originality. Drawing attention to this antithesis, Arthur C. Danto in his essay 'Masterpieces and the Museum' (1989) discussed matters that will concern us too in the opening chapters of this book. A *masterpiece* that was to be admired in a museum, contrary to the meaning of the term once used for a craftsman's presentation piece, now, paradoxically, reappeared as the free creation of a 'genius'. In this sense it was enshrined in a mystery that openly contradicted the earlier doctrine based on art education.

The 'absolute masterpiece', as Cahn calls it, came to epitomize a new idealism that left its imprint in every new work, including minor ones. With the collapse of the systems of training provided by guild masters and, in turn, by academies of art, objective and collective practice gave way to subjective and solitary creation. The new cult of art idolized works that could no longer be classified according to established rules. Art appreciation ceased to be the preserve of experts, and it was not long before writers and poets embarked on a new kind of 'art literature'. Since art no longer followed accepted criteria of judgement, its practitioners demanded a freedom that also resulted in their social isolation. Following the collapse of academic education, in which individual genres, for instance history painting, existed in a hierarchy (the genres were actually taught as discrete disciplines in the old academies), every genre was now invested with the full authority of art and with a quasi-religious dignity. It became what Theodor Adorno has called a 'monad' of art, which could only be judged by its own inherent standards, not by any external or general criteria.

The ambitious attempts that guided modern philosophy to develop

an ontology of the work of art in universal terms (i.e., beyond the limits of place and age) proved ultimately unsuccessful. European modernism anyway misjudged its thinking as representing universal standards. Since his ideas were both strongly influenced by his own era and rooted in a tradition derived from Romanticism, even Martin Heidegger failed to develop a universally valid theory of the work of art as such. It was easy for Adorno in his *Aesthetische Theorie* (1970) to expose the contradictions inherent in this discourse. The 'truth' discernible in a work changed with every new era, in which this truth was re-examined. Thus I feel justified in tracing our notion of the work of art as a modern concept, as against a universal idea valid for all times. Only when this is accepted does it make sense to describe the rise and decline of an idea of the work that was rooted in Romantic thought, fitted with the creation of the museum, reached a dramatic turn with early Abstract art, and, finally, fell into a crisis around 1960. Its changing modernity was not only represented by the works themselves but also confirmed in the debates they provoked. Thus at each stage of modern art there was a contemporary notion of art, to which the respective works bore witness. It seemed that art as an idea could only be realized in the authority of particular works.

The best-known criticism of this conception of the work was formulated as far back as 1936 by Walter Benjamin in his well-known essay 'The Work of Art in the Age of Mechanical Reproduction'. It should not be forgotten that Benjamin regarded the 'aura' of the work of art as an anachronism in the mass society of advanced modernity. This aura in his view was inherited from religious icons of the past. But the art-work's erstwhile status as a fetish of art seemed no longer compatible with the anonymous pictures produced by technological media and multiplied by reproduction. The unique single work, admired as an original in the museum, embodied a historical claim that in modern democratic conditions was no longer plausible. Such ideas were already being discussed in the 1920s at the Bauhaus in Dessau, where art and design, or the art-work and interior design, contradicted each another in artistic training. The Bauhaus wanted art to reconquer its place in life, not withdraw into its temple, the museum. Benjamin, however, questioned art as a legitimate project for his own times, and concluded in the negative with his critique of the outdated status of the art-work, now to be replaced by photography and film. His argument highlighted the gulf that had opened up between the art-work in the museum, even if it was of most recent origin, and the world of the technological media, a gulf also reflected in the conflict between high and low art, which nowadays

seems to have been decided in favour of mass culture.

In our time, now that photography and film-making follow a different discourse and yield to other media, Benjamin needs a critical revision. He was mistaken, anyway, when he simply equated the 'aura' of the work of art with that of religious images. He himself had identified another source of this modern 'aura' in his Berne university dissertation on Romantic art criticism, *Der Begriff der Kunstkritik in der deutschen Romantik*, published in 1920. The aura was redirected to the art work from literature and philosophy, whose spokesmen sought to 'transform the individual work of art into the absolute work of art'. In their longing to experience transcendence, the Romantics were ready to reduce art production to an 'idea'. This idea had become detached from the work, just as in the traditional sacred image the archetype was detached from its material support, the icon, in the minds of the faithful. Thus in the modern period there emerged a 'religion of art' that conceived of the work of art in metaphysical terms – though the best part of a century was to elapse before absolute art in Romantic music and poetry was followed by abstraction in the visual arts. In his dissertation Benjamin reminds us of the contradictions inherent in the conception of the modern work of art: 'Every work is necessarily incomplete in relation to the absolute of art, or – and this is the same thing – it is incomplete in relation to its own absolute idea.'

The dilemma of an individual capable of infinite feeling, and yet finite within his own body, aroused melancholy akin to that which the Romantic beholder felt when in front of a work of art. The idea of absolute freedom reached its limits anyway when, in the completed work, artists were left with only the memory of the creative process. Thus, in his book *Melancholy* (1988), L. F. Földényi describes the artist's discouragement when creating the work: 'Every significant work is unrealizable, because it exposes the nothingness concealed in the here and now.' Where the artist was preoccupied with *self*-creation, the creation of *works* inevitably proved insufficient. Friedrich Schelling gave eloquent expression to this dilemma when he observed in 1802 in his Jena lectures that art was gaining a new meaning as the 'concrete representation of the absolute', which, however, it could only ever represent through 'individual finite things' we call works – works that are things and yet more than things.

Here the discussion had reached a degree of subjectivity against which Hegel felt impelled to protest. He defended the objective aspect of art in representing a society or a culture. In his *Lectures on Aesthetics* he

complained of the subjectivity of contemporary art, which, he said, lacked the universal truth art once possessed. It was over-burdened with reflection and was wholly at the mercy of the feelings of its spectators. Here we find for the first time a philosopher complaining about art as no longer according with his own thinking. The self-reflection he observed in the art of his day also touched on the status of the self-sufficient work, which no longer symbolized, as he believed, the creeds of the society that had brought it into being. As a result, Hegel pointed out, 'we no longer find real truth [in art], which has been removed to the sphere of our own imagination', rather than making itself essential to society. Museum art, present neither in churches nor public spaces but only in its own temple, is clear evidence of this state of affairs. The art-work is no longer present in the public realm, but, confined in a kind of enclave, draws one's gaze only to itself. Its evidential rôle has become the capacity to incarnate a most uncertain idea of art. This presentation qualified it as a representative in the name of art. In such institutions the presence of art was synonymous with the presence (and presentation) of works.

There is an inherent contradiction in that art-works are, in the first place, things, bodies of art, which however, reject the corporeality of what they represent. In Balzac the 'unknown masterpiece' does not, as the painter Frenhofer claims, represent the body of a woman but the body of the work itself, the body of painting. In the twentieth century, abstract art completed this alienation from the empirical world. Art, it seemed, found its true destination only against the banality of the world. The paradox of its abstract body on the canvas, became the very goal of artistic endeavour. But if an idea was all that manifested itself in a work, one might ask whether works were needed at all. Would not verbal concepts – to which the painted works were in fact moving ever closer – do just as well? Readymades were not *made* by artists but were finished industrial products: only by consent and by the institutional setting in which they were exhibited did they reveal the fiction that had been ever present in works representing an idea of art.

Conceptual artists and members of the 'Fluxus' movement immediately moved in to substitute, so to speak, the traditional work – out of fashion in the 1960s – by using either writing or their own bodies. As a result they also rejected classical modernism, which invited spectators to identify with the abstraction in a museum piece rather than with their own bodies. Abstraction in art no longer involved the whole body, but only appealed to the sense of sight, in the same way that music had isolated the sense of hearing. Art had progressively substituted the repre-

sentation of human bodies with the self-representation of artistic media such as colour or canvas. Cubism developed a repertory of signs that ceased to be connected with the corporeal world and presented a linguistic–textual structure.

Even so, modern works were linked in two ways to the experience of bodies. Whether as canvases or sculptures, they had a material 'body' of their own – as a rule, that of a unique 'original' – and, like objects in our personal sphere, this 'body' occupied a place in the same space that our bodies reside in. Second, they had been formed by the bodies of their makers, so that they bore the signature of hands, whether in the form of brushstrokes or modelling-wax. The post-1960 generation reacted against both these bodily links. Instead of solid objects, artists now introduced ephemeral forms or preferred a production in multiple copies that made no claims to being unique originals. The personal creation, with its innate spontaneity and individuality, was being replaced by automated processes and anonymous techniques, where the artist's idea no longer needed the intervention of his 'own hand'.

For today's media society, fascinated as it is by virtual spaces, the traditional art creation has entered a truly critical phase. We no longer value objects, preferring on-screen information. Museum visitors gather around monitors in the entrance lobby to be informed about the institution's collection by a computer program. Video tapes featuring the artist in person occupy the place formerly given to works, whereas in the case of video installations, viewers find themselves in isolated, dark spaces in which they experience, as it were, themselves rather than the authority of an artist. Thus the experience of art is no longer tied, as once it was, to the exhibition of works in museums and galleries. This invites a reconsideration of museum works in the modern period, and such a retrospection also offers a new approach to modernism, which in a way has become history.

3

The pre-modern idea of the work was the one that prevailed from the Renaissance to the Enlightenment. This was the era of the academies that taught the 'classical' doctrine of art. Academies continued after 1800, of course, but lost their power as 'law-giving' centres that reigned over art production. In the post-1800 period the museum became more influential than the old-style art academy, which touched only a limited circle of experts. The avant-garde movements would be inconceivable without the museum, against which they rebelled. Living art now

contested with museum art. The artists either rejected the standard of the museum work (and the museum as such), or devised, through their works, an anti-museum idea.

This difference between pre-modern and modern art production requires closer analysis. From the time when Colbert turned the Académie Royale des Beaux-Arts in Paris into an official institution of the French state, the newly established critics gave lectures to artists in which they elaborated the 'classical doctrine'. It was also in this context that, from 1666 onwards, André Félibien provided the new institution with a strictly axiomatic theory of art. He identified the rules of art in the various individual beauties of a work in which particular 'schools' of painting had excelled – 'schools' meaning regional traditions of art, for example, those of Venice or Rome. Where there are rules, the rules can be broken. The totality of the rules in the old classicism resulted in a principle of perfect art – something that never materialized in a single work, but one that emerged from an imaginary synopsis of all existing historical schools and painters. This principle called for strict imitation, under the watchful eye of an all-powerful art criticism controlled by official authorities.

A simple calculation used by Roger de Piles may serve as an example to demonstrate the method. In his *Cours de peinture par principes*, a course given at the Paris Academy of Art *circa* 1700, he drew up a 'Balance of Painters' in which 57 painters are arranged in a kind of scale with a system of evaluation still in use in France's schools today. De Piles awards the number twenty for 'ultimate perfection, of which, however, we ourselves can form only an inadequate notion. Nineteen stands for the highest degree of perfection that we can imagine, which, however, no one has yet achieved. Eighteen is awarded to those who in our estimation have come closest to perfection.' But they are awarded in this way only in a given genre of painting, which is governed by its own specific rules, and not in any other. It characterizes this old theory of art that the appreciation and assessment of works can be broken down into four categories: 'composition, drawing, colour and expression'. For their use of colour Giorgione and Titian, who otherwise perform poorly, gain the top mark of eighteen, while Leonardo is placed very low with regard to colour. Raphael gains the top score for drawing, but not for colour, where Rubens comes off better.

Most of these concepts were already present in Vasari, but with De Piles they have been turned into rigid principles that are sometimes in conflict within one and the same work. The performance of composi-

tion, which was a mental construct, encompasses 'almost the entire theory of art, because it is conceived in the painter's imagination', whereas 'drawing and colour belong to the domain of practice'. All of this goes to show that painting is both complex and difficult, which, of course, was the reason for the exercise. André Félibien took a similar line in *De l'origine de la peinture* (1670): 'In order to be able to paint a picture, the painter must be familiar with all aspects pertaining to it.' But there 'has never been a painter who mastered every aspect of his art to utter perfection'. Even Leonardo 'committed faults', precisely when 'he was trying to achieve too high a degree of perfection'.

That is a revealing statement. Wherever rules hold sway, works remain within the boundaries the rules prescribe. For perfection lies *in* the rules, not in the freedom from the rules. Wherever the rules are disobeyed, the artist has erred. The critic, for his part, recognizes the error because he knows the rules. Furthermore, the painter must 'have a conception of nature as it would be in its perfect state if it were not disfigured by accidental circumstances'. This enables him to develop the grandeur of taste (*le grand goût*) by means of which painting lifts us above everyday life. *L'Idée du peintre parfait* (1707) – the 'idea of the perfect painter' – as Félibien called his book on the subject, rules out the possibility of a perfect masterpiece by the very fact that the 'perfect painter' is nothing but an abstract ideal formed by the critic. Theory is always in the right *vis-à-vis* the painter because, contrary to what the authors claim, the principles of art have to rule over practice. 'When we look at the artistry of a picture', according to Félibien in *De l'origine de la peinture*, we admire 'the invention and the mind of the painter, in which the picture was doubtless conceived even more perfectly than his brush would realize it. Thus all the various beauties in painting ultimately serve only to raise us step by step towards absolute beauty (*beauté souveraine*).'

The same doctrine was exemplified by the new-formed art collections of the seventeenth century. The 'picture cabinet' (*cabinet d'amateur*) that assembled ancient statues and 'modern' paintings of all genres and styles was a training-ground where the art-lover would experience the visible idea of art. The art collection offered a 'stage' on which art itself, as represented by its history and its various genres, was performed by way of exhibition. This panorama embraced works from antiquity and from the Renaissance onwards, where the presence of art included the presence of its history. In this sense the local art collection was a microcosm, a world gathered into one place, where art itself, in its visible manifestation, initiated the public into its mysteries. It was this idea that

caused the Early Baroque painters in Antwerp to use the *cabinet d'amateur* as the visible panorama of art that, by its very purpose, it was.

The miniature world of the art collection was paralleled by the Grand Tour in Italy. This directed the 'ingenious gentleman', so called by Henry Peacham as early as 1622, to the sites of antiquity, especially Rome, where he would visit the Roman statues Diderot was later to describe as the 'apostles of good taste'. Soon the Tourist was able to benefit from the guidance of the *ciceroni* in the new genre of travel books. Such literature gave rise to the art-history textbook, whereas the allegorical 'theatre' of the picture cabinet soon turned into the actual museum. The same abbé Luigi Lanzi who published a history of Italian painting began his career by compiling a catalogue of the Uffizi Gallery. The 'philosophical spirit of the age', he wrote, 'calls for a system' to enjoy art in the light of its true history. These emerging museums were already based on this idea of art history, one that differed from that represented by the picture cabinet. Art history took on the character of a body of objective knowledge that could be verified by studying the works on display.

The masterpiece in the old, pre-modern sense provided an opportunity to talk of art's perfection, which, after all, was an obvious way of speaking of art. But we must distinguish this concept as it was understood in art theory from its much older use in the exercise of the language of rhetoric. In rhetoric, perfection belongs to a technique of describing a work of art that is much too perfect to be described successfully in verbal terms. But this game in fact lives from the rhetorical effort to turn the tables and outdo the work in question by its description, in which it appears more perfect than it would seem by itself. The unique work, in this tradition, is in fact an invention of the rhetorical technique of *ekphrasis*. Lodovico Dolce was the first to apply this ancient method to a contemporary work painted by Titian in the mid-sixteenth century.

During the Enlightenment, on the other hand, the ideal of perfection received a moral quality from the new aesthetics. The perfection of art now became, paradoxically, merely the metaphor for a conceptual beauty. But *beauty* in art remained a controversial topic. In 1785 the young Karl Philipp Moritz argued that a work's 'own inner perfection', in which it is 'complete and perfect within itself', is clearly different from the exceptional status of the masterpiece, because it represents the general norm of art. Moritz's notion of art prevented him from calling a knife or a clock beautiful, as these are objects intended for use. The artwork, however, is characterized, according to Moritz, by a kind of 'inner

law', independent from its effect on the beholder. Moritz thus still dissociated artistic beauty from its perception by the individual beholder. Clearly, he belonged to another generation than the Romantics with their modern art devotion.

In his own time, beauty provided the viewer with an intellectual exercise that afforded 'a kind of higher existence'. The Enlightenment's ideal of humanity required a corresponding ideal of art. However, this ideal of art was soon to be given up because it excluded any self-experience on the part of the beholder. It was therefore the concept of 'the Sublime' that the Romantic theorists would employ as a weapon against 'the Beautiful'. The concept of the Sublime had been available ever since the first commentaries were written on the so-called pseudo-Longinus. While the full potential of this concept had yet to be discovered, there was already some sense of the extraordinary nature of 'the Sublime'. Precisely because it transcended any restrictive definition within a well-ordered system, the Sublime could be sought in the masterpiece once people were prepared to redefine an individual work of art as a world of its own. This happened in the Romantic era, when the masterpiece was no longer expected to demonstrate an objective idea. The *cult of the idea* lived on as the *cult of a work* that was rephrased as an absolute masterpiece. The perfection of art thus took refuge in single works, which in turn acquired an 'aura', whose definition will be pursued in the following two chapters.

1 The Farewell to *Apollo*

Our notion of the 'work of art' has its origin in the concept of the unique 'masterpiece', an idea that gained currency when the first museums were founded: revered icons or works of star quality were crucial to justify the existence of the temples of art that bourgeois culture demanded. Although it was the museum's function to display the entire panorama of art, not every work possessed the aura of great art: only specific individual works had this. Soon after the Louvre was founded as a national public gallery in 1793, a dispute broke out over whether the aim was to create a museum of masterpieces or a museum of art history. One side wanted a temple dedicated to timeless masterpieces, the other a home offering a chronological survey of art throughout history. Thus one wanted the museum to preserve the purity of the artistic ideal, while the other saw its rôle as documenting art's progress over the centuries. Admiring great art seemed to be incompatible with scrutinizing the whole history of art because the latter process inevitably relativized all works. Closely associated with this controversy was the idea of imitation. The defenders of the masterpiece saw the museum as a school of taste, while the promoters of art history envisaged it as a school of history in which every artist who had made a contribution should have his or her place. It is no coincidence that the connoisseurs of the *ancien régime* subscribed to an elitist ideal that they wanted to share only with artists, whereas the advocates of art history insisted on a museum for everyone, in which the whole spectrum of art would be represented.

What was overlooked in this controversy was that masterpieces were also part of the history of art. Shortly after the founding of the Louvre, its directors were forced to acknowledge that art appreciation had focussed far too narrowly on ancient masterpieces – that is, on Greek and Roman sculptures. This realization necessitated changes in the nature of the museum as a whole. The farewell to *Apollo* (the *Apollo Belvedere*, in Paris from 1798 to 1815) also marked a departure from a timeless ideal of art, not just a decline in the prestige of a particular statue. The historicist view of culture included the belief that there was

such a thing as historical progress. The works that now came to be regarded as masterpieces were paintings from the past centuries of European art, thus the monopoly formerly held by antiquity's sculptures was broken. The Louvre was no longer solely a collection of ancient art, as its predecessors in Rome had been. Its upper floor displayed the 'newer arts', its lower floor those of the ancient world.

At the beginning of the modern period, the 'masterpiece' – art's most profound achievement – had swiftly established itself as the symbol of a new art appreciation. The didactic ideal had been the guiding principle of the old academies. But as art came to be viewed in terms of absolutes, it began to defy any clear definition. Its nature had to be apprehended via masterpieces – miracles that could no longer be explained or taught by means of rules, and which transformed the creative act into an unfathomable mystery. The veneration of art replaced that of beauty. Even Quatremère de Quincy, a partisan of the old school, could only express wonder in his *Letters to Miranda* (1796) regarding the 'metaphysical debate about absolute and relative beauty': 'People are more certain of what beauty is not, than of what it actually is.' The presence of perfect works concealed the absence of a viable idea of absolute art. The ideal work could no longer be described in terms of an ideal means of producing it. The public's response to masterpieces was no longer informed by expertise, for now empathy prevailed. Masterpieces, those surviving specimens of excellence, stood firm against the surging tide of an ever more historical view of cultural production.

When the Louvre, formerly a royal palace, reopened its doors in 1793 as a museum, 'the people' triumphantly seized control of an artistic heritage that was formerly the preserve of Court and Church. It was now the property of 'the nation'. Beyond France's borders, however, the victorious Revolutionary armies chose – in the ringing phrases used in the National Assembly in 1794 – to 'rescue the immortal works of art from the tyrants and bring them home to the motherland of art and genius'. When the Louvre finally became a supra-national museum, it was fulfilling the Enlightenment's dream of bringing culture to all in a 'République de l'Esprit'. Although those utopian ideals were short-lived, it was because of them that old collections were not destroyed, but instead were exhibited in a museum that was open to everyone.

Under Napoleon's rule as First Consul, art quickly came to represent not so much the greatness of man as the triumph of France. The homage given to the masterpieces carried to France from Italy in 1798 also had the aim, as was declared at the time, of 'immortalizing our own

epoch'. This act of plunder paralleled the process by which ancient Rome had seized the artistic heritage of Greece, an event that seemed in retrospect to have laid the foundations of Rome's universal status. Moreover, art had become a symbol of the freedom in whose name victory was pursued, and so it could be used to make Napoleon's crude war of conquest appear in a more creditable light. Before long the Revolutionary state was transformed into an empire, and the new sovereign wished to rule over a history whose inheritor he felt himself to be.

When, after reorganization, the Louvre's gallery of antiquities was reopened on 15 August 1803, the main portal bore the proud inscription 'Musée Napoléon'. At six in the morning, three hours before the public was due to be admitted, the First Consul viewed the new rooms there at the hour when the troops were inspected. On reaching the *Venus de' Medici* (illus. 1), he was presented by the Louvre's director, Vivant Denon, with 'a medallion commemorating the arrival of this masterpiece', as the *Journal des Débats* recorded (illus. 2). Together with an

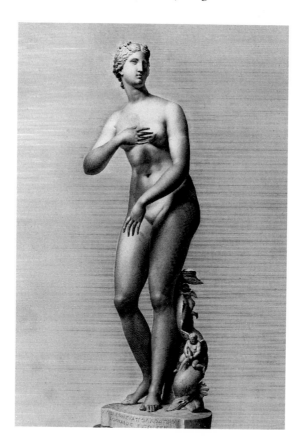

1 Jean-Baptiste Raphaël Urbain Massard, engraving after Pierre Bouillon of the *Venus de' Medici*, 1805.

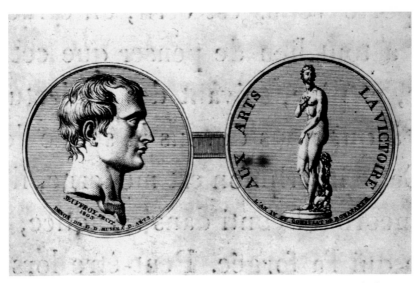

2 Romain Vincent Jeuffroy, Engraving of the medallion struck to mark the opening of the Musée Napoléon, 1803.

impression of the statue, the medallion bore the inscription 'AUX ARTS LA VICTOIRE' (Our victory is dedicated to the Arts). This classical *Venus*, pillaged from the Uffizi, was described in the museum guidebook as an 'incomparable work' that 'in the general estimation of Europe is alone in sharing the celebrity of the *Apollo Belvedere*'.

No other work had been more rapturously received in Paris than the *Apollo*, which had attracted the 'admiration of the world' when it stood in the Vatican Belvedere's courtyard (illus. 3). At its installation in Paris, Napoleon ceremonially unveiled a bronze inscription that gave not only the date of its installation but also that of its seizure. In this new setting, in which the *Apollo* looked like the brother of the *Diana* from Fontainebleau, the statue was subjected to aesthetic comparisons that soon led to doubts about its supposedly unique quality. Ten years later, it was not the *Apollo* but the *Venus de' Medici* that was 'accorded first place among the most celebrated works that have come down to us from the Ancients', as Joseph Lavallée wrote in his Louvre catalogue.

Two months after the opening of the Musée Napoléon, Vivant Denon devoted his inaugural speech before the 'Institute' entirely to the classical statues. He called them the true 'masterpieces' of art and congratulated himself and everyone else on the fact 'that they exist'. However, he went on to note that 'art declines once it has been brought to a certain degree of perfection; then it can be spoken of only in the

3 Jean-Jacques Avril the younger, Engraving after Pierre Bouillon of the *Apollo Belvedere*, 1805.

language of feeling', in which there is always a sense of loss. The new museum was initially presented as a museum of ancient art. In his speech, Denon conducted his audience through the rooms that housed the classical works, finally reaching the *Venus de' Medici*, which to him was the apogee of all masterpieces (illus. 1). 'She is only a woman, but she is the woman whose perfection is elsewhere found only in scattered fragments' – an allusion to classical legends about art. 'Her totality could

be conceived only by a genius. It has never been possible to describe her without doing her an injustice.' For Denon, the reason why masterpieces could not be described was because the ideal projected on to them was no longer explicable: 'Only in fear and trembling can one venture a few remarks about her perfections.'

The conception of the museum suffered from the same inherent contradiction as the period's notion of art. The desire to trace out the historical development of art was compromised by the fact that art was admired as the embodiment of a perfection that, it was feared, was slipping away. The course of history revealed a beauty that was quite distinct from any claims of an artistic marvel that transcended history. The new history-shackled point of view contradicted the philosophical ontology of the preceding generation by its inevitable relativism. In the *Musée français* catalogue, the declared aim was that of discovering not the 'rules' but the 'mysteries' inherent in works of art, in order to 'enhance the degree of admiration that these works inevitably inspire'. At the dawn of Romanticism, the *productions de génie* took on a fresh significance: the solitary creation supplanted the earlier ideal of an academic art, and academicism was soon understood as a mortal sin in art. The new myth of the genius merely obscured the fact that art became a venture undertaken at the individual's own risk. At that time the works that were recognized as masterpieces dominated both the rooms of the museums and the museum catalogues. Whether as the centrepiece of a museum or as the climax of a written history of art, the masterpiece was inevitably described in contradictory terms. Masterpieces were the products of history, and yet they triumphantly transcended history as they gradually acquired a status that placed them outside time. But perfection, once achieved, was necessarily followed by a decline that was seen as an inexorable law of history. This apparent truth was acknowledged even by ancient writers on art, who thereby subjected themselves to aesthetic norms that were not at all rooted in history itself.

Masterpieces were historical products in a double sense: they were born in history, but they also lived on as a result of the history of their interpretation. History was the context in which they had not only been created but also admired, imitated and misunderstood. Their fame was itself historical, so that it was becoming difficult to say anything new about them, as a writer in the *Musée français* complained as early as 1809. Instead, the intention now was to present a complete overview of the history of art, in which everything should find its place. In the early days of the Louvre, the policy was to acquire only works as 'were suitable to

serve as models for artists to study'. Only a decade later, in 1807, the public was being assured that the restrictive barriers associated with connoisseurship had been dismantled, and that even works that did not qualify as examples for artists to study would now be included. The idea of imitation was based on the assumption that the artistic ideal had been realized at some point in history. All that was needed was to find one's way back to that ideal. And with all the masterpieces of mankind gathered together in the Louvre, this seemed the perfect moment to do so. Imitation offered the prospect of a historical dynamic quite different from mere retrospection. Nevertheless, this optimistic view was soon discredited by those who pointed out that it promoted a sterile view of art. And so the masterpieces came to be praised as 'inimitable' because there was no longer any wish to imitate them. Artists instead turned to 'real' nature. But for the connoisseurs, great art was henceforth to be found only in the past.

THE IDEAL MUSEUM

The notion of an ideal museum had always been bound up with Rome. Rome itself had everything that people looked for in such a museum: the masterpieces of classical and modern art, and also the actual places associated with the only history worthy of the name. In addition, Rome then possessed the only museums that deserved the name – the Capitoline and Vatican museums. In the (partly imaginary) scenes painted by Giovanni Pannini, the city as a whole was one vast museum. There Winckelmann had conducted his research, Mengs had painted his canvases, and Cardinal Albani had assembled his collection. Rome was where so many men of genius had made art the very essence of their lives. When, therefore, the city became the main target for the French confiscation of art, it looked to contemporaries as if Rome was going to be relocated in Paris, and there was bitter controversy as to whether it was right that the city should lose its finest works, when Paris could surely never adequately take its place.

In his *Letters to Miranda*, Quatremère de Quincy deplored the forcible 'transplantation' of Italy's art treasures. His criticisms went unanswered, since the opposing side preferred deeds to words. But the masterpieces in Rome that were about to be carried off came to the attention of the general public for the first time as a result of this very public controversy. Quatremère, France's Winckelmann, acted for a long time as the arbiter of his nation in matters of art, precisely because, as a supporter of the old

school, he followed modern developments with a critical eye. In the *Letters* he argued passionately for Rome to continue to be the 'école centrale' of Europe, since there alone could the survival of the classical ideal of art be guaranteed. If Europe was being transformed into a 'Republic of the Arts and Sciences', Rome was a supra-national city that would not be subject to political pressures. For a time it seemed as though the future of the newly created museum might be steered in any one of several directions. But those who believed this were even then mistaken. The rise of the nation–states favoured a determination to assert a strong historical identity, for which a museum was the ideal vehicle – a museum that would make art into an emblem of the sovereignty of the state. To envisage a supra-national museum dedicated to the art lovers of all nations was therefore a delusion.

From today's perspective it is certainly hard to understand the 'Roman' position *vis-à-vis* the ambitions of the pro-French party. The issue was less about whose property the art-works were than with where, by their nature, they truly belonged: in other words, the approach was not legalistic but historical. Compared with Rome, the Louvre was a wholly artificial construct, a building in the midst of a modern city, where works would be imprisoned far from their rightful setting. For us, this kind of museum has long been the norm, but in those days the threat of a prison crammed with indiscriminately assembled works of art aroused deep repugnance among people who could not yet see the point of a mere survey of art's history. Naturally Quatremère was speaking for the elite of true 'amateurs' – those art lovers who had the means to spend years, if they wished, in Rome – and not for the new kind of public that had just emerged and which contented itself with a Sunday visit to the Louvre. He was uncomfortable with that public and always kept his distance from it.

But Quatremère knew very well that a new panorama of art might be created in Paris that would sound the death-knell of his old ideal of art: a panorama of all the European schools, in which Rome would be reduced to nothing more than local significance. He therefore opposed the idea of people availing themselves, in an undirected way, of an overcrowded museum that would inevitably destroy artistic standards and undermine true values. Once again he referred to great masterpieces in order to explain his position. Their 'number in any given genre is as small as that of men of genius. That number can be increased only in proportion to the diminution of their reputation.' Thus Quatremère warned against surrendering to a complete panorama of art history that

was destined to extinguish any true sense of art. To exhibit everything, he argued, would be to neutralize everything. It should not be imagined that 'a warehouse containing all schools of painting could possibly have the same impact as is achieved by those schools in their native setting'. And of course the Louvre did finally become just such a 'warehouse' presenting the totality of art history.

THE MUSEUM AS A REALITY

None the less, it took quite some time for the demand for a complete rethinking of art and history to be heard in the Louvre because of the extremely narrow view of art that still prevailed. The antiquities exhibited on the ground floor conveyed the sense that here were the foundations of the modern art that occupied the upper floor. But this so-called modern art was restricted to what Lavallée in his Louvre catalogue called *les beaux temps* – 'from the renaissance of the arts to our present day'. In all other periods, the arts – because they did not conform to classical rules – had amounted to 'nothing'. Between the two 'artistic epochs' that the Louvre's visitors saw in chronological sequence yawned the 'gaping hole in the history of art' that no one deemed worthy of study until Émeric-David boldly bridged that 'span of nine centuries' with his exhibition of monuments and relics from the Middle Ages.

Right at the start, in the vestibule leading to the collection of antiquities, visitors encountered a series of ceiling decorations that presented the mythic origins of sculpture in an extravagantly mythological visual imagery that clearly harked back to the Baroque. In the ceiling painting, dating from 1802 (illus. 4), Jean-Simon Berthélemy had depicted the Creation of Man. Prometheus has formed him, and Minerva descends from the sky to infuse him with a soul. He is raising himself up on a plinth in a pose inspired by the Creation of Adam on the ceiling of the Sistine Chapel. The programme derives from the archaeologist Ennio Visconti, who in the *Musée français* catalogue had prominently associated Prometheus, as mankind's first sculptor, with the birth of ancient sculpture. This vision of art's history was continued in the four roundels at the corners, which assign the four 'schools' of sculpture to four countries, each personified in a figure pointing to a masterpiece created in that country. Egypt points to the statue of Memnon, Greece to the *Apollo Belvedere*, Italy to Michelangelo's *Moses*, and France to Pierre Puget's *Milo* (illus. 5). So visitors gazed up at a painted treatise, which was elucidated in the museum's catalogue. There, too, the history

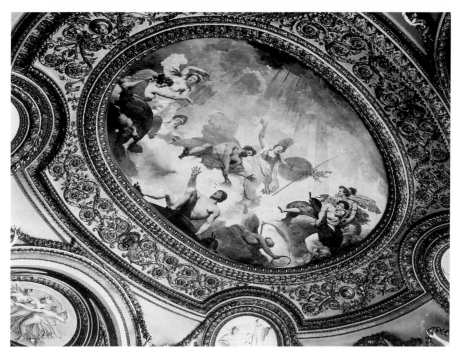

4 Jean-Simon Berthélemy, *The Creation of Man*, ceiling fresco in the Rotunda of Anne of Austria in the Musée du Louvre, Paris, 1802.

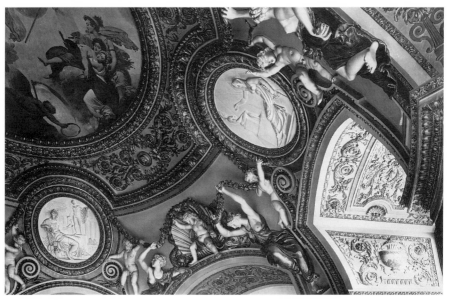

5 A detail of Jean-Simon Berthélemy's ceiling fresco *The Creation of Man*, in the Louvre (illus. 4).

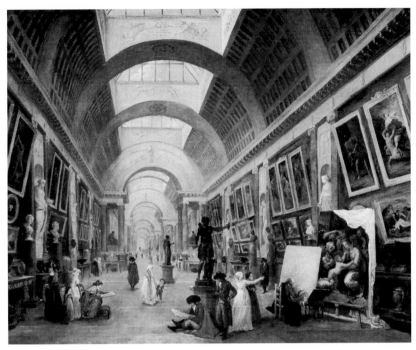

6 Hubert Robert, *View of the Grand Gallery of the Louvre*, 1796, oil on canvas. Musée du Louvre, Paris.

of art opened with a creation myth. Thus primed, visitors set off to view the famous originals – the *Apollo*, the *Venus de' Medici* and the *Laocoön*.

On the upper floor the approach was more pragmatic, following the decision in 1799 to use the Grande Galerie for a chronological display of the various schools of painting (illus. 6). In 1811 this display was divided into nine sections leading up to the climax as represented by the Italian schools. This so-called visual history of art, arranged in a way that conveyed a particular perception of the subject, offered an overview that was not available in books at the time. On the occasion of Napoleon's second wedding in 1810, all those invited to attend paraded past the paintings – as Benjamin Zix's engraving records (illus. 7) – tracing, as it were, the notional path of art history as they accompanied the Emperor to the marriage altar set up in the Salon Carré. Among the host of visitors drawn from across Europe, Friedrich Schlegel soon gazed in awe at the collection of over 1,000 paintings, and, standing before the assembled collection of works by Raphael, reverently studied the 'gradual evolution of a great artistic mind'. The new fascination for exploring the course of art history replaced the old-style appreciation of the single work of art.

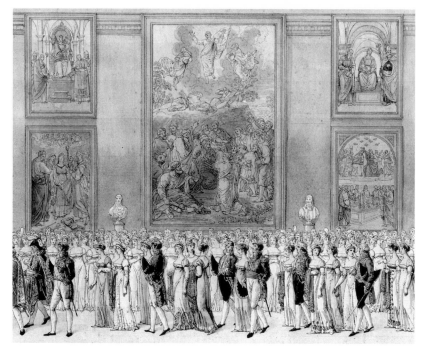

7 Benjamin Zix, Detail from an engraving showing Napoleon and Marie Louise in the Louvre's Grande Galerie, 1810.

This fascination for exhibiting art history is partly explained by the fact that photography was unknown. But the Louvre's management did its best by publishing, from 1803 onwards, a folio edition of the catalogue with more than 500 engravings of a quality that set a new standard. Through this catalogue, a museum in book form, the collection became known as a canon of art history. According to an accompanying text, the intention was that works that 'are unique and can be admired only at a single location by a small number of people [should] be made available for the enjoyment of the public at large'. But the true 'technical reproducibility' of the art-work to which Walter Benjamin has referred had not yet arrived. These monochrome engravings, a medium in their own right, exerted an influence on aesthetic taste that should not be underestimated. They formed a common denominator that made different works of art appear more alike than they actually were. People even spoke of a synthesis of sculpture and painting that only printmaking seemed capable of achieving. To compensate for the arbitrary selection of engravings, ambitious introductions to the history of art were published; these began with the Egyptians, or even with a time prior to

the Flood, but generally did not advance beyond the Italian Renaissance. A large number of authors collaborated on the six-volume *Musée français*, while the ten volumes of its rival, the *Galerie du Musée Napoléon*, were all written by Joseph Lavallée.

The two catalogues also strove to outdo each other in the engravings, which gave markedly different impressions of, for instance, that 'miracle of art', the *Venus de' Medici*. In the *Musée français* the reverently low viewpoint adopted by the engraver lifts the figure into an artistic heaven, like an apotheosis of herself, while her rounded limbs signal a vitality that was avidly sought for in the cold marble (illus. 1). Now that two centuries of archaeological research have irremediably diminished the prestige of these statues, they seem more beautiful, more alive in the engraved prints than in reality, because there they were viewed through the idealizing filter of the enthusiasm of that age. In the prints they were transformed into the very ideal of art, an ideal that invested the work of art with an almost metaphysical significance.

THE FIRST CRITIQUE OF THE MUSEUM

Art that was appropriated by the museum, soon enough lost the free flow of its existence in the outside world. True art was now to be found only inside, not outside the museum. The founding of the museum represented a drastic and irrevocable change, replacing the contemplation of art with the retrospective contemplation of art history. But what purpose would art serve if it was in a museum, shorn of all its functions? The answer to this question lay in the new view of history. Art offered a visible image of the 'progrès de l'esprit humain', as Lavallée explained in his catalogue. As a positive outcome of history, art gave an assurance of progress in human life. This progress was the metaphor for the future path of mankind, which in France had just won its freedom through the Revolution.

After Napoleon's fall, the status of the Musée Royal was reduced to that of a national museum. The bourgeoisie revered art works not as the ideal to be imitated but as the symbol of a lost history; they entered the museum in a nostalgic mood, not an optimistic one. Napoleon's abdication also meant that an essay by Quatremère could finally be published. This was a critique of the institution launched by a 'conservative', who, precisely because he opposed the new ways, observed museum culture with a sharper eye than did those who were happy to swim with the tide. His *Moral Reflections on the Purpose of Works of Art* were addressed to

those who 'produce art', those who 'judge art' and, third, 'to the senti-
ments of those who enjoy art'. These are the three types of visitors to
the museum – artists, connoisseurs, and laypersons.

The question that Quatremère posed was one that was to preoc-
cupy all his successors: what purpose do the exhibited works serve when
they are confined within a museum and have lost their 'public function'?
What is to become of them when, if they satisfied all tastes, they failed to
ensure the permanence of any particular taste? They were as changeable
as fashion, catering, as *arts de luxe*, merely for the entertainment of the
public instead of providing, as *arts du génie*, inspirational models for soci-
ety. As soon as works of art 'appear in too great a number', they lose their
influence as a school of taste and 'a kind of indifference to beauty' results.
In Quatremère's view, of course, there existed only one 'taste', which
acknowledged only one form of beauty, the classical. The museum, he
warned, promotes 'a superstitious respect for what is ancient ... and a
contempt for the new simply because it is new. This meant that any
hope of fresh masterpieces appearing was lost. Ever since museums had
been established in order to identify and promote masterpieces, master-
pieces were no longer being created to fill them.' The museum made
imitation superfluous, if only because the museum's art was already there
for everyone to see; in a museum the art of antiquity was not only out of
time but, it would seem, deprived of *any* time.

The historical 'esprit de critique' was bound to destroy the creative
'sentiment', Quatremère argued. The newly created art collections
produced 'well-informed connoisseurs who always knew best about
everything' and so merely undermined artists' confidence. The painters
wanted 'a public that feels, not one that reasons'. 'The misuse of the
museum and the misuse of criticism promoted admiration' of qualities
that were extrinsic to art. After all, the works as exhibited had predated
the advent of the museum as an institution. Having been 'condemned to
a passive rôle', these works 'have ceased to have any impact, because they
have lost their very reason to exist. To make such an accumulation of art
serve as a practical course of instruction in modern chronology is to kill
art and turn it into history.'

Quatremère knew very well that the blame lay not with art but
wholly with society. He was astute enough to recognize that the era of
unfettered imagination was giving way to an 'age of observation', that a
state of unreflective self-confidence was being replaced by a self-
consciousness that was the product of historical awareness. This was also
altering the meaning of culture. There was a 'principle of weakness', he

argued, in an attitude that was content to foster culture for its own sake and not for the sake of the ideals that people used to find in it. Thus he wrote of a 'culture artificielle', in which 'the fine arts' become merely museum or salon art. Naturally, he would notice only the negative traits in the emergence of bourgeois society. Thus he lamented the passing of an elitist culture in his incidental comment that the masterpieces now appeared slightly 'vulgar' – as vulgar, perhaps (if only to him), as the whole museum looked.

APOLLO IN THE MUSEUM

As late as 1805 Visconti, the Louvre's antiquary, still worshipped the *Apollo Belvedere* – that 'sublime statue' – as an 'unchallengeable proof of the perfection which the Greeks attained' (illus. 3). However, the worldwide fame of this sculpture, which was in fact soon to be challenged, rested not solely on its unique beauty but on its unique history of artistic imitation and literary acclaim too. So much admiration over so long a period had imbued it with an aura that was now inseparable from the work itself; it had come to embody the ideal of art that merited ceaseless imitation.

Setting the standard for other critics, Winckelmann had declared the *Apollo* to be a 'visible idea' (if such a paradox can exist) of absolute art. In support of this claim he attempted 'to describe an image that transcends all conceptions of human beauty'. His description of the *Apollo*, itself a kind of imitation, but one concocted in the mind, vied with the copyists' imitations in marble, and turned the carved physical object, 'the god and miracle of ancient art', into an idea. Since a realized work cannot actually be an abstract idea, Winckelmann urged his readers to measure the idea against the work and the work against the idea. 'Travel in your mind into the realm of incorporeal beauty, in order to prepare yourself for the contemplation of this image.' When you have 'created an image within yourself', step before the 'image of this divinity' and feel yourself 'humbled in your thoughts'. Your own imagination is vanquished by the image 'that you see here before you'. Art discourse is now moving away from artistic practice; instead, the philosophically educated public is offered the history of art according to the principles Winckelmann laid down. In the marble *Apollo*, art has discovered its ideal in a single, unique work.

The myth of antiquity, though purporting to be based on factual scholarship, was a fiction, as indeed it had to be in order to exert such power over the imagination. The *Apollo Belvedere* was celebrated in the

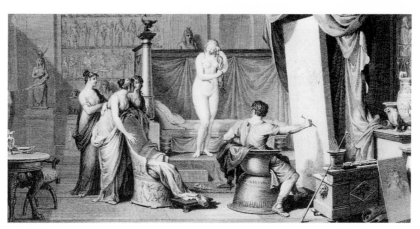

8 J. B. Simonet, Engraved vignette of Apelles in his studio (after Jean-Michel Moreau the younger), from 'Discours historique sur la peinture ancienne', 1805, in S.-C. Croze-Magnan, *Le Musée français...* (Paris, 1803–9).

tacit knowledge that the true masterpieces of antiquity – Phidias's sculptures and Apelles' paintings – were lost for ever. The myth of the masterpiece, which cast its glow over all the works that survived from antiquity, is well illustrated in three engravings by Jean-Michel Moreau the Younger that introduce the texts on painting and sculpture in the *Musée français*; naturally none of the works shown being carved in the artists' studios could be found in the Louvre. In the first vignette we are shown the studio of the legendary Apelles (illus. 8). Examples of Egyptian art are visible in the background, reminding us that art has progressed beyond that imperfect state. In the foreground the painter–god – not one of whose works has survived, however much we may read about them – sits before a painting, inspired by the Homeric hymns, of Venus rising from the waves. But he is gazing at a living model who, as it were, forms the link between nature and art. This model was Alexander the Great's mistress, the real woman who alone could bring flesh-and-blood vitality to the image of perfect art.

In the second engraving we see the great Phidias at work (illus. 9). He is turning from a monumental *Zeus* to face a male visitor sitting opposite him who appears to be the living model for the sculpture. But this impression is deceptive. The visitor is actually the blind Homer, to whose famous description of Olympian Zeus in Book 1 of the *Iliad* the sculptor – as if he could ever have met Homer! – is listening. While the poet's vision gives birth to the statue, art inspires the sculptor's craft. The accompanying text refers to 'Homer's sublime description', applying an

9 J. B. Simonet, Engraved vignette of Phidias in his studio (after Jean–Michel Moreau the younger), from 'Discours historique sur la sculpture ancienne', 1804, in S.-C. Croze-Magnan, *Le Musée français...* (Paris, 1803–9).

10 J. B. Simonet, Engraved vignette of Raphael in his studio (after Jean-Michel Moreau the younger), from 'Discours historique sur la peinture moderne', 1808, in S.-C. Croze-Magnan, *Le Musée français...* (Paris, 1803–9).

attribute of the masterpiece to poetry. This is evidence enough for the masterpiece as being regarded ultimately as an idea, *not* as a work.

The third engraving takes us forward to the Renaissance, to the studio of Raphael, the modern Apelles (illus. 10). He is painting the Christian God, not a pagan deity. However, in a theatrical gesture he directs our attention to a sketch of his own showing the classical Zeus, who is in fact also present in the form of a bust in the corner. The youthful genius is telling us, in case we did not know already, what ideal

he has imitated and, in so doing, surpassed. Of course everyone was aware that Raphael had never seen a work by Phidias. But he had formed such a perfect conception of ancient art that he was able to reinvent the ideal of art. With a degree of overstatement we might say that the idea of imitation is the imitation of an idea.

And this explains the enthusiasm aroused by the elegant yet somewhat empty *Apollo Belvedere*. Though on one level an artistic work, the *Apollo* is ultimately the representative of a conception of art. Winckelmann unwittingly revealed this by always speaking of it as an 'image' that surpassed everyone's idea of art. In Rome, after the seizure of art works by the French, it was as though the living embodiment of art had left the city. Antonio Canova was therefore commissioned to carve a statue of Perseus for the empty plinth that remained in the Belvedere courtyard. This was a bold move, because it demonstrated that the ideal of imitation had not vanished together with antiquity. In his statue, Canova, who had led the opposition to Napoleon's thefts, gave life and corporeal form to what was in effect an Apollo born in a later age. At the same time, his *Perseus* – gripping the severed head of Medusa – was a protective symbol to ward off further theft: the Medusa's baleful gaze threatened all would-be malefactors with transformation into stone.

The problem with the *Apollo*, however, was that it could not be identified with any famous work of antiquity. Its renown dated back only to its rediscovery in the Renaissance. One was on firmer ground with the *Venus de' Medici*, which shared the modern fame of the *Apollo* but had an ancient pedigree too, if one only read the texts aright (illus. 1). Félibien had eloquently acknowledged the modern estimation of the *Venus* when, on looking at two 'copies' (i.e., images) of it, he exclaimed that 'this is the most beautiful body and the most perfect work ever created by art.' Its fame in the ancient world could be deduced from the Greek signature on the statue's base, a name that was thought to be genuine: *Cleomenes*. The theme of Venus rising from the waves had become famous through a statue from Cnidus described by Lucian in a way that exactly fitted the *Venus de' Medici*: 'With one hand she concealed that which Venus had no need to conceal.'

But Lucian was describing a work by Praxiteles, so Cleomenes' sculpture, though a Greek work, could only be an imitation. This might easily have suggested, to anyone willing to accept this line of thought, that an idea of perfect beauty, transmitted from Homer to Praxiteles, had undergone a series of metamorphoses. But the experts were concerned only with the question of which originals had survived. In the case of

the *Apollo*, this became a burning question after the painter Anton Raphael Mengs had suggested that the marble from which it was carved had been quarried at Luni in Italy. A 'famous mineralogist', Déodat de Gratet de Dolomieu, confirmed Mengs's suspicion. The museum guide of 1803 attempted to reassure its readers, but in fact, to the horror of all those who revered the *Apollo*, the view bluntly expressed by the English illustrator and sculptor John Flaxman had become generally accepted: 'This is just a Roman copy and nothing else.' Winckelmann's followers were forced into the embarrassing admission that in their ignorance they had venerated a replica dating from the time of the Roman empire. (This would in no way have undermined the notion of the continuance of the idea of beauty, but it contradicted the new conception of an original work.)

Visconti mounted a defence in the *Musée français* by proposing a new theory of imitation. The masters of ancient art, he argued, 'were not afraid of being called imitators', so long as they 'could, with their imitations, put to shame the models they copied'. Even if the *Apollo* had been carved for the Romans, 'it nevertheless offers us an improved imitation of an earlier bronze figure'. With reference to the *Venus de' Medici* too, the Greek sculptors always 'sought a greater degree of perfection' whenever they copied famous originals. But there was no avoiding the painful moment when an 'inimitable' work had to be abandoned for ever, because it was itself nothing more than an imitation.

While the works on display in the Louvre had convinced William Sheperd that 'no copy is capable of reproducing the soul of these sublime originals', the archaeologists themselves undermined this idealistic view. By now the marbles from Athens acquired by Lord Elgin had arrived in London. Quatremère de Quincy, who went there to see them in 1818, confirmed to his friend Canova that in London one was indeed 'in the presence of original works'. But the Elgin Marbles lacked the literary fame that the *Apollo* had enjoyed for so long, and hence, despite being original works, they were, so to speak, newcomers to the world of art history. Moreover, they did not conform to the accepted view of ancient art because they belonged to a genre known as 'architectural sculpture', as Quatremère uncomfortably noted. He therefore felt he had to relinquish a particular view of ancient art because it had proved to be fallible. It was not just that 'the yardsticks of comparison established by the connoisseurs of several centuries were ruined'. His verdict on an art history that had been implicitly believed in is a sad one: 'Our collections of antiquities offer us only loose leaves torn from the volumes of an

immense lost library. Nowhere is there a complete whole to be found.'

Lavallée, comparing ancient and modern art in his Louvre catalogue, took advantage of this shift in the climate of opinion. 'We show an almost religious respect for the reputation of an Apelles, yet we should not blind ourselves to the fact that our cult of [these artists] is really based only on the testimony of the word, because none of their works of genius have survived.... With the moderns it is quite different. Everything created by the painter's brush since the renaissance of the arts in Europe is actually there before our eyes.' Confidence in the hard facts of the history of art quickly gave modern art the upper hand. Now suddenly there were masterpieces to be found in all schools of painting, if only one cast off the shackles of a timeless artistic ideal. Soon a Rembrandt was as eagerly sought after as a Raphael, although Rembrandt had not made antiquity his teacher. Above all, there was a rapid acceptance that so-called modern art was not modern but was as classical as people had formerly deemed only ancient art to be. This paradigm shift resulted from the gulf that had opened up between the present day and the 'older period' before 1800. Distance from that era prompted a reverence for it. According to Roland Barthes, history 'assumes a distinct shape only when one contemplates it – and to contemplate it one needs to be excluded from it'. After all this, the repatriation of the ancient masterpieces was not the disaster for the Louvre that such a loss would have been some years earlier. People took leave of the *Apollo* in the autumn of 1815 with a lighter heart because they had already been obliged to take leave of the ideal that was no longer discernible in it. The farewell to *Apollo* was also a farewell to a timeless ideal of what art should be.

The enforced departure of the *Venus de' Medici* late in 1815 resulted in demands for a replacement, despite all the disappointments caused by the doubtful repute of such statues. Venus was still the embodiment of both female beauty and the beauty of art. Soon people were eager to grace the empty pedestal with a new statue of Venus that had been excavated in 1820 on the Greek island of Melos (illus. 11). The *Venus de Milo* was at once included in the final volume of the *Musée français*, where the writer declared: 'Never was marble infused with such life under the sculptor's chisel as here, and it was nature herself who guided the chisel.' This sculpture's artistic rank now had to be assessed in relation to the Elgin Marbles. Its admirers in Paris claimed that the *Venus de Milo* was a work of comparable genius. Much as they would have liked to identify it with one of Praxiteles' famous statues, there was no evidence. So the

11 Zaché Prévost,
Engraving after Joseph
Ferdinand Lancronen of
the *Venus de Milo*, 1822.

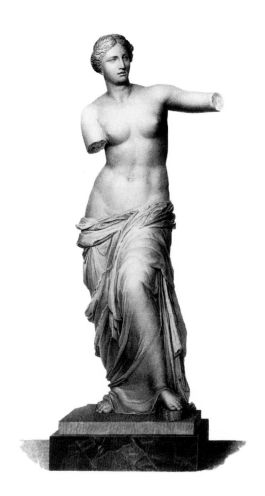

catalogue claimed that it was a reproduction of a famous original, in the style of that master. But what was the original?

It was known from ancient sources that Praxiteles carved two statues of Venus, one draped and one nude, for the island of Kos. Since only the draped sculpture found favour there, the nude was passed on to the people of Cnidus. If the *Venus de Milo*, which was not wholly nude, could be identified with the first and the *Venus de' Medici* (illus. 1) with the second, then the picture was wonderfully complete: the Venus of antiquity was recovered in her two most beautiful incarnations. And the two surviving statues had regained an identity, as imitations of two originals by Praxiteles.

This beguiling theory, which gave another short-lived impetus to the search for the lost art of antiquity, did not satisfy the contemporary

craving for scientific evidence. All the same, the new acquisition was greeted with enthusiasm in expert circles and stimulated a public response similar to that aroused by the *Venus de' Medici* twenty years earlier. The dream of a timeless masterpiece now enveloped the newly excavated marble of the goddess, but the public had become divided: in addition to the supporters of classicism there were now the partisans of Romanticism, who showed no enthusiasm for a work like this because their eyes had grown weary of ideal beauty. Renaissance and Baroque paintings were better able to feed the curiosity of a public that wished to see epic and dramatic compositions rather than ideal forms.

In 1828, Stendhal, standing with his friends before the *Apollo Belvedere* – now back in the Vatican museum, but no longer quite the same icon that had once been so revered – openly approved that change of taste among the Parisians. The sculptures from the Parthenon, he said, 'the casts of which are only twenty paces from here, will damage the reputation of this statue. The majesty of the god made a theatrical impression on my travelling companions. We read Winckelmann's description. Good heavens, this is German bombast of the worst kind.' In order to form one's own conception of antique beauty, he continued, one must 'leave out all the meaningless phrases from Plato and Kant and their school....What is especially wearying is the contemplation of nude statues in their ideal beauty. Why should one force oneself to admire the *Apollo*? Why should we not admit to ourselves that Canova's *Perseus* is far better?' And in another essay Stendhal found, in the 'beauty that Canova has invented, qualities that have a stronger appeal for us in the early nineteenth century'. Beauty was now bound to a particular time. The public wanted to see 'people of today'. It was bored with the ideals of the past. It demanded nature, not the 'imitation of an imitation'.

Looking back at the museum's beginnings, it is clear that the idea of the museum can be wholly identified with that particular idea of the work of art to which the term 'masterpiece', in its new sense, had begun to be attached. Only when confined within the museum's walls did art become divorced from all other purposes and was viewed in a pure and absolute way – a way, however, that was also limiting. To see the museum only as the site of a collection would be to give an inadequate description of it. It was a newly defined territory of art, a space in which modern culture could reflect on itself. As art began to serve a new visual culture, there was a reaction against ideals and symbols from another age. Now that the antique statues, which for centuries had dominated the way people thought about the work of art, were unserviceable icons in

art's own temple, they bequeathed their mystique to European paintings that were gradually taking their place in the museum. So, as *Apollo* departed, his cult was hastily transferred to newer masterpieces of European art.

2 Raphael's Dream

Like no other work of art, Raphael's *Sistine Madonna* in Dresden has fired the Germans' imagination, uniting or dividing them in the debate about art and religion (illus. 12). Over and again this painting has been hailed as 'supreme among the world's paintings' and accorded the epithet 'divine', not least because it presents a divine child as the highest ideal of art. 'What a treasure in Germany!', the painter Alfred Rethel excitedly wrote to his brother: 'I am quite intoxicated: I would not swop for a kingdom the delight I have had from standing before this picture.' Wagner planned a secret trip to Dresden just 'to see the *Sistine Madonna* again'. For Thomas Mann it was the 'greatest artistic experience', and Martin Heidegger summed up a debate that had continued for 200 years in his pronouncement that 'All the unanswered questions about art and the art-work cluster around this picture.'

The *Sistine Madonna* was a notable absentee from the Louvre's collection of Raphael originals, rounded up by Napoleon from across Europe. At the same time it was the sole significant Raphael that Germany could boast. In Berlin, Queen Louise gave her husband a copy of it by Friedrich Bury, of the same size as the original, for his birthday in 1804 (illus. 13). Despite the poor quality of this copy, Frederick William III dutifully accorded it the veneration due to a Raphael, and more and more Raphael copies found their way into the Berlin royal palace. When the Raphael Room at Potsdam's Schloss Sanssouci was created by Frederick William IV out of respect for his late father, it was a unique monument to wishful thinking, for it consisted entirely of copies, just as elsewhere there were whole collections of plastercasts and copies of admired sculptures. In 1858, when the 'Raphael Pantheon' was opened in the orangery of the Potsdam palace, copies of other works by Raphael formed a kind of historical passe-partout frame around the *Sistine Madonna*. The Germans took their only genuine Raphael to their hearts as though it had been painted especially for them. But they knew the facts. Back in 1753 Augustus III, Elector of Saxony and King of Poland, had arranged for this altarpiece to be transferred from the monastery at

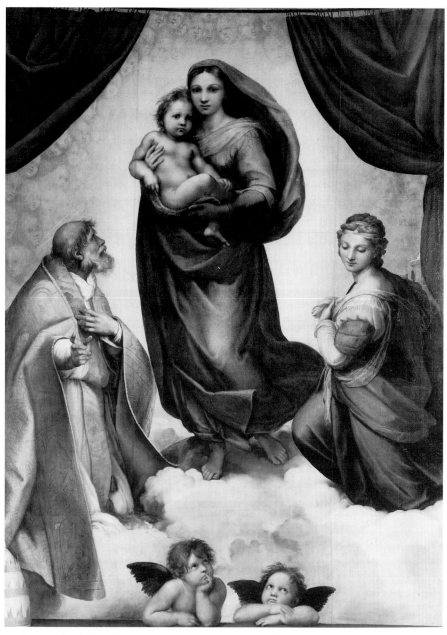

12 Raphael, *Sistine Madonna*, 1512–15, oil on canvas. Gemäldegalerie Alte Meister, Dresden.

13 Friedrich Bury,
Copy after Raphael's
Sistine Madonna,
1804, oil on canvas.
Orangerie, Schloss
Sanssouci, Potsdam.

Piacenza to the Dresden gallery. Seldom had there been such an abrupt change of rôle from Church icon to museum picture. This left a lasting sense of unease, particularly as the painting's Catholic subject-matter was an ineradicable reminder of its former purpose, which the Protestant disciples of art were doing their best to forget.

At some point during the three years (1512–15) when Piacenza was part of the papal state, Raphael's painting was apparently commissioned for the new-built Benedictine church, probably by Pope Julius II himself. He wanted the altarpiece to include the early pope and martyr St Sixtus, in honour of his own uncle, Sixtus IV. In 1698 it was given a grandiose frame, and when the painting was carried off to Dresden its place in the frame was taken by a copy. Raphael's painting is remarkable for the way it negates both its own picture plane and the customary illusion of space. Beyond the raised edge of a stage, on which two putti are resting their elbows, and behind extremely convincing painted curtains that have just been drawn apart, we see a heavenly apparition that embodies the quintessential *idea* of a painted vision. The painting presents itself as a vision, which culminates in the quiet gaze the Virgin bestows on the beholder. The way that the curtains are apparently

attached to the picture frame turns the painting into a sacred theatre, which its modern viewers saw as a theatre of art, while the elevation of the painted vision to a celestial region intensified the ecstasy of their aesthetic experience.

The *Sistine Madonna*'s instant fame in Germany was due to one of the happy coincidences of history, even if with hindsight it does not seem like a coincidence. Germany's premier apostle of art, Winckelmann, was on the point of leaving Dresden for Rome when the painting arrived. Although he was obsessed by the pure ideal he discerned in Greek statues – indeed, he was about to publish his *Gedanken über die Nachahmung der griechischen Werke in der Malerei und Bildhauerkunst* (Reflections on the Imitation of Greek Works in Painting and Sculpture), the book that was to make him famous almost overnight – now, quite unexpectedly, the crucial piece of evidence supporting his arguments landed on his very doorstep. Normally he enthused only about antique originals, but here was the one successful modern imitation that he was prepared to acknowledge. For him, Raphael's greatness lay in his affinity for antiquity, an affinity that Winckelmann felt could only be recognized by someone as steeped in the subject as he himself was.

Had Winckelmann left Dresden sooner, or had the *Madonna* arrived later, the controversy his essay provoked in that period of Rococo taste and values would not have happened. He never returned to Dresden, and his enthusiasm for the painting later waned. But others quickly made their voices heard. Artistic taste in Germany had barely begun to conform with international classicism and its ideals when it was caught up in a national cross-current. The Dresden painting became embroiled in the debate about the two opposed positions that had yet to acquire the labels of German classicism and Romanticism. If Raphael's Madonna looked to some like a goddess of antiquity, others saw her as a purely Christian saint. For some, Raphael's picture was a mirror of art, for others a mirror of religion.

In effect, the Germans created the work anew. At that time no other work in Germany so visibly embodied the essence of art. People were fascinated by the concrete presence of a *work* in which an *idea* of art had crystallized with such clarity. The idea seemed timeless, but really it was the work that was so, for it remained while the concepts that were projected on to it came and went. However, those who viewed it were seldom conscious of any contradiction between the work and the idea. They hardly noticed that their comments turned the work into a chameleon. Now it appeared devout, now classical, now it was pure soul,

now nothing but body. Fortunately, being an Italian painting, it evaded the controversy surrounding the demand – by this time in full swing – for specifically *German* art.

The true causes of this fascination became apparent in 1799, when the brothers Friedrich and August Wilhelm Schlegel published the Dresden 'Gemäldegespräche' (Conversations about Paintings) in their literary periodical *Das Athenäum*. The Schlegels were deeply conscious of the conflict between art and religion, but saw it resolved in the picture as by a healing hand. Once again art offered a refuge from that freedom, newly won and yet already feared, which offered no firm foothold. 'We gladly share in your devotion', one of the participants in the conversation assures another, 'for we can each experience it in our own way'. The object of this devotion is a miracle of art that is quickly imbued with sanctity. This is why (as one of the speakers declares) the work fascinates connoisseurs and untutored minds alike. Raphael is revered as a saint by those who have no belief in saints, and the perfection of his *Madonna* is seen as proof of a perfection that transcends all human limits.

Countless visitors to the museum marvelled at the fact that such a work existed before their eyes and yet did not belong to their time, so that it was simultaneously present and absent. It was not the mere material product of a transient act of painting, but had 'a sublime existence of its own' that transcended any individual person's subjective impression. Yet, in the conversation, 'Louise' (in reality Caroline Schlegel) acknowledges that, as she visualizes the Madonna of the painting in her memory, the image changes into one of her own making. In this way, then, the beholder also plays a meaningful rôle. He or she embodies the work in their imagination – an enigma that no one at that time attempted to investigate. The finite nature of the actual work dissolved in its boundless contemplation, whereby individuals experienced the painting, despite its historicity, as a kind of 'heaven of art'.

The 'Gemäldegespräche' offer an important model for a new way of looking at art. The Schlegels presented it so vividly that their readers arrived at Dresden with an impression of the work already in their minds. Henrik Steffens wrote bluntly of the 'deceptive aura of poetic writing' that was clouding the work. After widely read texts 'had given it a poetic consecration, every young writer was to be seen kneeling at the altar of the Madonna'. Here the ironic point is being made that writers would normally wish to kneel only at the altar of art. The illusion surrounding the work becomes apparent in the confusion surrounding the religion that some people still sought to discover in it. For a time

writers defended the Madonna against the suspicion of being a heathen goddess in Christian clothing, and praised the painting's profoundly Christian aesthetic, as far as they understood it. But then suddenly the Madonna no longer seemed Christian enough. Friedrich Schlegel wrote of Raphael's *Madonna di Foligno*, which at that time he was able to study in the Louvre, that the Madonna herself was portrayed 'with too generalized a divinity, so that she could quite easily be a Juno'.

This comment reflects unease about an artistic pantheon in which the divinities were becoming interchangeable. Juno was no more and no less unreal than the Madonna, even if people were loath to admit to themselves that the Christian religion, to which they were strongly committed, by now amounted to nothing but an aesthetic need. The true gods were not those represented in the paintings, but rather the artists who created such images. As a result, a religious war of sorts broke out, with one camp revering Raphael as a 'divine' pagan and the other as a devout Christian. These divergent schools of thought split one artist into two different people. The metamorphosis of the erstwhile classical artist into Romanticism's artistic saint reached its culmination in the legend of 'Raphael's Dream', which is directly connected with the Dresden picture.

GENIUS AND THE WORSHIP OF ART

The legend of 'Raphael's Dream' tells of the creation of a masterpiece that could only be completed after the painter had received a celestial vision. Here a *topos* from the miracle legends associated with medieval cult images has been put to the service of the new cult of art. Without explicit reference being made to this ancestry, Raphael's *Sistine Madonna* is regularly described as though it were a cult image of the old type. The legend seems to have been in the air in Germany in the later eighteenth century, for it appears in writings by both Johann Gottfried Herder and a young Romantic, Wilhelm Heinrich Wackenroder, in the 1790s. It was Wackenroder's *Herzensergiessungen eines kunstliebenden Klosterbruders* (Outpourings of an Art-Loving Friar) that, by becoming a cult text among the youth of that time, made the legend widely known, but it was also in Herder's mind when he wrote the poem 'Das Bild der Andacht' (The Picture Inspired by Devotion).

In musical theory of the period, the term *Andacht* – silent worship or devotion – was used to describe the attitude of the enraptured, soli-

tary listener giving himself wholly to the musical experience, like a Christian at prayer. Devotion, the theologian Herder had remarked, could more readily be achieved through the 'sacred' art of Church music than through the social music-making of the Courts. Here he was looking back to earlier ages, and he expressed the same kind of nostalgia in his poem on religious painting, in which he sharply differentiated Raphael's picture from the *galant* paintings of the Rococo. For him the difference lay in the state of mind of the artist, 'for what was created through devotion inspires devotion'. He relates the legend of a pious artist to whom the Mother of God appeared in a dream, and immediately draws a parallel with Raphael, asking, 'Did the image of the divinity, O Raphael, appear to you too?' That question is already answered by Raphael's masterpiece itself: 'I see her image. It was she.'

In the *Herzensergiessungen*, Wackenroder claimed to have found the legend among the papers of a 'devout monk', who for his part had come across it in a dusty parchment containing an account written by Bramante. The story was thus 'authenticated' by means of the old *topos* of rediscovery, which was itself a feature of religious legend. In this modern legend, the artist's pious devotion provided an appropriate model for every contemporary beholder of the painting to follow. The inner vision that the artist had experienced was carried over into his picture, and from there the beholder received it in turn, if he truly absorbed the work into his soul. The purpose of this miracle story was to give art a religious aura and to 'raise up a new altar to the glory of God' in art.

Though the *Sistine Madonna* is not actually named in the *Herzensergiessungen*, every reader would understand the reference to Raphael's passionate longing 'to paint the Virgin Mary in all her heavenly perfection'. The work, we read, was hanging 'still unfinished on the wall' when Raphael, who had fallen asleep in front of it, saw in a dream 'a perfect and truly living image [whose] divinity overwhelmed him'. That inner image became the work. Wackenroder cites a famous passage in a letter written by Raphael: 'I am guided by a certain image in my mind which enters into my soul.' Into this idiosyncratic rendering of Raphael's words, he casually dropped the key words of Romantic art theory, which was then only just emerging. The 'image in one's mind' is the visible idea of art itself. By a convenient shift of meaning, the idea of art became synonymous with the Madonna's beauty, so that he could mention the Madonna when in fact he meant art. The transcendent, flawless work was created with a mysterious perfection that was beyond the scope of conventional knowledge about art.

14 The Riepenhausen Brothers, *Raphael's Dream*, 1821, oil on canvas. Muzeum Narodowe, Poznan.

From about 1820 onwards many writers tried their hand at the subject of Raphael's Dream (there was even a five-act play). These efforts had a visual counterpart in sets of engravings illustrating the phases of Raphael's life, from birth to death, in the manner of a saint's life. One such cycle was published in 1816 by the Riepenhausen brothers, who had moved from Dresden to Rome in 1805. This, however, still sets the origin of the *Sistine Madonna* simply in an ecclesiastical context. Raphael is shown painting the Madonna as she had appeared in the picture known as the *St Luke Madonna*. Only in a second version in 1833 did the brothers replace the Luke *topos* with the Dream *topos*. But as early as 1821 they had depicted the dream in a small painting for Count Athanasius Raczynski (illus. 14). Here the night-time studio in which Raphael has fallen asleep is illuminated by a heavenly vision in which we see the Madonna as she will appear in the finished picture.

This pious legend was inspired by a work of which the idea of a vision was an intrinsic part. But for Raphael himself, that idea was simply the painting's subject-matter, which boldly declared itself to be a vision. Essentially, Raphael had painted a vision as if experienced by the viewer, but what was now being projected onto it was a vision experienced by the artist. Through this latter vision the real process by which the work was produced was shrouded in a mysterious origin from which art came forth with a pretension to metaphysical status: the work was something not made but 'received'. The 'dream' is a formula expressing the mystery that is woven around the artist (for now he, rather than any objective ideal of art, is the focus of attention). 'Absolute inwardness' – Hegel's term for Romantic art – reveals the boundlessness of the individual consciousness, which transcends the finite nature of a work.

But the metaphor of the dream also challenged the observer to make a work of art into an event taking place in his own mind. Soon, Dresden's museum visitors were remaining for hours in front of the *Sistine Madonna*, bursting into tears, and returning home to be haunted by the image in their dreams. It is not surprising that Sigmund Freud mentions the Dresden painting in connection with hysteria. His patient Dora remained in front of it for 'two hours ... rapt in silent admiration. When I asked her what had pleased her so much about the picture, she could find no clear answer to make. At last she said: "The Madonna".' The tautological nature of her response led Freud to suspect that she was speaking of a projection of herself. What normally occurred in so-called dream displacement was happening here on the borderline between picture and beholder. The picture was expressing what Dora did not consciously know about herself, and drawing her irresistibly towards the revealed Virgin who had become a mother. At the same time it offered Dora a therapeutic 'transference': the Madonna of the picture was replaced by yet another person conjured up by Dora. So she was able to experience this extraordinary image either as a reflection of herself, or conversely as a therapist who, with an authority that might be gentle or firm, guided and corrected her emotions.

The legend of 'Raphael's Dream' transformed a classical painting – one that possessed the clarity of ancient art – into the chief witness for the Romantic aesthetic. 'Greek' form was forgotten: instead, all the talk was of the emotional freedom shining forth from this religious work. At that time the inhibition against speaking of absolute art could only be circumvented by using the label of religion. In this respect the painting itself showed a useful ambiguity, for it depicted religious subject-matter

and did so with a beauty that might well rekindle its beholders' feelings for religion. It took someone of Hegel's stature to declare roundly in his 'Aesthetics': 'When we as present-day Protestants choose to make Mary the subject of a modern painting, we are not truly serious about this kind of subject-matter.' But it was possible to venerate an old representation of Mary with modern devotion, and this devotion took forms that still resembled the religious practices from which they were ultimately derived.

Johann David Passavant played on this ambivalence when, in his biography of Raphael, he spoke of the Madonna floating into view 'as if from mystery into revelation'. Revelation, a religious concept, now came to signify revelation through art. Baron Carl Friedrich von Rumohr played his part in stimulating the imagination of his contemporaries by devising the persistent but incorrect theory that the canvas had been an 'ecclesiastical banner' carried at the head of processions, a rôle that had intensified its 'impact'. The impact that the painting was now having on the cultivated world almost inevitably gave rise to such explanations, though of course they could not actually explain anything. Adopting a positively animistic attitude to the painting, people credited it with a life of its own that in reality came from those who contemplated it. This prompted a characteristically irreverent remark from Nietzsche: 'This vision radiates the joy on the faces of its beholders.'

ABSOLUTE ART

From an early stage, Romantic musical aesthetics were dominated by the idea of 'absolute music', even if Wagner was the first actually to use the term. In the concert hall and museum alike, an attitude of devotion was demanded. This aesthetic was expounded by the same writers who were propagating the cult of Raphael. In both these arts the metaphysical ideal found an effective formula in the 'religion of art'. For Friedrich Schleiermacher in his *Reden über die Religion* (Speeches on Religion), this still signified a path towards religion. Ludwig Tieck, on the other hand, credited music itself with the sacred quality of religion: 'For music is certainly revealed religion.' And Wackenroder saw the musical sentiment as divine, 'because it portrays human feelings in a way that transcends the human'.

This telling antithesis underlies Wackenroder's narrative concerning the composer Joseph Berglinger, which forms the concluding section of the *Herzensergiessungen*. Berglinger is 'utterly weighed down' by the overwhelming demands of art. Although by 'pushing himself to

the limit' he composes a Passion that 'will forever remain a masterpiece', he is psychologically broken by this self-inflicted act of violence and dies 'not long afterwards, in the flower of his manhood'. The mortal danger inherent in the modern form of 'service to art' had been unknown to Raphael, who 'in all innocence' had created works in which 'we see heaven in its entirety'. But now art, remaining alone in the place once occupied by religion, had to be written about in a radically new way. Amid the turbulent beginnings of bourgeois culture, absolute art was the reverse side of an art that had been relieved of all its previous functions.

Only in symphonic form did it seem that music could achieve the desired autonomy. Only in instrumental music, no longer tied to words, was pure music seen to emerge. Such ideas are expressed in Wackenroder's *Seelenlehre der heutigen Instrumentalmusik* (Psychology of Present-day Instrumental Music). The anecdotal treatment of feelings is here replaced by the metaphysical experience of an art that was nothing but the reflection of an 'infinite longing'. In painting, the parallel to the symphony would have been abstract art, which, however, was not to establish itself for another century, though it finally did so on the basis of a thoroughly Romantic pattern of thinking. But as yet, absolute painting could only be conceived of, not realized. Painting was tied to representational motifs even when it sought to express the infinite, which it found in depicting solitaries gazing at vast landscapes and seascapes. The concept of absolute art, on the other hand, either divorced itself completely from the need for actual works or attached itself to particular, special works that were then declared, logically enough, to be absolute masterpieces. These had to be works of great age, since this guaranteed that they had already become independent of their content and could now be looked at purely 'from the point of view of art'.

Thus the *Sistine Madonna* adopted the body of art absolute that had by then become disembodied. The actual work, sullied with the inadequacies resulting from its historical genesis, such as subject, age and artistic manner, could thus be cleansed of such impurities when representing art in the absolute. For this purpose a work's unique quality was of lesser importance than the determination to appoint, as it were, certain works to be the representatives of the absolute. In the visual arts, the idea generated the dream of experiencing absolute art in a masterpiece from an earlier period, that is to say a work which transcended every artistic category and, by virtue of its age, stood outside time. If we trace the idea back to religion, the analogy is perfect. Aesthetic contemplation replaced religious practice. As recent a thinker as Heidegger compared the Dres-

den picture to the sacrament in which the bread is transubstantiated into the body of Christ, just as Raphael's picture seemed to have been transformed into the body of art.

The analogy between museum and concert hall is revealing in our case. In the concert hall, noisy sociability, with a musical performance merely providing an accompaniment, was at this time being replaced by the silent devotion of listeners who were oblivious of the world despite being in a public place, individuals all hearing the same music but receiving it as their own experience. The museum that came into being in the same period was another place dedicated to the worship of art, where people were similarly able to find privacy in public. Here, too, visitors stood in silent awe before works in which they found their souls reflected. The success of the concert hall as a place of devotion was destined to last, while the museum, which has long since ceased to be a sacred temple of art, now echoes with the noise of guided tours. But during the Romantic period, which gave us both institutions, the meaning of the two cult spaces was entirely parallel.

The analogy between artistic and religious cult spaces is equally discernible in early accounts of visits to the *Sistine Madonna* in Dresden, though the analogy was only completed in 1855 when the new gallery by Gottfried Semper was opened. Here at last Raphael's *Madonna* dominated an entire room of its own – a new kind of chapel – where visitors sat in silence on velvet-upholstered chairs in front of the masterpiece that loomed over them intimidatingly in a golden frame on a veritable altar of art (illus. 15). Carl Gustav Carus, despite his old familiarity with it, only now 'properly understood this extraordinary work; and since I have seen it ... it has presented itself ever more radiantly and in its full significance to my soul.'

The very same ideas were playing a prominent part in musicology. Ludwig Tieck praised music as a 'separate world of its own', and Wackenroder regarded 'distance and withdrawal' as essential for the enjoyment of music. His Joseph Berglinger is a perfect model for concert-going, when he performs the kind of silent contemplation that is associated with religious practice: 'When Joseph attended a grand concert, he took a seat in a corner and listened with the same devotion as if he were in church.' The absolute, whatever name might be given to it, 'presents itself to the soul' (as Carus puts it) of a devotee of art who makes himself receptive to the experience.

However, this way of experiencing art had to be purged of any suspicion that it might simply be the product of self-delusion. Accord-

15 Raphael's *Sistine Madonna* (illus. 12) in a frame dating from 1855. Gemäldegalerie Alte Meister, Dresden.

ingly, Wackenroder's *Phantasien über die Kunst* (Fantasies about Art), which Tieck published after his friend's premature death, close with a section on the 'eternal nature of art'. This permanence of art cancels out the transient life of the individual beholder in a never-ending present. Art fulfils itself in a perfection that allows the relationship between the masterpiece and absolute art to be expressed in these terms: 'Whatever is perfect, in other words whatever is art, is everlasting and permanent, even if the blind sweep of time obliterates it'; a perfect work of art carries eternity within itself: 'In the perfection of art we see, in its purest and most beautiful form, the image of the paradise of our dreams.' Paintings may fade, but 'it was not the painter's colours that created their being. The present of art bears its eternity within itself, and it has no need of a future, for eternity signifies nought but perfection.'

Auratic art promised another kind of redemption than religion: redemption from one's own circumscribed personality. Wagner, who so often named things when their moment was already past, wrote in his late essay *Religion und Kunst* (Religion and Art) of the 'redemptive ... power of idealizing, true art', which he recognized in the *Sistine Madonna*. Carus had earlier felt himself released, in the presence of that painting, 'from the fetters of reality'. In the 'mystical concept of the Virgin Mother' he recognized his very personal dream of the *'incarnate purity of the idea'*. To him, the Madonnas of the period before Raphael were still too abstract, the later ones too worldly, or no more than imitations. Only Raphael's Madonnas were 'divine, because they *are*'. Here the timeless essence of the masterpiece is evoked in the language of religious worship.

The ambivalence between work and idea liberated every painted image from its externality and transformed it into an internal image. It was within the observer himself that the image came to life. Goethe perhaps showed the deepest understanding of that ambivalence when he crowned his life's work as a writer with a description of a painting that becomes transformed into the creation of an image. The connection between the closing scene of his *Faust*, Part II (1832), and Raphael's *Sistine Madonna* very quickly fell into oblivion, so that the poetic work was preserved from any comparison with the painting. Only Carus openly declared, as late as 1857, that Raphael 'chose the highest mystical task that is given to art', and quoted Goethe's final chorus: 'What is ineffable here is accomplished ...'. These are the words with which 'the greatest poet and visionary of our age concluded his greatest work'.

In Goethe's final scene the angels lift up 'the immortal part of Faust' to a celestial apotheosis that reunites him with Gretchen. The idea of redemption now brings the apprehension of the absolute into art. Ecstasy in the experience of art anticipates the coming transformation. The upward movement, as in Dante's *Paradiso*, is initiated by the 'look and greeting' of the 'Mater Gloriosa', who for a long time floats above, a silent image, only speaking a couplet almost at the very end. The other characters in the scene all behave like people looking at a picture, describing or directly addressing it – a picture of the 'untouchable' who acts as an image that evades physical touch. Perceived aesthetically, the Christian figure becomes again the Virgin 'pure in the most beautiful sense'. When Doctor Marianus, the Marian mystic who is the most

eloquent of all those contemplating her, urges the others to 'look up towards her redeeming gaze', the exchange of looks that follow represents the desire for self-redemption. The succession of epithets he applies to her – 'Virgin, Mother, Queen, Goddess' – no longer suffices to encompass a gaze freed from all constraints.

The argument so often rehearsed as to whether Raphael's *Sistine Madonna* is a heathen goddess or the Christian Virgin ends, in Goethe's work, in a startling synthesis of the 'ineffable'. In a draft that he later rejected, Goethe planned to extend Gretchen's prayer of supplication with the cry: 'Stay, O stay! With the globe at your feet / In your arms the sweet one / The holiest child / Wreathed with stars / To the firmament you ascend.' But these lines would have misled people into thinking that he was describing Raphael's altarpiece and not a vision of the absolute for which the painting was only a stimulus. This was also why he reversed the direction of the Madonna's movement: in the painting she is stepping into the world of the observer, but the apparition of the Mater Gloriosa draws Faust away into another world.

The final chorus promises experience of the absolute through the unfulfilled longing of the loving gaze. The distinction between work and idea, with which all beholders of the *Sistine Madonna*, as good Germans, were preoccupied, appears in Goethe as the distinction between poetic language and the truth of which it speaks. Raphael's work was 'transient', but as an image it was a 'metaphor'. Only under the beholder's gaze did the work in its 'inadequacy' become 'fulfilled'. The 'ineffable' that the beholder experienced was already 'accomplished' in the work. In the erotic quality of the gaze that 'the Eternal Feminine' attracted to itself lay redemption from the gulf between looking and the image itself, which in earthly life was unbridgeable.

> All that is transient / Is but a metaphor;
> Earthly inadequacy / Here is fulfilled;
> What is ineffable / Here is accomplished;
> The Eternal Feminine / Drawing us on.

The repetition of 'Here' evokes the spatial presence of a picture, as though we could see with our own eyes what in fact only takes shape in our imagination. Raphael's painting, too, had only been the locus where viewers were profoundly moved by an inner image of their own. The redemption they sought corresponds to Faust's redemption, which also occurred only in Goethe's poetic language, that is to say through art. Art seemed to have been transcended when it succeeded in expressing that

for which it had always been only a 'metaphor', and yet it could only fulfil its promise *in* art. Art emerges as the experience of all that had since become 'ineffable'. For a long time now the Christian subject-matter of Raphael's painting had also been seen as only a 'metaphor'. The same could be said of the 'figures associated with the Christian church' whom Goethe introduced to give more tangible form to his 'poetic intentions', as he remarked to Eckermann. The absolute was revealed as beauty that could not be understood but only 'beheld'.

We scarcely need Doctor Marianus, who also at the conclusion of the *Commedia* prepares us to look upon God, to make us aware of the deliberate parallels with Dante – though these reveal Goethe's modernity. The final scenes of *Paradiso* and of *Faust II* together silently perform an alternating chorus of European spirituality. In Dante's work, St Bernard exhorts the poet to see in the features of the Virgin Mary the resemblance to God (canto xxxii, line 85) before which 'our speech … fails' (xxxiii, 56). But the vision experienced by Dante, the believer, is still nameable, even if he likens the impossibility of describing it to that of squaring the circle (xxxiii, 133). Goethe's vision shares with Dante's only the energy of love, which is celebrated in the very last line of the latter's grand trilogy (xxxiii, 145). Goethe's 'mystical chorus' makes itself the advocate of a self-transformation that already contains within itself what was formerly the goal. But for Goethe, too, poetic language reaches its limit, beyond which a higher truth justifies the believer's faith in art.

The paradoxical relationship between Goethe's language and its 'metaphysics' was already prefigured in the way Raphael's painting was understood. Though an inanimate artefact, it appeared to the beholder as a living vision. Behind the thoroughly corporeal curtain that seems to be opening at the very moment the viewer steps in front of the picture, the Madonna approaches, floating on a heavenly cloud in which angels without number are depicted. As in *Faust*, the 'Eternal Feminine' was not the subject *in* the picture, but actually the embodiment of the look that the beholder directed *towards* the picture. Doctor Marianus is inspired by the image of the Virgin to what he himself calls 'sacred love'. He therefore desires more than he can see, and longs 'in the blue expanse of Heaven's vault, to behold thy mystery'. This is what the disciples of art also wanted to see in Raphael's painting, but Goethe transposes the location of the image from the museum to Heaven. In the last analysis he no longer needed the painted image, but produced an image of his own to kindle the reader's imagination.

In this scene of Goethe's, the concealed *description* of a picture, though

based on Raphael's painting, is transformed into the *creation* of an image that progressively detaches itself from the painting to describe an *idea*. The description thereby becomes a work in its own right, instead of merely a verbal account of another work. It is as if Goethe had brought back the classical Raphael, however religiously other viewers had responded to his work. And yet it is redemption through art, and thus the modern view of Raphael, that he evokes through Raphael's work. Precisely the recognition that when there is nothing more to be said one can only speak in images may have prompted Goethe in his old age to end his *Faust* with an image. If, in so doing, he had Raphael's picture in mind, he could be more certain of winning his readers' approval the less openly he revealed the link with Raphael's masterpiece. They should stumble on it themselves, as though it were their own discovery.

So it is not surprising that people soon started to think of the final scene of *Faust II* when they were discussing the *Sistine Madonna*. Carus was convinced that 'these remarkable words' of Goethe's must be 'seen as completely authoritative' in relation to the painting. For some time, both in commentaries on *Faust* and in books on Raphael, the comparison was drawn between the painting and the poetic work, until the fashion changed and it became *de rigueur* to speak of Raphael only in strictly historical terms. With French writers, too, this comparison came to mind when they thought of Germany's *Madonna*. In *The Gods and Demigods of Painting*, Théophile Gautier devoted three pages to the *Sistine Madonna*, in which 'the beauty of the goddess and the modesty of the Virgin are united in one artistic masterpiece'. Raphael, he remarks, has created a 'miracle of art' in which one forgets the human effort or looks in vain for traces of the actual execution. 'This sacred canvas is the last curtain of the temple: this is where visible beauty ends. Beyond this there is nothing more, nothing but the eternal beauty, that Eternal Feminine to which Goethe dedicated the last words of his life', and at this point the French writer switches to German, as though to grasp at a celestial quotation.

When that which Nietzsche called the 'artist's metaphysics' (*Artisten-Metaphysik*) grew stale, a new generation, bored with Raphael's painting, turned their backs on it and defiantly declared that the beauties of Raphael no longer convinced anyone. As so often, Nietzsche was the first to sum up this dissent in a nutshell when he devoted a short chapter to the painting in *The Wanderer and his Shadow* (1880). Some years earlier, in 1871, his mother and sister had given him an engraving of the *Sistine Madonna*, which 'of course' had to be hung 'above the sofa'. His brief

chapter bears the significant title 'Honesty in Painting', and focuses attention on Raphael's living model, so long forgotten because of the widespread fascination with the heavenly apparition. Raphael, we read, distanced himself from the belief in miracles prevalent among the elderly and the devout, and preserved 'his integrity even in that picture, an exception among his works', for it portrays nothing but 'the vision of his future wife, a woman of intelligence and refined sensibility, reticence and remarkable beauty, holding her first-born in her arms.'

The excessive cult of a masterpiece that people had set up as an exemplum of art left behind ambivalent memories that soon could no longer be distinguished from the work itself. Theodor Lessing, writing in 1908, was able to use them as a weapon against his own age, whose culture he judged in harsh terms. 'The supreme, the most beautiful manifestation of the old faith is the heavenly vision of the *Sistine Madonna*', he claimed, expressing what was probably a misconception, though an understandable one. 'She floats before us as the emblem of a great culture, but one which is dead and can never be revived.' And he adds the telling statement: 'We do not hope for a Saviour, we will save ourselves.'

Of course, Walter Benjamin, in his well-known essay of 1936, also referred to the *Sistine Madonna* when explaining the meaning of 'cult value', which he distinguished from the 'exhibition value' of the mere work of art. However, he could not make up his mind whether to place the Dresden painting under the heading of religious cult or of the post-religious aura of art. Paradoxically, it was only after it had become a museum piece that it became the focus of a cult, which it should have been as an altarpiece. Twenty years later Heidegger took up the theme, complaining that display in a museum meant the loss of the work's original purpose. The work lost its meaning when, by being put in the museum, it lost 'its place'. 'The fact that the *Sistine Madonna* has become simply a painting and a museum piece encapsulates the whole history of Western art since the Renaissance.' It is oddly contradictory when Heidegger reproaches the Romantics for having betrayed religion in the name of art, and yet claims to find in art that deepest mystery which had, after all, only entered people's cultural awareness with Romanticism.

AN ALTARPIECE IN THE SALON

In France, where the memory of the muster of Raphael's works in the Musée Napoléon lived on, there was a Raphael craze that was not concentrated, as in Germany, on a single picture. Moreover, France was

not reliant on copies of Raphaels, which could never be anything but substitutes for the originals. In the salons – which did not exist in Germany – every discussion of art soon turned to the question of modern artistic practice. An ideal in art was only acknowledged if it could be realized in paint, giving tangible proof of its contemporary validity. In the case of Raphael, Ingres took the bold step of recreating the *Sistine Madonna* in a modern alternative version. This was a wholly different project from the German retelling of the legend of 'Raphael's Dream'. In Germany people spoke with deep emotion of the genesis of Raphael's painting, and re-created it in their minds. The French did not hesitate to exhibit a modern adaptation of it for discussion in the salon.

After Napoleon's fall, public commissions had become scarce, and artists were running out of stirring subjects that could be painted with panache. Under these circumstances Ingres, still a young man, had to be grateful for the commission he received from the Ministry of the Interior to paint an altarpiece for the cathedral of his native city, Montaubon. But he was unhappy, all the same, with the religious subject-matter, and spent four long years in Florence labouring over it before exhibiting the finished work in the Salon of 1824 (illus. 16). His subject was more suited to the Baroque style, for the painting was of Louis XIII dedicating France to the Virgin Mary in 1636. In the Restoration years Catholic France was turning back to religion, which had remained acceptable even to those members of the middle classes that no longer had monarchist sympathies. Before Ingres could finish the picture, Louis XVIII died, and since the painting of his namesake was intended to honour him, the choice of subject lost part of its point. It was Louis's successor, Charles X, who awarded the prizes in person at the Salon, where the picture attracted much attention.

Admittedly Ingres took a good part of his inspiration from Raphael's *Madonna di Foligno*, which had been exhibited in Paris for a time, and copied from it the figure of the Virgin and the cherubs with the inscribed tablet. But the curtain is strongly reminiscent of the *Sistine Madonna*, and her celestial appearance in that picture is re-enacted here with pronounced theatricality. Raphael's vision, as imagined in the *topos* of the Dream, is transformed into the vision experienced by the monarch to whom the Madonna here appears. Ingres sensed that the dualism inherent in the subject might detract from the unity of the work. As a portrait painter he specialized in descriptive naturalism, while as a painter of historical subjects he favoured classical form. There is indeed a clash of styles in the two sections of the picture, and this drew complaints from all the Salon critics.

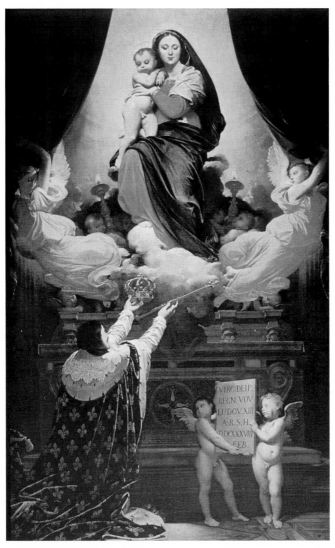

16 Jean-Auguste-Dominique Ingres, *The Vow of Louis XIII*, 1824,
oil on canvas. Montauban Cathedral.

But the real problem with the work lay elsewhere. Instead of bring-
ing back Raphael, as the picture seemed to promise, Ingres confronted
the public with his own, modern interpretation of Raphael, which
becomes the true subject of the picture. The curtains part to reveal a
perfumed actress who has not wholly renounced the coquettish pose of
the painter's model, however hard Ingres tried to make the figure
conform to the classical ideal of art, of which he was a fanatical propo-

nent. Precisely in the cliché of the vision, that ideal is like a mirage play-ing tricks on the modern pilgrim of art. The illusionism of the fore-ground contradicts the idealism of the figures emerging from the cloud, just as French history and classical art are associated with two ways of seeing that do not coincide in the modern mind. The monarch embod-ies France's history, but the Madonna is the incarnation of Raphael's art.

It may have been an enticing idea to attempt a modern master-piece in the classical spirit, but the undertaking was doomed to failure. A religious subject was the opposite of what was necessary for the modern idea of art to be experienced. When this idea has already entered the intention of the picture, the Madonna seems like a mere pretext. The worship taking place in the picture is the barely disguised worship of art, because it is not the Madonna but Raphael's art that Ingres nostalgically transfigures in his painting. The paradox in his work lies in the fact that he has made the Romantic view of Raphael, as expressed in accounts of visitors to the Dresden picture, the subject of his own composition. In his 'Salon of 1824', Stendhal sorrowfully observed that his age was able to achieve almost anything, 'but our hearts are cold. I now have even less belief in painting than before. Not one picture in the exhibition has the fire that one finds in one of Rossini's operas.'

Yet Stendhal was able to express respect for Ingres' picture once he had resolved to see it as a devotional painting that was out of place in the Salon: 'It will gain greatly from being seen in a church.' But this, too, proved not to be the case, for when the painting was transferred to Montauban Cathedral in 1826, the clergy divined its salon picture aspect, and Ingres was obliged to cover up the naked children's private parts, which he duly did with vine leaves of gilded metal. In the final analysis, this contradictory altarpiece testified only to the art of its painter, and it duly found a place beside his *Apotheosis of Homer* (see p. 96) at the 1855 Exposition Internationale. In Ingres' day there was a covert relationship between religion and art, but this appeared suspect the moment it was openly proclaimed in a painting's subject-matter. It was more discreet to sit in front of the *Sistine Madonna* in Dresden and dream of the art that gazed forth from a timeless masterpiece.

3 Shipwrecked

Following the opening of the Musée Napoléon, artists of the time must have begun to ask themselves whether they still had a chance to compete in the ongoing history of art. Art had been snatched from the mainstream of life and, as it were, consecrated to eternity within the museum's walls. Gone were the days when rich patrons dealt with old and new art as they saw fit, sometimes even preferring new art simply because they themselves were able to commission it. As yet, no one was planning to commission works for the museum, for additions by living artists would have constituted a slur on the eternal masterpieces. But the time was not far off when patrons, even monarchs, would be unable to compete with the museum. The museum's judgement on art seemed to be of a different order from the personal taste of any individual, because art's state guardians, acting as though in the name of history, decided what should gain a place in the museum. From now on art was irrevocably divided.

The plight of living artists in France was made worse by a general sense of unease that by then everything had been said and done. After all, how could the museum justify its existence except as the very home not just of ancient art but of art as a whole? Classical art was a matter of the past – even if some optimists doggedly believed that they could repeat it – for by then it had completed both its ancient and 'renaissance' cycles. Since art is difficult to assess, people put their trust in the new concept of the masterpiece, which was sufficiently intimidating to stifle superfluous debate. Even so, a patriotic urge provoked them into wishing long life and success to their own 'French school'. But how should this school set about proving itself?

If imitation was the assured road to success, originality, which was what the public demanded, could most easily be achieved through the choice of subject-matter. Not every subject had been treated by the Old Masters, and besides, recent history was continually providing new ones, though there was a drawback here: the risk of falling into mere reportage. Artists were expected to produce new masterpieces, and yet

such works of genius were only to be found in old, unrepeatable examples. This contradiction became all too obvious as time went on. The choice of subject-matter was by no means a minor consideration, because only history painting – the noblest of the genres, according to the academies – was considered to have the potential to allow for a masterpiece. Despite its name, history painting was simply a *mise-en-scène* of an edifying, didactic nature. Here was yet another contradiction. Anyone venturing to treat a historical subject found himself constrained by a genre that was judged less on its historical accuracy than on its presentation of a timeless fable.

This had been the state of affairs under the *ancien régime*, and the Revolution enhanced the status of the genre even more. The history painting's requirements were evidently still the same when, in connection with the 'Prix Décennaux' in 1810, it was described as 'permitting the painter to express characters and passions'. The subject might be 'historical or invented, or taken from fable or allegory', but the rules would be the same in every case. What mattered was the *beau idéal*, 'which captured Nature in her highest perfection'. This was an open invitation to give the raw material of historical fact a treatment that ennobled it. But if dramatic expression determined the rank of art, art itself determined the credibility of the subject.

In the eighteenth century, the choice of subject-matter had been a controversial topic. It had dominated art discourse ever since the theoreticians had themselves begun to offer suggestions when the Académie Royale was setting the subjects for competition. But history painting's real heyday came only in the short decade preceding the Revolution. Jacques-Louis David's *Oath of the Horatii* was a sensation at the Salon of 1784 not least because, like the stage works of the time, it offered a classical subject that was in tune with Republican sentiments. Before the actual outbreak of the Revolution, celebrating the memory of Roman freedom provided a covert form of expression by or for a class that found no representation of itself in art. Here the implicitly anti-monarchist subject could make a powerful impact, if not as reality, at least as a model. Painting as a kind of stage for dramatic representation could not be more clearly demonstrated. But everything depended on who gained control of the stage on which for so long the repertory had been dictated by the Court and the Church. In the Salon, too, the prizes had generally been won by works deemed suitable for acquisition by palaces and churches.

Following the turbulence of the Revolutionary years, the new age achieved its greatest triumphs on the battlefield, where Napoleon led his

troops from victory to victory. As the brilliance of the Revolution dimmed, people enthused about the army and its success in freeing the world from despotism. Whether those at home would identify with France's victories depended in part on propagandist paintings. Napoleon therefore invited artists and historians to accompany him on his campaigns. Suddenly contemporary history acquired a grandeur comparable to that of antiquity. Antoine-Jean Gros emerged as the master of contemporary battle painting. Eugène Delacroix, who wrote an emotional commemoration of Gros in 1848, recalled that back in the 1790s Gros had spent some time at Napoleon's headquarters in Italy. Soon after, this campaign chronicler was appointed a 'member of the commission charged with selecting the masterpieces that have fallen into our hands as a result of victory'. At once Gros was plunged into a crisis. Instead of achieving artistic triumphs of his own, he was serving as caretaker of the 'immortal masterpieces'. The result was that 'the magical impact' of what he saw in Rome led only to 'an increase in his natural melancholy'. So wrote Delacroix, who had himself envied Gros the success which the works of his maturity had brought him. His memoir recalls the conflict in which painters found themselves as they saw Napoleon triumphing in art. Battles were the only subjects that were likely to lead to a public purchase. Heroic subjects suddenly acquired a contemporary face. Official art had once again become possible.

Gros's huge painting *Napoleon at the Battle of Eylau*, which caused a stir at the Salon of 1808, turned the military victory of the previous year into one of history's great events (illus. 17). It is therefore worth taking a closer look at the dramatic means by which this unlikely metamorphosis was achieved. The hero is given a sacral quality through the heavenward gaze that was characteristic of Alexander the Great, and the gesture of authority familiar from the equestrian statue of Marcus Aurelius in Rome. The painting also drew on Charles Le Brun's series of the battles fought by Alexander the Great, which had been designed to flatter Louis XIV without portraying him personally. But now Napoleon appears in person. *Peinture* in the grand manner was once again admissible: it was plain for all to see that Rubens was the inspiration for the figures, while the Dutch masters were drawn on for the wintry landscape's colouring. By simultaneously venturing into reportage in his manner of depicting the battlefield, Gros produced an extraordinarily ambitious work, in which the imitation of reality and the imitation of art vie with one another. His treatment revealed his wish to encapsulate a history of art in this one picture, with the aim of impressing a public that acknowledged

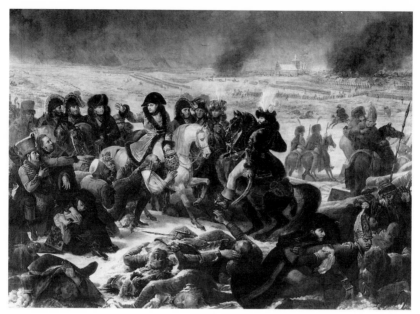

17 Antoine-Jean Gros, *Napoleon at the Battle of Eylau*, 1808, oil on canvas. Musée du Louvre, Paris.

such virtuosity. Here the contemporary historical composition was staged in operatic fashion, with the props of the actual event providing authenticity.

A generation later, Delacroix paid tribute to Gros for having 'elevated modern subjects to the ideal'. When Gros began his career, Delacroix wrote, only classical subjects were deemed worthy of art. But, as people had recently realized, these were of 'less interest than events taken from our own annals'. The only question was how contemporary history was to be represented if the ideal was to continue to hold sway in art. Rubens had already painted contemporary history in his Medici cycle, but he transformed it into a great allegory. 'Gros declines to paint such pictures. He sees his heroes through his own admiring eyes. He turns human beings into demigods.' This was in total contrast to the 'bare, prosaic history painting' that Rubens himself had rejected. Contemporary history seen in that way was no more than the raw material for art.

Even so, art found itself in crisis when heroic subjects were no longer available. Napoleon's fall marked the passing of the *gloire* in whose reflection art too had been bathed. The Restoration period offered only commonplace subjects or, when it did reach for the stars, amounted to

false pathos. The middle-class public, no longer educated to appreciate allegory, demanded topical subjects to feed its insatiable curiosity. The official art critics, however, insisted on an ideal of art that excluded reportage. The state and other public bodies had practically ceased to commission artists, but purchased works of art that selection committees deemed worthy of display in a museum. An element of dishonesty began to infect dealings with the artists. The authorities protested vehemently if the artists offered a picture of reality, but despised them if they simply painted the idealizing works expected of them. Each side suspected the other of bad intentions. The error of believing that art and life could form a unity slowly came to light.

Delacroix, still in his teens at the close of the Napoleonic era, identified the loss of the great subjects as the tragedy of Gros' later years. As Gros searched for new ones, David, directing him from his exile in Brussels, offered what Delacroix reckoned had been unsound advice: 'You have not yet created anything that could truly be called a history picture. Quickly, my dear friend, search through your Plutarch.' When Gros obediently returned to the classical subjects that had served a previous generation, he soon came to the end of his resources as an artist. Such subjects had lost the power to stimulate any artistic vitality – even though they still appealed to the public, which expected a great work of art to have a great subject.

Stendhal, who as a Bonapartist saw himself as being on the 'extreme left' in artistic matters, searched in the Salon of 1824 for masterpieces to satisfy his taste. 'I have seen two or three thousand pictures of battles. I have witnessed two or three battles myself, and on that basis I can declare Monsieur Horace Vernet's battle picture to be a masterpiece.' A war was being waged between two rival camps over the question of whether or not art must continue to be faithful to classicism, which meant 'copying every painted figure from a statue' and excluding all contemporary detail. Despite some 'fine, rather vague phrases, which are the weakness of this age', Stendhal preferred those who 'defend the new ideas'. He saw these being put into practice in Delacroix's large *Massacre of Chios*, but did not like them there (illus. 18). He wanted a more emotive scene – 'a fanatical Turk slaughtering angelically beautiful Greek women'. Thus he failed to see that an anonymous drama is acted out in *The Massacre of Chios*, which is why the event depicted reminded him more of a plague than it did a war. He did acknowledge that Delacroix, the great colourist, had effortlessly surpassed all the other painters who had large-scale works on show in the Salon, but did not

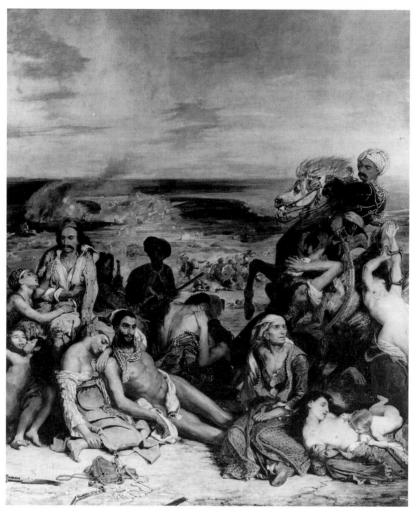

18 Eugène Delacroix, *The Massacre of Chios*, 1824, oil on canvas. Musée du
Louvre, Paris.

realize what made this picture so superior to the rest. Instead of a battle
scene, Delacroix had painted the Turks slaughtering Greeks at Chios. In
inventing this alternative to the battle scene he satisfied three different
interests at a single stroke: a contemporary subject, transformed into a
timeless tragedy, was depicted with a touch of the exotic. In the drabness
of the new domestic situation people could dream of distant places
where life was still heroic and picturesquely archaic.

There was little support for continuing history painting's old subjects as though the Revolution had never happened. It was enough that history was now history in a new sense – something irrevocably past and inapplicable to present circumstances, in other words a memory of the world before the Revolution. A similarly nostalgic perspective developed in relation to art. People dreamed of the old art as though it too, like the old days, was gone for ever. A year after the opening of the Musée Napoléon, pictures in the Salon featured subjects that had never before been seen in painting. The Old Masters now appeared in person as the heroes of a different kind of history – the history of art as seen through the lives of the artists. This was a wholly new phenomenon. It was art looking in its own rear-view mirror: for the first time, the history of art became a subject for art. The sole task of living artists seemed to be to depict the past masters whose works were admired in the museums. The new public wanted to be shown how those admired masterpieces had come about and what the masters who had created them looked like. Although this genre was of course based on thinly disguised fiction, the public had a burning desire to confuse the fiction with historical truth.

The new genre made a hesitant beginning when, in 1804, Nicolas-André Monsiau first painted the death of Raphael. The essence of the subject was the delightful paradox that the master had died, and yet lived on in his art. The tradition of art represented not death but life. There he lay in state, as Vasari had described him, in front of his masterpiece, the *Transfiguration of Christ*, which Napoleon had now transferred to Paris. In C. P. Landon's *Annales* (1800–22) the genre was celebrated as a great novelty, though people must have been aware that there had been a brief prelude around 1780, when several pictures showing Leonardo's death had been painted. But now, rather than merely a few isolated examples, there was a whole genre of popular anecdotal art that, in the age of the art museum, presented the history of art and its heroes through the medium of painting.

In Paris, Raphael's pictures provided an anachronistic experience of Rome. 'Raphael is to Rome what Hercules was to Greece in heroic times', Stendhal mused in his *Promenades dans Rome* (1829). Every great and noble achievement in painting was attributed to him. 'Even his life … comes to be the stuff of fable, filled with miracles by the admiration of posterity. We strolled slowly through the pretty garden of the Villa Farnesina close to the bank of the Tiber, where the orange trees are full of fruit. One of our

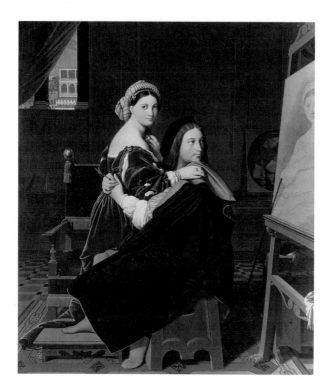

19 Jean-Auguste-Dominique Ingres, *Raphael and the Fornarina*, 1814, oil on canvas. Fogg Museum (Harvard University Art Museums), Cambridge, Massachusetts.

number told the story of Raphael's life, which seemed to intensify the effect of his works.' When the young Ingres took up this genre of painted biography, he developed it beyond individual anecdotes. His whole *œuvre* soon radiated the eroticism of a beautiful corpse. The painted anecdote of the artist phantasmagorically evoked a lost tradition by appearing old in every detail, as though Raphael had painted it himself, even though it had never been painted before and was thus undeniably new.

In 1813 Ingres embarked on an ambitious Raphael cycle, starting with a love scene (illus. 19) showing the painter and the beautiful baker's daughter, 'La Fornarina', who was thought to be the subject of an authentic portrait by Raphael. As a young married man and painter, Ingres identified deeply with the life and circumstances of his revered predecessor, as though time had stood still. The theme of his picture became so popular that he had to paint several more versions of it. The Queen of Naples, Caroline Murat, bought *The Betrothal of Raphael* from him. The love of art was mirrored in the love-relationship that had once inspired Raphael in his creation of art. The Salon of 1824 included a picture of Raphael arranging his beloved's hair before painting her. But Stendhal, who went with his guests to see the original portrait in Rome,

20 Jean-Auguste-
Dominique
Ingres, Detail
from illus. 19.

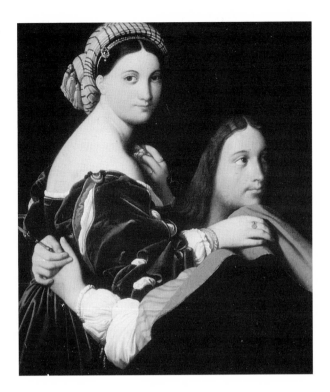

complained that there was an element of melancholy and physical weakness about the modern painted reincarnations of her that meant that any comparison with Raphael's original was out of the question.

In Ingres' *Raphael and the Fornarina* the youthful beauty looks at us seductively, while Raphael's eyes are turned towards her portrait on the easel (illus. 20). In Ingres' imagination she is still directing at us the loving look she had bestowed on Raphael as he painted her. Here the boundary between reality and dream, between then and now, dissolves. Everything becomes an enticing absence that at the same time stimulates the memory. A magical enchantment hovers about this sphinx-like painting, in which the puzzle of old and new creates a fiction of life that escapes life experience. But the viewer's imagination is powerfully aroused by the sense that a work of art familiar to everyone is only just being created, as though one had stepped back into an age that was really forever beyond reach. That perfect work of art is, as it were, made once again. Raphael's love, mirrored in the portrait of his beloved, was bestowed on the living woman before it lived on in the painted one. The subject has an emotional content that, in Ingres' re-creation, imbues a work of the past with false life.

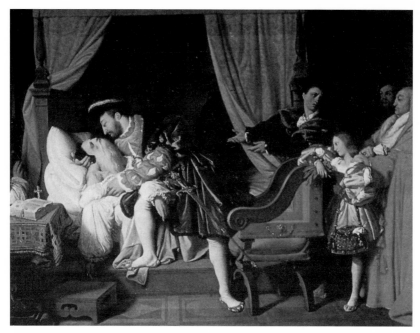

21 Jean-Auguste-Dominique Ingres, *The Death of Leonardo da Vinci*, 1818, oil on canvas. Musée du Petit Palais, Paris.

Ingres took his inspiration for this picture from Vasari's description, which was widely known in Landon's version. So he could count on finding an interested public among the readers of that great purveyor of anecdotes. Vasari had given a detailed account of Raphael's ardent love for the beautiful baker's daughter, whom Raphael wanted always to have near him. Vasari had also written the immortal description of the death of Leonardo that inspired Ingres' *The Death of Leonardo* of 1818, painted for the 300th anniversary of the event (illus. 21). According to Vasari, Leonardo was visited on his deathbed by the French monarch, François I: 'To show him favour and to soothe his pain, the King held his head. Conscious of the great honour being done to him, Leonardo took his chance and at once breathed his last in the monarch's arms.'

This is the moment that Ingres chose to depict, as though seeking a veiled metaphor for the passing of a 'beautiful epoch' in art. Who at that time would not have wished to hold in his arms the divine Leonardo, whose unknown burial place by the Loire was still sought for, following the destruction during the Revolution of his former resting-place. The monarch's gaze directed at Leonardo also represented the way art history looked on a tradition in which, once the Old Masters were dead and

gone, only imitation was possible. The King could be depicted in the manner of portraits of his period, while for Leonardo's appearance there was the profile drawing of him at Windsor Castle and the now disputed 'self-portrait' in Turin. The Turin drawing had been reproduced for the first time by Giuseppe Bossi in 1810 in his monograph on Leonardo's *Last Supper*. If it is indeed a forgery, as Hans Ost believes, then this would only confirm the desire to conjure up the lost age of classical art.

Compared with Ingres' astonishing vision, which informs his whole *œuvre*, in general the genre of the 'artist's anecdote' declined in power as fast as it gained popularity. Soon there were painters treating one master after another in ways that were both garrulous and arbitrary, thereby fostering a very shallow approach to art. Chief among these was the indefatigable Joseph-Nicolas Robert-Fleury, whose *Rembrandt's Studio* in the Salon of 1845 prompted sceptical comments from Baudelaire. In the same Salon an anecdotal Leonardo picture by Aimée Brune-Pagès was so successful that an engraving of it sold in vast numbers (illus. 46). Its subject was the creation of the *Mona Lisa*, whose myth really began at around this time. The painter gives free rein to her imagination in this scene, with its numerous characters, in which Leonardo is showing the famous portrait to the young Raphael – a subtle hint that, in the 1840s, Raphael's star was waning while that of Leonardo was in the ascendant. The living model sits beside the painting as though she had stepped out of it, because the fiction consisted of restoring to life the Renaissance, that magical age which still cast its radiance over art. The portrait in the picture seems oddly lacking in animation, because it receives only a second-hand vitality from the real woman, the model beside it. But the musicians' pleasing performance keeps the famous smile on the woman's face long enough for it to be captured on canvas for ever (see p. 141).

In its mystification of old works, the painted 'artist's anecdote' became a mirror of art history. It gave art lovers the opportunity to wallow in nostalgia. But some painters used the genre for disguised self-portraiture: Léon Cogniet, for instance, for the Salon of 1843, cast himself in the rôle of a tragic Tintoretto looking at us despairingly from the side of his daughter's deathbed (illus. 22). What was fascinating about this was the way in which Tintoretto's image, familiar to everyone from the self-portrait in the Louvre, became the actor in a story, as though there had been a secret that Cogniet sought to recover with his modern view of an old work. The serene Renaissance is here filled with dark shadows closing in on an aged, lonely artist who is a social

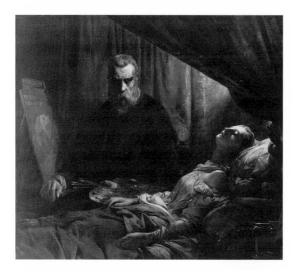

22 Léon Cogniet,
*Tintoretto Portraying his
Dead Daughter*, 1843,
oil on canvas. Musée
des Beaux-Arts,
Bordeaux.

23 Eugène Delacroix, *Michelangelo in
his Studio*, 1849–50, oil on canvas.
Musée Fabre, Montpellier.

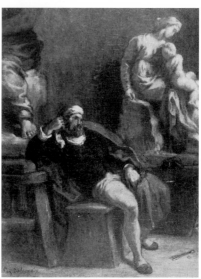

outsider. The death of living beauty boded ill for art, which was threat-
ened with isolation.

Delacroix's small study showing the aged Michelangelo in his
studio (illus. 23) may already have been the genre's swan-song. Nothing
could be more different from Ingres' early visions than this figure – again
a kind of self-portrait – embodying the melancholy of the Romantic
artist. Gone are the dreams of the blithe era of the Renaissance; they are
replaced by the unending drama of art, which looks out from this mirror
with a timelessly modern face. Delacroix, Ingres' great antagonist, also

tackled this theme in writing, publishing his texts on the Old Masters in 1830. His essay on Michelangelo is a sustained act of homage to his great model, who by now rivalled Raphael in general esteem, as if the Romantic cult of the genius needed an alternative hero. In this essay we read of the ceaseless struggle of creation and also of the despair that finds expression in a sonnet written by a Michelangelo complaining about the 'mistake' of allowing oneself to be driven by art's tyrannical demands. In the small oil sketch a gloomy Michelangelo sits beside the marble statue of the *Medici Madonna*, as though he had drained his soul in making it. He has been turned into the chief witness for modern scepticism as to whether it is still possible to create successful works.

The history of art appeared quite differently, however, in the dreams of art-lovers. François-René Chateaubriand created a literary monument to them in his account of his visit to Rome in 1828. In his autobiographial *Mémoires d'outre-tombe* (1849–50) he gave full rein to the nostalgia that had overcome him on seeing the venerable capital, where he felt himself to be in a city of the Renaissance. He imagined the Old Masters 'spending their days in adventures, fortifying cities and seducing women'. Honoured by popes and emperors, they were the true heroes of a great epoch. 'Today all that has changed, and artists live in Rome poor and forgotten.' He wishes that he himself had been born as an artist in those days. 'Then I would have been content with a piece of bread and a mouthful of water.' This vision, nourished by the dreamy wishes of an aesthete, could hardly have been more unreal. While fantasies of this sort fostered only passivity, he did take an active part in arranging for a splendid monument to be set up to the seventeenth-century French masters Nicolas Poussin and Claude Lorraine, both of whom had been buried in Rome. The bust of Poussin in S. Lorenzo in Lucina was dedicated 'to the glory of art and the honour of France'. Poussin's *Arcadian Shepherds (Et in Arcadia ego)* of *c.* 1640 was copied as a relief by Louis Desprez – a surprisingly good reproduction of the painting, as Chateaubriand assured Madame Récamier (illus. 24). In a Latin epigram on the life of art, Chateaubriand addresses the spectator: 'If, however, you wish to hear Poussin speak, then see, in wonder, that he lives and speaks in his paintings.'

By contrast Stendhal, in his essay on 'The Fine Arts and the French Character', argued that there was an essential difference between Rome and Paris, and that in it lay the germ of a 'revolution in the arts'. Rome, he said, was the embodiment of the culture of earlier periods, while in Paris, a city with 720,000 inhabitants, one would only hear about an artist from the press – a situation that encouraged all sorts of mischief.

24 Louis Desprez,
Funerary relief for
Nicolas Poussin,
1828, after Poussin's
*Arcadian Shepherds (Et
in Arcadia Ego)*.
S Lorenzo in Lucina,
Rome.

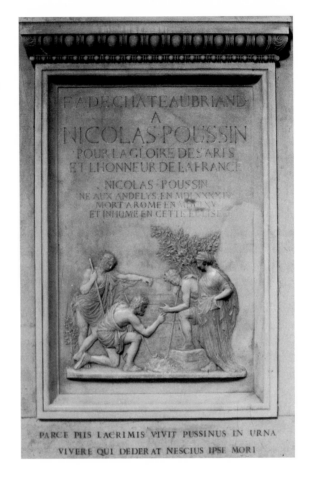

But of course as a writer he too was dependent on the public. He sought to cater for its new interests with a history of Italian painting that marked his publishing début. As early as 1811 Stendhal was planning a revised version of the abbé Lanzi's history of art, but he soon expanded the project by adding observations of his own drawn from his visits to Italy. In Milan, where he lived in proximity to Leonardo's *Last Supper*, he was inspired to write a chapter on Leonardo, and in Rome he was captivated by Michelangelo's *Last Judgment*. After the fall of Napoleon, to whom he had intended to dedicate the book, he felt that greatness could now be found only in the art of the past. His anecdotes and biographies are the literary equivalent of the painted art history of the Salon pictures. He published the work in 1817, under a pseudonym, but of the 1,000 copies he had had printed at his own expense, only 284 had been sold by 1824, while 270 had been given away.

THE SALONS

The Salon of 1817 opened on 24 April, the third anniversary of Louis
XVIII's return to France. By now a bust of the restored Bourbon king had
pride of place above what had been the entrance to the Musée
Napoléon (illus. 25). The author of the catalogue lamented the fact that
so many masterpieces seized by Napoleon had of necessity been
returned to their former homes, but enough works remained to serve as
models for young artists. To the lay public, the 'silent works of painting
and sculpture, unlike theatre and music' revealed their meaning 'mainly
through reflection'. But such reflection might lead to comparisons
unfavourable to contemporary art. The author therefore regretted the
decision to extend that year's exhibition beyond the Salon Carré into
the adjoining Grande Galerie, because the fact that one can 'observe the
development of the French school as one walks from the Salon to the
Museum' carried the risk that 'the living artists might be crushed by the
superiority of the dead ones'.

The author, a monarchist, firmly believed in the 'creation of new
masterpieces' that would do honour to the Restoration régime. New

25 Engraving of a bust of
Louis XVIII above the
entrance to the Musée
Napoléon, Paris, from
E.F.A.M. Miel, *Essai … sur le
Salon de 1817, ou Examen
Critique…* (Paris, 1817–18).

support for the arts, which was in the hands of two ministries, would make sure of that. The Salon had been much reduced in size, so that its quality would bear comparison with the treasures of the Museum. A high standard would reduce the danger of 'sacrificing the modern to the ancient. The arts are celebrating their triumph in the spacious halls of the Louvre. Paris is still the capital city with the largest number of masterpieces.' But Stendhal, responding to the Salon of 1824, heaped criticism on an arts policy that fostered mediocrity and favouritism. In Paris, the 'most demanding public in the world' mocked the conservatism of the authorities for the arts. Stendhal, for all his political nostalgia, was no longer satisfied by dogmatic classicism. 'People are growing bored with huge canvases containing thirty nude figures copied from ancient statues.' Whoever would go to war without clothes on nowadays? Though the critics were forever talking about style, they could not stifle the calls for 'good modern painting'.

The 1,152 artists who exhibited in that year's Salon were at the mercy of a panel of judges with an extremely narrow conception of art. Stendhal sensed that realism was about to become an important issue, but he sought for it only in the human soul. This is precisely why the Salon disappointed him, for the paintings conveyed nothing but an emotional chill: the more they purported to be full of feeling, the colder they seemed. When a society that denied itself any expression of feeling sought its grand passions in art, it was bound to fail. 'Civilization stunts the soul', he later wrote in his book on Rome, and in Paris it was fashion that determined taste. 'The roller of civilization flattens everything to one and the same level', robbing the 'exceptional individuals, several of whom deserve the name of genius' of their boldness. In the 1824 Salon two schools were vying for the right to be seen as new and original. In Stendhal's view, Romanticism – used at the time as a collective term for the opposition – simply 'portrays the people of today, while those of heroic times probably never were the way we imagine them'.

The Salon reopened on 25 August. Artists who successfully passed through the filter of the judging process were admitted to the Musée du Luxembourg, which showed works of the French school up to the present. In 1805 this museum, known as the Galerie du Sénat-Conservateur, was open to the public for two days a week, and to artists for the remainder. On 24 April 1818 it opened its doors as the Musée Royal, 'dedicated to living artists'; 74 paintings and sculptures of the 'modern French school' were exhibited there, among them François-André Vincent's late work, *Zeuxis and the Maidens of Kroton*, and David's *Oath of the Horatii*, an

engraved version of which was for sale. The work that caused the great-
est stir was *The Flood* by Anne-Louis Girodet-Trioson, which had
received the 'Prix Décennal' in the Salon of 1816. In his *Promenades dans
Rome*, Stendhal mockingly recalled that this picture was once thought
superior to Michelangelo, and was 'admired for ten years as a result of
ten thousand newspaper articles'. Only after their death were artists
graciously admitted to the Louvre, where they instantly became 'old
masters'. The '*Refusés*', on the other hand, who only succeeded in estab-
lishing a Salon of their own 40 years later, gradually became a despon-
dent artistic proletariat eking out a living by casual work. As early as
1840 'the artists who have not been accepted by the Salon' sent a petition
to both chambers of the Parlement demanding new legislation on the
organization of exhibitions. They felt themselves to be victims of the
selection panel's arbitrary decisions, and demanded the acceptance of all
works 'that do not offend against the law or morality'.

The transformation of art into a freely marketable commodity, and
the public's demand to be allowed to intervene democratically in the
judgement of art, inevitably compromised on the *idea* of the work. It was
dragged down to a more commonplace level, making its claim to auton-
omy more or less bereft of credibility. Even so, perhaps this adjustment
encouraged the mystification of any work that was beyond the reach of
social or economic forces. Balzac's famous novella *Le Chef-d'œuvre
inconnu* (see p. 123), written in this period, tells of an extraordinary work
that remained in the artist's studio and never reached the market.

THE RAFT OF THE MEDUSA

In the Salon of 1819 two works in particular compelled attention. Ingres'
Grande Odalisque (illus. 32), painted during the Napoleonic era, revived
the hope that classical form still had a future (see p. 102). Théodore Géri-
cault's *The Raft of the Medusa* once more dashed this hope (illus. 26).
Though visitors did not know it, this work marked the birth of Roman-
ticism. It was exhibited as '*Scene of a Shipwreck*', but every newspaper
reader knew that a shipwreck in particular was referred to here. This
contemporary subject gave rise to considerable confusion, especially as
the Michelangelesque style in which it was painted was so unsuited to
reportage. The subject was also the very reverse of the battle paintings of
the Napoleonic era, whose victories by now belonged to the past. While
they had foundered because of their imperial subject-matter, Géricault's
gigantic canvas took disaster itself as its subject. Later viewers saw this as a

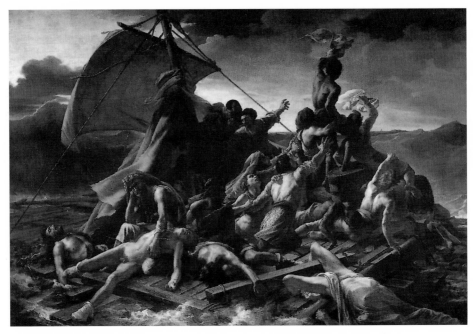

26 Théodore Géricault, *The Raft of the Medusa*, 1819, oil on canvas. Musée du Louvre, Paris.

metaphor for modernity, and because of this the picture has been subject to continual reinterpretation. Modern painting has produced only one comparable achievement – Picasso's *Guernica* (see p. 352).

This transformation of contemporary history into a timeless metaphor (for Julian Barnes, the painting has 'slipped history's anchor'), immediately produced a strong reaction. This was the triumph of an art that reinvented the narrative of a contemporary event and yet created an event in its own right, an artistic one. While the subject itself initiated an unending chain of interpretations, in which later generations included themselves, its metamorphosis unleashed a debate about the function of art. In the course of this it was easy to lose sight of the historical circumstances in which Géricault produced the work. He was faced with the discouraging question of whether, in an age of museum art and of pusillanimous imitation, it would ever again be possible, against all the odds, to force a masterpiece into being. The subject of *The Raft of the Medusa* is not only the struggle for survival by shipwrecked men. It is also, metaphorically, the struggle for the continuation of art.

Only by breathing new life into art could an artist escape the dead hand of an oppressive tradition. Géricault looked to a modern subject

for this new life, but he recorded it in the grand manner of classical art. At that time it was still an open question whether modern art would ever succeed in conquering the museum that modern society had founded as a kind of mausoleum of ancient art. This question was, in the end, decided in the Salon, where there was always a temptation to pander to the public's wish to be entertained. But a complacent *mise-en-scène* that pleased the public could compromise the work *as art*. In Géricault's case it therefore took a desperate effort to meet two wholly contradictory expectations: retelling the story of a catastrophe authentically enough, while at the same time creating the vision of a new art that was not reduced to its subject-matter.

The event that Géricault depicted was recorded in detail in a report that Géricault himself had read. Two survivors, the engineer Corréard and the ship's doctor, Savigny, provoked a scandal in 1817 with their accusatory pamphlet *The Wreck of the Frigate Medusa*. The *Medusa*, the flagship of a naval expedition, had run aground while on a voyage to the French colony of Senegal in 1816. The officers in the lifeboats had callously cut the tow-ropes attached to a raft carrying 150 people, who were left drifting to almost certain death in stormy seas. Only fifteen were found alive when, after twelve days, they were picked up by the *Argus*. This scandalous event not only contrasted starkly with Napoleonic deeds of heroism but was also evidence of the incompetence of the restored monarchy.

Géricault's preparations showed that he was planning an extraordinary work. He transformed his studio into the scene of the catastrophe: not having experienced it himself, he wanted to re-create it as though on a stage. He even induced the *Medusa*'s carpenter, who was one of the survivors, to build him a scale model of the raft. On this he positioned wax models of the figures, while sketches of dead bodies were hung on the studio walls. Thus, as Barnes points out, the carpenter and the authors of the report were made to pose for a 'reprise of their sufferings'. Géricault took the concept of history painting literally, filling it with factual truth. Antoine Montfort witnessed this macabre drama as a very young pupil in the studio, and Charles Clément met him a generation later while collecting material for his biography of Géricault. That was the time when the myth of the work was reaching its first peak.

The preliminary studies look like anticipations of a horrifically realistic reportage, but in the finished work no injuries are to be seen, and even the corpses look quite healthy. One has to search for the fifteen individuals that actually survived. Although Géricault had done his

preparatory research in the same way that a novelist or playwright would, the work is nevertheless at odds with the facts – not just because 'catastrophe has become art' (Barnes), but because Géricault's underlying intention was to modernize history painting on its own ground. His sketches after Rubens and his Michelangelo studies were already part of this plan. Géricault was of a generation that had grown up with the museum of world art. At an early age he threw himself into copying with such obsessive fervour that in 1812 he was barred from the Louvre. For Géricault the lure was to become a new Michelangelo while painting with the colours of Titian and Rubens. The newly fashionable 'genius' of Michelangelo gave him the courage to fight the next round in the arena of Parisian art.

Here we see the rise of a paradoxical conception of art – one steeped in art history but none the less attaching supreme importance to originality. The contradictory wishes of the public, which demanded both documentary reality and the experience of true art, required the impossible. So Géricault borrowed the realism from the event – a modern variation on the biblical Flood – and the ideal from an audacious synthesis of elements found in earlier painting. He served current taste by retaining the supporting cast, as it were, from Gros's battle scenes. The suffering people are posed with a heroic air previously reserved for the victor. The struggle for victory is replaced by resistance to an anonymous force that for some who saw the painting was ruthless Nature, and for others blind historical fate.

A desperate band is engaged in the ultimate struggle, enveloped as they are in a twilight of hope and despair. The eye of the viewer is dragged into a maelstrom of figures, seen from behind, who are drifting helplessly into an unknown tomorrow. The spatial order that is the pride of any composition is here replaced by the heaving surface of the sea; neither the raft, nor the far horizon, either of which might have provided some orientation, do so. Movement emanates not from the figures but rather from the raging element against which they are powerless. And yet, as they scan the horizon in hope of rescue, they initiate a counter-movement in response to a tiny ship in the distance – a ship that became smaller and smaller as the work progressed, until in the finished painting it is little more than a mirage.

Théophile Gautier, writing for the reopening of the Louvre in 1849, described the 'desperate gesture with which these unfortunates wave towards a barely perceptible point that could mean a faint hope of rescue'. He had, earlier, identified the men's leaden fear as the historical

truth of the picture, and the historian Jules Michelet saw the perilous voyage on the raft as a symbol of modern society. More than a century later, Peter Weiss has written in the same vein: 'The raft was shown as though from the viewpoint of a drowning man, and the rescue was as distant as a thought that had yet to be formed. This sighting of help might be a delusion, a hallucination. The isolated catastrophe had become the symbol of a condition of life.' Weiss pretends to be witnessing the actual event, but what he sees is a painted canvas. When he discovers the mastery with which Géricault re-invented the disaster, he suddenly understands 'the creative potential of what it means to paint'.

In the Salon of 1819 Géricault had hung the picture (which put people off by its gloomy colours) high above the entrance, as though to place it beyond the range of merely casual glances. He rehung it soon afterwards, as though driven by the expectation of a success, even though he himself did not consider a Salon success to be worth anything. It duly failed to materialize, and along with 31 others he received a medal as a sort of consolation prize for the lack of interest shown. However, the national art commission offered him a moderate sum to produce another work (in effect inviting him to paint a better subject). He attempted, instead, to gain recognition abroad for *The Raft of the Medusa*. Chance came to his aid in the person of the English entrepreneur J. W. Bullock, who in 1820 exhibited the painting for six months at his Egyptian Hall in London. More than 40,000 visitors came to look at a painted political scandal in which they quite enjoyed seeing France embroiled. This was the first time that empty sensationalism distracted attention from the significance of a work of modern art (as was to happen to *Guernica* in New York in 1939).

Since the work was misunderstood as reportage, a more effective piece of reportage soon overshadowed it. When the painting was exhibited in Dublin it was unable to compete with the modern medium of the 'panorama', which, like the cinema later on, was able to present sensational events in a sensational form. To borrow Julian Barnes's words once again, while the painting only displayed its 'stationary pigments', the public watching the panorama was 'offered some 10,000 square feet of mobile canvas.... Episode succeeded episode, while coloured lights played upon the unreeling fabric, and an orchestra emphasized the drama of events...'. "That is the way forward", one visitor remarked with enthusiasm: "Those painters will have to look to their brushes."

THE 'HISTORY OF THE FASCINATION' EXERTED BY A PAINTED CATASTROPHE

Peter Weiss is one commentator among many who is aware of the 'history of the fascination' of Géricault's painting. The phrase was coined by the Berlin theologian Klaus Heinrich, who even managed to smuggle the Medusa motif into the picture. At the time of its first appearance, the work immediately sparked a controversy that was later described by Gustave Planche in 1851. Some saw the picture as a 'sign of decadence' by comparison with the optimism of the 'imperial painting' of Napoleon's day, while to others it was a 'sign of progress' because it broke with the dogma of the old school. Planche complained that no one in 1851 any longer dared to emulate the Old Masters, as Géricault had done, without risking his innocence. Neither in Raphael nor in Michelangelo, Planche argued, did Géricault find modern reality, but he trained himself as an artist by studying them.

The myth of the picture was fed by the myth that formed around the life of the artist. For Weiss 'there was something of the dandy, of the libertine in this painter, who, while burning himself out, yet managed to live at a breathtaking pace'. He seems, in life as well as art, to have turned his genius into a public spectacle. This took the form of a passion for horses and soldiers, constant crises and escape from them through travel, and finally he dreams of a journey to the Orient, 'where he could lead a colourful life far away from our civilization', as Batissier recalled. Added to this were repeated suicide attempts, debt, illness and an agonizing death at the age of 33. It seemed to the Paris coterie of artists as though art, so lately resurrected, sank with his passing into a trough of bourgeois mediocrity. 'Today I saw the death-mask of my poor Géricault', Delacroix noted in his diary on 1 April 1824. 'O revered memory! I was tempted to kiss it. And his sublime *Raft*! I cannot express the admiration I feel for it.'

In his three-part novel *Die Ästhetik des Widerstands* (The Aesthetics of Resistance), Weiss identifies himself with Géricault, who, having been born too late for the Revolution, could only paint his own revolution like an artistic epilogue. But could such a rephrasing of past events rekindle the resistance that was no longer stirring anywhere else? 'In the experience of being torn out of all contexts the painter recognized his own situation.' He 'tried to imagine' the events which he, like Weiss, had not observed at first hand. Weiss, the writer, is engaging in art as remembrance when he creates a fictional past in which he participates in the Spanish Civil War in order to portray himself as one of the defeated who then turns to art. The 'aesthetics of resistance' was a necessary para-

dox. The narrator's fictive return from Spain leads him to Paris and in turn to the Louvre. Weiss first memorizes the shipwreck as represented by the *Raft of the Medusa* before the painting helps him to understand his own rôle.

In his works the painter had 'again and again staved off death by conjuring up new images'. But the deterioration of the painted surface of the canvas inspired 'not so much disappointment at the obliteration of the painting as sympathy for Géricault, whose creation was exposed to weathering, to chance'. Art, too, was mortal, but Géricault had been invulnerable as long as he was creating it. 'Imagination stayed alive as long as the man survived to resist.' True, events never happen in the way that painters portray them. Nevertheless, 'they had succeeded in setting up a memorial to decisive moments in history'. This produced a parable: 'what was merely drifting by had become something permanent, and if it was close to reality this was because we were suddenly moved by it.'

The playful manner in which Barnes makes the same painting speak to us could hardly present a greater contrast. But his highly imaginative commentary on world history preserves the status of the work as an imperishable pictorial invention. Like the biblical Flood, the shipwreck is a powerful 'image', Géricault's painted vision of which has been stamped on our consciousness. Like Weiss, Barnes first gives a résumé of the event before going in search of the shipwreck in Géricault's painting. Only after describing the making of the work does he pose the question 'How do you turn catastrophe into art?' And how does one look at a work of art, which is after all 'not an opinion', much less a factual report of an event? What survives is the painting 'that outlives its own story', the story of its making. Here too, 'religion decays, the icon remains'. Barnes, the writer, arrogates to himself the same right to the imagination that he has seen at work in the painter. 'Truth to life, at the start, to be sure; yet once the process gets under way, truth to art is the greater allegiance.' For as long as we look at Géricault's painting as though we ourselves were in the picture, the aftermath of the shipwreck is still taking place. Such pictures present themselves as memories, and we absorb them into our own memories. But time gnaws away at the condition of the work itself and does not leave it unscathed.

Painters are in a different position to writers. Reworking in their case means painting a new version of Géricault's subject and reverting his outcome. It includes the attempt to continue the Story of Art, thereby challenging the death that a work process suffers with its completion of the object. Artistic creation emerges as a continued act

27 Martin Kippenberger, one in a series of 14 lithographs comprising the *Medusa Cycle*, 1996.

of memory. Gestures are recognizable as gestures belonging to art; the poses of the painted figures as artistic quotations. We remember having seen them before when we see them anew. Here too a 'history of fascination' is at work, as is demonstrated by the painter Martin Kippenberger. He had been confronted with Géricault's picture when he was exhibiting his cycle *The Happy End of Kafka's America* in Copenhagen in 1996. An old copy of Géricault's painting had been included in the exhibition. Soon afterwards Kippenberger started on a series of photographs in which the positions of the figures on Géricault's raft were reenacted with increased emphasis. These photographs were followed by a cycle of 24 paintings in which Kippenberger portrayed himself now as a drowning man, now as one waving hopefully. The gestures are filled with a fresh energy. The artist next made drawings in which he boldly paraphrased Géricault's preliminary studies, as though preparing to paint a radically different picture. Finally he produced fourteen lithographs (illus. 27), and also a tapestry that took the place of *The Raft* in the exhibition. In 1997, just a few weeks before Kippenberger was due to exhibit the cycle at the Berlin Academy of Arts, he died at the age of 44.

A project like this is not only of biographical significance but also contains the metaphor of the life-raft of art. In one of the works, where every member of the raft's crew has the painter's own features, we read

the words '*Je suis Medus*', which are ambivalent enough for us to relate them to the wrecked ship of that name. In another, the figure seen from behind is waving a real piece of cloth (a fetish of establishing certainty) at a hope that is departing but not yet lost. In a third work Kippenberger assumes the pose of a drowning man, the very pose that the young Delacroix had once adopted to assist Géricault in his studio. The features of Géricault, Delacroix and Kippenberger are blended together in the appearance of an artist who is still acting out a rôle, while other people are mere spectators. Géricault's postponement of death, as Weiss saw it, also applies to Kippenberger. But in the *commedia dell'arte*, if one can imbue that term with a tragic meaning, Kippenberger occupies a different position. What in Géricault's day marked a beginning seems now to be constantly overshadowed by the impending end. Today, the work process has outlived the work's completion and introduces itself into the work, with each individual painting, like studies in earlier periods, showing only a single pose, which could be followed by any number of other poses – works that on the same day contradict the traditional claims of works.

4 Paris: A City and a Museum

HOMER THE GOD

'If Homer is a god, he must be set among the immortals. If he is not a god, he must be made into one.' These precepts are inscribed on one of the steps in Ingres' controversial ceiling painting for the Louvre, *The Apotheosis of Homer* (illus. 28). Nothing could be more anachronistic than this vision of antiquity allowing us a glimpse of a lost paradise, even if Ingres demands from us an affirmation that we are not conscious of that loss. Everything in the painting seems to be in its rightful place, but in fact everything has changed, for the blind poet has mounted the throne of Olympian Zeus and art has supplanted religion and philosophy. It makes no difference that Ingres took his inspiration from a Hellenistic relief. However classical it may look, the idea is modern – but its modernity is contradictory.

Because of this, a picture intended to transport us to the bright shores of Greece merely exudes the dusty atmosphere of the museum. The whole idea only makes sense in the context of a museum that, resisting the frenzied tempo of a modern metropolis, was becoming the refuge of an earlier age. In 1827, when the Musée Charles X in the Louvre's Seine wing was about to open, the decision was made to have the refurbished rooms decorated by well-known painters in order to add lustre to the museum. Ingres' picture is a sort of museum within a museum, for this painted museum was intended for a room in a real one. Where in the ancient world would there ever have been a temple dedicated to Homer as the god of art? But this temple was merely a symbol of the temple of art, in other words of the museum itself. All those gathered on this Olympus were the prototypes of the modern artists who hoped that the museum, dispelling the current atmosphere of doubt, would in turn confer immortality on them.

No one hesitated about commissioning a ceiling painting from Ingres as part of the new museum's *mise-en-scène*. But although visitors would be staring *up* at it, Ingres did not exploit the potential this offered (so different from the horizontal 'museum gaze'). Instead he retained a truly classical composition, so that the painting, though an element of

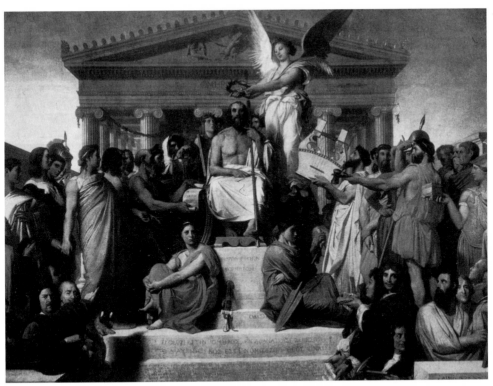

28 Jean-Auguste-Dominique Ingres, *The Apotheosis of Homer*, 1827, oil on canvas. Musée du Louvre, Paris.

interior decoration, should defend the autonomy of the work in the modern sense. It is thus a fictive ceiling painting as well as a depiction of a fictive antiquity. It was also foreseeable that one day it would be replaced by a copy. This happened in 1855, the year of the Paris International Exhibition, but it had the effect of awakening more doubts than ever about the work. Its ambivalence is the mark of that age. Ingres himself felt obliged to provide 'instructions' in the form of lengthy explanatory notes. In a letter of 1818 he had already put forward the idea of unchangeable *beauty*, which Homer had 'expressed as a set of rules and elucidated by means of immortal examples'. Ingres turned the old idea that 'all Greece's great men were born of Homer' into a homage to Homer's artistic successors. All of them, he explains in the letter, consistently followed 'the same principles. Later, in the great epochs of the modern age, men of genius did again (*refait*) what others had done (*fait*) before them. Homer and Phidias, Raphael and Poussin always, in fact, agreed in what they said.'

The old school had not needed the evidence of the outstanding masterpiece, because the perfection of art could be taught at any time. It repeated a creed handed down from generation to generation. Ingres, too, secretly hoped to convince everyone that his *Apotheosis* was an ingenious reworking of Raphael's *School of Athens*. But this very comparison prompts doubts about the success of the attempt. The steps of the temple now serve to separate two eras of art, thereby perpetuating an already outdated concept. The stage is reserved for the Greeks and Romans, while the space just beneath is given over to the 'moderns'. The moderns in this case were, of course, the French classical painters of the seventeenth century; Ingres wilfully ignored the new meaning of modernity, equated with the contemporary world.

A stage like this cannot be arranged without some manipulation of the facts. For instance, the young Raphael, who after all is one of the 'moderns', has already ascended the stage occupied by the 'ancients', where the unrivalled master, Apelles, leads him by the hand to Homer, as though this modern Apelles were a reincarnation of the ancient one. On the other hand, Poussin, the French Raphael, remains before and below the stage, which he shares with the classical poets of his century

29 Jean–Auguste–Dominique Ingres, 'Poussin', in a detail from illus. 28. Musée du Louvre, Paris.

(illus. 29). All the nearby figures occupy the interval, as it were, between those who have found their permanent place in the history of art, and us, the viewers, who are outside the picture. Their presence has the effect of extending distance between us and the stage beyond them. We gaze reverently up at the stage, where we cannot catch a glimpse of anything further back than Homeric classicism, while the foreground is so densely packed that there is no more room.

Ingres leaves open the question of whether a direct line of descent links Poussin and the ancients. Spatially, Poussin is close to us, as he is in historical time, and he looks straight at us to ensure that we notice his gesture. His extended index finger draws us into the picture, towards the great artists behind him, as if to say 'You must follow the ancients!' But a spatial gap separates Poussin himself from that tradition. Only his shadow falls on the flight of steps leading up to the stage. This recalls Poussin's famous self-portrait or his *Et in Arcadia Ego*, where the shepherd's shadow falls across the inscription on an antique tomb. If one looks more closely at Ingres' painting, the shadow is continued by the shadow of Poussin's finger on the stage itself. His gesture does not quite reach the stage that, in the ambivalent play of distance and proximity, remains beyond his reach. Tradition, it seems, escapes our touch.

In the context of the modern age a programme based on tradition inevitably contains an element of polemic. The great progenitor of the arts, Homer, is a blind seer who alone has command of his inner visions. Phidias points to his own forehead, behind which lies the source of his creative vision. And Poussin draws our gaze towards timelessly valid models as though, with a grand gesture, to wipe out the present day. Classical art, we gather, closes its eyes to the temptations of reality. Only by so doing can it remain faithful to a timeless ideal. Yet the ancient artists are names without works, and so the imaginary museum of classical art that Ingres conjures up for the real museum that is the Louvre is ultimately a fiction. Only in retrospect does the tradition come to life. Working within this tradition, Ingres uses this picture to present his own doctrine – which seems to be that whoever declares allegiance to Homer must also declare allegiance to Ingres. Perhaps classicism has ceased to be anything other than a modern perspective on past art.

DREAMS OF THE ORIENT

Long before Ingres painted the *Apotheosis of Homer* he had begun introducing the Orient into the classical ideal. Antiquity had always been the

30 Jean-Auguste-Dominique Ingres, *The Bather (La Grande Baigneuse)*, 1808, oil on canvas. Musée du Louvre, Paris.

lost *time*, and it was now replaced by the Orient as the unreachable *place* that had long been dreamed of. Early Orientalism 'extended the boundaries of art', as Victor Hugo wrote in 1829 in the introduction to his cycle of poems *Les Orientales*: 'In the days of Louis XIV people were Hellenists, just as we are now Orientalists. Hitherto, antiquity has been found in Rome and Greece. Would one's gaze not reach higher and further if one studied antiquity in the Orient?' The Orient became a watchword of Romanticism, just as antiquity had been the watchword of classicism. But Orientalism had already started to feature in the work of the young Ingres, who was certainly no Romantic, and there it had a different significance.

The Bather (*La Grande Baigneuse*, also known, after its owner, as *La Baigneuse Valpinçon*, illus. 30) was painted in 1808, only two years after

31 Antonio Canova, *Venus Italica*, 1804–12, marble. Residenzmuseum, Munich.

Ingres had arrived in Rome. (He had gone there to free himself from the tyrannical artistic ideal, based on antiquity, of his mentor David precisely by studying genuine antiquity.) In that same year he also painted a sleeping Venus, now lost, and began the sketch for a picture of Venus Anadyomene, which, however, he was only to finish many decades later. A year earlier he had painted the half-length figure of a nymph who turns away to shield herself from the gaze of shepherds and satyrs and flees into the forests of Arcadia. The Venus, however, looks 'as if she were ashamed to find herself naked'. The figure of the Bather seems not to be aware of us at all, but is hiding from the gaze of someone else, a beholder we cannot see. To put it paradoxically, the eroticism implicit in that gaze takes the place of the eroticism of the motif itself.

In 1809 Ingres sent *The Bather* to the judging panel in Paris, who

criticized the setting. The woman was evidently taken to represent Venus, and there was therefore some bafflement as to why she was shown in a room belonging to a harem. Her couch stands next to a sunken bath, into which a jet of water gently splashes. But Venus belongs to Greece, and the harem to the Orient. This contradiction was central to Ingres' idea for the picture. The presence in the painting changes into a seductive absence, for the unknown beauty turns away from us. What we desire to see is more alluring than what we actually do see. Each unveiling in the picture, which begins with the curtain that is drawn back, leads to a further concealment. The bathing room is not to be entered, and the woman's body, which she is also concealing with a towel, is untouchable. Canova created a similar erotic effect in 1812 with his *Venus Italica*, who turns her back to onlookers while also covering her front (illus. 31). The body in the antique style, which always seemed to be the expression of an ideal, suddenly looks naked. As a result of this subtle change, the Bather in Ingres' work ceases to look like a statue and seduces us with the modesty of her pose. Here nudity is not part of a style, it is the forbidden intimacy of an oriental bath-house.

Hugo seems to have had Ingres' *The Bather* in mind when he wrote 'Sara la Baigneuse' (Sara Bathing), part of his cycle *Les Orientales* (1829). Sara is swinging in a hammock above a pool, and as her foot touches the surface of the water her reflection becomes a 'picture in motion'. The reader is invited to conceal himself for an hour, after which he 'will see this child of nature stepping from the water, naked, her hands crossed over her breast'. But the lovely girl takes her time, dreaming of being in the Orient, so that there is a shift similar to the one we have seen in Ingres' painting. Like a picture within a picture, the Orient appears as a transient dream of perfect beauty, a new fiction of the ideal. Likewise, Ingres' Bather does not live in the East, but dreams – like the painter, who never went there – of an imagined Orient. The Orient is not the subject, but rather a kind of fragrance, a delicate perfume worn by a classical beauty who hopes to rekindle the ardour of an admirer who was tired of her. The Orient is a metaphor of longing for an unattainable ideal, and as such it enters into an unexpected fusion with the dream of the ultimate masterpiece.

Such a view emerges with more authority in a second work painted by Ingres in Rome. His *Grande Odalisque* (illus. 32) was undertaken in 1814 for Caroline Murat, Napoleon's sister, to serve as a pendant to a sleeping Venus. The title itself contains an allusion to the Orient, complemented by the hookah and other accessories. But the reclining nude,

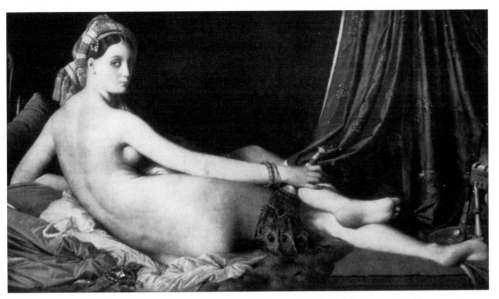

32 Jean-Auguste-Dominique Ingres, *La Grande Odalisque*, 1814, oil on canvas. Musée du Louvre, Paris.

who, like the Bather, turns her body away from us, is of the same genealogy as the Venuses painted by Renaissance artists. Perhaps the two Venus paintings for Caroline Murat together were meant to hide a programme: the oriental Venus looking seductively over her shoulder has come to join the antique-style Venus, who has fallen asleep.

Everyone was perplexed by the elongated body with its excessively extended spine and marble smoothness, which was plainly contradicted by the photographic realism of the setting. The contradiction between the unreality of the woman and the hyper-realistic space, which is by no means occupied by the body, creates an enigma. It seems as though we could step into this harem but would find there only the phantom of a woman. Ingres' changes to the figure's contours in successive sketches made her appear increasingly disembodied, while the insistent realism of the couch and the curtain further weakened her physical presence. In this eroticization of art, the viewer is duped. The female body systematically disembodies the work itself, reducing it to the mere phantom or memory of a work.

Once we have recognized the antique Venus in the *Odalisque*, we are prepared to see this woman, with her parted hair and striped turban, as the same Renaissance beauty, Raphael's *Fornarina*, which Ingres himself had paraphrased (illus. 20). It is bewildering to compare Ingres'

painting of the *Fornarina* with his *Odalisque*, for the same person seems to look out at us from both pictures. The *Odalisque* is neither Venus nor the *Fornarina*, neither an antique beauty nor a Renaissance one, and yet she is both at once, set in an imaginary Orient. And so the metamorphoses go on, under the spell of art as a fiction. The painting is a stage for our imagination. Ingres could not become Raphael again, nor did he want simply to imitate him. Instead, by eroticizing the motif, he created the dream of a work, or the work as a dream. As Norman Bryson has shown, tradition was now something that could only be desired.

No one understood this picture better than Balzac, who in *Le Chef-d'œuvre inconnu* (The Unknown Masterpiece, 1831) actually describes it, or rather, has the painter, Frenhofer, describe it, telling his friends about a work that he has hitherto concealed from them. This work, on which he has been engaged for ten years, has always suffered from the idea of an impossible perfection. He has never been able to complete it because he cannot find a living model of sufficient beauty. He has considered 'travelling to Turkey, Greece and Asia to look for a model there', but he abandons this idea and never goes, just as Ingres never reached the Orient.

Frenhofer finally agrees at least to compare the work with a living beauty. This is a young girl whom Balzac, again evoking the Orient, describes as looking like a Georgian girl seen at a slave market. More deluded than ever, Frenhofer believes that his painting is finished after all. 'Whoever eventually sees it will think he is looking at a woman lying on a curtained velvet couch. From a golden tripod beside her wafts a fragrant perfume.' That perfectly describes the *Odalisque*. The friends, however, see merely a 'wall of painting'. The 'body' of the painting has effaced the body of the woman, and where the eroticism in the painter's gaze showed him a beautiful woman, the others see nothing. Not only the representation of a woman but the very presence of a work appears to them to be an illusion: in their blunted expectation they fail to acknowledge this phantom work.

The situation was different when, 25 years later, Ingres painted his *Odalisque with Slave* (illus. 33). And yet the female nude whom the painter delineated in the preliminary studies once again presents a total contrast to the meticulously detailed realism of the harem. Again, too, the body is a variation on the ever old, ever young Venus, just as the dark-skinned slave-girl beside her is a picture-book Oriental. The eunuch in the background represents the gaze of impotence, while our gaze simulates the omnipotence of the owner of the harem. But the harem was not part of the original concept, for Ingres, when he sketched

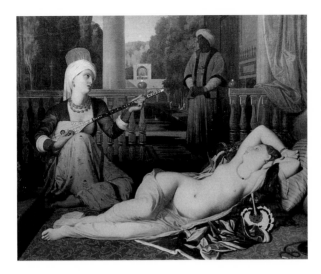

33 Jean-Auguste-Dominique Ingres, *Odalisque with Slave*, 1839–40, oil on canvas mounted on panel. Fogg Art Museum (Harvard University Art Museums), Cambridge, Massachusetts.

the seductive body, had in mind either a Sultana at leisure or an Italian lady having her siesta: both these descriptions appear beside the preliminary drawing. This is a most surprising discovery, but it confirms that Ingres is using the Orient merely as the setting for a dream of art. But the work also holds a further meaning.

A few years earlier Delacroix had caused a stir with a picture set in a harem, which he exhibited in 1834 under the title of *Women of Algiers* (illus. 34). It is possible that Ingres' picture was a direct response to this work. For Delacroix the Orient was a sensational subject for the creation of an artistic masterpiece, which by then lacked any recognized standards. People were prepared to believe in Delacroix's Orient because the painter, seeking to escape from his *ennui* and to revitalize his art with the Orient's colours, had actually travelled in Morocco and visited Algiers. When he entered a harem in Algiers, the city with the most beautiful women in the Arab world, it reminded him – surprising as this may seem to us – of a vanished antiquity. Charles Cournault records that he cried out again and again 'C'est beau. C'est comme au temps d'Homère' and 'The woman looking after her children, spinning wool and doing embroidery on wonderful fabrics, that is woman as I understand her.' Even before this he had felt himself to be in the presence of Greeks and Romans and had inwardly 'laughed at David's Greeks', as he wrote in a letter. Antiquity had become real, had shown its true face. And we are reminded of Frenhofer when Delacroix finally finds in the harem the ideal that he has been seeking for so long. Precisely because it has the appearance of an exact record of oriental reality, *Women of Algiers* only

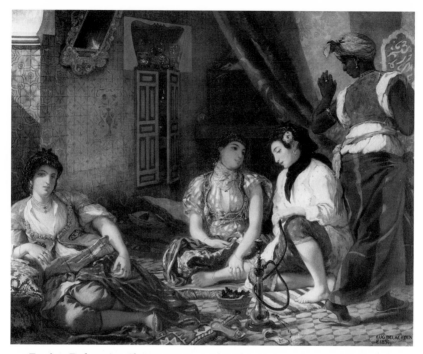

34 Eugène Delacroix, *Algerian Women in their Apartments* (*'Women of Algiers'*), 1834, oil on canvas. Musée du Louvre, Paris.

represents a new victory for the fiction that had long been part of the concept of art. Though the dimly lit room was based on a remembered impression, nothing shown in the picture had actually been recorded on the spot. Delacroix could not desecrate the harem by making a sketch. All the subsidiary motifs in the picture come from his travel journal, but the women are three Jewesses who were permitted to show themselves in public, not the Arab beauties who were hidden behind the harem's walls. So this picture too, however factual it may appear, is only the stage of a vision, ultimately intended to give the work of art itself the appeal of modernity, by fusing work and vision into one.

THE VOYAGE ON *THE BARQUE OF DANTE*

The search for a subject became an additional burden for artists. What subjects could still satisfy the public, given that every theme seemed to have become either dated or hackneyed? An artist now needed to devise new topics if he was to make an impact. Implicitly the future of art itself hung in the balance, because artists continually had to prove that art

could still maintain its credibility. And so once again the subject became a test, for it had to be one that could be made into art. Géricault had ventured to portray events from contemporary history, but this was not a sure road to success, for people wanted painted dreams that offered an escape from the narrowness of everyday life.

The young Delacroix therefore struck a chord with the public and its expectations when he exhibited the *Barque of Dante* at the Salon of 1822 (illus. 35). The picture released all the fantasies that the reading of Dante set free. This time they were transported not to an imaginary Orient but into another world – the Underworld – that was even more a matter for imagination. What subject could be greater than Dante's poem, which was indubitably art? Delacroix chose art itself to be the subject of art by painting literature. He was showing not so much the Underworld through which Dante travels, as the imaginative world of a poet who had turned an impossible subject into art. Dante himself is the true hero of the picture. This shift is telling. Painters had always

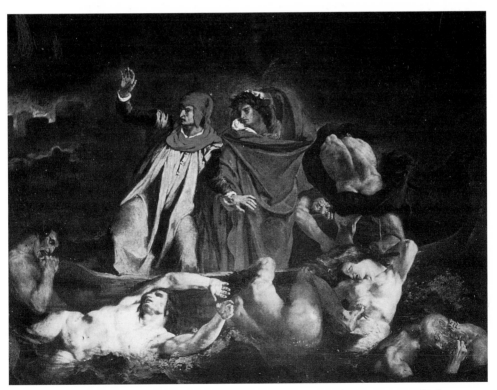

35 Eugène Delacroix, *The Barque of Dante*, 1822, oil on canvas. Musée du Louvre, Paris.

competed with poets, but now they painted poets, as though they wanted to turn culture into their subject. The *Barque of Dante* was an ideal choice for this purpose. The very title of the picture draws our attention to the new approach. After all, the boat belongs not to Dante but to Phlegyas, who rows Dante to the sixth circle of Hell. But then we are not travelling with Dante into the Underworld, but with Delacroix to Dante. The visions narrated by the great poet inspired Delacroix to narrate his own painted version of them.

Though considerably smaller, the picture unmistakeably alludes to Géricault's *Raft of the Medusa*, as though to lay claim, through this competition, to being a masterpiece in its own right. Here once again are the elements of water and sky, but they merge into one another in a gloom in which only the figures are picked out as though by spotlighting. The mood is equally sombre, and here too the journey, on the waters of the Underworld, leads into the unknown. The barque is another rescue craft, but this time the dead, with their Michelangelesque bodies and gestures, are clinging to the sides of a boat to which they are forever denied access.

The two poets, Dante and Virgil, whom we see making the journey hand in hand, are no longer merely eyewitnesses but active participants in the scene. Dante is the only living person in the realm of the dead, but however real he was as a person he catches only his own inner vision. Delacroix therefore felt justified in painting a vision – if this could still be successfully done in modern times. Virgil, Dante's guide, stands beside him, his eyes closed, with the dignity of a departed spirit. What he once saw, as the poet of the *Aeneid*, Dante now sees in his stead. And what Dante once saw, Delacroix now sees, so declaring himself the heir to this tradition. Poetry is an intrinsic element in this subject, which was expected to release poetic freedom for painting too.

The art of painting comes into its own in the use of bright colours that are very different in effect from the *chiaroscuro* of the poem. The colouring sets the key, as it were, in which the viewer sees the subject, and just like the Dantesque episode it contains a long history within it. The Rubenesque poses of the waterborne dead carry the signature of a master of colour. Those drops of water beading on their skin were already sparkling on the bodies of the figures in Rubens's masterly Medici cycle. There they were part of bodiless allegories, while here they belong to bodiless shades, to whom only the painting gives corporeality. Like a mirror, this Salon piece reflects back the image of Rubens's masterpiece, as though it borrowed from such a model its identity as a work of art.

As late as 1846, when writing about the Salon of that year, Baudelaire praised this painting for its power to draw on memory and so in turn to impress itself on our memory. The claim to inheritance was becoming a symbol of modern culture. In our case, we are reminded not only of Rubens's cycle but also of another masterpiece, Michelangelo's *Last Judgment*. This only increased the risk Delacroix was taking with the picture, but if he succeeded, the high stake would make his success all the greater. The link with Michelangelo's *Last Judgment* was provided by Dante, for Michelangelo had himself employed a motif from Dante, depicting the ferried crossing of the Acheron in Charon's boat. What had been a subsidiary motif in Michelangelo's picture became the main motif in Delacroix's. However, the young painter adroitly evaded direct comparison by choosing another crossing from Dante's journey in Hell, with Phlegyas as the ferryman. Delacroix makes us believe that, in transposing Dante's verses into painting he is doing what Michelangelo did, and thereby claims to be a new Michelangelo. Stendhal in his *History of Italian Painting* had by then proclaimed a Michelangelo renaissance and spoken enthusiastically of the *Last Judgment*: 'If Michelangelo had written poetry he would have created Count Ugolino, just as Dante would have made the *Moses*, had he been a sculptor. No one loved Virgil more than Dante, and yet nothing resembles the *Aeneid* less than the *Inferno*.... As in the case of Dante, Michelangelo's soul lends its own greatness to the subjects by which it is moved.' For comparisons between poetry and the visual arts, Michelangelo's view of Dante was a commonplace at the time.

Delacroix challenged his contemporaries to recognize the originality of his new work precisely in the convergence of the allusions to Dante, Michelangelo and Rubens. The synthesis of the two Old Masters was meant to arouse admiration of the kind enjoyed by timeless poetry. After achieving the desired success in the Salon, the painter followed it up in writing, expounding his concept of art in his great essay on Michelangelo. He comes to the nub of the matter in a passage where he justifies his use of the Dante motif by Michelangelo's earlier practice: 'A mythology which today seems hackneyed could then still have the charm of novelty. Dante, whom Michelangelo so passionately admired, had already used it with equal boldness', while Michelangelo 'transposed it most poetically into a different art'. Here Delacroix is speaking of his own achievement. He continues to do so when, quite unexpectedly, he suggests that the barque is an allegory of the artist's life, an interpretation based on Michelangelo's writings. In his manic urge to create, that

'sublime genius' had often been a prey to despair. 'I will quote from only one of the sonnets that portray the state of his feelings: "Carried by a fragile boat through stormy seas, I approach the end of my life's course – Ah, how clearly I now see that I have been wrong to pursue this art, which has been the idol and the tyrant of my imagination."' And Delacroix adds: 'That sonnet has just inspired a wonderful adaptation by M. Sainte-Beuve.' And so the circle is complete. The work in all its heights and depths was now, more than ever, the index of the modern artist's concerns, however much it used traditional motifs. The choice of subject was in effect a means for legitimizing the work of art, about which there was now so much uncertainty.

DELACROIX AND *ENNUI*

Delacroix liked to think he was reading the same Dante whom Michelangelo had read. While painting the *Barque of Dante* he had someone 'reading a canto of Dante aloud' so that the poet's energy should flow into his work, as he was to recall in his Journal on 24 December 1853. If Dante was the 'greatest among poets', as he wrote on 18 May 1824, Michelangelo was 'perhaps superior to him, or sublime in a different way'. Delacroix himself was feeling deeply discouraged. 'But do you imagine that Dante was distracted by trivial diversions when his soul was wandering among the shades?' The ominous question of whether art was still possible at all in the modern age goes beyond the self-doubt that even Michelangelo in his day had felt.

That question was in Delacroix's mind as he went to the Musée du Luxembourg, where his *Barque of Dante* was already hanging. He noted for Sunday, 11 April 1824: 'My picture gave me pleasure, but there is one fault in it which I am committing again in a new picture', and he resolved that in the *Massacre at Chios* he would paint the contours more boldly. The situation has a certain piquancy. Delacroix is still at the start of his career, yet his works are already hanging in a museum. This was a problem that, amid the loud laments of the rejected, tends to be overlooked. Even success in terms of acceptance by the museum could not cure the artist's self-doubt, because that success was bestowed by people whose judgement was not to be trusted.

He could only trust in himself, but for that he first had to know himself. Delacroix, therefore, at the age of 24, decided to keep a journal. Communing with it, he found a solitude that nurtured his creative power, while the other solitude which overcame him in the hurly-burly

of social life oppressed him. Suddenly, now that there were no certainties left in art, he himself had become the final arbiter. In an age of decadence, he wrote on 15 December 1847, there was nothing more for art to do: 'the traditions are exhausted. All the great problems of art were solved back in the sixteenth century.' And yet it was not Delacroix's aim that 'tradition should be the object of a positive cult' and that we should all see with the eyes of an earlier epoch (20 November 1853). But he had just as little 'sympathy for the present. I rather study the masterpieces of earlier centuries' (28 March 1853).

Doubts as to his own genius were enforced by *ennui*, the paralyzing world-weariness that pervades everyday life. The lay public treats art as entertainment and expects to be freed from its own *ennui* by the artist, who is himself tormented by it. After the day's work, society's idle gossip cannot conceal the fact that there is nothing worthwhile left to talk about. The artist, too, becomes an 'homme du monde', as Baudelaire was to call him, or, as a high priest of art, enjoys a brief period of favour before he is rejected by his erstwhile supporters. In this social world, art is more suited to being a fashion than a religion. People are obsessed with 'novelty' and 'progress', with the result that art is already *passé* by the very next day (23 April 1849 and 28 July 1854).

So now art only fosters *ennui* instead of dispelling it. The artists try to escape the vicious circle by seeking refuge in bohemian life or by travelling to exotic places. At home, as Delacroix confessed to his similarly 'tortured' friend Frédéric Chopin (14 April 1849), he was once again overcome by that 'unbearable emptiness', and fed his imagination with subject-matter that could now be found only in literature, not in life (11 April 1824). Reading replaced the study of nature, but did not help painting either. As an escape he would hasten to the museum to seek inspiration in the Old Masters (illus. 37). Since there were so many, tempting one towards eclecticism, it was best to keep to Rubens (illus. 36). That 'Homer of painting' (17 October 1853) had himself been an imitator, but 'by the strength of his genius recreated' the lost ideal of the Renaissance. All his life Delacroix studied Rubens in the most minute detail, as though intent on becoming a new Rubens himself (15 October 1847).

But his own disposition was modern, as he indicated most directly by his free sketching, which was carried over into the finished works. He became tormented by the question of the completion and perfection of art. Michelangelo's torsos were evidence that he had undertaken 'a task that he could not possibly complete' (9 May 1853). But Delacroix, if he was honest, could 'not remember having found, in any of the great

36 Louis Béroud, *The Joys of the Flooding (Copyist in the Medici Gallery)*, 1910, oil on canvas. Private collection.

painters, a real example of the perfection that I seek' (28 April 1824). Even as a young man he fretted over whether true beauty was only 'a sublime varnish' that made the underlying imperfection tolerable. 'I feel within me an infinite longing for what can never be achieved. This emptiness, which will never end, drives me to be creative at all cost and to fight unceasingly against the inexorable law of time which sweeps us all away'(26 April 1824). Later in life he came to understand that beauty is not attainable at all times. This is hard on those who are born too late, unless they are 'wholly independent geniuses' who accept that they are no longer living 'in an age of simplicity' (19 February 1850). The new gain is self-expression, after there has ceased to be a generally accepted ideal of art. The artist carries the ideal alone and unconsciously within himself.

The vulgarity of nature, so hostile to the unfettered imagination of the artist, was celebrating a triumph in the new invention of photography. On 21 May 1853 Delacroix noted that after seeing daguerrotypes of nude models one had to admit that their realism made Marcantonio Raimondi's engravings after Raphael, those 'masterpieces of the Italian School', look positively ridiculous. In the future, no doubt, a painter of

37 William John Whittemore, *Copyist in the Louvre*, 1889, oil on canvas (detail). National Academy of Design, New York.

genius would use photography as an aid. But up to now 'this mechanical art has only done us a disservice: it robs us of the masterpieces without offering us a satisfying substitute'. This technical invention further accelerated the break with tradition by discarding the study of nature that art had so prided itself on. On 12 October 1853 Delacroix was to warn artists against trusting too much to imitating nature if they did not want to risk losing their souls.

Toward the end of his life Delacroix believed masterpieces triumphed over the power of time (21 February 1856). Contemplating the current art scene, he saw that the day was not far off when he and his art would be an anachronism. He was consoled by the thought that masterpieces are unaffected by passing time. 'True masterpieces are an argument for the immortality of the soul.' Their mortal creator, whose soul is reflected in them, is absorbed by them into the life of art itself. 'The great works can never grow old if they are alive with true feeling. The language of the passions and the impulses of the human heart never change' (26 March 1854). Thus the great works contain memories that can even be our own, by inspiring our imaginations. This anthropological approach foreshadows that of Marcel Proust, while the younger Baudelaire in his chapter on 'L'Art mnémonique' focused more narrowly on the image preserved in the artist's memory.

The thought of the happy times he spent staying with his aunt in the country leads Delacroix to think about the rôle of imagination. The old days, as he remembered them, appeared in such magically beautiful

colours that one 'had to marvel at the involuntary workings of the mind' to suppress anything disturbing, leaving an impression of perfect harmony. This suddenly suggested to him a similar process in the creation of art: 'The beautiful works of the imagination' invented by the artist resembled, in their very personal hues, the images retained by the memory (20 and 28 April 1854).

Delacroix links this experience with the memory we retain of works of art: the works survive in the viewer. Unlike ordinary remembered objects, works of art are already images before the viewer makes them into his or her own images. 'How I worship painting! The mere memory of certain works floods my whole being with the same intensity of feeling that informs memories of events in my life. The emotion I feel when I imagine a particular work by Rubens (*en me le figurant*) awakens within me the sublime images of all those works that so profoundly impressed me when I saw them as a young man in the Musée Napoléon' (17 October 1853).

The modern gaze that Delacroix cast on old art was the result of his experience of the museum, where the works on display came alive again in the viewer. But what if the viewer was himself an artist? Memories of museum works passed into Delacroix's own works. The following generation felt an irresistible urge to break free from this fatal obedience to the past. But already Delacroix longed for a freedom that he could only hope to find in his own imagination. Just as the ordinary visitor to the museum appropriated the works, Delacroix used that same freedom to make them a source for his art. The real world beyond the museum was not compatible with his fantasies based on memory. Instead of depicting the world, which bored him, he preferred to lose himself in the imaginary realm of art, whose territory was the museum.

Just once, in his painting *Liberty Leading the People* (illus. 38), Delacroix had succumbed to the lure of realism, but he became enmeshed in contradictions. This large-scale painting, which paradoxically preserves the July Revolution of 1830 for eternity by freezing the action in a snapshot of a single moment, does not resolve the dualism of art and life but serves the cause of political propaganda in the guise of an artistic masterpiece. Accordingly, it depicts the figure of Liberty allegorically, but yields to the temptation to show the actual event in the style of reportage, thereby merely confirming the contradictory nature of history painting. This internal contradiction is also reflected in the reception of the work, for in the Salon it received only half-hearted praise, whereas later generations acclaimed it as a prime example of

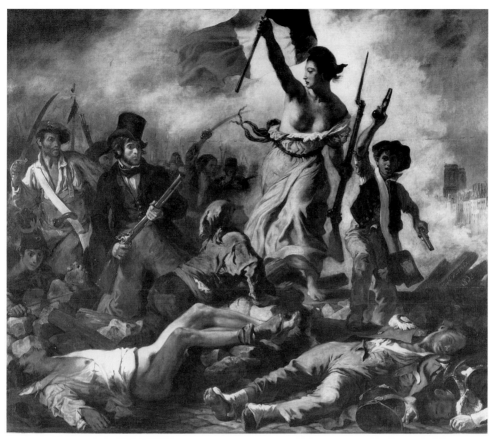

38 Eugène Delacroix, *Liberty Leading the People*, 1830–31, oil on canvas. Musée du Louvre, Paris.

politically engaged art. The 'Bourgeois King' was able to demonstrate his tolerance by acquiring the work, but steps were soon taken to ensure that it was no longer on view.

Even at the Salon of 1831 people were reluctant to identify themselves with Delacroix's view of the event. The bourgeois party rejected this 'ugly representation of the people', seeing in it only 'the mob'. Most were offended by the allegory of Liberty, which appeared not in classical guise but as a 'plebeian slut'. Had Delacroix presented the subject in the idealized form that people expected of him, he 'could have made a masterpiece' of the subject. Yet Heinrich Heine remembered that there was 'always a big crowd of people' in front of the picture. Eyewitnesses 'could not praise the work highly enough', even though there were 'very many on show, more than forty paintings' on the same theme. Heine was

prepared to applaud the work for its subject alone. Nowhere has 'colour been used as effectively as in Delacroix's *July Revolution*'. Together with the realism of its approach it gave 'the picture truth, immediacy, originality, and one gains a sense of the true physiognomy of those days in July'. As for the painter, who set off for the Orient soon afterwards, the July events had dispelled his *ennui* but they had not helped him as an artist. Soon he reverted to finding inspiration only in subjects from poetry.

THE SALON AS A MUSEUM

On 1 June 1848 the Louvre's annual Salon opened for the last time. The February Revolution had put the collections at risk, which meant that the museum had to be made more secure. Jeanron, the director, had prevented the rebels from setting his museum on fire, but only just. He now insisted that the desolate rooms had to be renovated. Bayle St John, a friend of his, supplies a detailed account of these events in his book on the Louvre, published in London in 1856. To commemorate the founding of the museum, Parlement voted a sum of 2,000,000 francs for the refurbishment. There was no longer to be a hectic round of exhibitions in the temple of art, but the opposite group thought that the new museum was more like a mausoleum. The Salon Carré, where the so-called Salons had been held, was transformed into a permanent pantheon of masterpieces (illus. 39).

In 1833 Heine had given a vitriolic description of the six-monthly alternation between Salon and museum: 'As usual, the old paintings that form the National Gallery had been concealed behind folding screens on which the new pictures were hung. The whole exhibition was like a palimpsest where one was even more angry about the neo-barbaric text if one knew what divine Greek poetry had been obliterated. Probably some four and a half thousand paintings were on show, and there was hardly a single work of real quality among them.' The contemporary art fair, which Heine characterized as a 'multi-coloured yawn', was bound to seem all the more banal for being held in a museum of world rank, in which every permanent work was famous. That particular location, the place where art history had most authority, made the year's offerings from the contemporary art scene look like a jumble sale. But those alternating displays in the same space did at least leave some hint of life in the museum.

Real life, however, was happening out in the city. But the noise of the city became less and less audible from within the enclosed world of

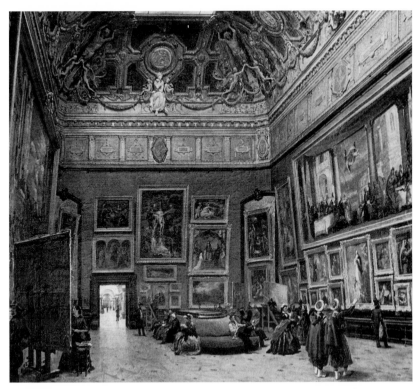

39 Giuseppe Castiglione, *Le Salon Carré*, 1861, oil on canvas. Musée du Louvre, Paris.

the museum. In the conflict between museum and city, artists soon found that they had to choose between being either mere imitators or true rebels. This situation came to be so general in modern art that one easily overlooks its Parisian origin. While, 'out there', new technology such as photography was producing the pictures that could capture fleeting reality, in the rooms of the museum a canon of art that had become questionable still held sway. Artists all seemed to follow the same career stereotype, starting as slavish copyists in the Louvre and later abandoning this in pursuit of total freedom. Then others would take their place to provide the flood of copies of 'museum art' that robbed contemporary art of any real chance of finding a market. Members of the art scene were therefore among those who, in the name of progress and change, wanted to storm the high museum walls behind which the 'cult of the arts', as Prosper Mérimée called it, was practised.

It is part of the myth of the modern artist that freedom had to be wrested from the dictatorship of the museum. But this freedom held a

danger for weaker personalities, who, it was said, sometimes went mad. The freedom to go out into nature became a symbol of the new approach. Nature seemed an appropriate argument against a tradition in which nature had been suppressed in the name of, precisely, nature. Sunlight was always invoked as the opposite of the gloomy interior of the museum. Imitation went out of favour. Turning away from the works that had been their accepted models for imitation, the artists set out on an unmarked path into the future, where the ideal could no longer be defined. To one side Naturalism beckoned, to the other abstract art. In the search for a common artistic ideal, the avant-gardes followed one another with such celerity that only abstract art seemed to promise the first resting-place on this headlong journey. There was a hope that it might once again show the absolute face of art, which had been lost with the unrepeatable masterpiece.

When the museum began to make serious preparations for a permanent exhibition, the *mise-en-scène* became a matter of public concern. Writers threw themselves into the fray for as long as they still hoped to have some influence on 'their' museum. Théophile Gautier reported on the state of affairs in February 1849, Mérimée implored the museum administration to follow his advice, and when the refurbished galleries were opened on 5 June 1851, Gustave Planche complained about all the mistakes that he considered the architect, Duban, had made. In 1849 Frédéric Villot, curator of the paintings department, compiled a scholarly catalogue that by 1853 had run to five editions. The *intérêt scientifique* was no longer willing to take orders from a self-confident public whose interest in the Louvre had even necessitated a 'Ladies' Guide' as far back as 1830. But the museum needed sponsors, since prices on the art market had risen steeply, and its budget, as Villot pointed out, was only just sufficient to buy one Old Master painting or one statue a year.

By 1849 it had been decided to display the masterpieces of the older schools in the Salon Carré and the highlights of the French school in the Salle des Sept Cheminées. This marked a final departure from the previous mingling of old and new, which had always provided opportunities for surprising comparisons. In the other galleries a strict chronology was to rule, while the two central galleries offered a double artistic Olympus. The 'Grand Salon' was 'a shrine to the Beautiful (*le beau*), where even from the *œuvre* of the most famous of artists only the masterpiece among his masterpieces would be admitted, his one utterly incomparable work' (Gautier). So here 'development' was excluded, out of a desire to venerate art itself in its timeless glory. In the new décor of the gallery, the

heroes of art history – accredited with the initials of the République Française – looked down in person from the ceiling decoration. But the 'holy sanctuary of painting' only allowed for works of equal rank. For a time there was a plan to put in several 'beautiful ancient statues'. 'Then a single room would have the whole history of art assembled within it. Wherever one looked, one's eye would light on a masterpiece' (Mérimée). But the idea was soon abandoned, in favour of a shrine to painting. To Gustave Planche the colours of the wall-hangings were suggestive of a beautiful crypt, and he could sympathize with the young people who had adorned the wooden frame of the sofa in the middle of the room with drawings of the tears they had shed at the graveside of art. Those who worshipped art in this room could also indulge their patriotic emotions in the Salle des Sept Cheminées on the same floor. Here the artists of the French school were represented, right up to Géricault's *Raft of the Medusa*.

Objections were raised only to the general hanging of the Louvre's paintings, with Planche indignantly complaining that they had been wholly sacrificed to the décor. The restoration of the old pictures, which Villot had undertaken himself, was also criticized, and Delacroix was convinced that the 'wretched' Villot had literally done to death the large Veronese in the Salon. Only Gautier refused to let his 'religious mood' be broken, enthusing, 'Are we not here in one of the most holy and venerable of churches, in the temple of human genius?' The idea of the temple of art had become so uncompromising that it pushed the contrast between museum and living art to the limit. The avant-garde very soon rejected such ideals as had only arisen as products of the modern museum. The myth of the museum fostered a myth of the work that the artist had either to subject himself to or else utterly reject. Was it simply a coincidence that the Paris school became the leading artistic force in the first century of the museum? Did the presence of the Louvre, a contradictory presence in the midst of the most advanced city life of the time, imprint itself on the developing conflict between art's vanguard and academicism?

5 The Artists' Curse

THE 'UNTRACEABLE VENUS OF THE ANCIENTS'

Artists' legends, which tell us more than their biographies do, often include the theme of the modern Pygmalion unable to bring his statue to life. Balzac irrevocably recast the same legend in *The Unknown Master-piece* (*Le Chef-d'œuvre inconnu*, 1831). At one point in this story the elderly painter Frenhofer, who has spent his life vainly seeking to capture the soul of art, talks to the young Poussin, who is just about to embark on that quest. Frenhofer has been labouring for a decade on a work that is still unfinished. 'But what are ten short years when one is wrestling with nature? We do not know how long it took the great Pygmalion to create the one statue that ever walked!' He then falls into a deep reverie, as though 'communing with his own spirit'. To the young Poussin it seems as if the old artist, in whom the Renaissance lives on, 'has, by a sudden transfiguration, become art itself, art with its mysteries, its ardours and its dreams'.

Emerging from his reverie, Frenhofer ventures an oracular pro-nouncement: 'I have been unable, so far, to find an irreproachably beautiful woman, a body with contours of perfect beauty.' Here he interrupts himself, exclaiming: 'But where does she exist in living form, that untraceable Venus of the Ancients, so often sought, of whose beauty one can at best find a few scattered details? Oh, if I could but for a moment, just once, see divine nature, the ideal, I would give my whole fortune for it – indeed, I would go and search for you in your Hades, celestial beauty! Like Orpheus I would descend into the hellish under-world of art to retrieve life from thence.' His companions realize that they may as well leave, since Frenhofer has forgotten them. His words are meant only for the imaginary woman to whom he has sacrificed his life.

Théophile Gautier, who advised Balzac on the second version of the story, returned to the theme of the impossible ideal of art more than twenty years later in the preface to *Les Dieux et les demi-dieux de la pein-ture* (The Gods and Demigods of Painting): 'Everyone has pursued beauty and yet no one has realized his dream, for the ideal retreats from advancing artists and withdraws into the absolute. If it were not beyond

the reach of any realization it would cease to be an ideal.' This, then, is the hell of art: one chases a phantom. What Gautier, in the same preface, calls the 'veil of Isis' cannot be lifted. And art becomes a Fury if one does tear off its veil, forcing it to reveal its impossible sight.

Yet Balzac's text remains enigmatic. What 'Venus of the Ancients' is Frenhofer referring to? Which Venus has this modern Pygmalion sought to bring to life? It is not enough to fix on the most obvious meaning, the futility of trying to retrieve nature from art. Moreover, Venus was infinitely more and yet infinitely less than any real woman. There was an insoluble paradox in the desire to find the soul of art in the body of a woman. But why the 'Venus of the Ancients'? Balzac's readers knew that the ancient ideal of art was embodied in the famous statues of Venus they encountered in the Louvre. They would therefore be surprised to be told that it was impossible to find her. They would also no doubt ask themselves what this had to do with Frenhofer, for his unfinished masterpiece was a painting. No wonder Frenhofer was unsuccessful, while Balzac's readers continued to admire the old masterpieces, which defied all description.

But Balzac's language itself provides clues to the purpose of his story. It alludes to texts describing ancient statues in the Louvre, but these references are now applied to a work that does not exist – and thus cannot be described. While the other texts describe perfect art, Balzac writes of the impossibility of art's perfection. That small shift changes everything. Those authors felt that they failed to do justice to masterpieces; Balzac's artist fails to create such a masterpiece. Frenhofer's failure is inevitable because what obsesses him is only an uncomfortable, modern idea of perfection. When that idea is projected onto ancient art it becomes utterly unreal. If one browses through the early Louvre catalogues, Balzac's language comes to seem oddly familiar. At that time the *Venus de' Medici* (illus. 1) inspired artists' dreams. Only with trepidation could Vivant Denon speak of the 'fullness of her existence' and enthuse about the maidenly smile on her lips. But then he singled out her foot, as though impelled to cast himself down before it in slavish devotion. 'This, the most beautiful of all feet, is so perfect that were it found in isolation it would be a masterpiece in its own right.'

And it is the foot that Balzac preserves as a last trace of such beauty when the painter's friends finally set eyes on the masterpiece he has concealed from them for so long. Amid a confusion of brushstrokes and colours 'they noticed in a corner of the canvas the tip of a naked foot.' It is 'a delectable, a living foot! They stand transfixed with admiration

before this fragment, which had escaped a gradual effacement' by the painter himself. 'The foot appeared there like a fragment of a Venus of Parian marble emerging from the ruins of a city destroyed by fire. "There is a woman under there, cried Porbus."' Instead of the painting *being* the woman, as Frenhofer believed, it had obliterated, or, more precisely, buried the woman under the abstract surface of art.

Through Balzac's hint at a fragment, the tangible model of art is removed to a past era. The foot protrudes from beneath the surface of the new painting. Whereas Denon praised the foot as part of a statue that was still whole, in Balzac the foot can never again become part of the whole, for that is irretrievably lost. The kind of fragment that could be seen in museums was easily turned into a metaphor for an idea of art that was no longer possible. Not only the imitation of antiquity but the idea of perfect art became a fiction when applied to modern art. But by now even the *Venus de' Medici* – that Roman copy – had lost its magic, and so there had been no great sorrow when it was returned to Florence after Napoleon's fall.

The *Venus de Milo*, newly excavated in Greece, occupied the abandoned pedestal in the Louvre from 1821 onwards (illus. 11) and held the same fascination for the art public. But this substitution also underlined the fact that visitors had been deluded when they admired the ancient ideal of beauty in the statues that had formerly enjoyed such fame. In a monograph on the new Venus written in the very year the statue was discovered, the Comte de Clarac once again expressed the belief that here the very embodiment of ancient art had been brought to light. So, amid a general loss of faith, the old but ever young goddess of beauty had returned once more to shore up belief in antiquity. Clarac thanked her for the 'delight without need for repentance' that he felt when gazing at her: 'She combines the divine beauties of the soul with all the perfections of the body.' The author of the *Musée français* catalogue, too, felt impelled to pen a description that would do justice to this masterpiece. The work had become so 'alive' (*animé*) that the author feared his own description might seem lifeless by comparison.

If, then, the 'Venus of the Ancients' had here really been recovered once more, Balzac's readers could not fail to notice that this was contradicted by his reference to the 'untraceable Venus of the Ancients'. The tale also contradicted the idea that marble could come to life, since life and art were mutually exclusive. Frenhofer was deluded when he confused his canvas with a living woman whose lover he felt himself to be. 'I think she took a breath just now! Her bosom here, do you see? Ah, who would not go down on his knees and worship her!' But Pygmalion's

miracle did not happen. People did indeed worship the *Venus de Milo* on bended knee, but Balzac was speaking of an 'illusory image' (*semblant*) of a woman. He was not only casting doubt on the ideal drawn from antiquity; he was also discrediting imitation of nature, much in line with the Romantic view. One could pursue either nature or the ideal, but not both at once. And to continue to relate absolute art to nature was sacrilege.

Gautier was unwilling to forgo an erotic experience that contemporary art failed to provide. So he continued to sing the praises of the *Venus de Milo*, which shone forth in Paris as a unique miracle of art and during the hostilities of 1870–71 was walled up to protect it from damage. Delacroix, however, unimpressed by this cult, came to a conclusion hardly less radical than Balzac's. Even masterpieces, he noted in February 1860, are subject to the laws of time. It was precisely the *Venus de Milo*, he said, that offered this insight. 'Who does not remember the confusion such masterpieces once wrought in people's minds? That type of beauty contradicted all our experience. Such an intolerable mixture of ideal and reality, elegance and strength, and nobility and nature put our artistic judgment to shame. It is in the nature of masterpieces to produce this kind of shock, jolting us out of routine admiration.' Everyone had experienced this when confronted with the Elgin Marbles and the *Venus de Milo*. 'Once these works had become accepted, they gradually ousted the masterpieces we had cherished hitherto.' As a contemporary painter, Delacroix profited by this change of attitude. And so, without intending it, he came surprisingly close to Baudelaire's modernism.

BALZAC'S IMPOSSIBLE MASTERPIECE

One cannot today separate Balzac's well-known tale from the views of those artists who saw themselves reflected in it. Right up to his suicide, Van Gogh was a reincarnation of Frenhofer, and Cézanne is said to have cried out, 'I am Frenhofer!' Picasso rented a studio in the very street in Paris where the story opens, and it was there that he painted *Guernica*. Ambroise Vollard commissioned him to make a series of engravings based on *The Unknown Masterpiece*, a series that is among the most profound commentaries on it. The four late series in which Picasso deconstructs famous masterpieces also revolve around the enigma of whether painting is more than just painting. Doris Ashton has traced the remarkable history of the reception and influence of Balzac's tale as the first modern artist–novella.

It has to be said that Balzac's title – *Le Chef-d'œuvre inconnu* – is

somewhat misleading. The expression 'unknown masterpiece' seems to imply that the masterpiece is as yet not known. The puzzle is only resolved when one recognizes in the title an allusion that I believe has been overlooked. Balzac was referring to *Le Chef-d'œuvre d'un inconnu*, published in 1714 by Themiseuil de Sainte-Hyacinthe under the pseudonym Chrisostome Matanasius. This work parodied literary criticism by applying its method to a 'masterpiece by an unknown author' that was in fact a banal poem quite unworthy of the effort expended on it. The interpretation is most impressive, but it achieves nothing because there is no masterpiece for it to describe. So whereas there the object of criticism, as a work, amounts to nothing, Balzac's story ends by revealing a work that is not a work. While in the earlier text the work is simply bad, in Balzac's version the work, in this case a painting, has become an impossibility.

Balzac's story begins in 1612, which suggests that it is going to take us back to the lost era of French classicism. The young man who knocks at a door in the Rue des Grands-Augustins on a winter's morning is none other than Nicolas Poussin, though this emerges only after he has given the first demonstration of his talent. He has come to visit François Porbus, who painted a celebrated portrait of Henry IV but was later supplanted in the royal favour by Rubens. But Poussin meets another visitor, a strange old man named Frenhofer, who, we later learn, was the last pupil of the Renaissance painter Jan Mabuse. When the two of them together enter Porbus's studio, their eye is at once caught by the first masterpiece that features in the story. Poussin is filled with admiration, but the old man loses no time in telling him that the picture lacks the ultimate degree of perfection. He reproaches Porbus: 'Your creation is incomplete. Life and death are at war with each other in every detail. At one point one sees a woman, at another a statue, and finally a corpse.' Frenhofer's verdict is merciless: 'What does it lack? A mere nothing, but that nothing is everything.' We do not yet suspect that this foreshadows the ending. We are only surprised that a survivor of the Renaissance should himself add the finishing touches to a work that belongs to a new age and which has failed to realize the old ideal of perfection.

Soon the scene of the story changes, and the three painters stay in a fine timber-framed house near the Pont Saint-Michel, where Poussin sees the second masterpiece. This time it is a genuine Renaissance work, by Mabuse himself, showing Adam, the creation of God, whom the painter has created anew. Frenhofer warns his young companion against looking at the picture for too long: 'You would only fall into despair!' In his view even this work is imperfect: 'I have produced better work!'

Although in this picture his teacher had surpassed himself and breathed life into the figure of Adam, the surrounding depiction of nature is not a success. Also Adam, who after all 'comes straight from the hands of God, should have something divine about him, which here is lacking'.

Discouraged, the novice starts to wonder if there can possibly be such a thing as a masterpiece. Then Porbus asks the old man if he will at last let him see his '*maîtresse*'. Only when Frenhofer indignantly refuses do we realize that they are speaking of a work. It is a painting he cannot complete, and which therefore, like a beautiful woman, keeps him wavering between hope and despair. Everything Frenhofer subsequently says about the still invisible masterpiece demonstrates his confusion between the idea and the work, the woman and the picture. He is hopelessly in love with an absolute idea of art that, because it is conceived against nature, cannot be realized as a work at all. 'It is not a canvas but a woman! A woman with whom I weep and laugh.' Since she is nude, he does not want to degrade her by showing her to others. Then 'I would cease to be her father, lover and God'. Here the blasphemy comes into the open. The painter wants to be a second God, a Creator. 'This woman is not a creature, she is a Creation.'

What follows is well known. The catastrophe occurs when the inadmissible is allowed to happen: Frenhofer compares the painted woman with a living one without awakening from his delusion, but when his friends at last see the work that until then they could only imagine, they find only an illusion where they expected to find a work. Behind closed doors, Frenhofer utters a cry of triumph as he makes the comparison between the beautiful female model they have brought to him and his picture. 'My work is perfect.' Nature, he believes, has lost the contest with art. Now at last the painter is willing to let his work be seen. The *painted* woman, who even has a name, Catherine Lescaut, no longer torments him with the wiles of a 'Belle Noiseuse' ('argumentative beauty'). The *living* woman is Poussin's mistress, Gillette, whose love the young artist sacrifices in order to see the other woman – though Poussin is convinced that she will win the contest because she 'is worth all the masterpieces in the world'. So his only fear when she undresses for the old painter is that she may be seduced by him.

But only his own work can seduce Frenhofer, in which he believes he has scored a triumph over Nature. His friends, admitted to the room at last, look around in vain for a masterpiece. But the old man misreads their searching glances: 'You were not prepared for such perfection! You are standing in front of a woman, and looking for a picture. Do you not

feel that you could place your hand on that back? For seven years I have been studying the effects of the combination of light and matter. Where is art here? Gone, vanished. You see before you the true forms of a young woman!' The friends have become accustomed to hearing him talk like this, but in the presence of the work the illusion is finally shattered.

They can see nothing but a 'wall of painting', lacking any inner meaning or coherence. Frenhofer has gradually destroyed the motif – all except for one of the woman's feet – in order to paint the idea of absolute art, which has made him blind to any motif from the real world. He has been deluded not only about the work but also about art, which he has confused with a woman. He still cannot interpret their helpless looks, and 'smiles at the imaginary woman' – 'Yes, one must have faith, faith in art.' Then the truth dawns as he hears young Poussin say that Frenhofer too will discover sooner or later 'that there is nothing to see on the canvas'. When everything is reduced to nothingness and the life of the picture dissolves into a phantom, Frenhofer's life too is at an end. Like a jeweller who senses he is in the presence of thieves, 'Frenhofer covered his Catherine with a green curtain' and bade a final farewell.

This story, though set in the seventeenth century, is about the modern artist's struggle. Perfect art was a shadow, a mere ghost of classical times, and not even Orpheus was able to bring it back into the world because he lost it when he tried to look at it. The ideal of perfection was transformed into an idea of art completely divorced from practice. The contradiction between idea and work could not be resolved, because only the idea could be absolute: the moment it became a work it was lost. Paradoxically, Frenhofer's painting contains the ideal of perfection only while it remains unfinished. In that state it still promises to deliver the impossible. As long as that promise is unfulfilled, hope remains that the impossible will be realized in a work. The tragic outcome ensues when the others cannot see what the painter believes in. What no one else can see has obviously not become a work. The work would have furnished the one proof that the idea was no mere illusion. Here we see the tightening of a knot that no one, even in the twentieth century, would succeed in undoing. Art was a fiction and not a work.

Gautier was dissatisfied with an ideal of art that had no place for actual works. While he conceded that 'beauty in art' was like a butterfly that would always flee when one chased it, this eccentric poet and failed painter found his ideal of *l'art pour l'art* precisely in that elusiveness. In his essay 'Du Beau dans l'art' (On the Beautiful in Art), published in 1856, he defended his Romantic ideal against both the new realist school of painters and the

old generation of classicists, whom he accused of having subjected themselves to a rigid canon of rules about art. The ideal, he said, existed only 'in the mind of the artist', where Balzac too had sought it. The true artist does not need nature, he 'carries his picture within himself'.

This was already a plea on behalf of abstraction, which renounced imitation of any kind. And abstraction required a truth that lay beyond figuration and revealed itself only in art. 'Without the idea of hidden beauty (*le beau*), works of art would not possess the universal and eternal character that gives masterpieces their final consecration: they would lack life.' Gautier gave the masterpiece a tangible location in the practice of art. As a writer he was able to draw on the past, where painters had demonstrated the power of art over time itself. The supreme example for him was the *Mona Lisa*, but he had to reinvent her. It was only through his description that she acquired the personality which led to her fame. Baudelaire respectfully dedicated *Les Fleurs du mal* to his 'mentor and friend' Gautier, but he renounced the timeless ideal of *beauté*. Beauty in his poem pours scorn on the servile lovers whose feelings leave her cold. She sits unattainably 'enthroned in the azure, like an inscrutable sphinx'. Was this an allusion to the sphinx-like *Mona Lisa* of Gautier's writings? Baudelaire regarded beauty as a 'divine opium' for men. Beauty could be captured only if it was given a radically contemporary face.

In the wake of Balzac's tale, attempts were made to give his theme a different outcome. These continued in the twentieth century, when artists turned seriously to abstraction. They were no longer prepared to let the motif doom their efforts to failure, and therefore sacrificed even the foot of the imaginary woman, whom they saw as the false ideal of art. For them the 'wall of painting' was the only reality to be seen in art. But they nevertheless remained faithful to the idea of destruction, which perpetuates the memory of nature. The very concept of 'non-representational art' retains this memory via the renunciation of the painter's former motif.

THE FAILED ARTIST

Among the novels about artists that appeared in the following decades, the first to achieve a major success was *Manette Salomon* (1866) by the brothers Edmond and Jules Goncourt. This is virtually a *roman à clef* about contemporary artistic life in Paris. The milieu becomes real, to the extent that Ingres and Delacroix are mentioned by name. Once again

there are three painters, but this time they are rivals all trying to make their way on the art scene. Whereas Balzac had placed a single character at the centre of his story, the artistic pluralism of the 1860s prohibited such a narrow focus. The painters in *Manette Salomon* fail for various reasons, and in less dramatic fashion. Grand allegory is replaced by descriptive psychology.

Of the three characters in the novel, we can quickly forget about honest Garontelle, who caters entirely for the conservative taste. This leaves the two others, whose careers take opposite directions, yet who both fail to attain their goal. Both are determined to undertake master-pieces, but each attempt ends in disaster. The one fails because of his choice of subject; the other achieves success but is destroyed by the self-doubt characteristic of the time. This latter case, where even success fails to provide any self-confidence, is the more interesting one. In the café the painters denigrate not only the aged Ingres but also the 'decadent' Delacroix, whose paintings of literary subjects were no more than 'embryonic masterpieces'. They finally agree that the future lies with the 'landscape painters'. The end of the novel sees the appearance, like a *deus ex machina*, of the outdoor painter Crescent, who bears the traits of Jean-François Millet.

First, however, we are introduced to Anatole Bazoche, a *bohémien* who barely earns enough to keep body and soul together and who curses art. He astonishes his friends by declaring that after a visit to the Louvre he suddenly has 'a masterpiece in his belly'. But the picture 'was not so much a painting as an idea'. Its theme is a transposition into painting of 'socialist tendencies' derived from the writings of Charles Fourier. The allegorical subject, a 'humanitarian Christ', remains ana-chronistic, however much Bazoche invests it with revolutionary ideas and presents it as an anticipation of the 'religion of the twentieth century'. The turning-point comes when, at the Théâtre aux Funam-bules one evening, he sees the popular mime artiste Debureau appearing as Pierrot (illus. 40). Watching Debureau performing his routine inspires Bazoche to produce not just a single painting but a whole series of works filled with movement, similar to the series of photographs of the same actor by Nadar. Pierrot seems to him to embody the situation of the modern artist. So 'he overpainted his Christ with a big Pierrot, who bows with an impudent look in his eyes', as though the painter himself were pulling a face at the public. We meet Bazoche again much later, when at a studio party he dances as Pierrot. In the 'infernal Parisian can-can' he sacrilegiously parodies famous motifs from masterpieces in the

40 Félix Nadar, *Pierrot Surprised (Debureau in the Théâtre aux Funambules)*, 1854–5, photograph. Private collection.

Louvre. The 'cynical *blague*' he conveys through the medium of the dance reveals the disillusionment prevalent in the artists' studios. There is even a joke at the expense of the *Raft of the Medusa*.

Next to appear in the novel is the Creole, Naz de Coriolis, a colourist who has found 'his own Orient' not in Morocco but in Asia Minor. The success of his Orientalism in the Salon fails to satisfy him, for he wants to prove himself by producing a masterpiece. For this he needs an appropriate subject, and he opts for a female nude, which he intends to treat in the heroic manner. Unwilling to forgo the exoticism currently in vogue, he adds 'a Turkish bath as the décor for his scene'. Every reader was bound to recognize this as a reference to Ingres' last picture, which had just been exhibited in the Salon. But the allusion is given an ironic twist in that Coriolis shows clouds of steam and sweating bodies, which are directly opposed to Ingres' artistic ideal and closer to that contemporary realism which Ingres eschewed. Coriolis could not therefore hope to succeed with the *Grande Baigneuse*, which is described as being in the Ingres manner, in the foreground. The painter destroys his main figure 'because there is no longer a body in Paris' that could still be depicted in accordance with the classical ideal. So Coriolis is left

gazing yearningly at Japanese woodcuts, the brightness of which helps him to bear the grey Parisian winter.

After this, the novel becomes the story of a body. A Jewish girl, Manette Salomon, has 'the aura of a masterpiece'. Her body is described, over several pages, with a degree of detail and sophistication hitherto found only in descriptions of pictures. By a whim of nature the ideal of beauty has appeared not in art but in a living body, so that to depict her the painter adopts a slavishly realistic style. In the Salon of 1853, 'the living flesh, which is still warm in the picture' is received with due admiration. But the man within the painter has fallen prey to this female body, and he becomes impotent as an artist when he makes the model his wife. On the evening of their wedding-day a heated discussion breaks out again on the subject of eternal beauty, which has supposedly been lost to the world when Manette ceased to act as a model, even though, ironically, she is present in person during the discussion. The fellow artists lose themselves in useless words and concepts that flitter away like butterflies.

But nature was all around, if one ceased trying to find it in one particular body, and also gave up looking to the Orient for it. At Barbizon, Crescent, the 'representative of modern landscape painting', returns 'to natural nature'. Meanwhile, Coriolis' intoxication with colours and his admiration of old ideals has left him deeply disturbed: 'there was something almost of madness in his eyes'. The admired canvases he once produced are a thing of the past. 'Even in the Louvre the four walls full of masterpieces in the Grand Salon seemed to have lost their radiance. The Salon grew dull and showed him only mummified colours beneath the yellow patina of time. The light had become no more than a faded memory. He felt that in this whole gathering of immortal paintings something was missing: the sun.'

SUICIDE IN THE PRESENCE OF THE WORK

For Claude Lantier too, the tragic hero of Emile Zola's novel *L'Oeuvre* (1885–6), the sun is the living light of reality, necessarily superior to the dead light of art. Although an enthusiast for progress, Lantier nevertheless attempts a masterpiece, but it proves a failure (*manqué*). There is an inherent contradiction in the masterpiece itself, since it has now become merely the arena for a hopeless struggle. In the spirit of the avant-garde, as Zola saw very clearly, his hero aims to become the 'genius of the new formula' and struggles to produce a 'masterpiece to stand as a monument to the departing century'. But the idea of progress was incompatible

with the intention of having the last word in art. Zola's boyhood friend Cézanne, whom many thought they recognized in the hero of the novel, was almost destroyed by the conflicting goals of aspiring to a modern classicism and keeping open every possibility in art.

The word 'œuvre' in the title had the double meaning of a single work of art and an œuvre or life's work. As Zola wrote in a letter in 1885, the novel was about 'the birth and the drama of the work in the brain of an artist'. As early as 1869 he had planned the content of the novel and placed his central character, the child of working-class parents, amid the decadence of the age. In a first outline Zola wanted 'to depict the struggle of the artist with nature'. The drama of creative work, which involves blood and tears, is one that also torments the author, who is himself 'wrestling with the angel'. This 'novel of art', as Zola called it, gives voice to his irritation with the painters of the day who did not bring the same zeal to the fight for Naturalism as Zola himself when he portrayed society.

Edouard Manet had successfully painted just the kind of pictures with which, in the novel, Lantier fails. The *Bar at the Folies-Bergère* (see p. 172) was the allegory of modern Paris for which Lantier struggles in vain; it was not mere reportage but had the enigmatic quality of a painting that questions its own medium. This enigma caused Zola so much unease that he vehemently set about discrediting all work of this kind. Not only does his painter, Lantier, fail to measure up to nature, he also reverts to the detested Romantic manner. If the painting's main figure is a 'Venus rising from the waves of the Seine', this is Zola caricaturing the subject. One could paint either a Venus, like Ingres, or the Seine, like the Impressionists, but not both in the same picture. If the intention was to paint an allegory of Paris, featuring the '*Quais* and their omnibuses', then the Venus motif was utterly absurd.

There is lengthy discussion in the novel about a composition in which Lantier hopes to 'modernize' Manet's famous *Déjeuner sur l'herbe* as thoroughly as Monet and Cézanne set out to do in their early days. The painting is a failure, and once again the struggle was with a female nude. 'How could a modern painter who prided himelf on painting nothing but reality' burden his work with such a subject? When asked by his friend Sandoz, Lantier has no answer, 'for he was tormented by a secret symbolism, a lingering trace of Romanticism, which caused him to make this nude woman the very embodiment of Paris itself, the naked, passionate city, radiant with feminine beauty'. It is impossible to resolve the contradiction between nature in this body and modernity in the city views (illus. 41).

The artists and critics in Zola's novel reveal the profile of a period

that has seen much progress. As well as the 'old Romantic lion' Delacroix, the 'conscientious worker' Gustave Courbet has also long since been accorded classical status. Courbet's realism convinces in his subject-matter, while in his manner of painting he perpetuated all the traditional features 'that one sees in the masterpieces in the museums'. Thus both Delacroix and Courbet were wholly of their time and had, each in his own way, 'taken a step forward'. Progress, it seemed, was the destination of art. Lantier had already appeared in *Le Ventre de Paris* (The Belly of Paris, 1873), but there Zola had dealt only with his early life. Even at that stage the artist was already thinking about exposing the worn-out practice of 'painting ideas' to the shock of Naturalism. 'For a long time he dreamed of a colossal painting in which Candine and Marjolin make love right in the middle of the central Halles, among the vegetables and the saltwater fish. It was to be an artistic manifesto for Positivism.' In the later novel Lantier spends three years painting in the streets of Paris, bathed in bright sunlight. They are 'pictures of revolt'. His sculptor friend Mahoudeau, for his part, becomes a caricature of Pygmalion when his wax model of a woman, placed next to the hot stove, starts to melt.

The woman's belly, a key motif in the novel, represents a rejection

41 William Adolphe Bouguereau (1825–1905), in a photograph taken in his studio in Paris.

of the ideals of the head. In the night, when the struggle for Lantier's own masterpiece seems already to have been lost, 'only the round abdomen remained lying there, its flesh gleaming, in the moonlight', but even this gleam slowly fades 'like a sick moon'. But Lantier is not ready to admit defeat: 'I will try once more, even if it kills me, kills my wife and child, but, so help me God, it shall be a masterpiece.' He is taken at his word. Within the hour, his sick child, whose mother had, as always, posed for the picture, dies in the next room. Here the conflict between art and life is brought to a shocking conclusion. But Zola, still not satisfied, caps even this. Lantier paints a portrait of the dead child, which symbolizes the death of the work, since Lantier had 'begotten' them both. The Romantic idea of a new creation of nature is defeated precisely by that reality which exists only in actual nature itself.

There is constant reference to the body, as though Zola wanted this work implicitly to represent the body of art. But there is a perverse relationship between the living model and the painted nude. The living woman becomes increasingly weak, and the painted one is a failure. Nature is sacrificed to a pointless depiction that can never itself become nature. Christine, the model and wife, 'nevertheless conceded defeat to the tyranny of art'. The colossal woman on the canvas, she fears, has defeated her in the contest for the man they share. But the painter sees things quite differently. In his 'mad eyes one could see the death of light, whenever they gazed upon his failed life's work'.

Long before this, Amélie Cogniet had represented the drama of the work in a depiction of her father's studio (illus. 42). As in Zola's story, the painter, standing on a ladder, faces a gigantic canvas. The model, who is perhaps already his wife, is sitting before it in a humble pose, apparently acknowledging her defeat. But as though intent on separating the two of them, another muse stands between the model and the painter. It is a statue of Venus, recalling the ideal that had once reigned supreme in art. But the painter now seeks the ideal in the living woman whom he wants to recreate in the painting. Amélie Cogniet leaves the outcome of these demiurgic dreams open. But Zola, for his part, paints in gruesome colours an outcome that is truly heart-rending.

'On the tall ladder facing the failed work' Lantier 'had hanged himself'. After finding him no longer in bed, his wife discovers him there 'with his face turned towards the painting, close to the Woman, whose sex had blossomed like a mystical rose. It was as though with his last gasps he had breathed his soul into her, and as if his fixed pupils still gazed at her.' Here Zola's much-vaunted naturalism is carried away by

42 Amélie Cogniet, *The Studio of Léon Cogniet*, 1831, oil on canvas. Musée des Beaux-Arts, Orléans.

his own virtuosity. There the dead painter hangs, between the living and the imaginary woman. But the surviving woman, filled with sheer hatred, raises her fists to art: 'Oh Claude! She has killed you, the bitch!'

A 'RAPHAEL WITHOUT HANDS'

Henry James's tale 'The Madonna of the Future', first published in 1873, is set in a different milieu. It is that of the American tourists who travelled to Europe with a list, updated each year, of the 'world-famous pictures' that simply had to be seen. This milieu is introduced immediately through the story's narrator, who remembers an incident from his youth. In Florence he had met a reincarnation of Frenhofer who was engaged in producing a new version of a Raphael Madonna. The very title of the story exposes the contradictory nature of this plan: the Madonna 'of the future' cannot point towards the future because the Madonna is a subject belonging to an age that is past.

The two men happened to meet one night when 'the present was sleeping; the past hovered about us like a dream made visible'. The following day they stand in the Pitti Gallery in front of Raphael's

Madonna della sedia, which 'intoxicates' the spectator 'with the fragrance of the tenderest blossom of maternity that ever bloomed on earth' (illus. 43). The narrator does not yet know that his companion, the eccentric painter Theobald, has got it into his head to outdo this achievement of Raphael's by a masterpiece of his own. They talk about how such perfection was ever possible: after this, Raphael 'could do nothing but die'. But nowadays 'visions are rare' in art. The reason may be that religion and aesthetics no longer go hand in hand. 'But in meditation we may still woo the ideal.' Theobald finally admits, with some embarrassment, that he does so in practice too.

Shortly afterwards the narrator is introduced to an elderly American lady who tells him more about Theobald. 'We all believed in him once. Another Raphael, at the very least, had been born among men, and poor, dear America was to have the credit of him. The women were all dying to sit to him for their portraits and be made immortal, like Leonardo's Joconde.' But 'our master never produced his masterpiece'. He did not know the first things about his craft. None the less, he made 'studies for a Madonna who was to be a *résumé* of all the other Madonnas of the Italian school, like that antique Venus who borrowed a nose from one great image and an ankle from another. It's certainly a masterly idea.'

The old painter smiles when the narrator reports this conversation to him. 'She knows as little about art as I know about Buddhism.' But the

43 Raphael, *Madonna della sedia*, *c.* 1514, oil on panel. Palazzo Pitti, Florence.

mysterious masterpiece remains invisible. Then the painter suggests that they go together to visit his model. She is 'the most beautiful woman in Italy. "A beauty with a soul!"' He had first encountered the woman, Serafina, begging in the streets of Florence, with her child in her arms. The child died, and the painter now helps to support her. When he sees her, the narrator cannot help exclaiming: 'She's an old, old woman!' He realizes that for years Theobald has been 'forever preparing for a work forever deferred'. True, the model retains vestiges of her former beauty, '*de beaux restes*', but it was high time to set to work and complete the masterpiece.

The discovery of the full truth, which the narrator has long suspected, takes place when, fearing that Theobald is ill, he visits him in his studio. The old man admits that he has been 'sitting here for a week face to face with the truth, with the past, with my nullity'. On the easel is 'a canvas that was a mere dead blank, cracked and discoloured by time. This was his immortal work!' Theobald starts to speak again: 'The elements of it are all *here*' – in his mind. 'But my hand is paralysed now, and they'll never be painted. I need only the hand of Raphael. I have his brain.'

The notion of a 'Raphael without hands' had been well known to the Romantics. The modern mind was familiar with the idea of a perfection that could no longer be achieved in painting. When the old masterpieces were produced there was no adequate concept; now the concept was there but the power to achieve it had been lost. Later generations lacked the necessary self trust. In Balzac's story Frenhofer had destroyed the work when he destroyed the motif of the woman in order to paint absolute art. Theobald, on the other hand, did not even dare to touch the blank canvas, which, as a symbol of the work that had become impossible, at least showed him that his idea was still intact because it was still unrealized. Absolute art could only be experienced when one sat in front of the white canvas. Theobald is resigned to being an imitator. So he and the narrator go to the Pitti to bid farewell to the old masterpieces that at least exist, even if they cannot be repeated. 'I shall never forget our melancholy stroll through those gorgeous halls, every picture on whose walls seemed … to glow with a sort of insolent renewal of strength and lustre. The eyes and lips of the great portraits seemed to smile in ineffable scorn of the dejected pretender who had dreamed of competing with their glorious authors; the celestial candour, even, of the Madonna in the Chair, as we paused in perfect silence before her, was tinged with the sinister irony of Leonardo's women. Perfect silence indeed marked our whole progress, – the silence of a deep farewell.'

6 A Hieroglyph of Art

The smile we receive from the *Mona Lisa* (illus. 44) once captivated our grandfathers – unless they were already rebelling against the devotion their own fathers had shown. This painting has become, as it were, the last bastion of the eternal life of masterpieces, apparently proving that here at least timeless beauty has withstood the forces of history. The banality of its popular fame inclines one to avoid altogether the subject of the *Mona Lisa*. After all, this is a work that has been talked to death. The fascination it exerted was only the result of a nineteenth-century obsession. Yet the reasons are far from clear. The cult of this work arose at a time when massive reconstruction was modernizing Paris, but when in poetry what H. R. Jauss has called 'aesthetic modernism' was compensating for the losses that people suffered from modern life.

Nothing seems less appropriate to a period characterized by rationality and empiricism than the morbidly ecstatic cult of a Renaissance beauty in whom people venerated art itself. But why did she suddenly attract so much attention then, when she had already been familiar for so long? She was worshipped much as a Madonna had been, and yet this seductive Florentine was anything but a Madonna. Nor is she reminiscent of an antique Venus, and yet a statue of Venus was her one rival (illus. 11). For a time the *Venus de Milo* attracted the same admiring looks that were bestowed on the *Mona Lisa*, and writers praised the two in the same terms. On Venus's face they saw the smile of the *Mona Lisa*, just as in the *Mona Lisa* they discovered the reflection of pale marble, as though they were speaking of the same person.

But a *person* is precisely what she was not: rather, she was a phantom and an obsession. Perhaps one might speak of a 'historic beauty' that was reinterpreted by the modern public as 'pure art'. Baudelaire, the new prophet of aestheticism, never mentioned the *Mona Lisa* in his writings, but constantly circled around the sphinx of beauty. There hangs about *Les Fleurs du mal*, the manifesto of a modern aesthetic, a fragrance similar to that which clung to the *Mona Lisa*. The poems were dedicated to Baudelaire's 'mentor and friend Théophile Gautier',

who had promoted the new myth of 'La Gioconda', the *Mona Lisa*. Was this picture, later to be despised as the epitome of the *passé*, chosen at the dawn of literary modernism to represent the new aestheticism?

Two essays on the myth of the *Mona Lisa* present matters in a very different light. Henri Focillon held Romanticism responsible for this cult. This was the time when lithography was invented, and its soft half-tones reproduced the smile of the *sfumato* painting in a way that had been beyond the technical range of the engraver. The Romantics succumbed to the 'hermetic charm' of the work, which in Focillon's view symbolized the whole 'psychological enigma of painting'. George Boas expressed similar views, citing in support a famous book by Mario Praz. The *femme fatale*, a creation of Romanticism, was all sensuality and feeling and thus posed a threat to the rationality of the male, tempting him with an allure that was further intensified by an apparent passive-ness. But the *Mona Lisa* represented not only a type of woman but also the mystery of art, which like a hieroglyph was intelligible only to initi-ates. The art critics surrendered themselves totally to the power of the work, a power with which they themselves had in fact invested it.

But we must distinguish Romanticism from the aestheticism that initiated literary modernism. The texts bearing witness to the new myth of the *Mona Lisa* do not predate the middle of the century. To attribute the picture's myth to Romanticism would be to call Baudelaire a Romantic. Art now suddenly wears the enigmatic mask of a no longer youthful beauty who exercises a morbid allure over the beholder. In nature, where only a generation earlier people had seen an ideal of innocence, there now yawned the abyss of a 'modern psychomachia' that was soon to be the subject of psychoanalytical study. This is the other side of that aestheticism which bred increasing resistance to the industrial age – hence the insistence that art must recede into an imaginary realm of its own. In Baudelaire, hyperbolic individuality gives a personified form to 'the alien forces of the unconscious', as H. R. Jauss has pointed out. The unnatural, the artificial, even the pathological not only reflect an alienation from nature but reawaken history too as an alarming and yet alluring memory. In this post-lapsarian world, which celebrates its obscene superiority to the unwelcome reality of modern society, the poets celebrate their own fiction.

The new descriptions of the *Mona Lisa*, inspired by Gautier, strangely resemble Baudelaire's visions in the twilight zone of 'Spleen et Idéal'. In this, the first part of *Les Fleurs du mal*, several poems are devoted to the ideal, but they leave open the question of whether the gaze of this beauty is 'infernal or divine'. In the prose poems that make up his *Spleen*

44 A photograph of the *Mona Lisa* with museum attendant, Musée du Louvre, Paris, *c.* 1970s.

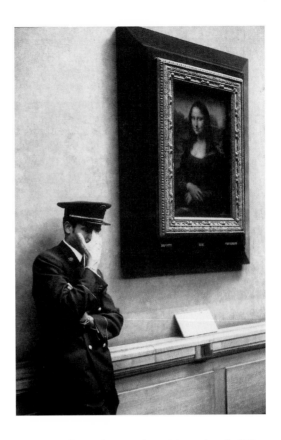

de Paris, aesthetic modernism itself speaks. In 'Les Tentations' (The Temptations; no. XXI), one female and two male devils parody the triad of Republican virtues. The 'bizarre charm' of the female devil has the allure possessed by beauties who are slightly past their prime but 'who do not seem to age any further and whose beauty retains the penetrating magic of ruins'. It is the eyes that fascinate the dreamer, while 'the mystery of the voice awakened the memory of the most wonderful counter-tenors', evoking the enigma of androgyny.

'Le Désir de peindre' (no. XXXVI) describes a painter 'torn apart by desire'. 'I burn to paint her who fled so swiftly. She is beautiful and more than beautiful: she is startling. Everything that emanates from her is nocturnal and deep. Her eyes are two caverns in which mystery faintly glows, but her gaze flashes like lightning.' She is like a predatory animal, this smiling stranger whose 'flaring nostrils breathe in the unknown and the impossible'. And this description, which is itself a painting, ends: 'There are women who arouse a desire to conquer and enjoy them. But this one produces a longing to die slowly under her gaze.' The viewers

of the *Mona Lisa*, too, have an ardent desire to surrender their souls as they give themselves up to the enigma of one who is absent, an enigma made more impenetrable by the presence of the work. Their consciousness is flooded by the existence of the work, from which a woman long dead gazes out at them.

In this atmosphere the *Mona Lisa* seemed to be watching over the modern mystery of the soul, a mystery that was threatened by a positivist view of the body. But she also embodied the mystery of art, which was felt to be threatened by the demands of realism. The more she was made the representative of a fiction, the less she could represent her earlier history. As a result the *Mona Lisa* became the target of a hostility that mocked her as a modern fetish of art. As, however, her modernity was unmasked as a falsification, she attracted the opposite criticism that people wanted to level against tradition. The picture soon began to seem older than it had ever been, and people quickly forgot that its career as a masterpiece was of very recent origin. The writers were filled with enthusiasm for the fictitious woman they had themselves created. The 'aesthetic modernism' that had made the picture its figurehead was a protest against modern reality. City life was changing with the coming of the mass society that has been best described by Walter Benjamin. Rationalist science and technology, in their inexorable march, joined forces in demystifying nature. In this sober light , the 'mystery' in the face of the *Mona Lisa* already seemed anachronistic. Psychology offered a new approach to the human soul. Not long after, in the Salpêtrière hospital in Paris, Jean-Martin Charcot was to embark on his clinical research into hysteria. This even led him to investigate works of art for symptoms of disease, for he looked at art with the eye of the scientist.

As early as 1854 the neurologist Guillaume Duchenne produced photographs of facial expressions that he induced by means of electric shocks. There is something Leonardesque about his attempt to record the emotions in terms of muscular movements, but all the same it represented an attack on the 'magic' of the *Mona Lisa*'s smile. The invention of photography changed the expectation of what the visual image should be. Gustave Le Gray had begun his training as a painter under Paul Delaroche in 1839, but his teacher advised him to change his profession because 'painting is now dead'. When the 'French Photographic Society' held its first exhibition in 1855, Le Gray contributed a large print of the *Mona Lisa*, who seemed to have more magic about her than ever as she smiled out of a photograph, just like a living person.

We have good documentary evidence of the historical person who sat for Leonardo. Vasari records that 'for Francesco del Giocondo, Leonardo undertook to execute a portrait of his wife'. In 1495, at the age of sixteen, Lisa Gherardini had married a man who had already been widowed twice. When Leonardo was painting the portrait, from 1502 to 1506, she was in her twenties. This identification has sometimes been questioned, but such doubts were dispelled by the recently discovered papers left after the death of a pupil of Leonardo's – Gian Giacomo Caprotti, nicknamed Salaì – who had returned to Milan from France in 1519, the year in which Leonardo died. Salaì was murdered in Milan a few years later, so that in 1525 an inventory of his belongings had to be made. Among twelve pictures listed, there are three on which such a high valuation was put that they can only have been by Leonardo himself. The most valuable of these was the original of the famous *Leda*, of which only copies have survived. The other two were valued at half the price, at 100 *scudi*. One of them was a 'painting' (*quadro*) 'known as the Gioconda'.

But why had Leonardo not handed over the portrait to the patron who commissioned it? Vasari states that Leonardo 'worked on this painting for four years and then left it still unfinished'. It is certainly not apparent that the work is unfinished: on the contrary, it has always been praised for its perfection. Perhaps Vasari was simply trying to account for the fact that the picture did not remain in Giocondo's family. But it is also possible that Leonardo only completed the picture later, adding the primeval landscape in the background that was essentially out of place in a portrait. Early imitations of the picture, by Raphael and his circle, do not reveal any evidence for this landscape. Did Leonardo later turn the portrait into a more ambitious picture, in which the diluvial landscape was intended to represent a kind of cosmogony?

Even during Leonardo's lifetime the work had already become independent from the woman it portrayed. The French king, who is not likely to have been interested in the painted person, bought it for his palace at Fontainebleau. It is doubtful whether Vasari ever saw the painting, although he describes it in great detail. It was quite unusual, in any case, to pay so much attention to a portrait, which came at the very bottom of the hierarchy of genres. So the work raises a multitude of questions, which will probably never be answered. But the long description by Vasari, who was after all a painter himself, can perhaps help us to

identify the way contemporaries looked at the work. It was primarily regarded as a proof that it was possible for art to imitate nature. The mouth, like the eyes, seemed to be not painted but alive, and 'one could swear that the pulses were beating' at the throat. In her face as a whole, however, 'there was a smile so pleasing that it seemed divine rather than human; and those who saw it were amazed to find that it was as alive as the original woman.'

In Leonardo's own writings, the terms 'analogy' and 'ambivalence' are the keys to his thinking. There is *analogy* between man and nature; *ambivalence* links light and shade, while also characterizing Leonardo's own temperament. Standing at the entrance to a cave, he felt both 'fear of the darkness of the cave and a desire for the mystery hidden within it'. The modelling of the body, which Leonardo saw as the soul of painting, was given vitality by the ambivalence of relief and shadow; the relief was perfected by the 'softly blurred shadows' in which the light penetrated even under the skin. The beauty of a face, according to Leonardo, was greatest when someone sat in the doorway of a dark house, for then the face reflected both the shadows of the surroundings and the radiance of the open air.

This fascination for nature is evident in Mona Lisa's face, where the set of the muscles around the eyes and at the corners of her mouth indicate hidden emotions (illus. 45). It is therefore not surprising that when Leonardo's *Treatise on Painting* was published for the first time, in 1651, the *Mona Lisa* was chosen for the frontispiece. But the picture contains more than just the face. The contrast between the figure in close-up and the infinitely distant landscape was originally heightened by the inclusion of two columns of a loggia. The body in the foreground and the space behind it are linked only by the light in which the whole picture is bathed. Perhaps early beholders of the painting saw the juxtaposition of a human body and a diluvial nature as a metaphor expressing the enigma of their own existence in the world.

In the bathing apartments at Fontainebleau, where the picture's condition soon deteriorated, its eroticism seemed an invitation to undress the lady and lure her into the bath, as was indeed done in some painted copies. Père Dan, writing a guide to the collections in 1642, had good cause to defend the virtue of the Italian lady, 'who is not a courtesan, as some imagine'. The historical woman had in fact been so completely forgotten as to be seen as an easily seducible *cocotte*. But when the picture was admired as an imitation of nature, it was considered 'a miracle of painting'. This was also the view of the Rome-based

45 Jean-Baptiste Raphaël Urbain Massard, Engraving after Pierre Bouillon of the *Mona Lisa*.

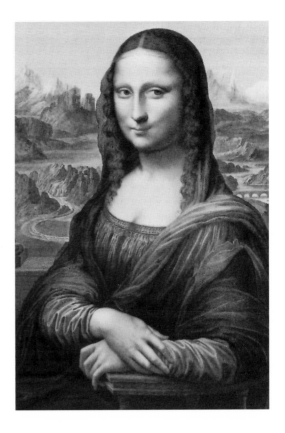

scholar Cassiano dal Pozzo, to whom we owe a revealing anecdote. In 1625 the Duke of Buckingham led a diplomatic mission to France. When taking his leave, he horrified the Court by asking if he could take the *Mona Lisa* with him as a souvenir. Everyone implored the monarch not to 'allow this most beautiful picture to leave his kingdom'. It was almost unheard of for a portrait to be so highly esteemed. Later, at Versailles, no one was interested in the *Mona Lisa* any more, and it was kept in storage. What induced Napoleon to demand it for his bedroom is not known. But he relinquished it soon after, when it was put to him that its rightful place was in the Louvre.

There the picture was for a long time regarded merely as a successful portrait and nothing more. Of the two catalogues of the Napoleonic period, one of them (by Lavallée) does not even mention it, while the other (the *Musée français*) openly criticizes it: 'The details lack delicacy, the flesh-tones are faded. The hands are more alive than the head, and the darkened background ruins the charm of the composition.' Not until the 1840s is there a change of tone. In the Salon of 1845 the painter

46 Paul-Prosper Allais, Engraving after Aimée Brune-Pagès of *Leonardo Painting the 'Mona Lisa'*, 1845.

47 Félix Nadar, *Théophile Gautier*, 1854–5, albumen print photograph. Musée d'Orsay, Paris.

Aimée Brune-Pagès achieved a major success with a picture showing a sitting for the *Mona Lisa* taking place in Leonardo's studio (illus. 46). In the 'Grand Salon', which reopened as a museum in 1851, Leonardo's original hung at eye level, as Bayle St John records, next to a van Eyck picture. Soon George Sand and the Goncourts were enthusiastically linking the smile of the figure they saw as an ever-young courtesan with the riddle of the Sphinx. Charles Clément was the first to rail against the mass hysteria the painting induced. Théophile Gautier (illus. 47), the prophet of the new cult, headed the first circle of devotees. Its members included writers such as Arsène Houssaye, who claimed to have found Leonardo's skull: it is to him that Baudelaire's *Spleen de Paris* is dedicated.

BEAUTY AS AN ENIGMA

Unfettered beauty, now associated with a freedom that was like an abyss, began to suggest terror. Instead of encouraging veneration, its pull was a dangererous allure. In the 'Hymne à la Beauté' in Baudelaire's first cycle of *Les Fleurs du mal* (no. XXI), beauty is a 'huge, terrifying monster' and one does not know whether it comes from Heaven or Hell. But he is satisfied 'if only your eye and your smile open for me the door to an Infinity [*Infini*]'. In Gautier's novella *La Morte amoureuse*, beauty is embodied in the courtesan Clarimonde, who, like the Mona Lisa, is a figure from the Renaissance. In a kind of metempsychosis or transmigration of souls she takes on a morbid pseudo-life in a dead body and endangers the soul of the beholder. 'That woman was an angel or a demon.' She stands physically quite close to the narrator, but always remains 'on the other side of the balustrade', as though Gautier were speaking of a figure behind a picture frame.

The new cult of beauty formed part of an evil religion in which all prohibitions were defied. The viewers felt disturbed and empty when they woke from this dream in which, before and afterwards, they were left alone. Hence the horror inspired by a fiction. Whether *Mona Lisa* or *Venus de Milo*, they were only metamorphoses of an obsession that lacked a body and therefore continually reappeared in different bodies. Ingres, too, was still painting the imaginary Venus, a subject that was only a beautiful way of clothing an idea.

In the Louvre Gautier wondered what the mutilated statue of the *Venus de Milo* (illus. 11) originally held in her arms. Was it the apple awarded to her by the Trojan, Paris? That might explain her 'almost ironical smile', expressing satisfaction at her victory over the other goddesses.

48 Joseph-Arnold Demannez, Engraving of *Leda*, frontispiece to Théophile Gautier (with Arsène Houssaye and Paul de Saint-Victor), *Les Dieux et les demi-dieux de la peinture* (Paris, 1863).

When, in July 1871, he described the removal of the statue to a place of safety during the Prussian siege, the goddess takes on a secret life. The author still trembles at the mere thought that this 'most perfect embodiment of the eternal feminine' might have suffered injury. The reader feels her presence when the rescued goddess welcomed her liberators with a 'smile of irresistible charm, never seen on modern lips'. Were the lips of the *Mona Lisa* modern? They were indeed, because Leonardo 'is the greatest modern master', as Arsène Houssaye declared in his biography, published in 1869. Modern in what sense? The late nineteenth century identified strongly with Leonardo the scientist who had penetrated the secrets of anatomy and geology, but who seemed in his paintings to have also understood that last remaining mystery, the soul. 'Leonardo', Houssaye insisted, 'created modern beauty in the radiance of body and soul'.

Gautier's Louvre essay of February 1849 celebrates the intimate looks of Leonardo's figures, whom he suspects of forbidden thoughts. 'These Virgins, infant Christs and angels have the faked innocence of the Sphinx.' There is as yet no mention of the *Mona Lisa*, but in Gautier's 1858 essay on Leonardo she takes on the personality with which we have become familiar. The mysterious mockery that plays about her knowing mouth intimidates the viewer, and the feeling of 'perhaps having known her in a previous life' prompts the alarming memory that 'three hundred years ago she met your declaration of love with the mocking smile that is still on her lips today'. The painting's presence creates the hallucination of a return to the Renaissance. But this is accompanied by

49 Paul Baudry, *Leda*, 1857, oil on canvas. Private collection.

images from the unconscious – 'Images that we have previously seen pass before our eyes', and as they confront 'the Leonardo faces, which seem to come from higher regions, it is as if they were reflected in a glass'. In this mirror, the image of the Gioconda is 'mysteriously fixed for ever as in a daguerrotype'. This simile is ambiguous enough, as though the magical person had imprinted herself in the memory as onto a photographic plate. The writer now liberates the person from the work, now turns the work into a person.

Gautier reprinted this essay in the book he published together with Arsène Houssaye and Paul de Saint-Victor under the title *Les Dieux et les demi-dieux de la peinture*. If there are still any gods in painting, they are now the painters themselves. 'They were all searching for the perfect formula of beauty', but even the twelve 'Olympians' presented in the book 'found only a single aspect of the ideal'. Delacroix, who sits with nine 'demigods' on the steps to the throne of the 'gods', was the only one who had 'the modern *passion* to give his soul to painting'. In the fancy frontispiece engraving, Leonardo's Leda unexpectedly smiles at us with the Mona Lisa's smile, instead of lowering her eyes, as she does in the lost Leda picture (illus. 48). Where we no longer have a reference to a concrete work, an imaginary person takes its place.

Only in passing does the chapter on Leonardo mention that 'Baudry gave something of this seductive smile to his own *Leda*, which attracted much attention in the Salon' (illus. 49). In the Salon of 1857, as Edmond About was to write, the artist was 'showered with gold, just to

paint his *Leda* again'. In his picture a coquettish Leda, with the swan nestling against her thigh, openly seeks to seduce the viewer. The ideal had lost its innocence, and the literati let themselves be seduced by its contemporary manifestations, even when, as here, they sank to the level of popular eroticism. In Gautier's book the Gioconda–Leda frontispiece, elusive as an image from a dream, heads the procession of beauties portrayed in art. They each embody an aesthetic ideal of femininity, filtered through the personalities of the painters who gave the ideal a historical existence. It is as if we were encountering the same person in a succession of different guises – as portraits, but also as Madonnas and mythological figures. The engraver has reduced the varying faces all to the same size, as if they were to act as a kind of identifying image, expressing each painter's personal ideal of art.

Writing a guide to the Louvre in 1867, Gautier confessed: 'My love for the divine *Mona Lisa* is not newly conceived, and many a passion for a living woman has been of shorter duration.' He reprinted his earlier text 'even though it is perhaps somewhat enthusiastic. Since then I have seen that *Joconde*, who is so worthy of adoration, many times… She is still there, smiling … at her innumerable lovers. Her brow has the happy serenity of a woman who is certain of remaining beautiful for ever and of feeling herself superior to the ideal of all poets and painters.' There it is again, the mask of the absolute. But for the public at large the writers were conjuring up *art* in the form of a female *doppelgänger*. While some looked to art for spiritual salvation, others used it as a therapy or an erotic drug.

Early in *Les Fleurs du mal* there is a poem 'Les Phares' (no. VI) that anticipates Gautier's *Les Dieux et les demi-dieux*. The 'lighthouses' or 'beacons' of the title are eight painters and sculptors who have illuminated modern poetry. The poem opens with Rubens and Leonardo, while Goya and Delacroix bring up the rear. Their art reflects a thousandfold search for beauty, multiplied by the 'echo repeated by a thousand labyrinths'. This is mankind's only means of bearing witness to eternally fleeting beauty. It is like a 'passionate sobbing that rolls on from age to age, dying on the shore of [God's] eternity'. As an enigma, beauty becomes the 'divine opium' for mankind. Even if people believed in the truth of the pictures, they were in fact seeing their own mirrors. So Baudelaire (in James McGowan's translation) polishes his own mirror in order to capture Leonardo's image in it:

Leonardo, a mirror, sombre and profound,
Where charming angels with ingratiating smiles
Burdened with mystery, are seen within the shades
Of glaciers and of pines that border the terrain.

Though Baudelaire was the partisan of modern life, he also was a dreamer who looked into the abyss of his soul. In an essay on Gautier, he observed that in his friend 'the exclusive love of beauty' was becoming an '*idée fixe*'. In his novels Gautier created a 'painting, a reverie pursued with a painter's obstinacy …'. When the text was about to be reprinted, Baudelaire asked the aging Victor Hugo to write a preface for it. The great Romantic writer complied, but expressed one reservation: *No*, he had never believed in either pure art or perfect art. One could only continue to produce new art, and he therefore unreservedly supported the progress of art just as others acclaimed the progress of mankind. Hugo thus resisted the dangerous ambivalence of Baudelaire's modernity.

CULTURE AS A DREAM

It was not Théophile Gautier but Walter Pater who completed the vision of Leonardo's masterpiece that was to become fixed in everyone's mind. Pater, who published his well-known essay on Leonardo in 1869, the same year in which Houssaye wrote his biography of the painter, had rejected a career in the Church because his religion was the aesthetic ideal, and he proclaimed the Renaissance as a golden age of pagan beauty. In this he did not always see eye to eye with the English Pre-Raphaelite poets and artists, who venerated the Middle Ages. Within that group, though, Dante Gabriel Rossetti, a painter in his poetry too, had portrayed not only chaste Madonnas but also sensual paraphrases of Leonardo in the guise of a *Monna Vanna* and a *Monna Pomona*. The 'Sonnets on Pictures', in which Rossetti pays homage to acclaimed masterpieces of art as though they were living persons, include verses on Leonardo's *Madonna of the Rocks*, where the poet asks 'Our Lady' whether the sea in the distance is the 'infinite imminent Eternity' towards which human souls struggle through the rocky landscape. The contradiction existing between the Madonna and the mystery of the work is repeated in the religious *topos* of a prayer that, however, remains mere surface. The name of God at the end of the poem dies away like a muffled echo 'in the dark avenue / Amid the bitterness of things occult'.

Pater also produced mental images, not mere descriptions of actual

works; in fact, 'art literature' could not enthuse about *art* without addressing it as if embodied in a *person*. In 1894 the young Hugo von Hofmannsthal characterized Pater as follows: 'We are all, in one way or another, in love with a past which is stylized, perceived through the medium of the arts. This is aestheticism, a grand and celebrated word in England … and as dangerous as opium.' And he continues: 'Aesthetic people who live by imagination and for imagination, whose very being is rooted in what is individually beautiful' always want to be artists themselves. Being an artist became *the* new way of life, just as the visual arts developed into the leading aesthetic currency. As W. B. Yeats recalled, Oscar Wilde, who himself appeared to Yeats to be a figure reincarnated from the Renaissance, described Pater's writings as 'a golden book'.

Otto Jahn's biography of Winckelmann inspired the young Pater with the idea that he should become an English Winckelmann, but rather than writing about antiquity Pater chose the Renaissance as his subject. In his famous collection of essays, *The Renaissance* (1873), the art of that time was not presented as irretrievably 'lost art', because Pater believed he could reincarnate it by his literary conjuration. In a reminiscence of Gautier's book on the gods of painting, Pater used an adapted Leonardo drawing as the frontispiece for his studies on the Renaissance (illus. 50). The bisexuality of this enigmatic head suggested an ambiguity in which any record of a historical work was suspended. As a consequence, works created the illusion of mysterious beings, with whom Pater narcissistically fell in love.

Pater's description of the *Mona Lisa* ushered in a new view of the Renaissance. If one were to place the painting 'for a moment beside one of those white Greek goddesses or beautiful women of antiquity, how would they be troubled by this beauty, into which the soul with all its maladies has passed!'. Such a perception of the picture immediately attracted the empathy of people in a modern age that had grown sickly and *énervé*. The old work was not merely the portrait of a Florentine lady: 'From childhood we see this image defining itself on the fabric of [Leonardo's] dreams'. This, then, was 'his ideal lady, embodied and beheld at last. What was the relationship of a living Florentine to this creature of his thought? … Present from the first in Leonardo's imagination … she is found present at last in *Il Giocondo's* house.' This idea gave Freud the impetus for a famous interpretation (see p. 152). Pater for his part was using the idea to solve the puzzle of how to transform a work into a living soul. Reanimating a work of art became the obsession of the age.

50 Frontispiece vignette
after Leonardo from Walter
Pater's *Studies in the History
of the Renaissance*.

But there was also a dream of humanity, as it was embodied in art. A masterpiece led a supra-temporal existence. Thus Pater saw in 'the unfathomable smile, always with a touch of something sinister' an expression of the whole life of culture. Just as the smile came from far away, so it also had an effect far beyond its own time, being both refined and corrupted by the progress of culture, but not perishing along with the Renaissance. Here was proof that even in modern times culture had a rightful place, so long as its aesthetic creed was guaranteed. The *Mona Lisa* represented culture itself. 'She is older than the rocks among which she sits; like the vampire, she has … learned the secrets of the grave … and, as Leda, was the mother of Helen of Troy, and, as St Anne, the mother of Mary. The fancy of a perpetual life, sweeping together ten thousand experiences, is an old one.' For this supra-temporal experience modern philosophy conceived the 'idea of humanity' as 'summing up in itself all modes of thought and life. Certainly Lady Lisa might stand as the embodiment of the old fancy, the symbol of the modern idea.' This interpretation itself calls for interpretation. Pater, in fact, was speaking of an eternal cycle of metamorphoses in which the mystery of art renewed itself.

In those same years Nietzsche was immersed in his dream of culture – of a culture that had once existed and might one day return. He sought liberation from the scientific spirit of the age in art, which he saw as the 'highest mission and truly metaphysical activity of this life'.

The medium that most attracted him, however, was not painting but music. Accordingly he dedicated *Die Geburt der Tragödie aus dem Geiste der Musik* (The Birth of Tragedy from the Spirit of Music, 1872) to Wagner. But his aesthetic creed was similar to Pater's, perhaps heightened by the contrast with his own classical background and by his more vehement temperament. The Dionysian confession in itself prevented any superficial aestheticism. And yet the dream of culture is present once again when, at the very end, readers are urged to imagine themselves 'if only in their dreams, back in an ancient Hellenic existence'.

'The beautiful illusion of the dream worlds, in the creation of which every man is a consummate artist, is the precondition of all visual art.' It is drawn across reality like a veil, to hide and suppress it. This 'beautiful illusion' also dissolves the solid surface of the art-work that for him is more a vision than a picture–object. If it 'lives', it must have taken possession of the life of a person, i.e., its creator. But Nietzsche retained some reservations about the static images produced by painting. He argued that the theatre differs from the 'vision of the painter only in that the life and action depicted continue through time'. This is why the French writers who describe paintings in a museum attempt to stage them by their vivid speech and thus testify to the modern *culture of the gaze.*

Nietzsche was by no means unaware of the art scene in Paris, and he later spoke of Wagner's betrayal of French Romanticism when he 'became *reichsdeutsch*... As far as Germany extends it *ruins* culture', he wrote in *Ecce Homo*. In the same work he also identified Baudelaire as that 'typical *décadent* in whom an entire race of artists recognized themselves'. 'As an *artist* one has no home in Europe except in Paris.' Only in Paris does one find the 'psychological morbidity', the 'passion in formalism' and 'artists such as Delacroix, such as Berlioz, with a *fond* of sickness, of incurability in their nature, sheer fanatics of *expression*'. This was a view from afar. What would have been Nietzsche's observations at close range, if, like Heinrich Heine, he had actually lived for a time in Paris?

FREUD'S LEONARDO

When Freud invented his own Leonardo in a famous essay of 1910, he did what many had done before him. What was remarkable, though, was that this was a scientific text, in which he was testing psychoanalysis by writing a biography. But there were problems with the sources he used, and various commentators have pointed out his errors in the interpretation of symbols. All the same, Freud's investigation into the enigma of the artist, in

other words the mystery of creativity, still merits attention. The same theme also underlies Dmitry Merezhkovsky's biographical novel *Leonardo da Vinci*, which Freud acknowledged as his main source. The myth of genius and the myth of a picture 'were like two mirrors that reflected each other to infinity'. It was perhaps wisest not to look into the mystery at all. Because of the prevailing fascination with androgyny, there was a tendency to see the painted woman's smile as reflecting the narcissism of an artist with homosexual leanings. Merezhkovsky thought he saw 'Leonardo's own smile' on the face of the master's 'female *doppelgänger*'. Paul Valéry, who felt that the topic was descending into farce, noted in 1906 that what the Gioconda 'says to us through her smile is: I am thinking of nothing. Leonardo is doing my thinking for me' (*Cahiers*, II, p. 429).

Merezhkovsky gave free rein to his imagination in his attempt to portray the drama of art and life through the relationship of the artist with his model. His Leonardo starts to ask himself whether the Florentine lady is 'a woman full of life or a being formed in his mind, the reflection of his own soul in the mirror of female beauty'. The picture remains uncompleted because of the woman's death. The artist has to admit to himself 'that he had robbed the living woman of her life in order to give it to a dead one' whom he has made immortal in the work. Sacrificing the model is the price that has been paid for the 'mystery of creation'.

Freud, however, takes the smile to be a childhood memory of Leonardo's, as he indicates in the title of his text. Leonardo's unmarried mother, from whom he was taken at an early age, owned 'the mysterious smile … that he had lost and that fascinated him so much when he found it again in the Florentine lady'. When he encountered the smile again 'he had for long been under the dominance of an inhibition … and strove to reproduce the smile with his brush', instead of falling in love with this woman who reawakened the image of his young mother from his unconscious. In starting out from the smile by which he himself was fascinated, Freud was following a line of argument that was possibly a modern trap. He was also probably on a false track in assuming that the smile appeared for the first time in the *Mona Lisa*. But this smile, which recurs so often in Leonardo's figures, may have been more than just a trademark or a device to simulate a living person. It may well represent a memory that found its way into Leonardo's pictures.

Georges Didi-Huberman criticized Freud's analysis of the picture on strictly psychoanalytical grounds, accusing him of having fallen below his own standards and, in his fascination, overlooked the 'tautology' that is present in everything visible. One might listen to a patient,

but one should not take what he says literally; Freud did take the picture literally, and swallowed the bait of the substantiated smile. It is true that Freud's description of the picture reveals little of what is actually to be seen in it. 'Anyone who thinks of Leonardo's paintings will be reminded of a remarkable smile, at once fascinating and puzzling … it has become a mark of his style and is commonly called "Leonardesque".….The need for a deeper reason behind the attraction of La Gioconda's smile, which so moved the artist that he was never again free from it, has been felt by more than one of his biographers.' But it was not enough to give the smile a name, calling it Caterina after Leonardo's mother. Freud's text fails to solve the problem of how the fascination with such a work comes about and how one can interpret this fascination without avoiding the need for a direct confession from the artist, as though he had bared his soul to the viewer. As soon as the viewers begin to ask themselves what it is that they really see there, they become analysts who need to analyse themselves. Freud, too, could have asked himself what it was about this picture that so fascinated his contemporaries.

Freud's monograph marks a watershed in the history of the reception of the work. It still reflects the nineteenth century's conception of the work of art, in that it relates Leonardo's picture to a person. On the other hand, Freud's identification of this person with the person of the artist who created the work takes place in a context of scientific enquiry. But here too he is still following an old trail, for he sees the work as reflecting its creator. In the artist's psyche he identifies an automatism that puts an end to the enigma of the individual. His cultural tradition led Freud to relate the painted work to an individual whose personality, with all its strengths and weaknesses 'lives in it'. Without Gautier and Pater it would not have been possible for Freud to examine the *Mona Lisa* in this way. After all, he saw in it again the person whom modern interpreters had invented. Individualism thus celebrated itself when looking into the auratic mirror of the personalized 'work'. But the heyday of such works was coming to an end at the very time when Freud was writing his book. The collective myths of the new avant-garde no longer tolerated the personal work, but only called for abstract and collective artistic ideals. There was therefore much mockery of the falsified person in the *Mona Lisa*, who was now seen only as a fetish of historical culture. The painting now attracted strong hostility (see p. 273).

7 In the Labyrinth of Modernity

There are some people who, when visiting the Louvre, look briefly at numerous works and then 'go and stand, lost in reverie, before a Titian or a Raphael, one of those that are most widely known through engravings. Then they leave, satisfied, and many a one will say to himself: I do know my museum.' This is the opening of Baudelaire's *The Painter of Modern Life* (*Le Peintre de la vie moderne*, 1863), and he mentions the masterpieces only in order to contrast their effect on visitors to works of the present day. They represent 'general beauty', or a classicism in which the present is effaced. Baudelaire, however, championed the painting of contemporary life, one that possessed a new kind of beauty and conveyed that sense of complete presence found only in the present, in the ever-changing life of the here and now.

Many commentators have wondered why Baudelaire chose Constantin Guys, whose drawings had the character of reportage, as the subject for his book about the 'painter of modern life'. He had only got to know Guys after completing his report on the Salon of 1859. Soon he was buying various drawings from him that were appearing in current issues of *The Illustrated London News*. But besides being attracted by the themes taken from urban life, Baudelaire was won over by the medium. These rapidly executed drawings, like a kind of shorthand dictated by a gaze of dispassionate curiosity, were utterly different from the prize-winning paintings in the Salon. Here the city triumphed over the museum, and temporality vanquished the eternity of art. The drawings were not even signed, and Baudelaire is said to have respected the 'eccentric wish' of Monsieur G. that he treat him as an anonymous chronicler. So Baudelaire here presented a type of artist that was in direct opposition to the idea of the genius. If artists hitherto had represented an imaginary world, Monsieur G. was a man who knew his way around in the real one.

By placing 'civilization' above nature, Baudelaire made modernism triumph over classicism. The depiction of nature had always promoted a timeless ideal of art. Now that was finally over. Life could be captured in

terms of urban society in three variants: the 'military, the elegant and the galant life'. The artist, an incarnation of the dandy, was a covert aristo, who affected a coldly arrogant stance to shield him from the triviality of what he depicted in his work. The lithograph was the medium best suited to the 'vast encyclopaedia of modern life', while the very concept of a slowly painted work was incompatible with the fleeting moment.

Baudelaire's ideal of beauty bound to a specific period was based on the notion of fashion, through which every age represents itself. Fashion is also the symbol of civilization, just as the female body is the symbol of nature. Baudelaire therefore saw no reason why art should always show nudes, as though these women existed outside time. Who, seeing an elegantly dressed woman, would not receive a single, indivisible impression of beauty? Clothing is part of the nature of a woman, just as the times are part of the ideal of beauty. Art changes its style just as a woman changes her clothes. Make-up is also preferred to unadorned nature. 'Face-painting', like the masks of so-called savages, is simply a way of enforcing nature via an effect of novelty and dynamism.

This whole-hearted defence of the present favoured a kind of historicism, which recognizes history as unrepeatable. What we deem historical was, at the time, simply 'today', the here and now, just as our own today is nothing more than history in its latest manifestation. The historical ideal of beauty becomes visible in the illustrations accompanying Gautier's *Gods and Demigods of Painting* (see p. 147). They all show a woman, but a different woman each time. It is Venus reappearing in ever new incarnations: Correggio paints her as a nymph, Leonardo as Leda and Raphael as a muse. Even Rembrandt found his ideal, as Gautier puts it, when he painted Venus as a Dutchwoman. Historical beauty is the face of a particular age, with which the eternal Venus, the symbol of art, looks at us. But the face of the age is always filtered through the artist's individual temperament.

Some years earlier, in his account of the Salon of 1846, Baudelaire had rejected the 'absolute ideal' as 'an absurdity'. 'In nature … I see only individuals. So the ideal is not … that tedious dream floating on the ceilings of the academies. An ideal is the individual as reconstructed by the artist.' The individual was a newly acquired value that no one was subsequently willing to abandon; hence there was an inclination to turn away from the universal ideal as cherished by the past. The same Salon report therefore included a chapter on the 'Heroism of Modern Life', in which Baudelaire defended the claims of the present. 'One can say with certainty that since all centuries … have had their beauty, we necessarily

have ours.' Against the 'abstraction' of 'absolute beauty' he held up transient 'modern beauty'.

Almost twenty years later, in *The Painter of Modern Life*, it is the artist Monsieur G. who ceaselessly studies, observes and captures what he sees: 'What is he really looking for? He is looking for that something which I may be permitted to call modernity' (*modernité*). There is the key word. 'Modernity' as a concept expressed a new view of the world. People wanted not only to be *modern*, they perceived their own period as an ideal, which would necessarily be as 'transitory' as the fleeting present. Modernity now produced its own antiquity, which was simply the modernity of yesterday; since modernity insists on being ever new, it must constantly reinvent itself and identify with whatever is there at the time.

But why does Monsieur G. search for modernity if it is already there? He wants, very much like Baudelaire, to create art, and therefore he breathlessly follows the fleeting traces of 'modern beauty', 'however incidentally it may prove, and however rapidly its metamorphoses may succeed one another'. It is thus a truly sisyphean task to seize hold of something that continually slips away, and yet *modernity* only deserves to be remembered when it has become a subject of *modern art*. As such it acquires its 'originality' only 'from the imprint of the age on our perceptions'. Here Baudelaire has set up a paradox, as his type of artist is very much *in* the world and yet watches it as an outsider. 'In short, if any modernity is to be worthy of becoming antiquity, we must extract from it the mysterious beauty with which human life has endowed it.'

Baudelaire, however, was far from happy with his radical 'today'. His *Salon of 1846* had already registered the cancerous doubt that was spreading through the art world. In his report on the International Exhibition of 1855 he deplored progress as the 'fashionable error' that, 'like a modern lantern, plunges into darkness' everything in art that fails to fall within the range of its light. But progress is an immutable law of civilization, and its oxygen is change itself. Only memory can pull free from the headlong dash of the present, and the next paragraph is accordingly devoted to the 'art of memory'. If the present is not to vanish without trace it needs to be remembered by art. The function of art is to capture the present and transform it into memory. In this it reflects the dualism that is present in human nature.

Baudelaire's concept of modernity resulted in a contradictory concept of the work that was to cause trouble. The work had two aspects that were difficult to reconcile: the museum picture which represented *art*, and the contemporary subject which represented *modernity*.

157

Baudelaire was constantly seeking compromises to avoid this conflict, and in Guys he also promoted a painter who worked in other media. But despite everything, the museum did provide the visual arts with, as Baudelaire saw it, a temple of memory. Timeless art cannot be intended by the artist in advance, because he can only work in the present. But the aura that burdens the concept of the work is accorded only to art that becomes detached, as time passes, from the merely contemporary. In Paris the opposition between city and museum, between modernity and art, was a perennial issue. Manet, an avid reader of Baudelaire, developed an astonishing virtuosity in maintaining a balance between tradition and the world in which he lived, between painting and subject-matter. In Courbet, on the other hand, the contradiction between the museum work, triumphantly exemplified by the Old Masters, and a contemporary perception, was deliberately pushed to the limit.

COURBET AND PAINTING AS 'REAL ALLEGORY'

Baudelaire's defence of civilization was different from Courbet's art, which deals with the conflict between nature and civilization. Here only nature has authority, an authority that Courbet was prepared to defend against all inauthentic conventions. The nude model standing casually in the centre of *The Painter's Studio*, her body depicted with unashamed directness, seems to be the living incarnation of actual nature (illus. 51). This real body triumphs over the generalized ideal of nature. Here is a subversive tactic to undermine the prevailing idealism of the masterpiece. Why have a unique composition, when reality is always inexhaustibly true? But art helps to see reality, a faculty that has become blunted. The seated artist at work in the middle of this large picture turns his back on the model because he is absorbed in painting a landscape, which, as the countryside, represents the exact opposite of the social group assembled in the studio.

Courbet wrote to Jules Champfleury that his aim here was 'to depict society, with its individual interests and passions'. But, unlike Baudelaire, he saw a corrupt society that he implicitly measured against an unspoilt ideal of nature. In the same letter he divided society into the art world and 'banal everyday life', in which there were only exploiters and the exploited. The artist in *The Painter's Studio* seems to be turning away from all these people in order to concentrate on pure nature. Courbet vehemently defended the finished work in an accompanying text, his 'manifesto of realism'. The term 'realism' was a battle-cry, but its

meaning was far from clear. The painter invoked it to dissociate himself from the 'idle goal of *l'art pour l'art*'. He did not want to disavow his 'individuality as an artist' but to use it 'to translate into art the habits and conditions, even the mentality, of my own time, and thus to make living painting'. This sounds similar to Baudelaire, but it reflects a conception of modernity that does not shrink from social criticism. This is far from the neutral, dispassionate gaze of Baudelaire's Monsieur G.

The committee of the International Exhibition of 1855 had originally invited Courbet to participate. But this came to nothing because of their intention to censor the submissions, which Courbet flatly rejected, convinced that he was the only painter who could give a truthful representation of society. He was unwilling to make propaganda for Napoleon III and his state, seeing himself as the educator of a new society: his whole *œuvre* was to fulfil the age-old aspiration of the masterpiece, that of establishing an aesthetic and moral norm. His project for the year of the International Exhibition, the huge canvas of *The Painter's Studio*, measuring 3.59 x 5.98 metres, was an attempt at a bold revision of the traditional masterpiece, one that embodied a new programme of art. Predictably, it was rejected, although – and this is often forgotten –

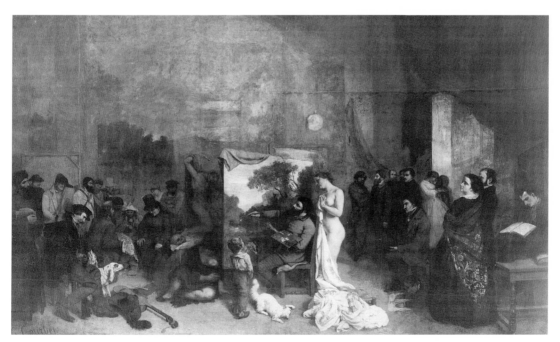

51 Gustave Courbet, *The Painter's Studio: A Real Allegory*, 1855, oil on canvas. Musée d'Orsay, Paris.

the jury accepted a large number of other pictures by Courbet. This provoked him to attack 'the whole institution of exhibitions as such', and in a revolutionary gesture he displayed his own works in a pavilion he erected opposite the exhibition ground, prominently emblazoned with the words 'Le Réalisme'. This term, with its political component, proclaimed a new movement in art that Courbet intended to inaugurate all by himself.

Since it was difficult to explain what realism was, Courbet created a painting that positively cried out for explanation. Even the elderly Delacroix was deeply impressed, although, as he recorded in his diary, he was perplexed by the picture's 'ambiguity'. He considered it 'one of the most unusual works of our day' and did not hesitate to call it a 'master-piece'. There is ambiguity in the very fact that the picture presents itself as an allegory, which is not to be expected from realism. 'It looks as if there were a real sky in the middle of the picture,' Delacroix noted. The sky is part of the radiant landscape that stands propped on the easel in the middle of the vast, gloomy studio, a picture within a picture. A landscape that is not painted in the studio is itself an allegory of nature. But above all, landscape was *the* modern subject of art. So the easel painting stands like art's self-quotation at the centre of this contradictory masterpiece.

The model in *The Painter's Studio*, who has dropped the trappings of civilization, is an allegory of a particular kind (illus. 52). The female nude had always embodied the ideal of art, which a painter had, as it were, extracted from it. Remembering the long tradition of paintings of artists' studios, one is struck by the oddity that here the woman stands, ignored, behind the painter and does not figure in his picture. And yet Courbet paints her *for us*, which significantly alters her rôle. The merely incidental glance that we bestow on her reduces her to a fragment of unembellished nature. Her awkward stance, which expresses her embar-rassment at the *un*natural prostitution of her body for art, speaks against any false idealism.

The two paradoxes of the landscape and the nude are part of this picture's rebellion against classical history painting and hence against the traditional masterpiece. Courbet crowds his picture with a large cast of people, enough to put on a major play. But they wait in vain for their entrances, while on the easel a landscape is taking shape in which none of them appears. This contradiction makes us understand that in real life too, Courbet's contemporaries could no longer unite in an ensemble performance. It was no longer possible for society to share a common ideal that could serve as the single theme of a painted morality. On the

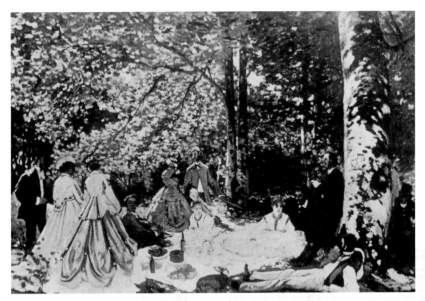

54 Claude Monet, *Study for 'Le Déjeuner sur l'herbe'*, 1865, oil on canvas. Pushkin Museum, Moscow.

the monumental canvas to a painted wallpaper. While he was still struggling with it, Monet remarked in a letter, 'If I were to fail with this painting, I think I should go mad. Everyone knows I am working on it.' After a year he admitted defeat and gave the unfinished work to a creditor, who left it to moulder in his cellar for twenty years. It was not until 1884 that the painter retrieved it; he then cut up the canvas and hung the central portion in his studio (illus. 55). Fostering his own myth, he liked to imagine in his old age that he had, with an early masterpiece, ushered in a different kind of modernism, that of Impressionism, as sensationally as Manet had done with his *Déjeuner*.

In Manet's painting the landscape forms a flat backdrop to the three seated figures. But the trio, idealized with only a hint of irony, turns the landscape into a modern Arcadia. While contemporary painters demythologized nature and banished the classical nymphs from it, Manet deliberately suspended that process. The Goncourts, in their novel *Manette Salomon* (1866), make the painter Crescent discover nature only 'in the banal, vulgar and despised suburbs of the big city'. Manet had a different aim: his use of landscape was intended as an undisguised revision of the history of art. In setting his stage, he took the liberty of indicating the depth of the woodland glade by means of the woman bathing in the stream, while making her too large for a figure placed at that distance. In

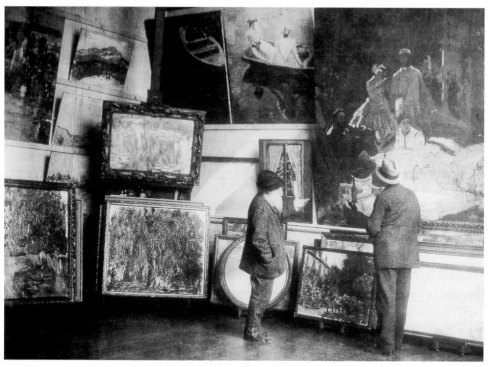

55 Claude Monet in his studio, a photograph taken in 1920.

the foreground a classical still-life leads into the picture: the clothes are draped not over the seated female but around an invitingly open basket of food.

These garments lying on the ground alter our view of the woman, whose nakedness they emphasise: the nymphs in the *Concert champêtre*, to whom she is an ironical allusion, cannot undress, as they are part of nature. Contemporary observers were quick to react with indignation (or amusement) to this indecent situation. This could only be a prostitute impudently taking the place of the former nymph. Here Manet also undressed a motif from the history of art, exposing it in a shocking manner, in order to turn it back into unvarnished nature. The two dandies show complete indifference to the woman's nakedness, which makes her appear still more exposed. Not only are they representatives of civilization in Baudelaire's sense, and thus the reverse of nature; since they were clearly painted from living models, this suggests that the woman too, sitting naked before us, must be based on fact.

But this produced further consternation. The woman in the picture stares at the viewer with the cold professionalism of the paid model in a

painter's studio. The male viewer of a picture normally had nothing to do with the artist's model, since he saw only a painted canvas, not a naked woman. So when, expecting an academic nude, he discovered the vulgarity of an actual body in which even the fold of the stomach was faithfully rendered, he felt as if he had been caught sneaking a glance at something forbidden. The public was taking a look behind the scenes of art, instead of being screened off from it. If a classical composition had really been performed in a *tableau vivant*, then the picture lost its innocence and became, in an unexpected way, as modern as nature (or reality) always is.

Once a viewer had understood this ploy, he was ready to take the next step and receive an ironical lesson in the history of art. For the three main figures are re-enacting a lost cartoon by the 'divine' Raphael, known in the form of an engraving by Marcantonio Raimondi. Manet had seen the engraving while visiting Degas, and Delacroix probably reflected the prevailing opinion when he wrote in his Journal that unfortunately the new medium of photography was capable of reproducing nature far more faithfully. This released the engraving to become, once more, an allegory of art. Manet arranged his living models in the poses used by Raphael. But the poses had belonged to a subsidiary group in his composition, whose main subject was the beauty contest between the three goddesses, judged by Paris, prince of Troy. The subsidiary group consisted of two river gods, whom Manet for his *Déjeuner* dressed in modern city clothes, and a naiad, whom he left naked.

This clarifies Manet's ideas in his painted discourse. The beauty contest is taking place in the present day, not in antiquity between three goddesses. The modern viewer, as judge, has the choice between the classical nude (nature) and the contemporary dandy (civilization). The Judgement of Paris is located in the city of Paris, where, in the Salon, the artistic contest is decided. This is cunning enough, but Manet adds a final trump by alluding to a Raphael masterpiece that was only planned and never executed, as though, with this painting, he is carrying out Raphael's project – except, of course, that he is giving it a radically modern look.

Manet's *modernité* reaches its height when the act of painting puts itself on show, no longer hiding behind the illusion of the subject. Manet insisted on visible brushwork, thus exposing to view the medium and method in which art is achieved. In this there is also an element of polemic, for the argument did not leave the Old Masters unscathed. After all, they too had only painted on canvas, as Manet was now doing. So what was the difference that loomed so large in the bourgeois

conception of art? Here Manet agreed with Baudelaire, who saw art as an ever-changing fashion (see p. 157). He also accepted what his new admirer, Emile Zola, praised in his work as the pure act of painting, even though the latter paid too little attention to the subject. Zola expected the public to look at the *Déjeuner* only 'as is proper for a true work of art', namely as a miracle of colour in which even the woman in the background merely 'forms a wonderful white patch'.

THE CONTROVERSY OVER *OLYMPIA*

The controversy unleashed by Manet's *Olympia* was in fact more about the rôle of art than about the subject-matter (illus. 56). The young Zola, replying to its many critics, argued that in this masterpiece Manet had found the purest expression of his art. 'Yes, I said "masterpiece", and will not retract that word.' Zola's essay was quickly republished as an independent pamphlet, in which *Olympia* is the only work reproduced. As an expression of gratitude Manet painted the writer's portrait, signing the large picture by way of including the title-page of Zola's pamphlet. Clearly Manet had come to like Zola's interpretation. While insisting on the truth of the frivolous motif, Zola also stressed that the picture represented an 'analysis' of art itself.

Olympia was painted in the same year as the *Déjeuner* but only submitted to the Salon in 1865, upon which, unexpectedly, it was accepted. Manet was promptly subjected to a hail of insults. Even fellow artists like the young Cézanne soon engaged critically with the work. When Manet died the picture was still in his studio. A subscription fund was organized to save it for a public collection in Paris and to offer it to the Musée de Luxembourg, the Louvre's waiting-room. There Paul Gauguin copied it in 1891 before leaving for Tahiti, and exhibited the copy in Paris two years later, exactly ten years after Manet's death, as a reminder that it was time for the original to be admitted to the Louvre. But it was only in 1907 and through the personal intervention of Georges Clemenceau that *Olympia* arrived there, where it was hung next to Ingres' *Grande Odalisque* and provoked lively discussions in which Matisse also intervened. Gauguin's copy joined the private collection put together by Degas, who kept it on display in his studio until his death.

This is the bare outline of an unusual history, in which the work established itself as a myth. It is as if here for the first time *modernité* triumphed in a masterpiece that was in fact a deliberate denial of the old

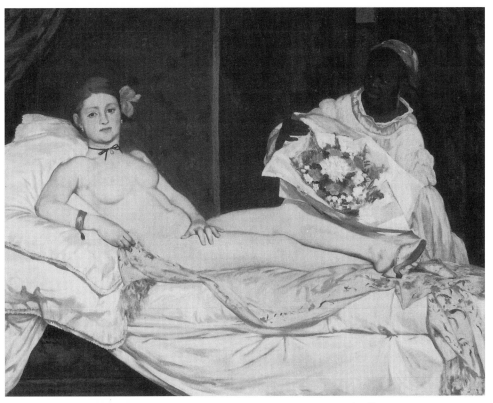

56 Edouard Manet, *Olympia*, 1863, oil on canvas. Musée d'Orsay, Paris.

masterpiece. This ambivalence was part of the strategy of the work itself. It was a renewed encounter with Titian's famous *Venus*, the epitome of a classical beauty represented in art – Manet had himself copied that painting – and yet she was hardly recognizable any more. A young Parisian model, still wearing a slipper on one foot, lies stretched out naked on a bed in front of the viewer as if she had been photographed in that pose. It was, in fact, the same model that Manet had used in the *Déjeuner*. Here again she adopted a familiar pose from the history of art, and again this changed into a concrete fact, as though art had given way to life.

The ambivalence of old and new is present in the very title, for 'Olympia' was a standard name for a Renaissance courtesan in historical novels, but many contemporary prostitutes also called themselves Olympia. So was this a prostitute posing as a courtesan, or had the historical courtesan now become merely a venal *grisette*? Manet was deliberately flouting a taboo when he blurred the boundary between culture and sexuality, between the noble cult of beauty and the vulgar satisfaction of

the senses. What took place may be expressed by the following scenario. A cultivated gentleman could, in principle, visit the museum in the morning and the brothel in the afternoon before going out in the evening and chatting about the museum, though not about the brothel. Now, in the Salon, he suddenly found himself confronted by the brothel – indeed, it was as if he himself were in the picture, as an unseen visitor, with the dark-skinned servant-girl bringing in the flowers that announce his arrival, and the cat hissing at him.

This could be dismissed as cheap provocation but for the allegorical hints that introduce art in its own right. There is, first of all, the unconcealed materiality of painting, which rivals the corporeality of the woman. There is a subtle interplay between the body of the canvas and the body of the *cocotte*, and no polished illusion cancels out this polarity. Contemporary critics found fault with the 'crude' painting that undermined the sensuality of the motif by having its own sensual reality. The seductiveness of the painted woman, which made the viewer into a voyeur, would probably have been heightened by the sophisticated creation of an illusion (see illus. 57). But Manet put on view not only the real body but also the actual painting. This is a confusing double strategy that invites the following conclusion. Just as the woman sells herself in the boudoir, so the painter sells himself in the Salon, for his picture too has a price and lays itself bare before a buyer. The model's appearance is soberly recorded; the seductiveness of the painting lies in the boldness of Manet's colours. However, this could be enjoyed only by a viewer looking at the picture in a 'modern' way.

But why am I reminded of a Venus when shown a prostitute? Why does she bear the name of a courtesan of Titian's day if that is not what she is? Why does the picture look similar to an old masterpiece but then go out of its way to show its dissimilarity? The solution is to be found in Baudelaire's *The Painter of Modern Life*, published in the same year that the picture was painted, and which Manet, as a friend of Baudelaire, very probably already knew. In the central chapter about the nature of *modernité* we indeed encounter a courtesan. If, writes Baudelaire, a painter 'paints a courtesan of our day and *takes his inspiration* (to use that hallowed word) from a courtesan painted by Titian, then he will almost certainly produce a work that is false, ambiguous and obscure. The study of a masterpiece of that day … will teach him neither the pose nor the look … nor the vital aspect of one of those creatures whom the dictionary of fashion has successively listed under the coarse or jocular designations of *impures*, kept women, *lorettes* or *biches*.' Here, at last, is the link we are looking for. And

this is Baudelaire's verdict: 'Woe betide him who seeks to study anything in antiquity but pure art' (*l'art pur*), for he will lose sight of the former modernity of the motif, which today, after all, contains 'the memory of the [then] present'. And Baudelaire continues: 'Nearly all of our originality derives from the imprint of *the age* on our perceptions.'

It almost seems as though Manet had wanted to set an example by fixing on the theme of Titian's courtesan but uncompromisingly locating that old motif in contemporary life. There were more modern subjects – for example, railway stations or pavement cafés – but Venus had always been the embodiment of a classical ideal, which Manet's vision brilliantly inverts. She speaks only through her body, but this body is now seen in a wholly modern way. By usurping what was once a timeless form, it becomes, in its unqualified *modernité*, all the more polemical. This looks like a response to Baudelaire's reference to the dualism of art. Beauty, Baudelaire had written, has both an unchanging and a changing face. Manet's conclusion is obvious. Art was a timeless pursuit, just as the masterpiece was. But the motif always belonged to its own time: it was the contemporary face of timeless art. In its subject, then, *Olympia* represented art, but in its *style* it stood for *modernité*. For the public, however, either art or modernity was placed in doubt when the viewer was expected to discover them both in one and the same picture. But the passage of time resolved the controversy. To quote Marcel Proust, it made 'the unbridgeable gulf between what [was] considered a masterpiece by

57 Alexandre Cabanel, *The Birth of Venus*, 1863, oil on canvas. Musée d'Orsay, Paris.

Ingres and what [was] supposed must for ever remain a "horror" (Manet's *Olympia*, for example) shrink until the two canvases seemed like twins'. Memory left the controversial painting inscribed in the annals of modernity. In the Louvre the picture became imbued with the kind of aura that Manet had wanted to banish from art.

As a myth it still fascinates writers like Michel Leiris, who praises it like the old pictures of Venus had been praised. The title of his book, *Le Ruban au col d'Olympia* refers to the ribbon Olympia wears around her throat, as though Leiris would like to undo it and so convince himself of the deceptive reality of this provocative body. Leiris takes up arms against time in an effort to rediscover the vitality in what has now become an old museum picture. After more than a century, he claimed, the young woman in the picture was still so young that one could dream at night of having seen her during the day. And yet she was the 'indescribable reflection of an absence' against which he was powerless, however loudly he might call for her, as his muse, to come to him. This seductive incarnation had never become a body but always remained a painting. Like the ribbon tied around a gift, the ribbon on the painted body, 'the last obstacle to complete nakedness', created the impression 'that Olympia exists'. A ridiculous detail like this was capable of arousing a man who was enough of a fetishist to look for sensual life in art.

THE MIRROR IN THE BAR

Manet, in his continuing fight against the dualism of art and life, finally produced the enigmatic *Bar at the Folies-Bergère*, which he signed in 1882, a year before his premature death (illus. 58). This picture marks a critical point in the lifelong struggle for redefining what it is that makes a work of art. The first thing one sees in the picture is a young barmaid patiently waiting for a customer. She would even be a main figure in the way that Olympia is if she were not a mere employee standing ready to serve an invisible patron (the viewer). And then there is the huge mirror, reflecting the world, or at any rate the world of the Parisian *beau monde*. It is impossible to see this mirror without recognizing the work itself, with the painted reflections of light dancing on its surface, as a mirror, and thus as ambiguous. Reflections usually are caught only fleetingly by a mirror: they do not settle in the glass forever. In Manet's painting, similarly, any lasting bond with a subject is, in principle, dissolved. The work itself becomes a mirror in which visible and as yet invisible motifs succeed one another like images in a mirror. Here is a new *modernité* ruthlessly under-

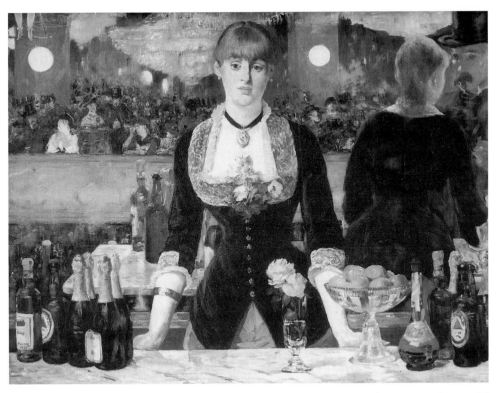

58 Edouard Manet, *A Bar at the Folies-Bergère*, 1881–2, oil on canvas. Courtauld Gallery, London.

mining the unchanging authority of a masterpiece. The subject becomes a momentary snapshot, but presented in the medium of an everlasting museum picture.

One is reminded of Zola's epic portrayal of the city of Paris, but there is also a subtle difference. Who could doubt that Manet's view encompasses the whole of Paris? But Zola attached great importance to characters, and these are absent here. The material body of the painting, too, which Zola in his novel *L'Oeuvre* (1885–6) so maliciously compares with a vulgar body of flesh and blood, is in Manet's painting reduced to mere reflections in a mirror. Zola seems to have been getting his own back on Manet when, two years after Manet's death, he made his novel's hero (whom most people, however, identified with Cézanne) fail in his final attempt at a masterpiece (see p. 131). Manet's last picture preserves a hint of the vehement dispute about art in which the two were engaged. But Manet's reputation as a painter was by now well-established, and the controversy over his *Olympia* was not repeated.

In this final masterpiece Manet was once again closer to Baudelaire than he ever was to Zola. The poet, long dead by this time, could never have foreseen how much his vision of the *vie moderne* would come to life in this great painting. Manet was 'the painter of modern life', even if, back in 1860, Baudelaire could not have anticipated this living incarnation of his idea. In that early text, to read the magnificent chapter about the women of Paris is to enter that phantasmagoric world that is still reflected in Manet's picture, as though the picture were a belated act of homage to the revered pioneer of *modernité*. Baudelaire even mentions the Folies-Bergère, the 'galleries full of light and movement', where multi-hued illumination 'imitating Bengal lights' provides the setting for an ever-changing panorama of beautiful women, some of easy virtue, whose favours are for sale. The Folies had changed since Baudelaire's day, and Manet faithfully recorded the change. But this 'gallery of Parisian life' was still the place where women gathered to attract the dandies' glances. There were also the women servants, of whom the poet says in his next chapter that their main characteristic is to have no characteristics. The barmaid in Manet's picture has this kind of professional presence, behind which she as a person withdraws. Even if for us she is a motif that suggests melancholy, she herself is probably not feeling melancholy. As Baudelaire says of a soubrette, she does not think – indeed, she receives her own image only from the crowd that washes past her and for whose benefit she shows herself. She exists 'rather to please the onlooker than for her own pleasure'. In the painting she makes an offer similar to the drinks and fruit on the marble-topped bar in front of her.

In this painted spectacle of life there is no room for psychology, for Manet is portraying the public. Its image is reflected by the mirror – a picture within a picture – behind the bar. This is no longer the private mirror in which female beauty contemplates itself, as in Manet's *Nana*. In the 1870s the painter had suddenly turned his attention to the pavements and cafés-concert in an attempt to seize '*la vie parisienne*' in fleeting glimpses. Here, in the *Bar at the Folies-Bergère* he captured that life in a mirror that shows, reflected in it, everything that lies before the blank gaze of the barmaid. Clouds of smoke ascend to the domed ceiling and the gas lamps spread a cold light – exactly as Guy de Maupassant described the place in *Bel Ami* in 1885. In this city atmosphere people exist only in the collective, unless they detach themselves from it by a look of chilly aloofness. *Modernité* is a show that never closes, and what we see in Manet's painted mirror is repeated every evening; there are no high points and no deeper meanings. A swift glance is sufficient to take

in this ambiance. The barmaid's lifeless gaze is a parody of the devotion that art had inspired for so long.

Did this mean that art had become a mirror which merely reflected whatever happened to pass before it? A mirror that could no longer capture a permanent image? But Manet's painted mirror did not work at all in the manner of real mirrors. The curious visitors who rushed to see his painting were, as Joris-Karl Huysmans wrote at the time, 'baffled by the deceptive image on the canvas'. If there was a mirror, they expected to see themselves reflected in it. Above all they were confused by the fact that the barmaid who stood facing them full on was reflected in the mirror behind her at an odd angle. There, she was turning to a customer approaching from the right, as though this was the next episode that cancelled the main view. They therefore concluded that Manet had made a mistake in his handling of the reflection. But there is method in the way that one's view into the mirror is refracted through an angle. A mirror constantly captures new images. A painting cannot do this, but it can perform like, or simulate, a mirror, in which the succeeding image is always imminent. So the twofold barmaid draws attention to the difference between a picture and a mirror: here, for once, the painting transcends its boundaries, incorporating the movement of time, the pulsating life taking place in front of the mirror.

The transformation of the picture into a mirror is, of course, a fiction that results in an ingenious paradox. It is precisely the contradiction between the work of art, frozen in time, and the stream of images passing before the mirror of the bar that reveals the metaphor. The time was long past when people were delighted by the analogy of a mirror and a painting. Manet stressed their dissimilarity in order to emphasize the dualism that, as with Baudelaire, was central to his conception of the work. He still used the ancient medium of painting, thus continuing the tradition of art despite his modernity, but he used it to represent not only a modern subject but also a modern way of looking, a look as dispassionate, mechanical and insatiable as the reflection in a mirror.

The 'transitory', as Baudelaire called it, can be incorporated into the work of art only in opposition to the medium. The museum picture forms the greatest possible contrast to the mirror, just as art forms the greatest possible contrast to the flow of modern life. When painting attempted to depict the world, it ceased to be the tranquil mirror it had once been. In the decade when Manet painted this picture, the movement in chronophotography, such as that of E. J. Muybridge, was already paving the way for film, which was to capture the images of modernity. Thus Manet's

metaphor is extraordinarily significant. The mirror is a static object that nevertheless catches the movement of the world. If, then, painting was to be regarded as a simile for a mirror – for it could never actually become a mirror – then this represented a call for a reconciliation between the old museum picture and the modern gaze on a new world.

8 Escape Routes to Freedom

THE ARTISTIC IDEAL BORROWED FROM JAPAN

In February 1888 a disappointed Van Gogh left Paris to start a new life in the south of France. A few days after his arrival at Arles he announced to his brother Theo that 'I feel as though I were in Japan' (Letter 469). This is an odd statement, unless 'Japan' was a way of speaking of utopia. Soon after this he expressed himself more clearly. The other artists – whom he simply called the Impressionists – should, he thought, continue to absorb the influence of Japanese painting. But 'why not go to Japan, that is to say to the equivalent of Japan, the South? I think that the future of the new art lies in the South. One's sight changes. You see things with Japanese eyes, you feel colour more certain' (Letter 500) – that is to say, uncorrupted and nature-like.

In Paris the new cult of Japonisme was at its height. Van Gogh begged his brother to add to their joint collection of Japanese woodcuts by buying more from Samuel Bing. He also asked about the periodical *Le Japon artistique*, in which Louis Gonse had just written on the 'Japanese genius for décor'. At Arles Van Gogh was reading, with growing wonderment, *Madame Chrysanthème* (1887) by the globetrotting Pierre Loti, who vividly described marvellously aesthetic houses in Japan, on whose walls not a single picture was to be seen. At the very time when Western-style oil painting was being introduced into Japan, the Japanese aesthetic caused a crisis in the West, for it was far too impressive to be ignored, and yet too alien to be easily assimilated. Van Gogh's abiding enthusiasm for the arts of Japan seems all the more surprising, as he had been forced to support himself in Paris by selling Japanese prints, while failing to sell his own work.

However, his daring attempt to 'translate' Japanese coloured prints into Western-style oil paintings was not merely a ploy to promote his work. Surrounded by the over-refined artistry of *décadence*, he was searching for a lost simplicity. There is something incantatory about the portrait in which Père Tanguy, the good-natured mentor of young artists, is depicted in front of a wall covered with Japanese woodcuts, as though he were trying to cast a spell over any viewer who still remained

59 Vincent van Gogh, *Père Tanguy*, 1887–8, oil on canvas. Private collection.

unconvinced (illus. 59). Here two artistic ideals are juxtaposed, with the prints forming a decorative background to the Western-style portrait. Following all the discussion in Paris about courtesans in art, it was hardly a coincidence that soon afterwards Van Gogh made a painting of a Japanese courtesan (illus. 60). Surprisingly, he wrote that he wanted actual Japanese art, 'decadent in its own country', to 'take root' in France (Letters 510 and 511). He can hardly have failed to realize that Japan had established a very different tradition, in which what appeared to be popular art also invaded the territory of 'high art'. Its alien motifs alone made irrelevant all Western genealogies of art, in which masterpieces played a significant rôle. Japonisme motifs could therefore be deployed in exuberant opposition to Western cultural authority. Van Gogh's picture, with tiny figures crossing a yellow bridge over a river in the rain, was a little Japanese dream captured in post-Impressionist oil painting; its subject-matter was of no great significance, but its colouring created a musical impression.

At Arles Van Gogh made no further attempts to use Japanese motifs, because nature itself sufficed as the subject if one looked at it

60 Vincent van Gogh,
Japonaiserie: Oiran, 1887,
oil on canvas. Rijksmuseum
Vincent van Gogh,
Amsterdam.

with the sensitivity of Japanese art (Letter 500). 'Here my life will become more and more like a Japanese painter's, living close to nature' (Letter 540). Could his brother not see that it is 'almost a true religion which these simple Japanese teach us, who live in nature as though they themselves were flowers?' (Letter 542). This was, of course, no more than a beautiful fantasy in the Dutchman's mind. But Van Gogh thought that his *feelings* were attuned to those of the Japanese when the colours of nature drew a musical echo from his soul, as if it were an instrument being played on. In letters to Theo he described his paintings only in terms of colours, one colour for each motif.

When Van Gogh included peasants in his work, he created figures based on prints after paintings by Jean-François Millet (1814–75), who, he considered, had known how to portray the rural working class. In July 1888 he was already planning to 'paint [Millet's] Sower in colour'. But he was still struggling to find a 'symbolic language' of colours so that the undertaking would not end up as mere 'metaphysical philosophy' (Letter 503). By November he was working on a sower at sunset, but the figure was not derived from Millet (illus. 61). Its powerful sense of movement

61 Vincent van Gogh, *Sower and Setting Sun*, 1888, oil on jute mounted on canvas. Collection E. G. Bührle, Zürich.

is underscored by the leaning tree-trunk, whose shoots, with calligraphic elegance, reach across the picture, just like the flowering tree in a Japanese print Van Gogh had copied in oils while in Paris. The whole composition, with this arboreal motif forming a bar across it, is reminiscent of that print, but here a surrounding landscape has been added. So there it is, the synthesis of Western ethos and oriental beauty. Behind the dark arrangement of sower and tree that foregrounds the picture, streams of colour flow melodically towards the 'immense citron-yellow disc' of the sun, as he wrote in a letter to Theo, enclosing a sketch (Letter 558a). He did not refer to it as a masterpiece, especially as even the large version, at 'size 30' (73.5 x 93 cm), was still relatively small, but he nevertheless hoped to impress Gauguin, who was then staying with him, by his cosmic treatment of the subject. So long as 'from time to time there's a canvas which will make a picture' (Letter 560), he would be satisfied with himself.

To the artists the Japanese style symbolized a new beginning, but to the general public it was a fashion for a sophisticated taste. Artists wanted to paint like French Japanese, and they were also starting to show

a leaning towards primitivism that in time developed into a radical enthusiasm for primitive art. Gauguin experienced the same sense of freedom in Brittany as Van Gogh did in Arles, but only a few years later he voyaged to the Pacific to escape from European civilization and live among beautiful 'savages' (see p. 192). The labels might change, but the impulse persisted to delve beneath modern civilization for the roots of art. European ideals of art were to be replaced by alternatives, through which a troubled modern culture hoped to regain its youth.

The public looked for its dream images in remote or imaginary places where the world was still beautiful. Around 1860 the vision of Japan gradually moved into the foreground, just as, around 1830, the dream of the Orient had replaced the ideal image of Greece. In their novel *Manette Salomon* (1866), the Goncourt brothers introduced both Orientalism and a fascination for things Japanese. The painter Coriolis had been successful in the Salons with his oriental subjects, but eventually we find him poring over albums of Japanese drawings, radiant with 'the daylight of a fairyland, filled with brightness and without any shadows'. He found 'in this natural art, so full of unaffected vitality' the springtime he so yearned for. He gazed, enchanted, at the branches and twigs, or 'the drops of paint weeping tears on the paper'; in the next drawing, landscapes and architectural subjects 'dissolve into pure fantasies'. Turning the pages, he espied women 'in their boats on the river, leaning nonchalantly out over the poetry of the fast-flowing water'. But these 'visions of Japan' finally came to an end, and Coriolis returned, sighing, to the harsh 'light of reality'.

Van Gogh knew this novel, for its cover can be seen in his portrait of Dr Gachet painted at Auvers-sur-Oise: it is as though the painter sought to explain himself to Gachet, the last doctor to treat him. Loti's *Madame Chrysanthème* stimulated curiosity about the art that must lie behind the modern colour prints emanating from Japan (Letter 511). Loti himself arrived in Japan expecting to discover a Garden of Eden, but he found the first place he visited, the city of Nagasaki, disappointingly ordinary. 'The time will come when it will be quite boring to live in a world which is the same from one end to the other.' But Loti also reflected on Japanese aesthetics. 'In France we have *objets d'art* in order to enjoy them, whereas here they hide them away.' House interiors revealed 'incredible preciousness in infinitely small details', revealing an affection for objects. This was very different from the West, where so-called Japanese rooms were 'crammed with imported knick-knacks'.

In Théodore Duret's *Critique d'avant-garde* (1885), his essay on Japan-

ese art occupies a central place. According to Duret, the 'fundamental distinction between art and industry' loses its meaning in Japanese art. It knows neither 'higher art', weighed down with ideas, nor low-ranking applied art, because what is called art is always applied. Japanese art retained its subtle sense of colour even in the smallest detail, and as a result it produced the world's 'first and most perfect Impressionists'. In their quite different concept of the work, Duret continued, the distinction between representational painting and pure decoration did not exist. Everything is 'decoration', but on a different level. Duret was not alone in expressing such reservations about Western art. He made reference to Louis Gonse, who had just published his major work on Japanese art. There was Félix Bracquemond too, who in his book *Du Dessin et de la couleur* (1886) wrote of *décoration*, making this the key word in his call for a synthesis of all the arts. Such ideas had been familiar to Van Gogh long before he applied them at Arles.

From his 'solitary life' Van Gogh wrote letters urging his artist friends to join him at Arles. In a letter to Gauguin he admitted that it was childish nonsense for someone living in Arles to pretend to be in Japan in order at last to establish a school of true colour. But in Arles, where in ancient times Venus had been worshipped, the art of the future could now be born. Prior to Gauguin's arrival there, he and Van Gogh had exchanged self-portraits that addressed their fundamental questions as artists. Self-portraits, which sometimes reveal a personal crisis, are primarily confessions, and thus override the picture's autonomy. In a self-portrait the artist indeed acts in his own name, asserting his stance against the medium and demonstrating his determination to win the case.

Gauguin indicated in a letter that his own self-portrait, although it seemed figural, aimed to be 'abstract art'. Van Gogh replied that he had a self-portrait of his own, but that he would have to 'do it all over again', for which he needed to 'recover from the stultifying influence of our so-called civilization'. But then Gauguin's picture arrived, and with relief Van Gogh reported to his brother that his own work 'holds its own' beside the other. He accordingly sent Gauguin the strangely mystical self-portrait that records him with his hair closely shaven, a depiction of the artist as a 'worshipper of the eternal Buddha' (illus. 62). Describing it, since his brother could not see it, he wrote, as always, entirely in terms of colours. The brown coat was 'exaggerated ... into purple', and the light background, in a cold bluish-green, had 'hardly any shadows. Only I have made the eyes *slightly* slanting like the Japanese' (Letters 544a, 545).

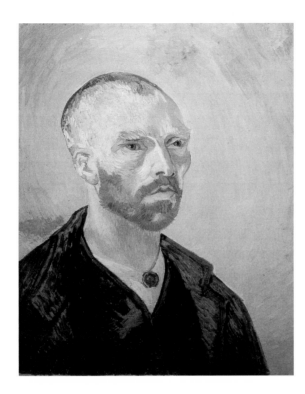

62 Vincent van Gogh, *Self-portrait*, 1888, oil on canvas. Fogg Art Museum (Harvard University Art Museums), Cambridge, Massachusetts.

AN AMERICAN IN PARIS

In the 1860s there was much talk in London of a 'Japanese artist'. James Whistler, who was causing a stir with his Japanese subjects, soon became the subject of serious critical discussion. This American outsider, looking for new directions in art, exemplifies the temptation of resorting to decoration as a new strategy for the picture. Exoticism was also a part of the same project. Whistler was twenty when he arrived in Paris in 1854, attracted there by the accounts of bohemian life supplied in Henri Murger's recent *Scènes de la vie de Bohème*. He soon made the acquaintance of Henri Fantin-Latour – while copying in the Louvre, naturally – and was introduced by him into artistic circles also frequented by the new star, Courbet. For a time Courbet mistakenly thought that he had found a disciple in Whistler, and even painted Whistler's mistress, Jo, the 'beautiful Irishwoman' with the flaming red hair. However, Whistler left Paris in order to try his luck in London, though he was to establish himself there, in the spiritual ambiance of the Pre-Raphaelites, no better than in Paris.

The Japanese woodcut was first popularized in the circles of Paris engravers and printers like Félix Bracquemond and Auguste Delâtre. No

doubt they had a professional interest in their Japanese counterparts who, like them, took daily life as their subject-matter and who had developed a truly great style while yet producing inexpensive popular art. Although prints in Japan were made and sold in amounts that France's printmakers and publishers could only dream of, they could not simply follow in the footsteps of the Japanese, particularly as modern city life in the West could not be reduced to a simple formula, which was where Japanese culture had the advantage. It must have tried their patience all the more to see a real fashion developing for all things Japanese and people like Zola decorating their homes with the improper Japanese prints they bought from Madame de Soye in the Rue de Rivoli.

Japanese motifs were part of Whistler's ambition to revise large-scale painting. He had quickly recognized that only the portrait remained the undisputed territory of painting, while the public at large preferred scenes of modern life in the form of cheap prints. By this time, however, the painted portrait was of course rivalled by photography, and could best maintain its position *vis-à-vis* that vulgar interloper if it continued, contrary to the tendency of the time, to imbue the bourgeois sitter with a special aura. So Whistler concentrated on portraiture and brought it to a peak of theatrical Japonisme, bringing back colour, which had been all but banished by the grey of Victorian fashion, and transforming his clients' dull domestic surroundings into elaborate stage-sets. His sitters give the impression of having donned costumes for their portraits, but it was in fact Whistler who autocratically added these, to the greater glory of his art.

Whistler's backgrounds are given over to 'decoration', which, properly speaking, seemed to be the enemy of an autonomous picture. The Japanese screen, like the Chinese or Japanese fan, was a welcome metaphor for a new ideal of the work. The screen, like a painted contradiction, had appeared by 1864 in Whistler's modern-style portrait of Christina Spartali, whom the picture's subtitle introduces to us as 'the Princess from the Land of Porcelain', as though a woman of Greek birth(!) appearing in Japanese guise needed such an introduction (illus. 63). This idealization was a means towards an autonomous colour composition, to which the motifs were only incidental. But the idea of a colour composition represented a further temptation to abandon the traditional work. Two years earlier, in 1862, Whistler had revealed the dualism implicit in his concept when he had given the portrait of his mistress, Jo, the double title of *Symphony in White* and *The White Girl*. A poem by Théophile Gautier seems to have inspired him to 'paint music':

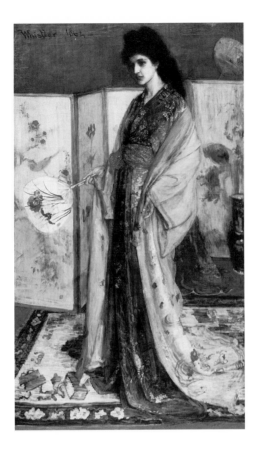

63 James McNeill Whistler, *Rose and Silver: 'La Princesse du Pays de la Porcelaine'*, 1864, oil on canvas. Freer Gallery of Art (Smithsonian Institution), Washington, DC.

the title of Whistler's painting echoes the title of the poem, 'Symphonie en blanc majeur', and invites the viewer to experience painting in the guise of music.

Despite Whistler's worthy intention of winning recognition for pure art, the use of a decorative background in his portraits matched the contemporary fashion for photographing people in studios stocked with sentimental scenery, and it may have been this coincidence that caused him to abandon the practice. While he was busy posing his models and sitters in front of a Japanese background, the Japanese were starting to be photographed against a background with 'Louis XV accessories'. Pierre Loti had described the crowds in front of a Nagasaki photographic studio, where he went together with 'Chrysanthème' (his 'wife' for the duration of his shore leave) and his friend Yves to have a group portrait taken to send home; but once inside, the trio found that 'the studio might just as well be in Paris or Pontoise: there are the same chairs in "antique oak", musty ottomans, plaster columns and cardboard cliffs'.

Whistler, for his part, made his English models pose on '*The Balcony*' of a Japanese-style house, in a painting whose main title is *Variations in Flesh Colour and Green*.

In England, where only realism was appreciated in a portrait and where people found even the Pre-Raphaelites difficult to accept, Whistler's art was hard to stomach because, for all its elegance, it called into question accepted notions of art. When Henry James came across Whistler's works in London's Grosvenor Gallery in 1878, he felt impelled to object that this was wall decoration rather than painting. Ruskin expressed himself more bluntly, declaring that purchasers needed to be protected from such incompetence, and famously accusing the artist of 'flinging a pot of paint in the public's face'. Whistler successfully sued him, but was awarded only one farthing by the court and no costs, as Henry James reported in the *Nation* (19 December 1878), which left Whistler bankrupt. Twenty years later James judged his compatriot more leniently and even brought himself to praise the works shown in the Grafton Galleries in 1897, remarking that this distinguished artist conferred on every room in which his pictures hung the atmosphere of a great museum.

SUNFLOWERS IN THE 'YELLOW HOUSE'

When Van Gogh first rented a house at Arles, he already had plans to 'decorate' it. It is clear that he was not thinking of 'precious' furnishings, though he did want everything to have 'character' (Letter 534). He envisaged 'studies' from nature, with the intention of building up a cycle of pictures, like variations on a theme, united by a shared motif such as a sunflower – a single sunflower, not growing outside but placed in a vase, thus representing nature in the house and nature as art. Whether he actually produced these series or only thought in such terms, this was a welcome means of escape from the single picture, which lost its binding authority as an entity of its own. By designing a whole aesthetic context for pictures, he was setting his own creative efforts at odds with the unique individual work. Even so, the idea was not yet wholly clear to him. When he was thinking of 'decorations' for the house, they were to be 'almost like French painted porcelain' (Letter 544), but when he thought of a possible exhibition in Paris he had the vision of a future *Gesamtkunstwerk*.

In the autumn of 1888 Van Gogh threw himself enthusiastically into 'decoration', for by then Gauguin's arrival was imminent. The

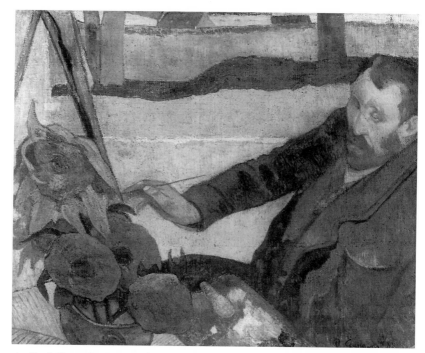

64 Paul Gauguin, *Van Gogh at the Easel*, 1888, oil on canvas. Rijksmuseum Vincent van Gogh, Amsterdam.

'Yellow House' was to provide a studio for a group of painters free from the constraints of the art market. Gauguin's visit, however, took a dramatic course that ended just before Christmas with Van Gogh's nervous breakdown and his visitor's flight from further clashes. Fifteen years later Gauguin described the drama as he remembered it, mentioning the portrait in which he showed Van Gogh painting sunflowers, though it was long past their flowering season (illus. 64). The pair had evidently argued about art once again, and Van Gogh was unsure whether Gauguin really liked his sunflowers (Letter 563). At any rate the nervous attack began, according to Gauguin, when Van Gogh discovered himself in the portrait, red-bearded and fanatical-looking, and cried out, 'That's me, but I've gone mad.' With his admission to hospital, followed by his stay in an asylum, he felt that his plan to set up a studio for a new art was 'shipwrecked' (Letter 588). Thus he resumed work on some unfinished paintings in order to provide a worthy epilogue for a lost future. At Saint-Rémy he also painted series of so-called 'copies' of Delacroix and Millet, but these were no substitute for what he had originally planned.

If we go back to the beginning of Van Gogh's stay at Arles, the

letters delineate a vision that he was constantly developing in new directions. In April 1888, before there was any mention of the 'Yellow House', he mentioned nine pictures of fruit trees in blossom that he was painting simultaneously in order to coordinate the colours (Letter 477). That August he was working on three pictures of sunflowers, which he wanted to expand into a dozen big ones, 'so the whole thing will be a symphony in blue and yellow' (Letter 526). He painted like a man possessed, one racing against time, for 'the flowers fade so soon'. Time and again his motifs died before his eyes.

As with Whistler, Van Gogh's term 'symphony' served as a metaphor. It pointed to music, music for several instruments and with several parts, that is, in 'harmony'. The sunflowers, though they were a kind of symbol for Van Gogh's chosen home of Arles, became the vehicle for colours that resonate together like a chord in music, especially when the same motif is repeated many times. A reference to music always indicated an intention to make pure or autonomous art, and in this context Wagner's ideas, at any rate as represented by his French interpreters, seemed to offer useful guidance.

For later generations the charm of the sunflower pictures lay precisely in the victory of the grand form over a small, modest subject: the whole of art in a single flower. Yet Van Gogh was not satisfied with such subjects but wanted, 'by the time I am forty', to do a large 'picture with (human) figures' (Letter 563). 'I would very much like to keep silent for ten years, doing nothing but studies, and then do one or two pictures of figures' (Letter 519). He was clearly referring to pictures that were never executed, figure compositions on grand themes like those produced by Delacroix, whom he so admired – pictures alongside which the surviving works would rank only as finger exercises or 'studies'. Posterity has taken a different view, and the fact that it has been spared those imagined paintings has probably, if anything, enhanced the painter's standing. But in voicing these ambitions, Van Gogh revealed a contradiction that epitomizes the European artist's internal conflict – always wanting to escape from the impossible masterpiece and yet always obsessed by its necessity.

Van Gogh was also anxious about his own place in the history of art: 'Who will be in figure painting what Claude Monet is in landscape?' (Letter 482). For the time being Van Gogh painted portraits, though they were not really portraits; studies, rather, for a new way of representing people. 'I would rather wait for the next generation, which will do in portraiture what Claude Monet does in landscape' (Letter

525). Every so often he was tempted to embark on a major painting with figures, but in July 1888 he regretfully abandoned a composition of Christ on the Mount of Olives, scraping the paint off again (Letter 505). He destroyed another attempt at the same subject in September. It was bound to fail, he told himself, because he had no themes to paint. It was apparently the olive trees that inspired him to tackle that heroic subject: 'You see, I can see real olives here.' All the rest was in his mind, 'with the colors, a starry night, the figure of Christ in blue, all the strongest blues, and the angel blended citron-yellow. And every shade of violet, from a blood-red purple to ashen, in the landscape' (Letter 540).

For the time being he applied all the energy ultimately intended for a great subject to his landscapes, giving them a mystical rebirth with ecstatic colour. But even at Saint-Rémy, for all his loss of confidence, he remained preoccupied with the idea of an iconography that was both modern and timeless, and he started to copy two religious paintings by Delacroix. 'We painters are always expected to *compose*', whereas in music, after all, one is also allowed to interpret. This is what he does with motifs from Delacroix and from Millet. If he has only a black and white reproduction, 'then I improvise color on it … searching for memories of *their* pictures – but the memory, "the vague consonance of colors which are at least right in feeling" – that is my own interpreta-tion' (Letter 607). When Van Gogh writes of modern 'performances' of great works, this constitutes a surprising rejection of the notion of creative omnipotence. One cannot in any case, he pointed out, surpass painters like Delacroix, for they were already modern, as also, at the other end of the scale, the Primitives were; of the classical painters it was better to say nothing.

For all the melancholy expressed in these letters, Van Gogh suprises us with a novel approach to the concept of the work. A work of art seemed to him merely a temporary staging-post where art resides for a time before setting off once more. This led to his copying as a creative activity in which he improved on the model he copied. Hence, too, his references to the performance of a musical repertory, and the suggestion that the idea in a copied model can be similarly restated in a kind of new painted performance or free recreation. Van Gogh also 'copied' his own works in this sense, repeating them in order to enforce their idea. Watching only the painter's continual struggle for the unique work, one may easily overlook the fact that he had already left that old concept behind and replaced it in terms of serial work.

In the letters he avoided the term 'masterpiece' because it had

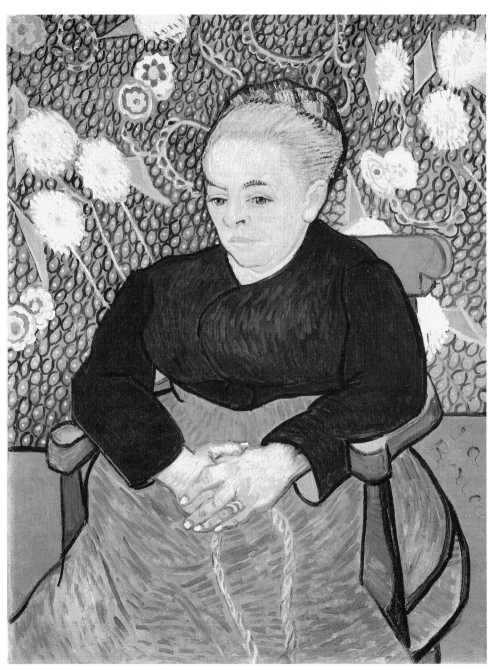

65 Vincent van Gogh, *Mme Roulin (La Berceuse)*, 1889, oil on canvas. Museum of
Fine Arts, Boston.

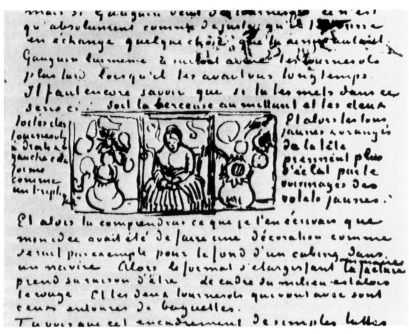

66 Vincent van Gogh, Letter-sketch explaining *La Berceuse* and *Sunflowers*, 1889.

become a cliché. But Van Gogh made a distinction between his serious 'pictures' (*tableaux*), which he thought were rarely successful, and the many 'studies' he was constantly producing. Finished pictures were the 'grave and elaborate works' he mentioned in one of the wonderful letters that he wrote in English to the painter John Russell (Letter 477a). But what was the justification for such works once the old hierarchy of works had been abandoned? It seemed natural to think in terms of music, where distinctions can be made not only between different keys and tempos but between genres and types of movements too, each with their appropriate means of expression. When Van Gogh praised Russell for showing equal mastery of the *adagio con espressione* and the *scherzo*, the analogy between music and painting seemed self-evident. This analogy led Van Gogh to dream of a pure 'music of colours' that as art attained a higher degree of purity. Painting should be like music, pure form, unhampered by considerations of content.

In the case of *La Berceuse* the search for a new work concept became a desperate struggle, for this picture was to demonstrate where the future of painting lay (illus. 65). Here, Van Gogh explained, he hoped to move people as deeply as Berlioz and Wagner had done, while he wanted to bring back to them the long-forgotten lullaby that

a mother (the mother in the picture) had once sung to them – the *berceuse* they would hear in the silent melody of the colours. In a bold utopian move he set about breaking down the aesthetic barrier between picture and viewer via the framed borderline. By the twisted cord in her hand the woman (Mme Roulin) seems to hold fast both the unseen cradle with her child in it and the viewer contemplating the picture. The mass of her somewhat shapeless body is outlined with furious intensity, and she seems about to balloon out from the picture. These areas bear the signs of desperate effort, but the painter relaxes in the flower-patterned wallpaper, from which, as if by some magic, the luxuriant heads of living flowers burst forth. Van Gogh told Gauguin that he had softened the 'discordant sharps of crude pink, crude orange and crude green' in the picture by the 'flats of reds and greens', so producing harmony (Letter 574).

The drama surrounding this painted lullaby took place in two acts. In the first, the picture was impressed into the argument between Van Gogh and Gauguin concerning the future of art. Van Gogh had already twice painted Mme Roulin, the postmaster's wife, holding her youngest child. Soon afterwards, however, Gauguin painted the same model, as if to impress on his host the need to paint not from nature but from the imagination, and left out the child as though it was an unnecessary detail. Van Gogh was not prepared to leave this challenge unanswered, and embarked on a plan for a work – *La Berceuse* – that was to have consisted of five variations but fell victim to the mental collapse caused by Gauguin's hasty departure from Arles. The second act of the drama began when Van Gogh, as he recovered, took up the work again but no longer had Gauguin there for approval. He wrote begging him to believe that he had never before created such a successful colour composition. In the 'yellow house' it would have been framed by two paintings of sunflowers, as if by 'torches or candelabra' (Letter 574). Since those happy energies were gone for ever, Gauguin received a pencil sketch of the picture with two accompanying sunflowers so as to make 'a sort of triptych' (Letter 592; illus. 66). Van Gogh had a vision of an altar for art on which his masterpiece might stand, but nobody was prepared to erect it.

EXILE IN THE SOUTH SEAS

Like Van Gogh, Gauguin had dreamed of a community of artists, but the dream of a shared 'studio in the tropics' had already evaporated when, on 1 April 1891, he boarded the *Océanie* for the voyage to Tahiti. There he

began to build the legend of a life among 'savages' that he hoped to use as propaganda for the avant-garde in Paris. After more than twenty years the Impressionists had finally gained recognition, which meant that artists like Gauguin no longer made common cause with them. Neo-Impressionism, too, had already passed its peak when Georges Seurat died, a week before Gauguin's departure. It was a year later that Albert Aurier hailed Gauguin as the pioneer of Symbolism. The flight from civilization that Gauguin undertook both in despair and as a result of calculation seems to have been a declaration of war on museum culture, and yet among Gauguin's baggage, as we will see, was still the idea of the masterpiece.

The journey was by no means a voyage into the unknown, for Parisians were familiar with life in the French Pacific colonies via exhibitions and travel accounts. Prior to publishing his book on Japan, Pierre Loti had written a bestseller, *Le Mariage de Loti*, about Tahiti, after which he adopted the name of 'Loti' (flower) as his pseudonym. There were various ethnological collections in the capital, of which Paris's Ethnographical Museum, the precursor of the Musée de l'Homme, was the most recent. At the International Exhibition of 1889, where the centennial Republic basked in the glory of its colonies, Gauguin gazed in wonder at a recreated Tahitian settlement. For some, a lost paradise still survived in that distant colony, but the majority, in the shadow of the newly opened Eiffel Tower, were more impressed with the triumph of Western civilization and its advanced technology, to which the ethnologists merely offered a satisfying contrast. In the face of this colonialist attitude, a protest artist like Gauguin inevitably took up a position rejecting civilization in favour of 'natural' man who, he assumed, lived in 'primitive' societies. While he was in Tahiti he therefore avoided contact with the French colony and searched among the natives for the last remaining traces of a culture, already in decline, that he reverently described as 'barbarism'.

We forget that in Gauguin's day 'art' seemed to exist only in Europe, for other cultures at best offered themselves for ethnological collections. Gauguin, however, wanted to free 'primitive art' from its ethnological label. But it was quite another matter to embark on 'primitive art' oneself, an undertaking inevitably fraught with insoluble contradictions. The Polynesian colours inspired Gauguin to radicalize his own gamut of colour. The women of Polynesia – like the Oceanic 'Eve' who appears in the picture with an imaginary paradise entitled *Jours délicieux* (1896) – were much admired as 'children of nature' and

67 Paul Gauguin, *Woman with a Flower*, 1891, oil on canvas. Ny Carlsberg Glyptotek, Copenhagen.

lent themselves to portrayal in an innocent manner that seemed to dispense with all academic iconography. The picture titles, which Gauguin inscribed on his works in Tahitian (sometimes with mistakes), adopted the character of magic formulae to restore to art the dignity of myth. For all his calculation, what he succeeded in producing were painted dreams, which were miraculously able to override the sarcastic aspect of his personality, while in Europe (where else?) they appeared as the triumph of liberated art.

Despite his departure from Europe, Gauguin did not intend to leave the history of Western art. He took with him photographs of ancient and modern works of art, a 'whole little world' of old friends, he informed Odilon Redon. Some he later pasted into the manuscripts of his theoretical writings, in which he propagated a global concept of art. He also carried with him books and long excerpts from texts by Delacroix. Art reproductions hung on the walls of his hut; Manet's *Olympia*, for example, which he had copied before he left, drew a surprised glance from a young native girl who visited him. It touched him that she found beauty in a picture that still attracted hostility in

Europe, and when she asked with curiosity whether the woman was his wife, he replied, with a certain sense of pride, that she was.

It was on this occasion, as Gauguin was later to relate in *Noa Noa*, that he painted the *Woman with a Flower* (illus. 67). It certainly was an anachronism to paint a European-style portrait of a 'savage'. But the woman's exotic beauty fascinated him, which he none the less described in Europe's terms: 'Her features had a Raphaelesque harmony, and her mouth, which seemed to have been modelled by a sculptor, knew the languages of speech and of kissing.' She had quickly put on a dress and wore a flower behind her ear, which prompted Gauguin to paint a scattering of flowers in the background of the picture, as though to add a multiple echo to the flower she brought with her.

The *Olympia* soon prompted him to devise variations in which the Paris whore was replaced by a Tahitian child of nature. In these pictures he contrasted decadent 'civilization' with the magical forces of natural 'barbarism', such as *The Spirit of the Dead Keeps Watch* (illus. 68). In two letters written on 8 December 1892, he mentioned a fear of the spirit of the dead that he aimed to symbolize with his use of colour. The woman's posture on the bed, a posture that must have appeared indecent

68 Paul Gauguin, *The Spirit of the Dead Keeps Watch*, 1892, oil on burlap on canvas. Albright-Knox Art Gallery, Buffalo.

to Western eyes, was, he said, purely a response to the presence of spirits (which also explains the frightened expression in her eyes while pressing herself on the bed). The colours are 'not painted from nature', but symbolize the domain of the soul via the mournfulness 'of a death-knell'. The flowers in the background 'are like sparks of light in the night' that the natives believed were the spirits of the dead. This work meant so much to Gauguin that he did not want to sell it. He even made an engraving of it, which appears in the background of a later self-portrait. The work, he reported to his wife, was painted quite simply, as was fitting for art of the 'savage' kind.

Such pictures were painted for Europe, but there it could not be expected that they would be understood. So in his commentaries Gauguin tried to explain their religious background, while at the same time forming his own legend. When, after two years of absence, he returned to Paris in the late summer of 1893, he planned to write a text on the ancient Polynesian religion, but he abandoned this in order to start his autobiographical *Noa Noa*, a project that suffered, however, from the autocratic behaviour of his collaborator, Charles Morice. The title describes Tahiti via the perfume that emanated from the island. In due course Gauguin produced woodcuts that would have made the book the manifesto of a new current in art if Gauguin had been able to publish it himself. In the event, the *estampe originale* of June 1894 contained only a single hand-coloured woodcut. It bore the same title as the painting of the Tahitian Olympia.

In the spring of 1895, Gauguin's permanent settlement in Tahiti seemed imminent. He therefore asked Strindberg to write a preface for the sale catalogue of his pictures at the Hôtel Drouot, but the Swedish playwright refused. Gauguin wrote to him in reply, and at the same time had Strindberg's refusal printed in lieu of a preface. This passage of arms represents the collision of two concepts that may be identified with civilization and 'barbarism'. Strindberg, who had only just come to appreciate the Impressionists, found civilization oppressive, but also felt alienated from the 'Titan' Gauguin, in whose idiosyncratic world he was ill at ease, because, as he explained to Gauguin, it lacked sufficient shade. He wished Gauguin *bon voyage* and expressed the hope of a future meeting when he himself had succeeded in 'becoming a savage'. Gauguin insisted on his right to seek his own paradise in a 'savage' kind of art. This was a paradise that could exist only in a painter's vision, just as he could not change into a savage and cast off civilization's fetters. After his return to Tahiti, anxieties about the European success of his *œuvre* were

voiced in his letters, ranging from practical concerns, such as obtaining paints, to the paradox of painting Western-style canvases among 'savages'.

The European concept of the work, however much he rebelled against it, pursued him even to the South Seas. It sometimes seemed more natural to produce wood carvings in a 'primitive' style, which Gauguin called 'sculptures'. The aura of the Tahitian cult images that crop up like quotations in his paintings plunged him into self-doubt, which caused him to give his art an emphatically religious tone. He deliberately turned his new life into a myth. Problems of style could be solved, but art remained a distant goal. He had so far not got beyond 'intentions and promises', for he had avoided the kind of perfection expected in Salon pictures. 'Our nature is simply not capable of the absolute.' One was therefore 'sometimes glad to find an unfinished picture in a museum, as one quite frequently did in the case of Corot'. So 'where does the execution of a painting begin and where does it end?', as he wrote in March 1898 in a letter to Monfreid. 'Who knows when a work is born within that being' that is an artist? 'Perhaps in the subconscious?' The idea is 'like lava breaking out of a volcano', and one risks destroying it if one stifles the eruption by over-elaboration of detail. The work reveals an inner

69 Paul Gauguin, *Nave Nave Mahana* (*Jours délicieux*), 1896, oil on canvas. Musée des Beaux-Arts, Lyon.

image that only emerges in the ecstatic act of creation.

Executed in a spare style that concentrates on essentials, Gauguin's pictures always cling to the very first idea. The composition preserves the unity of the vision without losing itself in details. Each figure behaves as though the harmony of the whole rested on its shoulders alone. This is, for all the Tahitian motifs, a legacy of French classicism, in which Gauguin perpetuated the ideals of artists like Poussin. This fact was soon recognized. In *Jours délicieux*, painted in 1896, the frieze-like arrangement of the figures in a sunny grove recalls Poussin's picture of Eleazar and Rebecca, as though Gauguin had unconsciously been trying to transpose Poussin's Arcadia to his Tahitian exile (illus. 69). No wonder this was the first work of his to find a home in a French museum (the art historian Henri Focillon bought it for Lyon). Much later, in the catalogue for the 1937 exhibition 'Masterpieces of French Art', Focillon said of Gauguin that 'in the South Sea Islands he erected the mysterious statue of ancient man'.

AN ANTIPODEAN MASTERPIECE FROM TAHITI

Focillon might also have reminded his readers that in December 1897, six months before his fiftieth birthday, Gauguin, who was both sick and destitute, made a dramatic attempt to end his life after producing a masterpiece. True, Gauguin never used that term, but 'the large canvas', a 'philosophical work' whose title – *Where do we come from? What are we? Where are we going?* – suggests a parable of life, was indeed a paradoxical masterpiece from the other side of the world (illus. 70). In its homage to the Tahitians, it triumphantly rejects Western civilization and its individualism. Like an archaic wall-painting, whose medium seemed unjustifiably neglected, the canvas that used 'a rough cloth full of knots' represented a self-critique of the contemporary Salon picture; and yet this criticism was expressed in a unique work that as such unintentionally complied with an ideal of art that Gauguin detested.

No other masterpiece has ever been described in such detail by its creator. This proves the ambiguity with which Gauguin in his exile eagerly informed his friends in France, through long descriptions accompanied by sketches, of an important artistic event. The great 'mystery' of life here is represented by means of figures so simplified as to become signs, which succeed one another from right to left like stages in the cycle of life. The landscape, with the ocean in the background and the neighbouring islands on the horizon, has the enhanced signifi-

cance of a cosmic space in which mankind lives. The dualism of the world and its inhabitants is also expressed in the colours. The landscape, 'all in blue and Veronese green', contrasts strongly with the naked figures 'in their bold orange'. Only the native idol, which represents unity with nature, glows in a kind of transcendent blue. 'The two upper corners are chrome yellow, with an inscription on the left, and my name on the right, like a weathered fresco which flakes off from a golden wall.'

The male figure, incidentally the only one in the picture, reaches up to pluck the apple from the tree of life, thereby dividing the canvas into two unequal parts. The right-hand half presents an image of an almost animal life, which includes a newborn child. On the left each figure is isolated, whether it be the growing child or the old woman cowering in the shadow of death. Behind them is the statue of the goddess, like a counterpart to the man plucking the fruit, erected at the threshold of earthly life. In the frieze, beautifully invented figures alternate with crude ones that are mere fillers. The symbolism would remain an artificial construct if the picture were not held together by the colours, which bathe it in a magical light. In an act of supreme exertion, Gauguin forced himself, during that December of 1897, to adopt a narrative style of naïve simplicity.

Two months later, in February 1898, he wrote the first of the letters to Monfreid and André Fontainas telling them about the painting: 'Before dying, I wanted to paint a big canvas which I had in mind, and during that whole month I worked day and night in an incredible fever.'

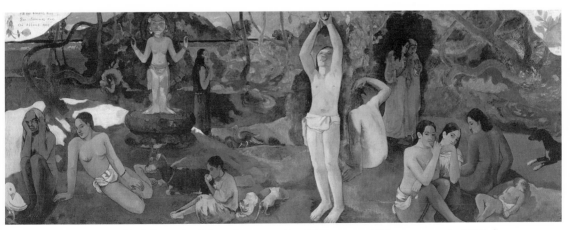

70 Paul Gauguin, *Where do we come from? What are we? Where are we going? (D'où venons-nous? Que sommes-nous? Où aloons-nous?)*, 1897, oil on canvas. Museum of Fine Arts, Boston.

Though people might say that it looked unfinished, Gauguin insisted 'that this canvas not only surpasses all the preceding ones, but that I will never do anything better or even similar to it. Before dying I put into it all my energy, such a painful passion under terrible circumstances, and a vision so clear without corrections, that the haste disappears and the life surges up.'

In March 1898 he was defending himself against the mistaken view that further work needed to be done. 'It will stay just as it is, a sketch if you will', for it was produced in one continuous process and represented the 'melting-point of extreme feelings in [my] innermost depths', thus embodying the unity of idea and work. Exactly a year later, when the work was exhibited in Paris, he rejected Fontainas' criticism that it was too abstract and like an over-complicated allegory. No, he had added the title only afterwards, when he awoke from the dream in which he had painted it. There it is again, the Romantic notion of the masterpiece springing directly from the artist's soul. Now it is a 'primitive soul' that is reborn in the artist and shapes his works. Having completed this work, Gauguin attempted suicide. He later gave as his reason the hopeless situation in which he found himself at the time, both physically and financially. He had therefore taken an overdose of arsenic and dragged himself to the mountains, where 'my dead body would have been devoured by the ants'. But there is a link between the artist's attempt to end his life and the achievement of the unsurpassable masterpiece, a tribute to the artists' legends (see p. 120), with which Gauguin was well acquainted.

Had the attempt at suicide succeeded, Gauguin would have created a new artist's legend – that of the artist who took his own life not in front of his failed masterpiece but after completing a successful one. This act alone would have transformed the work into a myth. The *absolute work* would have gained added resonance from the echo of the *absolute deed*. But was there not a danger at the time that the work might be forgotten and sold for next to nothing? We cannot see into Gauguin's soul, but the facts are that he survived the suicide attempt and soon began making every effort to ensure the picture's success. When he was separated from it he became painfully aware that he himself had been the only public that the work once had in Tahiti. 'I look at it continually, and, by God, I admire it', he had written to Monfreid in March 1898. In June he sent him a photograph, specially retouched with pastels so that it would show up more clearly. In Paris, where it was offered for sale by Ambroise Vollard, it was much admired but did not find a buyer. On 22 May 1901 Charles Morice told Gauguin that he planned to persuade 'a group of artists and

lay people', among them Degas and Redon, to raise the purchase price and offer the picture, 'which is without doubt a masterpiece', to the Musée du Luxembourg. Gauguin was delighted, but the idea came to nothing. Today, the work hangs in Boston. This masterpiece, though antipodean, remained a European project, despite the 'primitivistic' symbolism by which Gauguin sought to breathe new life into an exhausted tradition.

9 The Inferno of Perfection

ABSOLUTE ART AND THE *NON-FINITO*

At the end of the century Cézanne and Rodin emerged as the leading figures in a first crisis of modernism, a crisis that, with their paradoxical revision of the great tradition, they themselves aggravated. Utterly unlike in personality and working in different media, they were none the less similar in their single-minded struggle for the ideal of absolute art. Works turned into nothing but preliminary devices that were not intended to attain a final form – devices not for a work but for a vision of art behind the work. It was this vision that now came to represent the utopian idea of the former masterpiece. The idea could carry conviction only in the absence of realization; the individual work simply occupied the place of a perfection that was already impossible. With an almost pathological fear of perfection, both Cézanne and Rodin chased an inaccessible 'form' that, they thought, contained the mystery of art. The goal was no longer the perfected work, but the ceaseless perfection of an artistic vision that transcended simple visibility.

This conflict led to a dualism in their approach to figuration and to abstraction: either the figurative subject was lost or, on the contrary, it was overstrained. Behind the eroticism of Rodin's similes of bodies that contradicted the appearance of statues, or the visual experience Cézanne translated into the picture's internal visual order, there was always a stronger passion for self-expression. This not only provided artistic autonomy, it also made the artist independent *vis-à-vis* his work. However we may interpret their much-admired works nowadays, the two artists themselves hesitated to convert their vision into a completed work.

The *non-finito* became the most convincing manner of dealing with absolute art. Not only did the artist refuse to complete a work, he actually intended that every work should always be surpassed by its idea. Rodin's confessional *torso* is a new mask of the masterpiece that is only completed in our imagination (illus. 71). With Cézanne the creative process never arrived at a result: no single work was so perfected as not to lead to further works in an attempt to do better. The *eros* of the gaze

sometimes led both artists to uncompromising self-censorship, or drove them to an act of self-liberation from the work itself.

In *À la Recherche du temps perdu*, Proust describes the schism in the modern artist who subjugates himself to a hyperbolic concept of art and yet simultaneously doubts it. Wagner's works, he says, 'partake of that quality of being – albeit marvellously – always incomplete, which is the characteristic of all the great works of the nineteenth century, that century whose greatest writers somehow botched (*ont manqué*) their books, but, watching themselves work as though they were at once workman and judge, derived from this self-contemplation a new form of beauty … imposing on it a retroactive unity, a grandeur which it does not possess'. The 'retroactive unity' that so convinces us when we look at Cézanne and Rodin today was, in their lifetime, the unity of their search to reconcile idea and work.

Rodin and Cézanne, who were of almost the same age, both admired and criticized one another. In Cézanne's work Rodin found reduction and rigidity, while Cézanne accused him of a lack of discipline. In his conversations with Joachim Gasquet, if we can trust Gasquet, Cézanne observed in Rodin the lack of a 'cult, a faith and a system'. *The Gate of Hell* (*La Porte de l'Enfer*), which Rodin was unable to complete, was described by Cézanne as a 'monument of labour', which would never be erected. But Rodin would have been equally justified in pointing to Cézanne's vain struggle with the *Baigneuses*, on which he laboured for almost 40 years, forever coming up with new versions. In the final decade of his life he was working simultaneously on three large pictures on that theme, keeping them, like Rodin's *Gate of Hell*, in a permanently provisional state in order that their perfection would already belong to the realm of the imagination (illus. 72). He felt that old age was preventing him, when he was close to his goal, from 'realizing the artistic dream I have pursued all my life', as he put it in a letter to Roger Marx. The advances he had made, he wrote in his last year to Émile Bernard, were aimed at proving theories through painting. As he said in his famous letter of 15 April 1904, his concern was to 'treat' (*traiter*) nature by means of a geometry of vision.

Rodin was not in the position of the hermit of Aix-en-Provence. He received commissions for public monuments that were to immortalize new national heroes. But the genre of the public monument was already in crisis. In carrying out such commissions he was under a compulsion to finish them. But he was primarily concerned with other issues, ever since the neo-classical ideal of figural sculpture had

71 Rodin photographed in his studio with 'The Hand of God' (1898).

foundered. He did not want to leave it to the Salon sculptors to develop a new alternative for expressing the passions and travails of the modern psyche through carved bodies. The statue, quintessentially static and final, strongly resisted the representation of a mobile body. This is why Rodin so often resorted to drawing, and why he was so fond of making aphoristic plaster models that he gave liberally to his friends. The *non-finito* was also a victory over the genre, a way of transcending its boundaries and overcoming the conflict between absolute art and the modern fear of time (see p. 155).

Rodin became the antipode of the legendary Zeuxis, who painted an absolute masterpiece out of five living women. To Rodin every woman was a fresh wonder of nature, endlessly reborn, and, even in the case of a single body, changing with every moment. For these reasons he often worked with several models at a time and captured even the most fleeting of movements, when the models were unaware that they were being observed, in order to see beyond the pose and find nature. There was the constant allure of the female model, but the woman lost her autonomy *as a body* when she became instead the *impression of a body*, taking on the contradictory duration of a moment. This one moment contained all other moments, and the infinity of views contradicted the finiteness of art. Rodin's project was to make nature – chameleon-like

and resisting a single view – the implicit opposite of art.

Nature tormented and inspired Rodin and Cézanne alike. Nature always remains the same, whereas art is in a permanent state of flux. Victory could only be won where an individual temperament wrestled with a principle that took on one appearance under Cézanne's hand, another under Rodin's. The painter made an abstraction of pure space, the sculptor an abstraction of pure expression, though bodily expression could not dispense with the physical body. One venerated form as the eternal law, the other indulged himself in form as freedom, as if to provide it with a force that would transcend the work. If Gasquet is to be believed, Cézanne was able to say of Rodin: 'I admire him greatly, but he is just like his age, like all of us. What we make is fragmentary. We are no longer capable of composition.'

Whenever he was in Paris, Cézanne went to the Louvre (as Matisse was later to do; see illus. 73) in order to 'make drawings after the masters'. Often he took sculptures as his models, but he would always choose the particular angle that transformed the body into a flat surface. Like Rodin, he did not reject 'the masters'. 'I am more traditional than people think,' Gasquet reported him as saying. 'Rodin is just the same.'

72 Cézanne photographed in his studio in 1904 with one of the unfinished *Grandes Baigneuses* behind him.

Rodin was at home on the ground floor with the statues, and Cézanne on the upper floor with the paintings, and both took literary friends with them so that they could talk on the spot about their favourite works. 'The Louvre is the book from which we learn to read', Cézanne explained in a letter to Bernard in 1905. But then one had to free oneself from the schools. 'Pissarro was not mistaken, though he perhaps went a little too far, when he said that one ought to set fire to the necropolises of art', he wrote in one of his last letters to his son Paul. Michelangelo's example encouraged him to adopt an uncompromising artistic ideal so as to free himself from conventional practices and attempt a new master-piece even if it were to remain a torso.

In the Louvre, Rodin and Paul Gsell stood just as reverently in front of the old Venetian picture of the *Concert champêtre* (illus. 74), which seemed to Rodin like a dream of Arcadia. 'Every masterpiece has that mysterious character.' Despite the picture's cheerful mood, modern viewers felt the melancholy induced by a moment in art that now belonged to the past. Cézanne shared Rodin's admiration for the work, in which antiquity had been brought back to life. The small watercolour

73 Photograph of Henri Matisse in the Louvre, c. 1946.

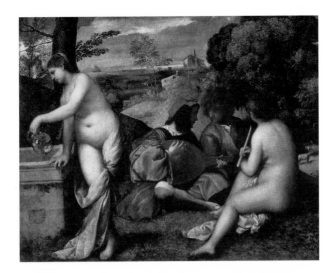

74 Giorgione (previously attributed to Titian), *Le Concert champêtre*, *c.* 1510, oil on canvas. Musée du Louvre, Paris.

75 Paul Cézanne, Watercolour sketch of 1878 after Giorgione, *Le Concert champêtre*. Musée du Louvre, Paris.

in which he reproduced it (illus. 75), probably from memory, reduces Giorgione's picture to its mere bones, as though he wanted to imprint its anatomy on his mind. In conversation with Gasquet he expressed his admiration for that 'great sensuous vision', whereas he thought little of Manet's painted revision (illus. 53). Compared with the *Déjeuner*, the Venetian original seemed to him all the more like 'a pastoral poem from an imaginary world, a moment of perfect balance in the universe'.

Such remarks offer a key to Cézanne's own dreams, which he pursued in his endless labours on the *Baigneuses*. In 1864 he registered at the Louvre to copy Poussin's *Arcadian Shepherds*, and twenty years later

he was still drawing individual figures from that famous evocation of antiquity. But in addition to the poetic subject-matter, what attracted him to Poussin was the classical composition. 'Imagine Poussin redone (*refait*) completely after nature, and there you have classicism as I understand it.' Poussin was an inevitable authority for almost all French artists, but Cézanne actually wanted to become a modern Poussin. However, this did not prevent him from admiring Rubens in the Medici Gallery and sketching the nudes, so full of movement, that he knew Rubens had derived in turn from classical statues (illus. 36). Perhaps he toyed with the idea of a modern synthesis of Poussin and Rubens, as a way of approaching the impossible ideal of absolute art.

There is a clue to Rodin's dream in a figure group associated with the *Gate of Hell*. It has a direct reference to Baudelaire's poem 'La Beauté' (see p. 145), the opening words of which, 'I am beautiful ...' (*Je suis belle*), are inscribed on its plinth (illus. 76). Rodin's bronze *Je suis belle* is easily understood as a pair of lovers, for the powerful male raises aloft a crouching female in an ecstatic embrace. But the passion is confined to the male, who vainly longs to be united in love, while the female remains unresponsive. Five years later, in 1887, when Rodin was illustrating *Les Fleurs du mal* for Paul Gallimard, the same poem was accompanied only by an enticing woman leaning towards her invisible lover, conveying both promise and denial (illus. 77). A wash drawing for the same edition presents a synthesis of the other two designs. Rodin has reverted to a pair of figures, but this time the enticing woman floats weightlessly in the man's arms while holding him back with her own (illus. 78). Next to this Rodin wrote the first line of Baudelaire's poem 'De Profundis Clamavi': 'I implore your pity, You, my only love.'

The bronze *Je suis belle* does not elucidate Baudelaire's poem, but instead uses the poem as a commentary on the sculpture, which reveals the erotic fire to be an unattainable ideal of beauty, a dream of absolute art. In Baudelaire's poem, Beauty speaks with her own voice, addressing herself to the 'mortals' who bruise themselves against her bosom. She is beautiful, 'like a dream in stone', and cannot be embraced any more than can a piece of stone or a dream. But she inspires in the poet a yearning 'love that is as eternal and mute as matter itself'. Rodin illustrated the poem only with the Beauty whose monologue it is, whereas in the groups he also introduced her male counterpart, the *eros* of the artist. Baudelaire's arrogant Beauty is not a vision of consuming love, but she becomes a fiction in Rodin's view of art. Though he cites Baudelaire, he is already conscious of the crisis that modern aestheticism has

76 Auguste Rodin, *Je suis belle*, 1882, bronze. Musée Auguste Rodin, Paris.

77 Auguste Rodin, Illustration for 'La Beauté' from Charles Baudelaire, *Les Fleurs du mal* (Paris, 1888).

suffered. The artistic ideal, so much discussed and now excessively inflated, is turning against itself: this is the crisis that is reflected in Rodin's work. We should not forget that the pair of lovers comprising *Je suis belle* was designed to be part of the *Gate of Hell* before it became a work in its own right. The latter's treatment of love alludes to the inferno of perfection, whose torments the artist suffered.

NATURE OR ART?

Rodin and Cézanne also experienced a crisis in their attempts to relate art to nature. Nature, the epitome of the *non-finito*, was forced by them into the work of art, despite the work's claim to completion. Their individual works no longer depicted nature, they performed it while focusing on an extract from its unity. Rodin designed vast numbers of figures as though he were producing the raw material for ever new metamorphoses. Cézanne favoured the eternity of nature, but constantly

changed the position from which he observed it, or tormented his living models, endlessly reworking their poses. As a result, nature was boldly conjured as a liberating force to overcome any traditional concern for art's identity as enclosed in a work.

In those years, the familiar face of nature was changing into a threatening sphinx who, the closer she was questioned, the more she withdrew. Scientific anatomical drawings were intended as teaching materials for artists, but broke nature down into an infinite variety of physical types in which any norm of beauty was lost. Paul Richer, who worked in the Paris hospital for mental diseases, La Salpêtrière, began to analyze the body as a source of clinical evidence. Suddenly the art of earlier periods also became for Richer the source for identifying partic-ular diseases. With clinical psychology, the human soul was no longer inseparable from the physical body. At the same time the moving picture captured the expression of life generated by bodies in motion. With his 'photo-gun', Etienne-Jules Marey took pictures of birds in flight in 1882, and initiated the hunt for the dimension of time, which now broke up the traditional image of nature. In the photographic studio of the Lumière brothers, finally, the *cinématographe* was invented, enabling the newly invented photography of movement to become moving photography – film.

Rodin was thus very much a child of his time in his alertness to the expression of emotions and the pictorial recording of movement. Imita-tion of nature became a drama with an open ending: if the living model could no longer be defined in the old way, then neither could the work of art be kept within set limits. Between nature and art, which were no longer amenable to an accepted definition, Rodin made bold and endless conjunctions. From a very early stage in his career he was study-ing the human body with such fanatical exactitude that his *Age of Bronze* sculpture unleashed the first 'Rodin Affair' in 1878, when he was accused of exhibiting nothing more than a cast moulded from a living model.

One could call Rodin's metaphorical handling of nature the *morphological threshold*. The form seems to take shape before our eyes, emerging from the block of stone from which Rodin has only partly carved it, as though to imitate the natural cycle of birth and death. In dramatizing the contemporary idea of evolution, form is what has *become form*. Space, hitherto the setting for three-dimensional sculpture, becomes an abyss in which bodies merely perform empty gestures of existence. Movement, as against the static stone block, becomes their essence. Rodin imitates the flowing *time of bodies*, which perform their

78 Auguste Rodin, Illustration for 'De Profundis Clamavi' from Charles Baudelaire, *Les Fleurs du mal* (Paris, 1888).

finite movements in infinite space. The apparent transformation of inanimate statues into animated bodies was a successful strategy for taking up the struggle with visible nature once more, before Rodin's successors began to seek nature *beyond* the visible world, in abstraction.

Here the similarity between Rodin and Cézanne is not immediately obvious, because with Cézanne nature is included in a two-dimensional canvas, which interrrupts our gaze like a transparent curtain. In the course of his career this pictorial cloth is woven, so to speak, ever more tightly. It closes over and enshrines the physical space beneath it. Since his was an analytical way of seeing, in which scientific and artistic interests were closely linked, each individual work by Cézanne became an experiment directed towards a distant synthesis of nature and art.

CÉZANNE'S STRUGGLE WITH *LES GRANDES BAIGNEUSES*

The similarity to Rodin becomes more apparent when one looks at Cézanne's endless series of *Baigneuses*, or *Bathers*. While classical painting favoured reclining poses, here there is such a countless variety of movements that the body itself is made elusive. The contours of the bodies, in which a last quiver of movement seems to persist, dissolve in order to capture time passing. The old motif of nudes is increasingly reduced to the fleeting expression of bodily life. But since no single movement can represent the flow of life, movement is multiplied in a continuum of rhythmical poses that Cézanne of necessity divided among numerous figures. In his studies the motifs are sketched singly, while in the paintings they are combined to form a composition built up like the musical elaboration of a leitmotiv. Nowhere does this technique achieve greater freedom than in Cézanne's late watercolours, where the bathers' movements are spread across the whole picture and become a single, flowing 'pictorial movement'. Even if, as Cézanne declared in the year of his death, he wanted to give Impressionism greater solidity, the opposite is also true – that, in his classical repertory of motifs, nature had become affected by modern restlessness and could no longer be convincingly caught in any work.

In the well-known photograph taken by Emile Bernard in March 1904 (illus. 72), the ageing Cézanne sits with what looks like an air of resignation in front of the great canvas that is one of three different versions of the *Grandes Baigneuses* on which he was working at the end of his life. When the photo was taken, two years before his death, the painting was not yet the canvas we can see today in the Barnes Collection (illus. 79), although he had already been working on it for many years. Nor did either the London version or that in the Philadelphia Museum of Art become the final statement on this subject, which one might have expected from a lifelong endeavour. While continuing to rework these large-scale paintings, Cézanne was still generating sketches for pictures he was never to paint, a stream of draughts without a destination. With regard to the triad of large paintings, we cannot now assess with certainty the extent to which they are finished. Indeed, when the London version was bought, half a century later, there was still a public controversy over whether it really should command the price of a masterpiece, given that it looked more like a study.

Perhaps it was this self-critical *non-finito* quality that later became so attractive to young people. One can picture the master going from one

79 Paul Cézanne, *Les Grandes Baigneuses*, 1900–05, oil on canvas. Barnes Foundation, Merion Station, Pennsylvania.

canvas to another and, when he can get no further with one of them, turning to the next. He was, so to speak, performing the same ritual on three stages. To begin with, the plot was a modern Arcadia, in which a group of women (or, alternatively, men) are gathered under shady trees while above them summer's clouds float by. Some figures rest beside the water, others are stepping into it, while yet others dry themselves after bathing. The later versions still retain this fiction of coming, going and staying, but the anecdotal, narrative element is increasingly subordinated to an abstract order pertaining to the composition.

Around 1870 modern-style bathers began to replace his earlier nymphs and shepherds, though they continued for a while to appear in pictures such as *The Battle of Love* and *The Temptation of St Anthony*. Soon, however, the poses associated with bathing served only as the cue for a free pictorial syntax that was detached from any content. Cézanne's move towards abstraction began, surprisingly, with his study of Giorgione and Poussin, whom he admired for having freely recreated the ideals of antiquity without blindly imitating them. He was bitterly opposed to Manet's method of modernizing art, which included depictions of the urban life and fabric of Paris, and countered it with his own strategy. For him nature and civilization remained in opposition, and it

was nature that he preferred to represent in art.

At first Cézanne's figures reproduced the postures of his living models, or else alluded to the well-known poses of ancient statues. These allusions, however, progressively faded as the individual bodies became part of an overall pictorial rhythm that extended to trees and clouds, almost reproducing the structural principle of nature itself. The bodies came to be deconstructed, so that fluid transitions opened between figure and landscape, forming bridges for the viewer's eye. Where, in this process, the individual figure lost its beauty, it increased in the picture as a whole. The outlines built up a sequence of planes that dissolve again in the texture of colours. Cézanne's pictures were thus exhibiting an internal system for the representation – or, so to speak, art's 'translation' – of nature.

In the *Bathers*, Cézanne continually repeated the same motif but played it through in endless variations, or metamorphoses, which we today call his works. They are metamorphoses not of nature but of the idea of the work. Not even the order in which the works and studies were made can be determined with certainty, so that one can hardly

80 Paul Cézanne, *Les Grandes Baigneuses*, 1906, oil on canvas. Philadelphia Museum of Art.

speak of a linear line of production. Where nature was treated as a formal problem, in which what counted was the *representation* itself rather than *what* was being represented, the artist was moving away from nature and towards abstraction. Thus the equation between art and nature was becoming an equation between two unknowns. The poets Rimbaud and Mallarmé, too, had by now dropped any attempt at descriptive language in favour of an artificial language that followed its own independent rhythm.

In the version of the *Bathers* owned by the Philadelphia Museum of Art (illus. 80), which, by its size, aspires to be a masterpiece and yet studiously avoids any ultimate perfection, a new motif is present that seems to signal a farewell to Cézanne's lifelong project. Two dressed figures – apparently men – seen in the middle distance, are gazing across the water that separates them from the bathing women. We, in fact, are closer to the women, but we realize that we remain outside the picture. The reversal of appearance and reality is fully achieved in the transforma-tion of the women into art that has happened in this painting. *The dream of the eternal summer of Arcadia* has become *the dream of absolute art.*

RODIN'S *GATE OF HELL* AS DRAMA

In Rodin's principal work, too (illus. 81), the drama grew out of an idea that already anticipated its own refutation. No doubt the work could have been completed in some way, and yet its completion was not prevented by external circumstances but by an inner conflict between idea and work. Rodin quickly succeeded in convincing the public that he was engaged on a project of historic importance; more surprisingly still, he impressed everyone by the mere claim. The public's imagination was fired by reports from the studio (illus. 71) no less than by the studies for individual figures that were exhibited here and there and which soon came to be regarded as independent works. The idea had gained such a power over the expected work that the *Gate of Hell* no longer really needed to be completed, because the completed state was bound to fall short of the expectation.

The very circumstances that led to the commission in August 1880 signalled the birth of an artistic dream. The portal was intended for a museum, but for one as yet unbuilt – a Museum of Decorative Arts, which by its nature could hardly be the right setting for an apotheosis of high art. Moreover, a portal with sculptures was by this time an anachron-ism. Rodin must have been thinking of Gothic cathedrals, which stood

81 Auguste Rodin, *The Gate of Hell*, 1880–90, plaster relief. Musée d'Orsay, Paris.

in the most extreme contrast to a modern museum. They had been dedicated to a single great idea, one that was contrary to the committed eclecticism of a new museum. Rodin, who loved cathedrals and their portal sculpture (see p. 243), chose the subject-matter from Dante's *Commedia*, thereby regaining a whole lost iconography of Christianity.

In terms of iconography, the commissioning body looked for a theme calculated to delight the conservatives, while the sculptor was looking for an artistic project that transcended iconography. And, indeed, his sketches after Dante were like finger exercises destined for a panorama of humanity that was conceived from the very outset – not after some change of plan – in the spirit of Baudelaire. Just as Dante had inspired Michelangelo's *Last Judgment*, so Rodin wanted to be inspired by great poetry in order to become a modern Michelangelo and, like him, to throw down a challenge to literature. He knew of Victor Hugo's poem 'La Vision de Dante', in which Hugo identified himself with Dante, even before it appeared in print in 1883 in *La Légende des siècles*. But it was Baudelaire whom Rodin recognized as the modern Dante. From an early stage he was attaching lines from Baudelaire's *Les Fleurs du mal* to individual figures from the *Gate of Hell*, and in 1887 he proposed to a patron that he might illustrate the whole cycle.

Rodin persistently served his contemporaries with literary references, in order gradually to accustom them to images that no longer carried any safe iconography. Though he began by speaking of Dante's trilogy, soon it was only Dante's gateway that offered a vista of the Inferno. But Rodin went further than this, even if individual subjects like Ugolino in his despair or the tragic lovers Paolo and Francesca still recalled Dante's Hell. Hell was only the metaphor for a drama that, as in Baudelaire, was played out among the living – a drama of longing and of separation, but also of coming into being and passing away, which Rodin translated into the drama of form as such. The age-old panorama of passions and suffering that surges up against the *Gate of Hell* is born of the inner vision of the 'poète-penseur' who sits enthroned above this chaos of life (illus. 82). The naked figures are not only variations on the body, they are also timeless images of the torments and passions of the soul in the midst of modern rationality.

In June 1900, after twenty years of work, the plaster model of the *Gate of Hell* was seen for the first time outside the studio, in a retrospective exhibition. But a photograph of 1882 already shows *The Thinker* sitting on a wooden structure in the place he would later occupy in the work, as though he had yet to devise the work. The state-owned studio

82 Auguste Rodin,
The Thinker, 1904,
bronze (seen here in
front of the Panthéon,
Paris).

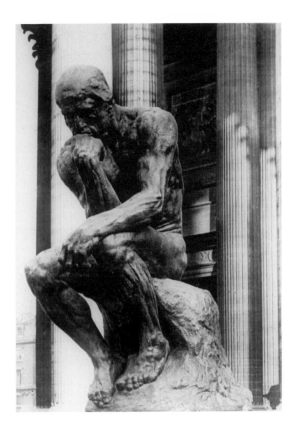

that Rodin was able to move into in 1880 became a theatre of physical spectacle in which for years two Italian sisters surpassed all Rodin's other models in their inventiveness. Small clay figures instantly captured each fleeting pose. From these Rodin developed ideas for works, ideas which seem like mere *aperçus* but which always bore some relation to the conceptual framework of the *Gate*. In 1889, the year of the great Paris International Exhibition, 30 motifs associated with the *Gate* were exhibited in the Galerie Georges Petit; they were to be sold individually, even if the catalogue indicated their link with that project. Those who did not have access to Rodin's studio would know the work, which had become a legend, from a lithograph of 1887. The polarity between the work and its underlying idea marks a turning-point in the history of art.

The *Gate of Hell* impresses as a whole before we note its individual parts. There is the double current of movement that draws writhing figures up the side pilasters and then, in the inner panels, tumbles them into a bottomless pit. This dualism was inspired by the Sistine *Last Judgment*, though here it is detached from any notion of an afterlife. The

circular movement of life, in which everything is linked, remains confined within the flow of earthly time. For a while Rodin planned to flank the Gateway with the mournful figures of the first human couple, abandoned by their Creator. The design for Adam survives in the *Three Shades*, standing in a bent posture above the Gate, who are essentially a single figure in triplicate – a figure turning in a circle without direction or goal. A strangely Gothic feature is the tympanum that surmounts and links the two door panels. Here, too, there is a transition between form and formlessness, by which Rodin simulated the metamorphoses of matter and of life. Only *The Thinker* has a stable position within the tympanum. He sits where on Gothic portals the Great Judge sits, but he has been made into a seer (see p. 223). At the lower edge of the tympanum a figure vainly attempts to struggle free from the maelstrom driving it down to the depths. Motifs derived from Last Judgment iconography now become episodes in the desperate struggle for life. The tombs in the depths that will never release their occupants mark the last station, where life's struggle is stilled. Rodin's drama is described in the catalogue of the Galerie Georges Petit as early as 1889 with a strength of feeling that amounts almost to a personal confession on the part of the critic.

Motifs from this descent into Hell reappear in the Baudelaire illustrations that Rodin produced for Paul Gallimard. On one sheet a despairing male figure is identified in Rodin's own hand as the 'Angel, journeying unwisely'. This quotation points to the *Fleurs du mal* poem 'L'Irrémédiable', in which the fallen angel, in the darkness of the abyss, strives in vain to reach the light. He had been 'an idea, a form, a being' and then had 'fallen from the azure into the dismal Styx', where all that remained to him was 'the awareness of his plight' and 'a heart which had become its own mirror'. Rodin looked at Baudelaire's poetry as into a mirror that might confirm and reflect his own desire.

In Baudelaire's cycle, Rodin also found an overall unity in which, in a mysterious way, each individual poem has its allotted place. The same synopsis, in the *Gate of Hell*, replaced traditional iconography. In a passionate drawing Rodin depicted the mortal combat with the demon who pursues his work of destruction in the artist's heart. This drawing accompanies a poem entitled 'La Destruction', which tells how 'le Démon', 'knowing my great love of art, sometimes takes on the appearance of the most seductive woman' in order to destroy his victim.

The composition continually stretches or contracts by the uneven distribution of the figures, and there is a bewildering variation in tempo.

The light, staging the visible world, sports indifferently with the seething mass of humanity, hungry for life, which strains towards it. All this makes the work hermetic, for in the drama of the whole, the detail is lost. When the Danish painter Per Kirkeby took his series of photographs in the Musée Rodin in 1985 he showed a real affinity with Rodin's *mise-en-scène*. In his view the interplay of light and materiality afforded 'great insight into transience'. In the *Gate*, the content merges with the form as if Rodin were performing illicit metamorphoses for which the work is only a framework. The multiplicity of mortal bodies complies with the *Gate* as a monument to transience.

The secret of its success lay precisely in its rejection of masterpiece status. By remaining unfinished in the studio while most of its motifs had already been cast, it became the symbol of the studio itself. To the Paris art world it seemed as if, in the *Gate of Hell*, the 'unknown masterpiece' in Balzac's story whose revelation is endlessly delayed (see p. 123) had become reality. When the plan to build the Museum of Decorative Arts was abandoned, there was no longer any need to have Rodin continue on the *Gate*. But by then he was no longer devoted to a public commission but used the project for a personal vision of art. When, in the 1890s, he was both hailed as a genius and accused of failure, he resolved to seize the initiative. An occasion was offered by the International Exhibition of 1900: like Courbet before him, Rodin presented his work in a pavilion of his own, in order to draw the public's attention to the unity of his *œuvre*, which was more important to him than the individual (or even the unique) work. The pavilion staged in a public place the studio where the *œuvre* had been produced. When the pavilion was dismantled, the body of work, homeless once more, was returned to the studio. It was only in 1916 that it was given an unusual home – the new Rodin museum, which was once again nothing but the studio exhibited for ever.

In this context the *Gate* was not merely a single work but symbolized the whole *œuvre* (and Rodin may have found it apt that '*œuvre*' in French can have both meanings). His *œuvre* too was unfinished and unfinishable. By 1900 the plaster model of the *Gate* had long been gathering dust and had deteriorated such as to require restoration, and so the *Gate*, which no one now would cast, remained its own model, still unfinished, and yet already an old memory. Not until after Rodin's death was the plaster casting permanently exhibited, and it was only in 1926 that the bronze casts were made. They sometimes make us think of the *Gate of Hell* as a finished work. Most of the literature on it overlooks the para-

dox this non-work, or beyond-work, represents. Far from becoming an apotheosis of the bourgeois ideal of a work of art, the project became the furnace of an idea of the work that was already outdated and auto-destructive.

THE THINKER – THE SEARCH FOR A LOCATION

It is no accident that we regard not the *Gate of Hell* but *The Thinker* – an *émigré*, as it were, from the *Gate* – as Rodin's masterpiece (illus. 82). A whole epoch identified itself with him, and he became a national symbol of the French. He was originally destined to sit high up on the *Gate*, whose panorama we are supposed to attribute to his vision. But *The Thinker* then turned into an individual work that had lost the original context. Unusually, this figure entered the public memory instantly, and was quickly adopted by the advertising world. There is a kind of anachronism in that it captured the popular imagination like the works of the Old Masters. It was Rodin himself who presented *The Thinker* as an alternative to the *Gate*: when the prospect of casting the *Gate* had, yet again, receded into the distant future, he made a bronze cast, three times the original size, of *The Thinker* (by then over twenty years old), and exhibited it in the Salon of 1904. And yet this world-famous sculpture never found a permanent setting, but ended up in the Musée Rodin, thus sharing the fate of Rodin's other works for which, even in the master's lifetime, no other place could be found but in a museum.

Rilke (who worked for a time as Rodin's secretary), in his Rodin essay asks the famous question – 'But whither the things made by Rodin?' There were no more cathedrals to be built, and so Rodin 'was not able to collaborate' on a collective idea. But the isolation of his works was not the only reason why he 'placed them in nature'. His work provided one more example of an individual vision at a time when the cry was for collective progress. Rilke spoke, in a solemn figure of speech, of the 'homelessness' of this art. Günther Anders used the same term when, in a lecture delivered in 1943 during his exile in California, he tried to explain Rodin's 'homeless sculpture' by saying that there was no longer any suitable social *locus* for it. Such isolation, Anders said, manifested itself either in blind desire or in unconsumed power – both of which attitudes he saw as being present in *The Thinker*. Though the Futurists were later to criticize this 'impressionistic sculpture', contemporaries hailed it as the archetype of human autonomy.

So long as *The Thinker* still occupied his place in the *Gate of Hell* he

could readily be understood to represent Dante, whose inner vision was manifest in the *Gate*. The question was not whether *The Thinker* actually *was* Dante, but whether, *like* Dante, he represented the artist as the creator of his own imagination. When the statue was first shown in an exhibition in 1889, it seemed natural to call it *The Poet*, in order to compensate for the loss of the 'poem' (i.e., of the work as a whole). In this secret self-representation, Rodin seemed to be putting himself in the place of the work. He had decided at an early stage where on the *Gate* his *Thinker* should be placed and how it should be viewed from below. That original angle of vision is an intrinsic part of the figure, as is its pose, that of a silent ruler over the surging flow of forms, which the figure also embodies. Later, it troubled viewers with the paradox that the powerful muscles were not braced for some physical action but for frozen introspection. The political Left was quick to see this muscular body as a symbol of Labour asserting its rights. But *the artist* remained the crucial meaning of the work. Rodin never rejected this interpretation, and in 1904, when the sculpture was being referred to as 'The Dreamer', he hastened to call it 'The Creator' – a rôle already contradicted in the new art scene. But artistic creation was in fact to be seen as labour, though not, of course, the alienating labour of the working-class.

When, soon after the retrospective held in his own pavilion in 1900, Rodin resolved to monumentalize the figure, he had already accepted that it should embody the 'invisible masterpiece' of the *Gate of Hell* and make the master himself the subject of the masterpiece. He achieved his aim when the bronze cast, accorded the place of honour in the Salon of 1904, stimulated widespread discussion in which the whole nation joined. Soon people wanted to see *The Thinker* set up as a public monument, especially as Rodin was still not represented in any of Paris's squares. After the necessary funds had been raised, a site was found in front of the Panthéon. There was some anxiety when the plaster model placed in the chosen position was attacked by a man who 'had nothing to eat' and felt himself mocked by the figure's pose. But on 22 April 1906 the unveiling ceremony passed off without incident.

Yet even this public location proved no more than temporary. After years of debate, in 1922 the figure was moved to the Musée Rodin, thus in effect returning to Rodin's studio. This museum setting itself contradicted the inscription the statue had acquired as a monument: 'Rodin's *Thinker* was dedicated by public subscription to the people of Paris.' Now all that remained of the monument was the self-representation of Rodin's art. Rodin himself had favoured this interpretation. In 1902 Edward

Steichen was carrying out the artist's wishes when he photographed him together with the model of *The Thinker*. The photo stages the figure as an allegorical double representing Rodin the artist alongside the shadowy profile of Rodin the man. Rodin conclusively acknowledged this reference to himself in 1917, the year of his death, when he arranged for *The Thinker* to be transferred to his plot of land in Meudon, close to the grave of his wife Rose, where he also wished to be buried. By the name *Rodin* on the plinth, the figure seems to signify the immortal body Rodin made for himself. In this way the creative process resulted in a self-image of the creator. Thus *The Thinker*, which, all by itself, came to represent the idea of the *Gate of Hell*, reminded the spectator of the never-completed ensemble that still retained an ambitious vision to the same degree as the idea that had never finally materialized.

10 The Cathedral of Memory

PROUST'S 'SELF' IN THE REFLECTION OF ART

Marcel Proust's great novel, *À la Recherche du temps perdu,* has often been compared with the structure of a Gothic cathedral, for in both even the most minor detail has its allotted place. Proust himself reveals, though not until the close of his novel, that it had been his intention to 'construct my book ... like a cathedral' (vol. VI, p. 432), 'build it up like a church' (p. 431). *À la Recherche,* fabricated piece by piece, drawn from a congeries of deeply personal sentiments and memories, portrays an inner world whose unity only the author himself can describe. Description is the basic means of construction, but what takes shape in the process is the territory of the writer's own 'self'. The rebuilding of the cathedral is a journey through past time, in which the unity of an individual life can be pieced together from stray fragments. The monumental edifice that has emerged in time and which represents an entire lifetime is a paradoxical metaphor for the 'self' which, though invisible, is conscious of being sovereign in its own inner world.

The Gothic cathedral, on the other hand, as it existed in reality seemed a symbol of the great loss sustained by the modern 'self' when it withdrew into its aesthetic consciousness. Viewed in this way, the cathedral no longer stands as the image of a personal cosmos, but instead evokes the memory of a lost past when people shared a common religion. In those days the cathedral was a place of collective belief, not merely a work of art as it came to be in the modern perception. This change made it a *locus* for nostalgia, which could only be reached by journeying into a bygone age, even though as a physical edifice it was still available for all to see and explore. In this second significance Proust viewed the cathedral as a lost masterpiece of religious art, one that existed only in memory.

The modern belief in art (replacing religious belief) was gradually distilled, among the cultured public, into a need for self-discovery. Art signified an aesthetic lifestyle that seemed to offer the 'self' a total, though transitory, autonomy. The fascination exerted by the cathedral, however, exposes a deficiency that the 'self' experiences when it looks

into the mirror of art and is thrown back on its own resources. When the cathedral is measured against the rapidly fading dreams of bourgeois art, it emerges as an ideal contradicting the modern Salon by embodying the period's utopian vision of a *Gesamtkunstwerk*, in which art seems to overcome its isolation and once again seizes a place in life. Places, for Proust, are those to which one must journey and which, for that reason, one remembers. This also applies to cathedrals, which exist as sites in the real world and yet possess meaning only as places of memory.

The cathedral Proust enfolded in his vision is a modern fiction, as modern as the absolute masterpiece in which art is both revealed and concealed. The ancient cathedral had been anything but a masterpiece of art, had indeed been the very opposite, and yet now reappeared as such for a gaze that accepted only the medium of art. This removed the cathedral from its place in history and transformed it into a timeless, utopian ideal of the modern imagination. Soon its Gothic form seemed like a vision of total art, soon it was a reminder of what was lacking in modern art. Thus the cathedral could mean very different things to different people. As an emblem of a vanished art it provided human memory with a strangely unfamiliar image. The great length of time taken over its construction was matched by the still longer span of time that distanced modern eyes from it. Thus we may speak in a twofold sense of a cathedral of memory that fed the overblown cult of the *self*. Before long the Bauhaus theorists were to use the image of the cathedral in the opposite way, speaking of a functional cathedral of the future, though this was to prove to be yet another of modernity's illusions.

It is only in a wider context, one that embraces Monet and Rodin, that the full significance of Proust's idea can be appreciated. All three made the cathedral the target of a modern gaze. Monet made Rouen's cathedral the leitmotiv of a cycle of 28 paintings that depicted it in the changing light, hour by hour. Rodin gathered together the sketches he had made over many years of French cathedrals for a book that distils the vision of an art suffused with nature into a single radiant retrospect. And when Proust described the cathedral at Amiens, he did so by using John Ruskin's words and Monet's colours, so that his view was filtered through both modern literature and modern art. His own memory thus incorporated the memories of two other artists; art is presented as a another art of memory. Proust's appropriation of past and present may serve as a guideline for understanding the growing freedom in handling the work of art as an accepted reality.

Museum pictures were introduced by Proust as mirrors into which

83 Jan Vermeer, *View of Delft*, 1660–61, oil on canvas. Koninklijk Kabinet van Schilderijen 'Mauritshuis', The Hague.

the modern person gazed. He selected Vermeer's famous *View of Delft* to serve as the secret leitmotiv underlying his great novel (illus. 83). Viewing art served as a catalyst to stimulate his energies, so long as it did not paralyse them. 'That's how I ought to have written', the fictitious writer Bergotte admits to himself in *À la Recherche* (vol. v, p. 207), as he stands before Vermeer's painting. When Proust sets about writing 'like that', the *View of Delft* turns into a 'View of Proust', and it is impossible to say where the one ends and the other begins. Proust also uses the word *vue* in another sense, that of a gaze, and he writes the artist's name as Ver Meer, to suggest a gaze directed 'towards' the boundless 'sea' (*vers … mer*).

Proust was not content simply to describe a picture, for he strove hard to paint it in words, emulating the eloquence of Ruskin, who had been praised for the painterly quality of his writing by Robert de la Sizeranne. Where Ruskin matched the colours of art, Proust engaged

the colours of the soul. By judiciously trimming Ruskin's rank profusion, he created an infinitely ordered composition in which the names of colours guide the reader like signposts from place to place. In this way the description of a picture changes into a narrative of life. The spectator's gaze is filled with a never-ending 'desire' (*désir*), in which he or she perceives their own self while looking at a picture. In this way a startling inversion of work and gaze occurs, and the work yields to the presence of its modern viewer. The modern gaze so much absorbs what it comes to see, that, as in Proust's view of Vermeer's *View of Delft*, it transforms the reality of the picture into a fiction of its own. Thus the experience not only of a motif in a picture, but of the picture itself merges with the beholder's imagination. We may speak of a growing abstraction in art's perception.

Vermeer's picture represents once again, though in the most discreet manner possible, an idea of the masterpiece – an idea by then vulgarized. Proust's literary technique reached its apex when he embarked on a vision of painting. Literally at the moment of his death Bergotte faces a revelation in front of the *View of Delft*. He fastens his eyes on the 'little patch of yellow wall' which, as we know, Proust invented. The spectator is duped by a fiction that nevertheless strikes him with the force of a lightning bolt. We can even identify the precise spot on the canvas, and yet the motif is not there. Balzac's 'unknown masterpiece' makes a reappearance here, subtly modified, when, in a well-known masterpiece, a motif is identified that doesn't actually exist. The small area of transparency that opens up in the work draws to itself art as transcendency. Such an apotheosis is close to being a fiction, but to admit this is not to diminish the hypnotic power exerted here by the experience of art. Hesitating between religion and fiction, Proust was unwilling to relinquish, in art, the hidden substratum of religion. He therefore disagreed with Robert de la Sizeranne – who, in his book on Ruskin spoke of a '*religion de la beauté*' – in the preface to his translation of Ruskin's *The Bible of Amiens* (see p. 234). He was not prepared to see Ruskin reduced to nothing but an aesthetic creed, content with the 'voluptuous contemplation of works of art'. Far from it: Ruskin, he argued, sensed in beauty a mystery 'for which he would have given his life'.

Remarkably enough, Proust came to this idealism through his interest in the Impressionists. In an essay on Monet, Proust enquired into the secret of Monet's visuality. A field of poppies, which no one would make a special trip to the countryside to see, was admired by everyone

84 An interior in Venice photographed by Elliot Erwitt in 1965.

in paintings by Monet. Monet makes us fall in love with places that would mean nothing to us in our real lives, because, as Proust explained it in the preface to his translation of Ruskin's *Sesame and Lilies*, 'they bear, like an intangible reflection, the impression they have made on genius'. Therein lies 'the essence of what constitutes a vision': the 'self' contemplates itself in art as in a mirror. In Proust's Monet essay the mirror metaphor becomes a leitmotiv of painting (illus. 84). Art lovers 'have hanging in their rooms mirrors … called pictures that are no less magical' than the mirrors which in former times showed astrologers 'all the things in life. In them were revealed aspects of life which we do not normally experience.' The metaphor is developed, step by step, in ever more daring language. 'There we stand, bending towards the magic mirror, seeking to understand the meaning of each colour. It calls to mind past impressions that in their turn compose themselves into an atmospheric architecture, like the colours on the canvas, and construct a landscape of their own in our imagination.'

Proust elaborated on these ideas in his preface to *Sésame et les lys* when critically examining Ruskin's theory of reading. The 'sesame' is the magic key that opens the door, as in the *Arabian Nights*. Books receive their truth by means of the act of reading. In this respect, reading books is like viewing pictures. In both cases the love of art prompts us to 'give a literal meaning to all those things which for [the artist] were merely signs

for personal emotions'. Places that seemed quite unexceptional acquire a new power when our imagination lends them all the radiance the painter has used to charm us. The mist over the Seine depicted by Monet suddenly becomes the symbol of a 'longing' (*désir*) seeking in vain to decipher art. 'The mist which our eager eyes would like to pierce is the final word in the painter's art.'

The works of the past 'contain a still more touching beauty' because they already possess the radiance that surrounds our own memories. The past time only serves to intensify their attraction, because the experience of time guides our experience of self. In the preface to *Sesame et les lys* Proust recalled two ancient columns standing in the Piazzetta San Marco in Venice that embody, with striking immediacy, the presence of the past in the midst of the here and now. Amid the hum of traffic in the square, they bear witness not only to the time lost, but also to the time of art that will never be lost in Proust's life. 'These beautiful strangers, come to us from the Orient over the sea, were living out among us, in a public square, the days of the twelfth century, interposing them in our today.' Not content with this, Proust used the image of the smile as a metaphor for the life of art when he wrote of the two columns that 'their pensive smile still shines forth'. Those two stone 'enclaves of that past which emerges in a familiar form in the midst of the present' seem 'risen again among us who can approach and touch them, as they stand motionless in the light of the sun'. Time past, restored to life in one's memory. Proust's travels are thus symbolic acts. In the time that lives both in the travels and in the memory of past travels, the 'self' reawakens to life the dead time that lies buried in works or in places.

A DEATH IN FRONT OF VERMEER'S 'PATCH OF YELLOW WALL'

In October 1902, as though embarking on a voyage into the past, Proust set out on his second visit to Belgium and Holland, in the course of which he was to encounter Vermeer's *View of Delft* (illus. 83). There is no record of his first impression of this work, which he happened on in The Hague at the Mauritshuis. It was not until 1921, when he saw the painting again in Paris, that he recalled the earlier encounter, and it was only on this later occasion, so he tells us, that he discovered the secret of the 'patch of yellow wall', whose dazzling brightness, like a revelation of art, ends the life of the writer Bergotte in *À la Recherche*. This 'element of pure painting which represents nothing', as Philippe Boyer puts it in his poetical Proust book, becomes the idea that runs like a thread throughout

Proust's *œuvre* – the *idée fixe*, as Jorge Semprún calls it in his Proustian novel, *The Second Death of R. Mercader*.

On his early journey to the Netherlands Proust took along with him, as a sort of tour guide, his copy of the eighth edition of Eugène Fromentin's travel book *Les Maîtres d'autrefois* (The Masters of Past Time). It was not a recent work, and the journey it describes had been made prior to 1876. In his preface, Fromentin declared at once that he was 'only presenting the … impressions of a complete dilettante' and offering no more than preparatory sketches for a book. Proust, who was himself preparing to write a major book when he embarked on a pilgrimage to an earlier age, started a fictitious dialogue with Fromentin. Fromentin's assertion that in Dutch painting 'there is a complete absence of what is nowadays deemed subject-matter for painting' reappears in Proust's essay 'Contre Sainte-Beuve' in the general dictum that 'the beauty of a painting is not dependent on what it portrays'.

But Fromentin made no mention of the one painter who meant everything to Proust, nor of the *View of Delft* that he so loved. This silence, which allowed Proust to fill the void, can readily be explained. It was not until 1866 that the radical democrat Théophile Thoré, using the pseudonym of Bürger (burgher), had made Vermeer's name widely known, even though the *View of Delft*, had been acquired on behalf of the Dutch nation as far back as 1822. André Malraux was therefore correct when he wrote in his *Musée imaginaire* that for a long time Vermeer's name had been forgotten, though Fromentin's silence may also have reflected an antipathy towards Thoré. On his arrival at The Hague, Fromentin went promptly to look at the sea and, finding it empty, had imagined it as a painting, as though the Old Masters might return the next day to paint the sea. Reading this passage, Proust suspected that the author had deliberately conjured up the invisible presence of Vermeer (*vers … mer*) in this passage.

Proust's journey, so it seems to his readers, reached its true destination when he gazed into the clear mirror of Vermeer's light. Many writers have followed him, like pilgrims, to The Hague, to let themselves gaze, as Proust once gazed, on the *View of Delft*. On 1 May 1921 Proust wrote to the art critic Jean-Louis Vaudoyer, whose first article on the 'mystérieux Vermeer' had just appeared: 'Once I had seen the *View of Delft* in the gallery in The Hague, I knew that I had seen the most beautiful picture in the world.' Now the *View of Delft* had come to Paris for an exhibition, but it was another three weeks before Proust, who was bedridden, could summon up the resolve to visit the exhibition: 'Would

you be kind enough to take along a dead man who will prop himself on your arm', he asked Vaudoyer in an early morning telegram. In the novel, Proust's *alter ego*, Bergotte, actually dies in the course of his visit. The novel's narrator reads of the death in the newspaper, and similarly it was in a newspaper that Bergotte had read about the exhibition at which he was fated to die.

In this labyrinth of fiction and reality, Vaudoyer's articles provide an unexpected clue. Proust even 'translates' them into his own text, so that Vaudoyer's gaze fuses with his own. Now that we are so familiar with Proust's version, it is a considerable surprise to read in Vaudoyer: 'The houses are painted with such precious matter that one could just as easily imagine that one was looking at a ceramic as at a painting, if one were to isolate a small area (*surface*) and forget about the subject-matter (*sujet*).' In a second commentary on the painting Vaudoyer adds, by way of elucidation, that there is in Vermeer's art 'a kind of Chinese puzzle'. There it is, the famous patch of yellow wall, which, however, only really began to shine when, in Proust's novel, it acquired a place that it lacks in the actual painting. Vaudoyer's reference to the 'precious matter' also has the ambivalent effect of making the colours shine with a radiance that does not stem from the pigment alone.

For Proust, Bergotte's death in front of Vermeer's painting pointed to the mysterious force that causes art to become an obsession in the real lives of artists and writers. 'Rashly', Bergotte had given up his life for the small patch of yellow wall, whose colour he had failed to match in his dry texts. 'A score of times' he had begun 'a piece of work … like the patch of yellow wall painted with so much skill (*science*) and refinement by an artist destined to be for ever unknown and barely identified under the name Vermeer' (v, p. 208). The work was directed at an imaginary goal, a goal that lay not so much *in* the work as *behind* it. The small area of yellow wall opens in Vermeer's picture like blinding light flooding in through a window, even though it is not to be found anywhere, unless one chose to identify it with the shining roof that in Proust's description has lost its materiality (illus. 85). Hypnotically, and with increasing intensity, Proust invokes this 'little patch of yellow wall', forcing it into being despite its absence from the actual picture.

Bergotte should have remained in his sick-bed. 'But an art critic [had] written somewhere that in Vermeer's *View of Delft* … a picture which he adored and imagined that he knew by heart, a little patch of yellow wall (which he could not remember) was so well painted that it was, if one looked at it by itself, like some priceless specimen of Chinese

art, of a beauty that was sufficient in itself' (p. 207). Thereupon Bergotte rose from his bed to visit the exhibition, just like Proust. 'At last he came to the Vermeer which he remembered as more striking, more different from anything else he knew, but in which, thanks to the critic's article, he noticed for the first time some small figures in blue, that the sand was pink, and, finally, the precious substance of the tiny patch of yellow wall', and 'he fixed his gaze, like a child upon a yellow butterfly that it wants to catch, on the precious little patch of wall' (p. 207). There and then he confessed to himself that he should have written using such colours and should have 'made my language precious in itself, like this little patch of yellow wall'. In a 'celestial pair of scales' his life was weighed against 'the little patch of wall so beautifully painted in yellow'. He repeated, over and over again, 'Little patch of yellow wall, with a sloping roof, little patch of yellow wall' (p. 208).

In the original French the patch of wall is 'un pan de mur', an expression that Proust employed to evoke an association with a field of vision or a window light. 'For a long time,' – so he introduces this *topos* – he used at night to think of Combray, which he remembered only as a 'sort of luminous panel (*pan*), sharply defined against a vague and shad-

85 Jan Vermeer, Detail from illus. 83.

owy background'; here he had spent his only night with his mother present in his room (I, p. 49). The yellow creates a light in the blue darkness of the work, but it symbolizes transparency in such a way that it could signify death just as well, or the transformation of life into art. In Balbec, so we read at the end of volume II, 'Within a Budding Grove', the open window looked out every day in summer on to the 'same patch of sunlight' (*pan de soleil*), but the summer daylight that Françoise let into the room when she opened the curtains 'seemed as dead … as a sumptuous millenary mummy from which our old servant had done no more than cautiously unwind the linen wrappings before displaying it, embalmed in its vesture of gold' (II, p. 618). In the excursus on Impressionism, we encounter the window again, this time in a more prosaic way. 'How often, when driving, do we not come upon a bright street beginning a few feet away from us, when what we have actually before our eyes is merely a patch of wall (*pan de mur*) glaringly lit which has given us the mirage of depth.' In the same way our mind substitutes for a painted motif 'that other [the real one] for which, in the flash of a first illusion, we mistook it' (III, p. 484). The close interpenetration of illusion and vision enabled Proust to focus the modern art of experience wholly on the viewer, who turns a given work into his own image.

Jorge Semprún and Philippe Boyer have, like other writers, re-enacted Proust's ritual of seeing what *is not there* but *comes into being* through the rapture of their gaze as it recreates Proust's own. To keep the yearning alive, Boyer writes, the work needed to withdraw into its absence, so that the longing gaze never came to rest on what it sought. Here psychoanalytical interpretations suggest themselves. And yet we must not forget that around 1920 art discourse had begun to explain the notion of art as a mere fiction based on agreement, as we notice most clearly in the work of Marcel Duchamp (see p. 281). In the new century, art continued to flatter the 'self' for a while. But the temptation to adopt a soberly rationalistic approach and focus primarily on neutral formalism or abstraction had already won the day, while Proust was still celebrating the 'self' in contemplating a patch of yellow wall.

RUSKIN'S CATHEDRAL IN PROUST'S MEMORY

When Ruskin died in January 1900, the young Proust wrote an obituary for him, as though he wanted to take on Ruskin's work in an exercise of memory. Proust also dutifully re-enacted the 'pilgrimages' that Ruskin had made in France, going in search of Ruskin in the places Ruskin had loved.

Proust first made these journeys mentally, through Ruskin's works, before setting out on real journeys to the places they described. These were journeys of memory or journeys back to Ruskin's time – just as Ruskin himself had gone in search of the memory of forgotten Gothic art. When Proust, following in Ruskin's footsteps, was at Amiens in September 1901, he had already started translating Ruskin's *The Bible of Amiens* into French (illus. 86). When the translation was published in book form in 1904, Proust prefaced it with his various writings on Ruskin.

It is unlikely – yet the thought is inescapable – that Proust visited Amiens cathedral with the intention of reading it as Ruskin's Bible. The cathedral, it seemed, was not solely a building, but a book whose pages Ruskin had read. Proust at last saw the Bible itself, the book of books, living on in the cathedral's sculptures. It lived on in Ruskin too, when he incorporated biblical texts into his own writing as a means of understanding the cathedral. Proust went further down this path, urging his readers to travel to Amiens equipped with Ruskin's writings, there to contemplate 'a statue beloved by Ruskin', but also to discover a cathedral which is not just a bible in stone but, in the light of Ruskin's reading of it, 'the Bible itself'.

The cathedral once had taught the faith to the people of its own time, but it continued to do so still 'in a kind of open book, written in a

86 John Ruskin, A drawing (engraved by G. Allen) of the northern porch of Amiens Cathedral, from Ruskin's *The Bible of Amiens* (Orpington, Kent, 1880–85).

solemn language in which every letter is a work of art but which no one now understands'. Even if it now had no more than aesthetic significance, this was nevertheless enough to evoke sensations that 'appear to us as true reality, beyond our [earthly] lives'. Proust chose Ruskin as his mentor to help him understand the cathedral. 'Even before I knew whether I would find it there, it was Ruskin's soul that I sought: it was imprinted on the stones of Amiens as deeply as were the sculptors' souls, for the words of a genius provide everything with an immortal form as surely as the chisel does.' And thus Proust went to Amiens 'with the desire to read Ruskin's Bible there', just as he made a pilgrimage to the *View of Delft* in search of Vermeer's 'soul'.

Ruskin's *Bible*, however, was a record of fleeting traces left on the building, or of personal forays through the building that would appear almost random if they did not reveal a different kind of unity, that of the pattern of Ruskin's thought (*pensée*). Contrary to an average response to art, Proust saw the Gothic motifs becoming imbued with Ruskin's ideas, as though the ideas had taken on a corporeal presence in everything that Ruskin's eyes had rested on. Reading Ruskin before visiting the actual sites, Proust encountered the lengthy description of a tiny figure that Ruskin had chosen from among a thousand others on the portals of Rouen Cathedral, and was 'seized with the desire' to find this inconspicuous detail for himself, 'for nothing dies which once has lived'. 'The sculptor's thought' had been reanimated, so to speak, by 'Ruskin's thought'. A cathedral reared up all around him like a mountain range, but in this landscape Proust headed confidently for the place where Ruskin's gaze had rested. In his architectural drawings too, Ruskin had repeatedly captured an ephemeral impression in order to invest it with the colours lent it by the time of day. On every stone sketched by Ruskin 'you see the nuance of an hour blended with the colour of the centuries'.

In the cathedral at Amiens, Proust followed the route prescribed by Ruskin, because he wanted to match the cathedral's topography with Ruskin's *Bible*. Repeatedly he paused to consider how the life of art was subject to the laws of time. Thus the *Vierge dorée* prompted an excursus that was almost a rehearsal for what was to be the topic of his life (illus. 87). This statue dominated the south portal, where the beggars – perhaps the same ones – still occupied the places where Ruskin had seen them. The statue had once been gilded, but now, at a set time each day, it was bathed again in the golden light of the passing sun's rays. 'It was this fleeting touch which seemed to call forth, again and again, her

centuries-old smile.' Ruskin had written of this smile as he 'recollected, and opened his heart' to his readers.

'Standing there with her unique smile, which not only makes a person of the Madonna, but an individual work of art of the statue', she seemed to dismiss the temptation to see the portal as a museum where one came to see her 'in the way that visitors from afar have to go to the Louvre to see the Mona Lisa'. It would be sacrilege to move her from here to any other site. 'As she stands there with her unique smile, how I love the *Vierge dorée*'; for Proust she fills the rôle of another, forbidden love. But the power of time will eventually bring to an end even this 'medieval springtime, so long extended', and with it our aesthetic appropriation of her. 'One day even her smile (which has, in any event, already outlasted our faith) will be lost through the weathering of the stones which bear its gracious charm.' In the statue's smile we may recognize another, which can be only a metaphor: the smile of art.

87 The *Vierge dorée* at Amiens Cathedral.

But Proust pursued still another train of thought that obliged him to admit a more powerful impression imprinted on the memory than that of art. 'I believe I am wrong to call [this Madonna] a work of art', as she belongs to a particular place from which she derives her name, just as people are individually named. Though it may not have the 'universal claim of a work of art', the statue nevertheless 'exerts a stronger hold on us than works of art can'. In museum works, which have lost all ties with a particular place and are like orphans in an institution, Proust saw a symbol of alienation. In the Louvre 'the *Mona Lisa* is only da Vinci's *Mona Lisa* … Who is concerned to know where she was born?' It was not even possible to regard her as 'uprooted', since there were no roots to connect her with a place that was her natural home. 'We cannot say the same of her smiling sister … She has gazed down for centuries upon the people of the city whose oldest and most permanent resident she is.' Thus the statue is 'not a work of art but a beautiful friend whom we have to leave behind on a melancholy provincial square'. But since works of art, too, remain imprinted on our memory, Proust introduces another hierarchy of values, so as to achieve a ranking of different kinds of memories: 'In my room a photograph of the Mona Lisa preserves only the beauty of a masterpiece, whereas a photograph of the *Vierge dorée* takes on the melancholy of a [personal] memory.' At this point, as though troubled at having said 'only' in relation to a masterpiece, Proust broke off this digression and resumed his tour of Amiens cathedral.

A place one loves will create, in Proust's view, a stronger bond than a masterpiece, which cannot be remembered as a place of its own. A museum offered only a kind of asylum for a randomly acquired collection. But in addition to having no place of its own, art also ceased, during Proust's early years, to represent real places in the Salon exhibitions. In his novel Proust describes a picture by Elstir in which the local hospital looks as beautiful as the cathedral, as though there were now 'no such thing as Gothic … no such thing as a masterpiece' (III, p. 486). In what he wrote about Vermeer, therefore, Proust turned the tables by identifying, in a painting from an age long past, a spot that existed only in his own imagination – the 'patch of yellow wall'. Yet Proust already sensed that the very concept of the individual was impermanent, and so he opposed its loss by glorifying an art that retained its significance through memory. Works of art had withdrawn into the private imagination.

MONET'S CATHEDRAL SERIES

In Proust, 'Ruskin's *Bible*' has, as it were, a secret counterpart in what one might call 'Monet's *Bible*'. Proust had already seen the series, famous even then, of 28 cathedrals (or 28 views of the same cathedral) in the Paris gallery of Paul Durand-Ruel, where they were exhibited for the first time in 1895. In his introduction to *La Bible d'Amiens* Proust referred to Monet's series as 'Rouen Cathedral at the different hours of the day'. Reading Ruskin imperceptibly changes into looking at Monet's paintings when Proust describes Ruskin's subject, the west front of Amiens Cathedral, much as Monet had painted the west front of Rouen Cathedral (illus. 88). This transition from one to the other has a subtle significance. Monet's painting and Ruskin's description exemplify the analogy between reading and seeing that Proust was to uncover. Whenever a place is encountered by the viewer or reader it has already been filtered through the gaze of a painter or a writer. Thus Proust found Amiens already located in Ruskin's memory. In a magnificent cascade of visual images Proust unfolds an epic of perception by translating Monet's painting into Ruskin's language in order to describe the 'vague but powerful impression' that the image of memory evokes as Proust looks at the building:

> When you see the west front of Amiens Cathedral for the first time − blue in the mist, radiant in the morning, drenched with sunlight and sumptuously gilded in the afternoon, roseate and coolly nocturnal at sunset − at whichever of these times … captured by Claude Monet in his sublime canvases where the life of this human creation is revealed, a creation which however nature has reclaimed by enveloping it in her embrace, a cathedral whose life, like that of our Earth in its double revolution, uncoils down the centuries and yet is daily renewed in a fresh beginning − then, when you peel away the changing colours in which nature clothes it, then you receive from this façade a vague but powerful *impression*.

The radical politician Georges Clemenceau had used the expression 'Révolution de cathédrales' as the title of a famous essay on Monet published in 1895, and Proust alludes to it here. In that essay, the term 'revolution' denoted 'a new way of seeing' and thus a revolution in art, whereas Proust speaks, in a subtle contradiction, of the temporal changes

88 Claude Monet, *Rouen Cathedral: Portico, Morning Sunlight, Harmony in Blue*, 1894, oil on canvas. Musée d'Orsay, Paris.

of light caused by the revolving planet. The 'life' Proust mentions, again in a verbal allusion, was seen by Clemenceau as shining out of the cycle of paintings that, hanging on all four walls of the gallery, re-enacted the daily cycle of the changing light. And, finally, the 'vision' mentioned by Clemenceau and reused in Proust's text on Ruskin, anticipated Proust's later comments on the *View of Delft*. It was natural for Proust to see Monet's portrayal of Rouen cathedral as a '*Vue de cathédrale*', because it represented a modern gaze that had supplanted the ancient cathedral itself. In fact, Vermeer's 'patch of yellow wall' gains a further significance when we realize that Proust intended it to remind us of Monet. For what else was Monet's painting but a '*pan de mur*' soaking up light until not just the cathedral's stone front but also the painted canvas became a window of transparency?

Monet, always (in Maupassant's phrase) 'hunting such impressions' as he could not translate fast enough into pictures, chose the cathedral's immobile facade as his subject precisely in order to contrast it to the shifts in light: 'Everything is in flux, although there is nothing but stone', he explained in a letter. By choosing precisely a sacred motif as the vehicle for displaying the declining importance of the figurative motif in art, Monet championed the modern liberation of the gaze, even when the motif is reinvested by our gaze with a utopian dignity. Though we discern nothing but light and our own gaze, we accept the motif as depicting a place – a place that, as a Gothic cathedral, has already transformed itself for us into a site of memory.

The same ambivalence that detaches the gaze from the picture's motif is also inherent in the concept of a series, a concept that marks a change in the aims of Impressionism. In the dynamic and open-ended series Clemenceau recognized a modern principle, one that captured the rhythm of life in the flow of time and denied, in a most striking manner, the self-contained entity of a single work of art. Monet confessed in his letters that he regularly had 'difficulty in painting what I perceive', and considered it 'dreadful arrogance' ever to claim that a picture was definitely finished. Despite everything, however, he re-established the myth of art when no longer working on a single picture frame, but, on a series that used an entire exhibition room as a stage where the artist's vision proclaims itself to be absolute (illus. 89). Clemenceau had understood this intention when he called on the French President to acquire the *Cathedrals* for the nation, thereby giving Monet the opportunity to demonstrate 'the ultimate perfection of art'. Rouen's cathedral itself was considered a national monument that Monet's modern set of paintings

89 Installation shot of an exhibition of Monet's paintings of Rouen Cathedral held at the Musée des Beaux-Arts, Rouen, in 1994.

re-enacted. The concept of the masterpiece re-emerged in an orchestrated set of works, as also in the later *Nymphéas* (Water-lilies) painted in his garden at Giverny.

Monet's *Cathedrals* represent that momentous shift in the relationship between work and gaze by which the gaze (rather than the motif seen) itself became the actual meaning of the work. In the city of Rouen, Monet subjected himself to a laborious ritual as he attempted to capture, in each of the many pictures in the series, the brief moment when a particular light fell on his motif. He regularly took his seat at an open window where he studied the daylight, almost watch in hand, surrounded by other canvases awaiting their turn. The pursuit of *instantanéité* – which, as he repeatedly complained, the process of painting was slow to capture – was a vain attempt to let rapid perception assume power over the time-consuming production: painting (unlike, for instance, sketching in ink in the Japanese manner) simply did not possess sufficient speed for such experiments. The transient moment, living on as a painted memory, celebrated a perceiving self that triumphed over matter. The work of art, whatever the subject, paradoxically embodied the passing gaze it attracted.

RODIN'S BOOK OF CATHEDRALS

The first instalments of Proust's great novel had already appeared when, in March 1914, six months before the outbreak of war, Rodin published his travel-book *Les Cathédrales de France*, the fruit of years of preparation. As exercises in perception his 'notes, made at various times', as he says in his chapter on Chartres Cathedral, resemble the spirited drawings included in the book. These drawings have found as little favour as the writing, because they have been erroneously treated as works, whereas in fact they were simply admiring glances recorded as *aides-mémoire*. Often they consist of inconspicuous details – a velvety shadow in a portal, for instance – which under Rodin's eye become living entities. In his dialogue with the subject, Rodin reveals a suprising affinity with Proust's way of looking at the cathedrals during his early 'pilgrimages'.

At that time French opinion regarding cathedrals was divided: some people were filled with national pride, others felt only distaste for what they saw as a useless and burdensome legacy. When, in 1905, anti-clerical legislation led to a total breach with Rome, Proust warned publicly that this shift could hasten the 'death of the cathedrals', which he would see as a betrayal of national culture. It took the destruction wrought by the Germans in the Great War to establish a fresh consensus, which Proust later, in 1918, supported in his essay 'En Mémoire des églises assassinées' (In memoriam to murdered churches). After the wanton bombardment of Reims had caused general outrage, Rodin was hesitant to align himself with a new consent that identified the enemy of the cathedrals with the foreign enemy. He had, after all, only recently been engaged in a struggle with his fellow Frenchmen, passionately defending the cathedrals and denouncing the dismal alternatives of slow decay or unsympathetic restoration. He wanted to open his compatriots' eyes to the living beauty of this ancient architecture in which sculpture too had been allotted the public rôle for which Rodin yearned.

A variety of reasons can be found to explain the lack of interest in Rodin's book, whose didactic message rapidly became dated. The book's argument could easily be interpreted as a cultural critique disparaging modern culture in comparison with the cathedrals. Not only was nature repeatedly invoked in opposition to civilization, but the impression was given that there was a need to return to the art of the ancient cathedrals, which, like nature itself, possessed a timeless modernity. At the same time, however, the idea of the 'cathedral of the future' was envisaged as a collec-tive endeavour that, in a new phase of modernism, would recall the spirit

of the old cathedrals, but emerge different in form and radically different in purpose. The cathedrals, as Le Corbusier pointed out, had once been white and thus modern, but they were no longer so and therefore presented a challenge to create a modern alternative. Rodin would have disagreed, and yet he too was fascinated by the ideal of the medieval masons' workshop in which, rather than egocentric artists, anonymous artisans offered their collective skills in the service of a great idea. There were masterpieces because masters had been at work, 'nameless masters of Gothic art', whose works 'are unified by one common spirit', as he wrote in his chapter on the church at Beaugency. The key word *masterpiece*, the term that one would least expect to find used for unspectacular elements of Gothic art, is positively drummed into the reader. 'A masterpiece is necessarily something very simple that contains only what is essential.' Even if nowadays people no longer understand 'the magnificent language of the masterpieces', the artist nevertheless needs to remain close to ordinary people and 'possess a kind of popular soul, so as to be able to conceive and create masterpieces'.

Leaving aside such polemics, the subject of the cathedral prompted two further ideas that united artists and writers prior to the Great War more than they knew themselves. In the discourse on the state of art, the cathedral contradicted a proliferating and arbitrary art production that had broken free from its moorings. Proust, when writing about the 'Death of Cathedrals', drew comparisons with Wagner's Bayreuth, for he still hoped for a new rebirth of the arts. The Gothic church inspired the modern mind to exalt its own melancholy and wallow in a sense of loss.

Rodin's written material slowly took shape, based as it was on the notes penned on his travels. The art critic Charles Morice offered to collaborate, but ultimately contributed only a so-called 'introduction' which was more than 100 pages long. He undoubtedly edited Rodin's notes, but Rodin's own prose was preserved, as the sketchbooks clearly reveal. The collection of notebooks built up over a lifetime became a fictitious travelogue with only a single subject, a subject filtered through the gaze of a single individual: the French cathedral, whose essence had been revealed to Rodin only by visits to many cathedrals. Appropriately these writings, which to Rodin represented the unity of his life, end with a 'Testament' in which he expounds, with reference to the cathedral, a concept of beauty he was unwilling to sacrifice to any kind of progress.

One hundred selected drawings embody the living gaze of the artist, which is the book's true theme. In the introduction Rodin sweep-

90, 91 Auguste Rodin, Illustrations for *Les Cathédrales de France* (Paris, 1914).

ingly equates the artistic approach 'of our Old Masters from the eleventh to the eighteenth century' with Gothic art. This artistic approach 'is man's unceasing co-operation with nature', whereas modern art has become alienated from nature. 'Gothic art is the religion that is natural to the atmosphere of France. Living art should not restore works of the past, but continue them.' This view also rejected the historicism of the time that treated Gothic art as a mere repertory of stylistic features.

In his travel notes Rodin repeatedly describes his experience of the cathedrals, so that his readers can turn them into their own experience. His casually written impressions include the life of ordinary people, of which the cathedral was a part. In a hand-written insertion on the page proofs Rodin apologized for his habit of placing himself centre-stage (*mise de moi*) – he wanted to be the medium through which the cathedrals regained their voice. 'As I enter this ancient church, it is as though I were entering my own soul', he wrote while visiting Melun. At Amiens the cathedral's forest of columns reminded him of a forest recalled from childhood. 'My memories rise aloft like these trees and become one with them.' In Reims, standing at night at the window of his hotel room, he contemplated the cathedral as though it were a living creature from which he yearned to extract its secret.

Rodin's coloured drawings celebrate the interplay of light and

92 Auguste Rodin, *Cambodian Dancer*, 1906, drawing on paper. Musée Rodin, Paris.

93 A 12th-century angel (incorporating a sundial of 1578) at Chartres Cathedral.

shade that he saw as the pattern of life (illus. 90, 91). The cathedrals themselves, he says, were once painted, not with brush and pigment but with the 'light and shadow of the day'. Medieval craftsmen had staged this drama with a sensitive touch. In this sense architecture too was produced with light and shade. In the coloured sketches individual motifs are broken down into the effect they have in a transitory light, so

that gaze and object fuse into a single *vue* of the kind painted in words by Proust. For this reason Rodin chose only motifs we can take in at once. The motif guides a gaze that in its turn represents the subject whose gaze it is.

The cathedral would appear to be the least suitable motif for this, and yet it stimulated Monet, Rodin and Proust to discover their own gaze as the tool of modern consciousness. It is not my intention to reduce these three to a single view, but they do have in common a nostalgic gaze that registers the cathedral as the symbol of a great loss. The modern *culture of the gaze* reached a new level when the latter was immersed in personal memory. This is why the next generation began to look boldly forward, appealing to the future against the shadows of memory. For Monet, Rodin and Proust the cathedral represented an old confidence that was missing from modern artistic practice.

The new self-confidence of the gaze, which compensated for the lack of confidence in the work itself, led Rodin to recognize in the statue of the 'angel of Chartres' (illus. 93) the beauty of the Cambodian dancing girls he had just sketched (illus. 92). He equated motifs that were irreconcilably different because they were identical in the impression they made on him: his way of seeing allowed him to transform the ancient motif into a modern impression. At an early stage in his life he had praised the angel of Chartres for the 'devotion with which it shows us the hour that wounds and kills. Its beauty gives my soul a sense of equilibrium.' In his old age the carved Gothic figure reminded him of the grace of the Asiatic dancers, and he had no qualms about describing them in his book on cathedrals. Never, he wrote, had anything else 'made a comparable impression' on him. 'I return [to Chartres] and look up – and this angel *is* a figure from Cambodia.' It was only because he had seen the dancing girls that he could discern the beauty of the angel. It is impossible to separate the gaze from the motif itself. Thus Rodin and Monet produced impressions in the guise of works that presented themselves as the enduring memory of a brief, intense moment of seeing – the gaze of memory turned into, or merged with, a work of art.

11 An Invisible Masterpiece

PICASSO'S 'ARDUOUS NOWHERE'

It is only in the opening years of the twentieth century that we encounter a work that for a considerable time could justly be described as an invisible masterpiece, although it did in fact exist. It seems hardly credible that Balzac's idea should, in this paradoxical way, have been embodied in an actual work, and indeed a famous one, a work that is like a fanfare announcing the triumphal entry of a new phase of modernism. This is the enigmatic painting *Les Demoiselles d'Avignon* (illus. 96), with which the young Picasso was struggling in the spring of 1907. Today, many understand it to be a masterpiece because it is more prominent than any other work from that period. Yet there was a time when it had been seen only by a few initiates. Back then it had quickly become a myth because, despite the fact it was absent from public view, everyone was talking about it. But its true invisibility was built into it, for it hid the old idea of the masterpiece, even though Picasso overtly contradicted that very idea in the picture itself.

Les Demoiselles was not a work like other works. For Picasso it was a kind of battlefield on which he could try out new strategies in his struggle for the work. This picture was not simply a milestone on the road towards Cubism – otherwise it would be hard to explain the drastic change of direction he made in his next large-scale painting, the *Three Women* (illus. 100). In the course of working on *Les Demoiselles* he had evidently encountered problems that could only be overcome by changing the direction he had then taken. Perhaps the splendid failure of *Les Demoiselles* was partly due to the fact that at the time Picasso was competing with Matisse, and thus was obliged to make a dramatic detour. Even so, Picasso's impulse would still puzzle us if we did not know that barely two years earlier he had completed a work of a similar size that left unresolved all the questions he now grappled with once again.

Les Saltimbanques (illus. 94) had also been an invisible work for almost ten years – but more of that later. Rainer Maria Rilke lived with the picture for a whole summer in 1915, and he immortalized it in the fifth of his *Duino Elegies* (1923), where, in an extraordinary phrase, he

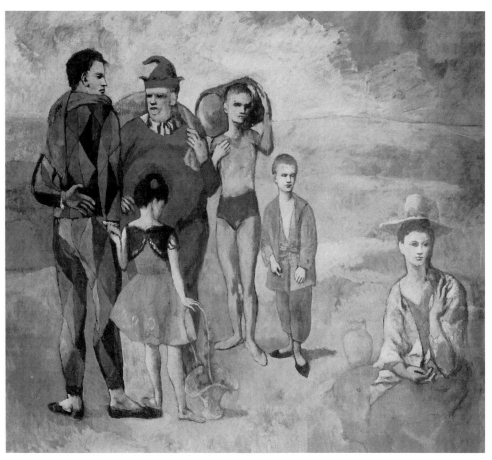

94 Pablo Picasso, *Les Saltimbanques (Les Bateleurs)*, 1905, oil on canvas. National Gallery of Art, Washington, DC.

refers to an 'arduous nowhere' (*dieses mühsame Nirgends*). The place where circus artistes perform is not a place in society, and these performers had long provided artists with an ironical, defiant image for themselves, as Jean Starobinski has shown in his admirable book. But Rilke's reference to an 'arduous nowhere' also provides a key to the concept of the work that Picasso so 'arduously' subverted in *Les Saltimbanques*. Once again he chose the large format suitable for a grand event, but ruthlessly purged it of all elements of action that would have required a specific setting. In this way the 'site' of the old pictorial narration was lost in the abstract 'nowhere' of a new kind of art.

The numerous preliminary sketches for *Les Saltimbanques* show clearly that Picasso reached his arduous goal only in stages, changing

direction on the way. This, of course, is the way that painters figure out the perfect composition for the work they have in mind, but in Picasso's case, step by step the sketches abandoned the original setting of a story. For a time he had envisaged a race-track close to where the jugglers are gathered, and for a while the young harlequin holding the little girl's hand was carrying a travelling-bag, as if about to depart, but in the course of the picture's development he lost his purpose for going. As though uncertain what to do next, the artistes loiter in their brightly coloured costumes, once meant for a performance, in a space that is no longer a specific place. With vacant eyes they gaze beyond each other so inexorably that their spatial unity dissolves.

Even while working on the canvas Picasso continued the process of freeing the subject from a defined environment and narration, as we can see from two earlier versions detectable beneath the final layers of paint. Both have circus settings, but it is as if the exercises have been abandoned because they are no longer performable. The artistes still look as though they are waiting for their entrances, but they are already becoming frozen in their rehearsal poses. This also means that the entertainment contained in the picture's subject-matter is at an end. This circus episode, depicted with wonderful empathy, recalls the tasks so long assigned to painting when it still had a narrative function; but the painting itself expresses resistance to that function, and Picasso comments only on his own situation. In this work he takes his leave of the great epic tasks in a collage of content whose motifs seem, in the picture itself, like echoes of a lost story. The isolated female figure who is partly cut off by the lower-right edges of the picture could have stepped out of a Pompeiian fresco, and she waves to us from the limbo of a time that is no longer present.

Yet the colours are bright: the morbid coldness of the 'blue period' is forgotten. Picasso now affirmed the artistes' milieu as a symbolic site of performing art, and so abandoned his earlier emotional railing against life. The melancholy that hovers over the picture is no longer inherent in the subject itself but pervades the void left by the disappearance of the narrative. Despite the new absence of narrative, Rilke decided to describe the picture in poetry. Yet he was sensitive to the new ambivalence lodged between subject and art. Picasso's jugglers have, as Rilke wrote, landed on a 'carpet forlornly / Lost in the cosmos'. He offered 'these itinerant artistes, even a little / More fleeting than we ourselves' a place within the beholder. The longer the viewer looks at the picture, the more 'the pure too-little' veers into 'that empty too-much' that reveals the victory of art over traditional subject-matter.

At that time, in the summer of 1915, Rilke's hostess, Herta König, had purchased *Les Saltimbanques* in Munich from Heinrich Thannhauser's gallery. Thannhauser had managed to buy it at auction in Paris at a sensationally high price in March 1914, when it had made a triumphant appearance on the art scene after slumbering for seven years in an investment fund's vault while André Level's business associates planned their art market coup. Today, fascinated as we are by a linear stylistic development, we all too readily tend to overlook *Les Saltimbanques* in revolutionary Cubism's prelude. But for Picasso the picture represented the longed-for breakthrough when, long after his Cubist period, it was the first of his works to attract the aura of a masterpiece (which only later passed to *Les Demoiselles*, painted two years after). It was probably this success that impelled him to resume figurative painting, which had been interrupted by the Cubist interlude. When Picasso took Ingres as his model, he was choosing a historical style in order to forge a connection with a great French tradition.

On 1 November 1905, before the canvas of *Les Saltimbanques* was even dry, Guillaume Apollinaire sent Picasso two poems he was not to publish until years later. One of them, 'Saltimbanques', seems to be a response to Picasso's painting. The same poem later inspired Picasso's theatre curtain for the ballet *Parade* in 1917 (illus. 140). The poem bathes the entertainers' stage in the mysterious light of that earthly transcendence Apollinaire saw in art, and in the closing line Harlequin is referred to as 'Trismégiste', which belongs to the Hermes of ancient esoteric lore. The Harlequin Trismegistos, who holds the keys to the hidden meaning of the world, is the prototype of the ever-reborn artist. Apollinaire's view of Picasso as a lyricist was to remain a certainty in Picasso's own view of himself (see p. 345).

MATISSE ON THE JOURNEY TO ARCADIA

While Picasso was painting *Les Saltimbanques*, Matisse too had 'a *tableau* in his belly', as the brothers Goncourt might have said, though he did not achieve success easily. *La Joie de vivre* (also called *Le Bonheur de vivre*) was exhibited in 1906 (illus. 95), and later that same year was displayed in the Paris salon of the American Leo Stein, whose sister, Gertrude, had recently been painted by Picasso (illus. 97). When the two artists met at the Steins' salon, Matisse, the older of the two, talked wittily, while Picasso, as Fernande Olivier later recalled, seemed ill at ease. Having suffered his rival's achievement thrust in his face, Picasso furiously

embarked on a larger painting in order to establish himself as the avant-garde's leader. But *Les Demoiselles* no more succeeded than *Les Saltimbanques* in solving the difficulties resulting from the anachronistic ambition of creating a grand work. Soon enough *La Joie de vivre* disappeared altogether, having been whisked off to the hideout of an eccentric collector, Albert Barnes, and only became known to the public at large at exhibitions held in 1993. The unequal history of the two pictures is therefore the reflection of their unequal myth of invisibility.

Matisse, too, was facing the inhibiting effect of the figurative motif contradicting the utopian purism of art, and he therefore chose a subject traditionally connected with a dream-like fiction – Arcadia, the land imagined by classical poets and painters, for which Poussin too had once embarked. Cézanne – a version of whose *Bathers* Matisse himself owned – had been another of the great travellers whose ranks Matisse now joined, but Matisse chose a new route. The classical and the avant-garde seemed reconcilable, so long as one did not mistake classicism for a stylistic ideal.

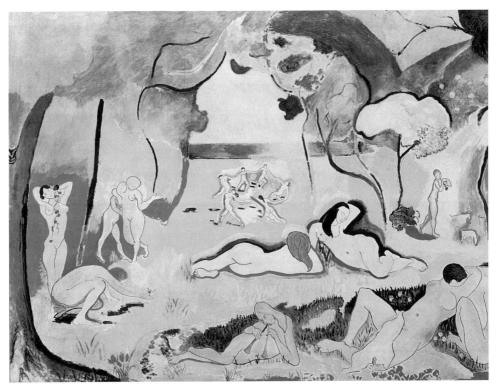

95 Henri Matisse, *La Joie de vivre*, 1906, oil on canvas. Barnes Foundation, Merion Station, Pennsylvania.

Matisse's preparatory exercises included the *Pastorale*, a title which of itself evoked the vision of Arcadia. Another painting placed Arcadia, with its sensual liberty, on a French seashore. The surprising choice of a literary title for the latter work – *Luxe, calme et volupté*, a quotation from a poem by Baudelaire – expressed a secret complicity with poetry as a guide. The title sounds like a description of Arcadia, where 'ease, peacefulness and sensuous enjoyment' reign, although Matisse omitted 'order and beauty', also present in Baudelaire's lines, because of their academic connotations. In his diary André Gide praised Baudelaire's 'verbal garland' as the 'perfect definition of the work of art'. One ought, he added, use those terms 'as titles for the chapters of an aesthetic treatise'. Although Matisse can hardly have known of Gide's comment, he did indeed create the large canvas of *La Joie de vivre* in terms of a painted treatise.

In *La Joie de vivre* the dream of Arcadia is a subject woven together in a rhythmic flow out of a number of individual motifs linked together as if by a process of free association. The deconstructed subject dissolves the boundaries between figures and pictorial signs, as though the creation of the painting was forever being renewed. All the figurative elements are subjected to a vibrating rhythm, in which transformation is the only law. There is a foreground 'prologue' where a piping shepherdess lies in blue grass and two lovers melt into one another. There is also the epilogue of a distant seashore, where dancers perform. But in between, the physical space dissolves into a carpet-like form, from which the nymphs, in small islands of colour, effortlessly rise. The colours are somewhat oriental, but the naked figures are akin to the beautiful boys and maidens of classical times.

We know that *La Joie de vivre* has an affinity with Mallarmé's famous eclogue 'L'après-midi d'un faune' (The Afternoon of a Faun), in which the poet achieved a similarly modern re-creation of classical antiquity in poetry. The poem, which appeared in 1876 with illustrations by Manet, depicts, as it were, the musical score of the dream in a free language that Matisse turned into a pictorial grammar. Mallarmé's faun wishes to 'perpetuate' the nymphs he has just glimpsed, whose 'bright, light rosy flesh so eddies in the air'. One could describe Matisse's picture in similar terms. But immediately the faun checks himself – 'Did I love a dream?' He becomes convinced that his confused imaginings are caused by his thoughts of roses: 'la faute idéale de roses'. Alas, the nymphs he desires seem to live only in his imagination. Even the 'languorous yellow hours' in which a flute is heard near the lovers elapse on a nameless island whose

flowers lose the shapes in which they had been enclosed.

Who would not be reminded by these words of the luxuriant plants in the painting, which subtly change into mere bright areas of paint and rich streams of colour? The metamorphosis of the representational motif seems to be the true aim in the picture. At times in Mallarmé's poem one feels that he describes the painting; though it is Matisse, of course, who was a reader of Mallarmé. Evidently the artist let himself be lured by Mallarmé, that idol of the avant-garde, into attempting to paint a dream-world, whatever the dangers of thinking in analogies might be. With its novel abundance of ever-shifting visual metaphors, 'L'Après-midi d'un faune' moved Matisse to compose a painting in which a congeries of images that collectively formed the subject was what the viewer experienced. In both cases free association replaced the need to depict only a world of objects. Just as in Mallarmé's case, the open structure of his eclogue no longer obeyed the dictates of that or any other literary genre, so Matisse no longer wanted to be constrained in the *tableau* by traditional pictorial genres such as landscape or history painting – even if he declined to turn his back on the world of objects.

What was happening here? This was no longer the struggle for a masterpiece, even if Matisse was once again ostensibly engaging in a traditional performance. He adopted the large format he knew would attract more attention, and he began his demonstration by transforming motifs into pure pictorial signs, as though concerned only to achieve a free syntax. Foreground and background survive in his painting like quotations from spatial perspective. They reveal themselves as a kind of stage direction that is no longer obeyed, and so force the viewer into a different order of perception. For a long time painting had only sought to attract the viewer's gaze in order to show him the world. Here that traditional readability is revoked, so as to focus the viewer's attention on painting as such. Starting with the title, the picture suggests associations among which the viewer is free to drift at will. The pictorial motifs, which have a strangely enchanted air, demand the kind of receptivity and understanding that we bring to poetry, thus inviting one to revive the ancient comparison – *paragone* – between the two art forms.

THE MASKS OF *LES DEMOISELLES*

We don't know what Picasso thought of Matisse's main work to date as he stood before it, sipping his aperitif, in the Steins' salon. But we do know that he responded to it by deciding to paint another large-sized

programmatic picture, even though he had only just finished wrestling with the large format of *Les Saltimbanques*. There could have been no more vehement contradiction of the serenely melodious *La Joie de vivre* than Picasso's aggressive *Demoiselles d'Avignon* (illus. 96), which he was working on by the spring of 1907. And yet the new picture occupies a comparable place in Picasso's *œuvre*. The deconstruction of the old concept of the definite work takes place precisely in the *topos* of the masterpiece, however little, by this time, the masterpiece was taken seriously. Instead of Matisse's tranquil tapestry with figures woven into it,

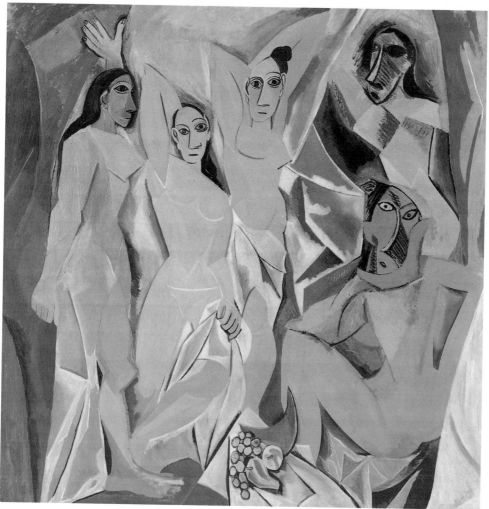

96 Pablo Picasso, *Les Demoiselles d'Avignon*, 1907, oil on canvas. Museum of Modern Art, New York.

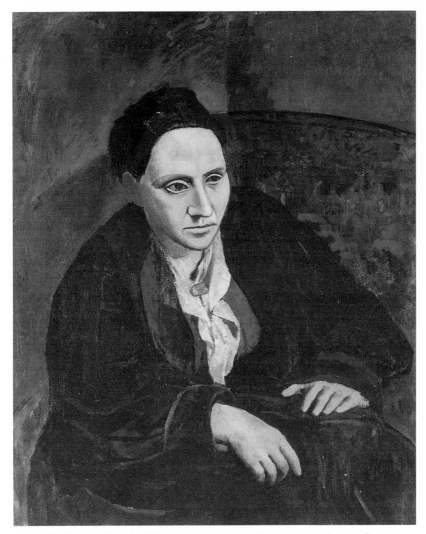

97 Pablo Picasso, *Portrait of Gertrude Stein*, 1906, oil on canvas. Metropolitan Museum of Art, New York.

here we meet the stare of a menacing wall of figures whose exotic masks warn us to keep our distance.

Picasso's painting, which at the time startled even his closest friends, abandons the traditional boundary that distinguished between a study and a work, now that the two no longer followed one another in a linear sequence. The various phases of the work contradict one other without either concealing or reconciling this contradiction. The African masks worn by the two figures on the far right were only added when

the canvas was repainted a final time, though this phase, like the previous ones, still left it looking like a study. The process of constant revision did not end with the numerous preliminary studies but continued on the canvas itself, as though the preparatory ritual had produced no result. The creative process was no longer directed towards a fixed goal. Picasso crossed a threshold as he progressively detached himself from any subject that could be narrated. For a time he had been thinking of painting a visit to a brothel by two male clients. One friend, the poet André Salmon, spoke of a 'philosophical brothel', as though to imply some kind of cultural prostitution. Picasso changed the subject into a parody that, at the same time, was intended to shock the public. The resulting change of perspective turned the viewer, before whose eyes a large curtain is drawn back, into a different kind of voyeur. For when this voyeur visits a painter's studio, he is a client with whom the painter negotiates a price. Such an implicit analogy impudently struck at the heart of art selling itself for money.

The naked women who, once the curtain has been raised, slowly disrobe are, as subjects, almost seduction personified. And yet they change before our eyes into sinister idols from a mythical world of sublime terror. Picasso builds this twofold effect into the way we perceive their bodies. The very fact that the figures are turned either towards us or away from us establishes them as physical bodies. And yet our perception of bodies is abruptly blocked by the missing space in which bodies could exist. They seem frozen into the surface of the picture. Instead of a window opening on to the world, the picture closes itself to form, in Balzac's phrase, a 'wall of painting'. The women look at us *from the picture*, not from somewhere else. They do still remind us of a situation in which they could seduce us, but they are sealed within what has been painted. Painting here overwhelms the viewer with its own total presence. In the crisis of any firm concept of the picture, a new self-evidence of the work has been achieved.

But Picasso could not force the work into this utter presence without revoking the idea of art itself. This is where the real problem began. Unlike Rodin or Matisse, Picasso did not turn to poets who would only answer the quest for art. But, like Matisse, he had fallen under the spell of 'primitives' that knew no national boundaries. Myths of origin were borne on the banners of a new art. Picasso determined to explore his own roots in order to become even more of a modern. For his own figures he used prehistoric sculptures from his Iberian homeland; its archetypes, he felt, looked at him. He had bought the sculptures from

Apollinaire's secretary, but without knowing that the secretary had stolen them from – of all places – the Louvre, whose stale museum atmosphere Picasso thought he was so determinedly leaving behind.

The search for a new canon was prefigured in the portrait of the writer Gertrude Stein (illus. 97), who had sat for Picasso 80 times by the winter of 1905. 'In the end he painted out the head, he told me that he could not look at me any more and then he left once more for Spain.... [I]mmediately upon his return from Spain [in 1906] he painted in the head without having seen me again and he gave me the picture and I was and I still am satisfied with my portrait, for me, it is I, and it is the only reproduction of me which is always I, for me. A funny story.' In a portrait, of all things, Picasso used an ancient face mask to create a picture that is a reminiscence of early Iberian art. The generic type, instead of the natural form, represented another kind of resemblance.

In June 1907, while *Les Demoiselles* was still on the easel, Picasso

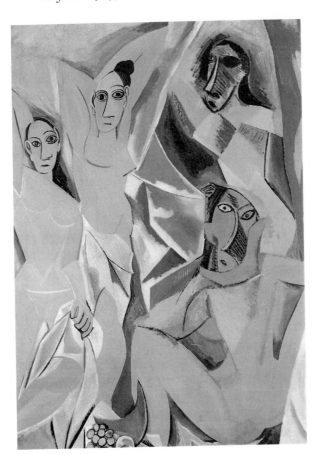

98 Pablo Picasso, Detail from illus. 96.

99 Painted wooden mask from Zaire. Koninklijk Museum voor Midden-Afrika, Tervuren.

visited the ethnological museum at the Trocadéro and, as he was frequently to recall, experienced a second initiation rite. Studying the African masks, which were, after all, nothing but sculptures, he suddenly knew 'what painting really is'. He found in them a 'logic and purity which European art has never attained'. He was not alone in this assessment, but it led him to place African masks over two faces in *Les Demoiselles* (illus. 98). As a result of this surgery, 'Africanism' confronts 'Iberianism' – in one and the same picture – with the evidence of an archetype that predates Western civilization. Though the African masks Picasso collected were only a few years old, 'primitive' art refuted art history's chronology.

A mask that enforces the ambivalence of presence and absence inherent in all images conceals a person, but with the paradoxical aim of presenting another person (illus. 99). Its transformative power made the mask the medium of mythic rituals. Picasso performed the theatre of art by carrying an ancient mask. Thus he transferred the iconic presence of ethnic art across an abyss of time into contemporary easel painting. This almost impossible synthesis was entrusted to the mimetic ritual of a self-styled Primitive. 'He always transferred those great rituals into his own picture', Gertrude Stein noted in her *Autobiography of Alice B. Toklas*, and in the process he reinvented himself as an artist. The ritual, which also

served to exorcise a secret fear was an act of animating the work with the soul of art, as it were, even if, as Gertrude Stein said, Picasso constantly 'emptied' his own soul. Picasso's ambiguous statement that this was 'the first picture I painted with a view to exorcism' plays with the idea of driving impure spirits *out* of the work.

Les Demoiselles positively trumpets the renunciation of the stereotypes of bourgeois art history. Confronted with the mythic age of the 'Primitives', the historical era even of classical antiquity shrank to insignificance. Over the horizon of art history, in whose annals there had been no place for it, *art nègre* came into view as the true art that had languished in oblivion for too long. Intoxicated by such a discovery, artists identified with the magi of ancient times. A few decades earlier, 'Primitives' had been either the early Italian painters or painters of naïve folk art in France. Now 'Primitives' were discovered outside Western culture. The myth of a prehistoric art supplanted the myth of classical art embodied in the historical masterpiece.

Such a utopian escape is easily explained by the situation in Paris at that time. Exhibitions, following one another in rapid succession, failed to provide the very orientation that was their aim. While the classicist Ingres was still in favour, the rebels Gauguin and Cézanne were already receiving retrospectives. Academicism seemed to survive on an equal footing with the avant-garde. Indeed, the avant-garde was itself in danger of becoming academic. In a similar situation, Gauguin had taken flight, but Picasso looked for a different escape route, one that did not involve actual exile. As a Spaniard from the peripherary of Europe, he felt free from the burden of the long tradition that so easily troubled French artists. But for him too, self-liberation needed a long road, and even forced him to unlearn his accustomred way of looking at the world. Thus the process of redoing the picture soon led him to Cubism, where the motif was to be neutralized by an analysis of its mere visual structure (see p. 335).

Primitivism offered fresh possibilities for bringing about a renewal of painting. The exchange of one paradigm for another at that time did not in fact prevent the crisis of the picture, however much it promised an escape from culture. The fascination exerted by the exotic and unfamiliar resulted from the lack of any explanation that could rob it of its mystery. The anthropological significance overshadowed the merely cultural. Since nothing in the 'primitives' resembled the familiar conception of art, they were identified with a quite different notion of art – as though they had not been thinking about 'art' at all. They had neither painted canvases nor taken part in fruitless discussions about the nature

of art. The beauty of the masks, at once naïve and savage, was misunderstood as an expression of freedom, while no one as yet paid attention to the formal constraints to which they were subject within their own cultures.

Compared with *Les Demoiselles*, Picasso's *Les Saltimbanques*, painted only two years earlier, appears surprisingly retrospective and sentimental, for it keeps alive the memory of a poetic narration. Though the physical world has been reduced to a pictorial metaphor, there still remains a space in which one can lose oneself. In the later work, the picture's surface absorbs this space within itself. The motifs, to the extent that they are still motifs, no longer introduce themselves by an association based on a narrative. Picasso's poetical friends complained about the loss of poetry that resulted from this unfamiliar iconism. The figures narrate nothing, resemble nothing, but they recall an archaic power of expression drawn from sources beyond Europe. The less one knew about the masks, the more one was willing to hail them as symbols for the birth of pure art. Their revision as new fetishes of art seemed to guide the faithful back to the shared roots of art and religion.

ANDRÉ BRETON AND THE MYTH OF *LES DEMOISELLES*

We now celebrate *Les Demoiselles d'Avignon* as the first masterpiece of modernism, although its revolutionary attitude hardly favoured such a celebration. A unique work usually has an equally unique genesis that is told and retold with a sense of awe. In the case of *Les Demoiselles* people feel all the more impelled to talk *about* the work because the work itself does not tell a story, except the story of its own origin. The discontinuities in its composition reveal the drama of a most unusual working process, and the questions *Les Demoiselles* still poses have prompted its interpreters to focus on the circumstances of its production, which by now have themselves become a myth.

We therefore tend to forget that the picture itself was a myth for many years, when people knew no more of it than the fact of its existence. Its long period of invisibility led them to dream of a picture that gave free rein to the imagination. In its absence it could only be present as a myth, like Frenhofer's 'unknown masterpiece' in Balzac's story. It stayed, unfinished, in Picasso's studio while he completed one new painting after another, as though it were the source of that whole generation of pictures. Only when it was released from the studio could it make its impact on the world, which it did not as a new work, but as one that had been

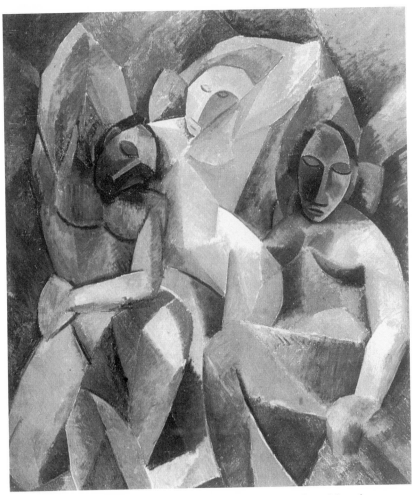

100 Pablo Picasso, *The Three Women*, 1908–9, oil on canvas. State Hermitage Museum, St Petersburg.

remembered for some time. Its second birth took place when it became visible to everyone. This time it was not the painter but the critics who ensured that the myth of the work survived its transfer into visibility.

The origin of this myth goes back to the spring of 1907, before the paint was dry on the canvas. Already the streams of visitors to the Bateau-Lavoir in Montmartre were spreading legends about that 'large painting', which shocked most of them. In April of that year Picasso invited Leo Stein, the owner of Matisse's *La Joie de vivre*, 'to take a look at the picture', but even in October, when Gertrude Stein arrived on the scene, there was no talk of buying it. An American journalist reporting

on 'the wild men of Paris' actually published a picture of the work in May 1910, but called it only a 'study by Picasso'. The 'six large female nudes', as they were numbered erroneously by André Salmon, still lacked a title in 1912 when he mentioned them in his essay on French painting. But in July 1916, nine years after the picture had been painted, Salmon included it in a small exhibition in which it was the only Picasso shown, and it was then that it was given its title, which contains an allusion to a red-light district in Barcelona. By this time Picasso was the undisputed leader of the Cubists, which made people curious to see the nine-year-old painting, even though it was not a Cubist work.

A different picture would have had a better claim to be a precursor of Cubism, if it had not already fallen into an oblivion that was to last for decades. This was *The Three Women* (illus. 100), the large canvas on which Picasso embarked immediately after completing *Les Demoiselles* and which he repainted several times between then and the autumn of 1908. Its primitivism, which here takes hold of the whole picture and brings out the corporeality of the figures in an almost violent way, was moderated only under the influence of the great Cézanne exhibition. In October 1907 it had been on view in its 'wildest' state when Gertrude Stein visited the studio with a friend. Some nine months later, in June 1908, Picasso wrote to the Steins, who were then in Italy: 'The big picture is progressing, but with what difficulty!' It was still not in its final state when, in that summer of 1908, Salmon had himself photographed in front of it, though by 1912 he was already confusing this work with *Les Demoiselles*. By then the Steins had bought it, but they sold it in 1913 to a Russian collector. The long odyssey of *The Three Women* that ended at the Hermitage at St Petersburg eliminated it as a rival of (and, maybe, a victory over) *Les Demoiselles* for ever.

As a result, the claim to be the first Cubist picture remained with *Les Demoiselles*. The legend was given its definitive stamp in the 1920s by André Breton, for now that Cubism had become synonymous with modernism and avant-gardism, Breton was able to establish the picture's 'historical significance' once and for all by linking it with Cubism. It seems strange that the Surrealists were prepared to adopt this cult of an old work, but they had not yet produced a 'school' in which the painters set the tone, and they therefore felt no constraint about reinventing Picasso's *œuvre*. They were not concerned to promote a particular avant-garde, but defined avant-gardism as a state of mind that created its proper style. This view helps to explain a number of apparent inconsistencies in the Surrealists' handling of Picasso.

At that time Breton had personal reasons for championing *Les Demoiselles*, since the death of Picasso's friend Apollinaire in 1918 gave him a chance of becoming the painter's official voice. Breton persuaded a prominent art collector, the fashion designer Jacques Doucet, to acquire an outstanding work. To this end he deliberately built up a myth designed to safeguard Picasso's position in the avant-garde, which by then was under challenge. Picasso was now living in the elegant rue La Boétie, and as a neighbour of the art dealer Paul Rosenberg, who was now exhibiting his work, he had become a favourite in smart society, which fuelled the doubts felt in avant-garde circles as to his loyalty to the cause.

Under these circumstances Breton decided to remind people of Picasso's contribution to the early avant-garde, and he chose for this purpose the work that had not featured in the controversy because of its relative invisibility. The debate he set in train is reflected in the letters written to Doucet. Even so, when Doucet finally bought the painting in 1924, the price he paid was so low that for a time Picasso refused to sign the canvas. Breton, however, continued to convince the owner of the importance of his purchase. 'I have blind faith in the beauty of this canvas', he wrote in December 1924, adding, in the same month, that without this picture it would one day be impossible to document the 'state of our culture'. In the Middle Ages, the picture would have been carried through the city streets like Cimabue's *Madonna*. 'I can only speak of it in mystical terms.' The great mythographer knew which examples to invoke. Picasso's early supporters also resurrected the work from the attic room of collective memory. Finally, André Suares drew a direct parallel between Picasso's *Demoiselles* and Manet's *Déjeuner sur l'herbe*.

The debate over the work is connected with the concern the Surrealists felt for their own rôle. Had the dead Apollinaire – who invented the term Surrealism – become part of the nation's history, or did he still live on in the activities of the Surrealists? Only Picasso could decide, for it was with Picasso that Breton wanted to create a new avant-garde. The doubts some expressed about Picasso's modernity, prompted by the ballet *Mercure* in 1924, therefore provoked indignation within Breton's group. There was a brawl in which Breton defended the painter's honour with his cane. The '*révolution surréaliste*' invented, in the journal of that name, a mythical genealogy in which the pre-war pairing of Picasso and Apollinaire was revived in the form of Picasso and Breton. Picasso delivered the requested portrait of Breton for the journal, and in return its July 1925 issue reproduced *Les Demoiselles* for the first time in France. The accompanying text, 'Surrealism and Painting', made it clear that Picasso had always been a

Surrealist. The masterpiece that had just been made visible was declared to be the mythic source of the movement.

In America the myth of the invisible masterpiece was revived when the veil of its invisibility was lifted in New York. By the 1930s New York was the place where the annals of modern art were being written. The Museum of Modern Art acquired *Les Demoiselles* in 1937, only a month after it had been purchased by the J. Seligman Gallery, while in the eight years that had followed the death of its former owner, Doucet, French museums had shown no interest in acquiring it. In the American press there was a huge upsurge of enthusiasm inspired by the myth surrounding the painting's creation, which gave it yet another new birth. MoMA's young director, Alfred H. Barr Jr, had used two spectacular exhibitions to invent a somewhat arbitrary historiography of European modernist art that was to become the official canon in the years to come. But his vision still needed the tangible corroboration of a work that at the same time represented the myth of art. Even the painting's early date had invested it with a mythic age.

The work's epiphany needed careful staging in order to achieve its public impact. The opportunity arrived when Barr succeeded in mounting his long-planned Picasso exhibition. This took place in 1939, when the skies were darkening over Europe while across the Atlantic America's culture brightened. The great retrospective of 40 years of Picasso's art was the ideal stage for introducing a modern work, surrounded by its preliminary studies and accompanied by evidence of the artist's full development, as a timeless masterpiece. The catalogue supplied ample historical background. True, *Les Demoiselles* is 'the masterpiece of Picasso's Negro Period'; true, the work is 'a laboratory or, better, a battlefield of trial and experiment'; but in the last resort what counts is its historic significance. In its dynamism it is 'unsurpassed in European art of its time. Together with Matisse's *Joie de vivre* of the same year, it marks the beginning of a new period in the history of modern art.' In Europe this history had now taken a tragic turn: a few steps further on the public encountered *Guernica* (1937) as a refugee from Europe. With the defeat of the Spanish Republic, Picasso's other masterpiece had lost its owner and entered the same museum 'on loan from the artist' (see p. 352).

PICASSO'S MONUMENT TO APOLLINAIRE: THE PHANTOM OF A WORK

In the 1920s Picasso was already suffering from doubts about the remaining status of the gallery picture. For the great retrospective held at

Paul Rosenberg's gallery in June 1926 he had created an avalanche of works, none of which stood for itself: only taken jointly in all their diversity did they bear witness to Picasso's cosmos. Breton's circle enthused about what they called not works but 'revelations' emerging from Picasso's studio. The combination of figure paintings and post-Cubist still-lifes that now dominated Picasso's work was drawn into the newly kindled controversy between realism and abstraction. Could one create pure art without embracing abstraction and wholly abandoning nature? With which single work could Picasso identify, given that there was no end to the contradictions in his *œuvre*? Could that single work still be that mythic picture *Les Demoiselles*, which had long been claimed by others for their own agendas?

Embroiled in the labyrinth of his own works and tormented by the rôle of an impartial oracle, in 1927 Picasso took on the illustration of Balzac's *Le Chef-d'œuvre inconnu* (illus. 101). This key text of modernity had shown that ultimately there was no way of reconciling the idea of art and the body of the work. Through his illustrations for it, Picasso conducted a non-verbal discourse that resulted in a profound commentary. When published by the art dealer Ambroise Vollard in 1931, the edition testified to Picasso's confession that Balzac's centenary novel was still relevant to him.

Because, in Balzac's tale, the painter's friends expected to see a woman in his picture but instead found only 'colours confusedly piled up and contained within a mass of bizarre lines which form a wall of painting', these words in the 1920s were bound to remind readers of abstract art, to which Picasso was unwilling to commit himself. He regarded himself as still involved in the struggle with nature, like Balzac's Frenhofer. There was no need for abstraction when even form, as Balzac had said, was as impossible to grasp as Proteus. Even line-drawing as practised here by Picasso was ultimately abstract, for there are no lines in nature, another point made in Balzac's tale. In the woodcuts accompanying the text, Picasso played a subversive game with the opposition between Cubist abstraction and figurative art; in so doing he was simply addressing the dualism in his own *œuvre*.

When interviewed by Christian Zervos in 1935, Picasso confirmed the principle of destroying the motif, which was the theme of Balzac's story. 'In my case, a picture is a sum of destructions', in which, nevertheless, nothing is really lost. If one could hold on to the metamorphoses of a picture, he continued, then 'possibly one might discover the path followed by the brain in materializing a dream'. In his own art he was

trying to keep alive the initial vision all too easily lost in a finished work. There could, therefore, be no abstract art, but only personal art sparked by an idea. This idea will leave 'an indelible mark' in the work, even if it does not materialize in any single motif. Destruction kept alive the freedom of an idea, which otherwise would be sacrificed to the demands of a work. 'Ideas and emotions will in the end be prisoners in the work.'

The thirteen etchings circle around the missing masterpiece, whose place is occupied by the painter and model. The painter (often half-naked and sometimes resembling a lovesick satyr) directs his paradoxical desire towards a still-resistant idea, as if he wanted it to surrender in the body of the work (illus. 103). His seduction is aimed not at the model but at the work, which unlike the model fails to satisfy its creator, who continues to labour at it. Congruence between work and model is play-fully avoided, especially striking in the case of a woman knitting that the artist transforms into a tangle of abstract lines (illus. 102). And yet this light-hearted comedy can easily change into a drama. In another etch-ing Marie-Thérèse Walter, Picasso's new mistress, stands wearing trousers in front of a Greek woman in classical costume, while in the background the painter, like an ancient demiurge, has eyes only for the work.

The drama plays out the idea against the work. It is the 'metamor-phoses of a picture' referred to by Picasso in his interview with Zervos that

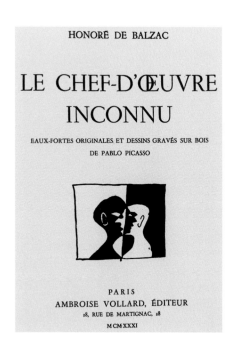

101 Pablo Picasso, Title-page woodcut for Honoré de Balzac's *Le Chef-d'œuvre inconnu* (Paris, 1931).

keeps the idea alive in the work. The process of continually self-destruct-ing the composition prevents the death of the idea, and 'in the end noth-ing is lost'. In the Balzac illustrations Picasso's whole *œuvre* seems to cover up an invisible masterpiece that can only exist as an idea and therefore keeps the works moving. The title-page (illus. 101) shows a battle that neither black nor white can ever win. Two profiled heads penetrating one another also hint at the relationship between idea and work.

In the same year, 1927, in which Picasso started on the Balzac illus-trations, he submitted a first design for the monument that was to be placed on Apollinaire's grave. It was rejected by the selection panel, as was the model Picasso presented a year later, on the tenth anniversary of Apollinaire's death (illus. 104). This later model returns by way of a surprising detour to Balzac's theme. Instead of an invisible painting it is an invisible statue representing the deceased poet at its empty centre. Picasso had a special reason for studying Apollinaire's novella *Le Poète assassiné* (1916), for he himself featured in it under the African pseudo-nym of *Oiseau du Bénin*. In the story the 'Bird from Benin' created a tomb monument for the poet, foretelling the situation in which Picasso now found himself.

Under the heading 'Apotheosis', the final chapter of *Le Poète assass-iné* describes an event that gives a new turn to Balzac's tale. 'I must raise a statue for him' (Croniamantal, the dead poet), says the Bird from Benin, 'for I am not only a painter, but a sculptor too'. Asked whether the statue is to be of marble, bronze or some other material, he replies 'No, that's too old-fashioned. I have to make a profound statue out of nothing, like poetry and glory.' This idea is well received: 'Bravo! Bravo! ... a statue out of nothing, out of emptiness, it's magnificent – when will you do it?' So here the usual relationship between sculpture and surrounding space is reversed, as Apollinaire's artist hollows out a hole in the ground and then turns its interior into a resemblance of the dead poet. The next day the artist returns with some workmen to wall the sculpted hole with cement. Thus the void was shaped like Croniamantal, and 'the hole was filled with his phantom'.

By November 1928 two models of a sculpture made of iron wire, undertaken for Picasso by the sculptor Julio González, were finished. Picasso's sketchbooks are full of 'drawings of space', as the gallery owner Daniel-Henry Kahnweiler called them: they span an empty space with geometrical grids. It is no accident that the designs for Apollinaire's tomb opened this series. A wire sculpture amid the massive tomb monu-ments in Paris's Père Lachaise cemetery would have made a magnificent

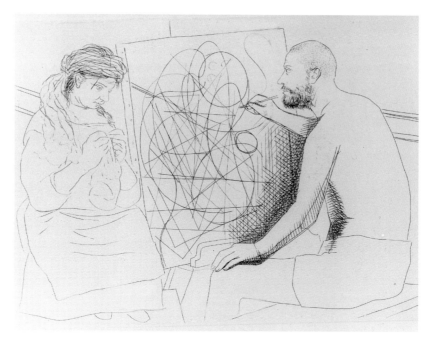

102 Pablo Picasso, An etching for Balzac's *Le Chef-d'œuvre inconnu* (Paris, 1931).

103 Pablo Picasso, An
etching for Balzac's *Le
Chef-d'œuvre inconnu*.

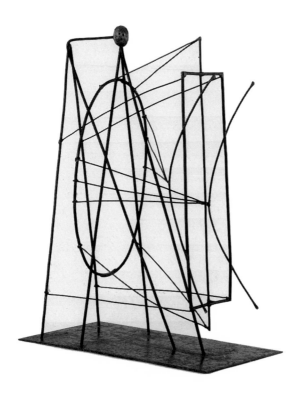

104 Pablo Picasso, Maquette for a proposed monument to Apollinaire, 1928, iron wire and sheet metal. Musée Picasso, Paris.

contrast. It would have transcended the dead stone that in other monuments blocked the imagination, and opened up an immaterial space as a reference to the poet's mind and spirit.

Here Picasso achieved a bold compromise between the freedom inherent in the idea for a work and the loss of that freedom in the materialization. The empty space, as circumscribed by the wire structure, takes on a visible shape that we fill in our imagination. Here we have once more the paradoxical interdependence of visibility and invisibility (or of work and conception) that was Balzac's theme. We can speak of an invisible masterpiece that displays the ever-open spirit of the avant-garde like an emblem of victory on the grave of its poet–idol. This sublimated concept of the work was discussed by Breton, Apollinaire's intellectual heir, with specific reference to Picasso's wire sculptures. In a photograph by Brassaï that Breton reproduces (illus. 105), the models can be seen standing next to bottles on a shelf in Picasso's studio, like small domestic gods watching Picasso at work.

Breton's famous essay 'Picasso in his Element', which introduced the first volume of the periodical *Le Minotaure* in 1933, is nothing less

105 Detail from a photograph of Picasso's studio in 1932.

than a comprehensive theory of the work, in which the wire sculptures play a key part. The very expression 'migrant bird', used of Picasso, alludes to the bird-name of the artist in *Le Poète assassiné*, but Breton is explicit where Apollinaire had left the reference open. According to Breton, Picasso's *œuvre* had fully elucidated the poetic truth of the artistic idea. Though Breton was following his own agenda, he shared Picasso's idea when a bold *mise-en-scène* in the studio, for instance a tower built of empty cigarette packets in front of the old mirror, fired his imagination.

Breton could remember 'those figures, those armed iron structures' standing next to the bottles on the studio's shelf . 'It is their intangible volume that is most striking, right next to palpable things. It is life itself, life in the making, that speaks to us out of their complete transparency' and spreads out like a magical essence filling the space between the metal rods. But neither did Breton want to lose sight of the rest (which is not yet work), 'that constant process of giving birth which in Picasso's life takes hold of a sequence of *momenta optima* to make itself visible.' The work is 'the great enigma, the eternal battle-ground between man and the world', because it expresses the fundamental need 'to form [one's

own] things *in opposition to* the things of the external world ... The reason why Picasso is so great is that he was constantly resisting the external things, even those [works] which had been drawn out of himself.' Even what was transient or ephemeral, like the already yellowing corners of newspaper pages used in the collages, appeared to Breton as a symbol of the vitality of the avant-garde, its determination to continue the eternal struggle against matter and against the death of the work.

12 The Fate of an Art Fetish

After tormenting artists for a century, the old idea of the masterpiece was now almost dead. Among the general public it lived on as an empty cliché, always on hand to cut short any serious discussion about art. When artists attacked the masterpiece as an antiquated artistic ideal, the label was all that remained of it. The idea of absolute art had become so far removed from any materialization that it had to be renamed. This left the old term 'masterpiece' free for a popular use that retained nothing of its former utopian meaning. The avant-garde, meanwhile, pilloried the best-loved pictures as false idols or fetishes of art. The *Mona Lisa* (illus. 45), which had only recently been idolized became the prime target of resentment, since it epitomized the trivial mystification of art. Seen from a progressive viewpoint this popular masterpiece appeared to stand for old-fashioned art, and thus for everything that young artists opposed. It embodied the sentimental expression of former times, and it perpetuated a static idea of museum art. As a result it became a focus of hostility, just as it had once generated admiration. Suddenly its aura, in which the mystery of art had seemed to reside, flaked off like a layer of varnish. Standing on the grave of the nineteenth century, the twentieth required the title of modernity for itself.

In their founding manifesto, written by Filippo Tommaso (Emilio) Marinetti and published in *Le Figaro* in February 1909, the Futurists, while opening war on the popular masterpiece, coined the famous slogan that a racing-car was more beautiful than the *Winged Victory of Samothrace*. The racing-car was indeed faster, or fast in a more modern way, than the Louvre's ancient goddess with outspread wings. 'Useless admiration of the past' should no longer be allowed to block the future. The museums, temples of the past, were nothing but cemeteries from which no new life could be expected to emerge. One might visit them once a year just as one visited the family grave on All Saints' Day. It was enough 'to offer a bunch of flowers to the *Gioconda* once a year' in remembrance of a dead woman who would never be restored to life.

Two years later the *Mona Lisa* could not be visited at all, having

been stolen from the Louvre in broad daylight. On 21 August 1911 this event elbowed all other news off the front pages of the world's press. The painter Louis Béroud had gone as usual to copy the picture in the Salon Carré, where it normally hung between works by Titian and Correggio (illus. 106). Finding an empty space, he reported the fact to the staff. At first many people thought that the report of a theft was no more than a bad joke, but they quickly realized that – as the papers had it – the 'unthinkable' had happened, and it was time to write the picture's 'obituary'. Thousands made the pilgrimage to the Louvre to gaze, overcome with emotion, at the blank space and the three nails from which the picture had formerly hung. The nation's cultural authorities were derided for failing to protect the temple of art, which had lost its prestige along with its icon. For some, the barren museum wall was like a tomb made meaningless by the theft of the body (illus. 107), while the majority felt not merely robbed but mocked: the lost work left them with nothing more than a dead memory, as its critics had called it for so long.

Recovering the picture would not restore its authority, for the audacious coup was a desecration that could not be reversed. The scandalous event raised the question of whether the work in fact justified its worldwide fame. The *Grande Revue* asked artists for their expert opinion, and it soon became clear how divided they were on the issue. Félix Vallotton acknowledged that the *Gioconda* was a masterpiece, but added the rider 'if that word still means anything'. This touched a nerve, because the concept had become so devalued it had no certain definition. Kees van Dongen, when invited to comment, poured scorn on the *Mona Lisa* as a picture that belonged to the 'historians, poets and philosophers' who had reinvented it, while it simply bored artists.

Young artists and writers saw the *Mona Lisa* as the showpiece of a false religion. She was the 'eternal Gioconda who sapped one's creative strength', as André Salmon wrote while the painting was missing. Picasso, he continued, had rejected the *Mona Lisa* fetish some time ago when he set out, in *Les Demoiselles*, to 'destroy the human face' that smiled in the picture in the Louvre. When Picasso and Apollinaire heard of the great scandal, they hastily got rid of some small items stolen from the Louvre that had come into their hands. This did not prevent Apollinaire from being arrested by the authorities in the vain hope of tracing the theft of the *Mona Lisa* to a plot by rebellious young artists.

As a result of this new publicity the absent work remained present only in the cliché so long associated with it. Now the cliché survived the work – indeed, the missing work was a negligible factor in the cliché.

When Max Brod and Franz Kafka arrived together in Paris on 9 September 1911, three weeks after the theft, the face of the Louvre's kidnapped lady was all over town, on 'every hoarding, chocolate box and picture postcard'. Earlier, in Milan, the two friends had seen the headlines announcing what had happened in Paris, and at the Louvre they joined the queues of people eager to gaze at the bare wall. Only weeks later was the empty space filled with a Raphael portrait. The *Mona Lisa* had become an 'invisible sight' – a phrase Kafka had used in his diary when writing of a night-time taxi ride through Munich during which he had been told the names of all the buildings he could not see.

With the original lost to view, the reproductions, displayed a thousand times over, had the field to themselves. The original's loss of visibility increased its fame. Famous cult images of the past had often been largely withheld from view in order to give their occasional appearance the quality of a rare privilege. But the invisibility on this occasion, the result of a crime, was different: it served simply to reinforce the absence of the work that was of necessity substituted so completely by reproductions. The mysterious smile of the *Mona Lisa* was reduced to a mere cipher familiar even to those with little or no culture at all. Its multiple reproduction was part of its truth, now that the viewer merely memorized a ubiquitous media image instead of actually looking at a picture.

Copies always derive from an original whose existence they confirm, but this time the work, reduced to being art's trademark, could only be quoted. The true original was not a picture by Leonardo but a cliché. The more people wanted to participate in art, the more the name of this work of art, which even the experts derided, dominated their talk. As a result, the experts of Italian painting such as Bernhard Berenson and Roberto Longhi defiantly spoke out against the picture, which was no longer a target of their expertise but now belonged to the masses who, as they both agreed, worshipped it blindly.

In 1932 Henri Focillon pointed out that 'it was Romanticism and lithography that made da Vinci's masterpiece popular'. These reproductions constituted a 'history of sensibility' in which the smile had always inspired interpretations, sometimes with sinister overtones; these memories of the smile reflected back onto the original painting and turned the latter into a cliché. When Gustave Le Gray, a former painter, showed a series of photographs of the *Mona Lisa* in the 1856 exhibition of the Société Française de Photographie, these were based on a pencil drawing after the original, with which Aimé Millet had achieved some success in the Salon of 1849. In the photographs any difference from the

original disappeared, and indeed the visitor could admire the work reproduced in various tonalities and degrees of brightness, all equally valid, making the original recede into the distance, a mere phantom.

The theft could only happen to the original work, of course. To some it smacked of a Dadaist stunt. It represented an absurd inversion of the picture's public fame, in that it ascertained the existence of the original, whereas a cliché could only be derided, not stolen. Parodies were as much an assault on the picture as the theft, while reverting the acts of reverence. The problem with the embarrassing theft was that no punishment followed. Impotent in that regard, the nation was equally helpless in the face of a further sacrilege, the shameless glee evinced in some quarters.

Through the humiliation inflicted on this masterpiece, painting as a whole suffered a loss of prestige. The popular press published photographs of women from the cabaret and film world 'whose smiles are still with us' (illus. 108). They all wore mourning dress, and this attracted admiration of a more impudent kind than the august phantom of the Louvre. The avant-garde reluctantly welcomed the recovery of the picture in 1913 with open derision, and the Futurist Ardegno Soffici

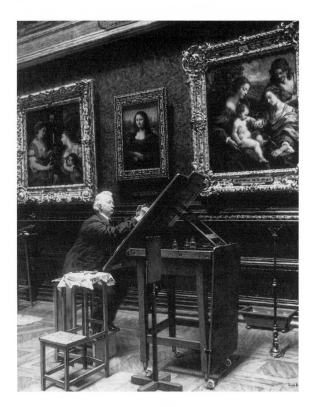

106 Louis Béroud, The *Mona Lisa* exhibited at the Salon des Artistes Françaises in the Louvre's Salon Carré, 1909, photograph on glass.

107 A photograph taken in the Louvré's Salon Carré on 22
August 1911, shortly after the theft of the *Mona Lisa*.

mocked it with the 'offering of flowers' of which Marinetti had written
in 1909. The thief, an Italian, had eventually handed the picture back two
years after having taken it in the vain hope of restoring it to the Uffizi in
Florence, where it would be 'at home'. Excitement over the picture's
return was short-lived, for it had, as it were, lost its honour and become
a vulgar celebrity. Now it invited Dadaist acts, in which the unique theft
was replayed in their own way.

KAFKA AT THE CINEMA

The theft was still front-page news when Kafka and Brod arrived in
Paris on 9 September and hurried to stare at the blank spot formerly
occupied by the world's most famous image. On the following evening
they watched the 'dazzling white, quivering screen' of the Omnia Pathé
cinema, where they saw a Parisian silent comedy film brimming with
gags. 'Finally, after the usual revolver shots, chases and boxing matches,
there was something topical. It was about her, of course, the woman
whose face is on every advertising hoarding, chocolate box and picture
postcard in Paris: Mona Lisa.' Brod also describes the five-minute sketch
Nick Winter et le vol de la Joconde (Nick Winter and the Theft of the *Mona*

108 *Comédia Illustré. Mlle Distinguel des Variétés*, photograph of 1911.

Lisa), filmed by Brusquet immediately after the robbery. Though this may be grouped with Dadaist responses to the event, in style it was a typical slapstick film comedy.

In *Nick Winter et le vol de la Joconde* the Louvre's director, roused from his bed by the sensational news, rushes, 'with his braces dangling', through the streets to the museum. There fate overtakes him in the shape of a shoe-button found at the scene of the crime, which leads to a frantic hunt for its owner, assumed to be the thief, in all the cafés in Paris. 'And now for the final twist: while everyone is charging around in the rooms of the Louvre and making a great commotion, the thief creeps in with the *Mona Lisa* tucked under his arm, hangs it back in place and takes the Velázquez *Infanta* instead. No-one notices. Suddenly the *Mona Lisa* is spotted, there is amazement on all sides, and in one corner of the returned picture a note explains: Sorry, I'm short-sighted. I meant to take the picture next to this one.' Brod's summary sets out to imitate the breathless pace of the film. It is a good joke when the museum director himself is wrongly arrested, but the farce gets even better when the real thief is able to smuggle back, unnoticed, the unwanted picture. A still included in Hanns Zischler's book epitomizes the film's parody of the theft: sneaking in to make his exchange, the thief hides behind his back –

so as not to be noticed – the most conspicuous item of the time (illus. 109). He is the one person in Paris *not* interested in the painting – a farcical inversion of the facts.

The *Mona Lisa* is not allowed to become the film's heroine, but instead is carted about the set like a lifeless prop. The leading rôles are taken by the actors, half acrobats and half clowns, who keep the action moving. Speed is the essence of this medium. The museum pictures in the film look down from the walls like bygone memories that once, mounted in their frames, had attracted people's attention. Not the picture but the theft was the subject of the film, which recast the news story as farce. Cinéma Pathé Frères' programme then carried straight on with other items. 'We saw, yes, we saw a great deal – it was like the Comédie, where they present eight acts with hardly any breaks … Finally there was the *Journal Pathé*. And to give the whole thing the look of a newspaper, it opened earnestly with a masthead and the subtitle "Third Year".'

This experience of the cinema suggested another analogy besides that of a newspaper. In the dark auditorium the two friends felt plunged once more into the mechanized traffic of the metropolis that flowed past them with the same indifference as the pictures on the screen. They could no longer play the part of *flâneurs*, strolling down the streets they selected

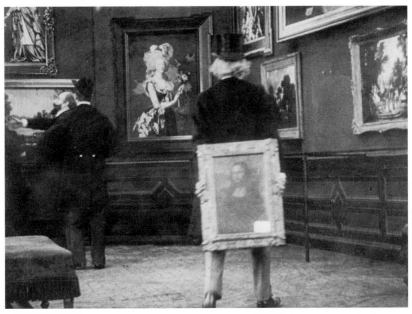

109 A still from Brusquet's short film of 1911, *Nick Winter et le vol de la Joconde* (*Nick Winter and the Theft of the Mona Lisa*).

and stopping as and when they liked, but were helplessly and incessantly bombarded with impressions that robbed them of their detachment and of any viewpoint of their own. In the Métro only the advertisement for Dubonnet stood out amid the stream of images, offering itself to the gaze of the 'sad and bored passengers'. The 'elimination of language' in the functioning of the Métro, where spoken communication had been abandoned, invited comparison with the silent film. Kafka described Paris as 'hatched' (with the lines of Venetian blinds, balcony railings and so on), using this term to detach his impressions from the objects as they were in reality. The 'hatchings' superseded the outlines of what they set in motion. As Zischler puts it, 'These showers of hatchings are the film, the projection, through which the city is perceived.'

Language, Kafka felt, began to lose control over the images, which more and more eluded it, whereas in the past it had been able to describe them. The new images rejected a perception that could be retrieved in language. Kafka raised this subject in the diary of his visit to northern Bohemia in 1911, when, not for the first time, he saw the so-called 'Kaiser Panorama', which allowed one to look at stereoscopic images, each for a few seconds. 'These pictures are more alive than those in the cinema because they allow the eye to rest on something, as in reality. The cinema tinges everything with the restlessness of its own speed; the eye's repose seems more important.' In mechanically following the rapid sequence of images, the eye lost any active rôle. To Kafka, cinema adverts (using stills in the posters) were like the handrails on a departing train – the last support in a stream of consumed images. But when he saw the posters in the thick of the city traffic, they seemed to belong to an outdoor exhibition that had taken the place of the pictures in a museum.

The theft of the *Mona Lisa*, therefore, like a welcome farce, perfectly suited the times: a museum picture was suddenly on the move. The *Mona Lisa* smile exerted a hypnotic fascination, especially as it never changed, even after the original left the Louvre. Popular wit put its own slant on the story when, in the 1912 Mardi Gras procession, the stolen *Mona Lisa* took to the skies in an aeroplane. Postcards showed her calling out of a train window that she wanted to return to the Louvre. This ultimate representative of traditional art also represented the static image, if only because it lived as a result of unhurried contemplation. Its loss of prestige reflected the decline of the static picture, when the chronophotograph snapped at its heels in order to supplant it. As the motion picture surged ahead, the old images took refuge on the shores of memory – they had been created for a different kind of perception.

The perception of space had already been changed in the nine-teenth century by the railway experience, in which speed blotted out the foreground in the window picture. Kafka reflected on this when reading Goethe's accounts of his travels by mail-coach. The speed of mechanized movement forced the spectator into a new visual mobility. The Italian Futurists took up this challenge by conjuring speed, if only as a gesture, since framed canvases exclude any real movement. The paradoxical simulation of movement in the visual arts has been an issue ever since. The masterpiece was rapidly discarded because its traditional make-up was no longer the right challenge, unless it resisted the fleeting media in its modern environment.

The young Marcel Duchamp, with his infallible gift for the strik-ing gesture, went straight to the heart of this paradox when he painted his *Nu descendant un escalier* (Nude Descending a Staircase, 1912). What was provocative about the picture was not so much its representation of movement by a multiple image as its title. What could be more contra-dictory than the classical nude and an image similar to a chronograph? The fixed frame contradicted this claim of mobility, and climbing down-stairs (which nudes do not normally do) provided only an apparent justi-fication. So it is hardly surprising that the Cubists refused to accept for the 1912 'Salon des Indépendants' a picture in which they suspected an ironic allusion. Not until the following year, at the 'Armory Show' in the United States – where the public was not yet familiar with the subtleties of modernism – did the painting provoke the desired scandal. The artist himself soon gave up painting pictures. He had demonstrated to perfection the paradox of reconciling the new mobility of images with the old profile of the gallery picture.

READYMADES AND OTHER MANIFESTOS

Duchamp soon bought industrial items with the intention of signing them as his own works. Way before the debate about 'readymades' began, he had expressed his opposition to the reputation of the work in bizarre ways. In 1919, six years after the scandal over the *Nude Descending*, Duchamp signed as a Readymade a colour reproduction of the *Mona Lisa* (illus. 111). But this reference to the old masterpiece is only a corroboration that followed his other actions targeting the now ques-tionable status of the art-work. Other artists, chief among them Kazimir Malevich and Fernand Léger, were following their own strategies, quot-ing the *Mona Lisa* as an outdated icon that seemed, in the surging

renewal of art, to be superfluous. Writers also joined in producing these 'obituaries', emphatically aligning themselves with radical modernism. All these manifestos confirm the remaining power the popular master-piece had by evoking passionate resistance.

The Readymades would appear to represent the anti-masterpiece *par excellence*. Yet they even increased the dominance of the idea over the work, though they cancelled the creative process, and took the conflict to extremes. The term 'readymade' was coined only after Duchamp had gone to New York in 1915. In a letter written on 15 January 1916 the artist instructed his sister Suzanne to sign his name on the bottle-drying rack which she would find in his studio. 'Here in New York I have bought objects of a similar kind and called them *ready-mades*. You know enough English to understand the meaning – "already finished" – which I apply to these objects. I sign them and give them an English title.' The bicycle wheel (again a subtle parody of arrested move-ment in works of art) was another object that his sister found in the studio. In a New York exhibition in the same year two Readymades, designated as such, are listed in the catalogue among the sculptures.

The scandal, however, arrived only with the Richard Mutt Affair in 1917. For the first exhibition of the 'Society of Independent Artists' Duchamp submitted an urinal, which he entitled *Fountain* and signed

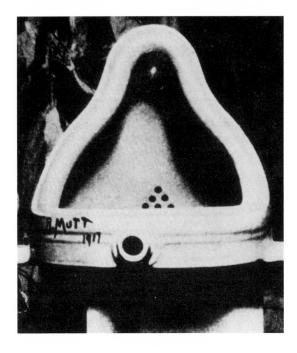

110 'Richard Mutt' (Marcel Duchamp), *Fountain*, 1917, vitreous china.

111 Marcel Duchamp,
L.H.O.O.Q., 1917,
collotype. Private
collection.

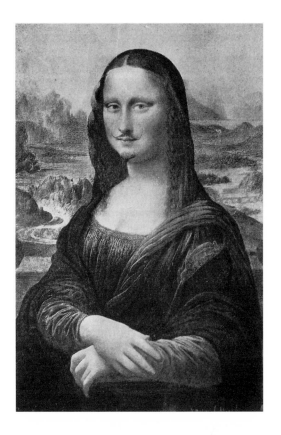

'R. Mutt', thereby concealing his own identity (illus. 110). The 'work'
was rejected by the jury, even though under the Society's statutes anyone
was entitled to take part, and Duchamp was able to resign from the jury
in protest without arousing the suspicion that it was his own rights that
he was defending. No rules had been violated, and yet the affair revealed
only too plainly the limits imposed on the freedom of art even by the
artists themselves, because they measured such a work against an existing
idea of art that, however, had never been agreed. When Duchamp had
failed, as planned, he played another trump card, opening a debate on the
Richard Mutt Affair in the art journal *The Blind Man*. The journal
carried a picture of the rejected work taken by the eminent photo-
grapher Alfred Stieglitz, who took a stand in this case for the freedom of
art. The photograph gave additional credibility to the controversial
object. There could have been no better proof that the recognition of
the work of art was based on a fiction. In the case of the Readymades,
Duchamp declared an object that he had not *made* but had found *ready-
made* to be a work, simply by attaching his signature to it. This new

approach to art demanded that a bottle rack be placed in the same category as the *Mona Lisa*.

Malevich took up a different position when, in 1914, he produced the small picture with the easily misunderstood title *Composition with Mona Lisa* (illus. 112). The artist, while still using the Cubist collage technique to conduct a pugnacious discourse about art, here presented a hybrid that is both a work and a critique of a work. The painting is a *work* insofar as it creates a non-figurative world simply through its areas of flat colour (see p. 302). It is a *critique of a work* insofar as, in the same context, it rejects the outdated concept of the work represented in the cliché of the *Mona Lisa*. A cheap colour print, carelessly torn across the top, is glued into place like a piece of criminal evidence. The face and upper body of the lady with the smile have been crossed out in red, to express Malevich's rejection of the humanist image of an individual. The masterpiece is thereby identified only with painterly illusion, which has rendered art impure (that is to say, alienated it from its purity).

In the manuscript on Suprematism that Malevich left behind when he departed abruptly from Berlin in 1927, criticism of figurative art is combined with criticism of a culture that has detached us from nature: portraits are neither as alive as actual people, nor are they art purged of tasks foreign to art. 'Portraits and *natures mortes* are both equally *natures mortes*, as indeed all culture consists of -*mortes*. The art of figurative representation is doubly *mort*, as firstly it depicts culture in decay and secondly it kills reality in the very act of depicting it.' The life of art could not consist of a borrowed life merely imitated in art. The recovered *Mona Lisa*, whose worship in Paris clouded over the true sun of art, was for Malevich an example of false consciousness. The advertisement for a Moscow flat glued on beneath the *Mona Lisa* appears to be just an ironical footnote, unless we read it as *No, we don't want her in Moscow*.

Léger attacked the *Mona Lisa* for different reasons. In the late 1920s he felt that his 'aesthetic of the machine' was threatened by a resurgence of nostalgia for the old myth of art. The *Mona Lisa with Keys* is a polemic response to the traditional bourgeois painting (illus. 113). The *Mona Lisa*, copied from a postcard but unkindly robbed of her smile, fades into the background behind the splendid bunch of keys whose metallic beauty the painter celebrates. Léger is arguing here against the ranking of the meaningful pictorial *sujet* above the *objet* that is free of meaning. Having already painted the bunch of keys, he was looking for something that 'would form a complete contrast to it'. In a shop window he happened on a postcard of the *Mona Lisa*. 'To me she

112 Kazimir Malevich, *Composition with Mona Lisa*, c. 1914, oil, collage and graphite on canvas. State Russian Museum, St Petersburg.

113 Fernand Léger, *Mona Lisa with Keys*, 1930, oil on canvas. Musée National Fernand Léger, Biot.

is an object like any other.' In his essay on 'The Aesthetic of the Machine' he argued for a 'beauté plastique', independent of either meaning or imitation, that is, free of anything not inherent in the physical form itself. He therefore saw the cult 'of the Italian Renaissance [the *Mona Lisa*] as the most colossal mistake'. It only meant decadence and thus an outdated concept of art.

From the 1920s onwards, literary writers made their own contribution to dismantling an artistic fetish that their nineteenth-century predecessors had so incessantly promoted. In 1922 Aldous Huxley alluded to the 'Gioconda smile' in his satirical story of that name. Miss Spence assiduously practises the smile in order to impress her lover: 'That was part of the Gioconda business.' In this way she almost succeeds in deceiving him as to her true nature, but by committing a murder she reveals herself to be the dangerous woman who also was supposed to lurk behind the famous smile. The cliché here becomes an entertaining motif in the story. André Gide, on the other hand, in his great novel *The Counterfeiters* (1925), joined the avant-garde by protesting against that artistic fetish. 'What is stupid is people's admiration for it, the habit of respectfully doffing their hat before speaking of such so-called masterpieces.' Gide places these words in the mouth of a young anarchist about to launch a new journal. It is to include 'a reproduction of the *Mona Lisa* with a pair of moustaches stuck on to her face'.

THE BEARDED *MONA LISA*

It is obvious where Gide found this idea. It was none other than Duchamp who had launched the most famous of all attacks on the *Mona Lisa* by adding a beard and moustache (illus. 111). Gide did not know that Francis Picabia had published that hirsute *Mona Lisa* without telling Duchamp. In 1919 Duchamp signed a postcard of the *Mona Lisa* as a Readymade, having given her a moustache and beard, and showed it to Picabia before taking it to New York. But Picabia needed this idea for the frontispiece of his periodical *391*, in which he was about to publish (i.e., in 1920) the 'Dada Manifesto'. For the moustache he used a random reproduction of the *Mona Lisa*, and, since Duchamp's signature was not available, entitled it *Tableau Dada*. So Duchamp's Readymade only appeared as a fake, or as a reproduction – just as a true original is reproduced. In fact the reproduction differed from the pseudo-original more than Picabia realized, for he had forgotten to include the Napoleon III-style beard – which is why Gide refers only to a moustache. The title in

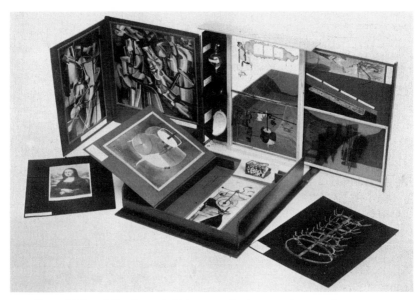

114 One of Marcel Duchamp's *Boîtes-en-valise* (1935–41) opened out.

any case marked this as an independent initiative by Picabia, for Duchamp never identified with the Dadaists. We therefore have to take a different route to discover Duchamp's own idea.

So let us start again. Duchamp took two souvenirs with him to New York to give to his patrons, the Arensbergs: a glass flask 'filled with Parisian air' and the Parisian postcard of the *Mona Lisa*. The latter was a commercial product just like the flask, but Duchamp had signed it – and also, with his own hand, added the beard and moustache, turning the lady into a gentleman and obscuring the celebrated smile. This led to an item that was unique, just like the original in the Louvre. Supplying a title was also part of the creation of a 'work'. It should have been *Mona Lisa*, but as usual Duchamp introduced a play on words, *L.H.O.O.Q.*, which could be read in two ways. If the five letters were pronounced sequentially in French, the result was an obscene comment on the woman: '*Elle a chaud au cul*' (She has a hot crotch!). But if the title was read as a one-word acronym in English, it did, just about, say '*Look*'. But what was is that one was actually looking at?

Even the beard and the moustache provide endless riddles. One might see them as a provocation, given that the Lady of the Louvre was supposed to embody the Eternal Feminine. In 1909 a cartoon had circulated showing a male visitor's beard that was reflected in the newly installed glass protecting the *Mona Lisa*. Soon after this, the Raphael

portrait of a bearded man that was hung in the space left by the stolen *Mona Lisa* caused a heated debate. The moustache and beard drawn by Duchamp seems to have been an attack not only on the identity of a masterpiece but on its eternal youth too, for this one had now grown a beard. But Duchamp always insisted on a different interpretation, which he later outlined thus: 'The strangest thing about that beard is that it makes the Mona Lisa into a man. In that case she is not a woman disguised as a man, but a real man.' But why was it so important to change her sex? Duchamp was revealing the illusion that is present in all images, for the impression of a man was deceptive in the case of the bearded Mona Lisa. The enigma of what it is that we see cannot be solved by a simple act of naming (what I see is the same as what is there).

At all events the ambiguity of the change of gender makes us reflect on the identity of the artist, since the artist was commonly believed to be a man. His works were therefore a masculine product even when they depicted women. In Leonardo's case the enigma of androgyny had previously led to a suspicion that the Mona Lisa might secretly be a man (see p. 152). So it can hardly be a coincidence that Duchamp produced this Readymade in 1919, the year of the 400th anniversary of Leonardo's death. But which Leonardo had died then? And how would he behave in this modern age? Here there is a startling reversal: Duchamp made fun of this popular fetish of art, and yet at the same time he identified with Leonardo. There are many indications of this in his writings. Leonardo's idea to paint a Mona Lisa that disguises the male nature of the artist could turned around. And suddenly we are back with the masterpiece that lives on mystery, not the mystery of the smile but that of an almost unfathomable *idea of art*. Beneath the surface triviality Duchamp was unearthing the great dream that had been part of the idealism invested in the masterpiece from the very outset.

Duchamp's new *Mona Lisa* presented itself not merely as a parody but also as a work that Duchamp claimed to have created. He had an opportunity to confirm this when, in 1941, he produced his portable personal museum, *La Boîte-en-valise* (The Box in a Valise; illus. 114). Works that were essentially blueprints of works could all be fitted into one case and exhibited in that ironical way. For this purpose he had reproductions made, of hitherto unequalled quality, including reproductions of some works that had never been exhibited. He therefore included the bearded *Mona Lisa*, with the striking annotation 'R.m. *rectifié*' (Rectified ready-made). The postcard was not only a cheap printed item, it also stood for a cliché that could be corrected.

115 Marcel Duchamp, Sketch of the *Beard and Moustache of the Mona Lisa*, frontispiece for Georges Hugnet's *Marcel Duchamp* (Paris, 1941). Private collection.

But what did he mean by 'correction' or 'rectification'? Once again Duchamp leaves us with many possibilities. No doubt the simplest is to think of the intervention required to transform a cheap print into a work. In 1944 Duchamp had the 'original' of this Readymade certified by a New York notary. But the possibilities do not end there. It is well known that Leonardo's *Mona Lisa* is not signed. Only now did it acquire the genuine signature of an artist, which in a paradoxical way 'rectified' its lack of authentication in the Louvre picture. This was a game that could be played almost *ad infinitum*. The various stages have been described so often that just two examples will suffice here to illustrate the principle. First there is a drawing Duchamp made and signed in 1941 to accompany the publication of a poem by Georges Hugnet (illus. 115). It contains nothing but the detached beard and moustache of the *Mona Lisa*, finely executed in silhouette using graphite dust. The *Mona Lisa's* moustache and beard, as Duchamp's invention, had for the initiated an unmistakable identity. Here one could speak of an invisible masterpiece. This applies still more in the case of the second example, the *Shaven Mona Lisa*. Duchamp had produced and signed this as a new Readymade in 1965, serving as the advertisement for a retrospective. Of course the

'shaven woman', as Duchamp called it, is simply a postcard, this time unmodified, but it is no less a genuine Duchamp. His mere signature forces us to look for the beard and supply it in our imagination. The shaven beard is nothing other than the idea of the beard, which Duchamp now simply alluded to instead of depicting it.

So the old paradox of the invisible masterpiece reappears. The utopian concept of art once sought in the masterpiece surfaces again like an archaeological find. Duchamp, with Picasso, understood its deep and contradictory meaning as no one else (see chapter 14). But his *jeux d'esprit* were too often taken to be nothing but the irreverence of a radical modernist. In fact they turn Balzac's old view into a modern idiom. In the meantime the *Mona Lisa* had become a convenient label for art; but then opinions were divided about the picture, with a majority wrongly identifying it with academic art, so that artists wanted to part from it. In all the brouhaha surrounding the *Mona Lisa*, Duchamp was the only one who would not be content with cheap parodies.

A CLICHÉ ON THE INTERNATIONAL CIRCUIT

The cliché the public looked for in the *Mona Lisa* was scarcely affected by this controversy. Its cult was even growing as the result of the media and mass culture, not least in commercial advertising. In the 1950s the *Mona Lisa* boom reached new heights, as though the famous picture was to testify against the worldwide fashion of abstract art. Once more the public at large used this official fetish of art to satisfy its desire for worship. A special issue of the periodical *Bizarre* marvelled at the – sometimes absurd – manifestations of this anachronistic '*jocondolâtrie*'. But artists readily took part in exhibitions that invited them to produce *Mona Lisa* paraphrases. The 1960 '*Mona Lisa* Show' at the Treadwell Gallery in London was the first of a series of such exhibitions, which culminated in 1965 at the Fels gallery in Paris under the patronage of a characteristically silent Marcel Duchamp.

Writers on art had meanwhile defended the *Mona Lisa* against the confusion with a mere cliché. André Malraux, whose *Musée imaginaire* had done so much to bring equal recognition to global art, was reluctant to abandon the idea of the masterpiece as represented by the Louvre's picture. In the closing days of the Second World War he wrote of this 'most celebrated and most insulted work' that it was, in truth, alone and still misunderstood. This painting, the 'most subtle homage that genius can pay to a living face', was an undisputed testimony of art. A full

exegesis by an art historian came only in 1952 when Charles de Tolnay published the first comprehensive study of the picture, which appeared in a periodical after the intended monograph came to nothing. Here he identified Leonardo's originality in his use of the portrait genre. The smile, he suggested, had for the first time in painting conferred the inner life of the soul on a face. It was precisely this sentimental animation that the avant-garde had objected to, because bourgeois society had turned it into their own fetish.

About a decade later Malraux, by then Charles de Gaulle's Minister of Culture, used the unique occasion to address a world public on the subject of the picture, which had been received in the United States with the honours accorded to a visiting head of state. On 8 January 1963 at the National Gallery of Art in Washington, DC, an exhibition devoted wholly to this one picture was opened, in the presence of 2,000 guests of honour, by the President of the United States himself – an event unique in the country's history (illus. 116). The speeches made by John F. Kennedy and Malraux show the subtle rivalry of the two countries at one of the climactic moments of the Cold War. The *Mona Lisa*'s visit was pure politics, and yet, as the massive attendance demonstrated, the exhibition answered a general need for worship, a need that very few people could have accounted for. In fact this picture embodied a cultural myth. There is no such thing as a unique original, and yet the painting had become art's undisputed title-holder.

This sensational success was repeated in 1974 when the painting travelled to Tokyo and Moscow; the Japanese broke all previous records of mass suggestibility. But it was only in the USA that there were significant repercussions: here an active art scene, like the European avant-garde long before, took exception to this idolization of a work of art by attacking the *Mona Lisa*. Moreover, the appearance of an auratic masterpiece was at odds with a consumerist mass democracy. Andy Warhol, with his *Mona Lisa* silkscreen prints, turned the repro-*Mona Lisa* into an American-style media heroine. The one-time aura had by now indeed become a commodity. A consumer product possesses its own kind of aura, which results from the unique range of its distribution. Consumerism, the cult of the commodity, was also an element in the noise surrounding the masterpiece on show. The *Mona Lisa* was successful in terms of the flood of visitors it attracted and the media presence it generated. And yet it was an original of a kind that does not exist in the commercial world of consumer goods. As a result, Warhol turned its aura around by equating it with the cult of the film star. The star, whom

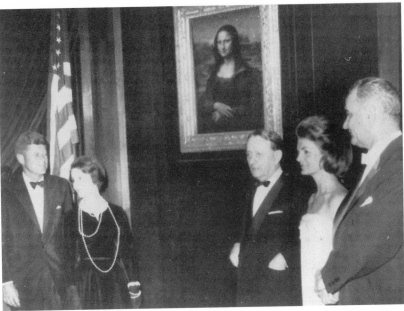

116 President Kennedy, Mme and André Malraux, Jaqueline Kennedy and Vice-President Johnson in front of the *Mona Lisa* in Washington, DC, 9 January 1963.

everyone knows and yet no one knows personally (in the original), exists only in the media, because outside the media she or he would be a private individual.

In a well-known silkscreen print (illus. 117), as though churned out by a rotary press, multiple images of the star, copies upon copies, parade across the large canvas. A single *Mona Lisa* would prove nothing, but 30 of them seem to prove the picture's media success. When Warhol represented American icons such as Marilyn Monroe or the widowed Jackie Kennedy as stereotypes of the visual media, he no longer referred to the actual individuals. While Marilyn Monroe did not matter as a real *person*, the *Mona Lisa* did not matter as a real *work* existing behind all the reproductions. So Warhol adopted the ploy of substituting the cliché for the work. If the *Mona Lisa* was a mere cipher for art, it was possible to hide the actual work behind the endlessly repeated stereotypes. In retrospect the American episode looks like a new version of the old parodies, because the same cliché of art was either openly combated or appropriated and subverted. But the new situation of art also changed the tone of the dispute. It would have been fascinating to overhear a conversation between Duchamp and Warhol about the fiction inherent in the concept of art. Perhaps such a conversation did take place in New York. After all,

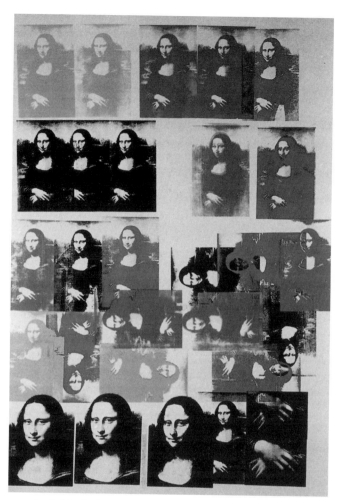

117 Andy Warhol, *Mona Lisa*, 1963, silkscreen print.

Duchamp's 'shaven' *Mona Lisa* was produced two years *after* Warhol's *Thirty* series. There was every difference between the crude popular parodies that merely trivialized the picture, and the avant-garde attacks that challenged the *Mona Lisa* while still pursuing a sophisticated discourse on art.

13 The Dream of Absolute Art

Absolute art had been a dream ever since the Romantic era. The free-
dom of art, both a liberation and a burden, strained the artistic ideal to the
extreme. In this respect the visual arts had been tardy, but seemed to be
making an advance when they abandoned figuration, an apparent obsta-
cle to progress. 'Abstraction', as the word implied, meant abstracting, or
eliminating, everything that was not intrinsic to art as such. But what is
art? Here the obvious, but all too rash, solution meant identifying *art* with
form. Art appeared to be form *per se* – not, however, the form of the
empirical world. Abstraction seemed synonymous with form absolute.

Freedom alone did not guarantee autonomy. Art would attain this
goal, as Samuel Beckett said, only by creating a 'universe apart'. Equating
art with form merely shifted the problem. In the case of Mallarmé's
poetry, an artificial language was intended to take the place of everyday
language. The writers, at least, still operated with words. Painters and
sculptors, on the other hand, had to *discover* a language of their own.
Discovery was preferred to invention, for it meant that a world of forms
truly existed, whereas invention remained an arbitrary act. Form, if it was
to speak with the authority of art, had to represent an objective quality,
like the laws of nature of which scientists were just then forming a radi-
cally new concept. The artists dreamed of a law of universal forms,
which, however, if applied, would terminate their beloved freedom, and
thus introduce a new conflict that none of them would be ready to
resolve.

'Non-objective' or 'abstract' were obvious terms, however inade-
quate, on which artists could easily agree. But at a time when people
were searching for the true meaning of art, form could quickly become
tyrannical. Moreover, form would have remained an empty term had not
each artist or critic filled it with his or her own ideas and ideologies. The
more general the canon of pure forms was, the more it offered itself to
every possible interpretation. Because it avoided figuration of the
mimetic kind, abstract art quickly turned into a vehicle for religious,
hermetic or socialist ideas, as though these were inherent meanings of

the forms themselves – and shared their universal truth. Once projected onto an individual *œuvre*, such highly personal beliefs also obscured the fact that individualism in artistic creation had recently been at odds with aims of collective rigour.

Another conflict resulted from the impatience to realize, at last, the utopian aspirations that had always been part of modern art. For a long time these aspirations had impelled the avant-garde towards the future, which beckoned like a Promised Land at the end of the road. The artists, like the utopian socialists, equally felt the need to obey the spirit of history and fulfil its purpose. Every lone fighter therefore saw herself or himself as part of an elite corps. The self-appointed heirs of history thought their hour had come when the Great War of 1914–18 weakened the old social order. The dominion not just of true art, but of definitive art, was heralded. A new society would bring a new art to power. But first society had to be educated and prepared for this ideal, which meant reversing the rôles of art and life. Yet the utopian vision undermined its own authority when it claimed to have become reality. As a result the image of an ideal future was obliterated by an ideal present. Thus it was that 'modernism' as an attained goal lasted for only a short time before meeting powerful counter-forces. This gave the wrong impression that modernism in art had been defeated by its enemies, when in fact it had been defeated by its own ideals.

The universalism that had supported the dream of an art absolute ignored national boundaries, where, however, rearguard actions soon ensued. The erstwhile rôle of classical culture was taken on by a modern culture that laid claim to the same authority. Not only in Paris, but in the epicentres of modernism, too, where the most radical believers came from, the first concern was universalism. To many, modern civilization seemed to have strayed onto the false path of materialism, while culture remained too much rooted in tradition. Many regretted the dualism of a modern world separated from historical culture. They expected culture to participate in the revolution that had taken place in modern science and technology. The concept of modernism was born with a new austerity, as though no modern art had existed hitherto.

A new culture was proclaimed in the name of the 'spirit', which was to confront and defeat 'unspiritual' materialism. But 'spirit' was an empty formula, just like 'form', which was venerated as its visible symbol. It could most easily be described in terms of what it was not. It differed from nature in being abstract, and as an objective spirit it rejected bourgeois individualism. It was virile and pugnacious, and represented the

triumph of reason. Since nature did not appear rational, spirit signified dominance over nature. In art, even feeling had to become 'pure' feeling, which surpassed the mere personal sentiment. Where reason could not reach, the 'soul' took its place, to 'experience' the universe of the spirit and to master the material world with spiritual energy.

Art divorced itself from the empirical world in order to create protected paradises where, however, all too easily the imagination was in danger of being drilled and disciplined. The old 'geometrical impulse' found a new opportunity in abstract art. Geometry was, in its own way, a kind of abstraction in which the spirit enjoyed control of itself. The human desire for order discovered the fundamentalism of forms as a symbolic order of a higher meaning. Not surprisingly it was architecture, with its construction of the spaces we inhabit, that benefited most. In the visual arts, on the other hand, the desire for order established an aesthetic domain in which traditional figuration was prohibited. In this rigid artistic world, a meta-language claimed to be the archetypal language of the eye, just as human rights were being represented as timeless, archetypal rights. For a time Cubism, the last artistic currency to originate in Paris, appeared as a basic visual alphabet. But it had only prepared abstraction; it had not become absolute art.

In 1908 Wilhelm Worringer's dissertation on *Abstraktion und Einfühlung* (Abstraction and Empathy) caused a stir in artistic circles. The author drew on the ideas of the sculptor Adolf von Hildebrand, who had described formal problems as absolute in artistic terms. Worringer's arbiter was Alois Riegl, who saw an absolute '*Kunstwollen*' (will to art), which he called the 'will to form', at work in the history of art. The particular mood of the day, with abstraction just being born, was demanding labels. Worringer believed in an ancient 'urge to abstraction' that had often dispelled 'empathy' (with things). Where he gave expression to his own feelings, he raved about the beauty of 'all abstract regularity and necessity' which offered a 'resting point amid the flux of phenomena'. Here man was rescued from 'arbitrary' life. And so Worringer hailed the geometrical style as the 'style of the highest abstraction, most strict in its exclusion of life'. It had been brought forth by primitive cultures in which 'a common instinct' provided the impetus. 'The single individual was too weak for such abstraction', and this is why, in the sequence of civilizations, this 'purest law of art' had been lost in which 'man, confronted by the utter confusion of the visible world, could find rest'.

Worringer exemplified the topical fascination with the purity of form found in the 'primitives'. Like his contemporaries he ignored the

old content, seeing only form. Nor was he aware that he was applying a modern concept of art to cultures that had possessed no such concept. It was in line with this homage to primitive art that he rejected the 'worldly' sensuousness of European classicism and advocated a strictly 'transcendental art'. The soul must 'create for itself a domain beyond all phenomena, an Absolute in which it can rest from the torment of the relative'. Only where all illusions end does 'salvation await'.

Carl Einstein, too, received a powerful impetus from 'primitive' art, prompting him to write his early book, *Negerplastik* (Negro Sculpture), in 1915. Soon he was one of the leading voices of the avant-garde, variously advocating either absolute art or abstract art as the only ideal worth fighting for. In an entry on 'Absolute art and absolute politics' which Einstein wrote as a contributor to the *Great Soviet Encyclopedia* in 1921, Kazimir Malevich, though not named, features as 'the Russian painter'. In this polemical text Einstein cleared the concept of the absolute from any metaphysical overtones and instead defined it in political terms as liberation from the object, which had hitherto been an instrument in the hands of the rulers. The object was now to be replaced by the power that resided in the act of perception. In analogy to the formula of the dictatorship of the proletariat, he wrote of a 'dictatorship of seeing', in which all barriers introduced by education were broken down, so that, paradoxically, this dictatorship would lead to absolute freedom, the freedom of absolute art.

In 1929, after settling in Paris, Einstein published a new essay on the absolute in which his earlier enthusiasm had given way to deep scepticism. 'The absolute is powerful insofar it is totally empty' and therefore as protected from attack as art works are by their very nature, since they do not 'exist as mere objects'. The concept of the absolute was man's greatest achievement and yet also 'his greatest defeat … Man has created his own servitude. So he dies from the absolute that signifies, simultaneously, his greatest freedom.' In the modern age the absolute had ceased to bear divine names. It now lent itself all the more to being an 'instrument of power, because it could be changed at will into anything at all'.

Einstein's disillusionment with intellectual and artistic modernism led him, in the 1930s, to write a furious denunciation of it that was published only long after his death, under the title *The Fabrication of Fictions*. He condemned the 'boundless hubris of intellectualism' that had caused modern art to lose its grip on life. The leading artists 'still believed in the supremacy of an inner world. But in fact they created a blueprint for a thoroughly utopian art, thereby demonstrating that they

found reality defective.' He rejected the 'rhetoric of abstraction' as a 'superlative in the realm of the unreal'. The concept of abstraction was only another name for 'a quality of the bankrupt gods' of the past. Modernism would 'be destroyed by autistic overbreeding'. Its very conception of art – actually a legacy of the bourgeois society that modernism claimed to oppose – was a radicalized and therefore irresponsible one. Einstein, the critic, contemptuously dismissed as fictions the very aesthetic ideals he himself had once so vigorously championed.

COLOUR IN KANDINSKY'S *COMPOSITIONS*

When Wassily Kandinsky 'painted [his] first abstract picture in 1911', as he wrote, creating his own myth, a few years later, he was not following the path of geometry. Nor had he passed through the preliminary stage of Cubism (he was too old for that) when he expelled figuration from his art. On the contrary, he knew that he followed the 'anti-geometrical, anti-logical path', as he said in his first letter to the composer Arnold Schoenberg, in whom he recognized a kindred spirit. In a later letter, too, he protested against the Cubists' 'insistently geometrical approach' (22 August 1912). Instead he wanted to stage the drama of pure colour, which he raised to the level of an absolute art form. But colour was the medium of painting anyway. He therefore advocated an emancipation of colour, and strove for pictures that would be 'pure painterly entities'.

With his link between colour composition and musical composition, Kandinsky reminds us of the fact that music had paved the way for absolute art (see p. 59). Kandinsky was not attempting to *paint music*, as his critics claimed, but to paint *like music*, when using colours instead of musical tones in his art. 'How infinitely fortunate musicians are', he wrote to Schoenberg, whom he also envied for his treatise on harmony, while he saw his own book *On the Spiritual in Art* (1912) as no more than the very first step along that path (9 April 1911). But in his abstract painting he felt close to the 'romantic-mystical sound' achieved in symphonic music for the past century (16 November 1911). Even so, Kandinsky much admired Schoenberg's music and wanted to meet a composer who had broken with tonality. Just as Schoenberg was freeing music from old boundaries, so the painter sought a kind of 'dissonance' that would be 'tomorrow's consonance'. A 'new harmony' was the key word that the painter borrowed from music – a harmony in the framework of absolute colour.

Kandinsky, however, was also approaching that intangible idea which is *art*. His 'Cologne Lecture', in which he outlined his former

development, addressed 'that art which has never yet been personified and, in its abstract being, still waits to be incarnated'. Here he named the very subject of my own book with a blunt precision, when confessing his desire to 'force absolute painting into existence'. As soon as he felt mature enough to experience absolute form, he had been able to paint 'absolute pictures'. In his *Rückblicke* (Reminiscences) of 1913, abstract art was simply equated with absolute art. But, he pointed out, 'pure art' had not yet arrived. Indeed, he could remain faithful to his aspirations only while he felt himself to be still journeying towards them. Only when the 'Blue Rider' had defeated the serpent of materialism could art look forward confidently to the age of pure spirit.

The autobiographical accounts in which Kandinsky turns his life into a myth describe a progressive illumination whose gift he felt he had been chosen to receive. He situated himself at a watershed of art that was also a turning-point in his life. There were key experiences, such as Monet's *Haystacks* or a performance of Wagner's *Lohengrin*. But these merely contributed to an extended process of maturation, at the end of which the artist had become like an instrument that sounded a pure tone. 'Thus the proper development of an artist consists of *his* search for *his* form.' This is a rejection of the objective ideals demanded by the dogmatists of geometry. The artist had to 'experience' form in his soul before he could make it visible in his art.

The new creed required a new community of believers. There were to be no programmes based on personal or political philosophies, and Kandinsky continually warned others against his own theories if only to avoid making art once more subject to content. This was why poets like Ezra Pound, who stood in a different camp, saw in Kandinsky a confirmation of their own vision of what art should be. Pound was referring to Kandinsky's writings when, describing Vorticism in 1914, he glorified the 'primary material' of art – form and colour. 'The image is itself language. It is the word beyond formulation', and thus the form of direct experience. 'We use form as the musician uses sound.'

Abstraction, however, was not only concerned with form but with the concept of the work, which required a very different theory. Indeed, the first question was whether the authority of the single work should not be completely jettisoned. The abstract language of forms no longer required the unique work but could, it seemed, materialize in every possible example. Similarly, in the serial works created by the Cubists, the hierarchical ranking of individual pictures was eliminated for a time. Here art emancipated itself not only from figuration but from the notion

of the unrepeatable work. Once it used a style, like a grammar, abstraction seemed no longer in need of the proof of actual works.

At first Kandinsky still employed titles like *Resurrection* or *Flood* to suggest a hidden subject to the viewer. But he needed first to individualize his works via their composition, although no reliable response to the 'sound' of their colours as yet existed. In order to accustom his viewers to a new and abstract iconography, he called his serious works *Compositions*, whereas, in a similar musical terminology, he called studies and sketches *Improvisations* and *Impressions*. He also numbered the compositions, just as pieces of music are ordinarily numbered or catalogued. But in the visual arts the term 'composition' applied more to a *design* for a work, and was directed towards a goal that could only be the work. Even now, art could only materialize in individual works, however difficult it had become to give them a profile of their own.

The very word *composition* 'affected me like a prayer', Kandinsky recorded in his *Reminiscences*. He declared composition to be the true aim of his life, for 'the creation of a work is the creation of a world'. This metaphor expresses an unwavering determination to create an autonomous world of art. When his initial idea or form was maintained in the final picture, then 'the work lives', as Kandinsky so often said. The creative process became part of the work itself, and thus it lived on even after the creation was complete. 'Today's harmony' in art is nothing other than the battle of the elements, as Kandinsky acknowledged in his 'Cologne Lecture'. This needs to be understood literally. The battle of the elements was, in essence, Kandinsky's own battle with the picture after he had eliminated all figurative motifs from it. Colour and drawing were all that remained, and in order to retain a sort of narrative, he devised a kind of battle between them. Staging a drama without characters, the painter turned the invention of the work into a drama.

When Kandinsky described individual pictures, he recalled memories of the work process to which he accorded psychological significance. He referred to the 'tragic nature of the colours', which he tried to mitigate by means of 'indifferent colours'. In *Composition VI*, he explained, he chose the theme of the Flood as a starting–point, but then turned it into pure painting. The picture itself expresses a water-like deep space, the darkness of which is crossed by violent bursts of light, and seems to be in a state of continual metamorphosis, as though its motifs were coalescing or drifting apart before our eyes. The pictorial elements perform a true and vivid spectacle merely of painting. Incidentally, the analogy between theatre and painting was more present in

Kandinsky's mind than he admitted in his theoretical writings. His stage work *Der gelbe Klang* (The Yellow Sound), in which no human actors appear, is dominated by colours and accompanied by music. 'Not the object, but colour, appears on the stage', as Malevich, the other Russian pioneer of abstract art, once observed.

No work was so carefully prepared for as the 'large canvas' (200 x 300 cm) of *Composition VII* (illus. 118), for which, in November 1913, Kandinsky produced no fewer than 35 studies. On each of the four days of its production he had a photographic record made of its progress (as Picasso was later to record the progress of *Guernica*). The links with the subject of the Last Judgment were progressively reduced. Schematic drawings for the work became filled with annotations, whose language is telling (illus. 119). Kandinsky refers to 'positive, i.e. reclining forms' or to 'forms gently dissolving with accompanying melodic tones', but also of 'soft forms, hard lines and dreamy hesitancies'. By writing in this way, he aroused the false hope that his pictorial language could be simply recorded in verbal language. His psychology of colours, too, had no basis in any objective science of colours. Years later Kandinsky saw his theory

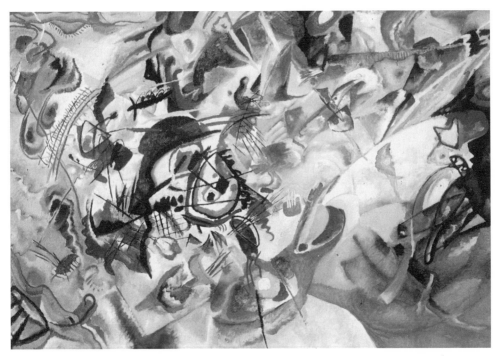

118 Wassily Kandinsky, *Composition VII*, 1913, oil on canvas. State Tretiakov Gallery, Moscow.

119 Wassily Kandinsky, Schematic study for *Composition VII*. Städtische Galerie im Lenbachhaus, Munich.

of forms dismissed in Moscow as pure 'subjectivism'.

At this time it also became apparent that a theory of composition in the visual arts could not measure up to its equivalent in the realm of music. The concept did not deliver what it promised. Other concepts also soon proved to be no more than empty formulae. One of these was 'construction', which the Moscow avant-garde emblazoned on their banner in 1921 (see p. 308). In his early letters to Schoenberg, Kandinsky had discussed whether that term was appropriate for the creative act. Shortly after others used the term as a weapon against free artistic creation. Kandinsky was thrown off course by the Great War, and as the inventor of painterly abstraction he found himself in Russia caught in the front lines of the new generation that refused to follow him. So he eventually took refuge in the Bauhaus, where, seeking a congenial response, he taught a formal grammar reduced to the application of signs.

MALEVICH'S ICON OF ART

Kandinsky had only just returned to Russia when, in December 1915, the avant-garde there mounted the exhibition '0.10' in Petrograd that

has become legendary (illus. 121). This is where Malevich first showed his *Black Square*, which he presented as an icon in the old sense, but it was an icon of art and therefore non-objective. 'The only content that art can have is itself', he wrote in 1922 in a text that was, however, only published 40 years later. But, like an original icon, the picture was venerated, condemned or copied, and acquired the myth of being the archetype of a radically new art. Malevich himself fostered the myth that this was the 'first-born' of absolute art, as though Kandinsky's abstract pictures had never existed.

If we accept the myth, we have to regard *Black Square* as a finished picture rather than as a mere symbol of a movement. Later, in 1927, while allowing himself to be fêted in Berlin, Malevich wrote home thus: 'The world as feeling … the ideas – that is in essence the content of art. A square is not a picture, just as a switch or a plug are not electricity. Anyone who … saw the icon as … a picture was mistaken. For he mistook the switch, the plug, for a picture of electricity.' And in his next letter: 'I have finally shattered the goal – the picture – and revealed a world of feeling.' But in public Malevich had promoted *Black Square* as the key work of his philosophy. It marked the beginning of a series in which the next stages were the red and then the white square, as he wrote in Vitebsk in 1920. A pamphlet that was on sale to visitors at the Petrograd exhibition of 1915–16 refers to the square as 'the creation of intuitive reason', as 'a living royal child. It is the first step towards pure creation in art.'

The same work, in Malevich's intention, refuted figuration by means of a new art that was nothing but 'absolute creation', creation as ritual. The old painters would have done better 'to discover the surface of painting rather than paint a *Gioconda*'. Here we have the first intimation of the legend of a new *Mona Lisa*. When Alexander Benois attacked the exhibition in January 1916, Malevich wrote an open letter in response: 'I am glad that my square cannot be confused with any other master or period.' If Benois did not have the enthusiasm he had for a Venus, this was precisely what Malevich intended: 'You will never see Psyche's smile on my square.' Here a rigorous spirituality combated any eroticism in order to purify the gaze by excluding the world. A feature that Malevich shared with old Russian icons was the white background, the symbol of infinite space. 'I possess only this one, bare, unframed icon of our age', he wrote, and he wanted to use it as a weapon against the enemies of art.

Still more significant is Malevich's *mise-en-scène* of his icon's first

exhibition. The '0.10' show was intended to mark the end of Russian Futurism and the advent of a radical shift in painting. One room was given over entirely to 39 pictures by Malevich, while another room was allocated to Vladimir Tatlin. The conflict between the two artists was the focus of this event. Tatlin introduced his own *œuvre* with the *Corner Counter-Relief*, which he fixed by wires to a corner of the room (illus. 120). The work was thus 'framed' not by a standard rectangle but by the very space of the room. Malevich, at the last moment, responded by hanging his *Black Square* across a corner of *his* room so as to symbolize a corresponding space (illus. 121). This was a successful move, as he recalled the traditional corner with the icon, 'the Orthodox corner', in which 'the sacred image hangs', as he wrote in 1924.

But Malevich's strategy had begun much earlier, when he decided to inaugurate his Suprematist paintings by means of an appropriate archetype. He was unwise enough to paint over another picture that he evidently did not like, so that this supposed archetype was an afterthought (illus. 122). Since then, x-ray examinations have recovered the earlier version (illus. 123), but the artist himself was soon reminded of the underlying picture when the *Black Square*, on the surface of the old varnish, began to crack; after only ten years the *Black Square* was in a ruinous state. It became necessary to maintain the illusion of a perfectly black square via his own copies. The picture was not only a palimpsest,

120 Installation shot of *0.10, Last Futurist Exhibition* in Petrograd, 1915–16, with Vladimir Tatlin's *Corner Counter-Relief*.

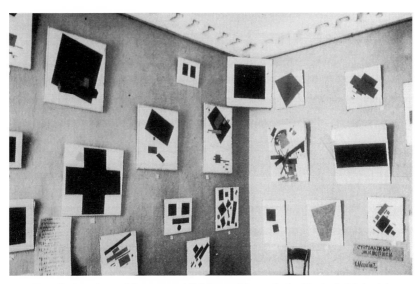

121 Installation shot of the *0.10* exhibition, with works by Kazimir Malevich.

but the fiction of an archetype as well.

Here two ideas are involved that are often confused: the archetype as a *picture* and as a *form*. A picture is a work, whereas a form is a motif. Malevich wanted to present the zero form, the square, in an inaugural picture representing Suprematism. In fact many critics have reduced the work to the black square, overlooking the white background that symbolizes the infinite space in which the traditional perception of art, with the expected horizon, disappeared. The square and the white ground even mark two distinct layers of painting, creating, by the brush-work, a difference in surface texture. Malevich also positioned the square off-centre in relation to the frame, in order to differentiate between the motif and the picture. An archetypal image was required on didactic grounds, in order to demonstrate, in Suprematism, the evolution of an archetypal form. This explains why the picture, in which the square is still at rest, was chosen to be the first in a series of paintings in which the same motif was to undergo a long series of transformation.

In the St Petersburg exhibition, *Black Square* was the first of a series of works in which the motif reappeared in different variations. (For this occasion Malevich took the precaution of back-dating the work to 1913.) But now that, in the archetype, the form had become a work, it was subject to ever new interpretations. In 1920 Malevich's supporters in Vitebsk, the 'Unovis' group, sewed it on their clothes as a badge to demonstrate their support. Meanwhile the pure square was defending the

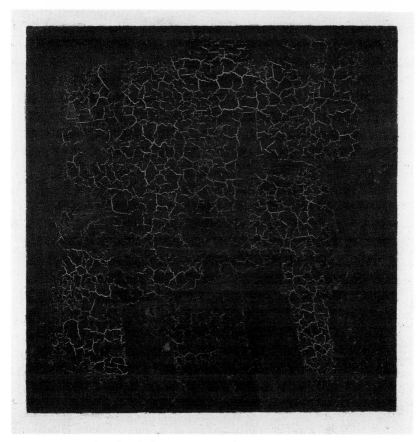

122 Kazimir Malevich, *Black Square*, 1915, oil on canvas. State Tretiakov Gallery, Moscow.

metaphysical aspect of art against the materialism of the 'production artists' (see p. 309). When the Revolution revealed its true nature, Malevich distanced himself from 'revolutionary influences', as he noted in 1927 in Berlin, where he left behind the manuscript for his major book. This text, written five years earlier, now seemed to him to contain errors, because by this time he only wanted to 'defend art'. When he died in 1935 the *Black Square* hung over his death-bed, just as the *Transfiguration of Christ* had once hung above Raphael's dead body (illus. 124). Next to it was displayed the late self-portrait in which Malevich appears in the guise of a Renaissance artist (Piero della Francesca). Figure painting was by now in need of rehabilitation because of the way that it was being misused by Stalin.

The *Black Square* expresses an idea of art that ultimately reaches

123 An x-ray photograph of Kazimir Malevich's *Black Square* of 1915.

beyond the capacity of a work. This is why it could not be repeated, but only exploited. In its endless transformations it assumed the quality of a sign or mark displayed on the unchanging white screen of painting. In 1914 the motif had appeared for the first time in a Malevich picture in which a reproduction of the *Mona Lisa*, the incarnation of an old-type work, was crossed out (illus. 112). There the black rectangle was still one motif among many, whereas a year later it was a pure form without a referent: the only referent was art itself, that is to say an idea. Paradoxically, the archetypal picture still recalls the old status of the icon, even though in religious icons art was not the theme. The invisible archetype, without which an icon lost its religious meaning, has here become a visible work, so that we can quite properly speak of an *icon of art*.

Art, however, did not lend itself to a clear definition, but was a generalized concept, or, as Malevich put it, 'a sentiment'. Suprematism, as he wrote – more clearly than usual – in a letter from Berlin, 'is only a method the content of which will be one feeling or another'. Non-objective art thus led to non-objective perception, the sort of perception that lived in 'mysticism, sound and colour'. In the pictures the artist had substituted the blue sky by means of white, which he described in 1919 as giving a 'true impression of the infinite'. In its attitude towards space, Suprematism was 'a purely philosophical movement'. In space things dissolved of their own accord, even if that space was still inherent in the old painted surface. In painting Malevich had been striving for the fourth dimension (time), and in his theory he was striving for the fifth dimension, a kind of logic of art which he called 'economy'. He did in

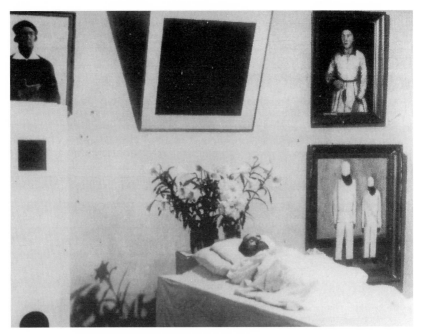

124 Kazimir Malevich on his deathbed in 1935.

fact use a repertory of signs he called 'forms'; these constantly referred to a system, a system like a 'philosophy', which he had spoken of in Vitebsk.

Burning with missionary zeal, Malevich unintentionally became an art historian whose writings describe, in a long-winded and monotonous style, the development of art towards its ultimate goal. He knew – so he assured his disciples – that he had reached that goal. It was all the more necessary to explain this achievement in writing too, because writing had become more important than painting. Despite this he soon found himself marginalized in a debate now dominated by others. Only in Berlin, where he was received in 1927 like a prophet, did he find serious support. With renewed self-confidence he wrote home that here he could 'reveal the hollowness of the new art, which has made an about-turn towards functionalism and utilitarianism and has changed into the soulless trickery of inventors, bringing art to an end'.

MOSCOW: THE WORK/PRODUCT CONTROVERSY

In the same letter Malevich lamented the fact that the development of the Russian avant-garde had long since left his ideas behind. Even Constructivism, which it was believed had defeated Suprematism, had

now been supplanted by production art. Kandinsky and Malevich had emerged as losers in the debate because they still believed in art and wanted to create works. Similar debates were taking place in Weimar, Berlin and Paris. But in Moscow artists were under political pressure as a result of their share in creating a new society. But the dream of an avant-garde supported by the state, which had awakened false hopes even in the West, had already come to nothing, even before the Communist Party embarked on its new direction. There was a certain logic in the fact that the left wing of the avant-garde wanted to abolish art, as a traditional ideal of human creativity, rather than make it absolute.

The discussion in Moscow's artistic circles centred on what Nicolai Tarabukin called the 'crisis of art'. The same controversy by necessity soon focused on the question of the work. The work of art was born from the concept of art. Even if it had lost its old content, its new content, namely form, was not only the emblem of a general aesthetic, as the believers claimed, but an emblem of art. For this reason the other side insisted that the work should be replaced by the product and the artist by a designer who produced a functional form. Inevitably there was also discussion about the rôle of the art gallery, which many would have liked to see replaced by an industrial fair, just as the old-style school of art seemed to end in a training laboratory.

The minutes of the meetings of the organization Inkhuk in the years 1920–21 reflect the euphoric hopes not just of creating a new aesthetic but turning it into the Party's official line. Inkhuk was a research institute set up in Moscow with the aim of fostering the production of art on a scientific basis. Kandinsky, who headed the theory section, was soon forced to defend himself against Alexander Rodchenko (25 years his junior) and his supporters. His idea of 'monumental' art meant the long-dreamed-of synthesis of painting with music and dance. The younger artists, in contrast, demanded interaction with architecture, which promised a 'space art' that would break the monopoly of 'two-dimensional art'. But lurking behind this was an attack on the old concept of the work. Kandinsky was therefore accused of propagating a subjective formalism. The individual – still an important element in his thinking – would be forced to yield to society's demands, just as culture was being supplanted by technology. Malevich too, whose exhibition in 1919 mobilized all his critics, was soon accused of having merely conducted the funeral rites of the formalist metaphysics of art.

But the debates, full of the rhetoric of the time, also reveal the conflict of the artists with the theoreticians who attacked their concept

of the work as well as their concept of art. Industrial production was to replace artistic creation, which the artists wanted at all costs to continue. The conflict came out into the open when Rodchenko founded the 'Objective Analysis Group'. Analysis of the elements for production seemed the only way to create works in objective terms, and 'construction', now with a technical connotation, became a compromise formula for artistic activity. But the gap between a work and a product soon could no longer be overlooked. While the product was intended for a practical use and for mass production, the aim of the original work was to be exhibited as a unique item.

Soon after marginalizing the artists, the theoreticians declared the primacy of art to be at an end. Panic broke out when Alexei Gan propounded the doctrine of an era *after* the end of art. In November 1921 Osip Brik urged the painters to participate in industrial labour, which 25 of them elected to do. The artists' rôle was to be reduced to that of execution, while the theoreticians would control the ideas. In his key text *From Easel Painting to Machine* (1923), Nicolai Tarabukin shattered the illusions of artists who hid their ambitions behind a mask of fashionable terminology. The Suprematists 'with their impenetrable black square on a white ground' come off no better than the Constructivists, who 'naïvely imitated technical constructions without putting them to any use'. Moreover, they had not even enough technical knowledge to supply models for buildings and machines. Aesthetics, declared Tarabukin, had been compromised by art itself, 'for empty form can never satisfy us'. Any aesthetic seemed to him to be an ideal whose time was past. In its place he wanted to see utilitarian forms that bore the stamp of technical expertise.

Tarabukin did not help Rodchenko's reputation as a painter when he declared a monochrome picture in red by him to be the 'last picture' in the history of painting. If Malevich's *Black Square*, 'despite the poverty of its artistic significance, still retained a vestige of an artistic idea', Rodchenko's picture was 'devoid of meaning, a blank, empty wall'. In this picture, painting had come to an end. It is immediately obvious that here a traditionalist had made himself a spokesman for the avant-garde. His argument implied that painting, as a representational art, lost its point if it ceased to represent anything. Even the Constructivists, he claimed, clung to representation, for what they represented was structure. 'But as soon as an artist attempted to depart from representation, his success would be to the detriment of painting.' Rodchenko's publication of his own maxims on production and art did little good. If he saw art as

the blueprint for a new form of living, he had to face the accusation that in absolute art painters like Kandinsky and Malevich had given birth to a utopian vision that was hostile to life. Here, then, we have the two faces of the new modernism, which in the West as well provided ample fuel for conflict.

MONDRIAN'S ONE-MAN INITIATIVE: 'PLASTIC EXPRESSION' AS ART

Piet Mondrian, too, was in a difficult position in the group with which he is so often identified. Though he did sign up to the programme set out in the periodical *De Stijl*, its principles did not have the same meaning for him, a painter, as for the architects and designers in the group. Accordingly he took no part in devising the canon of formal principles that the others called 'the style' and which was to be applied to the creation of an aesthetic environment. Instead he uncompromisingly followed the path of art – for the time being, as he diplomatically put it. He developed his own dream of creating absolute art, calling it either 'Neo-Plasticism' or 'abstract–real painting'. Those around him, threatened by this ideal, forced him to defend his position by writing articles. But he did better in his pictures, in which he visualized his personal artistic ideal.

Mondrian discovered his true expression as an artist when he returned to Paris shortly after the Great War. The geometrical elements, which one could even use for wallpaper, needed a careful *mise-en-scène* in order to form independent works – works representing an entity with an individual vision. This arrangement consisted of closing the interior of the picture while opening it at its edges. In the interior the grid of lines establishes an order that the viewer experiences as *intensity*. At the outer edges, where the areas of colour are not enclosed by a line but simply reach the edge of the canvas, the picture acquires an *extensity* that allows it to radiate out into space. The traditional frame becomes unnecessary because the picture reposes in a syntax that could be called a formal entity. It is both a whole and a *pars pro toto*, both a work and a microcosm. This procedure appears as early as 1919 in the *Lozenge Composition with Colours*. It is fully developed in the pictures painted in 1921, which Mondrian continued to call 'Compositions'.

A photograph taken in his Paris studio in 1929 reveals Mondrian's experiments with different formats and different kinds of framing in order to give individuality to works with interchangeable elements (illus. 125). Here he lived in an aesthetic enclave, constantly moving areas of

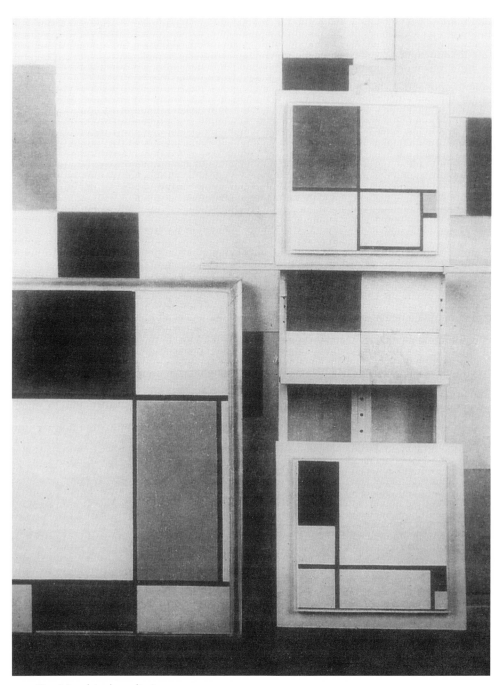

125 Piet Mondrian's studio in 1929.

colour around on the white walls in order to develop a new sensitivity for this pictorial programme. The paintings produced in this studio refer to each other like variations on a single theme that only materializes in variations, like never-ending circumscriptions. Only in a gallery room can they acquire their full autonomy. Even if united by the same syntax, they vary in their use of that syntax; while they all adhere to the same grammar, each of them has become a 'picture' in its own right. This relationship between an overall ideal and the single work cannot be summed up in a simple formula. A photograph of the artist's studio taken in 1926 in this respect comes close to a personal confession (illus. 126). Our attention is caught by an empty easel, which is set up almost ceremoniously, as though it held the invisible masterpiece, the matrix that lies behind all pictures, whose application is never exhausted. The painter who worked at this easel turned an idea into practice: the idea of absolute art.

But such an idea ran the risk of becoming a tautology. It therefore needed the proof of works. But what is it that the works convey? In 1920 Mondrian published his long text *Le Néo-plasticisme*, later published in German as *Neue Gestaltung*. '*Plasticisme*' ('plastic expression') or '*Gestaltung*' did not denote the designing of a product or the shaping of the environment in the way that Theo van Doesburg outlined in 1922. For Mondrian the term referred to a conception of the picture that was not 'description'. Hitherto painters had 'described' nature. 'Plastic expression' now meant taking an independent rôle as an inventor in art. But this applied to any abstract art – art that was self-referential, not imitative. What was the special direction Mondrian had in mind?

'Plasticism' meant the 'plastic expression of relationships' on a surface so that it ceased to be merely a surface and became a work that transcended itself. 'Plastic expression' would transmute the work's material nature into spiritual harmony. Perhaps one day there would be a city designed on the same principle. 'In the meantime the work of art must stand on its own – but that does not make it individual. For the plastic expression prevents it from being so.' Here Mondrian wrestled with the same ambivalence that the viewer suffered from. The universal anyway could only be represented in an individual work. 'Plastic expression' and perception could not be separated: if there was a universal 'plastic expression', then there must also be a universal perception that was timeless and inborn. 'In seeking plastic expression we express our universal perception and thus our universal being.'

Here Mondrian voices the same universalism that, in the gestalt psychology of Max Wertheimer and Wolfgang Koehler, had become the

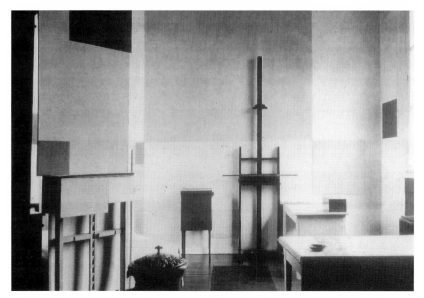

126 Piet Mondrian's studio in 1926.

creed of a worldwide modernism: in their work wholeness, 'gestalt' and structure were psychological concepts, while for Mondrian they were the symbols of a spiritual world. He therefore wanted to find a language in which to express these symbols. 'New man's vision' needed to liberate itself from time and space in order to find 'the new reality' beyond the 'individual consciousness'. For this purpose art was an absolute medium, as religion had once been. 'Art now stands where religious worship once stood.' As pure 'plastic expression' it could not become a visible idea until it had 'destroyed' not only the obstacle of the work but also 'the obstacle of form'.

Wherever Mondrian was beset by doubts he found encouragement in Theosophy. When he was exhausted with painting he argued with his fellow-artists in Paris over the latest sensations on the art scene. Though he followed a solitary path, he shared the same problems as all the others who reached out to grasp the phantom of absolute art. In his vision the single work would finally abolish itself. Similarly with art: Mondrian was searching for a universal, supra-personal art – a pure art that was no longer bound to an individual artist. And yet, fortunately, his art remained strictly personal. One hundred Mondrians as fellow-artists would have been a nightmare – or perhaps they would have degenerated into mannerism and mere decoration.

14 The Fiction of Absolute Art

DUCHAMP AND THE BRIDE'S WEDDING-DRESS: THE ALLEGORY
OF THE WORK

The dream of creating absolute art was everywhere when, in 1912, the young Marcel Duchamp gave up painting altogether (but did not stop making art). This was the start of the most amazing artistic career of the twentieth century, for Duchamp deliberately avoided creating works of the usual kind. He did produce an *œuvre*, but his *œuvre* consisted of ideas, which did not require the standard of the finished work. These were riddles rather than works. Works, too, as he would insist, were ultimately fictions. They had an imaginary exchange value derived from a great *idea*, the idea of *art*. That idea could with equal justification be described as a fiction, because it materialized in works that related to art in the same way as coins relate to an agreed currency.

Not surprisingly, the most radical theory modernist art produced from among its own ranks emerged at a moment when artists thought they were in sight of a universal language for art. Kandinsky, Mondrian and Malevich followed different paths, but they had a common aim. This aim was not even new – the nineteenth century had already proclaimed the imminent liberation of the concept of art. But with a new confidence, they now intended to cast off all of art's masks that were mere appendages. But artists were compelled to ask themselves whether they should realize utopia and thus betray it or whether they should equate the idea that is art with an absolute form (see p. 294). Duchamp was acutely conscious of these questions and doubts when he set out on his own path.

To call art a fiction was merely a way of protecting its utopian idea both from any banal application and from any dogmatism. As a Frenchman, Duchamp was probably reluctant to merge form and idea. A consistently pursued iconoclasm was more credible than an abstract, and therefore empty, world of forms. Duchamp's abstraction of the *idea* from the *work* is more radical than the abstraction of the *form* from the *object*.

His solution was to liberate art from the contradiction that works represent an idea without being one. So he began to conceive an allegory of the work (see p. 329). By choosing a different or non-descriptive language, which is the essence of allegory, he could also deal with the idea in another way than by applying it in works. Absolute art, for him, was ultimately art without a work, which is why an experiment, as an alternative or visible non-work, was the only adequate way to approach it. The absolute exists like 'a moon above time', as Mallarmé, Duchamp's literary model, says in his prose poem *Igitur*.

The *Large Glass* has often been seen as Duchamp's main work, although, strictly speaking, it cannot be called a work (illus. 127). Friedrich Kiesler even described the *Glass* in the *Architectural Record* as '*the* masterpiece that painting has brought forth in the first quarter of the twentieth century'. Kiesler was not troubled by the fact that this masterpiece was not a painting, because he saw its affinity with architecture, which 'exercises control over space', whereas an easel picture could only convey an illusion of space. Glass seemed to him well suited to marrying surface and space. The glass image is 'in a state of constant readiness for action', evidently because it always communicates with space. In the *Glass*, Kiesler was captivated by what he saw as a new synthesis of technology and art, without noticing how Duchamp subtly subverted this synthesis. He also enthused about Duchamp's invention of a new method of 'structural painting' that involved working with strings and wires, and spoke of an 'x-ray picture'. As a result of his early essay Kiesler lost his post on the *Architectural Record*, where there were suspicions that the whole thing was a spoof. Duchamp, however, congratulated the author, commenting that his interpretation was correct – though in this case that means nothing.

It seemed obvious to call the *Large Glass* a masterpiece when people learned of the years spent on it and the countless preparatory notes and sketches that preceded it. Duchamp seems to have done nothing of comparable significance over a period of ten years, and he continued to surround the work with publications and commentaries even after he had ceased work on it. But the devotion to this work may reveal his secret impetus to develop a travesty of the masterpiece. Travesty should not be confused with parody, because it simulates a masterpiece instead of actually producing one. What the artist produces is a commentary in which each individual statement is a negation, without thereby ceasing to be a definition. Only the discourse has changed. The fictitious character of the absolute masterpiece itself becomes the target. Balzac's

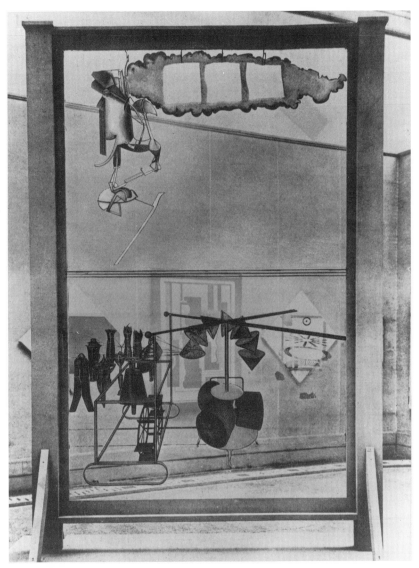

127 Installation shot of Marcel Duchamp's *Large Glass* as exhibited at the Societé Anonyme, New York, 1926–7.

'unknown masterpiece' is given a visibility that, paradoxically, does not reduce its invisibility.

The *Large Glass* is divided in half by a hinge that separates what Kiesler called the 'bioplastic exposition' of the virginal bride in the upper half from the 'mechanical mania' of the frustrated bachelors. Duchamp gave various names to this barrier, among them the metaphor of the 'garment' of the bride, whom the suitors cannot strip. Every work of art is such a garment. But in the *Large Glass* Duchamp aimed to reveal the ambivalence written into the concept of art itself. This view is a twofold one. First, one can think of art as being clothed by a work just as the chaste bride is clothed in her wedding-dress. The undressing of art is forbidden. The second view, however, does not identify art as the bride concealed in the garment (the work). Art is the bridal dress itself, in which there is no bride. This means that what is concealed within the work of art is either a mere concept or a higher truth that uses art only as a mask, as its clothes.

But the concept of the *Large Glass* does not end there. The work represents not only the old ideal of art but also, and to an equal extent, a new ideal of technology. At the time, the engineer seemed to win over the artist, unless the artist saw himself as an engineer who preferred rational construction to the intuitive creation of a work. This is why Duchamp designed the *Large Glass* like a perfect machine and used technical materials that exclude his own personal touch, as though his aim was merely to produce a design for a work. But the *Large Glass* does not function as a machine. The motor does not start, and the suitors never gain possession of the bride. So Duchamp in the end refers us back to art. By producing the perfect design for a machine he laid bare a fiction. The purpose of a machine is practical. But what is the idea of a machine? Behind every machine there is one idea, which we call its design. Here we are back at the relationship of art, as an idea, to the many works it is applied in.

THE WORK PROCESS AS RITUAL

Today the *Large Glass* stands in the Philadelphia Museum of Art in front of a window specially cut into the wall. On the back is a label with the title *La Mariée mise à nu par ses célibataires, même* (The Bride Stripped Bare by her Bachelors, Even), followed by the signature and the date '1915–23', with the added comment '*inachevé, cassé 1931, réparé 1936*' – unfinished, broken and repaired. The complicated history of the work

began in Munich, of all places, where, far from the Paris art scene, in the summer months of 1912 Duchamp undertook his last easel paintings while making his first notes for the *Large Glass*. Pictures such as *Virgin* and *The Passage from Virgin to Bride* already reduce the bride to mere anatomy and explain it as a kind of engine that has a carburettor but will not fire. Duchamp's abandonment of painting was a renunciation of the personal 'handwriting' in which a painter expresses himself. Duchamp simulated the production of a mechanical object in order to place the invention of a picture on the same footing as the production of a machine.

It is worth recounting the eventful history of the making of the *Glass*, for it turns all the usual procedures for creating a work upside-down. In Paris, in November 1912, Duchamp made the first design for the lower panel. In the course of preparation he produced many notes and sketches, which he saved and was later to publish. The written notes and comments even antedate the work itself. Like a novelist, the artist prepared his text in 'cahiers' and worked with pseudo-logical plays on words that he translated into images, like Raymond Roussel in his *Impressions d'Afrique*, which Duchamp later acknowledged to have been an important influence. With almost manic precision Roussel described the absurd mechanisms constructed by an inventor stranded in Africa (a parallel to the artist stranded in the modern age). By altering words in an almost mechanical way, he created a bizarre and confusing sequence of events. Duchamp followed a similar procedure, but in a pictorial medium.

The next act in the genesis of the *Glass* happened in the summer of 1915 when Duchamp went to New York, where he stayed with his patrons, the Arensbergs. Here he began work on the upper part of the *Glass*, the domain of the bride, which in 1916 was sufficiently advanced to allow work on the lower panel with the bachelor-machine. Duchamp took all his notes and sketches with him to Buenos Aires in 1918, and in 1919 to Paris, where, before he left, he produced the *Mona Lisa* with the moustache and beard. By the end of December he was back in New York, but spent his time supporting a 'Société Anonyme' that was to prepare the first museum of modern art. In September 1920 Duchamp had his friend Man Ray photograph the dust that had settled on the *Glass* – which had been laid flat – to symbolize the length of time that he had been working on it (illus. 128). The dust on the unfinished work, in a reversal of our usual experience of time in the art process, was then fixed to the work with varnish, as Duchamp had already planned in his early working

128 *Élevage du poussière*, a photo taken in Duchamp's New York studio of settled dust on his *Large Glass*, 1920.

notes: 'Let dust collect on this part of the glass for three or four months and clean carefully all round it so that it becomes a kind of colour.'

In the meantime the Arensbergs, who had bought the *Glass*, were moving to Hollywood and sold the work, which would not have survived the move, for $2,000 to Duchamp's fellow campaigner in the Société Anonyme, Katherine S. Dreier. In 1923 Duchamp gave up his studio in New York to devote himself wholly to chess tournaments in Europe, and in the same year Katherine Dreier moved to her new house in West Redding, Connecticut. It is idle to speculate on what degree of completion the work might have attained, because this hybrid between a work and an idea was not expected to produce a final result. It is therefore dangerous to adopt a literal approach to the work and construct an interpretation based purely on a visual analysis. If one consults the sketches for advice, it is impossible to determine what, out of that immense quantity of material, would have gone into the work. Perhaps Duchamp himself no longer knew.

By now the *Glass* had acquired a frame and a stand, so that it could be exhibited. It was not intended to be hung on a wall, because this would not have allowed the spectator to look through. When the 'international exhibition of modern art' at the Brooklyn Museum opened in November 1926, the *Glass* appeared in public for the first time. In

Europe, where it had never been shown, photographs had to be the means for conveying an impression of it. Amédée Ozenfant, who published one such photo (illus. 127), found it necessary to add the somewhat awkward explanation: 'Object painted on transparent glass. Through it can be seen pictures by Léger and Mondrian', which were also featured in the Brooklyn exhibition. Ozenfant included the work in his book *Foundations of Modern Art*, which appeared in an English translation in 1931. With a blind faith in its credibility, he quoted the work's title as 'The bride who has been unveiled by her chaste lovers' – as though what cannot be achieved had in fact happened. In a gloss Ozenfant added that Duchamp had wanted to draw attention to 'the plastic values inherent in "contraptions" and machines'. Since this intention could hardly appear plausible, Ozenfant admitted that Duchamp had deliberately launched a 'nihilistic protest against art'. He little suspected how close he was to the truth. Still less was he aware of how in the meantime the appearance of the *Glass* had changed.

On their return from the exhibition the two glass panels, lying one on top of the other, had been broken, with almost symmetrical cracks forming on the two halves. But since the *Glass* was then stored in a garage, the owner discovered the damage only five years later, in 1933, and informed Duchamp during a meeting in Lille. The so-called restoration, which Duchamp carried out with his usual patience, only took place during his next visit to the USA in 1936. He inserted three new sections of glass and wrote home: 'Three more weeks and the bride will be back on her feet again.' The accidental damage and the repair, which made the cracks part of the composition, once again seriously called into question the intended appearance of the work. Friedrich Kiesler declared at the time, somewhat mystically, that only the breaking of the glass had completed the circle joining 'the unconscious image to its visual realization'. He accordingly had the *Glass* photographed by Berenice Abbot from unusual angles, which allow the cracks to acquire an aesthetic attraction of their own (illus. 129). In 1943 the *Large Glass* appeared in an exhibition at the Museum of Modern Art, the same place at which Picasso's *Guernica*, the celebrated masterpiece of modernism, had arrived on loan. The opposition between the two works was, as it were, acted out on the same stage.

In the meantime Duchamp had also begun to provide a body of comments on the *Glass*. For, as he explained in a letter in 1949, the physical work had not been intended as an aesthetic product. 'It should be accompanied by a text that is as amorphous as possible and never takes

129 Detail photo of Marcel Duchamp's *Large Glass*, showing the damage done after the 1926 exhibition.

on a definitive shape. And the two elements, the glass for the eye and the texts for the ear and the mind, should not merely complement each other but should above all each prevent the other from forming an aesthetic-visual unity.' This removes the distinction between work and commentary. The idea was not the idea *for a work*, but an idea that transcended any work, with the result that the *Glass* and the commentary became equally important.

So there is nothing contradictory in the fact that the drawings and notes that had preceded the making of the *Glass* were published by Duchamp some twenty years later, as the author's own commentary. He did this in the *Boîte verte* (Green Box), which, in September 1934, contained 94 facsimiles of the texts and drawings made between 1912 and 1917 (illus. 130). The photographic printing and colour are of such quality that the purchaser might justifiably wonder whether the *Boîte verte* was a commentary *on* a work or a work in its own right. The *Glass* might even have been thought of as illustrating the *Boîte verte*. In a letter to Kiesler, Duchamp mysteriously referred to the *Boîte verte* as a 'manuscript of the *Glass*', as though it contained his personal 'handwriting',

which in the *Glass* is carefully avoided. At the same time the *Boîte verte* looked like a collection of blueprints for the construction of a machine. If Duchamp had only produced the notes and not executed the work, he would have anticipated the Conceptual art of the 1960s.

The publication of the *Boîte verte* caused André Breton, the leader of the Surrealists, to publish the first analysis of the *Glass* in the periodical *Le Minotaure* under the ambiguous title 'Le Phare de la Mariée', translated into English as 'Lighthouse of the Bride'. For this purpose Breton had studied the notes in the *Boîte vert*. Much as he had founded the myth of Picasso's *Demoiselles*, he now initiated the myth of the *Large Glass*, which he claimed for Surrealism. With the *Glass*, he wrote, the 'stupid' activity of the painting hand was over once and for all. 'It is unacceptable that drawing and painting should still be at the same stage as writing was before Gutenberg.' The new was possible only if one unlearned the old ways. It was 'absolutely new' about the *Glass* that it carried out in a *rational* manner what in its intention could only be *irra-*

130 Marcel Duchamp, *The Green Box*, 1934, mixed media.

tional. Its originality lay in its withdrawal into an idea, which meant that the visual arts could abandon their longstanding obligation to produce works. Duchamp had brought back 'the trophy from a fabulous hunting expedition in virgin territory' that had led him 'to the very limits of eroticism, philosophical speculation and sportive competitiveness'.

The essay culminates in a description of the work that with simulated naïvety gives a 'morphological overview' of the composition, before Breton goes on to describe the narrative as though it could be narrated. Since no discernible road runs through 'the written and graphical thicket' of the *Boîte verte*, Breton offered himself as a guide. This pseudo-logical description, a brilliant exercise in Surrealist technique, made history in its own right. It is precisely not 'a first introduction for those who want to understand', but, if anything, an official statement on behalf of the Surrealists, who would have welcomed Duchamp as a member. The interpretation that Breton dedicated to Duchamp's 'principal work'– beside which there could only be satellite works – thus remained as firmly attached to it as if the work had itself produced it.

From 1937 onwards Kiesler toured the USA giving lectures in which he would alternately read a sentence from the *Boîte verte* and illustrate a photographic detail of the *Glass*, as though this were a safe method of understanding the work. Duchamp, for his part, commented on the *Glass* in letters, essays and interviews over a period of decades, thereby building up a second corpus of hermetic texts that mirrors and complements the collection of texts in the *Boîte verte*. To complicate matters still further, most of the explanations were given in English, which meant that the French word-plays were put to a difficult test. The only edition of the *Boîte verte* in book form was published in English in 1960 by the pop artist Richard Hamilton under Duchamp's personal supervision.

THE ANATOMY OF THE WORK

Any description of the *Large Glass* is doomed to failure because Duchamp's title refers to a sexual act, while the work alludes to a motorcar engine, with the composition being made up of its elements. The sexual act does not happen, and the engine does not fire. In both respects the work remains a fiction in the way that pictures are by their very nature, but here the *fiction* takes possession of an alleged *function*: art, Duchamp tells us, can never function in the same way as processes in life or in technology. What was once, in descriptive art, the narrative of the

picture, has here been replaced by a function that cannot be carried out. The 'action' cannot be narrated in the work, any more than the work's 'composition' can be described without reference to content.

The perspective in Duchamp's *mise-en-scène* is understood in both a literal and a metaphorical sense. In the first sense, because traditional art always offered a particular perspective in the depicted space; in the second, because modernist art itself becomes a kind of perspective on, or way of looking at, the work. Taking this idea in a positive sense, perspective can be equated with the never-stilled eroticism of the gaze. Taking it negatively, perspective only falls back into the eternal game of illusion, but this time in the sense that art itself is illusion, as soon as one propounds it as an absolute. The bipartite form of the *Glass* contains an obstacle that only our gaze can cross. A drawing in the *Boîte verte* sums up this principle in a nutshell, by inserting a piece of glass that separates the bride above from the vain courtship of the bachelors below. In the notes, Duchamp calls this hinge between the partners in desire the 'cooler'. The stripping of the bride, we gather, will take place when the spark leaps across the gap. The kinetic energy in the picture, the mutual wish for undressing, remains a mere intention stated by the work. Just as the bachelors do not reach the bride, so we are equally duped by perspective when we think we see something 'there'. In a seemingly naïve manner Duchamp invites us – taking the meaning of the word 'perspective' literally – to 'look through'. The dividing line forms a 'horizon' that prevents the internal exchange of gaze between the two parties. On our side of the work, the glass surface itself makes our own gaze lose itself in empty space: we are deprived not just of a subject to look at, but of our gaze as such.

In the Renaissance, art wanted to become scientific, and perspective was the path towards this goal. Perspective was, in Leonardo's words, 'just the same as when things which are behind a transparent sheet of glass are recorded on the glass'. A diagram was to show the pyramid of vision, intersected by a glass surface. Duchamp strictly followed Leonardo's instructions, but subverted them by guiding the view through the glass into a void. The eye meets only motifs fixed to the rear of the glass, that is, which exist only in the picture. Since they do not correspond to anything outside the picture, they cease to be depictions. The base of the old visual pyramid (and therefore its whole point) is lost, and the two-dimensional projection loses its meaning when it no longer depicts a three-dimensional world. Duchamp used perspective in a contradictory sense when introducing it with the sole purpose of

making it undermine itself. A similar contradiction is present in motifs like the 'chocolate grinder' and the 'water-mill' in the lower part of the *Glass*. In the absence of a space to which they refer, their perspectivic renderings become traps for the gaze. They merely stop us looking through the *Glass*. And since they are supposed to move, their movement takes place only as an illusion. The objects from the real world do not escape the fiction represented in the *Glass*.

As if to reveal our perception as illusion, Leonardo's instructions to use a plumb and thread to transpose the shape of a real object to a picture are applied in an ostensibly correct manner in Duchamp's work *Trois stoppages-étalon* (Three Standard Stoppages). In *À regarder ...*, a small-scale variation on the *Glass*, an instruction given by Leonardo is quoted on a strip of metal in the picture itself: with an eye close to the glass, it says, one should look at the other side of the glass for almost an hour. A tree should be drawn on the pane of glass and one should spend a long time silently comparing the depiction and the tree beyond the glass. Duchamp also introduced a magnifying lens, but if one stands far enough away from the glass all one sees in the lens is oneself upside down. Only the deceptive image of a visual pyramid appears in the glass, like the memory of a lost faith. An instruction by Leonardo intended to be carried out in the studio as a teaching experiment, now appears as the title of a work.

Duchamp's repeated references to Leonardo open our eyes to the fact that the *Large Glass* is nothing other than the apparatus used for perspective in the Renaissance, albeit transformed into a modern work

131 Albrecht Dürer, 'Der Zeichner des liegenden Weibes', a woodcut from his *Unterweisung der Messung* (Nuremberg, 1538).

that subverts that old procedure. In the famous woodcut added to a later edition of Dürer's *Unterweisung der Messung* (Manual of Measurement), a pane of glass is used in the same way, separating the female model from the artist drawing her (illus. 131). What is separated in the *Large Glass* by the bar across the centre is to be found in the woodcut on the two sides of the pane of glass. The model, who is presented in the Dürer illustration in a blatantly sexual pose – the 'bride' – can be stripped bare by the artist not physically but only by his gaze crossing the glass. The painter transfers this gaze to his drawing hand, which translates what exists in front of his eyes into a picture. What he retains in his hand, then, is a drawing of the bride. That procedure once had the purpose of approaching painting and science. By reproducing the eye's perception, which is subject to the natural laws of optics, the aim was to apply an objective method in art too.

EROS AND TECHNOLOGY: ART AS PERSPECTIVE

In the old scientific perspective, however, Duchamp revealed a contradiction that makes art itself appear in a different light. This contradiction lies in the relationship between *eros* and technology. The gaze, in spite of its expectation of truth, remains bound to a distant subject, and is therefore also an erotic gaze driven by the desire to reach the world. Why else would Dürer's motif beyond the glass be an alluring woman and not a neutral object? In this way the visual experience becomes a desire in which the subject is experiencing its own gaze. But the eroticism of the gaze is rewarded with nothing but the deceptive image conveyed by the senses, or, in Duchamp's terms, the 'bride's garment'. We only own our view of things and not the things themselves: the world, as a 'world of appearances' is subject to the illusions created by our visual sense.

Unwilling to trust the eye alone, Renaissance artists required the aid of perspective, i.e., a visual technology that at the same time enabled art to become a science. Since technologies are meant to function, technology's rôle in art was to improve and control the gaze. Was it, then, now time to engage in a different method? Duchamp may have understood that by now the *eros* was directed towards the machine, which was transparent and functional in relation to the world. So were technology and art both surrogates taking the place of the world?

Perspective was pivotal to Duchamp's thought. 'Ordinary perspective', as he calls it in the Notes to the *Boîte verte*, was nothing other than 'a means of representing as different what is one and the same'. It made things look different, as though they actually were different, when in fact

they differed only in their distance from the eye. The very terms 'vanishing-point' and 'vanishing-line' amused Duchamp, since by 'vanishing' they admit to their illusory character. The *Large Glass* unmasks the science of perspective as a pseudo-science. It shows the hollowness of the claim that pictures portray the world, and disproves art as representation. In the Notes, which were published only in 1960, by Arturo Schwarz, Duchamp writes of the 'infra-thin' (*inframince*) experience of 'viewing a painting on glass from the non-painted side' (Note no. 15). One ought to 'execute a painting on glass with neither front nor back, neither top nor bottom' (no. 67). Only then, apparently, would one cease to be fooled by illusion.

But did 'true forms' actually exist, other than as an idea or an unattainable dream? In this context it is worth looking at a remark made on the first sheet of the *Boîte verte*. It refers to a planned subtitle for the *Large Glass*, which was to be *Retard en verre* (*Delay in Glass* in the English edition) – a delay made of glass or on glass. Duchamp made detailed comments on this remark. 'Use [the expression] "delay" instead of picture or painting', but not as if it meant a 'picture on glass'. The reader should not cling to the meaning of the word 'delay', but rather take the word as an 'indeterminate general term'. The word was merely a way of no longer speaking of a painting but instead of a 'delay in glass'.

But Duchamp usually redirects our attention from where he has hidden an important hint. Of course the *Glass* is not a painting, but it shares with a painting the aim of drawing our gaze to it. But here the gaze does not rest; is it only 'delayed' before it passes through the glass. We often experience this when we look at a painting protected by a slightly dusty glass overlay. Even the motifs Duchamp fixed to his work only arrest our gaze in front of nothingness. The glass offers our gaze only 'infra-thin' resistance before we look into nothing. This convincingly captures the essence of the illusion that art has so readily served. The glass, as a transparent surface, is the symbol of a great fiction.

In the preface to the *Boîte verte* Duchamp noted that the *Glass* was no more than a 'momentary repose' (*repos instantané*) among many similar ideas for works (illus. 130). This statement may be interpreted in various ways. He may have seen the *Glass* as a pause that allowed him to interrupt the stream of his ideas. But the reference to a 'glimpse' also makes us think of the 'delay' that our gaze is supposed to experience in the pane of glass, like in a 'momentary repose'? The delay of nothingness occurs when we encounter a phantom of a work. In the same preface Duchamp comments on the degree to which the *Glass* is a work and

calls it an 'allegorical appearance' (*apparence allégorique*).Where we expect a work, we instead experience the allegory of a work. An allegory is a rhetorical device that refers to something other than what it actually shows: in this case it refers either to art, whose place is taken by the work, or to nothingness, which masquerades as a work.

This idea is closely linked to the whole context of perspective.This was once a scientific technique for depicting the world. As such, in the Renaissance, it formed the basis for painting to be promoted into art. Duchamp, with this allusion, categorically sets apart the modern concept of art. Modern art has ceased to be a science, unless it is a science with a different meaning. Duchamp would not have wasted his time on refuting perspective in the old sense. Art, he tells us, is rather a perspective in its own right that guides our appreciation of a work of art. If art has discarded figuration, then it requires a new perspective. Not only perspectival representation but art itself has changed. It leads us beyond the ordinary perception of the world.

This is the enigma of the *Large Glass*. It is a work that subverts its own character as a work and yet, as a work, it has become as famous as if it were an absolute masterpiece. Its technological construction undermines the meaning of technology in the same uncompromising way that, as a work, it nullifies the usual meaning of a work. The invisible and yet supra-visible presence of the work raises challenging questions. Can technology on its own produce art? And is a work all that we need in order to experience art? The questions raised by the *Glass* give room to what may be classified as an idea or as a fiction – to *art*. In this process, perspective acquires the new meaning of an experience of art, and thus is linked with the *eros* of the gaze. In this radical departure Duchamp revealed the neo-Platonic rigour beneath the camouflage of his playfulness.

A NEW STAGING OF THE GAZE

On 7 July 1969, some nine months after Duchamp's death, a work was unveiled in the Philadelphia Museum of Art that came as a complete surprise (illus. 132, 133). Works in the usual sense were not expected from Duchamp, much less a work that turned out to be an installation, albeit one that the viewer could not enter. Duchamp had been secretly working on it for twenty years. Shortly before his death it had been donated to the museum by – of all names – the Cassandra Foundation. The dead Duchamp had left behind an installation manual consisting of detailed plans, photographs and notes that left nothing to chance –

132 Marcel
Duchamp, *Étant
donnés...* (exterior),
1946–66, mixed
media installation.
Philadelphia
Museum of Art.

not even chance.

An obvious way to understand this installation is by seeing it as a further commentary on the *Large Glass*. The title, *Étant donnés*, refers to facts that are 'given', and indeed Duchamp authorized its translation into English as *Given*. But what is given? The work's full title mentions a waterfall and also 'fluorescent gas'; the waterfall simulates movement, and the gas casts light on what we see. But these remarks appear as early as 1915 and thus refer not to the installation but to the *Large Glass*, even before the latter did exist. When the terms were repeated in 1934 in the *Boîte verte*, they referred back to the *Glass*, which by then was finished. Finally, in 1969, the waterfall and the gas come to refer to a new installation, and their very presence in the new work's title means that the installation must be related back to the *Glass*. The bride, too, recurs here, but in a way that no one could have been anticipated.

Duchamp introduces us into an installation, however, that we cannot enter, for it is hidden behind a heavy wooden door brought from

133 Marcel Duchamp,
Étant donnés… (interior),
1946–66, mixed media
installation. Philadelphia
Museum of Art.

Spain (illus. 132). The installation can only be viewed at any one time by a single visitor, who is forced to bend down and stare through the keyhole as if at a peep-show. The work remains invisible to other visitors, and the viewer himself, disturbed by his involuntary rôle as a voyeur, cannot report what he saw while taking that awkward position. Besides, it would be indecent to talk about it. This time the bride really is stripped naked and is lying, legs spread apart, in some undergrowth, looking like the victim of a rape, and violated by our gaze (illus. 133). Dürer's model has lost her last remaining coverings. The bride is no longer an apparatus but is tangibly present – and yet she is accessible only to a look that is firmly held at a set distance from her, the kind of distance established by traditional perspective.

The photographs of the hidden technical apparatus of the installation give some idea of how carefully, verging on the absurd, Duchamp once again set about his task. A hole in a brick wall reveals an idyllic landscape in which an artificial waterfall simulates movement. This is a resurrection

of the genre of landscape. But the landscape shelters the naked bride, perhaps dead, although her appearance is illuminated by a gas lamp that she herself holds in her raised hand. (In reality she is lit by concealed spot-lights.) Her head is not properly depicted at all, but our imagination supplies what is missing; her body is simulated in papier mâché. At this crime scene the viewer takes on the rôle of the bachelors, stripping the bride bare with his gaze. But the gaze itself is rendered absurd by being forced to pass through the keyhole. The door remains locked, just as the glass was impenetrable. It makes little difference that here Duchamp exchanged the mechanical signs in the *Glass* for straightforward depictions (the body and the landscape). This naturalism only increased the distance between the gaze and the motif. The viewer can only overcome illusion by forming his own idea of the world.

Throughout his life Duchamp was preoccupied with the unreliability of our gaze. He would even use visual jokes for this purpose. A photograph of a New York bookshop window, taken in 1945, playfully reveals the deceptiveness of what we see (illus. 134). Behind the glass of the window, in which Breton's books are displayed, stands the usual shop-window dummy, here in the guise of the partly dressed 'bride', holding some of Breton's books. Duchamp and Breton, standing in front of the window, are reflected in the glass in such a way that they appear to be standing on either side of the dummy and looking at it. But the appearance is deceptive. Not only are the two men separated by the glass from the bride, like the bachelors, but they are looking at each other. It is only we who gain the false impression that the two of them are directing their erotic gaze at the 'bride'.

The posthumous installation in Philadelphia, in presenting the trap in the gaze, even surpasses the implications of the *Large Glass*, which today is exhibited in the same museum space. It invites one to a retrospective look at the *Large Glass*, which Duchamp so persistently commented on – and enveloped in mystery – in his own texts. In the *Glass* the looking through the glass sacrilegiously replaced traditional perspective. The title promised an erotic narrative in the picture, as though Priapus were about to undress the sleeping nymph, but what the work delivered was a motor with an ignition system. The defloration machine, which of course cannot be operated – in the traditional painting, too, all movement is an illusion – turns into a fiction. The encoded profundity, allied with the cancelled iconography, alludes to the mystery of artistic creation that for so long had made the masterpiece the sacred idol of the absolute. The innumerable sketches, too, proclaim the preparation of a masterpiece.

134 Duchamp's window-dressing installation for André Breton, New York, 1945.
Duchamp's and Breton's faces can be seen in the reflection on the glass.

Even the decision to leave the *Glass* unfinished makes it resemble a work
like the *Mona Lisa*, which according to Vasari had been left unfinished.
Incidently, the planning of the *Glass* began soon after the theft of the
Mona Lisa in 1911, when the thief left behind only the glass of the
picture-frame. The *Glass*, with the format of a 'major' work, is not only a
technological *Mona Lisa* – a machine of art – but a consistent commen-
tary on the utopian masterpiece, whose collected definitions negate one
another. The unique history of interpretation prompted by the work is
proof that Duchamp achieved his intentions.

Thomas Zaunschirm has rightly interpreted the late installation
hidden behind a closed door as a paradoxical realization of Balzac's
'invisible masterpiece'. But this had already been, in effect, the theme of
the *Large Glass*. The less there is to be seen in the *work*, the more the
incorporeal *idea* of art appears. The absolute, true to the literal meaning
of *absolvere*, releases itself from the clothing of the bride and thus from
the material world. Duchamp analysed the fiction present in the usual
notion of art. Only the idea, and not a work, can be absolute. But he
took this thought still further. Art is the 'garment of the bride', but the

bride cannot be undressed. Either there is only the garment, that is, nothing but art, or else there is, beyond art, something else, of which art itself is only the garment.

15 The Absolute Artist

Cubism, created by Picasso and Braque, was hailed by the avant-garde as the epitome of modernism, and Picasso therefore seemed to be betraying modernism when he turned back to what again seemed figurative art. But Picasso had always seen Cubism as a stage along the way rather than the final goal, and would not accept any modern version of academicism. For him, art was not to be judged by the stylistic purists, whose resistance to the continuing authority of the art-work he did not share. A critical stocktaking of those old debates is therefore overdue today, even if some protect their belief in a single modernist credo. Had Picasso not been one of the fathers of modernist art, one might suspect him of having entertained a postmodernist attitude *avant la lettre*. As early as 1924 there was doubt as to whether he was still one of the avant-garde, and Breton was quick to defend him as the 'only authentic genius of our age'.

Cubism itself had been a response to a crisis in the traditional notion of the work. Picasso may have taken refuge in the Cubist style in order to solve the problems that had come to light in works like *Les Demoiselles*. Together with Braque, he attempted to devise a modernist pictorial syntax. But this visual language was not to be an end in itself. He therefore soon found himself at odds with the Cubist 'school', which considered the artist's individuality to be obsolete. Gertrude Stein understood that Picasso always expressed *himself* in painting. He therefore had 'the egotism of a writer', which was why he 'had only writers as friends'. She knew fairly well that Cubism had abandoned the humanist hierarchy between man and object, and thus treated all things or motifs on an equal footing. But this method, in which the act of seeing became, as it were, neutralized and objectified, was to cause a conflict with the artistic ego that 'emptied' itself in his work, as Gertrude Stein said in her inimitable way.

She herself was attempting 'the same thing in literature', expunging the old ideals of rhetoric and sentiment from her language. She knew at once what Picasso meant when, on seeing the first camouflaged military truck on the Boulevard Raspail, he exclaimed – 'yes it is we who made

it, that is cubism'. Indeed, in a letter to Apollinaire, Picasso had jokingly made suggestions for improving camouflage. The 'composition' of warfare had changed in the same way as the composition of pictures. Instead of being grouped hierarchically around the army commander and the flag, war had become anonymous and now renounced the desire for show and splendour on the battlefield. If the eye was thus deprived of old privileges of seeing the world, it had to learn a more dispassionate and acute view.

In her essay on Picasso, Gertrude Stein also described the Cubists' revolution in their notion of the work. 'The framing of life, the need that a picture exist in its frame' was incompatible with the present day. 'Pictures commenced to want to leave their frames.' In doing this they were also giving up a classical system of representation. The *tableau* renounced not only the focused gaze but also the feeling of the viewer. In Picasso's famous *Still-life with Chair Caning* of 1912, the *tableau* seems to be reduced to a 'table'. Instead of maintaining the old illusion of the gaze, it draws attention to the naked reality of the picture, which is nothing but a painted board or canvas. Only a nail, casting a fictive shadow, still recalls the *trompe-l'œil* tradition that Cubism had broken with.

In pictures with musical instruments Picasso establishes the equation with the mere instruments of art that Cubism forcefully presents to the viewer. The transformation of figuration into neutral pictorial signs brings painting closer to language. *Representation* survives a world *represented*. But the things can only become signs when they are absent as such from the picture. The surface is even filled with traces of writing, almost like clues – such as '*Jou[rnal]*', which leaves us to complete the word and its meaning. While not receiving an overall impression, the viewer is invited to analyse what he sees, like a reader. In the picture, motifs indicate the conception of a pictorial alphabet. This de-composition of the pictorial tradition also encompasses the status of the work. Individual work projects are replaced by infinite studies, most of which are not even signed. Writer friends spoke of 'scientific' experiments and of 'laboratory projects'.

But Cubism was at its most radical when, in bold montages, it invaded the picture with readymades from journals or department stores. When real things turned into signs they dissolved the old boundary dividing the picture from the everyday world. This happened sometimes in ephemeral installations made of perishable materials, which could only be documented by means of photography. Such a departure from the framed picture can be seen in a 1913 montage in which the

guitar player on the canvas holds a real guitar, which is held up by wires (illus. 135). This already announces an art form that Robert Rauschenberg developed almost half a century later.

Picasso's art, with its tendency towards the autobiographical, rebelled against the mainstream of Cubism. So it is not a question of style that explains his 'betrayal' of Cubism during the Great War. The

135 Picasso's studio in the Boulevard Raspail, Paris, in 1912, showing an assemblage with a guitar.

absence of the German gallery owner Daniel-Henry Kahnweiler, who had to leave France on the outbreak of war, may have facilitated Picasso's return to figure painting in 1914. But already in the spring of 1914 he had left Kahnweiler's line when he produced two drawings in the style of Ingres that seemed to him 'better than before' – better, that is, than anything he had done prior to embracing Cubism. In that same spring, the commercial success of *Les Saltimbanques* encouraged him to emphasize once more his rôle as an artist with a personality of his own.

But it is in his revision of Cubism that Picasso reveals his ideal of eternal metamorphosis, rather than the modernist idea of linear progress. The artistic self appears in the guise of the harlequin or the guitarist, regaining its voice through these rôles. Thus the sorrowful mood in the large *Harlequin* of November 1915 (illus. 136), with its black background, reflected the artist's persona. Picasso also reinstated the old reciprocal relation between the gaze of the picture and the gaze of the viewer. With the restoration of the former hierarchy of figure and background, the picture once again became a stage for a solo performer. In this way even Cubism could be performed as a stage rôle, once Picasso let his painted figures 'exhibit' Cubist still-lifes on a stage with a curtain. 'If you like' (*Si tu veux*), we read on the musical score held by a harlequin with a violin (*The Violinist*, 1918). Just as the work was a mask for the artist, so the chosen style continued to be the mask of art. Picasso was once again creating personal works that were distinct characters, not anonymous series.

Léonce Rosenberg, who wanted his gallery, 'L'Effort Moderne', to be the bastion of a Cubist school, pressed Picasso for years to toe the line of modernism. In his letters he begged Picasso to distinguish 'the allies from the neutrals and the enemies'. 'Only together can we remain victorious'. In 1915, in order to win him over, he bought the *Harlequin* for a high price. In that picture a harlequin *alter ego* of the painter, largely covering up a light-coloured figure, indecisively dangles a small, unfinished oil painting in his hand. Picasso's ironical response to Rosenberg was to make a realistic portrait drawing showing the reluctant owner with his back to his new acquisition. Jean Cocteau, who opposed Rosenberg's aims, recalled that at that time 'Montmartre and Montparnasse were under a dictatorship', and that under the rigid Cubist code 'such articles as may be found on a café table, together with a Spanish guitar, were the only ones allowed'. So the very motif of a harlequin, with his moods of playfulness or sorrow, was a symbol of liberation.

The dualism in Picasso's works during these years was an attempt to establish a modernity with several faces. For a time, however, he still

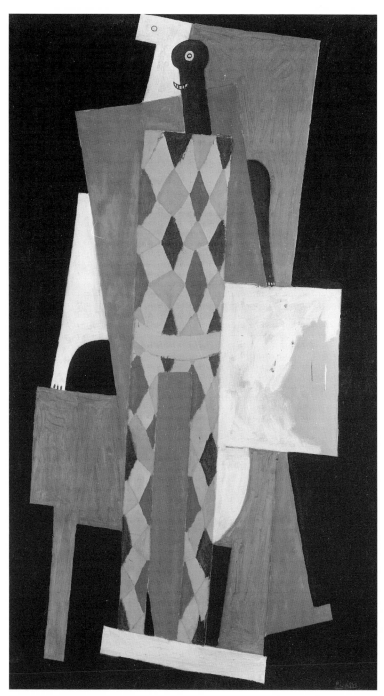

136 Pablo Picasso, *Harlequin on a Black Ground*, 1915, oil on canvas.
Museum of Modern Art, New York.

practised Cubism and neo-realism in separate media. Up to 1918 Cubism alone was accepted for his oil painting, while neo-realism was reserved for line drawings, where it was not subject to the authority of a finished work. Only in the early oil sketch with the revealing subject of *Painter and Model*, begun in the summer of 1914, did Picasso attempt neo-realism in painting (illus. 137). But after doing only part of the picture, he left the rest of the under-drawing untouched, like an unresolved question. The composition shows the painter sitting in a melancholy posture next to a female model who is undressing herself in vain for him in front of the easel.

Not until 1923 did Picasso have the opportunity to settle the score with Cubism's dogmatists. On the occasion of his first exhibition in the United States he gave an interview in which he declared that 'Cubism is

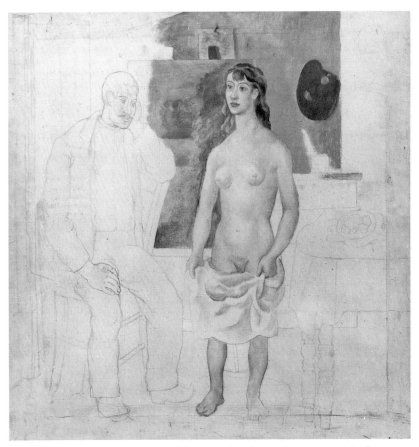

137 Pablo Picasso, *Painter and Model*, 1914, oil and pencil on canvas. Musée Picasso, Paris.

no different from any other *school* of painting'; what had been said about it had only 'blind[ed] people with theories. Cubism has kept itself within the limits and limitations of painting.' For Picasso it was not a programme that would discourage him in his work as an artist. On this occasion he made the famous statement that his concern was not to search but to find. 'To search means nothing … To find, is the thing.' In his view, the ambition to search meant the failure to find: 'In art good intentions are not sufficient.' It was 'perhaps the principal fault of modern art' that it pursued theories instead of proving itself in works. And so he firmly told the apostles of truth that 'Art is not truth. Art is a lie that makes us realize truth.' Truth *through* painting, not truth in texts. Surrounded by aging Cubists and besieged by the young Surrealists, Picasso went his own way. He was just embarking on a new variant of Cubism, though he chose not to mention this. In the quarrel among the factions, everyone wanted to present his own modernism as the one route to salvation. In this free-for-all, Cubism was no more than a term of convenience. If Cubism had won the case, the rôle of the artist would have lost its freedom. So there was method in the many-faceted phenomenon of 'Picassism', as it was already being disparagingly called. With the rôle of the artist under threat, Picasso played another trump and performed the rôle of the *absolute* artist.

HARLEQUIN IN THE THEATRE OF PAINTING

The rôle of the artist as embodied in the image of the half-clownlike, half-demonic harlequin fitted Picasso, with his theatrical nature, like a glove. Apollinaire, while in a field hospital in 1916, painted Picasso as a harlequin with the words 'The birds sing with their fingers' – a wonderful metaphor for the act of painting (illus. 138). Cocteau visited the painter in a harlequin costume, but could not persuade Picasso to paint him in that guise because the painter was, figuratively speaking, unwilling to lend that costume to others. When Cocteau had persuaded Picasso to collaborate on the ballet *Parade* in the summer of 1916, this produced the explosion of drawings in Picasso's sketchbook no. 59, showing Harlequin with slapstick, guitar and mask, and above all performing – performing on stage.

At this time Picasso decided to present himself on the public stage rather than in the exclusive art gallery. He therefore left the avant-garde 'laboratory' and seized the opportunity to promote new art by means of other strategies. 'Ballet' is not an adequate description of Sergei Diaghilev's Ballets Russes, for they broke down the barrier between

138 Guillaume Apollinaire, *The Birds Sing with their Fingers*, 1916, watercolour over black lead graphite pencil. Musée Picasso, Paris.

variety theatre and circus and, in the case of *Parade*, tried to reconcile 'high' and 'low' art. The success of the silent movie, to which the 'little American girl' in the ballet is an allusion, reinforced his desire to leave the ghettoes of pure art and high culture. Cocteau's 'screenplay' parodied the advertising of a showpiece that no one wanted to see. Everybody was familiar with the 'parade' of showmen in front of the entrance to fairground booths, enticing people in. In the ballet the Chinese magician and two acrobats joined in encouraging the public to go and see the play – which was supposedly not going to be performed because no one would come anyway. The mere *announcement* of a play, instead of a play as such, was a shrewd allegory of the avant-garde.

Picasso's brief was only to design the costumes and scenery, but the project brought his art back to the path he had set out on in his 'harlequin period'. He even succeeded in overriding the ballet's author, Cocteau, and introducing the celebrated figures of the 'Managers', whom he made into walking posters for Cubist art. Although there was no actual harlequin in the piece, Harlequin was a figure who tradition-

139 Pablo Picasso, *Harlequin and Woman with Necklace*, 1917, oil on canvas. Musée d'Art Moderne de la Ville de Paris.

ally belonged to the old *commedia dell'arte*, which was a sort of 'primitive' archetype for ballet. For Picasso the name stood figuratively for the 'comedy of art' in another sense. He felt called on to be an actor in the theatre of painting. Theatre, spectacle, a feast of illusion, the work as a performance of the artist's self – these were metaphors that were incompatible with the objective claims of dogmatic modernism.

Harlequin was an ambivalent rôle, but a 'rôle' implies an actor playing it. Picasso always took on a rôle whenever he created art. But in the twilight zone between art and life it was not clear where the self ended and the rôle began. In many of Picasso's works the harlequin has taken off his half-mask, so that one can see a face – but whose face? In a large picture painted during a visit to Rome in the spring of 1917, a harlequin and a woman with a necklace perform a dance (illus. 139). But the harle-

quin has a double face: his light-coloured profile is turned towards the woman, blending with her second profile, while the black frontal view of the face wears a mask. Picasso's harlequins often have a *doppelgänger* who accompanies them like a shadow. On other occasions they seem to be split into two beings, of whom no one can say whether they are acting together or against one another. However mystifying this rôle-playing was, it brought out into the open an aspect of art that at that time very few modernists were willing to acknowledge: art as a game and as illusion – painting as theatre. This was Picasso's choice, while dogmatic modernism quickly became history.

The drop curtain for *Parade*, with its *faux-naïf* tempera painting, was not a work but more an advertisement in painted form (illus. 140). For a minute and a half, while listening to Erik Satie's wonderful *Prélude du rideau rouge*, the audience looked at a painted stage before the real stage was revealed. Itinerant performers could be seen sitting at a table, watching a winged ballerina dancing on the back of a white Pegasus and reaching out her hand to a monkey climbing a ladder painted in France's national colours. A harlequin gazed longingly at this fragile Jacob's Ladder leading up to the heaven of art. Nothing that was shown on the curtain would actually appear in the ballet. Moreover, the scene it depicted seemed to be taking place at the back of the stage, although the painted curtain itself was in front of the stage. The artists seemed to be entertaining themselves without taking notice of the audience. The manner of the painting seemed pitched at the popular taste, as though to strike the note of the mass-media.

The curtain's announcement was not that of the ballet, but the proclamation of a new style. The *premiere* was therefore the equivalent of a *preview*, just as the performance was taking the place of an exhibition. There was a subtle irony in the fact that the new style, like an ephemeral veil, covered the eternal theatre of art. With this curtain Picasso officially proclaimed his neo-realism. But in the ballet itself, the 'Managers' appeared in Cubist costumes that made them look like walking collages. This offered a choice between two styles, with the same artist expressing himself in each of them. The picture on the curtain reminded the audience of Picasso's *Saltimbanques* (illus. 94), but the figures from that work reappeared here in a post-Cubist dissection. Apollinaire was also present at the Théâtre du Châtelet on that evening of 18 May 1917, and had the pleasure of seeing that his early poem 'Les Saltimbanques' had once again inspired Picasso's art.

In the preface he wrote for the programme, Apollinaire described

140 Pablo Picasso, Theatre 'drop' curtain for Jean Cocteau's and Erik Satie's
Parade, 1917, tempera on cloth. Musée d'Art Moderne de la Ville de Paris.

Parade as a 'scenic poem' in which the marriage of painting and dance
was achieved. Painting always awakened a desire to draw life out of the
silent work. An art work, art's ultimate coinage, required ever new
demonstrations of its validity. In his preface Apollinaire insisted on
Picasso's right to depict reality, not reproducing but representing it. And
here we encounter for the first time the term '*sur-réalisme*', describing
Picasso's art, with which he 'seduced the elite'. No wonder André Breton
tried firmly to link Picasso with Surrealism after Apollinaire's death. His
realism, so it seemed to Apollinaire, was only a variant of an essential
surrealism in which even a harlequin could strike a modern chord.

THREE WOMEN AT THE FOUNTAIN, OR THE WELL-SPRINGS OF ART

With his new fame, Picasso was suspected of 'returning to the museum
tradition', as his former supporter Maurice Raynal lamented. 'Fame is
dangerous when one no longer has it under control.' In this case fame
meant performing the old rôle of the artist. 'The museum tradition' was

a way of referring to the kind of timeless art on which the avant-garde had declared war. Picasso stated his position in 1923: 'To me there is no past or future of art. If a work of art cannot live always in the present it must not be taken seriously at all. The art of the Greeks … is not an art of the past; perhaps it is more alive today than it ever was.' In George Wildenstein's gallery, where Picasso was the only modern artist represented alongside the Old Masters, this coexistence became a central issue in his art. It is hard for us today to imagine the gulf in prestige that then existed, in the eyes of collectors, between the 'Old Masters' and contemporary artists.

In the years around 1920, Picasso seemed to be following a strategy dreamed up by his new dealers and advisers. He switched from Léonce Rosenberg, the stern spokesman for the Cubists, to Paul Guillaume's gallery. Then, while on holiday in Biarritz in the summer of 1918, he met Paul Rosenberg, who offered to represent him in Europe, while his business partner George Wildenstein would do the same in America. Picasso moved to the elegant rue la Boétie, where he was to be Paul Rosenberg's neighbour. This entry into what the other Rosenberg called 'ultra-chic' circles brought its rewards in the form of exhibitions in which Picasso seemed to have broken with the avant-garde. But he was only pioneering Modernism as the accepted canon. In Rosenberg's stock, which soon included 22 Picassos, the Impressionists still dominated, with 66 works by Renoir alone. Gradually the avant-garde had become an accepted part of art history.

But Picasso would not be the harlequin on the stage of art if he had tamely surrendered to commercial considerations: even this environment gave him scope to celebrate art in his own way. 'Art has always been art and not nature', as he declared in 1923. Its own kind of fiction was never concerned solely with contemporary realities. When Picasso painted his nymphs and bathers, he seemed to be deploying elements from the humanistic cultural tradition, whereas in fact this was no more than a 'reprise' of an old artistic vocabulary whose motifs had no literal sense: what appeared on the canvas anyway was abstract in relation to the representational motif and concrete only in relation to form, as Picasso said, also in 1923. Old works were engaged in a dialogue with new works, which opened a new round in the ongoing history of art. *Three Women at the Fountain* alluded to a well-spring of art that could never run dry.

But there were also the poets, who wanted to renew poetry after the rupture the Great War caused. We would have a different image of

Apollinaire if he had not died so early. In 1918, the year of his death, he wrote to Picasso: 'I should like to see you paint large pictures like those of Poussin, something in the lyrical spirit.' In a catalogue for Paul Guillaume's gallery, he called Picasso a 'lyrical painter' who 'has his equal only in the past'. This was a clear statement that Picasso had already become part of the history of art: he was born to be the 'heir of all the great artists'. Apollinaire's book on Picasso was still unfinished when the writer died in November 1918, but Picasso perpetuated an internal dialogue with his friend, who had become his second self, as if to paint the poetry that Apollinaire had not been able to write. This symbiosis was so close that he never again wanted to paint a self-portrait after the news of Apollinaire's death had reached him at a moment when he was looking at himself in a mirror. In the shadow of Apollinaire, which he felt resting upon him, his own death waited for him, however much he kept it at bay with his legendary zest for life. In the oppressively solemn painting *The Three Musicians* he immortalized Apollinaire, a Pierrot now already in the Hereafter; in this artistic epitaph, Harlequin does battle with the intimations of death, but goes on with the show.

For Picasso, the only law of creativity was metamorphosis, the very opposite of copying and plagiarism when it came to reworking earlier art. Metamorphosis, however, was also inimical to the completion of a work, which may explain Picasso's anxiety about it. What looked like classicism was only a borrowed mask for doing the same old thing again. Renoir had been inspired by Ingres, just as Picasso now let himself be inspired by Renoir; Renoir had transformed Impressionism much as Picasso now wanted to transform Cubism, in order to continue along the path of art. In the final year of Renoir's life, 1919, Picasso made a drawing of the infirm old man with his almost lifeless hands that still wrested life from art. It was Apollinaire who had defended Renoir, back in 1912, against the accusation of decadence in his Arcadia of female nudes.

It was this motif (see illus. 142) that Picasso pounced on with fanatical zeal after Renoir's death, as though to take possession of a vacant inheritance. He bought from his dealer a powerful nude by Renoir (illus. 141), the title of which, *Eurydice*, suggests that Picasso wanted to be Orpheus, bringing back the soul of art from the Underworld, to use Balzac's words, which Picasso knew so well. As a Spaniard, Picasso understood the meaning of ritual. In Renoir he discovered the same passion for redoing old art in a new spirit. Renoir in his oil sketches had assembled the vocabulary of different styles, striving for a synthesis of Impressionism and Classicism. Picasso had bought one of these studies (*Mythologies*), and

141 Pierre-Auguste Renoir, *Landscape with a Bather, called
'Eurydice'*, 1895–1900, oil on canvas (formerly owned by
Picasso). Musée Picasso, Paris.

in an oil sketch of his own (*Studies*, 1920) combined Cubist and neo-clas-
sical motifs in a very similar way. His studies were not preparatory exer-
cises for a particular work, but were like essays of the Montaigne kind.
The drive for metamorphosis never left him. The neo-classical style in
the context of modernism was an attempt to legitimize works – works
whose meaning went beyond the taste of a mere collector.

 In his large-scale painting *Three Women at the Fountain*, Picasso in
1921 created a work of calm solemnity (illus. 143). He was spending the
summer at Fontainebleau, where – for instance in his picture *La Source*,
now in Stockholm, or in his *Grande Baigneuse* – he effectively engaged in
dialogues with the classical paintings in the royal palace. In the metope-

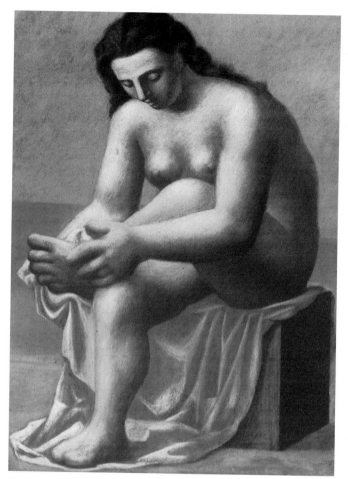

142 Pablo Picasso, *Seated Model Drying her Foot*, 1921, pastel on canvas. Berggruen Collection, Berlin.

like picture of the *Three Women*, the Greek women have come to the well in order to draw water with their jugs. But they seem engaged in a conversation that has been going on since time immemorial, in which they merely take on different speaking rôles. In addition, they present a single ideal of one painted statue seen from three different angles. Each of their hands was worked on in a separate preliminary drawing comparable to the design for a Cubist object. For the composition as a whole there is even an almost full-size sketch in red chalk and oil on canvas, which resembles the cartoons of the Old Masters (illus. 144). Picasso had this huge sketch hanging in his home, like a matrix for his future works. The Renaissance-style preparation of the work is like a confession, as though

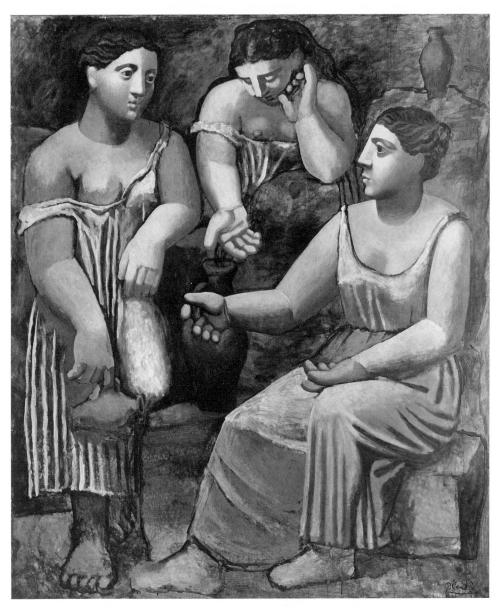

143 Pablo Picasso, *Three Women at the Fountain*, 1921, oil on canvas. Museum of Modern Art, New York.

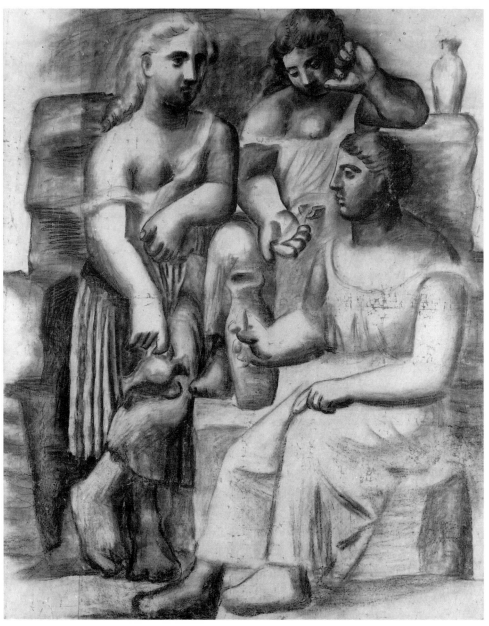

144 Pablo Picasso, Red chalk sketch for illus. 143, 1921. Musée Picasso, Paris.

in this painting Picasso wanted to perform art in its classical mode. The three women are, as it were, drawing their own beauty from the inexhaustible well of art.

GUERNICA: THE WORK AS MYTH

Picasso's *Guernica* was painted in May 1937 for the Spanish pavilion at the World Exhibition in Paris, and from the day of its unveiling it became the most famous work of the century (illus. 145). And yet it fits very awkwardly into my narrative, where it raises more questions than it answers. There is, first of all, the myth that was virtually forced on the work, which the work could not justify on purely artistic grounds. The myth arose from the fact that here art itself was making an accusation in the name of humanity. In so doing, art took on a political stance that it had long since lost in democratic societies, thus awakening premature hopes that it might regain a place in public life. But this political commitment led to a conflict. The desired propaganda success rested on the political cause which the picture supported, and yet only the work of art could achieve that success. If the work became an artistic myth, it lost the argument that was its true *raison d'être*. If, on the other hand, it succeeded in its political argument, then its artistic status became secondary. In the one case the *work* would succeed, in the other the *protest*. All those who wished the argument to succeed had to refrain from critical discussion of the work, and there was therefore a unanimous chorus of praise for *Guernica* before the canvas was even dry.

At that time the so-called struggle over realism was splitting the French intelligentsia in two, each half of which suspected the other of being, respectively, formalists or philistines. In the discussion of *Guernica* it is easy to distinguish those who championed the work on account of its political content from those who defended its timelessly artistic beauty despite the horrific subject-matter. So the work quickly came to be viewed in two ways that were almost completely irreconcilable. Either art was enhanced by the picture's subject, or the subject by the artist. It was in January 1937 that Picasso had received the commission from the Spanish Republic (which soon afterwards ceased to exist) long before the Basque town of Guernica was bombed. Artists within Spain, incidentally, were urged to depict the drama of their endangered country in a thoroughly realistic style; only famous artists were given a free hand, for the government needed to make use of their prestige even if it did not share their views on art. In the case of *Guernica* there was no mistaking the

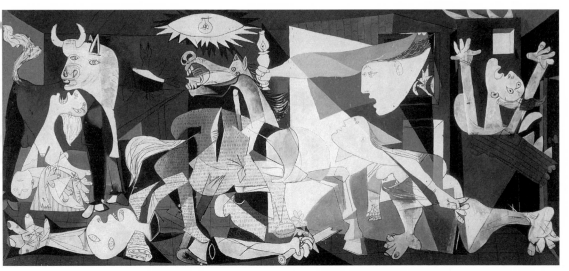

145 Pablo Picasso, *Guernica*, 1937, oil on canvas. Museo Nacional Centro d'Arte Reina Sofia, Madrid.

Republicans' disappointment with Picasso's concentration on suffering and defeat, for after all they still hoped to win the war. But the 'Victory of Guernica' that Paul Eluard praised in a poem published in 1938 was a victory won by art – or indeed a victory for art. At the time of the Spanish Civil War, Europe's artistic and literary avant-garde had, idealistically, embraced that struggle as their own.

It is still not quite acceptable today to say that people hoped for a great masterpiece, but *Guernica* seemed magnificently to fulfil such a hope. The conservative wing still criticized modern art for not having produced masterpieces on an equal footing with the art of the past. In 1934 this accusation was voiced even within the avant-garde camp, when E. Tériade, in the periodical *Le Minotaure*, demanded a return to the masterpiece. Seized by the 'phobia of the masterpiece', he said, the moderns had retreated into timid experiments, and had failed to demand greatness of their art. In view of the loss of the old concept of the work, Tériade called for the 'rehabilitation of the idea of the masterpiece', which alone could 'revitalize painting'. Now that modernism seemed to have failed in its political mission, there was a new demand for myths.

Picasso, for his part, was depressed by the fact that the myth of his *Demoiselles d'Avignon* was based on the picture's continuing invisibility, though in 1937 his early triumph was put on the market in America. He had also been working on Balzac's profound investigation of the nature

of the masterpiece, producing a series of illustrations in which he sub-
jected his own art to inquisitorial scrutiny. Even so, he persisted in casting
himself in the rôle of Frenhofer, as though he wanted to triumph with *the
sight of a work* where Frenhofer had been defeated by the *idea of a work*. He
told Brassaï that he had deliberately moved his studio early in 1937 to the
street where Balzac's story is set, the rue des Grands Augustins, and had
painted *Guernica* there, as a plaque now attached to the house records
(illus. 146). When *Guernica* appeared in public people hailed it as a rebirth
of the masterpiece. Admittedly Herbert Read was also referring to the
content when he wrote that it represented 'the modern Calvary'. But at
the same time he was celebrating the 'birth of a great work of art' that bore
the stamp of immortality.

146 Plaque on the building housing Picasso's studio between
1937 and 1955, which is also the location where Balzac set his
Chef-d'œuvre inconnu (site photographed in 1996).

For this picture Picasso made innumerable preparatory drawings and studies of individual motifs in which – reversing the practice of the Old Masters – he used colours, which he then eliminated from the finished work. He had the metamorphoses of the composition photographed at seven stages by Dora Maar, in order to preserve a record of the genesis of the painting. Other photographs showing the painter at work suggest that the real theme is the creation of the work as a ritual, which should be remembered when interpretations cling too much to the work in its final form. As always with Picasso, the studies have only a loose connection with the work, existing apart with a life of their own. This is why, while the studies were still leaning against the unfinished picture in the studio, Picasso, in a coded remark, commented to André Malraux: 'If only they could crawl into the picture all by themselves, like cockroaches.' It became difficult to incorporate them into the picture when they so obviously had an independent existence as poetic metaphors.

If Malraux remembered rightly, it was in this connection that they also spoke of the 'subject', because the infamous bombing of the Basque town of Guernica by the German Condor Legion was not the actual subject of the picture. Picasso is reported to have said that he no longer believed in subjects but that he favoured 'themes, provided that he could express them in symbols' derived from the ancient myths of humanity. In fact Picasso has sometimes been accused of using only motifs – such as the bull and eviscerated horse – from his own personal mythology, and that *Guernica* occupies a privileged place in his *œuvre*. He could have replied that the use of Spanish myths for this Spanish theme required no justification. And yet in deploying this familiar pictorial vocabulary he once again played the artist, while the world expected nothing more than a political statement. Max Raphael, who felt that the picture failed to achieve a synthesis of content and form, complained that 'not the historical event but the emotions of the artist form the true subject of the picture. He made himself the sole creator of order amid the chaos.' The question remained, he said, whether 'such an absolute ego' was capable of anything more than expressing itself. Raphael's Marxist criticism, which was written, and ignored, in New York in the late 1940s, was an exception amid the chorus of praise. He should have admitted that in the faceless violence that fills the narrative of the painting Picasso had captured a feature of the modern age. Yet Raphael was right in his view that in this work, as in all his others, Picasso was performing the rôle of the absolute artist once again.

For Peter Weiss the argument was not 'different' from the essence of

an art that responded to the war's 'attack on everything living' with a scream. 'The picture was a reminder of past moments of oppression' because Picasso was conducting a dialogue with Géricault's *Raft of the Medusa* (illus. 26). History had left behind images that refused to be suppressed. In *Guernica* 'every detail had multiple meaning, like the elements of poetry'. The metaphors in the narrative filled the painting with resonance. Weiss had not taken part in the Spanish Civil War, and he let himself experience that historical struggle in Picasso's picture. Having drawn its life from the myth of that war, the picture itself had by now become a myth.

When Weiss published his *Ästhetik des Widerstands* (The Aesthetics of Resistance, 1975), Picasso's picture was still in its New York exile. In 1969 the Spanish artists of the 'Crónica' group denounced the commercialization of what Weiss called Picasso's 'commemorative surface', and complained that its political message went unheard. When Spanish democracy was restored, the work, which had never been in Spain, was 'brought home' in the autumn of 1981 as the heroic emblem of a long suppressed chapter in Spanish history. In the Centro de Arte Reina Sofía, where it represents a masterpiece of Spanish art, surrounded by the full chorus of its preliminary studies, the vast work does not conform to the canon of the other museum pictures. Its strong evocation of a mural is a reminder of its former public status. The picture surface turns into a wall surface, on which a public indictment is made.

Picasso's figurative language, with its small stock of motifs, is pushed to its limits here. The agitation of the individual figures, witnesses of the terrible reality, meets the solemn order of the composition, in which Picasso allowed the medium of art to be seen. The picture stages the duel between light and shade, from which all colour has drained away. The night-time horror, feebly illuminated by a naked bulb, is mercilessly lit up by the lamp of a female figure who thrusts herself into the picture like Truth personified. This light challenges viewers to engage with the moral appeal of the picture.

The poor light in the picture forms the strongest possible contrast to the propagandistic illumination of the pavilions of Fascist governments at the 1937 'Exhibition of the arts and technologies of modern life'. Not by a single motif (unless one counts the light-bulb, which is, if anything, parodistic) did Picasso refer to the achievements of 'modern life'. Instead he denounced the anonymous violence of the modern age, which left its traces everywhere in the picture. But in fact Picasso also contradicted the mystification of modern technology which had long

since found its way into the arts – a technology that had shown its evil power in the bombing of Guernica. Thus the same work, which later appeared as the epitome of modernist art, denounced the blind faith in that kind of progress which was the pride of modernism. This was the secret overtone of a mythical vocabulary that Picasso used for representing contemporary history. Perhaps one might even go a step further. In a violent world of advertising, in which even politics had become aestheticized, a work of the old type, with its personal choice of images, survives like a silent protest.

The critical literature on *Guernica* has treated the picture as an isolated case in Picasso's *œuvre*. Analogies have been disregarded because they only appeared as artistic achievements. There is, first, the massive *Women at their Toilet* (1938), later misrepresented as a cartoon for a tapestry, and then *Night Fishing at Antibes*, which Picasso painted in August 1939, just before the outbreak of the Second World War. *Bacchanal*, the free adaptation of a Poussin painting, which celebrated the liberation of Paris in 1944, for a long time remained on his studio wall. Last, there is the gigantic pair of pictures, larger than *Guernica*, of *War* and *Peace*, which he painted at Vallauris in 1954 and which mark the culmination of his competition with Matisse. We should not dismiss these as secondary works simply because they have not prompted discussion. There is a deficiency in the Picasso literature if only political issues can draw attention to works that do not attract it by their art alone.

VARIATIONS ON THE THEME OF THE WORK: PICASSO'S LATE SERIES

The same applies to Picasso's late series of pictures. For each series he dedicated several months to an old masterpiece, which he addressed with untiring energy, now in a fury, now triumphant (illus. 147). They have been referred to as 'variations' on a common model to distinguish them from mere copies. Picasso opened the exercise in the winter of 1954–5 with Delacroix's *Women of Algiers* (illus. 34). In the autumn of 1957 he wrestled 58 times with the masterpiece by his compatriot Velázquez, *Las Meninas*. This was followed in 1959 by Manet's *Déjeuner sur l'herbe* (illus. 53) and with David's *Rape of the Sabine Women* in 1962. No adequate method has been found for dealing with these unusual series, nor has Picasso's choice of themes been satisfactorily explained. One can only note that on three occasions he chose nineteenth-century works that themselves harked back to earlier works. *Las Meninas* is nothing but a painted discourse on the art of painting, as Picasso knew better

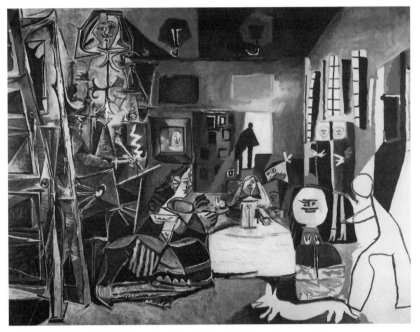

147 Pablo Picasso, *Study after Velázquez's 'Las Meninas'*, 1957, oil on canvas.
Museu Picasso, Barcelona.

than most of the critics.

However, it is the ritual of redoing another picture that provides the best route to an understanding of what Picasso was striving for. The ritual implied a series of metamorphoses that were always unpredictable. The model Picasso responded to allowed him to 'perform', as in a theatre, the inexhaustible repertory of painting. Just as the Old Masters departed from a motif in nature, so he started from a work of art, thus turning art into new art. He did not hesitate to interrogate and put in doubt the status of the work in principle. Whatever life resided in art could only be extracted by peeling off one layer after another, even if the surface beauty was damaged; but in these acts of destruction, as Picasso said in an interview with Christian Zervos in 1935, 'nothing is lost'.

Picasso's late series all share one and the same subject, but this subject (implied in the title of the model) is not *another* work but the work as such, the status of which Picasso deconstructed without paying attention to its consequences. He was attacking, or at any rate revising, his famous models by dissolving the boundaries between finished work, preliminary study and arbitrary re-creation. Picasso painted, as it were, in order to prevent the death of painting, which seemed imminent in the

funereal practice of the museum. In this endeavour he tossed off any number of Picassos, none of which were truly Picassos in as much as they bore another artist's name. To put it differently, he repainted the works of dead artists according to his own lights, until he ran out of steam. 'Art', which many treated at the time as a mere phantom, was not to be sacrificed to a concept of art, because painting for him remained the only ritual of creativity.

The series are like a liberating gesture that made painting explode in conjunction with a denial of the accepted status of the work. Picasso, who once had created studies *for* a work, now parodied that process by painting studies *after* a work, with no regard for ever producing a work again. In this mood of anarchy his exercises trumpet forth arbitrary motifs or colours, while inventing them anew. He instantly sketches a work or else refuses to redo a work in the normal sense. In this refusal Picasso was very much in tune with the times, while yet continuing the rôle of the absolute artist, who also would deal with the work production in a seemingly capricious way. When Nelson Goodman, with the help of Picasso's *Las Meninas* series, attempted to explain the nature of a variation, he failed to recognize the painter's intentions. Picasso, he wrote, produced variations on a composition by another artist, like a composer of music might do in order to exploit its hidden potential. The analogy with music is doubtful if (to use the same metaphor) it is the composing itself that Picasso called into question. A variation is still dependent on a given model, and it is precisely this certainty that Picasso abandoned.

His lifelong friend Jaime Sabartès would rather speak of 'confrontations' when referring to Picasso's furious attacks on venerated monuments of art. André Malraux preferred to call the series 'dialogues' – dialogues in which Picasso competed with earlier painters as though they were still alive. He also pointed out that the *Women of Algiers* series was begun just after the death of Matisse, who had so deeply revered Delacroix. Picasso, however, 'no longer even viewed Delacroix's picture as a score for his programme: he extracted his own picture from the source' without worrying about any resemblance. Malraux, in this connection, reminds us that Picasso had had the opportunity of seeing his own pictures displayed in the Louvre alongside the old masterpieces. 'This was the moment when the idea of his own *Women of Algiers* was born.' Rivalry was at play here. 'Rape came only with the metamorphosis of *Las Meninas*.' Metamorphosis is the only concept that is helpful here. In the late series Picasso invested the lifelong ritual of metamorphosis with a surprising new meaning: he

simply carried on the former creation of the old pictures, without caring about their history. To him metamorphosis meant resuming work on an old picture as though it had not already been ended for ever in a frame. Interpreters miss Picasso's intentions when they look for a theme *in* the work instead of identifying the work itself as the theme − a theme that caused modernism such difficulty.

On 17 August 1957 Picasso shut himself away for almost four months on the upper floor of his villa 'La Californie', in order to fight with Velázquez as if he were a living rival. The duel was christened by Hélène Parmelin as 'the battle of the Meninas'. It is significant that Picasso took up the challenge of old art as if he expected the threat to come from there. No one was allowed to assist in the silent battle, but occasionally close friends were admitted in a ritual that resembled Frenhofer's reluctance to reveal his invisible masterpiece in Balzac's tale. The series opens with a 'long shot' (to use the terminology of film), followed mostly by 'close-ups' which explore details of the narrative. In the 'long shot' Velázquez's self-portrait splits into a double face, as if two painters (the old and the new one) were staring into each other's eyes. In the other 57 shots of this painted film, Velázquez is usually absent. It was now Picasso's turn to paint *Las Meninas*.

The maids of honour (from whom the title of the old picture derives) dominate Picasso's series. Picasso was well aware that in the original picture they were not the subject that Velázquez was seen painting at his easel. The invisible subject, then, was possibly the royal couple featuring on the hidden side of the canvas within the picture, and also reflected in the mirror. Picasso therefore took the liberty of embarking on a new game of absence and presence. The maids of honour, who play only minor parts in the old picture, now have the leading rôles. At the time the maids of honour could be no more than bystanders in the picture. However, since they are secondary characters, Picasso used their painted figures, now that they were no longer living, in the guise of living models. In this ceremonial replay of the old picture, all barriers of historical time are removed. Painting no longer comes to rest in works, but changes the stage to allow the artist to perform the old pictures once again.

In 1973, the year of Picasso's death, Richard Hamilton took up this gesture in his 'Homage to Picasso', in which Picasso takes the place of Velázquez in *Las Meninas* (illus. 148). It is only the graphic medium, in that Hamilton keeps his distance from the two other painters. After Picasso's death it was as if the stage of art was waiting for the next artist

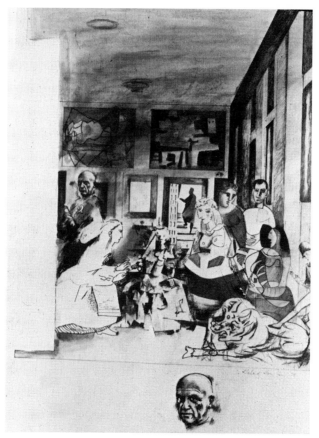

148 Richard Hamilton, *Picasso's Meninas, Study III*, 1973,
lithograph. Private collection.

to appear, though the dead Picasso lived on, as Velázquez had done.
Hamilton refurnished Velázquez's stage with motifs from Picasso that
had become memories, in just the same way as Picasso had used memo-
ries of Velázquez. The *Three Musicians* of 1921 hangs on the back wall,
while the mirror perhaps already reflects Hamilton's face. And yet a
significant change of practice has taken place in the theatre of painting.
The appearance of Hamilton's series coincided with the 'Art about Art'
movement (see p. 405), which differed from Picasso's late series in that its
aim was not to continue art but only to quote from it. As a result, the
exercise of memory no longer celebrates the life of art, but only reminds
us of a past that still believed in the production of works.

16 American Modernism

GERTRUDE STEIN'S 'MASTERPIECES' AND A NEW AVANT-GARDE

Picasso was a catalyst in contemporary art. In January 1939 on 57th Street, the young Jackson Pollock was stunned by his encounter with *Guernica* (illus. 145). The following November he experienced another 'awakening' when, in the sensational exhibition 'Picasso: Forty Years of his Art', he was confronted by *Les Demoiselles d'Avignon* (illus. 96), which the Museum of Modern Art had acquired more than 30 years after its completion. In celebrated works like these the future New York avant-garde came face to face with European modernism. The forthcoming myth of American art sprang from the desire to supplant the myth of European art. However, it was not until around 1950, a whole decade later, that American works were granted the possibility of entering, so to speak, the empty museum frames awaiting them. The script for the next act in the drama of modern art was written in New York. The American avant-garde wanted to demonstrate to itself that 'painting was not yet dead', as Barnett Newman later put it.

American 'modernism' in art was measured against European antecedants. There had been no previous accepted 'modernism' in art in America, even though America had always been the home of modernity, impressing Europeans not just with its technology and way of life but also with its cinema and jazz. The United States was the place where Europe's artistic élite was accorded canonical status, after which, re-imported, as it were, it swept to acceptance in Europe. In 1935 the Museum of Modern Art – founded in 1929 by powerful collectors, and the first of its kind in the world – mounted the famous exhibition 'Cubism and Abstract Art', followed by an exhibition of Dada and Surrealism. By tracing artistic genealogies and assigning historical labels to the respective 'currents', the young director, Alfred H. Barr Jr, established the canon of European modernism to such an extent that it was America, viewing European art from a distance, which initiated the cult of modern art. Barr cared little for American artists, whom he even discouraged with ideals they could not compete with. Instead of making common cause with the galleries, which so far had promoted European

modernism alone, he now wanted to achieve museum status for the avant-garde, whose prestige he elevated to another stage. Significantly, Barr had to sell a Degas when he bought Picasso's *Demoiselles*, and thus was setting the seal on a new hierarchy.

The saga of European modernism explains the conflicts with which the American avant-garde had to wrestle. The regionalist movements lost their case once the ideal of a universal modernism had been accepted. On the other hand, it was imperative to counterbalance the European inheritance. Exhibitions of 'primitive art' from America urged people to accept an alternative legacy. These exhibitions were curated by avant-garde artists, who presented their own work as a response to mythical art in the same shows. Barnett Newman spent many years writing texts as a way of mustering the courage to paint the pictures he dreamed of. He proclaimed an American variety of the 'sublime' that was to overcome the 'decadence' left from European modernism. During the war years the émigré artists from Europe had unwillingly strengthened the Americans' resolve to go their own way.

The key to all this is to be found in the American legend of European modernism. This is not to say that modern art had been a legend, but it was made into one. Gertrude Stein, of whom Picasso had painted a portrait as long ago as 1905–6 (illus. 97), was the chief mythographer, as she had not only been an eye-witness but also the official chronicler of the heroic years, at least in the opinion of the American public. Admittedly, her hour did not come until 1934, when she achieved recognition with a popular book in which she rooted her own myth in what she herself called Picasso's 'halo'. In the 'autobiography' of her companion Alice B. Toklas, which Stein reveals in the final sentence to be her own work, she portrayed herself as she wished to be remembered by posterity. The book, which was such a triumphant success, presents the legend of the avant-garde in a quasi-naïve manner, from the companion's point of view. Stein enjoyed her triumph during her one-year lecture tour of the United States, which she performed as the muse of modern art. In the same year, 1935, MoMA placed the first of its sensational exhibitions that shaped the legend of European modernism. In 1938 she wrote her short book on Picasso, a year before the Picasso exhibition opened. That is more than mere coincidence. Through Gertrude Stein, who had been in Paris from the very start, America held, so to speak, a place of honour in the European legend.

In the rue de Fleurus in Paris, Stein spent the greater part of a lifetime entertaining artists and writers, and there, in her so-called *atelier* with

its pictures by Picasso and Cézanne, she wrote her thousand-page book, *The Making of Americans*. She described this tome, in the purported auto-biography by her friend, as the 'beginning of modern writing', and also mentioned that her young protégé Ernest Hemingway had helped her with its long-delayed publication. At her writing desk she 'wrestled with her long sentences, which had to be constructed with such meticulous care'. She believed herself, in her writing, to be practising abstraction in alliance with Picasso, for, as she said in the 'autobiography', Americans and Spaniards were 'the only two western nations that can realise abstraction'. Here 'abstraction' and 'avant-garde' amount to the same thing. Since Picasso could hardly be classed as an abstract artist, she tells us that Spaniards express themselves by abstract ritual. It was probably her self-appointed mission to counter the irrestistible progress of modern mass media with a self-confident vision of high or avant-garde art that at that time in America was far from self-evident. For this purpose she used a new literary style that echoed avant-garde painting. As a result, literature and painting once again settled in the modern world as a familiar experience.

On the back of her new fame Gertrude Stein gave a lecture in Oxford in 1936 in which she asked the question of the 'masterpiece'. One searches in vain for an answer in the hermetic text. At first sight it looks as if she says nothing at all on her subject. On re-reading the text, one is inclined to think that she has said everything about it, but in the manner of saying nothing. Here she created a masterpiece of her own in which the subject is shielded from any superficial opinion. Art, she believed, was the last bastion against the onslaught of mass culture, and thus she defended creative autonomy as a right of its own. Masterpieces, we read, 'have nothing to do with time' and ignore contemporary fashions. In the act of creation the artist ceases to be the same person who comes home and is greeted by the dog. 'For as long as you are creative you do not think of yourself' and your everyday identity. She was convinced that she had created masterpieces, but she declared to her audience that it was impossible to explain them. Her untimely defence of timeless art ends with the convoluted sentence: 'And there we are and there is so much to be said, but at least I do not say that there is no doubt that masterpieces are masterpieces in their way and that there are very few of them.'

In 1947 Thornton Wilder republished this short text with a lengthy commentary, and in 1984 Donald Judd alluded to it in his critique of the art scene in his own day. In 1948, shortly after Gertrude Stein's death, the

San Francisco Museum of Art mounted, in her honour, an exhibition of the three Spanish painters – Picasso, Juan Gris and Joan Miró – while Kahnweiler, Herbert Read and Man Ray contributed texts to the catalogue. The preface quotes from Stein's Picasso book, a comment whose sense is plain, though it is nowhere elucidated: 'Painting in the nineteenth century was only done in France and by Frenchmen, apart from that, painting did not exist; in the twentieth century it was done in France but by Spaniards.' If, then, the Spaniards had saved modern art, it was now time Americans took up the torch, for Stein insisted on their close affinity with the Spaniards. She, as a writer, had pointed the way that America's painters were to follow.

CLEMENT GREENBERG'S AMERICAN *LAOCOÖN*

Europe and America competed with one another in a way that shaped the cultural ideas of the next generation. While Europe, ever since Charlie Chaplin, looked to America as the epitome of the modern world to which it yearned to belong, America worshipped a European idea of culture. Clement Greenberg called the latter 'avant-garde culture' because it enjoyed the privilege of disregarding commercial conditions and that of aspiring to political goals, albeit in the powerless position of culture. To capitalist eyes a culture like this might look quixotic, but, as it had gained a reputation in Europe, it was accorded almost cult status in the USA. There, art and élite culture bore European names. Fascist persecution, which had deemed art worthy of attention by the state, enormously enhanced the prestige of such art in the United States. The mutual fascination of the two hemispheres – nourished by transatlantic visits – seems to have been about 'high' culture in the one instance and 'low' culture in the other, though these terms were not yet applied. Mass culture aspired to serious values, while élitist culture sought to join modern life. Barnett Newman's individualistic ideal of the 'sublime' had no backing in mass culture as it revived the aura of art. And yet the avant-garde informed its public that American art must restore the aura that art had pursued in the old days.

The twofold notion of culture appears in the first published piece by a young art critic who was to become the official voice of the New York avant-garde. In the autumn 1939 number of *Partisan Review*, Greenberg published his influential essay 'Avant-Garde and Kitsch'. His choice of the German word *Kitsch* implied an arrogant concept of culture that turned against the American context and aimed at a positive

affront. Kitsch provides the masses with an 'ersatz culture', he explained, using another German borrowing. As regards kitsch, he then enumerated all the 'achievements' that represented America – magazines, advertising, 'pulp fiction', comics and Hollywood movies. Kitsch, he wrote, 'will become a universal culture'. Kitsch could also be used to suppress the masses and to stifle political thinking. As a Marxist, the young Greenberg saw socialism as the only salvation for a threatened culture – a view that he later deined, once the avant-garde had become accepted.

Greenberg critically observed his own society while he longed for the lost ideal of 'formal culture' he missed in America. He demonstrated what was missing with the visual arts, for which the school of the émigré Hans Hofmann, who rejected all figurative iconography, provided a model. An artist who was searching for 'the expression of an absolute', would only find it in the proper medium of art, the picture surface. The abstraction had freed the artists from the dependence on society, which anyway had exploited them by commercial interests. More significantly, it depended on the artists whether America would develop an authentic culture of its own. *Art and Culture* (the title of the volume of his collected essays) had, effectively, become synonyms. The essay 'Towards a Newer Laocoon' (1940) reverses Lessing's division of poetry and the visual arts. Only when the visual arts 'escape from literature', Greenberg argued, can they pursue their own goals. They must focus their attention on the actual 'medium' instead of seeking to be rescued by ideas. The Surrealists, he said in a review of Surrealist painting in 1944, had threatened art by their new taste for the anecdotal. The mortal sin was eclecticism, which was to be avoided at all costs.

Greenberg's reduction of art to its own 'medium' – canvas and paint – had already been preached by European 'concrete art', which defended the realm of the 'plastic', as the French call the visual domain, in an altogether purist manner. But after the development of the popular mass media, the same purism in Greenberg's writing took a retrospective note: art's only chance was to radicalize its traditional medium. In Greenberg's view it was America's mission to lead art to its final destination. In such an act of purification, any contemporary reality had in art to disappear: hence the devotion of American primitive art, with its images resembling hieroglyphs. The *icon of art* would only emerge from an iconoclastic procedure that excluded any image from everyday life.

Greenberg's theory of a universal grammar of art in a formalist sense had, however, one notable flaw. He not only wanted mimesis but also imagination to be banished from abstract art. The freedom of paint-

ing, as Greenberg saw it, was aniconism. True, as he summarized the argument in 1944, abstraction made it possible to 'express the inner self as directly as possible', but this unmediated self-expression meant renouncing any given images, whether they derived from imitation or from imagination. The abstract gesture alone was to represent personal emotions. Greenberg exhorted the artists with the sternness of Mosaic Law: 'Thou shalt not make unto thee any graven image.' Art had to banish iconography on its path to its true identity.

But the artists wanted to speak with a 'living voice', as Barnett Newman wrote, not an abstract one. In order to communicate with their public they needed common symbols, which, however, were lacking, as Robert Motherwell complained in 1947. It would be impossible to paint a *Guernica* in America. Newman and his fellow artists therefore championed, through exhibitions of primitive art, a universally iconic language with anthropological roots. Native American paintings, Newman argued, depicted a primeval ritual from which art had always derived its vital force. Their cryptic signs, indeed, resembled living beings. Newman engaged in a public discussion in which he criticized Greenberg for still adhering to the European model when discussing abstraction. Responding in 1947 to Greenberg, he defended the right of American artists to 'evoke their own world of emotion and imagination by a kind of personal signature…. This is a metaphysical act.'

In 1948 Newman had his first success with the small, tranquil painting *Onement, I.*, in which he created an archetype for his entire *œuvre* (illus. 149). Also in 1948, after years of preparation, he finally published his theory of art in an essay entitled 'The Sublime is Now'. The work enters the world 'now' as in an act of birth. The title *Onement, I.* indicates that the work derives its aura from a rigorous 'oneness', while polemically rejecting the '*ornament*' into which abstraction so easily degenerates. A single upright 'figure', with a swelling outline, dominates a field of dark colour like a solo performer. Newman made this into a leitmotif for his dialogue between subject and space. Two years later he expanded the motif in the polyphonic painting *Vir Heroicus Sublimis*, in which he overwhelmed the viewer with a work on a new scale (illus. 150). In his texts he now distinguished 'size' from 'scale', using scale as a metaphor for 'greatness', in which the conventional form of the work was to be transcended. The work now offered the spectator a hallucinatory presence in which it merged with his imagination and invaded his space.

The Latin title provoked a legendary dispute between the painter and the art historian Erwin Panofsky – in which Panofsky, however, was

149 Barnett Newman, *Onement, I.,* 1948, oil on canvas. Museum of Modern Art, New York.

concerned only with the language's correct grammar. In the Betty Parsons Gallery in 1950 Newman presented the public with a text that sounded like an official manifesto on behalf of the new art. The works on display – so the astonished visitor read – were neither depictions of pure ideas nor abstractions. They resembled people in that they were 'embodiments of feeling', and revealed their inner passion. Here Newman effected a startling change in the definition of a picture. Now that painting had expelled figuration from itself, the aniconic work changed into an image of itself. Renouncing painted rhetoric, it turned into the icon of a spiritual idea.

In a cycle of lithographs named *Cantos,* Newman admitted the presence of the artist's own personality even by the title. In the article 'The Sublime is Now', on the other hand, he focused on the viewer. In a new

150 Barnett Newman, *Vir Heroicus Sublimis*, 1950–51, oil on canvas. Museum of Modern Art, New York.

Romanticism he warned him against demanding formal 'beauty' in a work. The absolute is not synonymous with artistic perfection, but by way of 'absolute emotions' it shares a vision with the viewer. 'The image we produce is the self-evident one of revelation, real and concrete, that can be understood by anyone.' In the 'we', artist and viewer join their experience. Only a *tabula rasa*, then, led to an experience of absolute art. Once cleared of the stage-props of art history, the work could be a new stage for that experience. The quintessence of American 'abstraction' was to cast off all historical ballast. And yet Newman was here once more subscribing to the Romantic concept of the absolute work, which ultimately transcended the reality of any physical work.

POLLOCK'S DRAMAS: THE ARENA OF THE 'SELF'

After a period of uncertainty it was clear by the summer of 1949 that the leading American painter was Jackson Pollock. *Life* magazine none the less introduced him as such with a question-mark: 'Jackson Pollock: Is he the greatest living painter in the United States?' But Greenberg, back in 1944 had called him 'the greatest painter this country [has] produced'. Pollock answers the question which had troubled American art for more than a decade, the question of 'whether there can still be art after Picasso'. In 1948, New York artists were still urged to mount an angry demonstration outside MoMA in order to bring themselves to the public's notice. At the time sixteen critics were holding a debate in the museum on whether an American avant-garde existed. But by 1950

things had changed, and Barr, MoMA's Europhile director, exhibited works by Pollock and six other artists at the Venice Biennale. On that occasion Bruno Alfieri hailed Pollock as the true heir of Picasso, and this growing recognition in Europe removed the last remaining doubts in America.

Pollock's engagement with Picasso's work had begun ten years earlier, prompted by the cosmopolitan émigré John Graham, who in 1937 had published an influential article on 'Primitive Art and Picasso'. Perhaps as a result of the Picasso experience, Pollock decided in 1940 to destroy almost all his early works. Picasso confirmed the obsessive images of an artist's imagination, which had been explained to him by his therapists as the phantoms of his subconscious. Soon he shared the company of the Surrealists, who offered automatism as an adequate theory for artistic creation. At a breathtaking pace Pollock worked himself through the European styles and doctrines, while in addition the psychoanalysts urged their symbolism on him. In order to stimulate his subconscious, in the winter of 1942 Pollock dutifully undertook exercises in which he used an automatism in applying the paint.

His time came in the spring of 1943, when the collector Peggy Guggenheim fell out with the Surrealists and, partly as a vengeful gesture towards them, opened her recently founded gallery, Art of this Century, to young American artists. Soon Pollock was introduced to her as 'an American genius'. After consulting Mondrian and Duchamp she initiated his first one-man show in November 1943, for which he had created one work after another in rapid succession. It didn't need Greenberg's prohibition on iconography to convince him that he must conquer his own demons on the canvas. In a process of self-censorship, all the images that lived in his memory and required representation were surpassed and, finally, in an act of exorcism, overpainted, indeed completely covered behind what he later called a 'veil' of painting. If painting had become a weapon, the work was now an arena in which the fears of the 'self' awaited him.

Pollock's large *Mural*, after months of hesitation, finally materialized in a single night's labour (illus. 151). It would not fit on to the wall it was intended for in Peggy Guggenheim's apartment, and Duchamp himself was obliged to cut down the canvas at its edges. Since any figuration was buried under this powerful gestural painting, Greenberg jubilantly proclaimed the victory of abstraction. In fact the act of painting had become a ritual of its own. Pollock had just studied mythic art and its creative rituals. Like his fellow-artists, he believed that the true artist's self had

been lulled to sleep by modern decadence. However, any attempt to revive an ancient ritual would be contradicted by the concepts dividing modern gallery art from the old mural painting of the native Indians.

In his wall-size pictures Pollock was thus pursuing the rebirth of an archaic art that he evoked as the rescue from a crisis in painting and as a means of revolutionizing the art markets in the wake of Picasso's *Guernica*. It was Greenberg who, in 1947, announced 'the historical death of "easel painting"', and thus openly admitted that a crisis existed. This was a paradoxical slogan that Greenberg explained with the further remark that Pollock 'points a way beyond the easel'. In the absence of alternatives, people took refuge in the old myth of the mural, of which Kandinsky had already dreamed. Pollock intended to take his leave of the easel and in future paint murals instead, as he wrote in 1947. He had already initiated this project, though in fact he did wall-size canvases, which he painted on the floor from every side in order to liberate himself from a face to face view when creating the picture. On the floor he felt closer to the work: 'This way I can literally be *in* the painting.' This was an act of rebellion against the limits of the usual gallery picture, but it also forced a mythic perception on the beholder by a deliberate act of the artist's will. Thus the modern picture was to remind the audience of ancient myths in which a sacred art had been created.

Gertrude Stein had spoken of abstract rituals, but Pollock actually performed another kind of ritual by introducing, in 1946, his legendary 'drip' technique. The canvases that received the dripped paint became a species of arena of his own self. Such a performance transformed the

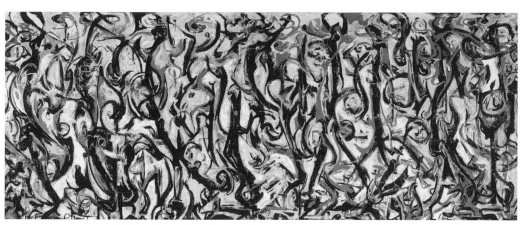

151 Jackson Pollock, *Mural*, 1943, oil on canvas. University of Iowa Museum of Art, Iowa City.

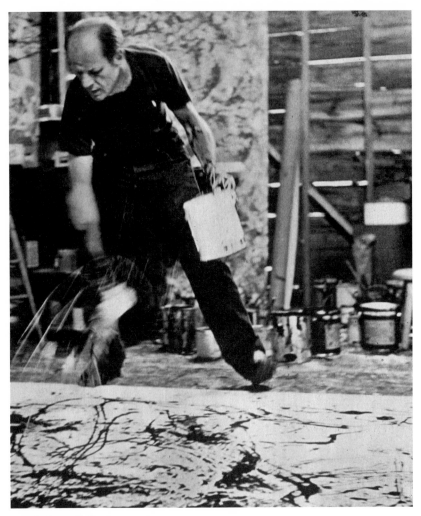

152 Jackson Pollock at work on a canvas.

creative act into a ritual dance, as Allan Kaprow later insinuated in 'The
Legacy of Jackson Pollock'. In order to direct the flow of paint onto the
canvas, Pollock practised body movements that in a brilliant metamor-
phosis became movements of paint, in which the actual touch of the
artist was not involved. His inner images, previously hidden under coat-
ings of paint, were now performed in mid-air before even reaching the
canvas. The old myth of the work lived on in the myth of the creation
ritual. 'Painting is self-discovery', as Pollock explained his body experi-
ence. When he agreed to a documentation of his performance, he was
once again inspired by Picasso, for Picasso had allowed himself to be

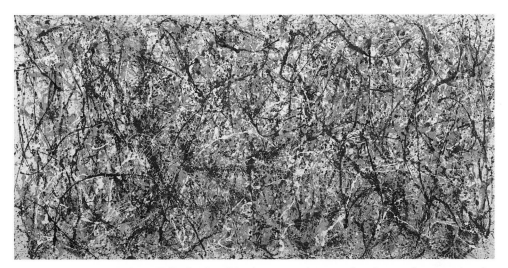

153 Jackson Pollock, *One (Number 31, 1950)*, 1950, oil and enamel on unprimed canvas. Museum of Modern Art, New York.

photographed in the fury of creation while at work on *Guernica*. In the summer of 1950 Pollock was also filmed by Hans Namuth while performing his own creative ritual (illus. 152). Film was an ideal medium for capturing the archaic gesture of the work, which dies in the finished picture. This deliberate act of archaism was simply the other side of modernism.

Pollock's work from the summer of 1950 was readily acclaimed as including the first masterpieces to have been produced since Picasso's major works. Greenberg endowed *Number One, 1950* with the poetic title *Lavender Mist*, and *Number 31, 1950* was later mythically named *One* (illus. 153). With its lateral size of 17 feet 6 inches – very like Newman's *Vir Heroicus Sublimis* – Pollock's *One* bears an obvious resemblance to wall painting. This mural-like character is reinforced by the fact that we can see straight through to the canvas, which is not wholly covered by paint but is visible through the network of coloured trails. Standing in front of what Pollock painted like a *wall*, the viewer was to recall the mythic murals of the Native Americans. The *calligraphy* survives from the creative ritual that has been enacted here, and thus itself provides an indecipherable writing spreading over the surface, as though the creative process had been taken over by anonymous forces. The modern myth of the work was renewed in a truly paradoxical manner.

RAUSCHENBERG'S COLLAGES: THE IMAGE STRIKES BACK

The young Robert Rauschenberg stirred up interest when, in 1951, he approached contemporary abstraction through the medium of photography – hence the title of his exhibition 'Abstraction in Photography'. Via the automatic printing of the real motif (a nude model), the technical medium took the place of the human artist, and so Rauschenberg here set an important precedent. Images from the real world, which had just been banished from art, returned by this detour. They emerged from a chemical process that, however, had no connection with the automatism of the unconscious. These monotypes, produced by the blueprint process, were distinguished from the usual art-works by their name 'photograms for mural decoration'.

But how could Rauschenberg turn the concept of the work against the dominance of Abstract Expressionism? He found his opportunity in the urgent atmosphere of North Carolina's Black Mountain College, where he was introduced to John Cage's ideas about art. The current abstraction suddenly seemed not abstract enough if one took it literally. Made vulnerable by their monochromy and use of white, Rauschenberg's 'White Paintings', which strongly reflect Cage's influence, offered an ideal surface for attack by the slightest traces of dust or degeneration, so that continual repainting was necessary in order to keep the idea of the work abstract enough. Emptied of any personal intervention, the paintings compare with Cage's music in that they invite the viewer to become aware of his own perception. Rauschenberg resisted any temptation towards subjectivity. As he wrote to Betty Parsons, it was quite irrelevant who renewed the white paint, since it was applied mechanically with a roller: '*Today* is the creator' of these pictures.

These works expressed a positively mystical concept of reality. The self-depiction of the real – through a suitable medium, of course – replaced the depiction of the artist's self, and this is in keeping with the Zen Buddhist ideas of Cage. Rauschenberg soon afterwards felt the urge to perform a ritual exercise when reducing a given work to a zero point by *annulling* all incidentals. For this purpose he used a drawing by Willem de Kooning, and spent an entire month rubbing it out it before putting it into a gold frame with the title *Erased De Kooning Drawing, 1953* (illus. 154). A drawing is an artist's most personal expression, and De Kooning, who was involved in the project, was asked to provide an important specimen. The ritual of erasing, which took far longer than the time De Kooning had spent on drawing, symbolized the retracing of the artistic

154 Robert Rauschenberg, *Erased De Kooning Drawing*, 1953, traces of ink and pencil on paper. Museum of Modern Art, San Francisco.

genesis of the work back to its departure. Rauschenberg could simply have taken a blank sheet, but he decided to empty a sheet – to make it empty of any personal expression. And so Balzac's invisible masterpiece returned in a new variant. Rauschenberg devised a work from which the presence of the artist's self was ceremoniously dismissed. Only when purged of *all* artistic gestures could a work re-attract images of the external world without falling victim to the old opposition to figuration.

Rauschenberg soon began to question the nature of the work. For Merce Cunningham and the Dance Company he was constantly designing sets and costumes. His own works, too, became a kind of performance, in that they introduced found images and real objects. A picture now exhibited the props of everyday life, as if to provide them with a new stage for memory. Against Pollock's analogy of the wall, Rauschenberg used the analogy of a noticeboard on which information is posted. The pseudo-mural changed into a pseudo-pictureboard. The poster itself became the venue for a performance. Everyday objects, like woven materials and faded prints, initiated a new kind of perception in which seeing was blended with reading (signs). In Dutch still-lifes, everyday objects had once given rise to a similar *trompe-l'œil*. But Rauschenberg replaced the painted *nature morte*, which did not decay, by industrial products that are transformed into a new kind of *still-life*. These are objects that in real life have been used but which are now to be looked at. Their ambivalence lies in the fact that they have been removed from life but gain a new visual life. The viewer is now implicitly the actor, since the work confronts him or her with objects and painted images that he or she might have possessed.

For works like these Rauschenberg coined the term 'combine paintings': painting as a result becomes an everyday prop like any other, and thus Rauschenberg felt able to depict even the brushstrokes of other painters. 'Collage', in its broadest sense, means a composition with ready-made items. Rauschenberg dissolves the boundaries between collage, montage and assemblage. *Short Circuit*, which he exhibited in the Stable Gallery in 1955, has to be seen as a 'combine painting', and yet in 1967 Rauschenberg casually designated it as a collage (illus. 155). Incidentally, it incorporates three works by other artists that are exhibited in his own picture. When he showed it again in 1967, like in a replay, Rauschenberg called it a 'double document'. He could equally well have spoken, with reference to the repeat showing, of a double event. Rauschenberg's preference for the ephemeral moment of an exhibition shunned nothing so much as that permanence which is the museum.

Collage, as we saw, allowed Rauschenberg to reintroduce images of

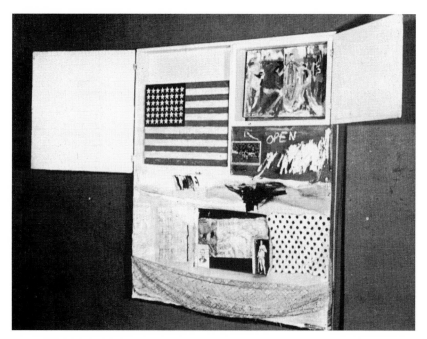

155 Robert Rauschenberg, *Short Circuit* (combine painting), 1955, oil, fabric and paper on wood supports and cabinet with two hinged doors. Untitled Press, Inc. Collection.

everyday life into art. He reproduced them from printed sources that were themselves reproductions. These might be snapshots from life, or magazine photographs, but they could also be reproductions of works of art that, outside the museum, circulated only in the form of reproductions. Thus images intended for use and consumption now entered the context of a different *mise-en-scène* when they offered the unfocused gaze on a personal world of media, objects and memories. Rauschenberg started by simply gluing on such images, but the process of screenprinting enabled him to incorporate them in his paintings. For this purpose he preferred motifs from works by Rubens that even in their day had startled the viewer, or possibly voyeur. The *Venus at the Mirror* is quoted in Rauschenberg's painting *Persimmon* (1964) like a memory of the work in the history of art: it had already become a reproduction before Rauschenberg reincorporated it in his own work, in order, as he saw it, to 'demuseify' it. Walter Benjamin could never have dreamed that the 'age of reproduction' would supply new possibilities for producing works of art.

Rauschenberg constantly drew new energy from his struggles with the old concept of the work. He was unable to resolve the problem of

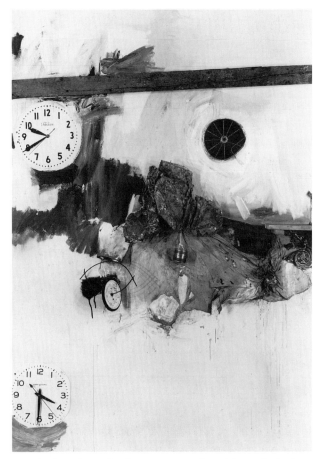

156 Robert Rauschenberg, *Reservoir* (combine painting),
1961, oil, wood, graphite, fabric, metal and rubber on canvas.
National Museum of American Art, Smithsonian Institution,
Washington, DC.

the arresting of time, which made every work different from a genuine
stage performance. But sometimes he could not resist escaping from the
studio to participate in the Happenings, as he did in his *First Time Paint-
ing*, which was the outcome of a live performance put on by the Paris
avant-garde in June 1961. The title signified that it was the first painting
to be done according to time, that is, by the clock. When the bell rang,
Rauschenberg stopped painting and carried the work off the stage, with-
out allowing the audience to see it. It had simply been part of a 'live
performance'. In 1961 in *Reservoir* he recorded the work process allegori-
cally, using two clocks built into the work (illus. 156). As the title indicates,

he conceived of the work as a kind of reservoir of time. One of the clocks had been set going when he began the work, and the other at the moment when he finished it. The interval between the starting of the two clocks was *the time of the work*, but there was another, different time. As long as the clocks were going, the work too would remain alive – *in the spectator's time*. This theatrical presentation revealed the basic conflict that faced the static work of art in the latter part of the twentieth century, now that pictures had begun to move. But Rauschenberg was tied to an artistic form that, however imaginatively he staged it, intrinsically looked back to the past. The shadow of the museum fell on his pictures.

ANDY WARHOL'S 'FOUR THOUSAND MASTERPIECES'

After 1960 the initial avant-gardism gave way to a thoroughly non-utopian development, when Andy Warhol opened up a hitherto forbidden territory for art. The 'kitsch' of the world of consumer goods, which Greenberg had rigorously excluded from art, established itself in Warhol's works as an omnipresent motif. The images from the world that now came back into art undermined art's claim to be exempt from time. The everyday image and the work of art were no longer shielded from one another, as Warhol subversively related them to each other as 'pictures'. Before the spectator's eyes they entered into a bewildering game in which Warhol blurred the concept of the picture with that of the image. Works were suddenly nothing more than media for pictures that were familiar from billboards or magazines. Whatever was a picture in everyday life was also one in art, except that it had the scale of a canvas and existed in an exhibition. The artist, as their agent and performer, no longer pretended to be their creator.

The concept of the 'medium' was also involved in this strategy. Whereas Greenberg had once declared the painted surface to be the authentic medium of art, Warhol, more radically, accepted it as a mere surface. He asserted a straightforward equivalence between the painted surface and the surface of the mass media, on the basis that both kinds of images are no more than surfaces, manipulated ones in each case. Warhol thereby fulfilled Greenberg's second rule, but in a way that was a parody of the latter's intention, for the images from which Greenberg wanted to purge abstraction were themselves an abstraction compared to the reality they depicted. But the 'medium' was to be understood in a further sense. Not only the canvas but art itself was a medium (not a goal), i.e., not different from other media. Images are the medium through which we

experience the world. Warhol formally demonstrated this twofold signif-
icance of the medium when, for a time, he accompanied every major
'picture' he had painted with an empty canvas of the same size.

Though Warhol destroyed the aura of the work more radically than
anyone else, he reintroduced it, as a cliché, thus making it untouchable.
The aura returned as a quality of the commercial product. When con-
sumerism was to be considered as a cult of the commodity, then it would
qualify as art too. For almost twenty years the *Mona Lisa* remained
Warhol's only readymade, because it represented art as a *topos*. Although
a single motif would have sufficed for that purpose, it could still be
multiplied for ever. When, in 1963, an entire exhibition was dedicated to
the *Mona Lisa* alone (see p. 290), Warhol instantly produced his silkscreen
print reproductions of the work in a series. *Thirty Are Better Than One*
nullifies the original's status, replacing it with its own cliché (illus. 117).

In 1962 Warhol founded the 'Factory' in order to increase his
output. Hitherto he had wrestled with his work alone, but now he had
a 'staff' turning out series of works on a production line. Where Pollock
had enacted mythic rituals, Warhol engaged in the plain production of
commodities. The important thing was the standard quality of the goods
that carried the Warhol trademark. In fact he used a camouflage for the
artist's ego and thus renewed the expected ritual in which he played a
paradoxical game with the public. Far from being undermined by this
so-called commodity fetishism, Warhol's artistic reputation was enhanced
by it. The Warhol 'company' produced art of an exquisite kind.

According to his theory, every picture was as good as any other.
Since a picture could in any case be nothing *but* a picture, neither more
nor less, no matter what it represented or what size it was, the disregard
for conventional aesthetic criteria also implied the collapse of the
conventional hierarchy of works. 'You always do the same painting,
whether it looks different or not', Warhol said in an interview with
Barry Blinderman. Every picture produced by the Factory was a Warhol.
In *The Philosophy of Andy Warhol* the painter took this idea further:
'When Picasso died I read in a magazine that he had made four thou-
sand masterpieces in his lifetime and I thought, "Gee, I could do that in
a day" … with my technique. … And they'd all be masterpieces because
they'd all be the same painting.' The same picture 4,000 times over, by
Picasso or by himself. If one picture among them was a masterpiece,
then so were all 4,000. In principle, each product was of the same stan-
dard as all the others. Thus he cancelled the aura of age and history in
which an original differs from its copies.

Warhol's nominalism prompted his reference to the 'space writers' who are paid by the page. 'I always think quantity is the best gauge on anything, so I set my sights on becoming a space artist.' This was an artist who was paid by the quantity of his production. Production, he continued, could be increased if one always chose the same format and also repeated the colour, so that the pictures are 'all interchangeable and nobody thinks they have a better painting or a worse painting'. Thinking about pictures was a waste of time: it would be better to get on with doing pictures. Leonardo had convinced his patrons that his 'thinking time' was of greater value than his 'painting time'. But Warhol said that he expected to be paid only for his '"doing" time'. With this clownish proposition Warhol once again rigorously separated the idea from the practice of art: the only idea that he would allow for art was that of making it.

These statements stand in admitted contrast to Warhol's actual *œuvre*. His feigned naïvety enabled him to talk about the history of art as though he had not. The new analogy of art and consumption deliberately undermined Greenberg's concepts of 'art and culture'. Warhol himself, who had started out as a commercial artist, wanted to finish up as a 'business artist', as he said in the same book. How one maximized one's individual creation was only a matter of organization. On this premise, he cunningly maintained, he too was merely continuing the history of art, whose linear production of works had itself become a cliché. Since the name of an artist was needed for this purpose, he could brazenly use his own name as a brand label once he had made it famous.

But works of art also existed like consumer goods in the public media. There they spawned printed replicas of themselves and so circulated in massive numbers in the collective imagination. The mass media mediated but also produced pictorial clichés that usurped the place of the originals. As a result, one could remember works that one had never seen. In the media they received their second life, where the reproduction already carried the mark of their distribution. Thus the artistic heritage had been turned into a collection of contemporary readymades with a stubborn resilience. It did not take much to trigger a memory that was not of an original but of a cliché. There were infinitely more images in the collective memory than Warhol could ever have produced. But he profited from the omnipresent clichés of memory by re-embodying them, and thus once more turning them into gallery pictures. One currency tempted one to exchange it for the other, the product form for the remembered form and vice versa. The images permitted a ceaseless exchange, without ever losing their identity.

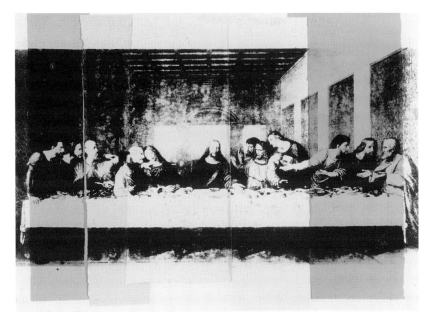

157 Andy Warhol, *The Last Supper*, 1986, screenprint and coloured graphic art paper, collage on paper. The Andy Warhol Foundation for Visual Arts, New York.

Warhol had an opportunity to demonstrate this procedure on a grand scale when he was invited to exhibit a series of pictures based on Leonardo's *The Last Supper* in a Milan gallery in the neighbourhood of the monastery that houses the original. The exhibition of a dozen pictures of monumental size opened in January 1987, a month before Warhol's death. The artist could not have used a better example than that famous ruin of a work that had become a mere shadow of itself. Its vivid presence in the collective memory was spectacularly at odds with the state of the original. The picture survived in the memory of countless replicas, which Warhol simply treated as works. The fresco on the wall, and its memory (as reproduced in the mass media or remembered by people) that had become detached from it, are played off against each other in Warhol's *Last Supper* series (illus. 157).

Here Warhol created a highly personal mythology of the work as fetish, which he used as an *image trouvé*. He deployed his whole range of techniques in order to play off the scale of changes that a work would undergo once it had become a reproduction. A deep chasm now opened up between the originality of a work and the ubiquity of its reproductions, which could take an almost unlimited number of shapes. Yet

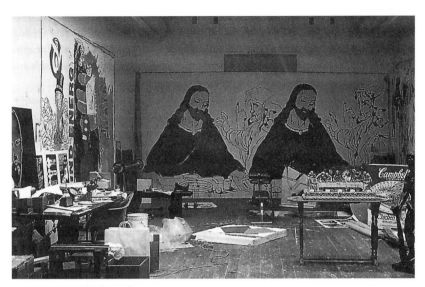

158 Andy Warhol's studio.

amazingly, the reproductions, even if they kept only the vaguest traces of
the original, still retained its aura. Warhol's *Last Supper* pictures reproduce
this amorphous or multiform presence either by choosing a detail that
evokes our memory, or by lining up multiple copies of Leonardo's
picture as on a film strip (illus. 158).

In each case Warhol's canvases become charged with a borrowed
life that surfaces from the layers of collective memory. He worked from
a whole range of copies – a nineteenth-century, black-and-white repro-
duction, an outline drawing from a children's book, a cheap devotional
sculpture – in order to extract from them the cliché image that had
already started a life of its own. And yet each of these mass-produced
images contained the reminiscence of a unique work. So Warhol's *Last
Supper* paintings are a paradoxical homage to a lost concept of the work
that he still admired. If the idea of the work had come to be no more
than an item of memory, then in the case of Leonardo he reproduced a
memory that actually appeared more real than the almost effaced origi-
nal. The works produced by Warhol thus changed into pictures after a
work – pictures by Leonardo in the currency of the Warhol trademark.

17 The Call to Freedom

The living modernism that began in the 1960s is our own modernism, even if at times we have called it 'postmodernism' to distinguish it as a phase of its own. Though I neither speak of an epilogue to art nor of one to modernism, I have to speak of an epilogue to the history that is narrated in this book, given its emphatic rejection of the practice of producing works in the previous sense. The freedom of art, we are constantly told, means freedom from the authority of the obligatory work. Works continue to be created, but they are works that deny the concept of the work in the legacy of modernism. If artistic creation in recent decades shares a common denominator, it is the opposition to qualities that characterized painting and sculpture – autonomy, form, authorship and originality.

It is not my intention here to recount the recent story of art; many of those who witnessed it will, in any case, give their own, widely differing, accounts. Instead, the 'work', as an ever-present *pièce de résistance*, which has been both overrated and attacked with equal passion, will serve as a thematic link, though my own choice of examples may be challenged. 'I would like the work to be a non-work,' wrote Eva Hesse in 'Untitled Statement' (1968), where she also declared her intention to go beyond all that she knew about form and about art. In another 'Untitled Statement' of 1969 she described work processes that were kept open so that they did not actually lead to works. And Sol LeWitt remarked in 1967: 'I dislike the term "work of art" because I am not in favor of work and the term sounds pretentious.' The Conceptual artists claimed that once a work did materialize it no longer represented the idea of art, but fell prey to mere 'formalism'. Joseph Kosuth would replace the term 'work' with 'proposition' as a way of presenting 'within the context of art a comment on art'. The work's self-reference was out of date if the idea of art could be evoked in a more direct way, through signs or language. The scripts that were framed and exhibited contradicted the necessity to perform the work once again.

In Conceptual art a complex of problems that has dogged the

whole history of modernism is dealt with in an abstract way – abstract in the sense that it opposes the work as the visibility of art. The participants in this debate were not addressing altogether new problems, but they wanted to solve them no longer *in* the work but *in opposition to* the former status of the work. Paradoxically, their passionate deconstruction of the work simply underlined the difficulty of escaping from its shadow. Symbolic actions soon culminated in the production of works whose only function was systematic self-destruction: the artists now set about deconstructing works as systematically as they had previously tried to construct them. In the 'auto-destructive art' of which Gustav Metzger wrote in 1959, the work only existed for the length of time required for the act of self-destruction. In 1960, in the gardens of New York's Museum of Modern Art, Jean Tinguely organized a Happening in which a machine destroyed itself, with much smoke and noise, in front of an audience; this assemblage of scrap materials was entitled *Hommage à New York* (illus. 159). In his writing Tinguely invoked the ideals of life and

159 Jean Tinguely's auto-destructive *Hommage à New York* in action in the garden of the Museum of Modern Art, New York, 17 March 1960.

movement, which he wanted to rescue from an inescapable death in a static work. The old work process – which in the cases of Picasso and Pollock had been photographically recorded as it progressed – now reversed its direction in the new process of destruction.

Tinguely's machine was programmed to act without the artist himself acting. Instead, he watched along with the audience as the work disintegrated into its component parts. Machines were also an expression of revolt against the ideal of personal authorship, which had dominated the concept of the work of art for so long. Now collectives of artists began to renounce the authority of the artist–creator as a megalomania. Objects and materials (whether manufactured or natural) were to replace the former presence of the work with a new physical kind of presence. In the place of 'works', 'objects' were now exhibited in order to introduce art.

This rejection of the author/creator/artist echoed the old crisis surrounding the bourgeois concept of the individual at the start of the twentieth century. Now, in the 1960s, the individual seemed synonymous with the modern artist's self. In 1969 Michel Foucault questioned the 'authorial function' as one that was bound to a certain time and which might one day end in the 'death' of the author. In 1971 Roland Barthes insisted on the reality of 'texts' as opposed to the fiction of 'works' tied to the creation of an author. These views themselves resulted from a given intellectual climate, just as artistic manifestos did in their own way. Art criticism soon took up the theme: in 1981 Rosalind Krauss declared artistic originality as a cliché of the avant-garde that refuted itself in practice.

While artists were reluctant to express themselves through works, they were, however, willing to demonstrate their bodily presence in ephemeral actions. Works that no longer bore any visible trace of artistic intervention were replaced by performances in which artists renounced the proof of the work apart from themselves. Here the bond between artist and work was severed. There remained, in principle, either works without the personal voice of an artist or artists without a working habit. Where the evidence of the work was replaced by a stage effect, artists appeared as 'performers' of themselves, presenting a spectacle that took on the old meaning of a work. When artists used their own bodies as a medium, photographs or videos were needed to record the performance in a visible trace, not in a work.

Bruce Nauman had started early to use his body 'as a piece of material', as he said in an interview in 1970. He communicated the

160 Andy Warhol, *Invisible Sculpture* (captioned 'mixed media, 1985').

experience of his physical self, via a kind of theatre, to the spectator. The theatrical performance centred on the artist's person and body. The question was whether the artist would speak with his own voice instead of hiding behind a work. Women artists like Valie Export or Ulrike Rosenbach added feminist issues to the body spectrum. In Body Art the 'presence' of a living artist replaced the 'presence' of the usual work. In this way the 'presence' of art was recreated by an artist's personal presence, in which he renounced the former claim of creativity and self-confession.

Not suprisingly, Andy Warhol found his own subversive answer for this rôle of the artist. In 1985 he exhibited his *Invisible Sculpture*, which was in fact the artist himself while he was physically absent (illus. 160). He had himself photographed in a New York nightclub, a living simulacrum of himself. But the label – 'INVISIBLE SCULPTURE' – which was fixed to the wall from the outset, only became accurate after he left.

Only in the photograph did Warhol occupy the location of the invisible work. So the work could be reproduced, but there was no original except the artist himself, who was not a work and had only simulated one. Where he himself was present, there was no work. But where a work was present, even if invisibly, the artist was not.

Jean Tinguely's Action at MoMA, described above, also illustrates another aspect of these new and telling rituals, in that he replaced the static work with an event in time (illus. 159). The work of art has often been called an *event*, but this metaphor related to an event in art history, or else to the completion of a working process. It was always their essential difference from the performing arts that the visual arts were exhibited, not performed, and resisted participation. (The works, otherwise, could not have been immobilized in museums.) The Enlightenment's philosophy of art had completed the temple status of works by consecrating them for mere aesthetic contemplation. This explains the logic behind Tinguely's Action, in which the work destroyed itself in order to produce a performance. An event is usually something that one can participate in (or remember) because it takes place in time. So now time returned to the visual arts, not just symbolically but empirically, whereas the traditional work had been existing in the time of art, not in real time.

Now visual artists participated even in stage performances in which the visual and the performing arts blurred. Rituals that once would have disturbed the solitary production and silent appreciation of art returned to the art scene. Happenings, festivals, Hermann Nitsch's 'mystery theatre', workshops and performances were, from the late 1950s onwards, part of the new repertory of the visual arts. Even Environments and installations presented themselves as stages for past or simulated events. Theatre usually addresses itself to a larger audience. But the audience, unlike that of a public theatre, was here expected not only to watch but to participate. An event that takes place in the presence of spectators, it was said, retrieved the gestures of life that the visual arts had hitherto frozen in the silence of their works. *Presence*, to take this idea further, was no longer represented by works but instead was *produced* by living persons for instant viewing.

When Allan Kaprow organized Happenings that were a vehicle for cultural criticism, few people attended them, but they were remembered as mythic events signifying a turning-point in art (illus. 161). The Environments Kaprow mounted in 1958 in the Hansa Gallery in New York, came to life only through the living presence of the visitors, and thus differed utterly from the face-to-face encounter with the expected

161 Allan Kaprow,
The Apple Shrine,
photograph of a 1960
Happening.

single 'work'. Kaprow's catalogue insists on 'total art' accessible to all our senses. 'We do not go to such an exhibition to look *at* things', but to move about freely within a situation 'that is as open and fluid as is our everyday experience'.

In the same year Kaprow published his essay on 'The Legacy of Jackson Pollock' in order to give a historical logic for going beyond Pollock. Pollock's 'near destruction of [the] tradition [of painting] may well be a return to the point where art was more actively involved in ritual, magic, and life'. The next step along this path could only be to exhibit 'the space and objects of our everyday life', i.e., everything that had always been excluded from art. In a prophetic tone Kaprow heralded the 'alchemies of the 1960s', when people would speak not of painters, poets or dancers, but only in collective terms of 'artists'. For a time it seemed as if this would happen, when representatives of all the arts shared common performances and thus formed an alliance of art against society.

It is obvious that artists, including painters, could only succeed in this manner when they shared a stage, though painters found it difficult

to perform painting in front of a live audience. Even when, for instance, the Reuben Gallery used to serve as a stage on such occasions, any similarity to the established theatre was avoided. The separation of stage and auditorium – reminiscent of picture and viewer – was also to be overcome. The audience therefore either had to take part or be provoked, what Susan Sontag, in her essay 'Against Interpretation', saw as the essential strategy. Meanwhile, on the stage itself, texts or pieces of music dissolved into wild plots incorporating gestures of free creativity. In the visual arts, Robert Morris or Bruce Nauman were soon transcending the barriers existing between performance art and installation, between stage presentation and exhibition. The new space installations either evoked the memory of a performance or borrowed its idea. As theatrical sets they staged, as it were, a silent drama. The life of a stage, however, could not be moved across into a conventional exhibition of visual art: what had always been performance excluded the silent presence of the exhibited work. The autonomy of art, which seemed an unwelcome heritage from Europe, had exhausted itself together with the aesthetic of the framed easel picture.

MINIMALISM: THE CONTROVERSY OVER OBJECTS OR THEATRE

Though sharply contradicting the Happening movement, the austere exhibition practice of Minimal art (illus. 162) was also accused of sacrificing art to 'a new genre of theatre', as Michael Fried wrote in 1967 (see p. 392). Experimental artists and Minimalists alike hailed Robert Morris, Carl Andre and Donald Judd as producing true anti-painting and anti-sculpture. But they disagreed on whether this was still art. Judd wrote in 1964 that Morris's work, in which the whole focus was on the surfaces, pointed to the simplest, most object-like existence in empty space. It implied that 'everything exists in the same way through existing in the most minimal way, but by clearly being art…. It sets a lowest common denominator…. You are forced to see the ordinary things' in a new way. Despite this early text it was the philosopher Richard Wollheim who introduced the term 'minimal art'. And yet he was not familiar with the new direction in art when, in his famous essay of 1965, he expressed the view that modern works in general 'have a minimal art-content'. He shared, none the less, the Minimalists' view in that he accepted works of art in general only as objects.

The ever-unresolved questions clustering around the modern work thus surfaced once more. But the young artists, who knew little of

162 Installation shot of pieces by Donald Judd, Green Gallery, New York, 1963.

the old debates, enjoyed the freedom to explore new paths in their artistic practice. They rediscovered the conflict inherent in the embodiment of an *idea* in a *work* that had a material existence. But the two movements of Conceptual art and Object art now tended to polarize the one and the other. In their desire to split the hybrid nature of a work into an idea (art) and a thing (the work) they were, in fact, continuing down an old road. Though they dismissed the old dualism with all due ceremony, yet thereby they rehearsed the old discussion once again.

In a 1965 exhibition catalogue Richard Smithson, who later initiated American Land art, made himself a spokesman for Donald Judd. Many people looking at Judd's works wondered either 'where the "art" went or where the "work" went'. They would not understand that these structures 'brought into question the very *form* of matter'. In the dialogue between matter and space, abstraction gained a new dimension in which psychological factors no longer had a share. The aging school of Abstraction was told that the world itself was abstract enough if reduced to its elements (objects and spaces). Here abstraction turned into a concrete art in empirical space.

Judd himself preferred to speak of 'specific objects', and made this the title of an essay he published in 1965. His works were specific in that they were exhibited as things and showed their solid materiality (illus. 162). 'Materials … are specific. If they are used directly, they are even

more specific.... There is an objectivity to the obdurate identity of a material.' This concept of the specific was an attack on the 'illusionism' of prevailing art; 'actual space is intrinsically more powerful and specific' than painted space could ever be. An object was more specific in this sense than an old-style sculpture, for it *appeared* only as what it *was* and did not try to present the illusion of a living body and an inner life. It consisted only of surface and volume, as things normally do. Materiality was its true nature and not the symbol of an anthropomorphic form. In general terms, Object art isolated the *work as physical form*, whereas Conceptual art detached the *idea of art* from its materialization in a work. So in their tendencies the two movements were re-enacting the old dualism of mind and matter. Yet the aesthetic cult of matter involuntarily introduced a new aura of the work, and, moreover, assumed an archaic attitude, disregarding the world of cheap merchandise and electronic media.

The presence of objects was clearly a rejection of what Clement Greenberg celebrated as art. Michael Fried therefore used Greenberg's own weapons when, in 1967, he questioned the new direction in art. In order to avoid the concept of Object art he preferred to speak of 'object-hood', even though he reminded the artists that they were dealing merely with *forms* of objects that pretended to be objects. He argued that the objects of Minimalism derived their sole energy from their effect on the viewer. They were staged in a given space, in a given light and from a given distance. The anthropomorphism that they rejected by their shape returned via their impression on our perception. Thus in reality the objects were props in a space, and there arranged for the benefit of the visitor. Their presence was theatrical, 'a kind of *stage* presence', and therefore 'antithetical to art'.

Here Fried was describing a fundamental change in the production of art, a change that was taking place on many fronts. While the Minimalists preferred to speak of three-dimensional objects, Fried astutely saw spatial art as the emerging fashion. Works now shared their space with a viewer where they denied him a privileged view. What had previously been an *exhibition* of works was now an *installation* with objects. Even inanimate sculptures produced the theatrical effect that has been an essential part of the experience of art ever since. Works suddenly became 'site-specific', to use a term current in American criticism. They lived from an effect which in turn depended on their space situation. Spatial art even today lacks reliable definitions. Although Minimalism seemed to continue exhibition art, it changed the meaning of art

exhibitions. It was no accident that the champions of experimental art accepted the Minimalists as allies, even though they used only ephemeral materials, and for live performances.

FLUXUS AS A SOCIAL DREAM

Fluxus would be a perfect umbrella term for a period in which all former artistic practice dissolved into flux, if the name had not already been coined by that particular movement which the Lithuanian-born George Maciunas (1931–78) dominated like the founder of a sect. Since it attracted constantly changing groupings of anarchists of every hue, the unity of this experimental movement only materialized in common activities. All the same, the participants gradually became aware 'that Fluxus only existed in George's imagination', as Willem de Ridder recalls. Maciunas distributed the cheap Fluxus products that related to the collecting instinct, but in all other ways positively derided the items of art collection. The group identified with performances, protests and ideas, most of which were vetted by Maciunas if, indeed, he had not personally instigated them.

It was Maciunas's dictatorial behaviour that led to a breach with the older Happening movement, whose founder, Kaprow, refused to submit to his authority. The leaders of the two schools vied with each other in trying, as Kaprow writes, 'to break with all artistic references' and yet to make art. With his Environments, which were often exhibited in galleries, Kaprow himself was closer to the visual arts, while Maciunas was initially guided by experimental music such as that of John Cage. The Fluxus festivals Maciunas organized in Wiesbaden during his stay in Germany in 1961–2 were only an episode in the history of Fluxus, though they had a lasting effect on the German art scene (illus. 163). When an attempt to promote Fluxus in the Soviet Union proved unsuccessful, Maciunas expelled those responsible for the failure 'from the cathedral of Fluxus', as Eric Andersen put it – a remark that recalls the Bauhaus idea of the 'cathedral of the future'. From 1964 onwards the movement was centred on New York, where Maciunas was active in founding cooperatives in SoHo. In subsidized working and living spaces for artists he wanted to create models for a new form of living based on a collective ideal. The artistic activity was to revolutionize the social space.

The aims of the movement are expressed in the innumerable letters Maciunas sent out like official proclamations to the members, whom he regarded as unreliable. 'High art is what you now find in museums. You

don't find Fluxus in museums', he still maintained in the year of his death
to Larry Miller. Performances with living artists, an open-ended experi-
ment, were an attack on the finished art-work, which was declared to be
inimical to life (illus. 164). The destruction of a grand piano became a
symbolic act of destroying a work (see p. 385). An 'artistic attitude' to
everyday things meant to 'become liberated from making works of art'
and instead join the economic process, as Jackson MacLow recalled in
1983. In a letter to Tomas Schmit, Maciunas made himself clear as early
as 1964: 'The aims of Fluxus are social (not aesthetic) and are directed
towards a gradual elimination of the fine arts…. Thus Fluxus is strictly
against the art object as a useless commodity which is meant only to
be sold.' At most, one might 'temporarily' teach people how superflu-
ous art is. The artists ought to devote themselves to 'socially construc-
tive goals' in order to pave the way for a free society. The social dream
that had already played a utopian rôle in the Bauhaus was now leading

163 George
Maciunas, Poster
for the 'Festum
Fluxorum', Paris,
1962.

164 George Maciunas, *In Memoriam to Adriano Olivetti* at the 'Festum Fluxorum', Düsseldorf, 1963.

to anarchistic actions. The dream was not only to decommercialize art but also to deprofessionalize it, to place it in the hands of all. Only a utopian aspiration of this kind could close that old, festering wound, the incompatibility of art and life.

The Fluxus items – sent out like talismans to the adherents of an international sect, to arm them against the temptations of the commercialized work – were an alternative to the production of works, just as live performances were. However, soon many of Maciunas's associates broke away from him when he forbade them to take part in a concert by Karlheinz Stockhausen so as to avoid any complicity with official culture, even of the avant-garde variety. But no stage event is wholly free from such complicity. Kaprow therefore tried to counter the danger in a different way, through the Happenings put on by his own movement in New York, which he described in 1961. Every performance must be subjected to 'chance' with its attendant risks, to experiments which could not be controlled by a script. The sense of adventure that, Kaprow claimed, was more in tune with the 'American way of life' ruled out any

planned form of work. Maciunas took a different view, and increasingly tended to obstruct free activities.

Although, decades earlier, attempts had been made by Dada artists to combine the various arts in ephemeral events, Fluxus refused to hark back to precursors. Kaprow even urged artists to forget the art history they had learned – despite the fact that he was professionally employed as a college lecturer in art history. None the less he did refer, in an essay of 1967, to a tradition that sheds a different light on the endeavours of his own day. Among the various forms of Happening, he says, 'the Extravaganza is an updated Wagnerian opera, a *Gesamtkunstwerk*.'

This concept warrants a closer look. In 'The Tendency towards the *Gesamtkunstwerk*', a celebrated exhibition held in 1983 (which, as it happens, did not include work by Kaprow), Harald Szeemann traced the long history of utopian aspirations in the *Gesamtkunstwerk* idea that, like a Messianic gospel, was to save the individual arts from their isolation. Kandinsky, too, dreamed of uniting dance, drama and painting in a 'monumental art'. Revolutionary trends have often taken up this idea. The *Gesamtkunstwerk,* designed to be a fusion of different media, has resisted the temptation to resolve itself into a work, unless, as in the case of Wagner, music was the dominant art form. But its utopian energy had become much diminished by the time it reappeared in Fluxus and Happenings. Now it was more concerned with the anarchistic critique of culture than with the establishment of a new élite culture.

However, the idea of the *Gesamtkunstwerk* also had the vision of an art beyond the arts. An absolute art that would no longer entertain the usual concept of the work would depend on a synthesis of the arts. At the same time the *Gesamtkunstwerk* was a symbol for a loss: Michael Linger traced its origin to the 'impossibility of absolute art', as he wrote for Harald Szeemann's exhibition, and yet implied the failure of the single work. But the work possessed a resilient immunity to both 'the all' of absolute art and 'the nothing' of anti-art. Happenings and Fluxus, therefore, despite their 'anti-art' ideas, paradoxically lent themselves to the longing for an all-powerful art. Although art resisted the fusion with life, this impossible fusion semed reason enough for continuing art. But the inherent ideology was unmasked as soon as life was defined. In the case of Fluxus, *life* was the term that signified a social dream. It designated a liberated society for which an experimental art was to pave the way. Art was now to create a blueprint for a better future.

CONCEPTUAL ART: THE LANGUAGE OF THE FILM SCRIPT

The different currents that gathered under the banner of Conceptual art shared the common resistance to the practice of the art market, which they saw as a capitalist abuse of art. Their refusal of art production was to prevent the existence of works that could be abused. By subverting the exhibition practice, works were replaced by signs and texts that would no longer be at the mercy of the market (though in the event the market remained victorious). If only art was purged of a degenerative praxis, it would be restored to its true concept. 'Formalism', it was said, had lost the competence to represent the idea of art. If art was indeed an idea, then, like any other idea, it would also lend itself to being represented in language.

When we speak of a script, we automatically think of a film or drama for which such scripts were intended. If, however, we admit the assumption, at least as a hypothesis, that a script may be an end in itself, then we are approaching the contradictory way Conceptual artists dealt with the work, in that they wanted to reduce it (in the double sense of tracing it back and that of limiting it) to nothing but its own idea or concept. They exhibited texts in the manner of exhibiting pictures, i.e., with a frame and behind glass, and acted under the premise that art in its modern definition had been reborn as a concept more than as a practice. Art had become a concept transcending its own practice, and yet, paradoxically, only materializing in that visible kind of proposal we call work. New, therefore, was not the blurring of art, as an idea, and art as a work, but the new decision to break that conjunction and to detach the idea from the work, as had been the privilege of art theory, and to make the idea visible without using the visibility of a work.

As early as 1961 the Fluxus artist Henry Flynt spoke of the ideal of pure 'Concept Art'. If art was a concept, then, like all concepts, it allowed the use of language. Accordingly, 'concept art is a kind of art of which the material is language'. As a mathematician he proposed that art should in future be expounded through the logic of language. Sol LeWitt, who had at first joined Minimalism before he turned to Conceptual art, not only rephrased texts as an artistic medium, but also exhibited 'serial projects', whose permutations in fact were to demonstrate an essentially constructional logic. In his 'Paragraphs on Conceptual Art' of 1967, he distinguished *conceptual art* from the usual kind of *visual art*. Subjectivity would be out of place, as it was in a treatise on logic. The personal expression of an artist was irrelevant if the purpose was to define art.

The choice of concrete materials would also distract from that aim. The artistic idea, in this comprehension, 'is as much work as is any finished product'. The whole polemic was directed against the executed work, which the Conceptual artists wanted to discard like an outer skin that was no longer needed.

For that purpose the conventional exhibition space needed a thorough redefinition, for it was here that the public's habits of viewing were formed. In 1967 an exhibition in New York bore the paradoxical title 'Language to Be Looked At'. Could one 'look at language' in the way one had looked at pictures, and 'read objects' as one had read texts? What seemed contrary to all experience nevertheless had to be taken seriously. The former exhibits were to be entrusted to the catalogue, which Mel Bochner used as a portable exhibition. The catalogue was more democratic as a medium and thus was chosen to take over the former rôle of the exhibition. Art analysis was to discard art as collection.

Artists paid for columns in magazines and journals and thus publicized their ideas in images and words, just as their colleagues had exhibited works in galleries (illus. 165). 'My role as an artist ends with the work's publication', Joseph Kosuth wrote in a short 'Untitled Statement' of 1968. 'I changed the form of presentation … to the purchasing of spaces in newspapers…. This way the immateriality of the work is stressed and any possible connections to painting are severed.' The concept of art could only change when artistic practice changed. Since art was nothing but the production of meaning, the production of art itself also had to be given a different meaning, as Kosuth said, looking back in 1993. 'I tried to make *art* without using traditional genres.'

In 1965 Kosuth exhibited the famous *One and Three Chairs*, his threefold 'definition' of a chair that shows the influence of Ludwig Wittgenstein. His reading of Wittgenstein had also convinced him that academic philosophy no longer offered a way forward, and he therefore wanted to transfer its old functions to a text-based form of art. Kosuth's essay 'Art after Philosophy' (1969) became the bible of the Conceptual movement. Art, he wrote, had nothing to do with aesthetics. It had, after all, always served other functions. 'Works of art are analytic propositions' of what art is. In this they are tautological, for after all an artist is only trying to say in a work 'that that particular work of art *is* art, which means, is a *definition* of art. Thus, that it is art is true *a priori.*' In other words, a work can only be art if it takes this quality as given. So why still produce it if this proof was no longer necessary?

Modernity had already reached this troublesome position at an

165 Joseph Kosuth, *The Seventh Investigation (Art as Idea as Idea), Context D: Political*, in the newspaper *The Daily World*, 5 September 1970.

early stage, even though Balzac, in his famous tale, had not so much dealt with art as a concept, but had treated art in the absolute, which he introduced as being unrepresentable in the familiar manner of works. All the same, modern artists had not given up attempting new works as a way round the problem of what never could be achieved in a single work, or, possibly, in no works at all. Essentially, any given work contradicts the claim inherent in ideas, because otherwise it would deny its material existence. The only escape was its novelty, by which it proved that the idea of art was inexhaustible and thus allowed for ever new (and ultimately unlimited) attempts in the guise of works. Kosuth, in his early work, also testified to the so-called linguistic turn, to use the coeval term of the philosopher Richard Rorty, even in a radically new attempt at producing art. The linguistic term, in the most general sense, means analyzing language as a semiotic structure. It was in keeping with this cultural paradigm when artists aimed at using language as a medium to phrase art.

In 1969 the British artists Terry Atkinson and Michael Baldwin founded the periodical *Art–Language*, which became the official organ of Conceptual art. But a controlling organ of this kind was not appropriate to a movement launched in the name of freedom. If one subjects oneself to a theory, then there can only be one truth. In the first issue, which the editors wished people to see not as a periodical but as a work of art, the editors proposed to deprive 'visual art' of the possibility of 'remain[ing] visual'. They thus revealed their narrow view of visual expression in art. Since then there has been an explosion of new visual experiences in art. It has also become evident to what extent the domain of the visual itself is nurtured by concepts. The dualism that the Conceptual artists promoted, in the end had the mere effect of allowing art to gain new areas of freedom.

FROM VIDEO INSTALLATION TO INTERACTION

In the 1980s the electronic media channelled the arts in a direction that also affected the experience of the work. The traditional configuration of work and spectator is questioned when the 'media space' distances the viewer even from his own body. 'VIDEOPLACE', wrote Myron W. Krueger in 1977, 'is a conceptual environment with no physical existence'. Virtuality deprives both work and viewer of their born place in the physical world. Digital technology invites the viewer to enter a space in which his body is not present. We are reminded of the fact that the work production, despite its tendencies towards abstraction, had been geared to the body of the viewer. The work loses its own right when the viewer loses his.

But the technologies do not explain the changes in the experience of the work. The pioneers of media art all emerged from the experimental movements that revolutionized the concept of the work in the 1960s. Nam June Paik, whose ideas were formed by the Fluxus movement, in 1965 used his first video camera to record a Fluxus event in New York. Four years later he had the cellist Charlotte Moorman presenting live videos on monitors which she wore on her body (illus. 166). In video, the performance tradition for a long time dominated all other conceptions. In the same years Bruce Nauman recorded his live performances on video, which captured them like a mirror. The artist interacted with this private mirror without being exposed to an audience that was to encounter him later, in public, via the video presentation. The artist's use of his or her own body as a motif or as an actor was

166 Nam June Paik and Charlotte Moorman during a performance of Paik's
TV Bra for Living Sculpture at the Howard Gallery, New York, in 1969.

a way of compensating for the loss of the traditional production of a
work. 'This prompted the fundamental question of what an artist does
when he is left to himself in the studio', Nauman said, looking back, in
an interview in 1978. 'Whatever I did there was bound to be art. At that
point art as an activity took over from art as a product.' The studio, the
place of the artist's performance, was, by video, transmitted to the place
of exhibition, the gallery.

Similarly, the dematerialization of art had already begun, without
the aid of electronic equipment, in the experimental currents of the
1960s. Lucy Lipman's *Six Years: The Dematerialization of the Art Object*
(1973) proves the case, though the author does not refer to technology at
all. The dissolution of a clear definition of art, and with it the abandon-
ment of any static form of work, opened the way for so-called media art.
The involvement of the viewer, via digital interaction, had also been on

the agenda of experimental movements in the Sixties. 'Participation' was the buzzword, by which a passive audience, whose loyalty could not be relied on, was to be dragged into complicity. The shared stage did not allow for spectators. But electronics introduced a new automatism that eventually did away with experimental freedom (if we leave aside the internet) in favour of a pre-programmed game. The public, instead of responding 'live', rather acts like a part of the system, within the parameters of the controlling program. Now the old manner of looking at a work was defamed as passivity – and yet contemplation was always interaction, even if this was restricted to the eyes and mind. The new form of interaction offers the spectator the means to intervene and play at being the artist. But the rôle of *homo ludens*, as described by Johan Huizinga, is in fact both the older and the more naïve role compared with the analytical attention involved in silent contemplation.

In 1974 Allan Kaprow, in his article 'Video Art: Old Wine, New Bottle', voiced the suspicion that the video camera was inhibiting free experimentation and replacing it with something 'ritualistic and hieratic'. This was not the 'participatory art' he wanted to see; on the contrary, in his eyes it made the viewers into 'stereotypes' who let themselves be seduced by a sentimental use of technology. Kaprow also shrewdly noted that the video artists' 'relentless fondness for time-lag devices' tended towards a suspension of time that afforded no room for political visions of the future. So the field was left to *private self-inspection* in which at best questions of identity were at stake. Even so, the balance between the public and private domains has inexorably shifted, and the internet has changed the situation beyond recognition.

In the 1960s Bruce Nauman was more interested in the rôle of the private visitor in the public space of the gallery. He therefore set out to capture the spectator on closed circuit television monitors, a procedure normally used only in surveillance (illus. 167). In so-called corridor installations the visitor loses him- or herself in narrow corridors between the camera and the monitor. Here 'the video helps the private part, even though it's a public situation', as Nauman later said in an interview. It was perhaps one of the main aims of media art to return mass-media technology to private use. The early works by Nauman or Dan Graham now make us see in retrospect how much they were still influenced by free, physical performance. The self-perception the viewer experienced on the threshold to the imaginary space of the media was rooted in the perception of the body, which has lost much of its presence in the digitalized world.

167 Bruce Nauman, Detail from *Corridor Installation (Dick Wilder Installation)*, 1970, wallboard, closed-circuit video cameras, scanner and mount, monitors, videotape player and videotape.

But in another branch of media art, as in the multi-media installations of artists such as Bill Viola or Gary Hill, the perception of the body is still forcibly continued. By immersing the viewer, so to speak, in the darkness of a room, these artists have created meditation spaces where the ordinary act of perception is transformed into a solemn ritual (illus. 168). An installation of this kind produces an experience of the work that can be characterized only by two contradictory descriptions. On the one hand the experience takes place in a closed-off, cell-like space in which the viewer feels left alone by himself, as though this stage had been set up only for him. He therefore identifies all that he sees as his

168 Bill Viola, *Slowly Turning Narrative*, video/sound installation at the
Whitechapel Art Gallery, London, 1992.

own perception. Where no artist with a personal voice speaks to the
viewer, there seems to be no work. But when this same visitor has left
the installation he retains a strong impression for which no reproduction
can serve as a substitute. Installations like this are not reproducible, unlike
the conventional work, but became a matter of memory. Thus, precisely
where the old concept of the original no longer seems applicable, it
reappears as an original impression that seems to take on an independ-
ent existence. The impression generated by an installation amounts to
what Walter Benjamin called the 'aura of the here and now', which
indeed generated the classical experience of the work.

18 The Work as Memory

At the very time when work production seemed an unloved legacy of
modern art, works were re-enacted in an exercise of memory. The loss
of the work as a self-evident standard thus seemed to be an accom-
plished fact. Artists who no longer continued to produce works in the
old sense were ready to invoke works by quotation, by which they kept
their distance from a mere repetitive act and from a naïve belief in the
old truth of the work. The very fact of quoting proved that works could
now only be recalled as memories. Quotation was thus simply another
form of opposition to the work, possibly even a more radical expression
of opposition than outright rejection.

Rituals of memory are, therefore, significant for a new phase of art
practice. Though works did not cease to be generated, they were works
of a different kind, epilogues or masks, anti-works, work-slogans, or even
frivolous gestures that denied a great modern tradition of works alto-
gether. Art, it seemed, had broken away from the compulsion to produce
works. Yet this new freedom resulted in anxieties of another kind. A
personal confession no longer seemed justifiable after the status of a
personal creator had suffered so much. Where works could fail, simula-
tion could not. Simulated works would no longer be accused of self-
expression; rather, they qualified as self-denial on a new stage of art.

'Art about Art' was a short-lived movement of the 1970s, culminat-
ing in the exhibition with that title which opened at the Whitney Mus-
eum in New York in 1978. Visual art, to be sure, was always prone to
self-quotation in the same medium, not least in painting. It is necessary,
therefore, to exemplify the new spirit that emerged with an art that was
nothing but quotation or which identified itself as art only by way of
quotation. This, of course, affected the uncertain status of the work,
which again survived with a borrowed label, i.e., via quotation. The
situation was different when media other than painting, for example
photography, film and literature, introduced museum pictures as issues of
memory, whose loss in the living art scene was not their primary
concern. The description of paintings in literary texts suddenly adopted

a tinge of melancholy, the melancholy of a loss. Literary description was now tempted to provide the past creations of art with a second life or with a life of memory. Photography and film took different routes when exculpating their own difference with the reference to a past time of pictorial art in which the creative act had enjoyed another meaning. Finally, technical media via quotation rejected the self-confidence of past painting and thus testified to its anachronism in a changed world. The spectacle of memory, whether polemical or melancholic, nevertheless revealed the continuing presence of works that could only be remembered.

In gallery art, however, the fashion for quotation resulted in a new art discourse. Recreation of past art no longer nourished the confidence that art and creativity survived in an undisputed sense. Thus the new work was introduced via the quotation (or rather doubt) of the traditional claim of art: creation shifted to quotation. Quotation now insisted that the claim inherent in imitation was an exhausted possibility. Imitation ceased to be a possibility of continuing art. The older pictures, via quotation, not only appeared like lost names retrieved from memory, but as vehicles of a lost claim of the art-work as an entity of its own. Via quotation, as a *conditio sine qua non*, creation was either mourned or rejected as a past concern of art. The continuity of art, which as such was subject to doubt, rested on the ritual of quotation. Artists quoted an individual picture like an *objet trouvé*, which kept alive the trace of a lost certainty of art and thus resulted in a confession. In their avant-garde phase, predecessors had voluntarily smashed this historical mirror, and a new, and, as it were, postmodern generation of artists in part pieced it together again in order to put its magic to the test once more. But the cracks in the glass remain, and they prevent us from creating a false semblance of a wholeness that has, in fact, been lost. The rituals of remembering were informed not just by the sense of melancholy that results from a loss but also by the insight that the old concept of art had to be relinquished.

Discouraged by the radical departures of the 1960s, but also driven by a desire for self-assertion, artists turned once more to the mirror of the history of art. Large-scale exhibitions set out to prove that the development of art had always been nurtured by the replica and the copy. The public was assured that the history of art had not only been the quest for the new, but an arduous reconnaissance of territory with models for guidance. Thus in his well-known essay 'The Glorious Company', Leo Steinberg placed the new movement in the historical perspective of art through

the ages. The 1978 exhibition at the Whitney Museum, mentioned above, set the mood with a simple reasoning: given that art had always been made out of art, it should still be possible to do so. American artists favoured this argument, for it made them the happy heirs of European art.

It is revealing that the emergence of Quotational art coincided with the rise of Pop art. As early as 1962 quotations were a major theme in the work of Roy Lichtenstein, and in Tom Wesselmann's series of the *Great American Nude*. American everyday life is invaded by art stereotypes that either adorn a wall in the background or turn the principal figure into an art quotation (illus. 169). An American Olympia, complete with cat, stretches out in front of a Matisse portrait while its artistic pose refutes any suggestion of pornography. Wesselmann introduces an art that had already fallen victim to commercialism and was at the mercy of the mass media. And yet, quotable and saleable as it had become, it still harboured a disturbing memory that broke through the present's glib surface.

Lichtenstein, who raised the screened Benday dots of the mass media to an art form, was experimenting with art quotations from 1962 onwards. Soon the word 'art' began to creep into his pictures, as though the artist wanted to advertise art just as commercial products were promoted by the use of brand names. The 'brushstrokes' that he did from 1965 onwards reintroduce the painted gestures of the New York school, like a commercial item put back into production to meet increased demand. *Masterpiece*, which subverts the concept of the painted work, was created as early as 1962 (illus. 170). The words spoken to the young painter by his girlfriend – that 'this painting is a masterpiece' and that soon the whole of New York will be clamouring for his work – seems like a frame from a comic strip about a painter's private life. But this impression disappears when we stand in front of the picture, which is suddenly no longer part of a narrative but a work in its own right. Reviving an old art-historical cliché, Lichtenstein forces us to look with the intense gaze of a painter at a picture hidden from sight that indeed may be or may have been 'a masterpiece'.

In Europe Quotational art, which profited from the loss of ground suffered by painting, made its first collective appearance in 1971 in an exhibition held at Lugano under the title 'D'après'. There René Berger posed the question of whether the new current was a phenomenon or already an epiphenomenon of art history – a question he wisely left unanswered. If re-creations had always been within the rules of the game of art, there was no reason why the game should not continue. In a play



408

169 Tom Wesselmann, *Great American Nude # 26*, 1962, oil on canvas. Private collection.

on words, the title of an exhibition held in 1979 at the Hannover Kunstverein turned *Nachbildungen* (reworkings, or re-creations) into *Nachbilder* ('after-pictures'), leaving it open whether these were still independent 'pictures' or only a postscript to pictures. In their contributions to the catalogue, art historians celebrated a painted history of art, though they could not dissipate the suspicion that this was turning into an epilogue to art. The works on display confronted visitors with a veritable maze of reflected images designed to disorientate them. Among these were pictures like

409

170 Roy Lichtenstein, *Masterpiece*, 1962, oil on canvas. Private collection.

Malcolm Morley's *School of Athens* (1972), which presents a cultural cliché, Raphael's famous work, in a cliché of gallery art – as an oil painting on canvas, whereas the original is a mural (illus. 171). But by disturbing the spatial construction, and by alluding to a fresco, the picture deliberately negates the status of a gallery work.

A special place is occupied in this context by Renato Guttuso, the veteran realist painter, who in 1973, the year of Picasso's death, created his 'banquet' or 'symposium' series of paintings, which should not be confused with Quotational art. The paintings are like a wake arranged by Guttuso in honour of his friend Picasso, and the very brushstrokes demonstrate his confidence in the vitality of Picasso's art. The painterly gestures follow the language of Picasso's works while possessing a spontaneity that belongs to Guttuso's own personality. The motifs from Picasso are quoted with nostalgia and yet with a firm belief in the indestructible energy of art. In *Entertainment of the Painters*, Picasso sits at the

171 Malcolm Morley, *The School of Athens*, 1972, acrylic on canvas. Stefan T. Edlis Collection.

172 Renato Guttoso, *Entertainment of the Painters*, 1973, acrylic and mixed media transferred onto paper. Graphis Arte, Livorno.

173 Renato Guttoso, *The Banquet*, 1973, acrylic transferred onto paper. Private collection.

table conversing with the Old Masters with whom he engaged in dialogue throughout his life (illus. 172). This picture stages Picasso's affirmation of the life of art that, with his death, seemed to slip into the realm of memory. In *The Banquet* Picasso is surrounded by the figures he created, who live on as works even if, like Gertrude Stein or Apollinaire, they were once also living people (illus. 173). But this too is a farewell to works that, with Picasso gone, were credited to the past. Although they survived his passing, their creation ended with his death.

MARCEL BROODTHAERS: MUSEUM AS MEMORY

In these same years the Belgian artist Marcel Broodthaers presented the art world with his fictional museum. This gradually evolved in a series of exhibitions held between 1968 and 1972. These exhibitions opened like Happenings, while their arrangement was reminiscent of Conceptual art. But Broodthaers was pursuing different aims, for his topic was the museum itself. Just as in Quotational art the *work* adopted an existence only through quotation, Broodthaers reintroduced the museum via quotation. The focus of attention shifted from the production of works, which no longer seemed justified, to the customary exhibition of

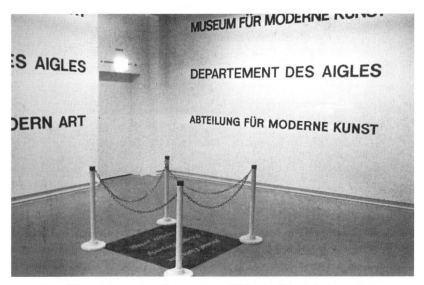

174 Marcel Broodthaers, Installation shot of 'Musée d'Art Moderne, Département des Aigles, Section d'Art Moderne' at documenta 5, Kassel, 1972.

works. Broodthaers did not recall the history of the work but insisted on the history of the museum. To this end he played the rôle of a museum director, performing the latter's duties with bureaucratic precision while carrying them to the point of absurdity. In the guise of an archaeologist of the modern period, he traced the first exhibition in his fictional museum back to the early nineteenth century. By degrees the solemn ritual of remembering changed into an analysis of the museum as an institution. But Broodthaers himself admitted that his attack had failed precisely because of its success in the art scene amd by its poetical manner. As a result, the very museums he attacked are now nostalgically re-enacting the events of those days.

Broodthaers used poetry as a weapon against Conceptual art and its pedantic use of language. Having started out as a poet, he disagreed with Anglo-Saxon conceptual logic and therefore set about opposing the texts of Conceptual art by means of images. In September 1968, after taking part in a violent occupation of a museum, he opened his own 'Musée d'Art Moderne', even including an inaugural address. The exhibition was filled with empty crates whose content, invisible gallery pictures, could only be imagined; the crates emphasised the character of the works as objects that would lend themselves to commercialization. The 'Nineteenth-Century Section' was a sub-section of the art department that Broodthaers placed under the emblem of the eagle, as the

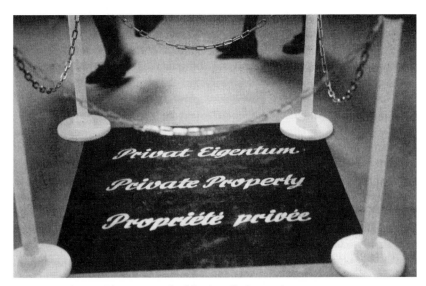

175 Marcel Broodthaers, Detail of the installation at documenta 5.

'Département des Aigles'. The rigid classification was a way of indicting the museum's bureaucratic structure, which extended into the exhibition space. The 40 postcards displayed at the 'museum' were merely stand-ins for works known mainly as reproductions. Four years later Broodthaers published a catalogue in which the same postcards were given specific locations on a fictive plan of the museum. The accompanying text asks: 'Where is the original?' The postcards reprinted here were reproductions of those on view in the first version of the fictional museum. But by signing the new reproductions Broodthaers declared them to be originals. The concept of the 'original' thus wavered between uncertain memory and written authentication. The fictional museum also implied a critique of André Malraux's 'imaginary museum', which was a museum without walls. For Broodthaers there could not be a museum without walls precisely because a museum immured art. In his view the museum had become – or, perhaps, had always been – not a living idea but a dead institution.

In the promotional events that accompanied Broodthaers's museum in different places, he also asked the puzzling question of ownership. A museum was public property, and yet it prevented the public from freely exercising its rights over the works. Similarly, the director was not free in his own museum, but was bound by institutional rules. In 1971 Broodthaers offered his museum of modern art for sale on the Cologne art market on the grounds of bankruptcy, as was stated on the cover of

nineteen catalogues at the art fair. Of course it was not the 'museum' but the printed version of it that was being sold. A year later, as part of Harald Szeemann's 'Individual Mythologies' section at the fifth 'documenta' exhibition, Broodthaers created an installation that raised the question of ownership in the guise of legal warnings. Alone with the name of the museum and its departments ('Département des Aigles', 'Section d'Art Moderne'), there were imaginary signposts indicating the director's office, the cloakroom and so forth (illus. 174). In the middle of the floor, a black surface, chained off, offered the phrase '*Private Property*' in three languages (illus. 175).

So here Balzac's 'invisible masterpiece' was literally delimited by a prohibition sign. As a piece of museum property, a work is no longer identified by its own qualities, but by the aura of an institution. Broodthaers's commentary speaks of 'the satire of an equation of art and private property'. Such installations reached their climax when Broodthaers opened his exhibition 'Section des Figures' in Düsseldorf in May 1972. Ever since 1968 he had been using the eagle, a symbol of sovereign jurisdiction, as an emblem of art. Now he exhibited 300 eagles, yet the exhibition compromised the ritual of an art administered by the state. 'The Eagle from the Oligocene to the Present' was represented by examples from nature, art and advertising, ranging from a stuffed bird to a heraldic emblem (illus. 176). The 'majestic representation' of the eagle formed a parallel to the majestic exhibiting of art. The key statement in the two-volume catalogue explains that 'the project of the exhibition emphasises the identity of the eagle as an idea with art as an idea.'

That idea was undermined by providing each numbered exhibit with a warning –'This is not a work of art' – in three languages. The customary museum label turned into its own denial and thus deprived the public of its legitimate expectation. According to the catalogue this labelling 'signifies quite simply "Public, how blind you are!"', meaning how easily people were willing to accept the museum's guarantee – 'This is modern art'. We are reminded that we view art in the same way that we look at an eagle, i.e., as an idea, and by the same token art is stamped with an idea. As a self-appointed archaeologist of institutions, Broodthaers traced the idea of art back to the idea of the museum. The eagle stood for an idea (the idea of art), which materialized in an object (a work). The idea (art/eagle) raised anything to which it was attached to the status of a work of art.

Even so, the traditional museum, in Broodthaers's view, only qualified for an epilogue. Institutions, while they live on, are irreparably

176 Marcel Broodthaers, Detail of an installation of 'Musée d'Art Moderne, Département des Aigles' in Düsseldorf, 1972.

damaged when they are remembered with a mixture of sadness and irony, and thus lose their credibility. This is what distinguishes Broodthaers's installations from the old avant-garde's attacks against the power of the museums. He no longer believed in that power, however patiently he dissected its mechanisms and restaged its old status. After he deprived the museum of its trophies, replacing its works with fictions, he caused the museum to lose prestige, changing it from a stage of high drama into a setting for comedy. Today it looks as though the institutions have won, and yet it may be a pyrrhic victory.

PHOTOGRAPHY'S *MISE-EN-SCÈNE* OF THE OLD PICTURE

Photography had always longed to be recognized as an art form, until it was given this recognition almost too readily. Photographs have for a long time adopted museum-style formats, that is to say, they have grown to the size previously reserved for gallery pictures, which they increasingly aim to simulate in their aesthetic structure. While it is clear, then, that photographs have been accepted as works in their own right, it is equally true that in this they are imitating the old status of the museum piece. But there is more at stake than mere genealogy, when photography and paint-

ing make use of each other's self-representation. Looking at one of Cindy Sherman's History Portraits, we find a confusing hybrid in which painting and photography give the lie to one other (illus. 177). The photograph also adopts the composition of a historical portrait. In the process, however, it neither becomes painting nor continues to be photography in the old sense. Equally, it is impossible to confidently separate the portrait's historical guise from its contemporary remake. Even the model, while it is quoted, is simultaneously disclaimed. In speaking of 'a work' I am referring not so much to the Renaissance portrait as to the museum piece as

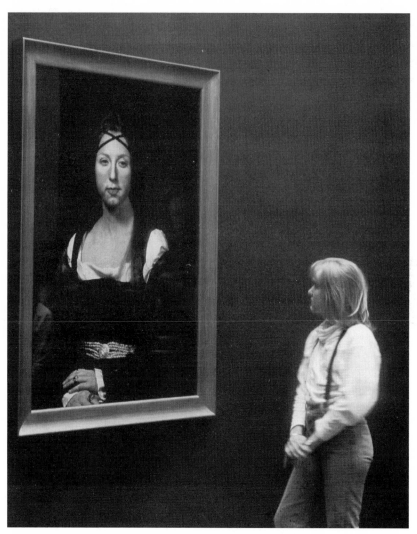

177 Installation shot with Cindy Sherman's *Untitled # 209*, 1989.

such, which receives a new ritual, the ritual of remembering.

The memory of the picture, no less than the historical costume used by the American artist, reminds us of the loss of confidence that the human representation has suffered since the time when the portrait was an accepted genre. Further, the choice of the old picture schema reminds us of the fact that the acting out of a kind of stage rôle was already a primary concern of historical portraiture. In our case, however, the artist herself is performing in the portrayal, though she does not aim at a self-portrait. Artists have for a long time played the rôle of the ever-uncertain self on behalf of their viewers, as I have shown repeatedly in this book. But in order to measure up to this capacity, they had to be certain about their own status as artist–creator. Today this status has, in its turn, become so uncertain that they increasingly play the rôle of the artist, as if it were the rôle of the double – which means that the old game has changed considerably.

Any kind of *mise-en-scène* runs counter to the old function of photography, whose automatism was to capture whatever happened to be in front of the camera lens. Instead, such staging reveals the photographer's claim to be the creator of a work. This is Cindy Sherman's counter-presentation of photography, and with the change of medium (replacing old pictures with her own photographs) she is playing a double game with the experience of the museum piece. The History Portraits resemble paintings not only by imitation but also by their reference to museum pieces, 'as though' they were works of another kind. Where the two media intersect in this way, we are reminded of works of which we cannot be sure whether they live only in our own memories. Thus the interaction of the two media makes use of memory in a paradoxical way. Sherman so strongly emphasizes the props she uses to alter her appearance that she draws into complicity her construction of phantom works. Despite this, the rituals of memory she performs have a powerful impact on us.

The Canadian artist Jeff Wall stages photography in a completely different sense, and yet he also offers a reminiscence of traditional painting. His composition guides the eye of the viewer as much as does conventional painting. In his light-box pictures, which borrow their technology from advertising, Wall chooses static views that, however, include secret stories, which change, in the midst of banality, into silent dramas. They are placed in the picture as though wafted there by chance. But their understated presentation generates an energy that imparts itself to the impression made by the picture as a whole. In the giant-size *Story-*

178 Jeff Wall, *The Storyteller*, 1986, Cibachrome transparency on a light-box.
Museum für Moderne Kunst, Frankfurt am Main.

teller (1986), a piece of sloping ground beside a highway bridge, literally on
the margin of civilization, ignored and arbitrary, is occupied by a group of
people who have chosen to come to this out-of-the-way spot (illus. 178).
The storyteller is not only holding her two listeners spellbound, but allures
them to a place of the imagination that transcends this real place. Wall has
long been an admirer of Manet, and the memory of *Le Déjeuner sur l'herbe*,
though it is no more than an allusion, gives force to Wall's aspiration to
become, in this new medium, a 'painter of modern life'.

It is the change of medium that makes the ritual of memory here
markedly different from Quotational art. Wall's photography does not
merely seek the genealogy of painting: he actually incorporates such
images as he has seen in painting into his photographic work, and even
counterbalances the colours that painting uses to deck out its subjects.
By invoking painting he also conjures grand narrative, for which there is
so little place in contemporary painting. Any narrative turns the world
into an occasion for storytelling – asserting that it still has a meaning that
can be narrated. At the same time epic narrative is an ancient property
of painting, of which photography reminds us precisely because it is
other than painting. Wall thus, unlike his fellow artists, seems still to
believe in the possibility of *refaire*, without falling victim to a subversive
scepticism. If we share his belief, this would mean that the history of art,
as embodied in works, is not at an end, even if it can only be continued
in different media. Wall's modern epics hang in the same museums that
we visit in order to see the old epics of painting.

LITERARY RE-CREATIONS

Literature has always been a mirror reflecting the visual arts. It appropriated or recreated visual images by verbal means. The old convention of *ekphrasis* in the era of classical literature did not merely describe pictures, but re-created them with a commitment to an artistry and inventiveness of its own. In the modern period this literary genre was even practised by painters, such as Dante Gabriel Rossetti, but it culminated in the work of those writers who reinvented the perception of the *Mona Lisa* and founded the myths of Picasso's *Demoiselles* or of Duchamp's *Large Glass*. Recently, however, the old contest between image and language has taken second place to new rituals of memory when literature in a retrospective and nostalgic mood evokes paintings that are no longer continued in contemporary visual art. Here we do not experience a 'return to the masterpiece', as Germain Bazin once called the surge of such literary evocations, but encounter a dream of art that is nourished by works of other periods. The aura that clings to the examples chosen in literature is not that of the museum original, of which Walter Benjamin treated. It is their aura in collective memory, from which the old pictures resurface as our own images, even when they have remained visible in a museum.

Peter Weiss, as a latecomer in twentieth-century history, had his own reasons for admiring a revolutionary energy that was reflected from the mirror of great works of art. However, he also testified to a change of consciousness when art experience turned into looking back at art of the past. Picasso's *Guernica*, for Weiss, symbolized the 'memorial surface' of the Spanish Civil War in which he had not taken part. In his novel *Die Ästhetik des Widerstands* (The Aesthetics of Resistance), the description of Picasso's painting affirms art's spirit of resistance. The painting 'cried out for all those past stages of memory' that had been captured in paintings by Goya, Géricault and Delacroix. Weiss, as a writer, therefore had 'no interest in breaking with the works of the past' as the modern avant-garde had done, for 'our thinking has been shaped by those works'. In the museums he admired the 'works of the imagination' whose painters had 'raised themselves above their own uncertainty and overcome the unreliability of their thinking'. In the process of creating a work they were part of a 'historical continuity' in which Weiss wanted to be included.

Weiss's views, nevertheless, are far apart from the position now commonly called 'postmodern'. It was not art's own *mise-en-scène* but the

'truth of art' that had become his vital problem. Since he viewed art from a moral perspective, though without losing sight of its aesthetic power, he was concerned with truth *in* art rather than truth *of* art. The art of painting for him only survived with the timeless dignity of past works, which drew him into a dialogue that became his source of literary re-creation. His views differ from the nostalgia for the past work that, since the 1970s, has become widespread for a whole range of reasons. Yet, when confronted by the history of art, Weiss also experienced a sense of loss that caused him to respond with affection and wonder.

Weiss's belief in the truth of single works strongly contrasts with the picture offered by André Malraux, who, in his great trilogy known as *Les Voix du silence* (The Voices of Silence), replaced the singularity of works with the ubiquity of styles, which are matched with one another by means of photographs. In his premature commitment to world art, which in his belief possessed, in all cultures, a timeless modernity, he dissolved the firm profile of a given work that was tied to a particular culture. In his *Musée imaginaire*, part of the trilogy, he replaced the real museum with an imaginary one, that is, with a universal memory in which the experience of works yields to the free interplay of single forms. The real museum, he insisted, as a place 'not of painting but only of pictures', had narrowed the common understanding of art.

Malraux nevertheless willingly admitted that 'the masterpiece remained victorious in its struggle against the fiction that surrounded its own perfection'. Against this fiction he used photographic evidence for an imaginary panorama that reduced works to illustrations of art as a global idea. 'What do they lose by this? Their identity as objects (*qualité d'objets*). What do they gain? The greatest possible capacity to convey a particular style.' In contrast to Oswald Spengler with his *The Decline of the West* (1918–22), Malraux wanted to celebrate human creativity as an achievement that transcended all nations and ages. He therefore disengaged the works from their particular message that later was to fascinate Weiss, and shifted the accent from the single work to human self-expression. The forward-looking idealism, very much of its time, which is abstracted from Malraux's art of the human race, is in striking contrast to the following generation's nostalgia for the irretrievable possibility of the work as an accepted domain of art.

Soon hermeneutic exercises, previously to be found only in literature studies, became common in art criticism. In his essay on *Las Meninas*, Foucault analyzed Velázquez's masterpiece as a variant of classical

representation that preceded modernity. In this picture, Foucault explains, the painter enters into a dialogue with the viewer about the rules that representation has employed in this work. The dialogue is not directed to what is represented (for instance, the royal couple, or the painter) but concerns representation itself, which hinges on the interplay between what is, and is not, visible. Foucault does not contradict the idea that *Las Meninas* was intended as an allegory of painting, but as such it also symbolized a historical style of thinking. Seen in this way, the work is not an example of timeless art but has become for any present-day viewer an object of memory.

In contemporary literature, museum works are stripped of all historical baggage, which turns them into personal impressions, regardless of their age. The literary strategy deviates from the strategy of Quotational art by turning old pictures into private mirrors in which any historical distance disappears. While Giorgione's works nostalgically reappear in Alfred Andersch's novel *Die Rote* (The Redhead), and Carpaccio becomes a hero for Anne Duden in her novel *Das Judasschaf* (The Judas Sheep), authors such as Julian Barnes adopt an ironic tone when discussing art, as he does in his treatment of Géricault's *Raft of the Medusa*. Georges Perec's *Un Cabinet d'amateur* (A Collector's Cabinet) turns the picture collection of former times into a modern hall of mirrors. Here the fictions inherent in the concept of the work are played over in a new variation: it takes only the existence of copies to accept even forgeries as works in their own right, for they indubitably become works as soon as they are copied.

Thomas Bernhard, in his novel *Alte Meister* (Old Masters), uses a parodistic approach to the masterpiece as a mask for a philosophical statement. The novel's protagonist spends his whole life sitting in front of a single picture, Tintoretto's portrait of a man with a white beard, which he studies with infatuated attention in Vienna's Kunsthistorisches Museum. One day there is a rival contender for the seat, an Englishman who claims to possess an identical exemplar of this work. So the art lover may have spent all his life in front of a forgery, having mistaken it for a masterpiece. He feels utterly 'let down' by the Old Masters, since, after all, they do not equal life itself, and they never even achieved truly perfect art. His lifelong attention had been directed to the discovery of a 'serious fault' in the masterpiece, which would dissipate its claim to perfection. The art lover wanted to deconstruct the completed work back into 'a fragment', for 'only when we have realized that the whole and the perfect do not exist is it possible for us to survive.'

Bernhard's conclusion markedly differs from the one envisaged by Balzac. Frenhofer lived only for his dream of one day completing a work that would be perfect. But this dream was dangerous, for if he succeeded, his life would cease to have further meaning. If he failed, then his life had never *had* a meaning. Even while he worked on the painting, he feared losing control over the work. He remained its master only for as long as his idea remained a dream. Thereafter it would reduce him, like anyone else, to a mere beholder or reader. The battle of the work also implied the struggle between the artist and his own self. Frenhofer feared the finished work, which, however, at the same time would offer only the certainty of his own existence. Bernhard's viewer matches Frenhofer in that each of them identifies himself or loses against the work he is creating or studying. But Bernhard gives the story a new twist, in that he accuses the authority of the work of being at variance with the demands of life.

THE AFTERLIFE IN FILM: RIVETTE AND BALZAC

Balzac was the inspiration behind the film that won Jacques Rivette the Grand Prix at the Cannes Film Festival in 1991. Frenhofer's painting, an invisible work, now enters a film where again it is at the very centre and yet is never shown to us, not even at the end. It is only reflected in the intense gaze of the characters whose lives it profoundly changes. The creative struggle is played out between the painter Frenhofer (Michel Piccoli), his wife Liz (Jane Birkin) and his model Marianne (Emmanuelle Béart). The title of the painting, *La Belle Noiseuse* – 'a magical title, which has always set me dreaming', as Rivette said at Cannes – is also the title of the film. In the first version of Balzac's tale (1831), the painter Porbus begs the elderly Frenhofer to show him, at last, his '*belle noiseuse*' – his quarrelsome beauty – which he indignantly refuses to do, on the grounds that 'she' is as yet unfinished (see p. 125). In his second version (1837), Balzac no longer calls her '*belle noiseuse*' but '*maîtresse*', emphasizing her tendency to be domineering (*maîtriser*). The beloved is a work, but the work makes its creator suffer the pangs of a tormented lover.

Balzac's theme, with its long history, was given a dramatic treatment by Pascal Bonitzer in his adaptation of the story for Rivette's screenplay. The result, as Rivette said, was a film 'about painting' and the process of creating a painting. In the painter's studio, where much of the action is set, the drama of the creative process is enacted between artist and model (illus. 181). Here the old ritual between artist and sitter has become a ritual of memory. The drama that unfolds between painter and model

recalls a myth of painting that has been epitomized in the myth of the work. The model had to be naked, because the female body had always been the emblem of the work, representing the body of art. So Rivette does not have contemporary artistic practice in mind, but re-enacts an ancient legend of painting, with the creative act metaphorically embodied on the canvas in the form of the female nude. The conflict between art and life has to be resolved either in favour of life or against it. Rivette creates images much as painters do, but his filmic images relate to a less certain notion of a work. The old-fashioned scenario presented by Rivette therefore has to be read allegorically. At the same time this scenario necessitated a proper filmic language for Rivette's story, since the film does not lead to a painted work (however much it seems that it will) but is itself the work.

The film here becomes a stage on which the memory of the work's aura is performed once again. Since, as in Balzac, the painted work remains invisible, its place is taken by the mere idea of the work. A different approach was adopted by Jean-Luc Godard in his magnificent film *Passion* (1982), where he re-created famous paintings in *tableaux vivants* that are like precious memories interpolated among the everyday scenes of the film. The first two are Goya's *The Third of May, 1808* (*Execution of the Rebels*) and Rembrandt's *The Night Watch* (illus. 179). In another, later, setting, the Polish director who is a character in the film hovers above the stage like an all-powerful demiurge, in an allusion to Tintoretto's *Bacchus and Ariadne*. But the moment he joins with the actors, they menacingly demand to know what is going on in the story they are supposed to play. Delacroix's *Entry of the Crusaders into Constantinople* requires particularly complicated preparations, until the large cast of actors are finally in position and all movement on stage suddenly freezes into the 'picture' invented by Delacroix (illus. 180). More often than not, however, the attempts to stage a tableau are broken off by the actor who plays the film director on the grounds that 'the light is wrong'.

'The famous classical paintings', as Godard called them in a sort of screenplay, here invite one to share in a ritual of memory. Godard saw legendary pictures like these, which have for so long been part of our collective memory, as expressing 'the fictive spectacle of love', while he could shoot 'the real world of labour' with the tools of his own medium. The difference between the images of memory and those of everyday life was, for him, the difference between metaphor and reality. The paintings had always been fiction, but they expressed human 'passion' via a metaphor that had become unrepresentable in today's world. These

179 Still from Jean-Luc Godard's 1983 film *Passion* (after Rembrandt's *Night Watch*).

180 Still from Godard's film *Passion* (after Delacroix's *Entry of the Crusaders into Constantinople*).

181 Still from Jacques Rivette's 1991 film *La Belle Noiseuse*.

two views – the metaphor of painting and the realism of film – were to come together 'like teeth and lips'. In this way 'emotion and action' would be reconciled in the images of the film.

Pascal Bonitzer counted Godard among the 'plan-tableau' directors, those who think in images and introduce us into their very nature. It was soon after completing his fine book on painting and cinema that he offered Rivette the idea for *La Belle Noiseuse*. In the screenplay that he co-wrote with Christine Laurent, he adapted Balzac's story, one of the archetypes used in my book, for a film plot with Bonitzer's own words. At the time when the film begins it is ten years since Frenhofer abandoned his work on a picture, *La Belle Noiseuse*, which, ever since then, he has been afraid to return to. In his studio he talks to his visitors about the mythic act that brings a work into being, the 'bruit de l'origine'. The work is the great 'gamble', because it offers only the alternative of winning or failing. When he finally prepares to make another attempt at the painting with his new model, Marianne, the painter dictates her poses and uses physical force to change the living body into a mere motif, as in fashion photography. But the relationship between them is reversed when

it is she who persuades him not to give up. At that stage Frenhofer brings out the old canvas to overpaint the frontal figure of Liz with the crouching back view of Marianne. But the picture, which we never see in the film, reveals 'a harsh truth' to the two women. The painter's ambition of capturing life on a canvas is called 'shameless' (*impudique*). In the night the artist had made a streak of blood-red paint across the picture; later, Liz secretly paints a cross in front of the artist's signature.

The overpainted picture is not a new beginning but 'an end', as Liz says; Frenhofer himself uses the formulation 'first posthumous work'. But which picture do they mean? The picture that only the characters in the film have seen? The same one that the painter secretly bricks up in a wall, when we catch a momentary glimpse of the foot mentioned by Balzac? When, having been walled up, the masterpiece has ceased to exist in the lives of the characters, the artist quickly paints a new version that he wants his visitors to believe is the invisible masterpiece. At a party in the garden of Frenhofer's château, Liz speaks of the 'real painting' (*vrai tableau*), but they have seen only the false picture, whose resemblance to the masterpiece remains open. One of the guests who ignores Frenhofer's secret, asks the price of the picture in the mistaken belief that it is the great work. But no trace remains of the invisible masterpiece except in the lives affected by it. In the course of the film's narrative we see many preliminary sketches for a work that, as an artistic concept, is more intensely present in the artist's mind than it could possibly be on a canvas. Thus Frenhofer's creative efforts merely form a horizon beyond which the invisible masterpiece sets no limits on our imagination.

Bibliographical References

General Bibliography

Adorno, T. W., 'Ästhetische Theorie', in *Gesammelte Schriften*, VII (Frankfurt am Main, 1970)

Aragon, L. and J. Cocteau, *Gespräche über die Dresdener Galerie* (1957; Leipzig, 1988)

Arnold, M., *Van Gogh und seine Vorbilder* (Munich, 1997)

Asemissen, H. U. and G. Schweikhart, *Malerei als Thema der Malerei* (Berlin, 1994)

Asholt, W. and W. Fähnders, eds, *Manifeste und Programme der europäischen Avantgarde* (Stuttgart, 1996)

Ashton, D., *A Fable of Modern Art* (London, 1987)

Aulanier, C., *Histoire du Palais et du Musée du Louvre*, 11 vols (Paris, 1950–71)

Balzac, H. de, *Le Chef-d'œuvre inconnu*, ed. M. Eigeldinger (Paris, 1981); for a recent English translation, see Anthony Rudolf's *Gillette, or The Unknown Masterpiece* (London, 1988)

Barolsky, P., *Why Mona Lisa Smiles and Other Tales by Vasari* (University Park, PA, 1991)

Bätschmann, O., *Ausstellungskünstler. Kult und Karriere im modernen Kunstsystem* (Cologne, 1997)

Belting, H., 'Das Kleid der Braut', in H. M. Bachmayer *et al.*, eds, *Nach der Destruktion des ästhetischen Scheins: van Gogh – Malewitsch – Duchamp* (Munich, 1992), pp. 70ff.

——, 'Le Musée et la conception du chef-d'œuvre', in E. Pommier, ed., *Histoire de l'histoire de l'art*, I (Paris, 1995), pp. 345ff.

Benjamin, W., *Das Kunstwerk im Zeitalter seiner technischen Reproduzierbarkeit* (1936; Frankfurt am Main, 1963)

——, *Der Begriff der Kunstkritik in der deutschen Romantik* (1920; Frankfurt am Main, 1973)

Berger, U.–M., *Mr Fluxus. Ein Gemeinschaftsporträt von George Maciunas* (Wiesbaden, 1996)

Bernauer, M., 'Die Ästhetik der Masse und das Werk', in H. Gassner (1992), pp. 212ff.

Beyer, A., 'Künstler ohne Hände – Fastenzeit der Augen? Ein Beitrag zur Ikonologie des Unsichtbaren', in J. Stöhr, ed., *Ästhetische Erfahrung heute* (Cologne, 1996), p. 340ff.

Bilang, K., *Bild und Gegenbild. Das Ursprüngliche in der Kunst des 20. Jahrhunderts* (Stuttgart, 1989)

Boersma, L. S., *The Last Futurist Exhibition of Painting: 0.10* (Rotterdam, 1994)

Bois, Y.-A., *Painting as Model* (Cambridge, MA, 1990)

Boyer, P., *Le petit pan de mur jaune. Sur Proust* (Paris, 1987)

Bramly, S., *Mona Lisa* (Paris, 1995)

Brown, J., *Kings and Connoisseurs: Collecting Art in 17th-century Europe* (Princeton, NJ, 1994)

Busch, W., *Das sentimentalische Bild* (Munich, 1993)

——, *Die notwendige Arabeske* (Berlin, 1985)

Cahn, W., *Masterpieces: Chapters on the History of an Idea* (Princeton, NJ, 1979)

Cassagne, A., *La Théorie de l'art pour l'art en France* (Paris, 1959)

Champa, K. S., '*Masterpiece' Studies: Manet, Zola, van Gogh & Monet* (University Park, PA, 1994)

Chapeaurouge, D. de, *Raffaels Sixtinische Madonna* (Frankfurt am Main, 1993)

Chastel, A., *L'Illustre incomprise. Mona Lisa* (Paris, 1988)

—— , ed., *Leonardo da Vinci. Sämtliche Gemälde und die Schriften zur Malerei* (Munich, 1990)

Chrétien, J. L., *Corps à corps. À l'écoute de l'œuvre d'art* (Paris, 1997)

Ciardi, P. and C. Sisi, *L'Immagine di Leonardo. Testimonianze dal XVI al XIX secolo* (Commune di Vinci, 1997)

Collins, B. R., ed., *Views of Manet's Bar* (Princeton, NJ, 1996)

Conrads, U., *Programme und Manifeste zur Architektur des 20. Jahrhunderts* (Berlin, 1964)

Daniels, D., *Duchamp und die anderen* (Cologne, 1992)

Danto, A. C., 'Masterpieces and the Museum', *Grand Street Magazine* (Winter 1989), pp. 108ff.

Delacroix, E., *Journal (1822–1863)*, 3 vols, ed. A. Joubin (1932; Paris, 1960)

Didi-Huberman, G., *La Peinture incarnée* [with an edition of Balzac's *Le Chef-d'œuvre inconnu*] (Paris, 1985)

Dorn, R., *Décoration. Vincent van Goghs Werkreihe für das gelbe Haus in Arles.* Studien zur Kunstgeschichte, vol. 45 (Hildesheim, Zurich and New York, 1990)

Duchamp, exh. cat. (Paris and Cologne, 1984)

Duthuit, G., *Le Musée inimaginable*, vols 1–2 (Paris, 1956)

Duve, T. de, *Kant nach Duchamp* (Munich, 1993)

Eagleton, T., *The Ideology of the Aesthetic* (Oxford, 1990)

Eitner, L., *Géricault's 'Raft of the Medusa'* (London, 1972)

Elsen, A. E., *The Gates of Hell by Auguste Rodin* (Stanford, 1985)

Fath, M., ed., *Malewitsch – Mondrian. Konstruktion als Konzept* (Ludwigshafen, 1976)

Fitzgerald, M. C., *Picasso and the Creation of the Market for Twentieth-century Art* (New York, 1995)

Földényi, L. F., *Melancholie* (Munich, 1988)

Franciscono, M., *W. Gropius and the Creation of the Bauhaus in Weimar* (Chicago, 1971)

Franz, E., *In Quest of the Absolute* (New York, 1996)

Freud, S., *Eine Kindheitserinnerung des Leonardo da Vinci* (1910; Frankfurt am Main 1990); trans. as 'Leonardo da Vinci and a Memory of his Childhood', in *The Standard Edition of the Complete Psychological Works of Sigmund Freud*, ed. James Strachey, XI (London, 1957)

Fried, M., *Manet's Modernism or The Face of Painting in the 1860s* (Chicago, 1996)

Friedrich, S., *Das auratische Kunstwerk. Zur Ästhetik von R. Wagners Musiktheater-*

Utopie (Tübingen, 1996)

Galard, J., *Visiteurs du Louvre* (Paris, 1993)

Gamboni, D., *The Destruction of Art: Iconoclasm and Vandalism since the French Revolution* (London, 1997)

Gassner, H. et al., *Die Konstruktion der Utopie. Ästhetische Avantgarde und politische Utopie in den 20er Jahren* (Marburg, 1992)

Gautier, T., *Guide de l'Amateur au Musée du Louvre* (1867; Paris, 1994)

Gedo, M. M., *Picasso: Art as Autobiography* (Chicago, 1980)

Geelhaar, C., *Picasso. Wegbereiter und Förderer seines Aufstiegs* (Zurich, 1993)

Genet, G., *L'Œuvre de l'art. Immanence et transcendance* (Paris, 1994)

Georgel, P. and A. M. Lecoq, eds, *La Peinture dans la peinture*, exh. cat. (Dijon, 1983)

Goehr, L., *The Imaginary Museum of Musical Works* (Oxford, 1992)

Greenberg, C., *Perceptions and Judgements 1939–44: Collected Essays*, I, ed. J. O'Brian (Chicago, 1986)

Gropius, W., *Ausgewählte Schriften*, III, ed. H. Probst and C. Schädlich (Berlin, 1988)

Halder, A., *Kunst und Kult. Zur Ästhetik und Philosophie der Kunst in der Wende vom 19. zum 20. Jahrhundert* (Freiburg, 1964)

Hannoosh, M., *Painting and the Journal of Eugène Delacroix* (Princeton, NJ, 1995)

Hanson, A. C., *Manet and the Modern Tradition* (New Haven and London, 1977)

Harrison, C. and P. Wood, eds, *Art in Theory, 1900–1990* (Oxford, 1992)

Haskell, F. and N. Penny, *Taste and the Antique* (New Haven and London, 1988)

Haus, A., ed., *Bauhaus-Ideen* (Berlin, 1990)

Heidegger, M., 'Der Ursprung des Kunstwerks' (1935), in *Holzwege* (1950; Frankfurt am Main, 1980)

Hofmann, W., *Das entzweite Jahrhundert* (Munich, 1995)

——, *Das irdische Paradies. Motive und Ideen des 19. Jahrhunderts* (1960; Munich, 1974)

——, *Gegenstimmen. Aufsätze zur Kunst des 20. Jahrhunderts* (Frankfurt am Main, 1979)

——, *Grundlagen der modernen Kunst. Eine Einführung in ihre symbolischen Formen* (Stuttgart, 1987)

——, *Von der Nachahmung zur Erfindung der Wirklichkeit. Die schöpferische Befreiung der Kunst* (New York, 1969)

Hoog, M., *Les Grandes Baigneuses de Picasso* (Paris, 1988)

——, *Paul Gauguin* (Fribourg and Munich, 1987)

Kandinsky, W., *Die gesammelten Schriften*, I, ed. H. Roethel and J. Hahl-Koch (Berne, 1980)

Kaprow, A., *Essays on the Blurring of Art and Life*, ed. J. Kelley (Berkeley, CA, 1993)

Kasimir Malevich, exh. cat. (New York, 1991)

Kesser, C., *Las Meninas von Velázquez* (Berlin, 1994)

Khan-Magomedov, S. O., *Rodchenko: The Complete Work* (Cambridge, MA, 1987)

Körner, H., *Auf der Suche nach der wahren Einheit* (Munich, 1988)

Krauss, R., *The Originality of the Avant-Garde and Other Modernist Myths* (Cambridge, MA, 1985)

Kris, E. and O. Kurz, *Die Legende vom Künstler* (1934; Vienna, 1980)

Krumrine, M. L., *Paul Cézanne. Die Badenden,* exh. cat. (Basle, 1989)

Kuhlmann-Hodick, P., *Das Kunstgeschichtsbild,* I (1993)

Kuspitt, D., *The Cult of the Avant-Garde Artist* (Cambridge, 1993)

Ladwein, M., *Raphaels Sixtinische Madonna. Zeugnisse aus zwei Jahrhunderten deutschen Geisteslebens* (Stuttgart, 1993)

Lavallée, J., *Galerie du Musée Napoléon,* vols I–X (Paris, 1804–13)

Lipman, J. and R. Marshall, *Art About Art,* exh. cat. (New York, 1978)

Lyotard, J. F., *Die Analytik des Erhabenen,* ed. C. Pries (Munich, 1993)

Mai, E. and A. Repp-Eckert, eds, *Triumph und Tod des Helden. Europäische Historienmalerei von Rubens bis Manet* (Zurich, 1988)

Maison, K. E., *Themes and Variations: Five Centuries of Master Copies* (London, 1960)

Malevich, K, *Essays on Art, 1915–28,* vol. I, ed. T. Anderson (Copenhagen, 1968)

Malewitsch, K., *Suprematismus – die gegenstandslose Welt,* ed. W. Haftmann (1962; Cologne, 1989)

——, *Über die neuen Systeme in der Kunst,* ed. V. Fedjuschin (Zurich, 1988)

Malraux, A., *La Tête d'obsidienne* (Paris, 1974)

——, *Le Musée Imaginaire* (Paris, 1949) [*Les Voix du silence,* vol. I, Paris, 1951]

Marcel Duchamp, exh. cat. (1973; University Park, PA, 1989)

Margolin, V., *The Struggle for Utopia: Rodchenko, Lissitzky, Moholy-Nagy* (Chicago, 1997)

McClellan, A., *Inventing the Louvre* (Cambridge, MA, 1994)

McMullen, R., *Mona Lisa: The Picture and the Myth* (Boston, 1975)

Mona Lisa im 20. Jahrhundert, exh. cat. (Duisburg, 1978)

Neumann, E., *Künstler-Mythen. Eine psycho-historische Studie über Kreativität* (Frankfurt am Main, 1986)

Ockman, C., *Ingres's Eroticized Bodies* (New Haven and London, 1995)

O'Doherty, B., *Inside the White Cube* (San Francisco, 1976)

O'Neill, J. P. et al., eds, *Manet 1832–1883,* exh. cat. (Paris and New York, 1983)

Orwicz, M. R., ed., *Art Criticism and Its Institutions in Nineteenth-century France* (Manchester, 1994)

Passetto, L., ed., *Museo dei Musei,* exh. cat. (Florence, 1988) [with contributions by Umberto Eco et al.]

Picasso – Apollinaire, Correspondance, ed. P. Caizergues and H. Seckel (Paris, 1992)

Pickvance, R., *Van Gogh in Arles,* exh. cat. (New York, 1984)

——, *Van Gogh in Saint-Rémy and Auvers,* exh. cat. (New York, 1986)

Posselle, L., ed., *Copier Créer. De Turner à Picasso,* exh. cat. (Paris, 1993)

Pries, C., ed., *Das Erhabene* (Weinheim, 1989) [with contributions by J. F. Lyotard et al.]

Proust, M., *Essays, Chroniken und andere Schriften,* in *Werke,* III, ed. L. Keller (Frankfurt am Main, 1992)

——, *John Ruskin. Sésame et les lys,* ed. A. Compagnon (1906; Paris, 1987)

——, *On Reading Ruskin,* ed. J. Autret et al. (New Haven and London, 1987)

Proust et les peintres, exh. cat. (Chartres, 1991) [with an article by M. Hoog]

Quincy, Q. de, *Considerations morales sur la destination des ouvrages de l'art* (1915; Paris, 1993)

Read, P., *Picasso et Apollinaire. Les métamorphoses de la mémoire* (Paris, 1995)

Rosenblum, R., *Jean-Auguste-Dominique Ingres* (New York, 1985)

———, *Modern Painting and the Northern Tradition* (New York, 1975)

Rothschild, D. M., *Picasso's 'Parade'* (London, 1991)

Rubin, A., ed., *Pablo Picasso: A Retrospective*, exh. cat. (New York, 1980)

———, ed., *Picasso and Portraiture*, exh. cat. (New York, 1996)

———, ed., *Primitivism in Twentieth-century Art*, exh. cat. (New York, 1984)

Ruskin, J., *La Bible d'Amiens,* ed. M. Proust (1905; Paris, 1986)

Schelling, F.W.J., *Philosophie der Kunst,* in *Ausgewählte Schriften*, II (Frankfurt am Main, 1985) pp. 181–565

Schellmann, J., *Andy Warhol: Art From Art* (Cologne, 1994)

Schlegel, F., *Ansichten und Ideen von der christlichen Kunst,* in *Kritische Schlegel-Ausgabe,* IV, ed. H. Eichner (Munich, 1959)

Schneeberger, P. F., *Gauguin und Tahiti* (Stuttgart, 1991)

Selle, G., *Geschichte des Design in Deutschland von 1870 bis heute* (1978; Cologne, 1981)

Sello, K., ed., *Nachbilder*, exh. cat. (Hannover, 1979)

Stauffer, S., *Marcel Duchamp. Die Schriften*, I (Zurich, 1981)

Stemmerich, G., ed., *Minimal Art. Eine kritische Retrospektive* (Dresden, 1995)

Stierle, K., *Der Mythos von Paris* (Munich, 1993)

Stiles, K. and P. Selz, eds., *Contemporary Art: A Sourcebook of Artists' Writings* (Berkeley, CA, 1996)

Szeemann, H., *Der Hang zum Gesamtkunstwerk. Europäische Utopien seit 1800*, exh. cat. (Zurich, 1983)

Tilborgh, L. van *et al.*, eds, *Van Gogh & Millet*, exh. cat. (Amsterdam, 1988)

Uitert, E. van *et al.*, eds., *Van Gogh. Paintings*, exh. cat. (Amsterdam, 1990)

Warncke, C. P., *Das Ideal als Kunst. De Stijl 1918–1931* (Cologne, 1990)

Weidlé, W., *Gestalt und Sprache des Kunstwerks. Texte aus den Jahren 1957–1966* (Mittenwald, 1981)

Weiss, J., *The Popular Culture of Modern Art: Picasso, Duchamp and Avant-Gardism* (New Haven and London, 1994)

Whyte, E. B., *Bruno Taut and the Architecture of Activism* (Cambridge, 1982)

Wyss, B., *Der Wille zur Kunst* (Cologne, 1996)

———, *Trauer der Vollendung* (1985; Munich, 1989)

Yves Klein, exh. cat. (Paris, 1983)

Zeiller, A., *Guernica und das Publikum. Picassos Bild im Widerstreit der Meinungen* (Berlin, 1996)

Zöllner, F., *Leonardo da Vinci. Mona Lisa* (Frankfurt am Main, 1994)

Chapter References

Introduction

For Balzac, see chap. 5 ('The Artists' Curse') with bibliography. For the concept of the work's 'aura', see Benjamin (1936, 1963) and the discussion in chap. 2 below. For the *Mona Lisa* see chaps 5 and 6. The history of the museum is dealt with in chaps 1, 2 and 4. 'La Monnaie de l'Absolu' is the title of part 4 of A. Malraux, *Les Voix du silence* (Paris, 1951). For Schopenhauer's view, see H. Belting, *Bild-Anthropologie* (Munich, 2001), p. 16. For the crisis of the art-work in the 1960s, see chap. 17; for Duchamp, chap. 14; for Manet, chap. 7. On Picasso's late series, see the final paragraph of chap. 15. For Cahn's views (1979), pp. 84ff. and 104ff., but see also A. Danto's masterly analysis: Danto (1989), pp. 108ff. Adorno (1970), pp. 263ff. and Benjamin (1920, 1973), pp. 62ff. Földényi (1988), pp. 159 and 215ff. Schelling (1985), pp. 370, 380 and 389. For Hegel, see his *Vorlesungen über die Ästhetik*, ed. F. Moldenhauer and K. M. Michel (Frankfurt am Main, 1986), I, pp. 24ff. (see also Wyss, 1985, pp. 197ff.). On the Readymade, see chap. 12, third paragraph. On Conceptual and Fluxus art, see chap. 17; on Cubism, chap. 15, first paragraph. The pre-modern work is discussed in Cahn (1979) and in chap. 2 of the German edition of my book. For Félibien's quotations from his books: *Entretiens sur les vies ... des plus excellents peinture* (Paris, 1666); *De l'origine de la peinture* (Paris, 1670), pp. 2ff; *L'Idée du peintre parfait* (Paris, 1707), pp. 4ff and 12. For Roger de Piles see *Cours de peinture par principes*, ed. T. Puttfarken (Nîmes, 1990), pp. 218ff. For the picture cabinet, see Z. Filipczak, *Picturing Art in Antwerp* (Princeton, NJ, 1987) and Brown (1994). For the art book, see F. Haskell, *The Painful Birth of the Art Book* (London, 1987). For the quotation from L. Lanzi, see Lanzi's *La Storia pittorica dell'italia inferiore* (Florence, 1792), p. 6. For rhetoric, M. W. Roskill, *Dolce's 'Aretino' and Venetian Art Theory* (New York, 1968), pp. 213ff. Karl Philipp Moritz, *Werke*, ed. H. Günther, vol. 2 (Frankfurt am Main, 1991), pp. 543ff. On the Sublime, see C. Pries, ed., *Das Erhabene* (Weinheim, 1989).

1 The Farewell to *Apollo*

THE BIRTH OF THE LOUVRE

On the foundation of the Louvre see Y. Cantarel-Besson, ed., *La Naissance du Musée du Louvre*, 2 vols (Paris, 1981); McClellan (1994), pp. 49ff., 91ff., 124ff.; see also Bayle St John, *The Louvre, or Biography of a Museum* (London, 1855); Aulanier (1950–1971). On the discourse on beauty see Quatremère de Quincy, *Lettres à*

Miranda, ed. E. Pommier (Paris, 1989). On the opening of the Louvre in 1793 see
A. McClellan (1994), p. 91ff.; E. Pommier, *L'Art de la liberté* (Paris, 1991), pp. 93ff.,
331ff. On the seizure of art works under Napoleon see P. Wescher, *Kunstraub unter
Napoléon* (Berlin, 1976), pp. 55f.; C. Gould, *Trophy of Conquest: The Musée Napoléon
and the Creation of the Louvre* (London, 1956). On the veneration of the
masterpieces from Italy see Aulanier, I, p. 17. On the 1803 gallery of antiquities see
Aulanier, VI (1957), p. 78 (*Journal des Débats* also quoted here); on the medallion see
also J. Lavallée, X (1809), pp. 714ff. For the quotations see *Notices des Statues de la
Galerie des Antiques du Musée Napoléon* (Paris, 1803), pp. 102ff. On the *Apollo
Belvedere* see Haskell and Penny (1988), no. 8, pp. 148ff. On the Cortile del
Belvedere see J. S. Ackermann, *The Cortile del Belvedere* (Vatican City, 1954); H. H.
Brummer, *The Statue Court in the Vatican Belvedere* (Stockholm, 1970). On the
setting up of the Apollo in the Louvre see Aulanier, X, p. 73; on the *Diana* from
Fontainebleau see Haskell and Penny (1988), no. 30, pp. 196ff.; no. 88, pp. 325ff. For
the quotation about the *Venus de' Medici* see Lavallée, X (1809), pp. 714ff. On
Vivant Denon see P. Lelièvre, *Vivant Denon* (Paris, 1993), pp. 101ff. For Denon's
inaugural speech see D. V. Denon, 'Discours sur les monuments d'antiquité arrivés
d'Italie', in J. Chatelain, ed., *Dominique Vivant Denon et le Louvre de Napoléon* (Paris,
1973), pp. 317ff., 324ff. (*Venus de' Medici*). On the catalogues see C. Weissert, *Ein
Kunstbuch? Le Musée français* (Stuttgart, 1994); Guizot on the conception of the
museum, see the catalogue *Le Musée Français*, V ['Discours préliminaire'] (Paris,
1812). On the problem of arranging the museum see *Le Musée français*, III
['Discours historique sur la peinture moderne', by T. B. Émeric-David] (Paris,
1809). On the acquisitions policy followed in the early years of the Louvre see
Aulanier, V (1955), p. 65. On the choice of works later on see Lavallée, IV (1807).

THE IDEAL MUSEUM

On the museums in Rome see Haskell and Penny (1988), chap. 9, pp. 62ff.
('Museums in Eighteenth-century Rome'). On Q. de Quincy's criticism of the
plundering of art-works under Napoleon see de Quincy, *Lettres à Miranda* (see
chap. 1) and *Lettres sur le préjudice qu'occasionneraient aux arts et à la science le
déplacement des monuments de l'art de l'Italie* …(1796; Paris, 1815). On the
beginnings of the museum idea see J.-B. P. Le Brun, *Réflexions sur le Muséum
national* (1793), ed. E. Pommier (Paris, 1989). For de Quincy's objections to the
museum, see de Quincy (1993), pp. 40ff., 73ff. (masterpieces).

THE MUSEUM AS A REALITY

For Lavallée's assessment of modern art see Lavallée, IV (1807), pp. 2, 13. On the
history of medieval art see T. B. Émeric-David in the catalogue *Le Musée français*,
III (Paris, 1812). On the ceiling programme of the Louvre see H. Belting, 'Le
Musée et la conception du chef-d'œuvre', in E. Pommier and J. Galard, *Histoire de
l'histoire de l'art* (Paris, 1995); Aulanier, X (1955), pp. 75f. On the depiction of
Prometheus see E. Q. Visconti, 'Discours historique sur la sculpture ancienne', in
Le Musée français, IV (Paris, 1805). On the Grande Galerie see Aulanier, I (1950)

[which also reproduces the picture by Benjamin Zix, no. 38]. On Schlegel's visit to the Louvre see H. Dilly, *Kunstgeschichte als Institution* (Frankfurt am Main, 1979), pp. 143f. For the folio edition see *Le Musée français*, I–VI (Paris, 1803–18) [with contributions by S. C. Croze-Magnan, E. Q. Visconti, T. B. Émeric-David, H. Laurent]. The catalogue of the Galerie du Musée Napoléon: see Lavallée, I–X (1804–13). For the engravings of the *Venus de' Medici* see *Le Musée français*, IV (Paris, 1805), no. 4; Lavallée, X (1809), p. 714.

THE FIRST CRITIQUE OF THE MUSEUM

On the function of art in the museum see Lavallée, I (1804), p. 9 ('De l'origine et de la marche progressive des Arts'). On the post-Napoleonic development of the Louvre see Aulanier, I (1950), pp. 29ff. On Quatremère's early criticism of the museum see de Quincy (Paris, 1993). On de Quincy see R. Schneider, *Q. de Quincy et son intervention dans les arts* (1788–1830; Paris, 1910), pp. 166ff.

APOLLO IN THE MUSEUM

On the perfection of the *Apollo* see E. Q. Visconti in the catalogue *Le Musée français*, IV (Paris, 1805), no. 14. On Winckelmann see A. Potts, *Flesh and the Ideal: Winckelmann and the Origins of Art History* (New Haven and London, 1994), pp. 118ff.; E. Pommier, ed., *Winckelmann. La naissance de l'histoire de l'art à l'époque des Lumières* (Paris, 1990). For the engravings see *Le Musée français*, I (Paris, 1803); for the Apelles vignette, vol. IV (Paris, 1805) on Phidias and vol. III (Paris, 1809) on Raphael. On Apelles see Kuhlmann-Hodick (1993), pp. 154ff. On Canova's criticism see E. Jayme, ed., 'La repubblica delle arti ed il diritto internazionale', *Rivista di Diritto Internazionale*, LXXV (1992), pp. 889ff. On the *Venus de' Medici* see A. Félibien, *Entretiens sur les vies et les ouvrages des plus excellens maîtres anciens et modernes* (Paris, 1672), p. 5 (Third conversation); on the artist's inscription see Haskell and Penny (1988), p. 326; Lucian on the *Cnidian Venus* is quoted in *Le Musée français*, IV (Paris, 1805). Mengs's doubts quoted in *Notice des statues ... composent la Galerie des Antiques du Musée Central des Arts* (1800), pp. 117ff.; the position of *Le Musée français* on this question in *Le Musée français*, I (Paris, 1803); for the quotation from Flaxman see the reference in Haskell and Penny (1988), p. 150; for the defence of the *Apollo* by Visconti in *Le Musée français*, IV (Paris, 1805), no. 14; on Sheperd see the quotation in Haskell and Penny (1988), p. 54. On the Elgin Marbles see Q. de Quincy, *Lettres à Canova sur les marbres d'Elgin à Londres* (Paris, 1818); see also *Le Musée français*, VI (Paris, 1818–23), no. 63. On the new estimation of modern art see Lavallée, IV (1807), p. 3. For Roland Barthes' statement about history, see R. Barthes, *Die helle Kammer* (Frankfurt am Main, 1985), p. 75. For the *Venus de Milo* see Haskell and Penny (1988), no. 89, pp. 328ff.; A. Pasquier, *La Vénus de Milo et les Aphrodites du Louvre*, exh. cat. (Paris, 1985); *Le Musée français*, VI (Paris, 1818–23), no. 63. For Stendhal's views on the *Apollo Belvedere* see Stendhal, 'Promenades dans Rome', in *Voyages en Italie* (Paris, 1873), pp. 778f. and *idem*, 'Des Beaux-Arts et du caractère français', in *Mélanges d'art* (Paris, 1932), p. 173.

2 Raphael's Dream

On the *Sistine Madonna* see M. Ladwein (1993); A. Walther, *Die Sixtinische Madonna* (Leipzig, 1994); D. de Chapeaurouge, *Raffael. Sixtinische Madonna* (Frankfurt am Main, 1993); M. Putscher, *Raphaels Sixtinische Madonna* (Tübingen, 1955); M. Rohlmann in *Jahrbuch der Bibliotheca Hertziana*, xxx (1995), pp. 221ff. On Raphael's reception in Germany see W. Hoppe, *Das Bild Raffaels in der deutschen Literatur*, ed. E. Lommatzsch *et al.* (Hildesheim, 1974). On Rethel see Ladwein (1993), pp. 75ff. On Wagner see the diary of Cosima Wagner, quoted in Ladwein (1993), p. 112. For Heidegger see M. Heidegger, *Denkerfahrungen* (Frankfurt am Main, 1983), pp. 69f., first in M. Putscher (1955) (see above), pp. 174f., also quoted in Ladwein (1993), p. 160. For Thomas Mann's *Berliner Tageblatt* article (1919), see T. Mann, 'Reden und Aufsätze', in *Gesammelte Werke*, xi (Frankfurt am Main, 1969), quoted in Ladwein (1993), p. 130. On the Raphael room at Sanssouci see R. Bussler, *Der Raffaelsaal* (Berlin, 1861); G. Eckart, *Die Orangerie im Park von Sanssouci* (Berlin, 1988). On the picture gallery at Dresden see H. Magirius and H. Marx, *Gemäldegalerie Dresden* (Leipzig, 1992). On Winckelmann's views see M. Ladwein (1993), pp. 9ff.; on his activities in Dresden see G. Heres, *Winckelmann in Sachsen* (Leipzig, 1991). On the brothers Schlegel and their 'Kunstgespräche' (Conversations about Art) in *Athenäum* see Ladwein (1993), pp. 27ff., 34ff. (Steffens).

On this subject see Kuhlmann-Hodick (1993), pp. 273ff. Wackenroder's *Herzensergiessungen* now in W. H. Wackenroder, *Sämtliche Werke und Briefe*, ed. S. Vietta and R. Littlejohn, i (Heidelberg, 1991), pp. 51ff.; the original edition by L. Tieck appeared in 1797. On J. G. Herder's 'Das Bild der Andacht' see Ladwein (1993), where it is quoted on p. 18f. For the quotation from Herder's essay 'Cäcilia' see J. G. Herder, *Werke*, ed. H. Düntzer, xv (Berlin, n.d.), p. 337. On the Riepenhausen brothers see Ladwein (1993), p. 183. On Freud's patient see 'Fragment of an Analysis of a Case of Hysteria', in *The Standard Edition of the Complete Psychological Works of Sigmund Freud*, ed. J. Strachey, vii (London, 1953), pp. 3–122, esp. pp. 96, 100n., 104n., 119; see also G. Didi-Huberman, 'Une Ravissante Blancheur', in *Un Siècle de recherches Freudiennes en France*, Colloque Centre G. Pompidou (Paris, 1986), pp. 80ff. On the cult of genius see E. Neumann, *Künstlermythen* (Frankfurt am Main, 1986). On Hegel see G. W.F. Hegel, 'Vorlesung über die Ästhetik' in *Werke*, xv (Frankfurt am Main, 1990), pp. 129ff. For J. D. Passavant's description of the *Sistine Madonna* see his monograph, *Raffael von Urbino und sein Vater Giovanni Santi*, 2 vols (Leipzig, 1839), quoted in Ladwein (1993), pp. 72ff.; on the *Sistine Madonna* as a church banner see the reference to Rumohr's theory in Ladwein (1993), pp. 63f. For Nietzsche's comments on the *Sistine Madonna*, see Ladwein (1993), p. 110. On T. Lessing see Ladwein (1993), pp. 127ff. On the 'cult value' of the *Sistine Madonna* see W. Benjamin, *Das Kunstwerk im*

Zeitalter seiner technischen Reproduzierbarkeit (Frankfurt am Main, 1977), section v, pp. 18ff., and footnote 11, p. 19; on the *Sistine Madonna*; on its changed status as a museum work and the consequences of this see the letter written by Heidegger to M. Putscher, quoted by Ladwein (1993), pp. 160f.

ABSOLUTE ART

On absolute music see C. Dahlhaus, *Die Idee der absoluten Musik* (Kassel, 1987), pp. 91ff.; on the concept of the 'religion of art' see F. Schleiermacher, *Reden über die Religion*, ed. H. J. Rothert (Hamburg, 1958), pp. 92ff.; L. Tieck, 'Symphonien', in W. H. Wackenroder, *Sämtliche Werke und Briefe*, ed. S. Vietta and R. Littlejohn, I (Heidelberg, 1991), pp. 240ff.; W. H. Wackenroder, 'Musikalische Aufsätze von Joseph Berglinger', in *Werke und Briefe*, ed. F. von der Leyden, I (Jena, 1910), pp. 155ff. On the symphony as an autonomous art see W. Wackenroder, 'Das eigentümliche innere Wesen der Tonkunst und die Seelenlehre der heutigen Instrumentalmusik', in *Werke und Briefe*, ed. F. von der Leyden, I (Jena, 1910), pp. 182ff.; E. T. A. Hoffmann, *Schriften zur Musik*, ed. F. Schnapp (Darmstadt, 1971), pp. 34ff.; W. Wackenroder, *Phantasien über die Kunst*, ed. L. Tieck: new editions by W. Nehring (Stuttgart, 1994), and S. Vietta and R. Littlejohn (1991, see above), pp. 147ff. On Semper's gallery building see C. G. Carus, *Betrachtungen und Gedanken vor ausgewählten Bildern der Dresdner Galerie* (1857), quoted by Ladwein (1993), pp. 82ff.

THE REDEMPTION OF FAUST

For Wagner's remarks on the *Sistine Madonna* see his text *Religion und Kunst*, quoted in Ladwein (1993), pp. 111f. For Goethe's description of the picture see *Faust II* in A. Schöne, ed., 'Faust. Kommentare' in J. W. Goethe, *Sämtliche Werke*, ed. D. Borchmeyer, VII/2 (Frankfurt am Main, 1994), pp. 456ff. For Carus's quotation of the final chorus see Ladwein (1993), p. 84. For the discarded draft of Gretchen's supplication see *Faust II*, ed. A. Schöne (1994) (see above), pp. 735, 743f. (Goethe's remarks to Eckermann on the 'Christian subject-matter' are given in the commentary.) On the connection made between the *Sistine Madonna* and *Faust II* in France see T. Gautier, *Les Dieux et les Demi-dieux de la peinture* (Paris, 1864), pp. 66ff. For the statement that people were weary of the *Sistine Madonna* see F. Nietzsche, *Der Wanderer und sein Schatten* (1880), quoted in Ladwein (1993), p. 109.

AN ALTARPIECE IN THE SALON

On Raphael's reception in France, see M. Rosenberg, *Raphael and France: The Artist as Paradigm and Symbol* (University Park, PA, 1995). For Ingres' version of the *Sistine Madonna* see Rosenblum (1985), no. 33 (*The Vow of Louis XIII*). For Stendhal's views on contemporary art see Stendhal, 'Salon de 1824', in *Œuvres Complètes*, vol. 'Mélanges III' (Geneva, 1972), pp. 67f.

3 Shipwrecked

VICTORY AND DEFEAT: THE BATTLE PAINTING

On the genre of the history painting see E. Mai and A. Repp-Eckert, eds, *Triumph und Tod des Helden. Europäische Historienmalerei von Rubens bis Manet*, exh. cat. (Cologne, 1988) [with bibliography]; E. Mai, ed., *Historienmalerei in Europa* (Mainz, 1990). For the Prix Décennaux evaluation see Eitner (1972), pp. 16f. On the subjects of the paintings see T. Kirchner, 'Neue Themen – neue Kunst?', in Mai (1990), pp. 107ff (also on the Comte de Caylus). On the *Oath of the Horatii* see *Jacques-Louis David*, exh. cat. (Paris, 1989), no. 67, and no. 116 for the *Death of Marat*; see also J. Traeger, *Der Tod des Marat* (Munich, 1986). On Gros' life see Mai and Repp-Eckert (1988), pp. 226f. For E. Delacroix's obituary for Gros see 'Revue des Mondes' in E. Delacroix, *Literarische Werke*, ed. J. Meyer-Graefe (Leipzig, 1912), pp. 140f, 145f, 161f. On *Napoleon at Eylau* see H. Lemmonier, *Gros. Biographie Critique* (Paris, n.d.), p. 97; M. H. Brunner, *Antoine-Jean Gros. Die napoleonischen Historienbilder* (Bonn, 1979), pp. 233ff. Stendhal, 'Salon de 1824', in *Mélanges d'art* (Paris, 1932), pp. 13, 67f. (Delacroix's *Massacre of Chios*); see also A. Daguerre de Hureaux, *Delacroix. Das Gesamtwerk* (Stuttgart and Zurich, 1994), p. 55.

ANECDOTES OF THE OLD MASTERS

On the Old Masters as a subject see Kuhlmann-Hodick (1993), esp. Part B, chap. 3, and chap. 4, pp. 224ff.; F. Haskell, 'The Old Masters in Nineteenth-century French Painting', *Art Quarterly*, XXXIV (1971), pp. 55ff.; Bätschmann (1997), pp. 78ff. On the new genre of painting see C.-P. Landon, *Annales du Musée et de l'École Moderne des Beaux-Arts*, X (Paris, 1815), p. 102. On the theme of the Death of Leonardo see, for instance, Angelica Kauffmann (at the Royal Academy 1778, now lost) and François Guillaume Ménageot (1781, see Haskell in *Art Quarterly*, XXXIV, 1971, fig. 1 and p. 57). On Raphael as a Roman hero see Stendhal, 'Promenades dans Rome', in *Voyages en Italie* (Paris, 1973), p. 635. On Ingres' Raphael cycle see Rosenblum (1985), pp. 98ff. For the *Betrothal of Raphael* see G. Wildenstein, *Ingres* (London, 1956), illus. 37, cat. no. 85; also several versions of *Raphael and the Fornarina*, figs 46, 47, 48. Stendhal on *La Fornarina* is in 'Promenades dans Rome' in *Voyages* (1973), pp. 638f. On contemporary retellings of Vasari see Q. de Quincy, *Histoire de la vie et des ouvrages de Raphael* (Paris, 1824); C.-P. Landon, *Vies et œuvres des peintres les plus célèbres de toutes écoles*, vol. 'École Romaine' (Paris, 1805); see also E. Müntz, *Les Historiens et les critiques de Raphael, 1483–1883* (Paris, 1883), pp. 60ff. For Vasari see G. Milanesi, ed., *Le Vite*, IV (1906; Florence, 1973), p. 366 (Death of Leonardo). On the profile drawing of Leonardo see A. E. Popham, *The Drawings of Leonardo da Vinci*, a new edition ed. M. Kemp (London, 1994), p. 154. For the Turin 'self-portrait' see frontispiece to the monograph on the *Last Supper* by G. Bossi, *Del Cenacolo di Leonardo da Vinci* (1810). On the 'self-portrait' as a forgery see H. Ost, *Das Leonardo-Porträt in der königlichen Bibliothek Turin und andere Fälschungen des Giuseppe Bossi* (Berlin, 1980). On the artist anecdote in painting see F. Haskell, *Art*

Quarterly, XXXIV (1971), and on J. N. Robert-Fleury see *ibid.*, p. 77. For Baudelaire's comments on Robert-Fleury see C. Baudelaire, 'Salon de 1845', in *Œuvres Complètes*, I (Paris, 1961), p. 825. On Aimée Brune-Pagès see A. Chastel, *L'Illustre incomprise. Mona Lisa* (Paris, 1988), p. 24; for Vasari's account of the painting of the picture, see *Le Vite*, IV (1973), pp. 39f. On Léon Cogniet's *Le Tintoret et sa fille* see Haskell, *Art Quarterly*, XXXIV (1971), fig. 12. On Tintoretto's self-portrait see L. Gowing, *Die Gemäldesammlung des Louvre* (Cologne, 1988), p. 270. On Delacroix's study of the aged Michelangelo in his studio see A. Daguerre de Hureaux, *Delacroix. Das Gesamtwerk* (Stuttgart and Zurich, 1994), p. 16; on the writings see E. Delacroix, *Écrits sur l'Art*, ed. F.-M. Deyrolle and C. Denissel (Paris, 1988), pp. 89ff. (Michelangelo). For Chateaubriand see *Mémoires d'outre-tombe*, II (Paris, 1962), quotations p. 240; on the commission given to Lemoyne see *ibid.*, V, pp. 100, 172 (as reported to Mme Récamier); see also S. Lami, *Dictionnaire des sculpteurs de l'École Française au XIXe siècle*, II (1916), p. 183 and III (1919), p. 311. On Rome and Paris see Stendhal, 'Des Beaux-Arts et du caractère Français', in *Mélanges d'art* (1827; Paris, 1932), pp. 188f.; see also Stendhal, *Histoire de la peinture en Italie*, 2 vols (Geneva, 1969).

THE SALONS

On the Salon of 1817 see M. M.★★★, *Essai sur le Salon de 1817 ou Examen Critique des Principaux Ouvrages* (Paris, 1817) [with frontispiece]. On public subsidy of the arts see Stendhal, *Salon de 1824* (Paris, 1932) (see chap. 3), pp. 21 (conservatism), 23, 162 (lack of feeling), 141 (on the Homeric and the Shakespearian). On art criticism see M. R. Orwicz, ed., *Art Criticism and its Institutions in Nineteenth-century France* (Manchester, 1994). On the painting by Vincent see P. Rosenberg, ed., *Musée du Louvre. Catalogue illustré des peintures. École française XVIIe et XVIIIe siècles*, II (Paris, 1974), illus. 900, p. 159, and on David's *Oath of the Horatii* see chap. 3. On Girodet and the *Scène du Déluge* see G. Bernier, *Anne-Louis Girodet 1767–1824* (Paris, 1975), p. 117; for Stendhal on this picture, 'Promenades dans Rome' (1973) (see preceding section), pp. 649, 770. On the petition by the rejected artists see *Note publiée par l'assemblée des artistes dont les ouvrages n'ont pas été admis à l'exposition de 1840. Pétition aux deux chambres* (Paris, 1840).

THE RAFT OF THE MEDUSA

On Ingres' *Grande Odalisque* see Rosenblum (1985), illus. 24, pp. 104ff. On Géricault's *Raft of the Medusa* see the exh. cat. *Géricault* (Paris, 1991), p. 136, and the monograph by Eitner (1972), pp. 176ff on the hanging in the Salon of 1819; on the event depicted see Corréard and Savigny, *Naufrage de la Frégate la Méduse* (Paris, 1817). On the work process see Eitner (1972), pp. 176ff. On Montfort's eyewitness account see the exh. cat *Géricault* (Paris, 1991), p. 309 (where there is also a reference to C. Clément). For an early description see T. Gautier, 'Études sur les musées. Tableaux à la plume', in *Œuvres complètes*, II (Geneva, 1978), pp. 44ff. On the *Raft of the Medusa* in England see L. Johnson in *The Burlington Magazine*, XCVI (1954), pp. 149ff.

THE 'HISTORY OF THE FASCINATION' EXERTED BY A PAINTED CATASTROPHE

On the picture see K. Heinrich, 'Das Floss der Medusa', in R. Schlesier, ed., *Faszination des Mythos* (Basle and Frankfurt am Main, 1985); G. Planche, *Revue des Deux Mondes* (1851), II, pp. 478ff., esp. p. 500. The quotation from Batissier is in *Géricault*, exh. cat. (Paris, 1991), p. 288 ('La tentation de l'Orient'); for Delacroix's words about Géricault see Delacroix, I (1932; 1960), p. 66. P. Weiss, *Ästhetik des Widerstands* (Frankfurt am Main, 1988), Part 1, pp. 343ff, and Part 2, pp. 21ff.; A. Söllner, *P. Weiss und die Deutschen* (Opladen, 1988), pp. 145ff.; K. R. Scherpe, in G. Palmstierna-Weiss and J. Schutte, *Peter Weiss. Leben und Werk* (Frankfurt am Main, 1991), pp. 242ff. J. Barnes, *A History of the World in 10 ½ Chapters* (London, 1989), pp. 125ff. (also on the exhibition in England and Ireland); see also Bätschmann (1997), pp. 44ff. On the reception of the work see also D. Bachmann, 'Folgen eines Untergangs', in *DU*, II (1994), pp. 11ff. On Kippenberger's cycle see M. Kippenberger, *The Raft of Medusa: 15 Lithographs* (Copenhagen, 1997); *M. Kippenberger, Käthe Kollwitz-Preis 1996* (Berlin, 1997).

4 Paris: A City and a Museum

HOMER THE GOD

On the *Apotheosis of Homer* see P. Rosenblum (1985), illus. 35, pp. 130ff. On the Musée Charles X and the decoration of it by well-known painters see B. Schlenoff, *Ingres. Ses sources littéraires* (Paris, 1956), chap. VI, pp. 148, 173 (Ingres' explanations), p. 153 (letter of 1818).

DREAMS OF THE ORIENT

On the beginnings of Orientalism see V. Hugo, *Les Orientales*, in *Œuvres poétiques*, I, ed. P. Allbouy (Paris, 1964), pp. 577ff., Introduction. For the *Grande Baigneuse* see Rosenblum (1985), illus. 12, pp. 78f. and for the *Vénus Anadyomène* illus. 41, pp. 150f.; see also D. Ternois, *Ingres* (Paris, 1980), p. 38 (*Baigneuse Valpinçon*), p. 163 (*Vénus Anadyomène*). On Canova's *Venus Italica* see *Canova*, exh. cat. (Venice and New York, 1992), no. 132. On Victor Hugo's *Sara la Baigneuse* see Hugo (as above), pp. 638ff. On the *Grande Odalisque* see Rosenblum (1985), illus. 24, pp. 104ff.; Ternois (1980), pp. 50ff; C. Ockman, *Ingres' Eroticized Bodies* (New Haven and London, 1995), pp. 33ff; see also P. Condon, ed., *In Pursuit of Perfection: The Art of J.-A.-D. Ingres*, exh. cat. (Louisville, KY, 1993), pp. 126ff. On the painting's eroticism see C. Ockman (1995), chaps 2 and 4, and D. Ternois, 'L'Éros Ingresque', *Revue de l'Art*, no. 63 (1984), pp. 35ff. On Ingres' *Fornarina* see chap. 3. See also N. Bryson, *Tradition and Desire: From David to Delacroix* (Cambridge, 1984), chap. 5, pp. 124ff. On Balzac's description of the *Grande Odalisque* see the References. for chap. 5, 'Balzac's Impossible Masterpiece'. For the *Odalisque with Slave* see Rosenblum (1985), illus. 38, pp. 142f; D. Ternois (1980), p. 124. On Orientalism see Edward

Said, *Orientalism* (London, 1991); P. Jullian, *Les Orientalistes* (Fribourg, 1977); R. Bezombes, *L'Exotisme dans l'art et la pensée* (Paris, 1953); R. Schwab, *La Renaissance orientale* (Paris, 1950); J. Alazard, *L'Orient et la peinture française au XIXe siècle* (Paris, 1930); see also T. Gautier, 'L'Orient', in *Œuvres complètes*, II (reissued Geneva, 1978). On Delacroix's *Women of Algiers* see Daguerre de Hureaux (1994) (see chap. 3), p. 179; *Eugène Delacroix*, exh. cat. (Zurich, 1987), p. 43. On Delacroix's journey see M. Arama, *Le Maroc de Delacroix* (1987); the essay by G. Metken in *Eugène Delacroix*, exh. cat. (Zurich, 1987), p. 40ff; A. Joubin, ed., *Eugène Delacroix. Voyage au Maroc 1832* (Paris, 1930); R. Escholier, *Delacroix et les femmes* (Paris, 1963), p. 77ff; P. Burty, 'Eugène Delacroix à Alger', *L'Art*, IX/1 (1883), pp. 76ff. On the travel diaries with the sketches see the facsimile edition, M. Arama *et al.*, eds, *Eugène Delacroix, Le Voyage au Maroc* (Paris, 1992). On the visit to the harem, arranged by C. Gournault, see P. Burty, *L'Art*, IX/1 (1883), pp. 94ff.; see also Escholier (1963), pp. 81f. On the motifs used for the *Women of Algiers* see Joubin (1930), pp. 28f.

THE VOYAGE ON *THE BARQUE OF DANTE*

On the *Barque of Dante* see Daguerre de Hureaux (1994) (see chap. 3), pp. 42ff.; on Géricault's *Raft of the Medusa* see chap. 3. On Rubens's so-called Medici cycle see L. Gowing, *Die Gemäldesammlung des Louvre* (Cologne, 1988), pp. 322ff. Baudelaire's comments on the *Barque of Dante* in his essay on the Salon of 1846 are quoted in M. Fried, 'Painting Memories: On the Containment of the Past in Baudelaire and Manet', *Critical Inquiry*, III (1984), pp. 510ff. Stendhal on the *Last Judgment* in *Histoire de la Peinture en Italie*, II (Geneva, 1969), pp. 261ff. On the essay on Michelangelo see Eugène Delacroix, *Literarische Werke*, ed. J. Meyer-Graefe (Leipzig, 1912), pp. 71ff., and works cited in the References for chap. 3, 'Anecdotes …'.

DELACROIX AND *ENNUI*

For the diary entries see Delacroix (1932; 1960), I, p. 43 (4 January 1824), pp. 72ff. (11 April 1824), pp. 85ff. (26 April 1824), p. 104 (24 December 1824), pp. 247ff. (15 December 1847), p. 246 (15 October 1847), p. 288 (14 April 1849, also on *ennui*), pp. 289f. (23 April 1849), pp. 342f. (19 February 1850); II, pp. 12f. (28 March 1853, also on *ennui*), pp. 22f. (20 April 1853), pp. 27ff. (28 April 1853), pp. 43f. (10 May 1853), pp. 57ff (21 May 1853), pp. 84ff. (12 October 1853), pp. 90ff. (17 October 1853), pp. 116ff. (20 November 1853), pp. 134ff. (24 December 1853), pp. 145ff. (26 March 1854), pp. 154ff. (26 March 1854), p. 167 (20 April 1854), pp. 173ff. (28 April 1854), pp. 218f. (28 July 1854), pp. 430f. (21 February 1856), and III, pp. 263f. (8 February 1860); see also M Hannoosh (1995). For Baudelaire on art and memory see Baudelaire, 'L'Art Mnémonique' in *Œuvres complètes*, X (Paris, 1976), pp. 697ff. On *Liberty Leading the People* see Daguerre de Hureaux (1994) (see chap. 3), pp. 87ff. (ill. p. 93); on the contemporary reception of the painting see N. Hadjinicolaou, 'La "Liberté guidant le peuple" devant son premier public', *Actes de la recherche en sciences sociales*, no. 28/6 (1979), pp. 3f. For Heine's commentary, see his series of articles, 'Gemäldeausstellung in Paris', in *Morgenblatt für gebildete Stände*, 27 October to 16 November 1831.

THE SALON AS A MUSEUM

On the Louvre at the time of the Revolution see Bayle St John, *The Louvre or a Biography of a Museum* (London, 1856), pp. 86f., 97f. (the events of February 1848), pp. 109ff. (reform of the Louvre); also Aulanier, II: 'Le Salon Carré' (1950), pp. 65ff. On the alternation between Salon and museum see Heine, 'Nachtrag' (1833) in M. Windfuhr, ed., *Heinrich Heine. Historisch-kritische Gesamtausgabe der Werke*, XII/1 (Hamburg, 1980), pp. 51ff (quotation from p. 53); for contemporary commentaries see T. Gautier, 'Le Musée Ancien' in *Œuvres complètes*, II (Geneva, 1978), pp. 3ff; Prosper Mérimée, *Revue des Deux Mondes*, I (1849), pp. 813ff. (also on the new décor); G. Planche, 'Le Musée du Louvre', *Revue des Deux Mondes*, III (1851), pp. 526ff. On the new catalogue see F. Villot, *Notices des tableaux exposés dans la Galerie du Musée National du Louvre* (1949; Paris, 1953). The ladies' guide to the Louvre: *Guide des dames au Musée Royal de Peinture* (Paris, 1830). On the division into the old and the French schools and the new ceiling programme see Aulanier, II: 'Le Salon Carré' (1950), pp. 65ff. On criticism of the picture restorations see Delacroix, II (1932; 1960), p. 84 (12 October 1853). On the Salon Carré see T. Gautier, 'Guide de l'Amateur au Musée du Louvre', in *Œuvres complètes*, VIII (Geneva, 1978), pp. 25ff.

5 The Artists' Curse

THE 'UNTRACEABLE VENUS OF THE ANCIENTS'

On Balzac's short story see Balzac (1981), with commentary; for details of the German edition (1987) with Picasso's illustrations see the References for chap. 11, 'Picasso's Monument …'); see also G. Didi-Huberman, *La Peinture incarnée* (Paris, 1985); V. I. Stroichita, '*Le Chef-d'œuvre inconnu* et La Présentation du Pictorial', in R. Passeron, *La Présentation* (Paris, 1985), pp. 77ff.; Cahn (1979), pp. 131ff; A. Timar, 'Le Chef-d'œuvre inconnu', *Acta Historiae Artium*, 17 (1971), pp. 91ff.; P. Laubriet, *Un Catéchisme esthétique* (Paris, 1961). On the impossible ideal of art see T. Gautier *et al.*, *Les Dieux et les demi-dieux de la peinture* (Paris, 1864), p. 1; on the art of antiquity see chap. 1 and especially D.V. Denon, 'Discours sur les Monuments d'Antiquité arrivés d'Italie' (1803), in J. Chatelain, *D. V. Denon et le Louvre de Napoléon* (Paris, 1973), pp. 317ff. (p. 325 for the foot of the *Venus de' Medici*); on the *Venus de Milo* see chap. 1 and especially Comte de Clarac, *Sur la Statue antique de Vénus Victrix découverte dans l'île de Milo* (Paris, 1821); the catalogue *Le Musée français*, VI (Paris, 1818), no. 63; on the report on the *Venus de Milo* see T. Gautier, 'Tableaux de siège, Paris (1870–1871)', in *Œuvres complètes*, III (Geneva, 1978), pp. 348ff.; Delacroix on the *Venus de Milo*, see E. Delacroix, III (1932; 1960), diary entry of 3 February 1860, pp. 259ff.

BALZAC'S IMPOSSIBLE MASTERPIECE

On Picasso see the edition by A. Besnard (Paris, 1931); Goeppert and Goeppert-Frank (1987). On the history of the influence of Balzac's story see Ashton (1987),

pp. 9ff. On T. Sainte-Hyacinthe see C. Matanasius, *Le Chef-d'œuvre d'un inconnu. Poëme heureusement découvert & mis au jour, avec des Remarques savantes* (Lausanne, 1754). T. Gautier, 'Du Beau dans l'Art', in *L'Art moderne* (Paris, 1856), pp. 129ff. On Gautier himself see R. Snell, *Théophile Gautier: A Romantic Critic of the Visual Arts* (Oxford, 1982); M. C. Spencer, *The Art Criticism of Théophile Gautier* (Geneva, 1969). For *Les Fleurs du mal* see C. Baudelaire, *Œuvres complètes*, I (Paris, 1961), pp. 2ff.

THE FAILED ARTIST

For artist novels after Balzac see E. and J. Goncourt, *Manette Salomon* (1866; Paris 1876); E. Zola, *L'Œuvre*, ed. H. Mitterand (Paris, 1966); on this subject see T. R. Bowie, *The Painter in French Fiction*, Studies in the Romance Languages and Literatures, vol. XV (1950); W. Hofmann, *Anhaltspunkte* (Frankfurt am Main, 1989), pp. 91ff. On Zola's *L'Œuvre* see Champa (Chapel Hill, NC, 1994), pp. 51ff.; J.-M. Guieu and A. Hilton, eds, *Émile Zola and the Arts* (Washington, DC, 1988); R. J. Niess, *Zola, Cézanne, and Manet: A Study of L'Œuvre* (Ann Arbor, MI, 1968); P. Brady, *'L'Œuvre' de Émile Zola. Roman sur les Arts* (Geneva, 1967); V. I. Stoichita, 'L'Œuvre, La Tête, Le Ventre', *Recherches Poétiques*, no. 1 (Spring / Winter 1994), pp. 39ff.; see also Bätschmann (1997), pp. 94ff.

SUICIDE IN THE PRESENCE OF THE WORK

On Zola's novel see Brady (1967) (listed in section above, 'The Failed Artist'), chap. VI: 'Préparation Directe…', pp. 151ff., 155 (Zola's first draft). For Zola's letter of 1885 see B. H. Bakker *et al*, eds, *Émile Zola. Correspondance*, V: *1884–86* (Montreal and Paris, 1985), pp. 288f., 'À Jacques van Santen Kolft', dated 26 July 1885. On Manet's *Bar at the Folies-Bergère* and the *Déjeuner sur l'herbe* see chap. 7. On Zola's relationship with Manet and his rôle in *L'Œuvre* see Niess (1968) (listed in section above), esp. chap. VI: Lantier – Manet; Brady (1967), pp. 30ff. On the early life of the protagonist of 'L'Œuvre' see Émile Zola, *Le Ventre de Paris*, in *Œuvres complètes*, ed. H. Mitterand, 'Les Rougon-Macquart I' (Paris, 1967), pp. 566ff. In connection with L. Cogniet's painting see A. Cogniet's painting *The Studio of L. Cogniet* (1831) in Orléans; W. S. Talbot, 'Cogniet and Vernet at the Villa Medici', *Bulletin of the Cleveland Museum*, LXVII (1980), pp. 135ff.

A 'RAPHAEL WITHOUT HANDS'

For James's *The Madonna of the Future* see M. Aziz, ed., *The Tales of Henry James*, II: *1870–1874* (Oxford, 1978), pp. 202ff. On James's writings on aesthetics see chap. 8. For Raphael's *Madonna della sedia* see W. Kelber, *Raphael von Urbino* (Stuttgart, 1993), no. 83. On Leonardo's *Mona Lisa* see chap. 6.

6 A Hieroglyph of Art

AESTHETIC MODERNISM

On the *Mona Lisa* see R. Huyghe, *Leonardo da Vinci. La Joconde* (Fribourg, 1974); K. Clark, 'Mona Lisa', *Burlington Magazine* (1973), p. 114; C. de Tolnay, 'Remarques sur la Joconde', *Revue l'Art* (1952), pp. 18ff. On poetry after the Revolution see H. R. Jauss, *Studien zum Epochenwandel der ästhetischen Moderne* (Frankfurt am Main, 1989), pp. 89ff. For *Les Fleurs du Mal* see C. Baudelaire, *Œuvres complètes*, I (Paris, 1961), pp. 2ff. On the history of the reception of the *Mona Lisa* see H. Focillon, 'La Joconde et ses interprètes', in Focillon, *Techniques et Sentiments* (Paris, 1932), pp. 78ff.; G. Boas, 'The Mona Lisa in the History of Taste', *Journal of the History of Ideas*, I (1940), pp. 207ff.; on Boas's sources see M. Praz, *The Romantic Agony* (1933; London, 1977). On the myth see McMullen (1975); J. Suyeux, *Jeux Joconde* (Paris, 1969). On aesthetic modernism see C. Baudelaire, *Le Spleen de Paris*, in *Œuvres complètes*, I (Paris, 1961), pp. 228ff. On the study of hysteria see J. M. Charcot, *Les Démoniaques dans l'art*, ed. G. Didi-Huberman (Paris, 1984). On Duchenne's photographs see F. Duchenne, *Méchanisme de la physiognomie humaine ou analyse électrophysiologique de l'expression des passions* (Paris, 1876). On Le Gray see L. Posselle (1993), p. 416.

THE HISTORICAL GIOCONDA

See Vasari, *Le Vite*, ed. G. Milanesi, IV (1906; Florence, 1973), pp. 39f. On the history of the *Mona Lisa* see A. Chastel, *L'Illustre incomprise* (Paris, 1988); E. Müntz, *Léonard de Vinci* (Paris, 1899), pp. 415ff.; J. Shell and G. Sironi, 'Salai and Leonardo's Legacy', *Burlington Magazine* (1991), pp. 95ff. On Vasari's description see Barolsky (1991). For Leonardo's writings see Chastel (1990). On the defence of the *Mona Lisa* by Père Dan see McMullen (1977), p. 156. For the anecdote told by Cassiano del Pozzo see Müntz (1899), p. 421. On Brune-Pagès see chap. 3. On the *Mona Lisa* in the Louvre see Bayle St John, *The Louvre, or Biography of a Museum* (London, 1855), p. 535; on the reception of the picture in the nineteenth century see A. R. Turner, *Inventing Leonardo* (Berkeley and Los Angeles, 1994), chap. 7 ('Leonardo the Harbinger of Modernity'); J.- P. Cuzin, 'Autour de la Joconde', in L. Posselle (1993), pp. 412ff.; E. Hüttinger, 'Leonardo- und Giorgione-Kult. Materialien zu einem Thema des Fin de siècle', in *Fin de siècle* (Frankfurt am Main, 1977), pp. 143ff. On the reception of the *Mona Lisa* by George Sand, Clément and others see McMullen (1977), chap. 12, esp. pp. 168f.

BEAUTY AS AN ENIGMA

On the danger of beauty see C. Baudelaire, 'Les Fleurs du mal', in *Œuvres complètes*, I (Paris, 1961), pp. 23f.; T. Gautier, 'La Morte Amoureuse', in *Œuvres complètes*, IV (Geneva, 1978), pp. 265ff. On the smile of the *Venus de Milo* see T. Gautier, 'Le Musée des Antiques', in *Œuvres complètes*, II (Geneva, 1978), pp. 72ff. On the measures taken to protect the statue in 1871 see T. Gautier in the

References for chap. 5; on the biography of Leonardo by Gautier's co-author see A. Houssaye, *Histoire de Léonard de Vinci* (Paris, 1869). For the first description of paintings by Leonardo see T. Gautier, 'Le Musée Ancien', in *Œuvres complètes*, II (Geneva, 1978), p. 26; T. Gautier's Leonardo essay of 1858, 'La Vie et les Œuvres de Quelques Peintres', chap. I, in *Œuvres complètes*, VIII (Geneva, 1978), pp. 197ff., 218 (*Mona Lisa*). On the type of the demonic woman see M. Praz, *Liebe, Tod und Teufel. Die schwarze Romantik* (Munich, 1963) (1st edn Florence, 1930), esp. chap. IV, 'La belle dame sans merci', pp. 132ff. Gautier republished his Leonardo essay in T. Gautier *et al.*, *Les Dieux et les demi-dieux de la peinture* (Paris, 1864), pp. 1ff. On Paul Baudry's *Leda* and the Salon of 1857 see E. About, *Nous Artistes au Salon de 1857* (Paris, 1875), pp. 78ff. (*Leda*); see also C. Ephrussi, *Paul Baudry. Sa vie et son œuvre* (Paris, 1887), p. 175 and plate facing p. 20. Gautier's 1867 guide to the Louvre: see T. Gautier, 'Guide de l'Amateur au Musée du Louvre', in *Œuvres complètes*, VIII (Geneva, 1978), pp. 3ff. For *Les Phares* see C. Baudelaire, 'Les Fleurs du mal', in *Œuvres complètes*, I (Paris, 1961), pp. 12f. The stanza quoted in English is taken from C. Baudelaire, *The Flowers of Evil,* trans. James McGowan (Oxford, 1993), p. 23. On *l'art pour l'art* see T. Gautier, 'Du Beau dans l'art', in *L'Art moderne* (Paris, 1856), pp. 129ff. For the preface by Victor Hugo to Baudelaire's essay on Gautier see Baudelaire, *Œuvres complètes* (Paris, 1954), p. 1487 (in the 1976 edn vol. I, pp. 1128f.). Criticism of the Romantic ideal of womanhood already appears in Guy de Maupassant's description of the 'Venus of Syracuse', which he published in 1890 in his travel journal, *Vie Errante*.

CULTURE AS A DREAM

On the myth of the *Mona Lisa* in England see W. Pater, *The Renaissance: Studies in Art and Poetry*, ed. A. Phillips (New York, 1986). On the reception of Leonardo see Turner (1994) (listed in References to chap. 6), pp. 117ff. On Rossetti's pictures of women see C. Wood, *The Pre-Raphaelites* (1981; London, 1994), pp. 16, 96f., 102; for his sonnets based on pictures see G. Hönighausen, ed., *Die Präraffaeliten. Dichtung, Malerei, Ästhetik, Rezeption* (Stuttgart, 1992), pp. 165ff. For the poem 'Our Lady of the Rocks by Leonardo da Vinci', see *The Collected Works of Dante Gabriel Rossetti*, ed. William M. Rossetti, I (London, 1897), p. 344. For contemporary commentaries on Pater see H. von Hofmannsthal, 'Walter Pater', in *Gesammelte Werke: Reden und Aufsätze I*, ed. B. Scholler (Frankfurt am Main, 1979), pp. 194ff.; Oscar Wilde, 'Mr Pater's Imaginary Portraits', in *The First Collected Edition of the Works of Oscar Wilde: Reviews 1908–1922*, ed. R. Ross (London, 1969), pp. 172ff. On Walter Pater see P. Barolsky, *Walter Pater's Renaissance* (University Park, PA, 1987); B. Bullen, 'Walter Pater's "Renaissance"', *The Modern Language Review*, XXIV (1979), pp. 258ff.; W. Iser, *Walter Pater* (Tübingen, 1960); B. Fehr, 'Walter Paters Beschreibung der Mona Lisa und Théophile Gautiers romantischer Orientalismus', *Archiv für das Studium der neueren Sprachen und Literaturen* 70/135 (1916), pp. 80ff. For Nietzsche's *Geburt der Tragödie aus dem Geist der Musik* see G. Colli and M. Montarini, eds, *Kritische Studienausgabe*, I (Munich, Berlin and New York, 1988), pp. 9ff.

FREUD'S LEONARDO

For the English translation of Freud's *Eine Kindheitserinnerung des Leonardo da Vinci* (Vienna, 1910) see 'Leonardo da Vinci and a Memory of his Childhood', in *The Standard Edition of the Complete Psychological Works of Sigmund Freud*, ed. J. Strachey, XI (London, 1957), pp. 111, 117, 107, 110. On Freud's source see D. Mereschkowski, *Leonardo da Vinci. Ein biographischer Roman aus der Wende des 15. Jahrhunderts* (Leipzig, 1903). On the *Mona Lisa*'s smile see P. Valéry, *Introduction à la méthode de Léonard da Vinci*. On Freud's analysis see G. Didi-Huberman, 'Une Ravissante Blancheur', in *Un Siècle de recherches Freudiennes en France. Colloque Centre G. Pompidou* (Paris, 1986); see also the essays by B. Farrell and R. Shattuck in M. Philipson, ed., *Leonardo da Vinci: Aspects of the Renaissance Genius* (New York, 1966), and the response from an art-historical perspective by M. Schapiro, 'Leonardo and Freud: An Art Historical Study', *Journal of the History of Ideas*, XVII (1956).

7 In the Labyrinth of Modernity

BAUDELAIRE'S IDEAL – THE HERE AND NOW

On the masterpieces in the Louvre see C. Baudelaire, 'Le Peintre de la vie moderne', in *Œuvres complètes*, X (Paris, 1976), pp. 683ff., 714 (the woman in art), 714ff. (cosmetics). On the original of M. G. see P. Duflo, *Constantin Guys. Fou de dessin, grand reporter, 1802–1892* (Paris, 1988). On the timeless ideal of beauty see the illustrations in T. Gautier *et al.*, *Les Dieux et les demi-dieux de la peinture* (Paris, 1864) and *ibid.*, pp. 241ff. on Rembrandt. On the reaction against the ideal of absolute beauty see Baudelaire, 'Salon de 1846', in *Œuvres complètes*, II (Paris, 1976), pp. 415ff., and also the edition with commentary by D. Kelly, *Baudelaire. Salon de 1846* (Oxford, 1975). On Monsieur G.'s search for modernity in 'Le Peintre de la vie moderne' see Baudelaire, *Œuvres complètes*, X (Paris, 1976), p. 718. For Baudelaire on progress, see his 'Exposition Universelle de 1855', in *Œuvres complètes*, II (Paris, 1976), pp. 575ff.

COURBET AND PAINTING AS 'REAL ALLEGORY'

On Courbet's *The Painter's Studio* see S. Faunce, *Gustave Courbet* (New York, 1993), pp. 78f.; M. Fried, *Courbet's Realism* (Chicago, 1992), pp. 155ff.; Hofmann (1989), pp. 212ff.; G. Winter, 'Peinture Parlante. Gustave Courbets "Atelier des Malers"', *Pantheon*, XLVIII (1990), pp. 135ff.; K. Herding, *Realismus als Widerspruch* (Frankfurt am Main, 1978), pp. 223ff.; W. Hofmann, *Das irdische Paradies* (Frankfurt am Main, 1961); full documentation in H. Toussaint, 'Le dossier de "L'Atelier" de Courbet', in *Gustave Courbet (1819–1877)*, exh. cat. (Paris, 1978), pp. 147ff. (see pp. 246f. for the letter to Champfleury: the 'Manifesto of Realism', p. 77 of the catalogue). For Delacroix's diary entry on Courbet's rival exhibition, see E. Delacroix, II (1932; 1960), pp. 363f. On the tradition of painting a studio see H. U. Asemissen and G. Schweikhart, *Malerei als Thema der Malerei* (Berlin, 1994), pp. 146ff.; P. Georgel and

A. M. Lecoq (1983), pp. 109ff. On the figures in the painting see the letter to Champfleury (see above); on Champfleury's letter to George Sand containing the explanation of the term 'real allegory' see Herding (1978), pp. 53ff.

MANET'S ARCADIA BY THE SEINE

For the *Déjeuner sur l'herbe* see O'Neill (1983), no. 62 (also on the Salon des Refusés); W. Hofmann, *Édouard Manet. Das Frühstück im Atelier* (Frankfurt am Main, 1985); W. Hofmann, *Nana. Mythos und Wirklichkeit* (Cologne, 1974), pp. 38f.; H. Körner, 'Der moderne Akt. Zur Form–Inhalt-Beziehung in Édouard Manets "Frühstück im Freien" und in der "Olympia"', in *Sechs Beiträge zur kunsthistorischen Forschung*, published by the Fachschaft der Universität des Saarlandes (Saarbrücken, 1991), pp. 15ff.; Fried (1996), pp. 305ff. On the copy of the *Concert champêtre* in Manet's studio see the reference in O'Neill (1983), pp. 168; for Degas' sketch of the painting see Posselle (1993), p. 202, fig. h (some of the copies of the painting *ibid.*, pp. 200ff.). For A. Proust's life of Manet see A. Barthélemy, ed., *Édouard Manet. Erinnerungen von A. Proust* (Berlin, 1929), esp. p. 43 (an account of the excursion to Argenteuil). For Degas' reaction see D. Halévy, *Degas parle* (Paris, 1960), pp. 110f. For Monet's rival version see *Claude Monet*, exh. cat. (Paris, 1980), nos. 5–7 (and, *ibid.*, the letter expressing his doubts about the undertaking); see also M. Alphant, *Claude Monet. Une Vie dans le paysage* (Paris, 1993), pp. 117ff. For Manet's sketch see O'Neill (1983), no. 63. On the Goncourts' *Manette Salomon* see chap. 5 (quotation, pp. 266ff.). On Manet's model see Körner (1991) (see above), p. 15. On the reaction to Manet's picture in the Salon des Refusés see O'Neill (1983), pp. 165f. and 168, fig. c (Raimondi's engraving after Raphael). For Delacroix's diary entry see E. Delacroix, II (1932; 1960), pp. 57ff. (21 May 1853). On Manet as a copyist of Delacroix see Posselle (1993), p. 258. For Manet's *Spanish Guitar Player* see O'Neill (1983), no. 10, and no. 19 (*The Discovery of Moses* and the *Nymph taken by Surprise*).

THE CONTROVERSY OVER *OLYMPIA*

On *Olympia* see O'Neill (1983), no. 64 (also for reactions to the painting); Fried (1996), p. 281 and *passim*; see also T. J. Clark, *The Painting of Modern Life* (Princeton, NJ, 1984), pp. 79ff.; Körner (1991) (see References to chap. 7, 'Manet's Arcadia …'). For Zola's response to the criticism see T. Neu, ed., *Émile Zola. Schriften zur Kunst* (Frankfurt am Main, 1988), pp. 47ff. For the portrait of Zola see O'Neill (1983), no. 106. For Manet's letter about the indignant reactions at the Salon of 1865 see C. Pichois, ed., *Lettres à Charles Baudelaire* (Neuchâtel, 1973), pp. 233f. For Cézanne's *Modern Olympia* see Krumrine (1989), illus. 50, p. 86. On the history of the picture see O'Neill (1983), p. 183. For Gauguin's copy of the *Olympia* see *The Art of Paul Gauguin*, exh. cat. (Washington, DC, 1988), no. 117. On Ingres' *Grande Odalisque* see chap. 4. On the name 'Olympia' see Clark (1984), pp. 86ff. For Baudelaire's views on the nature of *modernité* see C. Baudelaire, 'Le Peintre de la vie moderne', in *Œuvres complètes*, X (Paris, 1976), chap. IV, pp. 694ff. Proust's remark in the translation by C. K. Scott Moncrieff and T. Kilmartin, revd D. J.

Enright, *In Search of Lost Time* (London, 1992), III ('The Guermantes Way'), p. 485; M. Leiris, *Le Ruban au cou d'Olympia* (Paris, 1981), pp. 193, 285.

THE MIRROR IN THE BAR

For Manet's *Bar at the Folies-Bergère* see O'Neill (1983), no. 211; see also B. R. Collins (1996). On Zola's novel see chap. 5. On the relationship between the novel and the picture see Champa (1994), pp. 38ff. For Manet's *Nana* see O'Neill (1983), no. 157; 156 (*The Mirror*). For the contemporary description of the Folies-Bergère by Maupassant, see his novella *Bel Ami* (1885; Paris, 1973), p. 43. On the reaction of those who viewed the painting see J.-K. Huysmans, *L'Art moderne* (Paris, 1883), pp. 277f.

8 Escape Routes to Freedom

THE ARTISTIC IDEAL BORROWED FROM JAPAN

For a bibliography on Van Gogh see the catalogue by E. van Uitert (1990); Champa (1994). On Van Gogh generally see K. Tsukassa, ed., *The Mythology of Vincent van Gogh* (Tokyo and Philadelphia, 1993). Quotations from Van Gogh's letters are taken from *The Complete Letters of Van Gogh*, vols 1–3 (Greenwich, CT, 1958); J. Le Marie, ed., *Letters of Vincent van Gogh 1886–1890* [a facsimile edn] (Amsterdam, 1977). Pierre Loti published *Madame Chrysanthème* in Paris in 1887 (republished 1948). For the portrait of Père Tanguy see van Uitert (1990), no. 33 (no. 32 is the picture of the courtesan); catalogue by F. Cachin, *Van Gogh à Paris* (Paris, 1988), no. 64 (no. 62 is the *Bridge in the Rain*). On Van Gogh and Millet see van Tilborgh (1988), pp. 174ff. (*The Sower*), pp. 186ff. (copies after Millet), pp. 122ff. (*Work in the Fields*). On Japonisme see L. Gonse, *L'Art Japonais* (Paris, 1886); T. Duret, *Critique d'avant-garde* (Paris, 1885), pp. 131ff. (L'art japonais); *Le Japon Artistique* (1888), parts 1 and 2; T. Duret, *Voyage au Japon* (Paris, 1974). For a survey of research see Hanson (1977), pp. 185ff. ('Japanese Art'); D. Croissant *et al.*, eds, *Japan und Europa*, exh. cat. (Berlin, 1993), with 27 pages of bibliography. On the Japanese influence on Van Gogh see Arnold (1997), pp. 155ff. For the portrait of Dr Gachet see E. van Uitert (1990), no. 123. For the quotations from P. Loti (see above) see pp. 4ff., 140ff. On the concept of 'decoration' see F. Bracquemond, *Du dessin et de la couleur* (Paris, 1885); interpretation by Dorn (1990), pp. 45ff., 159ff. For the correspondence with Gauguin see V. Merlhès, ed., *Correspondance de Paul Gauguin* (Paris, 1984), pp. 235ff.

AN AMERICAN IN PARIS

On Whistler see James Laver, *Whistler* (New York, 1930), esp. pp. 78f., 112ff.; D. Sutton, *James McNeill Whistler* (London, 1966), esp. pp. 26ff.; the new biography by R. Anderson and A. Koval, *James McNeill Whistler: Beyond the Myth* (London, 1994). For the *Portrait of Christina Spartali* and *Symphony in White* see, most recently, R. Dorment and M. F. Macdonald, eds, *James McNeill Whistler*, exh. cat. (London,

1995), no. 14, fig. 7 on p. 16; D. P. Curry, *James McNeill Whistler at the Freer Gallery of Art,* exh. cat. (Washington, 1984), no. 5, p. 105 (*Portrait of Christina Spartali*), no. 6, p. 106 (*Variations in Flesh Colour and Green: The Balcony*). On the photographic studio in Japan at that time see P. Loti (see chap. 8a), pp. 161ff. For Henry James's critique see H. James, *The Painter's Eye*, ed. J. L. Sweeney (London, 1989), pp. 161ff., 258ff.

SUNFLOWERS IN THE 'YELLOW HOUSE'

On the sunflowers in the 'Yellow House' see R. Dorn (1990), with extensive documentation [pp. 45ff. on *Série d'études: Décoration*, pp. 58ff. (sunflowers), pp. 73ff (four sunflower series), pp. 159ff. (the idea of decoration), pp. 166f. on the Japanese woodcut and the Western easel painting]. For Gauguin's account of the quarrel between him and Van Gogh see Paul Gauguin, *Avant et Après* (Tahiti and Paris, 1989), pp. 26f.; H. Graber, *Paul Gauguin. Nach eigenen und fremden Zeugnissen* (Basle, 1964), pp. 118ff. On the copies of Delacroix and Millet see van Tilborgh (1988), pp. 88ff.; M. Arnold (1997), pp. 77ff., 94ff. For Gauguin's self-portrait in Arles see Pickvance (1984), no. 142. *La Berceuse* is discussed in detail by Champa (1994), pp. 91ff.; see also Pickvance (1984), no. 146 (and nos. 136 and 137, the portraits of Mme Roulin); R. Dorn (1990), pp. 103ff. (the sketch from the letter, now in the Rijksmuseum Vincent van Gogh in Amsterdam).

EXILE IN THE SOUTH SEAS

On the reception of Oceania see P. Peltier in W. Rubin, ed., *'Primitivism' in 20th-century Art*, 1 (New York, 1984), pp. 99ff., with further bibliography (also, on pp. 179ff., K. Varnedoe on Van Gogh's encounter with 'primitive' cultures). On the work produced by Gauguin in Tahiti see Schneeberger (1991); the early book on Tahiti from which Gauguin took material about the ancient Polynesian religion was J. A. Moerenhout, *Voyage aux îles du grand océan* (Paris, 1837). Gauguin's writings: see *Ancien culte mahorie* (Paris, 1951), *Cahier pour Aline* (Paris, 1897) and *Noa Noa* (1894–5); the rediscovered original text in P. Petit, ed., *Noa Noa* (French/German bilingual edn, Stuttgart, 1992); for his articles about Tahiti see B. Danielsson and P. O'Reilly, *Gauguin, Journaliste à Tahiti & ses articles des 'Guêpes'*, published by the Société des Océanistes, Musée de l'homme (Paris, 1966). On Gauguin's *œuvre* see, most recently, M. Hoog (1987); *The Art of Paul Gauguin*, exh. cat. (Washington, DC, and Chicago, 1988). For *Terre Délicieuse (Te nave nave fenna)* see Schneeberger (1991), no. 18. On the art reproductions that Gauguin took with him see R. S. Field, *Paul Gauguin: The Paintings of the First Voyage to Tahiti* (New York and London, 1977). For the *Woman with a Flower (Vahine no te tiare)* see Schneeberger (1991), no. 3. The quotations from *Noa Noa* (Stuttgart, 1992) (see above), pp. 31ff., *The Spirit of the Dead Keeps Watch (Manao tupapau)*, see Schneeberger (1991), no. 13, pp. 30f. (the letter to D. Monfreid is also reprinted here); for the letters to his wife about the picture see B. Denvir, ed., *Gauguin: Letters from Brittany and the South Seas* (New York, 1992), pp. 68f.; the woodcut with the same title is in Hoog (1987), no. 152. P. Petit's edn (1992) of Gauguin's text *Noa Noa* (see above) has a detailed commentary and describes the planned

cycle of woodcuts, pp. 92ff. On Strindberg's 'preface' see P. Gauguin, *Avant et Après* (Tahiti and Paris, 1989), pp. 30ff. For the letters to Monfreid see V. Segalen, ed., *Paul Gauguin. Briefe an Georges Daniel de Monfreid* (Potsdam, 1920), pp. 102ff. (May 1899), pp. 81ff. (March 1898). For *Jours Délicieux (Nave Nave Mahana)* see Schneeberger (1991), no. 28; For Focillon's comments on this work see *Chefs-d'œuvre de l'art français* (Paris, 1937), p. XXI.

AN ANTIPODEAN MASTERPIECE FROM TAHITI

On *Where do we come from? What are we? Where are we going?* see Hoog (1987), pp. 235ff. (reproduction, no. 182 on pp. 258–9; sketch, no. 178, p. 255). The letter to Fontainas in Schneeberger (1991), p. 68; the letters to Monfreid in A. Joly-Segalen, *Lettres de Gauguin à Daniel de Monfreid* (Paris, 1950), pp. 118f. (February). Some statements by Gauguin in this chapter section, translated by John Rewald and by Robert J. Goldwater, are quoted from Herschel B. Chipp, *Theories of Modern Art* (Berkeley, Los Angeles and London, 1968), pp. 69–72.

9 The Inferno of Perfection

ABSOLUTE ART AND THE *NON-FINITO*

On the torso in Rodin's work see J. A. Schmoll (Eisenwerth), *Rodin-Studien* (Munich, 1983), pp. 99ff., 143ff. For the Proust quotation see the translation by C. K. Scott Moncrieff and T. Kilmartin, revd D. J. Enright, *In Search of Lost Time* (London, 1992), V ('The Captive'), p. 176. On Rodin's life see F. V. Grunfeld, *Rodin. Eine Bibliographie* (Berlin, 1993); R. Butler, *Rodin: The Shape of Genius* (New Haven and London, 1993). For Cézanne's remark about Rodin see M. Doran, *Gespräche mit Cézanne* (Zurich, 1982), p. 159. For the conversations with Gasquet see J. Rewald and R. Shiff, *Joachim Gasquet's Cézanne* (London, 1991). On the *Gate of Hell* see J. A. Schmoll (Eisenwerth) and M. Fath, *Auguste Rodin. Das Höllentor. Zeichnungen und Plastik* (Munich, 1991); A. E. Elsen, *The Gates of Hell by Auguste Rodin* (Stanford, CA, 1985). On Cézanne's works see G. Adriani, *Paul Cézanne. Gemälde*, exh. cat. (Cologne, 1993); *idem, Paul Cézanne. Aquarelle* (Cologne, 1990); R. Kendall, ed., *Cézanne par lui-même* (Paris, 1989); L. Gowing, *The Basel Sketchbooks of Paul Cézanne*, exh. cat. (New York, 1988); S. Geist, *Interpreting Cézanne* (Harvard, 1988). On *The Bathers* see Krumrine (1989) [with documentation]. For Cézanne's letter to R. Marx see J. Rewald, *Cézanne. Sa vie, son œuvre, son amitié pour Zola* (Paris, 1939), pp. 381f., 400 (letter to E. Bernard). On Cézanne's studies in the Louvre see Posselle (1993), pp. 107ff. On Vollard see A. Michel, ed., *Ambroise Vollard. Souvenirs d'un marchand de tableaux* (Paris, 1989), p. 297. For Cézanne's remark to Gasquet see Doran (1982), p. 159. For Cézanne's letter to Bernard about the Louvre see W. Hess, ed., *Paul Cézanne* (Mittenwald, 1980), p. 83. For the letter to his son Paul, see P. Cézanne, *Briefe*, ed. J. Rewald (Zurich, 1979), p. 309. On Rodin's visits to the Louvre see P. Gsell, ed., *Auguste*

Rodin. Die Kunst (Leipzig, 1918), pp. 145ff. (Michelangelo), p. 138. On his studies there see Posselle (1993), pp. 182, 440. On Rodin's visit to Italy see Grunfeld (1993), pp. 113f. On Cézanne's watercolour of the *Concert champêtre* see Posselle (1993), p. 208; for his statement about the original see Hess (1980), p. 47; J. Gasquet, *Cézanne* (Munich, 1930), p. 133. On the copies of Poussin see Posselle (1993), pp. 148ff. For Rodin's pair of figures *Je suis belle* see R. Crone and S. Salzmann, eds, *Genius Rodin. Eros und Kreativität* (Munich, 1991), no. 3. For the poem 'La Beauté' see C. Baudelaire, *Œuvres complètes*, II (Paris, 1975), p. 21. On Rodin's illustrations for *Les Fleurs du mal* see A. E. Elsen (1985) (see above), pp. 112ff.; C. Judrin, *Inventaire des Dessins* (Musée Rodin), V (Paris, 1992), pp. 311ff.

NATURE OR ART?

On Paul Richer's analysis of mental illnesses see *Identity and Alterity*, exh. cat. (Biennale, Venice, 1995) with articles by P. Colmar, pp. 45ff., 165 (on the drawings); see also F. Cagnetta and J. Sonolet, eds, *Nascita della Fotografia psichiatrica*, exh. cat. (Venice, 1981), pp. 39f.; P. Richer's own publications: *Les Démoniaques dans l'art* (Paris, 1866); *Les Malades et les difformes dans l'art* (Paris, 1889); *Introduction à l'étude de la figure humaine* (Paris, 1902); on this subject see also E. Bourneville, *L'Iconographie photographique de la Salpêtrière* (Paris, 1888); P. Topinard, *L'Homme dans la nature* (Paris, 1891). On the nature of the soul in early clinical psychology see, for example, H. F. Baraduc, *L'Âme humaine, ses mouvements, ses lumières* (Paris, 1896). On the *Age of Bronze* see Crone and Salzmann (1991) (listed in the chapter section above), no. 15.

CÉZANNE'S STRUGGLE WITH *LES GRANDES BAIGNEUSES*

On the Bathers as a theme in Cézanne's work see Krumrine (1989); on the late watercolours see also G. Adriani (1990), nos. 117–21. For the photograph by Bernard see Krumrine (1989), p. 238. For a colour reproduction of the version of the *Bathers* in the Barnes Collection see the catalogue *Great French Paintings from the Barnes Foundation* (Boston and London 1993), pp. 160ff.; on the London version see M. L. Krumrine (1989), pp. 211f., 215 (Philadelphia version).

RODIN'S *GATE OF HELL* AS DRAMA

On the *Gate of Hell* see M. Fath and J. A. Schmoll (Eisenwerth), eds, *Auguste Rodin. Das Höllentor. Zeichnungen und Plastik*, exh. cat. (Mannheim, 1991); Elsen (1985) (see references to chap. 9, 'Absolute Art …'); Schmoll (Eisenwerth) (1983) (see chap. 9, 'Absolute Art …'), pp. 215ff.; J. De Caso and P. B. Sanders, *Rodin's Sculpture* (San Francisco, 1972), pp. 121ff.; on the studies for it see C. Judrin, 'Das "Höllentor"', in E. G. Güse, ed., *Auguste Rodin. Zeichnungen und Aquarelle* (Stuttgart, 1984), pp. 97ff. On reactions to the *Gate of Hell* see Elsen (1985), pp. 151ff.; also the anthology edited by R. Butler, *Rodin in Perspective* (Englewood Cliffs, NJ, 1980). On Hugo and the poem 'La Vision de Dante' in *La Légende des Siècles* see Victor Hugo, *Œuvres complètes*, Poésie III, ed. J. Delabroy (Paris, 1985), pp. 675ff. For studies on individual aspects of the *Gate of Hell* see Elsen (1985). For the

1882 photograph of *The Thinker* see A. E. Elsen, *Rodin's 'Thinker' and the Dilemmas of Modern Public Sculpture* (New Haven and London, 1985), no. 36. For the account by G. Geffroy, 'Le statuaire Rodin' (which originally appeared in *Les Lettres et les Arts*, Paris, 1889, pp. 289ff.), see Fath and Schmoll (Eisenwerth) (1991), pp. 162ff.; on the partial view published in *L'Art* see C. Lampert, *Rodin: Sculpture and Drawings*, exh. cat. (London, 1986), p. 50. On Per Kirkeby in the Rodin Museum see Per Kirkeby, *Rodin. La Porte d'Enfer* (Berne and Berlin, 1985). On the Rodin Pavilion at the International Exhibition see Grunfeld (1993) (see References to chap. 9, 'Absolute Art …'), pp. 453ff.

THE THINKER — THE SEARCH FOR A LOCATION

On the history of *The Thinker* and its exhibition in the Salon of 1904 see A. E. Elsen (New Haven and London, 1985) (see chap. 9, 'Absolute Art …'), esp. pp. 85ff. For the 1907 lecture see R. M. Rilke, *Auguste Rodin*, 3rd, expanded edn, Part II, ed. R. Muther (Berlin, n.d.). For the 1943 lecture by Günther Anders see G. Anders, *Obdachlose Skulptur. Über Rodin*, ed. G. Oberschlick (Munich, 1994). On the positioning of *The Thinker* on the *Gate of Hell* and on the photographs see Elsen (1985), pp. 65ff. On Rodin's reinterpretation of *The Thinker* in 1904 see De Caso and Sanders (1972), p. 133 (quotation of the letter to Marcel Adam, first published in 1904). On the setting up of *The Thinker* on Rodin's grave see Schmoll (Eisenwerth) (1983), p. 84. For Steichen's portrait of Rodin see *Edward Steichen: Meisterphotographien 1895–1914*, exh. cat. (MoMA, New York, 1978), no. 11, p. 45.

10 The Cathedral of Memory

PROUST'S 'SELF' IN THE REFLECTION OF ART

On the modern idea of the cathedral see M. Bushart, *Der Geist der Gotik und die expressionistische Kunst* (Munich, 1990), esp. pp. 188ff.; P. Frankl, *The Gothic: Literary Sources and Interpretations* (Princeton, NJ, 1960); S. Giedion, *Space, Time and Architecture* (Cambridge, MA, 1967); Le Corbusier, *Quand les cathédrales étaient blanches* (Paris, 1937). On Ruskin's influence on the perception of Gothic see J. Ruskin, *Our Fathers Have Told Us: The Bible of Amiens* (London, 1897); R. Macksey, *Marcel Proust: On Reading Ruskin* (New Haven and London, 1987); O. Carrigan, *Ruskin on Architecture* (Princeton, NJ, 1960); J. S. Dearden, *Catalogue of the Drawings by John Ruskin* (Bembridge, 1967); J. Unrau, *Looking at Architecture with Ruskin* (Toronto, 1978), pp. 70ff. On Proust and the visual arts see, among others, M. E. Chernovitz, *Proust on Painting* (New York, 1945); D. F. Wakefield, 'Proust and the Visual Arts', *Burlington Magazine* (1970), pp. 291ff.; Macksey (1987); Y. le Pinchon, *Le Musée retrouvé de Marcel Proust* (Paris, 1990); above all *Proust et les peintres*, exh. cat. (Chartres, 1991); G. Deleuze, *Proust und die Zeichen* (Berlin, 1993); last, and especially, P. Boyer, *Le Petit Pan de mur jaune* (Paris, 1987). For Ruskin's influence on Proust mediated by R. de la Sizeranne: R. de la Sizeranne, *Ruskin et la religion*

de la beauté (1897; Paris, 1907), pp. 112ff., 169ff. Proust's unfinished essay on Monet, see M. Proust, *Contre Sainte-Beuve*, ed. P. Clarac and A. Ferré, vols I–III (Paris, 1971), pp. 657ff.; *idem, Essays, Chroniken und andere Schriften* (in German), ed. L. Keller (Frankfurt am Main, 1992), pp. 521ff.; for Proust's preface, 'Sur la lecture', to Ruskin's *Sesame and Lilies*, see M. Proust, *J. Ruskin. Sésame et les lys* (1906), ed. A. Compagnon (Paris, 1987). For English translations from which some quotations have been taken: Marcel Proust, *On Reading Ruskin: Prefaces to 'La Bible d'Amiens' and 'Sésame et les Lys'*, trans. and ed. Jean Autret, William Burford and Phillip J. Wolfe, intro. Richard Macksey (New Haven and London, 1987); Proust, *By Way of Sainte-Beuve*, trans. Sylvia Townsend Warner (London, 1958).

A DEATH IN FRONT OF VERMEER'S 'PATCH OF YELLOW WALL'

The quotations from Proust's great novel are from the translation by C. K. Scott Moncrieff and T. Kilmartin, revd D. J. Enright, *In Search of Lost Time* (London, 1992), 6 vols. The articles by J. L. Vaudoyer that Proust read in 1921 are in *Proust et les peintres*, exh. cat. (1991), pp. 129f. For the correspondence with Vaudoyer see M. Proust, *Correspondance*, XX: *1921*, ed. P. Kolb (Paris, 1992), no. 117 (1 May), nos. 143, 157, 160. For a thorough discussion of the subject see Boyer (1987), esp. pp. 35ff., 53ff., and *passim*; *Proust et les peintres*, exh. cat. (1991), pp. 55, 129ff., 151ff. For the passages in Fromentin that inspired Proust see Eugène Fromentin, *Les Maîtres d'Autrefois* (1876; Paris 1896), pp. 2 (about painting), 155ff. (The Hague), 158ff. (the sea), 193 (Dutch painting). Semprún's travel book: see J. Semprún, *Der zweite Tod des Ramón Mercader* (1969; Frankfurt am Main, 1979), pp. 9ff., 21ff., 135ff., 269ff. For the comment in 'Sainte-Beuve' see Proust (1971) (see section above, 'Proust's "self" …'), p. 137. On Vermeer's painting and its history see A. Blankert, *Vermeer of Delft* (Oxford, 1979) pp. 67ff.; S. Meltzoff, 'The Rediscovery of Vermeer', *Marsyas*, II (1942), pp. 145ff.; P. Grate, *Deux critiques d'art de l'époque romantique* (Stockholm, 1959).

RUSKIN'S CATHEDRAL IN PROUST'S MEMORY

For Ruskin's work see J. Ruskin (1897); for Proust's various texts (1900–04) see Proust (1971) (see chap. 10, 'Proust's "self" …'), pp. 69ff., 105ff., 160ff.; Proust (1986), pp. 9ff. ('Avant-Propos'), 15ff. ('Notre-Dame d'Amiens selon Ruskin'), 48ff. ('John Ruskin'), 78ff. ('Post-Scriptum'); Proust (1992), pp. 185ff., 187ff., 207ff., 306ff. (in German). On Proust and Ruskin see the introduction by H. Juin to *Proust* (1986); Macksey (1987), *passim*; *Proust et les peintres*, exh. cat. (1991), pp. 45ff., 116ff. The influence of R. de la Sizeranne (see chap. 10, 'Proust's "self" …'), p. 97 (mirror of the self), p. 128 (Monet and painting with words), p. 212 (concept of art). On Ruskin's conception of architecture see the bibliography given above and under chap. 10, 'Proust's "self" …'. For the drawings by Ruskin see Dearden (1976); Unrau (1978) (see chap. 10, 'Proust's "self" …'), illus. 33 (the gable at Rouen drawn in 1854); *Proust et les peintres*, exh. cat. (1991), illus. 44 (sketch of Abbeville); a drawing by Ruskin of the North Portal of Amiens Cathedral appears as a plate in the edn of Ruskin (1897). For the individual statements by Proust on

Ruskin and Amiens see Proust (1986), p. 33 (a Bible in stone), p. 45 (Ruskin's soul), p. 91 (the small figure at Rouen), pp. 23ff. (the *Vierge dorée*).

MONET'S CATHEDRAL SERIES

On the 1892–94 series see J. Pissarro, *Monet's Cathedral* (New York, 1990), pp. 7ff. (genesis of the paintings), 23ff. (the significance of Gothic), 28ff. (critical reception); *Les Cathédrales de Monet,* exh. cat (Rouen, 1994) [with contributions by F. Bergot ('Révélation des cathédrales'), pp. 15ff.; G. Grandjean ('Monet in Rouen'), pp. 23ff.; S. Patin (the artistic concept of the series), pp. 37ff.]; see also D. Wildenstein, Claude Monet, *Biographie et catalogue raisonné* (Paris, 1979). Proust's comment in: Proust (1986), p. 32, n. 2. The description of the west front also p. 32. For Clemenceau's essay 'Révolution de Cathédrale', see G. Clemenceau, *Claude Monet. Cinquante ans d'amitié* (Paris, 1965), pp. 105ff., *passim*; *Rouen*, exh. cat. (1994), pp. 99ff. For Monet's letters (W. 1208 and W. 1201) written in 1893, see the quotations in *Rouen*, exh. cat, (1994), pp. 40f. On the water-lilies series see K. Sagner-Düchting, *Claude Monet. Nymphéas* (Hildesheim, 1985).

RODIN'S BOOK OF CATHEDRALS

The only official edition, with a preface by C. Morice, is A. Rodin, *Les Cathédrales de France* (Paris, 1914), which contains Rodin's texts (on, among other things, the French landscape, the Romantic style and the cathedral at night, pp. 1–160) and 77 plates after drawings by Rodin. The proofs of the 136 facsimiles of the lithographs are now in the Rodin Museum in Philadelphia. On Rodin's drawings see E. Chase Geissbuhler, in A. E. Elsen and J. K. Varnedoe, *The Drawings of Rodin* (New York, 1971), pp. 141ff., and E. G. Güse, *Auguste Rodin. Zeichnungen und Aquarelle* (Münster, 1984), pp. 167ff. and illus. 79–98; H. Judrin, ed., *Inventaire des dessins* (Musée Rodin), v (Paris, 1992), *passim*, with illustrations and transcriptions. For Proust's texts on the cathedral see Proust (1971), pp. 63ff., 141ff. On the project of a Monet picture, never painted, of bombarded Rheims cathedral see M. Hoog, in *Revue du Louvre*, I (1981), pp. 22ff. For the letters written by Rodin that reflect the development of the book see A. Beausire and F. Cardouot, eds, *Correspondance de Rodin*, III (1908–12; Paris, 1987), nos. 187, 206 (also has further quotations from letters and the quotation 'mise de moi'); and IV (1913–17; Paris, 1992), nos. 113, 169 (with reproductions of the page proofs of the book). On the 'angel of Chartres' see Rodin (1914), pp. 118f.; on Melun and Amiens see pp. 56, 78.

11 An Invisible Masterpiece

PICASSO'S 'ARDUOUS NOWHERE'

On *Les Demoiselles* see the extensive documentation in J. Cousins and E. Seckel, *Les Demoiselles d'Avignon*, exh. cat., vols 1–2 (Musée Picasso, Paris, 1988) and the titles below (chap. 11, 'The Masks …'). On *Les Saltimbanques* see P. Daix and G. Boudaille, *Picasso: The Blue and Rose Periods* (New York, 1966); E. A. Carmean Jr,

Picasso: The Family of Saltimbanques (Washington, DC, 1980); on this subject see Jean Starobinski, *Porträt des Künstlers als Gaukler* (Frankfurt am Main, 1985); T. Kellein, *Pierrot. Melancholie und Maske* (Munich, 1995); on the picture's history see Fitzgerald (1995), pp. 15ff., 31ff. Three Rilke quotations in English are taken from R. M. Rilke, *Duino Elegies*, trans. J. B. Leishman and Stephen Spender (1939; London, 1963), pp. 55, 61. On the connection with Apollinaire and his poem see Rothschild (1991), pp. 252ff.; *Picasso – Apollinaire* (1992), pp. 35ff.; Read (1995), pp. 43ff.

MATISSE ON THE JOURNEY TO ARCADIA

On the Steins' collection see J. Rewald, *Cézanne und die Sammler Stein* (Berne, 1986). On Matisse and *La Joie de vivre* see *Great French Paintings from the Barnes Foundation*, exh. cat. (New York, 1993), pp. 226ff.; also A. H. Barr Jr, *Matisse: His Art and his Public* (1951; New York, 1974), pp. 81ff. On his relationship with Picasso in general see Gilot, *Matisse and Picasso* (London, 1990). For André Gide's remark about Baudelaire's lines see A. Gide, *Journal 1889–1939* (Paris, 1951), p. 664. On Mallarmé's eclogue see, among others, C. Fischer, ed., *Stéphane Mallarmé* (Heidelberg, 1984), pp. 75ff.

THE MASKS OF *LES DEMOISELLES*

On *Les Demoiselles* see J. Cousins and E. Seckel, *Les Demoiselles d'Avignon*, exh. cat., vols 1–2 (Musée Picasso, Paris, 1988); B. Leal, *Picasso. Les Demoiselles d'Avignon: A Sketchbook* (London, 1988); K. Herding, *Pablo Picasso. Les Demoiselles d'Avignon* (Frankfurt am Main, 1992), which contains further bibliography; Fitzgerald (1995), pp. 143ff., 24ff. On Primitivism see, among others, W. Rubin, ed., *'Primitivism' in 20th Century Art*, exh. cat. (MoMA, New York, 1984), vols. 1–2; K. Bilang, *Bild und Gegenbild. Das Ursprüngliche in der Kunst des zwanzigsten Jahrhunderts* (Leipzig, 1989); Bois (1990), p. 65ff. On the famous portrait of 1905 and on the painter's life see G. Stein, *Picasso* (London, 1938; New York, 1984). For Gertrude Stein's *Autobiography of Alice B. Toklas* see the 1990 New York edn.

ANDRÉ BRETON AND THE MYTH OF *LES DEMOISELLES*

On the reception of *Les Demoiselles* see the documentation in the 1988 catalogue referred to above (chap. 11, 'Picasso's "Arduous Nowhere"'); with reference to Breton's rôle see also M. C. Fitzgerald (1995), pp. 147ff., 240ff.; *André Breton. La Beauté Convulsive*, exh. cat. (Paris, 1991). On *The Three Women* see P. Daix in *Gazette des Beaux-Arts* (1988), pp. 141ff.; *idem*, in W. Rubin, ed., *Picasso and Braque: A Symposium* (New York, 1992). On the purchase of *Les Demoiselles* in New York and the rôle of A. H. Barr see Geelhaar (1993), *passim*; Fitzgerald (1995), pp. 208ff., 243ff. Barr's famous 1936 exhibitions were 'Cubism and Abstract Art' and 'Phantastic Art, Dada, Surrealism'; on A. H. Barr, Jr see A. G. Marquis, *Alfred H. Barr Jr: Missionary for the Modern* (Chicago and New York, 1989); on the great Picasso retrospective of 1939 see A. H. Barr Jr, *Picasso: Forty Years of his Art* (New York, 1939), pp. 59ff., 174ff. (on *Guernica*).

PICASSO'S MONUMENT TO APOLLINAIRE:
THE PHANTOM OF A WORK

For Picasso's Balzac illustrations see H. de Balzac, *Le Chef-d'œuvre inconnu*, ed. A. Besnard (Paris, 1931), republished with the illustrations, by S. Goeppert and H. Goeppert-Frank (Frankfurt am Main, 1987); for a detailed treatment see D. Ashton, *A Fable of Modern Art* (London, 1987), pp. 75ff. (Picasso and Frenhofer). Quotations from the interview with Christian Zervos, as published in English, are from Herschel B. Chipp, *Theories of Modern Art* (Berkeley, Los Angeles and London, 1968), pp. 267–70. On the designs for Apollinaire's tomb see C. Lichtenstern, *Pablo Picasso. Denkmal für Apollinaire* (Frankfurt am Main, 1988); M. C. Fitzgerald (1995), pp. 169ff. (Fitzgerald wrote his doctoral thesis on this subject in New York in 1987); Read (1995), pp. 147ff. For Apollinaire's text see Apollinaire, *Œuvres en prose I*, ed. M. Decaudin (Paris, 1977). For the photograph of the wire models see the catalogue *Picasso vu par Brassaï* (Paris, 1987), no. 9; see also A. Breton, 'Picasso dans son élément', *Minotaure*, I/1 (Paris, 1933), p. 13.

12 The Fate of an Art Fetish

THE THEFT OF THE *MONA LISA*: THE MUSEUM'S BLANK WALL

See, among others, S. V. Reit, *The Day They Stole the Mona Lisa* (New York, 1981); McMullen (1977), pp. 197ff.; Chastel (1988), pp. 37ff.; M. Esterow, *Mit Mona Lisa leben. Die grossen Kunstdiebstähle unserer Zeit* (Hamburg, 1967), p. 167ff. For bibliography on the *Mona Lisa* see notes to chap. 6, and also the contribution by J. P. Cuzin to *Copier Créer*, exh. cat. (Paris, 1993), pp. 412ff.; Zöllner (1994); Bramly (1995). On the Futurists' manifesto see Harrison and Wood (1993), pp. 145ff.; see also the 1910 manifesto in E. Crispolti, *La macchina mito futurista* (Rome, 1986), appendix. For the reaction in the *Grande Revue* see *Copier Créer*, exh. cat. (Paris, 1993), pp. 413f. For the text by A. Salomon see R. Fry, *Der Kubismus* (Cologne, 1966), pp. 88ff.; E. Lipton, *Picasso Criticism* (London, 1976), p. 80. Apollinaire had also commented on the theft, see H. Düchting, ed., *Apollinaire* (Cologne, 1990), pp. 125, 331. On Kafka see below ('Kafka at the Cinema'). On the art historians see R. Longhi, 'Le due Lisa', in *La Voce*, VI/1 (1914); Chastel (1988), p. 81; H. Focillon, 'La *Joconde* et ses interprètes', in *idem*, *Technique et sentiment* (Paris, 1932), pp. 78ff. On Gustave Le Gray see *Copier Créer*, exh. cat. (Paris, 1993), p. 416, no. 298. The portraits with the 'Sourires qui nous restent' are reproduced in Chastel (1988), pp. 51ff.

KAFKA AT THE CINEMA

On Max Brod and Franz Kafka's visit to Paris and the 'Mona Lisa' film they saw there, see H. Zischler, *Kafka geht ins Kino* (Hamburg, 1996), pp. 68ff. (on the film), p. 58 (Munich seen from a taxi), p. 40 (the 'Kaiser Panorama'), p. 68 ('hatched' Paris), p. 73 (cinema and newsreel). For the travel diaries see M. Brod

and Kafka, *Eine Freundschaft*, I: *Reiseaufzeichnungen* (Frankfurt am Main, 1987); Kafka, *Reisetagebücher in der Fassung der Handschrift* (Frankfurt am Main, 1994). On silent film comedy see the essay by S. Kracauer, *Kino* (Frankfurt am Main, 1974), pp. 16ff. (written in 1951). On the 1911 carnival procession and the picture postcards see Chastel (1988), pp. 44, 49. G. Deleuze, *Cinéma 2. L'Image-Temps* (Paris, 1985). On the nineteenth century see D. Sternberger, *Panorama oder Ansichten des 19. Jahrhunderts* (1934; Berlin, 1955). On the railway see W. Schivelbusch, *Geschichte der Eisenbahnreise* (Frankfurt am Main, 1989). On Duchamp's 1911 nude see *Duchamp*, exh. cat. (1984), no. 32 (Philadelphia Museum of Art); D. Daniels (1992), pp. 53ff., 59ff.

READYMADES AND OTHER MANIFESTOS

Notable recent additions to the vast literature on readymades include T. Zaunschirm, *Bereites Mädchen, Ready-Made* (Klagenfurt, 1983); *Duchamp*, exh. cat. (1984), pp. 182ff.; H. Molderings, *Marcel Duchamp* (Frankfurt am Main, 1987); Daniels (1992), pp. 166ff. (with useful historical information); de Duve (1993), with a comprehensive interpretation; Judowitz (1995), pp. 75ff.; Weiss (1994), pp. 125ff. The letter of January 1916 is reproduced in D. Daniels (1992), p. 168. On the Richard Mutt Affair see. W. A. Camfield, *Marcel Duchamp: Fountain* (Houston, TX, 1989). For Malevich's picture see, most recently, E. Weiss, ed., *Kasimir Malewitsch*, exh. cat. (Cologne, 1995), no. 54; *Kasimir Malevich*, exh. cat. (New York, 1991), no. 41; see also *Mona Lisa im 20. Jahrhundert*, exh. cat. (Duisburg, 1978), p. 196. For Malevich's exposition of Suprematism, see K. Malewitsch, *Suprematismus. Die gegenstandslose Welt* (1962; Cologne, 1989), p. 118. On Léger's picture see J.-L. Ferrier, 'Comment se délivrer de la Joconde?', in *Hommage à Léger* (Paris, 1971), pp. 82ff.; *Mona Lisa im 20. Jahrhundert*, exh. cat. (Duisburg, 1978), pp. 210ff. On the crisis around 1930 see R. Golan, *Modernity and Nostalgia* (New Haven, CT, 1995), pp. 61ff. For Léger's text see Léger, *Fonctions de la peinture* (Paris, 1965), pp. 53ff. For Huxley's story see Aldous Huxley, *The Gioconda Smile and Other Stories* (London, 1984), pp. 103ff.; idem, *The Gioconda Smile: A Play* (London, 1948); for *The Counterfeiters* see André Gide, *Les Faux-Monnayeurs*, in A. Gide, *Romans, Récits et Soties. Œuvres lyriques* (Paris, 1958), pp. 1229–30.

THE BEARDED *MONA LISA*

On Duchamp's 1919 *Mona Lisa* and its publication by Picabia see S. Salzmann and T. Reff in *Mona Lisa im 20. Jahrhundert*, exh. cat. (Duisburg, 1978), pp. 57ff., 79ff. (further information p. 198ff.); E. Bonk, *Marcel Duchamp. Die grosse Schachtel* (Munich, 1989), p. 241, double-page 9; Daniels (1992), pp. 186ff.; *Copier Créer*, exh. cat. (Paris, 1993), pp. 340 (B. Ceysson), 414, 421. On the drawing by Métivet (published in *Le Rire,* 20 November 1909) see Bonk (1989), p. 242. On the discussion about the Raphael portrait and the bare wall see R. de la Sizeranne in *Revue des deux mondes* (1912); McMullen (1975), p. 206. On the pseudonym 'Rrose Sélavy' adopted by Duchamp from 1920 onwards, there are numerous statements by Duchamp, as well as interpretations, most recently by Judowitz (1995), pp.

144ff. On Man Ray's photograph of the perfume bottle reproduced in *New York Dada* see Bonk (1989), p. 247, no. 61 with illus. nos. 234–6. The *Boîte-en-valise* in the edition by Bonk (1989), double-page 9, p. 97, no. 54. The 1944 authentication of the 1919 ready-made reproduced in Chastel (1988), p. 125. On the subsequent metamorphoses of the beard see *Mona Lisa im 20. Jahrhundert*, exh. cat. (Duisburg, 1978), p. 202 Zaunschirm (1986), p. 82, uses the expression 'unknown masterpiece' with reference to *Étant Donnés*. On the reception of Duchamp see S. Gohr, ed., *M. Duchamp und die Avantgarde seit 1950*, exh. cat. (Cologne, 1988).

A CLICHÉ ON THE INTERNATIONAL CIRCUIT

For the paraphrases of the *Mona Lisa* see M. R. Storey, *Mona Lisa* (New York, 1980); *Mona Lisa im 20. Jahrhundert*, exh. cat. (Duisburg, 1978), *passim*; Chastel (1988). The *Spiegel* article appeared on 7 October 1959. The magazine *Bizarre* with texts by J. Margat *et al.*, nos. XI and XII (May 1959). On the text by A. Besnard and the publication of Picasso's illustrations see chap. 11, 'André Breton and the Myth …'. A. Malraux, *Les Voix du silence III: La Création Artistique* (Paris, 1951), p. 462. The text by C. de Tolnay, 'Remarques sur la Joconde', in *Revue des Arts*, 2 (1952), pp. 18ff. On the *Mona Lisa*'s visit to America see Zöllner, 'J. Kennedy and Leonardo's Mona Lisa: Art as the Continuation of Politics', in W. Kersten, ed., *Radical Art History* (Zurich, 1997), pp. 467ff.; see also P. Salinger, *Mit Kennedy* (Düsseldorf, 1967); J. Walker, *Self-Portrait with Donors* (Boston, 1969). For Warhol's 1963 works see R. Crone, *Andy Warhol* (Stuttgart, 1970), p. 136, no. 128; *idem, Das bildnerische Werk Andy Warhols* (Berlin, 1976), no. 138; *Andy Warhol Retrospektive*, exh. cat. (Cologne, 1990), nos. 237, 238, nos. 235, 236; *Copier Créer*, exh. cat. (Paris, 1993), no. 310. See Andy Warhol, *The Philosophy of Andy Warhol* (New York, 1975), p. 148.

13 The Dream of Absolute Art

ABSTRACTION: THE 'WILL TO ABSOLUTE ART'

On Beckett see S. Beckett, *Materialien zu Becketts Endspiel* (Frankfurt am Main, 1986), p. 90. On Mallarmé, and also on abstraction, see chap. 14, 'Duchamp and the Bride's Wedding-dress'. On abstraction see also *Abstraction: Towards a New Art, Painting 1910–20*, exh. cat. (London, 1980); most recently C. Harrison, in C. Harrison *et al.*, *Primitivism, Cubism, Abstraction* (New Haven and London, 1993), pp. 184ff., 263ff. (bibliography). On the concept of a utopia see Gassner (1992). The concept of a 'utopia' was newly canonized in the USA by the exhibition mounted by Alfred H. Barr Jr. in 1936, and by C. Greenberg's essay, 'Abstract Art' (1944), in C. Greenberg, *Collected Essays and Criticism*, I (Chicago, 1986), p. 199ff. On the absolute image see Franz (1996), pp. 38ff.; W. Worringer, *Abstraktion und Einfühlung. Ein Beitrag zur Stilpsychologie* (1908; Munich, 1949), pp. 36ff., 42ff., 86ff. (also on Riegl); on Worringer see Wyss (1996), pp. 126ff., 247ff. On the 'Primitives' see the section in chap. 14. For Einstein's 1921 essay, 'Absolute Kunst und absolute Politik',

see the reprint in M. Fath, ed. (1976), p. 24ff. For Einstein's 1929 essay see
'Dictionnaire critique' in C. Einstein, *Werke*, III (Berlin, 1985), pp. 36ff. C. Einstein,
Die Fabrikation der Fiktionen, ed. S. Penkert (Frankfurt am Main, 1973), pp. 16, 22,
86, 190 (the manuscript was discovered in 1963).

COLOUR IN KANDINSKY'S *COMPOSITIONS*

On Kandinsky's years in Munich around 1910 see, most recently, V. Barnett, *Das
bunte Leben. Wassily Kandinsky im Lenbachhaus* (Cologne, 1995), esp. pp. 123, 301.
For his correspondence with Schoenberg see J. Hahl-Koch, *W. Kandinsky. Briefe,
Bilder und Dokumente* (Munich, 1983), pp. 19, 71, 25, 35 (quotations follow this
order). For the 'Cologne Lecture' ('Mein Werdegang') see H. Roethel and J. Hahl-
Koch (1980), pp. 51ff.; for the 'Reminiscences' ('Rückblicke') see *ibid.*, p. 27ff., esp.
pp. 41, 48ff. On the Blaue Reiter see R. Gollek, *Der Blaue Reiter in München*
(Munich, 1989). On Kandinsky's 'key experiences' see Roethel and Hahl-Koch
(1980), p. 32 (also p. 51). On Ezra Pound see E. Hesse, ed., *Ezra Pound Lesebuch*
(1953; Zurich, 1985), pp. 102ff. ('Vortizismus', 'Das Programm der Moderne'). On
Kandinsky's themes see Barnett (as above), pp. 301ff. (also on his compositions,
improvizations and impressions). For further 'Reminiscences' see Roethel and
Hahl-Koch (1980), pp. 36, 41 (and also 53, 55, 57). On Malevich's Vitebsk
Programme see Malewitsch (1988), p. 14. On *Composition VII* see Barnett (as
above), pp. 445ff.

MALEVICH'S ICON OF ART

On the exhibition '0.10' see Boersma (1994), *passim*. For the remark in *Die
gegenstandslose Welt* (The non-objective world) see Malewitsch (1989), p. 76. On the
Black Square see Boersma (1994), p. 57ff.; Crone and Moos, *K. Malevich* (Munich,
1991), pp. 113ff.; *K. Malevich*, exh. cat., (Amsterdam, 1989), *passim*; *K. Malevich*, exh.
cat. (1991), frontispiece and no. 68; see also E. Martineau, *Malévitch et la Philosophie*
(Paris, 1977); K. Malévitch, *Les Arts de la Représentation* (Paris, 1994); B. Groys,
Gesamtkunstwerk Stalin (Munich, 1988); B. Groys, *Über das Neue* (Munich, 1992).
On Malevich see also Franz (1996), pp. 33ff. On Malevich's letters from Berlin see
Malewitsch-Suetin-Tschaschnik, exh. cat. (Cologne, 1992), pp. 262ff., esp. p. 263. On
the December 1915 pamphlet see Malevich (1968), p. 38. On the letter to A.
Benoît see Malevich (1968), pp. 44, 243. On the Malevich room in the 1915
exhibition see Boersma (1994), pp. 50ff. (pp. 63ff. on Tatlin's Counter Reliefs), pp.
67ff. (on the devotional corner). On Tatlin's Corner Counter Relief of 1915 see A.
Strigalev and J. Harten, *V. Tatlin. Retrospektive*, exh. cat. (Cologne, 1993), p. 29, cat.
nos. 349, 352. On the restoration and examination of the *Black Square* see M.
Vikturina and A. Lukanova in *Malevich*, exh. cat. (1991), p. 194. On the group in
Vitebsk see Malewitsch (1988), p. 3 On the 1927 note in the book manuscript see
Malewitsch (1989), p. 33. On the hanging of the pictures above Malevich's
deathbed see *K. Malevich*, exh. cat. (1991), p. 20. On the letter from Berlin about
Suprematism see the Cologne catalogue (1992), p. 263. For the text relating to the
1919 exhibition see Malevich (1968), p. 120.

MOSCOW: THE WORK/PRODUCT CONTROVERSY

For a general account of the situation in Moscow around 1920 and the rôle played
by Kandinsky, see Khan-Magomedov (1987), pp. 55ff., 83ff., documents pp. 286ff.;
see also N. Avtonoma, in *New Perspectives on Kandinsky* (Malmö, 1990), pp. 78ff.; N.
Misler, in *Kandinsky tra oriente ed occidente*, exh. cat. (Florence, 1993), pp. 84ff.; G.
Kleine, *G. Münter und W. Kandinsky* (Frankfurt am Main, 1990), pp. 504ff.; Fath
(1976), pp. 16ff. (with a chronology of events); Gassner (1992), pp. 48ff. (with
contributions by several authors). On Tarabukin see Khan-Magomedov (1987), pp.
71ff.; see esp. N. Tarabukin, 'From the Easel to the Machine' [in Russian] (Moscow,
1923), English translation in Frascina and C. Harrison, eds, *Modern Art and Modernism*
(London, 1982), pp. 132ff. On the part played by Rodchenko and on his writings see
also A. M. Rodtschenko and W. Stepanowa, *Die Zukunft ist unser einziges Ziel*, ed.
Peter Noever (Munich, 1991), pp. 33ff., 115ff. (writings). On the debate about the
museums and O. Brik's agitation see Khan-Magomedov (1987), pp. 72ff., 79ff.

MONDRIAN'S ONE-MAN INITIATIVE: 'PLASTIC EXPRESSION' AS ART

On De Stijl see H. L. Jaffé, ed., *De Stijl 1917–1931: The Dutch Contribution to Modern
Art* (Cambridge, MA, 1986); E. Strietman, 'De Stijl', in E. Timms and P. Collier,
Visions and Blueprints (Manchester, 1988), pp. 270ff. ; C. P. Warncke, *De Stijl*
(Cologne, 1990); P. Overy, *De Stijl* (London, 1991); R. Günter in Gassner (1992),
pp. 163ff.; Bois (1990), pp. 101ff. On Mondrian see especially H. Locher, *P.
Mondrian* (Berne and Berlin, 1994), pp. 7ff. (*Composition A*), pp. 17ff. (utopian
function) and illus. 3, 6 (photographs of studio in 1926 and 1929); S. Lemoine,
Mondrian et De Stijl (Paris, 1987), pp. 38ff. ('Néoplasticisme'), 46ff. ('Du Tableau à
l'Atelier') and other photographs; *Mondrian – From Figuration to Abstraction*, exh.
cat. (The Hague, 1988) [with a contribution by H. Henkels, 'Mondrian in His
Studio', pp. 175ff., with photographs]; Bois (1990), pp. 157ff. For texts by
Mondrian see P. Mondrian, *The New Art – The New Life: The Collected Writings of
Piet Mondrian*, ed. H. Holtzman and M. S. James (London, 1987); *Le Néo-plasticisme*
(Paris, 1920), German trans. *Neue Gestaltung* (Bauhausbücher, no. 5) (Munich,
1925), reprinted in H. Winger, ed., *Neue Gestaltung* (Neue Bauhausbücher) (Mainz,
1974), pp. 5ff., 8ff., 10ff., 15 (the work of art), 58ff. (the work, the painting,
Gestaltung, also colour); Harrison and Wood (1992), p. 282.; Y.-A. Bois *et al.*, *Piet
Mondrian* (Berne, 1995), pp. 347ff. (Neo-Plasticism). On Gestalt psychology see K.
Koffka, *Beiträge zur Psychologie der Gestalt* (pub. from 1913); M. Wertheimer, *Über
Gestalttheorie* (Berlin, 1925); W. Koehler, *Gestalt Psychology* (New York, 1929).

14 The Fiction of Absolute Art

DUCHAMP AND THE BRIDE'S WEDDING-DRESS:
THE ALLEGORY OF THE WORK

For an earlier version of this chapter see Belting (1992), pp. 70ff. For other

references to Duchamp (readymades and *Mona Lisa*) see chap. 12. For a general bibliography on Duchamp see Stauffer (1981). For the texts and interviews see S. Stauffer, *Marcel Duchamp. Interviews und Statements* (Stuttgart, 1991); Daniels (1992); De Duve (1993); see also O. Paz, *Marcel Duchamp* (New York, 1987); H. Molderings, *Marcel Duchamp* (Frankfurt am Main, 1983); J. Lyotard, *Die Transformatoren Duchamp* (Stuttgart, 1986) and the titles given below. On the idea of the case containing the *œuvre* see E. Bonk, *Marcel Duchamp. Die grosse Schachtel* (Munich, 1989). On art as a fiction see De Duve (1993). On Kandinsky, Mondrian and Malevich see chap. 13. On Mallarmé see S. Mallarmé, *Sämtliche Gedichte* (Heidelberg, 1984), pp. 262ff. (*Igitur*). On the article by Kiesler see J. Gough-Cooper in D. Bogner, ed., *Kiesler* (Vienna, 1988), pp. 287ff.; S. Gohr and G. Luyken, *Kiesler, Selected Writings* (Stuttgart, 1996), pp. 38ff. (reprint). On Balzac see chap. 5. On the *Large Glass* see, most recently, D. Judowitz, *Unpacking Duchamp: Art in Transit* (Berkeley, CA, 1995), pp. 52ff.; see also Bonk (1989), as above, pp. 73ff., 198ff. (history); Daniels (1993), pp. 73ff.; see also *M. Duchamp*, exh. cat. (1973), pp. 58ff.; *Duchamp*, exh. cat. (1984), pp. 124ff.; Weiss (1994), pp. 109ff. On the idea of the machine see theh catalogue *M. Duchamp* (1973), pp. 70ff. (L. Steefel).

THE WORK PROCESS AS RITUAL

On R. Roussel see A. Breton, *Anthologie de l'humour noir* (Paris, 1972), pp. 271ff.; T. Zaunschirm, *Marcel Duchamps unbekanntes Meisterwerk* (Klagenfurt, 1986), pp. 26ff. On the 1926 exhibition see also the literature cited with reference to the *Large Glass*. On Marcel Duchamp in this connection see the complete biography by J. Gough-Cooper and J. Caumont in *Marcel Duchamp*, exh. cat. (Venice, 1993). On Ozenfant see A. Ozenfant, *Foundations of Modern Art* (1931; New York, 1952); the quotations here are from pp. 117–18. On the *Green Box* see the edition by R. Hamilton, *The Bride Stripped Bare by Her Bachelors, Even* (1960; London, 1973); Daniels (1992), p. 102ff. On Breton's essay in *Le Minotaure* and on the shortened version in the *London Bulletin* (4 July 1938), pp. 17ff. ('The Lighthouse of the Bride'), see *A. Breton, La Beauté convulsive*, exh. cat. (Paris, 1992), pp. 217ff.; R. Lebel, 'Marcel Duchamp und André Breton', in *M. Duchamp*, exh. cat. (1973), pp. 136ff. On the interviews given by Duchamp see Stauffer (1991), *passim*.

THE ANATOMY OF THE WORK

For the reference to the hinge, in the notes in the *Green Box*, see Hamilton (1973), listed in the section above, nos. 3-4 (with a drawing and English text). On Duchamp and Leonardo see T. Reff, 'Duchamp und Leonardo', in *Mona Lisa im 20. Jahrhundert*, exh. cat., (1987), pp. 57ff. On the methodological guidance given by Leonardo see A. Chastel, ed., *Leonardo da Vinci. Sämtliche Gemälde und die Schriften zur Malerei* (Munich, 1990), pp. 359ff. On the work *À regarder...* see Hamilton (as above); Bonk (1989) (see above, 'Duchamp and the Bride's ...'), p. 107. On Dürer (this woodcut is evidently not the original illustration, which was the one with the lute), see E. Ullmann, ed., *Albrecht Dürer. Schriften und Briefe* (Leipzig, 1993), pp. 204ff. (see also illus. 28).

EROS AND TECHNOLOGY: ART AS PERSPECTIVE

On the planned subtitle for the *Large Glass* see Hamilton (1973) (see above), p. 1 (also on the 'allegorical appearance'); and, with reference also to the following section for chap. 14, Duchamp's later comments in M. Sanouillet, ed., *Marcel Duchamp. Duchamp du Signe. Écrits* (Paris, 1975).

A NEW STAGING OF THE GAZE

On *Étant Donnés* see A. d'Harnoncourt, ed., *Manual of Instructions for Étant Donnés* (Philadelphia and Munich, 1987); *Marcel Duchamp*, exh. cat. (Cologne, 1984), pp. 160ff.; Daniels (1992), pp. 276ff.; Zaunschirm (1986) (see above, chap. 14, 'The *Large Glass* ...'), *passim*, esp. pp. 80ff. On the notes in the *Green Box* see Hamilton (1973) (see above); Judowitz (1995) (see above), pp. 195ff. On the Breton display in the bookshop see, among others, *M. Duchamp*, exh. cat. (1973), p. 137. On T. Zaunschirm, who rightly speaks of the 'unknown masterpiece', see T. Zaunschirm (1986) (see above), pp. 80ff.

15 The Absolute Artist

PICASSO'S 'BETRAYAL' OF CUBISM

On Cubism see W. Rubin, ed., *Picasso and Braque: Pioneering Cubism*, exh. cat. (New York, 1989), with bibliography. G. Stein, *Picasso* (London, 1938; New York, 1984), pp. 4, 11, 12; see also G. Stein, *Picasso* (Paris, 1978); on Cubism in general also Bois (1990), pp. 65ff.; Weiss (1994), pp. 3ff. On the portrait in Cubism and on the portrait of Gertrude Stein see, most recently, P. Daix, in Rubin (1996), pp. 255ff. On the *Still-life with Chair Caning* (Musée Picasso) see Rubin (1989), p. 229. On signs in Picasso see R. Kraus, 'Re-Presenting Picasso', *Art in America*, 12 (1980), pp. 91ff. On Apollinaire and Cubism, see, most recently, Read (1995), pp. 81ff.; H. Düchting, *Apollinaire zur Kunst* (Cologne, 1989), *passim*. On the 1913 montage see Rubin (1980), p. 152; Bois (1990), p. 91 and illus. 24. On the 1914 drawings see Fitzgerald (1995), pp. 47ff. On the *Harlequin* see Fitzgerald (1995), pp. 60ff.; Zervos, vol. 2. 2 (1961), no. 555; Rubin (1980), pp. 191, 209 (*The Violinist: Si tu veux*). J. Cocteau, *Picasso* (Paris, 1923). On the picture *Painter and Model* (1914), see M. C. Fitzgerald, in Rubin (1996), pp. 297ff.; Hoog (1988), no. 16. Picasso's interview in *The Arts*, 5 (1923), 'Statement about Art'; see also M. McCully, ed., *A Picasso Anthology* (London, 1981), pp. 155ff.; U. Weisner, ed., *Picassos Klassizismus*, exh. cat. (Bielefeld, 1988), p. 342.

HARLEQUIN IN THE THEATRE OF PAINTING

On Apollinaire's watercolour see Read (1995), pp. 129ff. On sketchbook no. 59 and on the theme of the harlequin see T. Reff, in A. M. Glimcher, ed., *Je suis le cahier*, exh. cat. (London, 1986), pp. 81ff.; T. Reff, 'Picasso's Three Musicians', *Art in America*, 12 (1980), pp. 125ff. For a comprehensive treatment of the *Parade* project

see Rothschild (1991), *passim*; *Picasso in Italia,* exh. cat. (Milan, 1990); Weiss (1994), pp. 167ff. For the painting *Harlequin and Woman with a Necklace* (1917), Centre Pompidou, see *Picasso in Italia*, no. 17. On Apollinaire and the *Saltimbanques* see References to chap. 11, 'Picasso's "Arduous Nowhere"'. On Apollinaire and *Parade* see *Picasso – Apollinaire* (1992), pp. 149ff. (with other texts from 1918); Read (1995), pp. 17ff., 135ff. The best illustrations of the Cubist 'Managers' are in Zervos (see section above), nos. 162-4.

THREE WOMEN AT THE FOUNTAIN, OR THE WELL–SPRINGS OF ART

P. Raynal, *Picasso* (Munich, 1921), p. 135. On Picasso's dealers, L. P. Rosenberg and Wildenstein, see Fitzgerald (1995), pp. 71ff., 80ff. For Apollinaire's remarks see *Picasso – Apollinaire*, pp. 201ff. On Picasso and the self-portrait see Read (1995), pp. 135ff. On the *Three Musicians* see bibliography above under 'Harlequin in the Theatre ...'. On Picasso and Renoir see Fitzgerald (1995), pp. 100ff.; Hoog (1988), no. 1 and p. 10. On the oil sketch *Studies* (1920) see also Rubin (1996), p. 312. For Renoir's *Eurydice* see Fitzgerald (1995), illus. 39. For Picasso's *Seated Model Drying her Foot* see the catalogue of the Berggruen Collection; Fitzgerald (1995), illus. 40. On the *Three Women at the Fountain* and the preliminary studies see Rubin (1980), p. 232; illustration of the oil sketch in Picasso's house in U. Weisner, *Picassos Klassizismus*, exh. cat. (Bielefeld, 1988), p. 194 (photograph by Brassaï), pp. 238ff.

GUERNICA: THE WORK AS MYTH

On the reception of *Guernica* see the summary by Zeiller (1996). On the 1937 exhibition see the catalogue *Pabellón Español* (Madrid, 1987), and O. K. Werckmeister in *Arts and Sciences* [Chicago] (Fall 1984), pp. 11ff.; W. Spies, *Kontinent Picasso* (Munich, 1988) pp. 63ff. The first reviews by C. Zervos in *Cahiers d'art* (1937), pp. 51ff., 105ff. (also with reference to 'Degenerate Art'); followed by H. Read and P. Éluard in *London Bulletin*, 6 (1938), pp. 6ff. On the 1939 exhibition at MoMA see A. H. Barr Jr, ed., *Picassso: Forty Years of His Art* (New York, 1939), pp. 280ff. The first monograph, which included the poem by P. Éluard, was J. Larrea, *Guernica* (New York, 1947). Published after the return to Spain: *Guernica – Legado Picasso* (Madrid, 1981). On the realism controversy see *Paris 1937–1957*, exh. cat. (Paris, 1981). E. Tériade, 'Réhabilitation du chef-d'œuvre', *Le Minotaure*, 6 (1934), p. 60; on Tériade see the catalogue *Hommage à Tériade* (Paris, 1973). For the conversation with Malraux see Malraux (1974, 1975), pp. 41ff., 75. M. Raphael, 'Zwiespalt zwischen Inhalt und Form. Picassos Guernica', in *idem, Wie will ein Kunstwerk gesehen sein?* (Frankfurt am Main, 1984), pp. 132ff. P. Weiss, *Die Ästhetik des Widerstands*, I (1975; Frankfurt am Main, 1988), pp. 332ff.; on P. Weiss see G. Palmstierna-Weiss and J. Schutte, *Peter Weiss. Leben und Werk* (Frankfurt am Main, 1991). On the Crónica group see *Equipo Crónica*, exh. cat., (Frankfurt am Main, 1977); G. Eichinger, in *Guernica. Picasso und der Spanische Bürgerkrieg* (Berlin, 1980), pp. 70ff., 77ff. For the texts about *Guernica* see the collected volume ed. E. C. Oppler, *Picasso's Guernica* (New York, 1988). For Picasso's *Bacchanale* see R. Penrose, *Homage to Picasso on His 70th Birthday* (London, 1951), no. 68. On the Second World War period see S. Gohr, ed., *Picasso im Zweiten Weltkrieg,*

exh. cat. (Cologne, 1988). On the pair of paintings, *War* and *Peace*, see C. Roy, *Picasso. La guerre et la paix* (Paris, 1954).

VARIATIONS ON THE THEME OF THE WORK: PICASSO'S LATE SERIES

M. Leiris, *Picasso et les Menines de Velázquez*, exh. cat. (Paris, 1952). C. Zervos in *Cahiers d'art*, 33–35 (Paris, 1960). D. Cooper, *Picasso. Le Déjeuner* (Paris, 1962). L. Steinberg, 'The Algerian Women and Picasso at Large', in *idem, Other Criteria. Confrontations with Twentieth-century Art* (New York, 1972), pp. 125ff. N. Goodman, 'Variationen zur Variation – oder von Picasso zurück zu Bach', in N. Goodman and C. Z. Elgin, *Revisionen* (Frankfurt am Main, 1987), pp. 93ff. On *Las Meninas* see also Malraux (1974, 1975), pp. 46ff.; J. Sabartés, *Picasso. Las meninas y la vida* (Barcelona, 1969); J.P.I. Farbe, *El secreto de las Meninas de Picasso* (Barcelona, 1982); and esp. Kesser (1994), pp. 168ff. On Hamilton see Kesser (1994), p. 188 and illus. 44; R. Schleier, 'Spiegelungen der Malkunst – Las Meninas von Velázquez', in *Nachbilder. Vom Nutzen und Nachteil des Zitierens für die Kunst*, exh. cat. (Hannover, 1979).

16 American Modernism

GERTRUDE STEIN'S 'MASTERPIECES' AND A NEW AVANT-GARDE

On the integration of American modernism into the history of so-called Western art see L. Glozer and K. Koenig's exh. cat. *Westkunst. Zeitgenössische Kunst seit 1939* (Cologne, 1981). On the 'history of an artistic fascination' see *Europa – Amerika*, exh. cat. (Cologne, 1986). On this subject see also G. Celant and A. Costantini, *Roma–New York 1948–1964: An Art Exploration* (Milan, 1993). The catalogues of A. H. Barr Jr's exhibitions of 1935–6 were republished in 1964 and 1974. On MoMA's history and on its first director see R. Lynes, *Good Old Modern* (New York, 1973); A. G. Marquis, *Alfred H. Barr Jr: Missionary for the Modern* (Chicago, 1989). On the artist émigrés in the Second World War see S. Barron, *Exiles and Emigrés: The Flight of the European Artists from Hitler* (New York, 1997). G. Stein, *The Autobiography of Alice B. Toklas* (New York, 1933). For Gertrude Stein's book on Picasso see the reference under chap. 15, 'Picasso's "Betrayal …"'. On the collection of Leo and Gertrude Stein see J. Rewald, *Cézanne und die Sammler Stein* (Berne, 1987). On Gertrude Stein see R. Stendhal, ed., *Gertrude Stein. Ein Leben in Bildern und Texten* (Zurich, 1989); more recently S. Sabin, *Gertrude Stein* (Reinbek bei Hamburg, 1996), pp. 92ff. (on her American tour and her fame). On the commemorative exhibition see D. Gallup, in *Picasso-Gris-Miró. The Spanish Masters of Twentieth-century Painting*, exh. cat. (San Francisco, 1948), pp. 15ff. The text 'What Are Masterpieces and Why Are There So Few Of Them' was republished in G. Stein, *Four in America*, intro. T. Wilder (New Haven, CT, 1947). The essay by D. Judd, 'Long Discussion Not About Master-Pieces But Why There Are So Few of Them', *Art In America*, 9 & 10 (1984), pp. 9 ff. in each case.

CLEMENT GREENBERG'S AMERICAN *LAOCOÖN*

The problems posed by 'high and low' are understandably not addressed in the catalogue of that title by K.Varnedoe (New York, 1991). On this subject see also H. Belting, *Das Ende der Kunstgeschichte* (Munich, 1995), pp. 52ff., 77ff. For Greenberg's early texts see the convenient new edition, C. Greenberg, *The Collected Essays and Criticism*, ed. J. O'Brian, I (Chicago, 1986), pp. 5ff. ('Avant-Garde and Kitsch'), pp. 23ff. ('Towards a Newer Laocoon'), p. 199ff. ('Abstract Art'). On Greenberg see the bibliography, *ibid.*, pp. 250ff. (with references to the debate between T. J. Clark and M. Fried). See also T. de Duve, *Clement Greenberg Between the Lines* (Paris, 1986). R. Motherwell, *The Modern Painter's World* (New York, 1947) (in the same year as the monograph on *Guernica* referred to in chap. 15's References). For texts by Barnett Newman see B. Newman, *Selected Writings and Interviews*, ed. J. P. O'Neill (New York, 1990), pp. 138ff. ('The Plasmic Image'), 161ff. (response to Greenberg), 170ff. ('The Sublime Is Now'); see also, in the same edition, the texts on exhibitions of Primitive art, and pp. 182ff. (text on the *Cantos*, with the distinction between size and scale). On Newman see, among others, T. B. Hess, *Barnett Newman*, exh. cat., (New York, 1971), p. 55ff. (*Onement*), p. 72 (*Vir Heroicus Sublimis*); on the main exhibitions see B. Richardson, *Barnett Newman: The Complete Drawings* (Baltimore, 1979); Bois (1990), pp. 188ff.; Bätschmann (1997), pp. 198ff.; J. Strick, *The Sublime is Now: The Early Work of Barnett Newman* (New York, 1994) with illus. 50 (*Onement I*) and the preliminary drawings for it, nos. 37–41; see also G. Didi-Huberman, *L'Empreinte*, exh. cat. (Paris, 1997), on the principle of the 'zip'. On the dispute with Panofsky see B. Wyss, *Ein Druckfehler. Panofsky versus Newman* (Cologne, 1993).

POLLOCK'S DRAMAS: THE ARENA OF THE 'SELF'

On Pollock see the informative 900-page biography by S. Naifeh and G.W. Smith, *Jackson Pollock: An American Saga* (London, 1989), esp. pp. 342ff. (J. Graham and the Surrealists, and also Picasso), pp. 383ff. (the school of H. Hofmann), p. 435ff. (Peggy Guggenheim), pp. 466ff., 494ff. (the mural and. C. Greenberg), p. 533ff. ('dripping'), pp. 551ff. (the end of the easel painting), pp. 590ff., 613ff. (*Life* article and the masterpieces). See also the biography by J. Potter, *To A Violent Grave: An Oral Biography of Jackson Pollock* (New York, 1985). On Pollock's œuvre see the early monograph by B. Robertson, *Jackson Pollock* (Cologne, 1960), and the innumerable catalogues; most recently C. Ratcliff, *The Fate of a Gesture: Jackson Pollock and Postwar American Art* (New York, 1996). For Kaprow's article see A. Kaprow, *The Blurring of Art and Life*, ed. J. Kelley (Berkeley, CA, 1993), pp. 1ff. ('The Legacy of Jackson Pollock').

RAUSCHENBERG'S COLLAGES: THE IMAGE STRIKES BACK

On Rauschenberg's early work see W. Hopps, *Robert Rauschenberg: The Early 1950s*, exh. cat. (Houston, 1991), pp. 161ff. (*Erased de Kooning Drawing*). R. Feinstein, in *Arts*, 59 (1985), pp. 166ff. (Betty Parsons's 1951 exhibition); *Arts*, 61/9 (1986) (the

White Paintings); on the *White Paintings* see also R. Smith, *Robert Rauschenberg: The White and Black Paintings*, exh. cat. (New York, 1986). Catalogues used by me include L. Alloway *et al.*, *Robert Rauschenberg* (Washington, DC, 1976), no. 1 (*Blueprint*), no. 6 (*White Painting*), no. 38 (*Short Circuit*, 1955), with further references; D. Ruckhaberle, *Robert Rauschenberg. Werke 1950–1980* (Berlin, 1980) [with a contribution by G. Adriani (p. 56ff.), p. 57 (*Blueprint*), cat. no. 1 (*White Painting*), no. 88 (De Kooning drawing), p. 300 (*Reservoir*)]. On Rauschenberg's collage technique see Steinberg (1972) (see chap. 15, 'Variations …'), pp. 85ff. On the 'combine paintings' see the Karlsruhe dissertation by J. Jäger, *Die späten Combine-Paintings von R. Rauschenberg. Die Zivilisation als Tafelbild* (Karlsruhe, 1997). On Rauschenberg's life and artistic environment see C. Tomkins, *Off the Wall: Robert Rauschenberg and the Art World of Our Time* (New York, 1980). The catalogues of the comprehensive retrospective at the Guggenheim Museum (New York, 1997) may be regarded as constituting the standard work on this artist.

ANDY WARHOL'S 'FOUR THOUSAND MASTERPIECES'

On Warhol see the bibliography given under chap. 12, 'A Cliché …'; also references in the Lenbachhaus catalogue (Munich, 1981), and the contributions (esp. those by R. Rosenblum and B. Buchloh) to the catalogue of the Warhol retrospective at MoMA (New York, 1989). For the interview with Blinderman see *Arts Magazine*, 56/10 (1981), pp. 144ff. The quotations are from *The Philosophy of Andy Warhol (From A to B and Back Again)*, on which a team of writers collaborated (New York, 1975), p. 92 ('business artist'), p. 148 (Picasso; the 'space artist'). On the *Last Supper Paintings* see L. Glozer, 'A Guest Performance on the Painter's Olympus', in J. Schellmann, ed., *Andy Warhol: Art From Art* (Cologne and New York, 1994), pp. 6ff., catalogue pp. 72ff. (with illustrations of all the paintings); L. Cook, *Andy Warhol: The Last Supper Paintings* (New York, 1994).

17 The Call to Freedom

STAGES AND ACTIONS: LIBERATION FROM THE 'WORK'

The texts by Eva Hesse are in Stiles and Selz (1996), pp. 593–7; for the remark by Sol LeWitt see footnote to his 'Paragraphs on Conceptual Art' quoted in Harrison and Wood (1992), p. 837; Kosuth's formulation in his text 'Art after Philosophy' (1969): see Harrison and Wood (1992), pp. 837ff.; Stiles and Selz (1996), pp. 840ff. On Conceptual art see the References below under 'Conceptual Art'. On Gustav Metzger's 'auto-destructive art' see Stiles and Selz (1996), pp. 401ff.; J. Tinguely's 'Untitled Statement' (1961) *ibid.*, p. 404ff. On Tinguely see, amongst others, P. Hulten, *J. Tinguely. ' Meta'* (Paris, 1967); *idem.*, *A Magic Stronger Than Death* (Milan, 1987), pp. 74ff. (containing the text by B. Klüver on *Homage to New York*); Bätschmann (1997), pp. 208f., though the destruction of art – see Gamboni, 1997 – should be distinguished from this destruction of the work. The text by M.

Foucault appeared first in *Bull. Soc. Franc. de Philos.*, XLIII (1969); then in J. Harari, ed., *Textual Strategies* (Ithaca, NY, 1979), pp. 141ff. The text by R. Barthes, 'De l'œuvre au texte' first in *Rev. d'esthétique*, III (1971). R. Krauss (1985) in the edition available to me. On Barnett Nauman see the interview with W. Sharp in *Barnett Nauman: Interviews*, ed. C. Hoffmann (Dresden, 1996), p. 27. On Warhol see Bätschmann (1997), p. 215 with illus. 145. On the history of the visual and performing arts see H. Belting, 'Die Ausstellung von Kulturen', in *Jahrbuch des Wissenschaftskollegs* (Berlin, 1994–5), pp. 214ff. On Process art see K. Stiles, in Stiles and Selz (1996), p. 577ff. On Kaprow's 'total art' see Kaprow (1993), pp. 10ff.; this also contains 'The Legacy of Jackson Pollock', pp. 1ff., and various essays concerning the definition of Performance and Happening. See also K. Stiles, in Stiles and Selz (1996), pp. 679ff., with bibliography.

MINIMALISM: THE CONTROVERSY OVER OBJECTS OR THEATRE

M. Fried, 'Art and Objecthood' (1971), reprinted in Harrison and Wood (1992), pp. 822ff.; Stemmerich (1995), pp. 334ff. D. Judd, 'Black, White and Grey', first in *Arts Magazine*, 3 (1964); see also D. Judd, *Complete Writings* (New York, 1975), pp. 117ff.; Stemmerich (1995), pp. 195ff. The text by R. Wollheim first in *Arts Magazine*, 39 (1965); see also Harrison and Wood (1992), p. 787. The text by R. Smithson originally in *Seven Sculptors*, exh. cat. (Philadelphia, 1965), now see Stemmerich (1995), pp. 202ff. D. Judd's famous essay, 'Specific Objects', originally in *Arts Yearbook*, 8 (1965), now in Stemmerich (1995), pp. 59ff. (see esp. p. 70); Harrison and Wood (1992), pp. 809ff. On Minimalism see R. Krauss, *Passages in Modern Sculpture* (Boston, 1981), pp. 264ff.; Colpitt, *Minimal Art: The Critical Perspective* (Seattle, 1990); Stemmerich (1995).

FLUXUS AS A SOCIAL DREAM

On Fluxus see, among others, H. Sohm, *Happening und Fluxus. Materialien*, exh. cat. (Kunstverein, Cologne, 1970); *Fluxus. Wiesbaden 1962–1982. Eine kleine Geschichte des Fluxus in 3 Teilen*, exh. cat. (Wiesbaden, 1982); J. Hendricks, 'Fluxus. Kleines Sommerfest', in E. Roters, ed., *Stationen der Moderne* (Berlin, 1988), pp. 493ff.; U. M. Schneede, *J. Beuys. Die Aktionen* (Düsseldorf, 1994); above all see U.-M. Berger (1996) [containing many documents and texts], esp. pp. 344ff. (XII.6) (A. Kaprow's text about Maciunas), p. 80 (III.39) (the text by W. De Ridder), p. 116 (the text by E. Andersen), p. 257 (letter to L. Miller), p. 95 (the text by J. MacLow), p. 110 (the 1964 letter to T. Schmit). The text by Kaprow, 'Happenings in the New York Scene' (1961), in Kaprow (1993), pp. 15ff. (including the remarks about chance, etc.); Kaprow, 'Experimental Art' (1966), *ibid.*, p. 66 and esp. p. 74 (against art history as memory). The text 'Pinpointing Happenings' (1967) *ibid.*, p. 85, with the ref. to the *Gesamtkunstwerk*. On the *Gesamtkunstwerk* see Szeemann (1983), which gives further bibliography (also the text by M. Lingner, pp. 52ff.); Friedrich (1996); U. Bernbach, *Der Wahn des Gesamtkunstwerks. R. Wagners politisch-ästhetische Utopie* (Frankfurt am Main, 1994).

CONCEPTUAL ART: THE LANGUAGE OF THE FILM SCRIPT

On Conceptual art see T. Dreher, *Konzeptuelle Kunst in Amerika und England zwischen 1963 und 1976* (Frankfurt am Main, 1992), which has a comprehensive bibliography; J. Aliaga and J. M. Corez, eds, *Conceptual Art Revisited* (Valencia, 1990); G. Battcock, ed., *Idea Art: A Critical Anthology* (New York, 1973); Harrison and Wood (1992), pp. 873ff.; K. Stiles, in Stiles and Selz (1996), pp. 804ff. On H. Flynt see Stiles and Selz (1996), pp. 820ff. (also texts by S. LeWitt, *ibid.*, pp. 822ff.). On S. LeWitt see catalogue of the Gemeentemuseum (The Hague, 1992) [with bibliography]; R. Metzger, *Kunst in der Postmoderne. Dan Graham* (Cologne, 1996), pp. 62ff. On the 1967 exhibitions in New York see Stiles and Selz (1996), p. 805. J. Kosuth's 1968 text in Stiles and Selz (1996), p. 840; the text 'Art after Philosophy' (1969), *ibid.*, pp. 841ff. (esp. p. 844); see also Harrison and Wood (1992), pp. 840ff. Kosuth's interview in *J. Kosuth. Zeno at the Edge of the Known World* (Venice, 1993), pp. 102ff. (interview with M. Szegedy-Maszak). On 'Art and Language', see the handbook of that title which appeared from 1973 onwards.

FROM VIDEO INSTALLATION TO INTERACTION

For a general overview see S. Breitwieser, ed., *Katalogbuch. White Cube / Black Box. Werkschau V. Export und G. Matta-Clark* (Vienna, 1996) [with contributions by M. Le Grice *et al*]; A. Hünnekens, *Der bewegte Betrachter. Theorien der interaktiven Medienkunst* (Cologne, 1967) [with full bibliography]; the catalogues of Ars Electronica (Linz, Austria) and those of the ZKM (Karlsruhe, 1997). For M. W. Krueger on *Videoplace* see Stiles and Selz (1996), pp. 473ff. On N. J. Paik see E. Decker, ed., *N. J. Paik. Niederschriften eines Kulturnomaden* (Cologne, 1992); K. Bussmann, ed., *N. J. Paik. Eine Data Base* (Stuttgart, 1993). On Barnett Nauman see J. Simon, ed., *B. Nauman. Ausstellungskatalog* (1994). See also C. Hoffmann, ed., *B. Nauman. Interviews* (Dresden, 1996), pp. 112ff. (interview with J. Wallace, 1978) about the studio. L. Lipman, *Six Years: The Dematerialization of the Art Object* (New York, 1973); A. Kaprow, 'Video Art: Old Wine, New Bottle', in Kaprow (1993), pp. 148ff. On G. Hill see H. Belting, 'G. Hill und das Alphabet der Bilder', in T. Vischer, ed., *G. Hill. Arbeit am Video* (Stuttgart, 1995), pp. 43ff.

18 The Work as Memory

ART ABOUT ART

On Quotational art see, for example, the exhibition catalogues *D'Après* (Rassegna Internazionale delle arti e della cultura, Lugano, 1971) containing texts by Russoli *et al.*; *Art about Art*, exh. cat. (Whitney Museum, New York, 1978), which has texts by J. Lipman and R. Marshall and also the essay, 'The Glorious Company', by L. Steinberg; and *Nachbilder. Vom Nutzen und Nachteil des Zitierens für die Kunst* (Kunstverein Hannover, 1979) with texts by Katrin Sello. On Guttuso's series of paintings see the catalogue for the exhibition *Guttuso: Das Gastmahl* (Frankfurter

Kunstverein, 1974), which has a text by G. Bussmann. On Lichtenstein's *Masterpiece* and *Art* see the catalogue by D. Waldmann, *R. Lichtenstein* (Guggenheim Museum, 1993), p. 54, illus. 53, and p. 72.

MARCEL BROODTHAERS: MUSEUM AS MEMORY

Among the vast literature on Broodthaers see, most recently, D. Zwirner, *Marcel Broodthaers* (Cologne, 1997), which contains a wealth of material; W. Dickhoff, *Broodthaers. Interviews und Dialoge* (Cologne, 1994); and the articles in *October*, 42 (1987). On the fictive museum in particular see J. Cladders, 'Die Realität von Kunst als Thema der Kunst', in *documenta 1972*, section 16, pp. 1ff. B. Buchloh, 'The Museum Fictions by Marcel Broodthaers', in A. Bronson and P. Gale, eds, *Museum by Artists* (Toronto, 1983), pp. 45ff., and *idem*, article in *October*, 42 (1987), pp. 67ff.; D. Crimp, 'This Is Not a Museum of Art', in M. Goldwater, ed., *Marcel Broodthaers* (Minneapolis, 1989), pp. 70ff. (with chronology pp. 180ff.); C. David, ed., *Marcel Broodthaers*, exh. cat. (Jeu de Paume, Paris, 1991), pp. 190ff., and Zwirner (as above), *passim*.

PHOTOGRAPHY'S *MISE-EN-SCÈNE* OF THE OLD PICTURE

On Cindy Sherman's *History Portraits* see A. Danto, 'Past Masters and Post Moderns', in A. Danto, *Cindy Sherman: History Portraits* (New York, 1991); *Cindy Sherman*, exh. cat. (Basle, 1991); M. Meneguzzo, *Cindy Sherman* (Milan, 1990); C. Schneider, *Cindy Sherman. History Portraits. Die Wiedergeburt des Gemäldes nach dem Ende der Malerei* (Munich, 1995); A. Jones, in A. Cruz *et al.*, eds, *Cindy Sherman: Retrospective*, exh. cat. (Chicago and Los Angeles, 1997–8), pp. 33ff. On Wall see his own writings, published in 1997 by Verlag der Kunst, and K. Brougher, *Jeff Wall*, exh. cat. (Los Angeles, 1997), containing the text 'The Photographer of Modern Life', pp. 13ff., and a full bibliography, pp. 43ff. (*The Storyteller* reproduced across two pages, pp. 84–5). See also T. de Duve, 'Survey. The Mainstream and the Crooked Path', in T. de Duve *et al.*, *Jeff Wall* (London, 1996), pp. 24ff.

LITERARY RE-CREATIONS

G. Bazin, *Histoire de l'histoire de l'art* (Paris, 1986), pp. 356ff.: 'Retour au chef-d'œuvre'. P. Weiss, *Die Ästhetik des Widerstands* (Frankfurt am Main, 1975–81) (Edition Suhrkamp, 1988), I, pp. 339ff., and II, pp. 15, 58 (on Weiss see also the References for chap. 3, 'History of the Fascination …') A. Malraux, *Les Voix du silence* (Paris, 1951), vol. 1: *Le Musée Imaginaire*, pp. 11ff., 16 and 43; on Malraux see H. Belting, *Das Ende der Kunstgeschichte* (Munich, 1995), p. 160; on criticism of Malraux see G. Duthuit, *Le Musée Inimaginable* (Paris, 1956), vols I and II. M. Foucault, *Les mots et les choses* (Paris, 1966), p. 19ff.. A. Andersch, *Die Rote* (Zurich, 1960; 1972), p. 28 A. Duden, *Das Judasschaf* (Hamburg, 1985) and *Der wunde Punkt im Alphabet* (Hamburg, 1995). G. Perec, *Ein Kunstkabinett. Geschichte eines Gemäldes* (Munich, 1989). T. Bernhard, *Alte Meister* (Frankfurt am Main, 1985), pp. 41ff., 150ff. and 301ff.

THE AFTERLIFE IN FILM: RIVETTE AND BALZAC

On Rivette's *La Belle Noiseuse* see the programme to the two-hour shortened version (*Divertimento*) (Munich), which may be hired from Prokino; another text in *CICIM*, 33 (Munich, 1991); V. Lueken, 'Liz, Marianne and "La Belle Noiseuse"', in *DU*, 5 (May 1994), p. 70 (this issue as a whole is entitled *Der widerspenstige Cinéaste J. Rivette*). On Rivette see also J. Rosenbaum, ed., *Rivette: Texts and Interviews* (London, 1977). On Godard's film see J. Paech, *Passion oder die Einbildung des J.-L. Godard,* Cinematograph, VI (Frankfurt am Main, 1989); J. L. Leutrat, *Des Traces qui nous ressemblent. Passion de J.-L. Godard* (Paris, 1992); K. Krüger, 'J.-L. Godards Passion', in H. Korte and J. Zahlten, eds, *Kunst und Künstler im Film* (Hameln, 1990), pp. 81ff. For Godard's screenplay texts see A. Bergala, ed., *J.-L. Godard par J.-L. Godard* (Paris, 1985), pp. 586ff. Bonitzer's remark in P. Bonitzer, *Décadrages. Peinture et Cinéma* (Paris, 1985).

Photographic Acknowledgements

The author and publishers wish to express their thanks to the following sources of illustrative material and/or permission to reproduce it (excluding sources credited in full in the captions):

ADAGP, Paris and DACS, London, 2001: 111, 118, 119, 159; Alinari: 43; Galerie Thomas Amann, Zürich: 117 (© The Andy Warhol Foundation for the Visual Arts, Inc/ARS, New York and DACS, London 2001); ARS, New York and DACS, London, 2001: 151, 165, 167; Michèle Bellot: 101–3; J. G. Berizzi/© Gilbert Boudar: 138; E. Bernard: 72; Gérard Blot: 30, 53; Stiftung Sammlung E. G. Bührle, Zürich: 61; Balthasard Burkhard: 174; Leo Castelli Gallery (© Robert Rauschenberg/DACS, London/VAGA, New York 2001): 154; A. C. Cooper Ltd: 58; DACS, London 2001: 172, 173; Fogg Art Museum (Harvard University Art Museums), Cambridge, MA: 33 (bequest of Grenville L. Winthrop), 62 (bequest from the collection of Maurice Wertheim); Lysiane Gauthier: 22; Haagse Gemeentemuseum, Den Haag: 125, 126; Richard Hamilton: 148 (© Richard Hamilton 2001. All Rights Reserved, DACS); © President and Fellows of Harvard College: 19, 20 (bequest of Grenville L. Winthrop, photo Rick Stafford); Evelyn Hofer: 158; University of Iowa Museum of Art, Iowa City, IA: 151 (copyright 1999 © The University of Iowa Museum of Art, All rights reserved (gift of Peggy Guggenheim); Donald Judd Foundation/VAGA, New York/DACS, London, 2001 (photo: Rudolph Burckhardt): 161; The Estate of Roy Lichtenstein (© The Estate of Roy Lichtenstein/DACS 2001): 170; Robert McElroy: 161; Gary McKinnis: 168; © Succession H. Matisse/DACS 2001: 95; Photos courtesy of J. Matisse Monnier (Succession Marcel Duchamp/ADAGP, Paris and DACS, London 2001): 128–30, 132, 133; Courtesy, Museum of Fine Arts, Boston: 65 (bequest of John T. Spaulding), 70 (Tompkins Collection); The Museum of Modern Art, New York: 96 (acquired through the Lillie P. Bliss Bequest, © Succession Picasso/DACS 2001, photo © 2000 Museum of Modern Art, New York), 98 (© Succession Picasso/DACS 2001), 136 (Lillie P. Bliss Bequest, © Succession Picasso/DACS 2001, photo: © 2000 Museum of Modern Art, New York), 143 (gift of Mr and Mrs Allan D. Emil, © Succession Picasso/DACS 2001, photo © 2000 Museum of Modern Art, New York), 149 (gift of Annalee Newman, © ARS, New York and DACS, London, 2001, photo © 2000 Museum of Modern Art, New York), 150 (gift of Mr and Mrs Ben Heller, © ARS, New York and DACS, London, 2001, photo © 2000 Museum of Modern Art, New York), 153 (Sidney and Harriet Janis Collection Fund), © ARS, New York and DACS, London, 2001, photo © 2000

Index

Numerals in *italics* refer to illustrations